CHUCK CLOSE | WORK

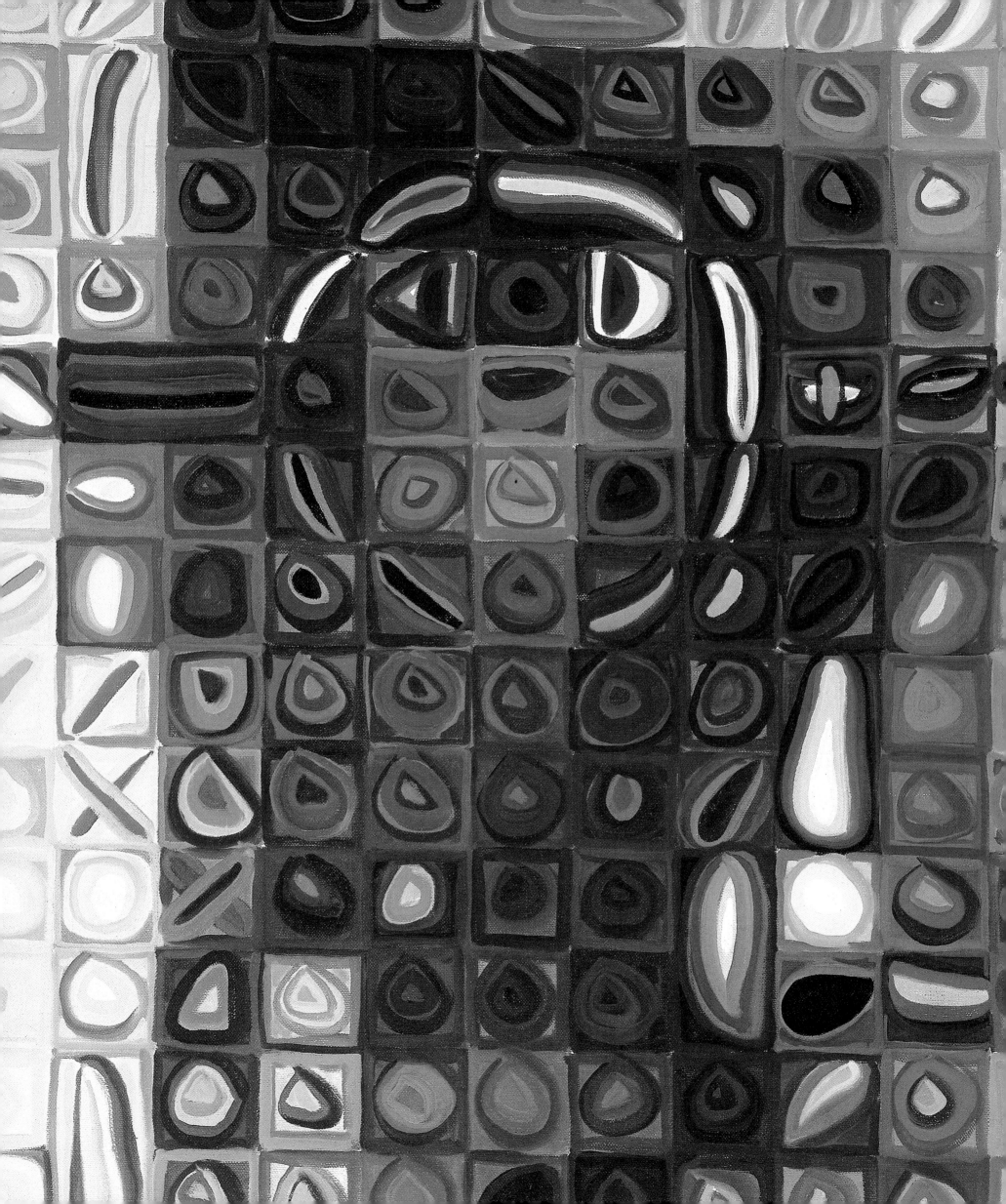

CHUCK CLOSE | WORK

CHRISTOPHER FINCH

Prestel

MUNICH · BERLIN · LONDON · NEW YORK

For Linda, with love.

Front cover: Chuck Close painting *Self-Portrait*, 2000–1 (p. 293) • Back cover: Studio view, *Self-Portrait*, 2000–1
Endpapers: Chuck Close daguerreotype series *Five Self-Portraits* (full progression, p. 332)
Frontispiece: Chuck Close painting *Self-Portrait* (detail), 2004-5 (p. 295) • Opposite this page: *Self-Portrait* (detail), 1987 (p. 167)
Opposite contents page: *Self-Portrait* (detail), 1988 (p. 258)
Opposite Acknowledgments: *Self-Portrait/Watercolor* (detail), 1976–77 (p. 109)

PRESTEL VERLAG
Königinstrasse 9, 80539 Munich
Tel. +49 (89) 38 17 09-0 • Fax +49 (89) 38 17 09-35

PRESTEL PUBLISHING LTD.
4 Bloomsbury Place, London WC1A 2QA
Tel. +44 (0) 20 7323-5004 • Fax +44 (0) 20 7636-8004

PRESTEL PUBLISHING
900 Broadway, Suite 603, New York, New York 10003
Tel. +1 (212) 995-2720 • Fax +1 (212) 995-2733

www.prestel.com

Prestel books are available worldwide. Please contact your nearest bookseller or one of the
above addresses for information concerning your local distributor.

Library of Congress Control Number: 2007929944

British Library Cataloguing-in-Publication Data: a catalogue record for this book is available from the British Library.
The Deutsche Bibliothek holds a record of this publication in the Deutsche Nationalbibliografie;
detailed bibliographical data can be found under: http://dnb.ddb.de

Editorial direction by Christopher Lyon • Design and layout by Mark Melnick, New York City
Origination by Reproline Mediateam, Munich • Production by Amanda Freymann and Astrid Wedemeyer • Printed and bound by Passavia, Passau

Printed in Germany on acid-free paper

ISBN 978-3-7913-3676-3

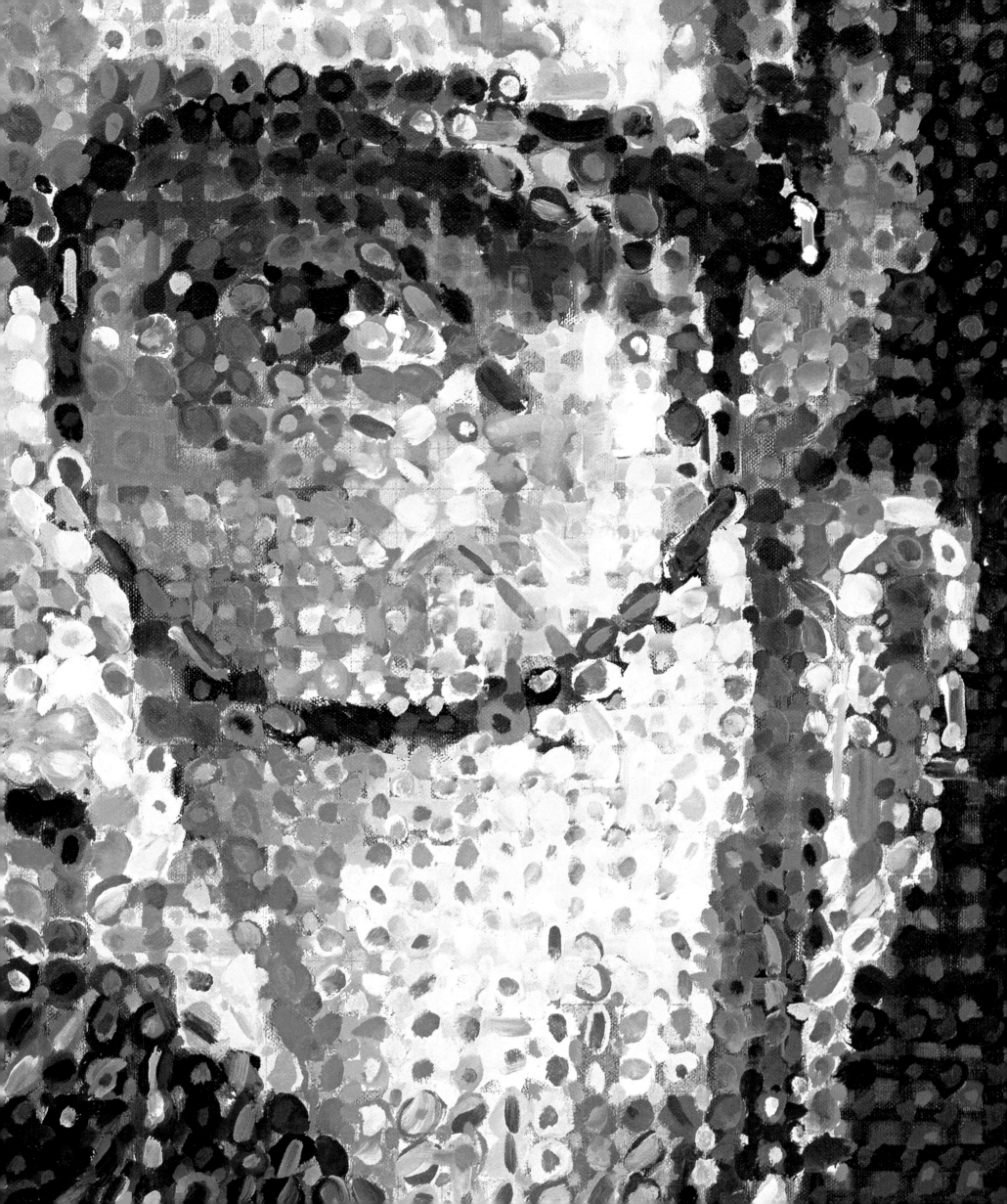

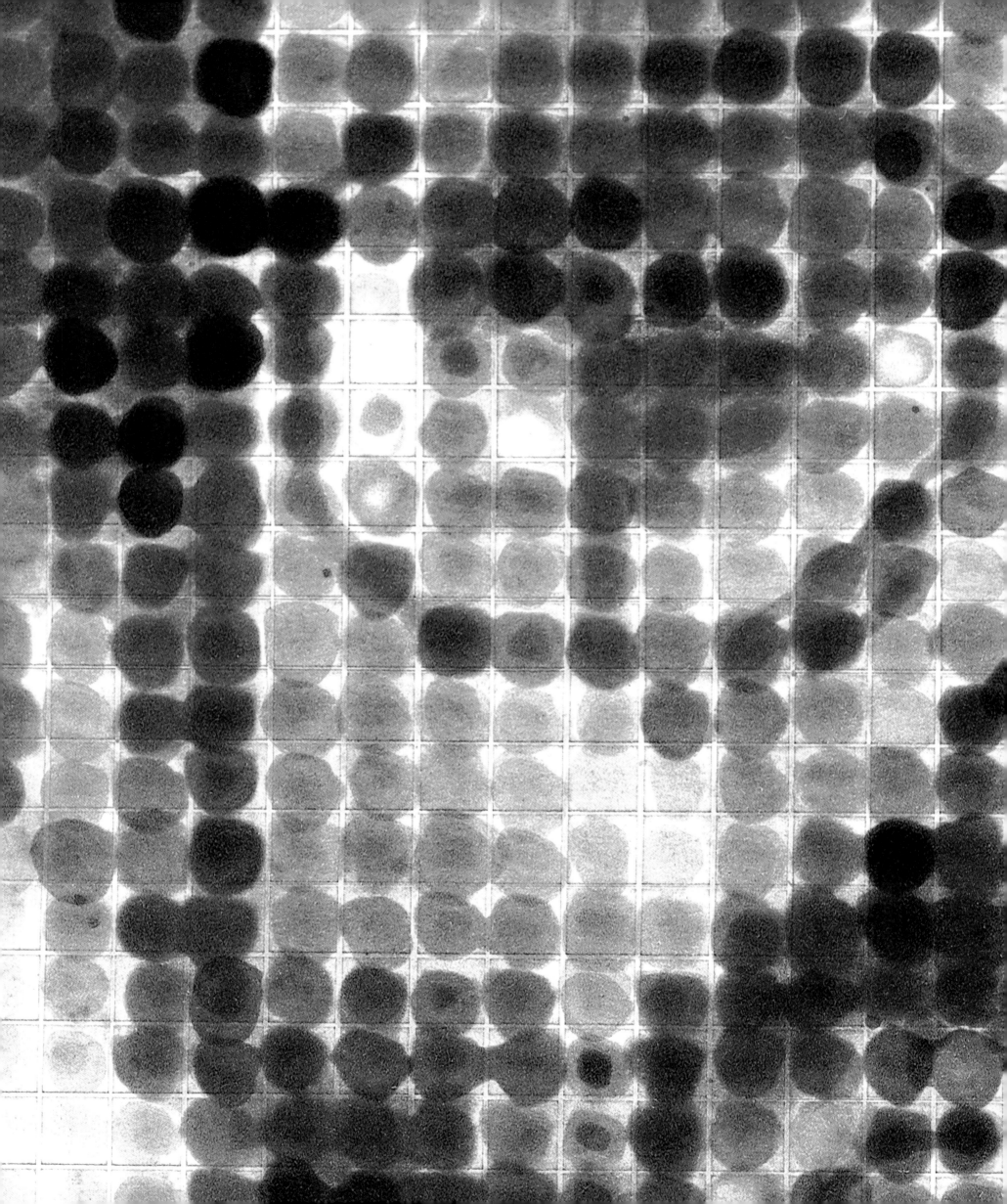

ACKNOWLEDGMENTS

Writing this book has been an enormous pleasure, due largely to two things. One has been meeting the challenge of finding the words to describe the visual richness of Chuck Close's work; the other is the fact that the project has given me the excuse to spend even more time than usual talking with Chuck about past events and present projects. If this book lacks one thing, it is a sense of the exhilarating digressions that every conversation seemed to generate—looping expeditions into art world politics, SoHo folklore, and beyond. It is my intention to include a potpourri of these in a future volume.

Not only did Chuck make himself available at all times—in person, by phone, and by Internet—he allowed all of us involved with the book virtually free run of his Manhattan studio, so that at times photographs, transparencies, catalogues, and notebooks were spread out and piled deep over multiple tables and light boxes for days at a stretch, while Chuck remained available to answer questions, to retrieve a snapshot from a childhood album, or to check a slide for color accuracy. No one could have been more gracious or generous.

I am also enormously indebted to Leslie Close, who provided comments and suggestions regarding many aspects of her husband's life and work, and whose contribution was crucial to the pages that deal with the crisis that engulfed the Close family following the collapsed artery that paralyzed Chuck from the neck down in December of 1988. It is difficult to present the consequences of an episode of this sort objectively, especially when embedded in a text focused primarily on the subject's achievement as an artist. In this context—and given the fact that, against the odds, Chuck successfully resumed his career—the temptation to mythologize is always a danger. Leslie's recollections of events that were extremely painful for her to relive enabled me to maintain a balanced view that, I hope, brings a sense of reality to this account.

Thanks are due to the staff of Chuck Close's studio, members of which, as already indicated, suffered extended invasions of their world. They provided a hundred kinds of assistance without which this book would have taken a great deal longer to produce. In particular, I extend my gratitude to Janie Samuels, Beth Zopf, Manolo Bustamente, Michael Marfione, and Field Kallop. Chuck's long-time studio assistant Michael Volonakis provided special insight into the days at Rusk Institute when Chuck began to paint again after months of painful treatment and rehabilitation.

Special thanks are due as well to Arne Glimcher, Chairman of PaceWildenstein, and to the gallery's staff—especially Aram Jibilian, Ola Czarnecka, Ken Fernandez, and Heather Palmer.

Among those who supplied me with important recollections were Mark Greenwold, Barbara Harshman, Robert Israel, and Peter MacGill. Thanks are also due to Kate Hirson, Sam and Martha Peterson, Judith Stonehill, and Richard Brockman and Mirra Bank, each of whom helped facilitate my research.

I owe a huge debt of gratitude to my editor, Christopher Lyon, who championed this project from the outset, made many valuable suggestions, and managed to stay in control of the logistics of what became an enormously complex project, while still finding the time and concentration to remain on top of the smallest detail. The team at Prestel, led by Publisher Jürgen Krieger, have been unwavering in their support, and I especially thank Curt Holtz in Munich and Stephen Hulburt in New York.

Designer Mark Melnick has been a joy to work with and has contributed an outstanding layout that is elegant, logical, and never intrusive. Amanda Freymann has handled the very demanding production chores with consummate skill.

Finally, my special gratitude goes to my wife, Linda Rosenkrantz, whose readings of the manuscript have spared me many blushes. The fact that her likeness appears several times in these pages is only appropriate.

8

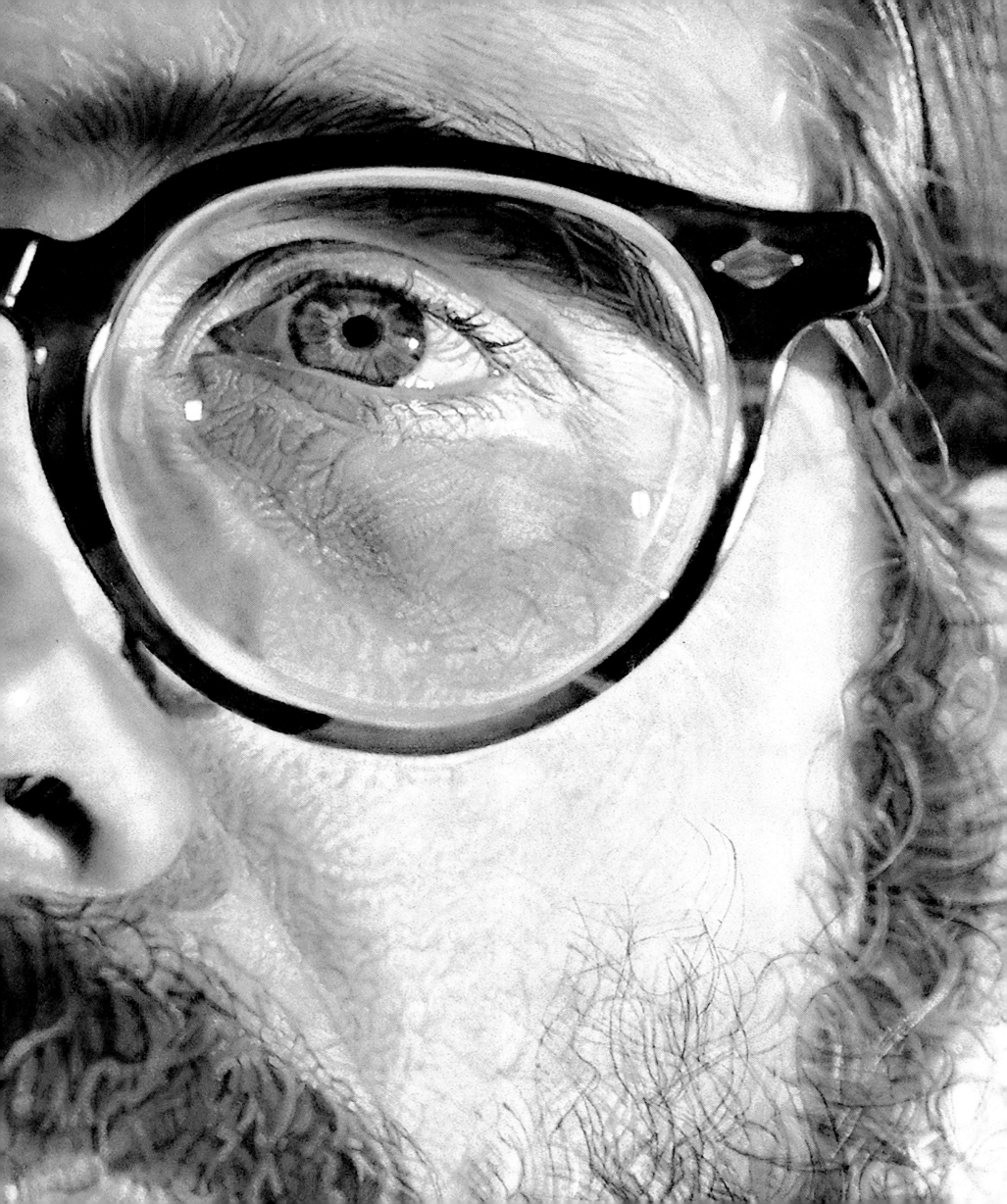

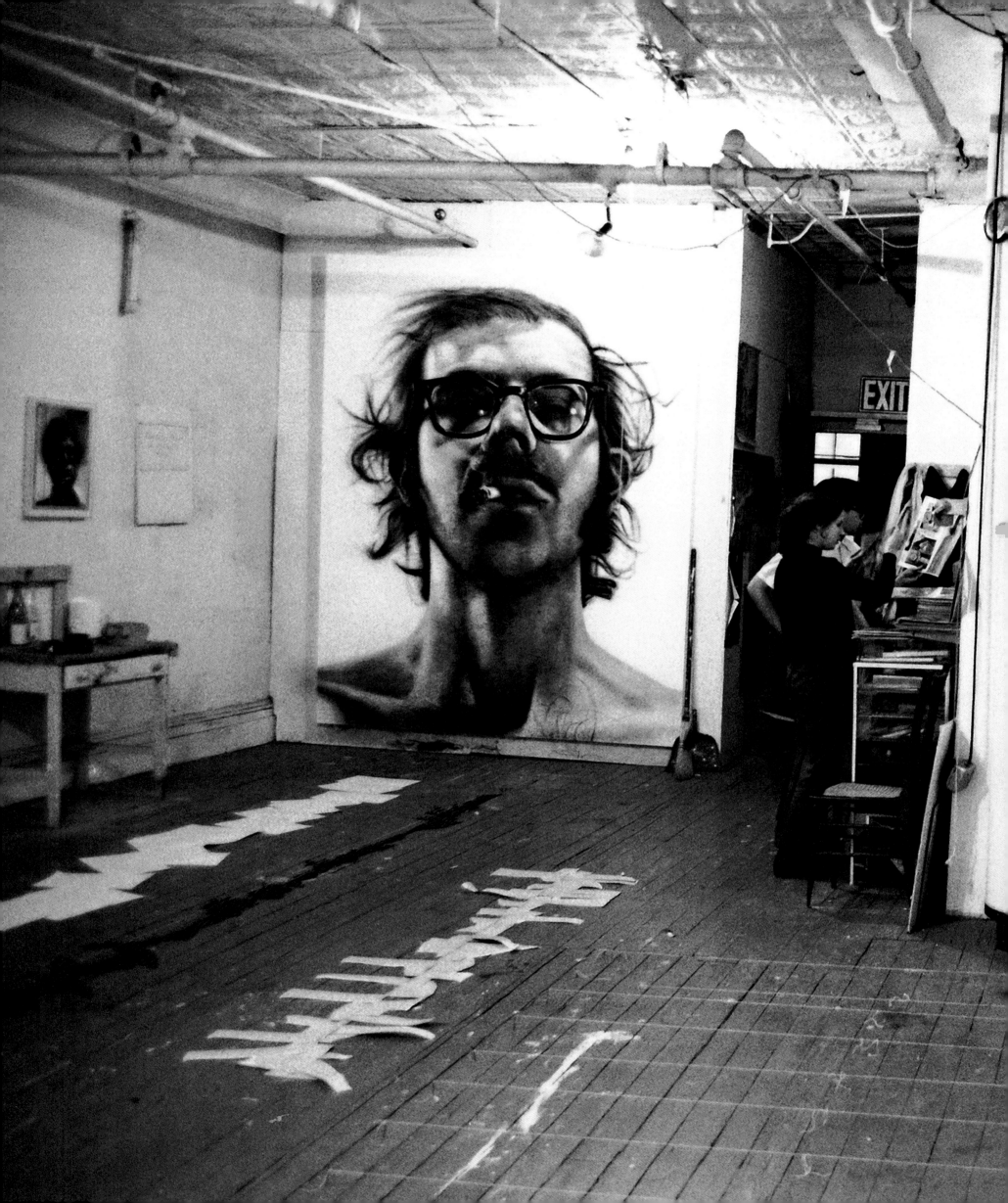

INTRODUCTION

I first heard the name Chuck Close towards the end of 1968, when I was an associate curator at the Walker Art Center in Minneapolis. My friend Robert Israel, then at the beginning of a distinguished career in theater design, called from New York to tell me he had just seen an amazing painting that I absolutely must check out next time I was in town. Bob began to describe the painting but quickly broke off and said, "You have to see it for yourself."

When I was next in New York, I arranged to visit Close's studio at 27 Greene Street. In those days, the future SoHo was a rundown manufacturing district that became more decrepit and garbage-strewn the further downtown you went. Close's loft was almost as far south as you could go before hitting the traffic snarls and side-walk bazaars of Canal Street.

It must have been early evening, because although it was still daylight I recall that Greene Street was almost deserted, free of the chaos of trucks that cluttered the cobbled roadway during business hours. The only clues to the neighborhood's daytime commercial activities were refrigerator-sized bales of brightly colored rags and shredded paper, bound with wire and left out on sidewalks. The district is now venerated for its classic cast iron buildings, but in those days its architectural merits were hidden under layers of grime, and number 27 proved to be an especially unprepossessing building. To reach the entrance, you had to climb onto a battered and rusting loading dock. I did so and rang the bell, and after a short wait the door was opened by a denim-clad man about my own age, well over six feet tall—bearded, friendly, his long hair prematurely thinning—who introduced himself as Chuck Close.

He led me up to the third floor, where I was ushered into a large, sparsely furnished room. There, I was confronted by two enormous paintings—one filled an entire wall—that knocked my socks off. The larger was a black-and-white reclining nude, twenty-one feet long and rendered with resolute objectivity and a minute attention to detail. The other was a nine-foot-tall black-and-white portrait, even more detailed, to the extent that at first glance it appeared to be a photographic blowup. It was in fact a likeness of the artist himself, rendered with an airbrush, the image cropped just below the collarbone, the face mustachioed but beardless, though with a healthy growth of stubble. A cigarette dangled from slightly-parted lips and, because of the angle chosen, this supersized face seemed to stare down at me with a confrontational sneer, as if daring me not to be impressed.

I was impressed. My first thought was, "This is the real thing." My second was, "The Walker should buy this." Perhaps Chuck read my mind because at some point during the course of that studio visit, the first of many over the next four decades, he remarked, in an apparently offhand way, "I'm not interested in selling to private collectors. My paintings should be in museums where everyone can see them."

To a large extent, things worked out according to plan.

. . .

Chuck Close paints portraits, but to describe him as a portrait painter is patently inadequate. His reputation as one of the most accomplished and compelling artists working today derives from the imagination and skill with which he has repeatedly reconceived how a human likeness can be set down on canvas or paper, so that, despite the restricted parameters of his subject matter, the arc of his career reveals him as endlessly inventive.

Close first made his mark with that initial self-portrait and a group of seven other black-and-white, explicitly photographic heads that presented their subjects with pitiless objectivity. Implacable and defiant, these paintings managed to combine outright shock value with a sense of seeming inevitable, even essential, at that moment in the evolution of painting.

Those first portraits capitalized on Close's ability to simulate, faithfully and by hand, the end product of a process that allows a camera to mechanically capture a two-dimensional semblance of reality. The paintings he has made in recent years derive equally from photography, yet are utterly different in character. In these, the picture plane is broken down into a clearly delineated grid. Each of the grid's units, which resemble tiny abstract paintings, contains minute pieces of visual information that, when the painting is seen as a whole, evoke a convincing likeness. If the early portraits derive their strength from counterfeiting the camera's ability to record external particulars, the recent paintings dazzle with painterly exuberance.

Between these two series came continuous-tone color portraits, portraits composed of various densities of airbrushed dots, ones made from thumbprints, and still others from wads of tinted paper pulp. Close has also explored the possibilities inherent in a wide variety of print-making techniques—often working on an unprecedented scale—and has experimented with Polaroid photographs and daguerreotypes. The purpose of this book is to present the full range of his work, and to investigate the complex interplay between the varied pictorial strategies he has devised, while at the same time demonstrating how those derive from the single premise that underlies all of his output, namely an unwavering faith in process as a creative protocol.

Close's devotion to process is shared with other New York artists of his generation, but he is unique in having applied the principle so consistently to what had long been an unfashionable traditional genre, transforming it and claiming it for the present. Despite his chosen subject matter—initially seen by some observers as heretically perverse—he is in fact an archetypal product of the New York branch of modernism in its post–Abstract Expressionist phase. Because of his subject matter, and his protean approach to solving self-imposed pictorial problems, he also anticipated much of what came to be known as postmodernism. In addition he has explored, again and again, and with striking originality, the potent interplay between representation and abstraction pivotal to much of the great art of the past century.

Not only has Chuck Close reinvented a genre, he has also constantly reinvented himself. Even during those recurring moments in the cycle of art world fashion when painting has been pronounced dead, the relevance of his work has remained evident. One of the strengths of his work is that, since it has never been in style, it can never go out of style. It is unaffected by fashion.

· · ·

Chuck Close's art would command our attention even if he lived as a hermit, denied all access to interviewers, and kept his background a closely guarded secret. In fact, Close is a very public figure, a willing subject for interviews, a familiar face at art world events and on the streets of Chelsea and NoHo. He is much in demand for panel discussions and other forums at which his verbal skills and wit, along with a well-developed flair for showmanship, are always in evidence.

When discussing his work, Close often addresses topics such as the fact that his life has been shaped, at least to some extent, by the dyslexia which, as a child, led him to think and invent in pictorial terms, devising a visual semantics to compensate for his perceived learning disability. When an exam was looming, and pictorial solutions would not suffice, he was forced to learn to break problems down into manageable bites of information, and this strategy may well have predisposed him towards a certain way of making paintings. Close also suffers from a disorder known as prosopagnosia—a difficulty in recognizing faces—that may not be entirely irrelevant to his devoting his career to the painstaking fabrication of larger-than-life portraits.

On the other hand, his chosen way of applying the notion of process to making art owes at least as much to the intellectual climate of the 1960s New York art world as to his battle to overcome dyslexia, and it could be argued that his initial decision to paint provocatively enormous heads was equally motivated by the desire to make a decisive visual statement that could not be ducked or sidestepped by fellow artists or critics.

Certainly Close's art can be appreciated without any knowledge of the struggles involved in overcoming a daunting set of early hardships, but an awareness of the character of those struggles can contribute to an understanding of how it evolved and how these struggles shaped his artistic personality. This book is primarily a study of Chuck Close's art, not a biography, but it does take the point of view that having some pertinent information about his background is useful in gaining a fuller grasp of his achievement.

The author of a book like this has to be wary of the fact that the selective use of biographical material can easily degenerate into mythmaking. In the case of Chuck Close, this is complicated by the fact that the one thing that many people know about his life is that he was struck down in mid-career by a traumatic event—a collapsed spinal artery—and has since been largely confined to a wheelchair. Especially because Close is such a highly visible figure in the art world, that wheelchair has taken on an iconic status, a useful hook to hang a story on, like van Gogh's severed ear.

Chuck Close was a highly accomplished and respected artist long before the catastrophe that put him in a wheelchair, and, devastating as the calamity was for him and his family, it in fact had remarkably little impact on the continuity of his work, which has not deviated from its previous trajectory and has maintained the same high level of accomplishment.

That said, the commitment, determination, and agonizing daily grind that went into overcoming his misfortune, and the unswerving support he received from his family and others close to him, is a story that cannot be ignored. It tells a great deal about Close's character, and the power of art to resurrect a life, but it is actually his ability to have overcome and capitalized upon the learning and perceptual difficulties that he struggled with in his early life that is more relevant to understanding him as an artist.

When Close says, "Art saved my life—twice," it's no casual remark, but salvation is only part of the story. The statement also points us back to the work itself, the paintings, drawings, prints, and photographs that have taken on a life of their own. It is Close's ability to instill his works with this kind of vitality—to imbue them with an independent and self-sustaining existence—that makes him an artist of enduring consequence.

Chapter 1:

AN UNSENTIMENTAL EDUCATION

Born in Monroe, Washington, on July 5, 1940, in a cottage that might have been appropriated from a Grant Wood painting, Charles Thomas Close was named for his maternal grandfather (he was not known as Chuck until his teens), and grew up in and around Everett and Tacoma, Washington, mostly the former. Everett was a gritty, blue-collar town, its economy built primarily on lumber and paper mills. (As an adult, Close would make art from paper pulp but recalls with distaste the pervasive stench produced by the commercial pulping process.) In the late 1960s, the town would become home to Boeing's 747 production line, which inevitably changed its character, but in the forties and fifties it retained much of the atmosphere of an old-fashioned labor stronghold, having been in 1916 the scene of a violent clash between members and supporters of the Wobblies—the radical Industrial Workers of the World union—and local sheriff's deputies, during which seven men were shot and killed. Union towns tended to be places where books were respected, even revered, and it can be assumed that, when Close was growing up, Walt Whitman and Jack London had a place of honor on plenty of bookshelves around Everett. There was a lively music scene there too, but visual culture was mostly limited to demotic—though admittedly lively—expressions such as billboards. It was not the kind of milieu likely to divert an ambitious youngster towards a career as an artist, unless

he was strongly predisposed that way. Nonetheless, Chuck Close recalls deciding at the age of four or five that an artist was precisely what he intended to be.

If the broader cultural setting was not encouraging to such aspirations, the micro-environment of the Close household—modest though it was—was another matter entirely. Mildred Emma Wagner and Leslie Durward Close had met while singing in a church choir in Auburn, Washington, then the center of a truck farming district operated largely by Japanese-Americans. Both had migrated to the Pacific Northwest from the nation's heartlands. Mildred was twenty-seven years old when her son was born, her husband ten years older. He was what the French would call a *bricoleur*—eclectically imaginative and capable, able to turn his hand to many different tasks—whose name would eventually be attached to several patents. Shortly after Charles was born, he would leave the hardware store where he had been employed to take a civilian job with the US Army Air Corps. During World War II, and in the postwar years, he ran sheet metal shops at military airfields.

Mildred Close was a determined, energetic woman with a highly developed sense of social justice. When, in 1942, Japanese-Americans—including many ex-school friends from Auburn—were deported to internment camps, she took part in a protest on the steps of the State Capitol, a brave thing to do, given the mood

15

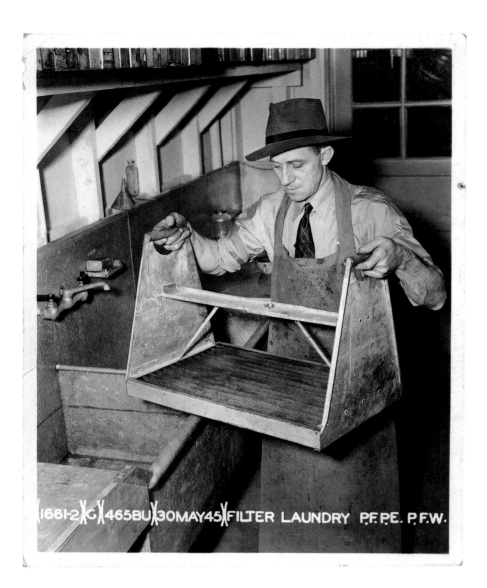

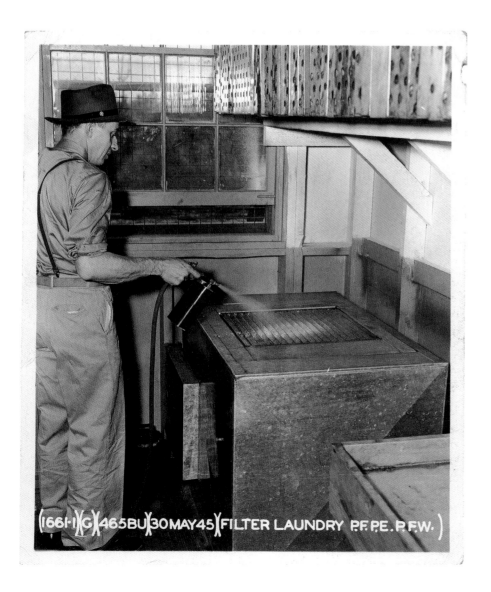

top and bottom:
Photographs of Leslie Durward Close, May 1945; taken
for a patent application for a filter laundering system

that followed Pearl Harbor. She was also a gifted pianist who had taken lessons with the best local teachers, but had been prevented from pursuing her studies to their logical conclusion by lack of funds, allied to the fact that her mother was a chronic agoraphobic who could not accommodate the thought of her only child leaving home. Chuck Close remembers that there was always a grand piano filling half the living room of the succession of tiny houses they lived in. Mildred gave lessons, but undoubtedly felt frustrated at not having had the opportunity to pursue her dream, realistic or not, of becoming a concert pianist.

Outwardly, the Closes were a regular, lower-middle-class American family, much like their neighbors, but as a unit they possessed an internal dynamic that was not entirely typical. Leslie Durward Close had been sickly since childhood, suffering from rheumatic fever and other heart-related problems. Although he grew up on a ranch, he had been unable to perform the normal farm chores, and had instead helped his mother in the kitchen. He would in fact become a skilled mechanic and metal worker, but Chuck Close remembers that a typical Saturday would find his father baking a pie while his mother (not noted as much of a cook) mowed the lawn or changed the piston rings on the family car. Often Leslie Close was at home for extended periods because of various illnesses, some of them life threatening, as when he suffered a coronary seizure while working atop a utility pole, surviving only because of his safety harness.

Charles must have been aware, however subliminally, of the precariousness of his father's health. In retrospect, he wonders if it was because of this that his parents decided to have no more children. It was key to the family dynamic that Charles Thomas, an only child, was brought up by another only child, Mildred, and a virtual only child, Leslie Durward Close, whose sole sibling was a much older half-brother. Both parents, it can be assumed, had known loneliness and could feel for a boy who was likely to find himself spending many solitary hours. Mildred, the frustrated artist, anxiously encouraged her son to fill that solitude with creative activity. Leslie, the semi-invalid, must have identified with the boy's physical problems, manifested when he was very young. Charles was well-built and strong, but a neuromuscular condition

Chuck Close with his mother and father, c. 1943

prevented him from playing most sports. If he tried to run, his legs would "seize up" after a few yards, and he would trip and fall. It's not difficult to imagine how mortifying this must have been for a young boy with a powerful desire to be popular. It was at this early stage in his development that the future artist began to absorb the crucial lesson that, when faced with what the world categorized as a disability, it was vital to find some compensatory skill at which to excel. He might not possess the coordination needed to shoot baskets or steal bases, but he did have precocious eye-hand coordination when it came to drawing and painting, and he discovered that this could be extended to such skills as performing sleight of hand tricks. An old top hat and a battered frock coat were unearthed in a Salvation Army thrift store, and Charles Close the magician was born (see p. 18). At around the same time, his father built him a puppet theater, which provided another way of keeping the other kids amused. Charles Close, it emerged, was a natural performer, as anyone will attest who has heard the adult Chuck Close address a public assembly. He also had a knack for organization that enabled him to persuade other boys to participate in activities he excelled at, so that his athletic shortcomings were overlooked, or at least minimized.

The boy's alleged disabilities were not limited to this neuro-muscular problem. Almost as soon as he began to form letters, he discovered that he could do mirror writing, and upside-down writing too, as easily as conventional writing. This is now often interpreted as a symptom of a form of dyslexia. In those days, dyslexia was unheard of within the mainstream educational community, and the fact that some children had difficulty reading was explained, if at all, by such theories as deficiencies of vision. More commonly it was it was dismissed as the product of stupidity. From his grade school days, Charles Close had difficulty reading, and though he is now proficient at scouring texts for information (especially those dealing with art), he has never been able to develop the ability to enjoy reading for its own sake, claiming to have made his way through no more than three or four works of fiction in his entire life.

Today it's noted that dyslexics are commonly exceptionally bright, and also both visual and creative. Certainly Close is not alone in the art world in having had to cope with this condition. Robert Rauschenberg, for example, is severely dyslexic, and Andy Warhol almost certainly was. There is some evidence to suggest that prominent historical figures from Picasso, to J. M. W. Turner,

to Leonardo da Vinci (think of the mirror writing in his note-books) were dyslexic. The dyslexic's creativity is commonly seen to arise from the need to process information in imaginative ways to compensate for lacking the processing tools that most people take as standard issue. In Close's case, the relationship between his dyslexia and his art goes beyond that generalization. From an early age, he learned to break information down into small bites that could then be incrementally reassembled into a whole that was in fact a fresh synthesis. This is precisely how he now goes about making a painting.

It was also in grade school that Close became aware of his prosopagnosia, the condition that makes it difficult for him to recognize faces (its cause, a malfunction in a certain area of the brain). He might spend the afternoon playing with a new friend, then walk past him on the playground the next day without saying "hello." Chronic victims of prosopagnosia cannot identify close relatives, or in some cases their own face in a mirror. Close does not fall into that extreme category though it's reasonable, as I have said, to wonder about the relevance of this condition to his having spent his career painting faces, and especially self-portraits. Still, his face blindness is sufficiently developed to be a potential cause of embarrassment. Seeing him today—at a museum opening for example—the casual viewer might assume he knows everyone in the art world. His half-joking explanation for his sociability is that he has to be nice to everyone because in many cases he is not sure who he is talking to.

"It might be someone who did me a big favor, or who bought one of my paintings."

It seems likely that this kind of compensatory technique developed quite unconsciously when he was very young, to help secure his popularity.

. . .

From the beginning, Close's parents helped him minimize these potentially crippling problems by encouraging his strengths. Although the family had very little money, his father had the skill to build toys that matched or bettered anything available from the stores. When, at about age six, Charles asked for "real paints," the genuine Weber Oil Color set—its fat tubes bulging with pigment

suspended in luscious poppy and linseed oils (the smell so seductive, so different from the stench of the nearby paper mill)—was ordered from the Sears, Roebuck catalogue, but the easel that came with it was lovingly constructed by Leslie Close.

Leslie Close's ability to turn his hand to almost anything—and to do so with dexterity and flair—was an important legacy to his son. Everything Chuck Close has produced as a mature artist has been marked by superb craftsmanship—a respect for skillful fabrication for its own sake—that must have derived in part at least from watching his father fashioning toys and other items in his garage workshop. (More elaborate items, such as the easel, were made in the fully equipped shops at the airfields where Leslie was employed, and where Charles also spent time.)

Mildred, meanwhile, willed her son to live out her ambitions by proxy, fighting to ensure that he was not penalized for his academic shortcomings. Unfortunately, she seems to have had little sense of when enough was enough, attempting to insert herself into all of the boy's activities. If he joined the Cub Scouts, she became den mother. Interventions of this sort would become increasingly oppressive, but that should not be allowed to disguise the fact that the emphasis she placed on creativity for its own sake, and on nonconformity, was something Chuck would carry with him for the rest of his life.

It was Leslie, though, who initiated the greatest coup with regard to their son's early art education. After the war, when he was employed at McChord Field, a military airfield near Tacoma, Leslie was in the habit of stopping for breakfast at a nondescript diner that Chuck recalls fondly as a place where you mixed your own soda from seltzer and syrup. There were paintings hanging there, quite professional, and these proved to be the work of another regular customer, a woman who lived just across the street. She had studied at the Art Students League in New York, and Charles's father asked if she'd consider giving him lessons. This led to the boy—aged eight at the outset—making Saturday visits, for the next two-and-a-half years, to a ramshackle building, not much better than a flophouse, where his teacher shared quarters with several other women. Close remembers her as having a solid knowledge of academic technique, and she set him to work on

still lifes and sometimes landscapes *en plein air*. There were also figure drawing lessons, and, astonishingly, some of the other women living there were willing to pose nude, or semi-nude. Close recalls male visitors knocking on the door and being told to come back when his lesson was over. In retrospect, he's inclined to think that his earliest art training may have taken place in a bordello.

Parallel with this instruction, Close pursued a self-devised program of extracurricular studies, analyzing and imitating the work of illustrators who came into the house by way of magazines like *Collier's* and the *Saturday Evening Post*. He particularly admired portraits painted for

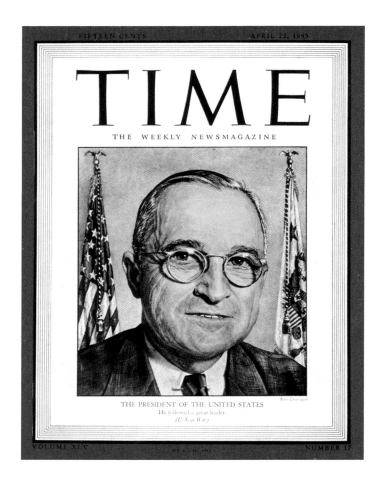

FIFTEEN CENTS · APRIL 23, 1945

TIME
THE WEEKLY NEWSMAGAZINE

THE PRESIDENT OF THE UNITED STATES
He followed a great leader.
(U.S. at War)

VOLUME XLV · NUMBER 17

the cover of *Time* by artists like Ernest Hamlin Baker and Boris Chaliapin. These men were heirs to an academic tradition that had been discredited in the world of high art, but flourished in this journalistic context. Close admired them for their skill, as he still does, devouring their paintings in reproduction, studying details through his grandmother's magnifying glass to learn everything he could about how the illusions were engineered. He also applied the same analytical keenness to reproductions of old master paintings in books borrowed from the library. Today, he is convinced that his hunger to understand the mechanics of pictorialism had much to do with his learning disabilities, and with his prosopagnosia. He had difficulty recognizing faces even in two dimensions—in a photograph, for example—but understanding how an artist like Chaliapin created a likeness by distributing light and shadow to obtain a chiaroscuro effect made the recognition of faces more accessible. Analyzing how an image was built taught him to break down a whole into component parts that could be more easily digested. For Charles, painterly illusion was a magic trick he wanted to master for himself.

When he was about eleven, Close had an experience that momentarily challenged his infatuation with illusion. His mother took him to the Seattle Art Museum to see "real" pictures. There he encountered his first Jackson Pollock, a smallish drip painting that shocked him profoundly. It was, he reports, as if he had heard profanities screamed from the pulpit of a church. This was not art, it was sacrilege. Transgression has its allures, however, and he soon found himself dribbling paint onto his carefully rendered student works.

. . .

Nineteen-fifty-two was a traumatic year for Charles Close. He spent most of it at home, forbidden to attend school because of nephritis, an inflammation of the kidneys. The treatment prescribed in those days called for complete bed rest and a high protein diet that meant eating horsemeat twice a day, alternatives being too expensive. His consolations were a boxed set of eighty Mongol colored pencils, and—vital for someone who didn't read for pleasure—the radio, still in that era offering an enticing variety of situation comedies, soap operas, and dramatic serials. More isolated than ever from his contemporaries, he filled his imagination with characters from shows like *Young Doctor Malone*, *One Man's Family*, and *Sergeant Preston of the Yukon*.

Meanwhile, his father's health had deteriorated to a critical point. The medication he had taken for the rheumatic fever that had weakened his heart caused blood clots as a side effect, leading to frequent hospitalizations and long periods of home recuperation. One afternoon when Charles was in his own room, he heard his father attempting to get out of bed. Through an open door, he saw his father pitch forward and crack his head on a chest of drawers. With no one else in the house, Charles rushed

to his father's aid, finding him in a pool of blood. Weakened by his illness, the boy tried to help his father get up, but couldn't budge him. This time Leslie Close didn't return from the hospital, but succombed to a massive cerebral stroke. He was 48 years old.

With her husband gone, Mildred Close would now focus her full attention on her son.

· · ·

Mildred and Charles moved to a small house in Everett, next door to her parents. It was in Everett that Charles underwent a sometimes difficult passage through middle and high school, his dyslexia causing more problems at this level, where tests and exams were the principal measure of success. His academic fortunes tended to fluctuate with changing teachers. In seventh grade he did well because of a sympathetic teacher who responded positively when he imaginatively employed his talents to compensate for his reading difficulty. On one occasion, for example, he presented an account of the Lewis and Clark expedition as a ten-foot-long illustrated map, which, not surprisingly, was very well received.

In eighth grade, however, Close ran up against Ruth Packard, a by-the-book pedagogue who was impervious to his efforts to impress her with creativity. She handed out straight Ds to Charles, which had a long-term impact because it led to him being directed to a stream of low achievers.

Close's greatest problem was an inability to retain information. He used mnemonic tricks, and before an exam he would engage in a study ritual that depended in part upon establishing a state of sensory deprivation. This involved spending hours in a bathtub filled with lukewarm water, a wooden plank placed across the tub to hold books and file cards, the bathroom in darkness except for a single lamp focused on the notes he was memorizing by rote.

(This watery study routine inevitably conjures up Jacques-Louis David's 1793 portrayal of the dead Jacobin revolutionary Jean-Paul Marat, assassinated in his bath. Marat worked and received visitors in the tub because of a painful skin condition. Close reports that the hours he spent partially submerged had the effect of giving his skin the texture of a prune.)

If the test took place the next day as scheduled, Charles generally did reasonably well. If it was postponed, it was back to the tub. Even employing such unconventional study methods, he could not manage certain subjects at all, never taking algebra, geometry, chemistry, or physics (though some of these courses he made up in college).

It might be assumed that these problems would have a negative effect on his standing in the school community, but he remained popular thanks to well-developed social skills, and also by utilizing his considerable arsenal of compensatory abilities to create niches for himself in various school activities: building and painting sets for plays, producing posters for a variety of events, and making cartoons and illustrations for the school magazine. He had also inherited his mother's musical talent, though he fiercely resisted her attempts to teach him the piano. Instead he chose an instrument she did not play, the saxophone, mastering it well enough to hold down the lead chair in everything from the school orchestra to the marching band.

Also during these high school years, Close developed practical skills that would stand him in good stead as an artist involved with process and high levels of craftsmanship (and also as a pioneer loft dweller). He firmly believes that this might not have happened had his father lived longer, because Leslie Close had not made any effort to pass along his craftsmanship to his son. "He did everything so well there seemed no point in me learning."

21

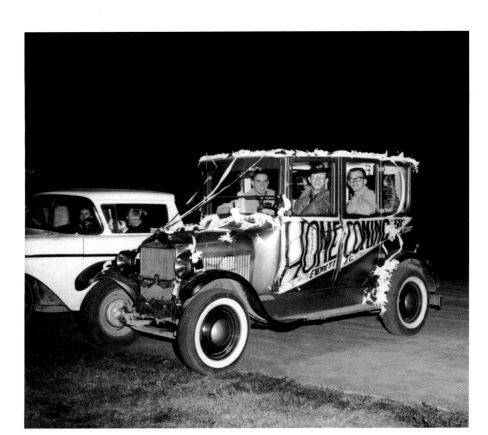

Chuck Close and friends in a 1926 Model T decorated for
the Everett Junior College Homecoming celebration, 1958

Self-Portrait, 1961. Ink on paper

22

As it was, he inherited his father's tools, and the responsibilities that went with them, discovering that he enjoyed mastering the use of saws and wood planes and bevels, and also figuring out how things were made, how things worked, developing a kind of curiosity and fascination with practical problem-solving that later would typify his approach to art.

• • •

Choosing a place to pursue his further education was not an issue for Chuck Close (as he came to be called at about this time). He planned to study art, but did not have the grades to get into a good four year school. Instead, he enrolled at Everett Junior College (now Everett Community College) which had an open enrollment policy for local residents. His announced intention at the time was to become a commercial artist, it having occurred to him that such a career might provide an income that would allow him to drive the kind of dream car that would attract girls.[1] His mother was appalled. In her view, either you did something because you loved it for its own sake, or you didn't do it at all, and she made her opinion very clear. Given that he was attempting to free himself of her overbearing efforts to mold him, it's tempting to think that Close's temporary detour towards mammon may have been prompted in part by sheer contrariness.

In any case, Close was soon back on course towards the fine arts. The art department at Everett Junior College happened to be one of the best of any two year school in the country. Although small, it was very well-equipped, its founder and director, Russell Day, having achieved such a position of influence that art supplies took precedence over football jerseys. An accomplished artist, Day had hired two others, Donald Thompson and Larry Bakke, to teach alongside him. Had Close gone to a four year school, he would have spent the first two being instructed by teaching assistants. Instead, he had the attention of three experienced professionals.

Close thrived in this environment and began to get a sense of the full range of twentieth-century art, becoming especially enamored of postwar American modernism. It was at this time that his infatuation with Willem de Kooning's work began, Close being impressed by the way de Kooning was able to incorporate

figurative elements into the Abstract Expressionist idiom. Close began to emulate de Kooning and other New York School artists, even though access to their work was mostly limited to small black-and-white reproductions. He became obsessed with mastering the style and would sometimes hide from the janitors at locking-up time so that he could return to his easel and paint till the small hours. Interestingly, in light of his mature work, Close also made, during this period, a number of self-portrait photographs, sometimes deliberately manipulating the image in the darkroom to achieve effects such as solarization.

His time at Everett Junior College was an unqualified success and, at the end of two years, he was able to transfer to the University of Washington in Seattle. There he came under the sympathetic tutelage of Alden Mason, whose own paintings of the period also owed a good deal to Abstract Expressionism. Born in 1919, in Everett, Mason (who had lost his own father at an early age) became something of a father figure for his talented student. In a 1984 interview, he spoke of his early impressions of Chuck Close.

"He used to knock on the door of the office about ten times a day for a while. At that time he chewed his fingernails down short and he was very nervous, and he painted kind of big gesture, abstract sort of expressionist things which I was doing at the time . . . and which he liked very much. He in a sense was emulating what I was doing, and he did it really very well. But he'd come in and ask, 'What'll I do with this painting, Alden? What'll I do? He was always so nervous and upset and, you know, wanted some kind of confirmation [that] what he was doing was okay."[2]

These early insecurities didn't stand in the way of Close's successful progress through the art education system. Since he was now in a situation that played to his strengths, he was no longer seen as a handicapped striver but as a star student, and in 1961, towards the end of his junior year, he won a scholarship to the Yale Summer School of Music and Art in Norfolk, Connecticut. Fellow students included Brice Marden, Vija Celmens, and David Novros, and the teaching staff featured major art world figures such as the painters Philip Guston and Elmer Bischoff, and the photographer Walker Evans. The approach to teaching was unlike anything Close had encountered before. Guston, for example,

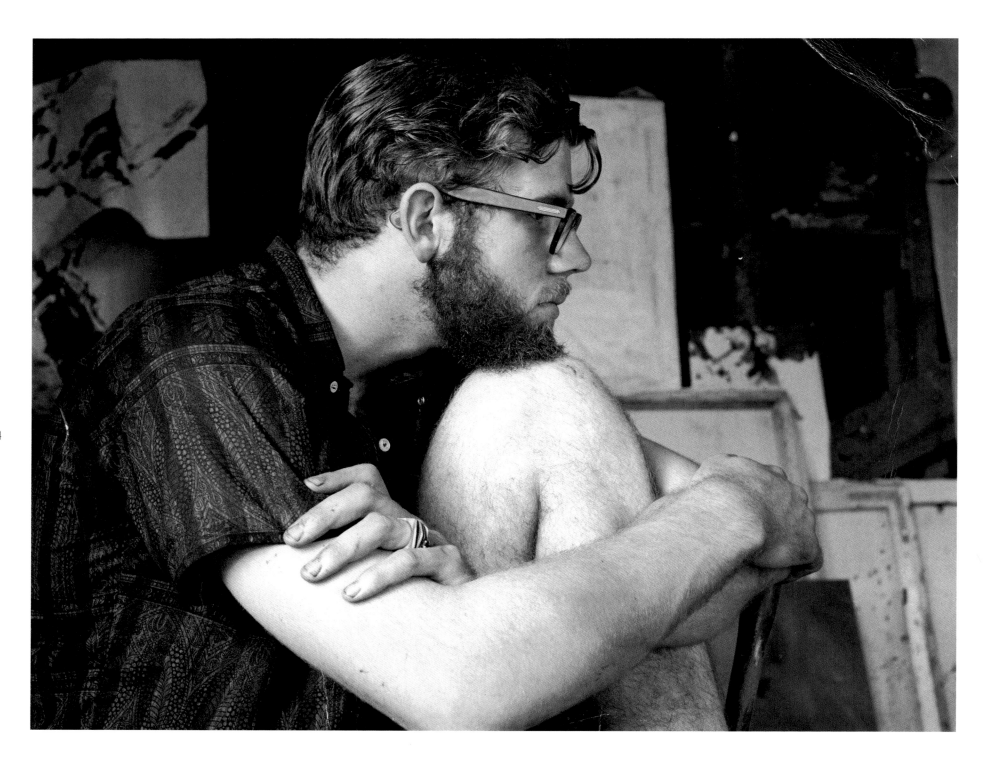

◄ Chuck Close at Yale University's
Summer School of Music and Art,
Norfolk, Connecticut, 1961

Betsy Ross Revisited, c. 1961.
Mixed media on canvas, 86 x 111 in.
(218.4 x 281.9 cm)

attempted to short-circuit acquired habits by having students draw with long sticks dipped in ink, a lesson Close would have reason to remember decades later when paralysis turned his forearm into deadwood.

The trip East also afforded him the opportunity for a first visit to New York, where he stayed for a week. He spent his days in galleries and museums, and his evenings listening to musicians like Thelonious Monk and Charles Mingus. His first taste of the Big Apple was every bit as sweet as he had imagined it would be.

Back in Seattle he managed to precipitate a significant local scandal when he submitted to the Forty-Seventh Annual Exhibition of Northwest Artists a painting titled *Betsy Ross Revisited*. He had a large flag, bought in a thrift shop, mounted on a canvas and overlaid it with elements such as an Abstract Expressionist rendition of a mushroom cloud scrawled with the words "E Pluribus Unum." The nod towards Jasper Johns's flag paintings was probably a bit obscure for most people, but the anti-nuclear message could not have been clearer. (It must have given his activist mother some satisfaction.) The selection committee awarded the painting third prize, but the director of the Seattle Art Museum refused to hang it. When the painting was exhibited at the Puyallup Fair (the Western Washington State Fair) it narrowly escaped destruction at the hands of irate American Legionnaires, all of which attracted a good deal of media coverage. Even at that stage in his career, Chuck Close demonstrated a useful knack for being noticed.

In 1962, he graduated magna cum laude from the University of Washington and, through the good offices of Bernard Chaet, administrator of the Yale Summer School, he was accepted into the Yale MFA program. Fellow students would include Brice Marden, once again, Richard Serra, Nancy Graves, Janet Fish, Jennifer

Bartlett, Kent Floeter, Steven Posen, Don Nice, Robert Mangold, Rackstraw Downes, and Newton Harrison, a notable group by any standards. Close had been making ambitious work for some time, but now he found himself in the position where it would be subjected to withering critiques by staff members, some of them with international reputations, by visiting artists like Robert Rauschenberg (who remarked on arrival, "This place reeks of Matisse"), and by the ongoing scrutiny and unsparing comments of gifted and competitive peers. Students were, in effect, given a taste of what it would take to succeed in the real world. Close singles out Al Held as a faculty member who demystified the business of making art, passing on tips for survival. Held's father had operated a coffee stand on Prince Street, in what would become SoHo, and young Held had grown up delivering coffee and bagels to local sweatshops that would soon be transformed into artists' lofts. He warned students they should be prepared to support themselves by slapping up sheetrock or driving taxis, adding that this was infinitely preferable to the living death of a provincial teaching job.

It was during Close's Yale years that Jack Tworkov became chairman of the Art Department, letting in a gust of fresh air. Although identified with Abstract Expressionism, Tworkov was in fact very open to new ideas and championed, for example, Rauschenberg and the Pop artists. Under him, the visiting artist program was rejuvenated, and it was he who was largely responsible for bringing people like Rauschenberg and Frank Stella to the campus.

Significantly, Close was almost totally unaffected by the famous color theory courses that had been initiated at Yale by Josef Albers, and that had been considered central to the school's teaching program. Albers had retired by the time Close arrived in New

25

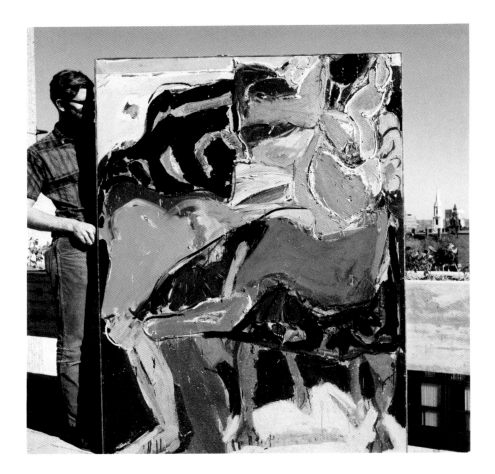

26

Haven, but his philosophy was still very much entrenched there, with Sewell Sillman serving as the master's surrogate. In Close's opinion, however, the Albers courses had become dry and academic, and he managed to avoid them entirely.

One academic course that Close enjoyed was Jules Proun's "History of American Art," which Close had hoped would offer insights into Pollock and de Kooning, but which proved to be concerned with early American architecture and furniture. Close used this course as the occasion for perhaps the most spectacular of his nonverbal papers, coming up with the idea of making comparisons between, for instance, a Hepplewhite-style chest and a Federal Period villa by superimposing an image of the former over the latter—the chest flipped upside down so that its legs corresponded with the villa's chimneys—a device that allowed similarities of structure and ornament to became immediately apparent. For years, Proun used this as an example of how an exceptional paper could be produced without recourse to words.

While at Yale, Close became assistant to virtuoso Hungarian printmaker Gabor Petardi, who had spent most of the 1930s in Paris, where he was associated with Atelier 17, the studio/workshop of another master printmaker, Stanley William Hayter. Petardi's Surrealist-influenced imagery had little to offer Close, but working alongside this veteran craftsman gave him insights into, and experience of, the processes of printmaking, which would prove invaluable later in his career. This practical experience was amplified by the lessons Close absorbed from a course in the history of printmaking taught by Egbert Haverkamp-Begemann, during which students were given the opportunity to study at first hand how prints by great masters of the past evolved from state to state, proof by proof, a practice that once again placed an emphasis on the importance of process in arriving at a satisfactory end product. Close recalls the excitement he felt handling proofs of etchings by Rembrandt, understanding how they were a record of the artist's evolving thought processes, each state evidence of the shifts of direction that could effect a work in progress, with figures being added and subtracted, shadows being scraped away, or chiaroscuro intensified until the entirety satisfied the master's eye.

Lessons learned from Petardi and Haverkamp-Begemann would be felt not only in Close's own extensive activities as a printmaker, but also in his approach to making art in general, since both teachers placed an emphasis on the way in which images are fabricated—on the means to an end, and the patience this sometimes demands. For the time being, Close's paintings remained highly gestural, but the seeds of a more deliberate approach to fabrication were being sown.

· · ·

New Haven's proximity to New York allowed for regular access to Manhattan galleries, so that Close could now experience new trends at first hand. His admiration for de Kooning never waned, but he was open-minded enough to buy a signed poster by Roy Lichtenstein, which at this remove may not sound especially adventurous but at the time was looked on as rather radical by some of his fellow students. Lichtenstein and his fellow Pop artists—Andy Warhol, James Rosenquist, Claes Oldenburg, Tom Wesselman, Robert Indiana—were causing quite a stir at the time,

but were outnumbered by young and innovative nonfigurative painters and object makers—Frank Stella, Larry Poons, Donald Judd, Dan Flavin, Carl Andre, Eva Hesse, Sol LeWitt, and Robert Morris among others. Oldenburg, Red Grooms, and Jim Dine were staging Happenings, and Billy Name was applying silver foil to the walls of Warhol's East 47th Street loft, transforming it into the Factory.

While he found all this incredibly stimulating, Close was also rather intimidated by it. Flying in the face of Held's advice, part of him nurtured the idea of securing a teaching job at some not-too-remote liberal arts college where he could pursue his art in Olympian isolation, making occasional forays into Manhattan to recharge his batteries. A factor in this must have been the recognition that he had not yet achieved a personal vision—there was so much to absorb—and that to set up shop in New York as a de Kooning imitator would not cut much ice.

The need for a decision was postponed by the award of a Fulbright Scholarship to study in Europe for a year. Close made Vienna his base but trekked all over the continent to visit the great repositories of western art. It was a broadening experience, the finishing touch to an educational career that had gone from unpromising to illustrious. As the year ended, he received the offer of a teaching job from the University of Massachusetts at Amherst, made on the recommendation of his Yale mentor Bernard Chaet. Amherst seemed to be the Arcadian outpost Close had craved, but two years there taught him that tranquility was not what he needed, and that occasional forays into Manhattan would not suffice.

At U Mass, Close taught three classes, each made up of forty students. As can be imagined, this presented something of a challenge to someone suffering from prosopagnosia. Since he was unable to recognize many of his charges from one class to the next, he hit on the device of making little drawings of their paintings in a notebook, and writing the artist's name alongside. As he went from easel to easel, he could greet people as if the face was familiar, when in fact it was the work he recognized. He claims he can look at these forty-year-old notebooks and recall each painting in detail, not just as they were when finished but as they looked at

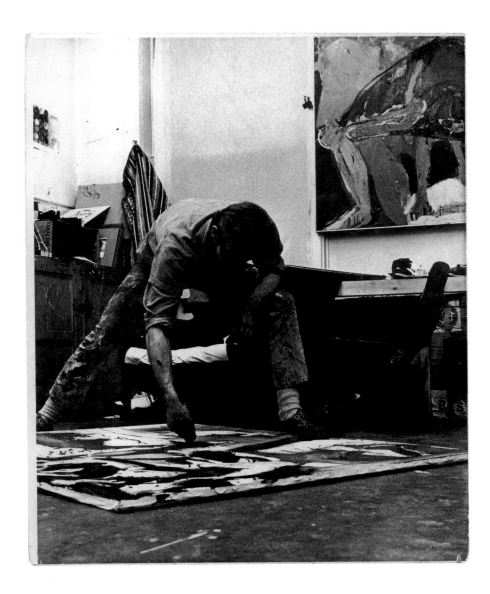

27

every stage. It's been a godsend, he says, when ex-students have asked for references.

While at Amherst, Close was going through a crisis in his own work. The de Kooning–inspired gestural habits were so ingrained they had become a kind of addiction. It was time to go cold turkey, and he began to move towards explicit figuration, turning to photographic imagery as source material, borrowing images from magazines and record album sleeves. In some cases, this Pop-inflected imagery was incorporated into three-dimensional constructions that utilized real objects, Plexiglas panels, and vacuum shaped plastic forms. Little has survived from this period, somewhat to Close's relief since these pieces apparently displayed an awkward eclecticism indicative of his continuing struggle to find an authentic personal idiom.

In 1967, towards the end of his second year at the school, a selection of these works was hung in the Student Union Building, provoking a scandal comparable with the one stirred up by *Betsy Ross Revisited*. This time official ire was sparked by the perception of obscenity, arising from the inclusion of full-frontal male nudity in some works. Unfathomably, someone in authority concluded that a patch of yellow paint in one work represented urine. Campus police raided the show, which was then re-hung in a local gallery where it became the focus of protests against the administration. With the support of the American Civil Liberties Union, Close brought a suit against the college. The case was initially decided in his favor, but that decision was overturned on appeal.

The practical outcome was that his career at the University of Massachusetts was at an end.[3] He had learned Al Held's lesson the hard way.

• • •

By far the most ambitious work Close embarked on during this period was a mural-scaled nude, twenty-one feet long, based on photographs he had taken of a young woman employed by the school. This was to be an entirely realistic painting, its impact dependent upon scale and fidelity to the photographic source. The project was prophetic of the direction in which Close's work would evolve, but it did not get far in this original form. The photographs were black-and-white but his intention was to make the painting in full color. Looking back, he cannot imagine what he was thinking. In any case, it quickly became apparent that flesh

tones could not be improvised to his satisfaction, and he found that conventional brush-on-canvas technique was not giving him the look he had hoped for. The painting was abandoned, but the project would be revived not long after, with important differences.

• • •

The choice of where to relocate was never in doubt. By now Close knew that he had to be in New York, and he eagerly accepted the offer of a part-time teaching job at the School of Visual Arts, instigated by his former Yale classmate Don Nice. Appropriately, he was hired to teach painting and drawing in the photography department.

In the summer of 1967, he began to hunt for a studio/living space in Lower Manhattan. Joining him in the search was Leslie Rose, whom he had met when she was a student in one of his classes at U Mass. Close admits to having been a mess when he met Leslie, his frustrations with his work spilling over into his life, so that he found himself living in squalor, drinking excessively, and running up debts. He credits Leslie with straightening him out and putting him back on course. Since that inevitably pointed to setting up shop in New York, she joined Close in trudging garbage-strewn downtown sidewalks in search of an affordable loft space, though this was not a move she relished at the time. Eventually they found a vacancy at 27 Greene Street, in the future SoHo, and moved in their few belongings. On Christmas Eve, 1967, Chuck Close and Leslie Rose were married.

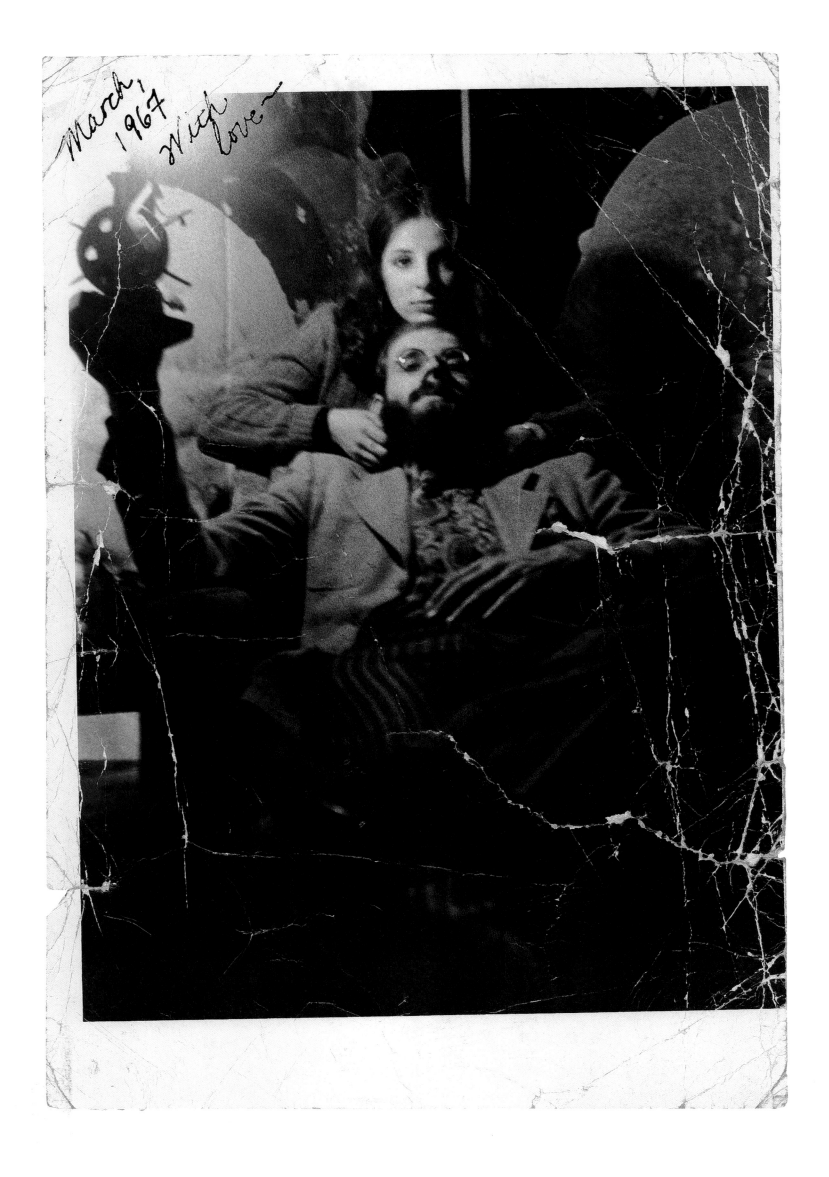

March, 1967 With love~

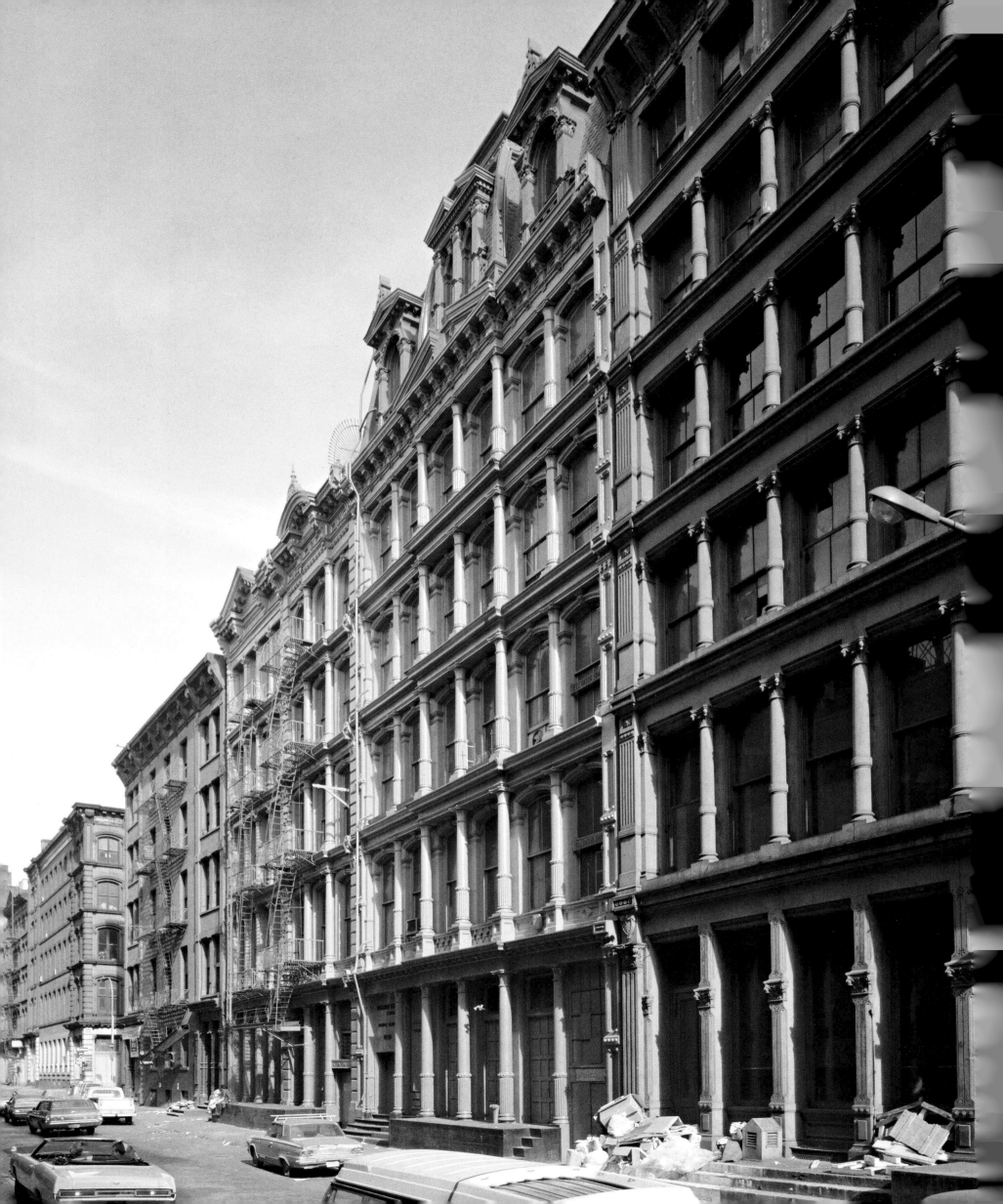

◄ East side of Greene Street, looking north
from the approximate location of Chuck and
Leslie Close's loft, c. 1970

Leslie and Saka in the Greene Street loft, 1968

Chapter 2:

HELL'S HUNDRED ACRES

The SoHo that Chuck and Leslie Close moved to in 1967 bore little resemblance to the crowded, up-market neighborhood that tourists flock to today. The area wasn't even called SoHo yet—that dignification was a half-dozen years away—in fact it didn't have a proper name of any kind, though reverential city historians referred to it as the Cast Iron District. The artists who began to move in during the 1960s generally called it the loft district and left it at that. New York City's firemen had a more sinister name for the neighborhood, having dubbed it "Hell's Hundred Acres" after a series of fires and fatalities in the late fifties and early sixties. When one of those ornate cast-iron loft buildings caught fire, the wood floors burned like tinder, and the metal framework softened in the intense heat so that the structure quickly collapsed under its own weight. As long as the area remained an industrial enclave, deserted at night, Fire Department policy had been to fight loft fires from the street and not risk men's lives by asking them to enter unstable blazing buildings. The arrival of artists as illegal residents in the neighborhood changed all that, since there was no telling where a painter, with his highly flammable materials, or a sculptor with his acetylene welding tools and blowtorch, might be hiding out behind shutters or blackout curtains to escape the notice of city inspectors. Buildings could no longer be allowed to burn to the ground with minimal intervention, so the lives of

the men in fire stations around Lower Manhattan became that much more dangerous.

As for the artists, they were prepared to take their chances on living in fire traps, with ancient wiring and substandard sprinkler systems, in exchange for rents that were so low they barely covered landlords' property taxes.

The rundown industrial building at 27 Greene Street, where the Closes' established their initial toehold, was next door to a brush factory. By day the street was clogged with commercial vehicles of various kinds, many laden with brightly colored rags and shredded paper, bound into bales by the local scrap merchants. These were the most cheerful things around since the Victorian buildings themselves were coated with decades of grime, and the sidewalks were littered with industrial detritus. Street life was largely limited to the loading and unloading of trucks. By night, Greene Street, like all of its immediate neighbors, was deserted, an urban wasteland, with rats frolicking in the gutters.

"Rags and rats" is Close's succinct description. "Rats and rags."

Many prospective collectors were hesitant to visit artists' studios after dark because the district seemed scary—a muggers' paradise. (On one occasion, a cab driver refused to let Leslie out of his taxi outside her own home, saying he would not be held responsible for what might happen to her.) In reality, leaders of the

31

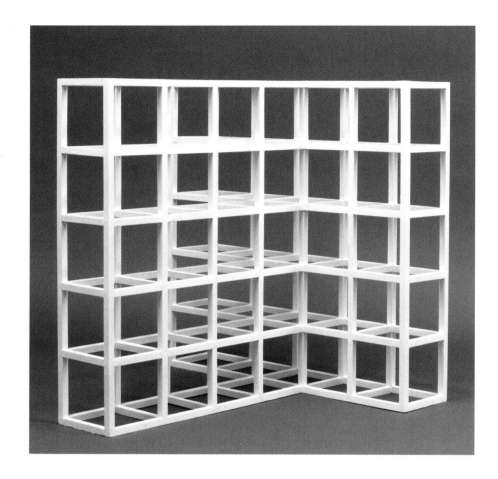

Sol LeWitt, **Modular Piece T**, 1971.
Wood painted white, 24 1/4 x 24 1/4 in.
(61.6 x 61.6 x 61.6 cm)

32

Italian communities that flanked it to east and west made sure that the area remained largely crime free, at least so far as random violence perpetrated by unaffiliated outsiders was concerned. Greene Street was home, however, to private sanitation companies rumored to have mob connections, and it was hinted that the victims of gangland hits—or their dispersed body parts—routinely found their way there to be mingled with the refuse from pasta joints and construction sites, aboard trucks that ferried garbage to various New Jersey landfills. During the Closes' tenure on Greene Street, a turf war between rival sanitation companies gave the Fire Department something to think about besides artists in unsafe buildings, as parked garbage trucks mysteriously burst into flame on moonless nights.

By 1967, artist residents of the loft district had begun to develop a strong sense of identity with the scruffy yet scrappy neighborhood. For the Closes, it was an easy place to network since so many friends had already established themselves there. To New York artists of that generation, SoHo was Montmartre and Montparnasse rolled into one, every colonized loft building an Americanized reincarnation of Picasso's Bateau Lavoir. If the area's immediate attractions were low rents and space in which to work, its indus-

trial character proved to be of considerable importance to at least some of the newcomers. This was a period when many younger artists—including Close and several of his Yale MFA contemporaries—were experimenting with a systemic approach to art, one that depended upon faith in process rather than inspiration. The loft district was the perfect place to observe and absorb the liturgy of industrial process on a scale that was consistent with the technology available to these impoverished young artists. Those bales of rags and paper, for example, could be seen as sculptural objects created by the processes of shredding, shaping, and binding.

Process art was one of the key ideas of the 1960s, and it remains the concept that determines the character of Close's work. To fully appreciate his art, it's important to understand what it was that he and his contemporaries understood by this idea.

The process trend had been inspired by the example of Jackson Pollock whose drip paintings derive their strength from the radical way in which they were produced—the process of splashing loops and swirls of paint onto the canvas—rather than from any preconceived pictorial concept. Even allowing for a generational turning away from Abstract Expressionism, this was a notion that opened up many possibilities for young artists, especially within the context of nonfigurative art. By persistently, even monotonously, applying a particular procedure to a particular material, or combination of materials, an artist could create entities that were original and informed by a consistent logic. To take one instance, Richard Serra (often assisted by Close) experimented with ideas such as creating forms by hurling molten lead into a corner, so that the conjunction of floor and masonry walls served as a kind of open-faced mold and the velocity of the impact determined the end result.

That particular example, with its emphasis on the way that a given material behaves when subjected to a specific process, clearly derived rather directly from Pollock. Other artists, though, applied process in a different way. Several years older than Close and Serra, Sol LeWitt had devised a process for creating impersonal yet dynamic modular sculptures (he preferred the term "structures") and large-scale wall drawings that could be made by other people who were simply asked to follow his directions. Many of

LeWitt's early wall drawings took the form of grids. Close was aware of these and the grid would come to serve as the matrix of almost his entire output.

What made Close different from other process artists was the fact that he had not finished with representation, though his attitude towards it had become far from traditional.

• • •

Bounded by Houston and Canal Streets to the north and south, and by Crosby Street and Sixth Avenue to the east and west, much of the land on which Ur-SoHo stood had once been owned by the buccaneer capitalist John Jacob Astor. In the mid-nineteenth century it had been the city's most fashionable retail and entertainment district, and a center for upscale prostitution, concentrated on Greene Street. Starting around 1850, old masonry buildings were torn down and replaced by a unique style of ornate cast-iron architecture that soon was much imitated elsewhere. In terms of concentration of sheer quantity and quality, the idiom reached its peak in the future SoHo.

At the beginning of the twentieth century, as theaters and department stores migrated uptown, SoHo was inherited by small manufacturing and warehouse companies, mostly owned and staffed by immigrants. Leases were reasonable, the location was conveniently central, and the layout of the cast-iron buildings, with open, well-lit floors, was well-suited to the needs of sweatshop operators. You could fit a lot of sewing machines into one of those lofts, and it was easy for a supervisor to keep an eye on the underpaid employees.

For more than half a century prior to the arrival of the artists, these buildings had been pretty much fully occupied by commercial tenants. That situation was coming to an end, however, partly because the lofts did not lend themselves to modernization, and also because the neighborhood was becoming a transportation nightmare. On top of that there was the Robert Moses factor. For forty years, as head of a dozen state and city authorities, Moses had transformed New York—sometimes for better, sometimes for worse—building spectacular bridges and providing parkways to

give access to well-maintained public beaches, but simultaneously destroying neighborhoods to accommodate his megalomaniac vision of a metropolis bent to the needs of the automobile. One of the last of his grandiose schemes was a plan to drive a superhighway across Lower Manhattan, smack through the heart of what would become SoHo. A major reason for businesses quitting the loft district was the assumption that before long it might cease to exist.

This worked to the short-term advantage of artists because it meant still more empty spaces owned by landlords who were prepared to let them for low rents, turning a blind eye to the fact that many of those who signed leases were intending to live in these strictly nonresidential commercial buildings. If they were prepared to put up with harassment from a variety of city authorities, artists were given the opportunity to establish themselves in the New York incarnation of the painter's garret.

The Closes' Greene Street loft, which they occupied until 1970—and for which they paid a rent of $150 a month—was typical of these early downtown studios in its utter lack of creature comforts. Unbearably hot during the summer doldrums, it was often intolerably cold in the winter. Some loft buildings were heated at least during business hours, but that was not the case with 27

Greene Street, and at first the only heat came from a small space heater. When they could afford to, the Closes supplemented this with electric stoves that they would huddle over for warmth, but on cold nights they continued to sleep fully clothed under an electric blanket. When the weather was really frigid, coffee left in a mug overnight would freeze. To make the place marginally habitable, everything had to be fitted from scratch, even the plumbing—heavy duty to avoid burst pipes—which was installed by Philip Glass, who, while establishing himself as a musical presence on the downtown scene, performed the same service for many pioneer loft dwellers.

With all its hardships, 27 Greene Street was not a bad place to work and Close wasted no time in setting about his most ambitious project to date, a very large nude, based on the same photographs he had used for the monumental nude he had started and then abandoned in Amherst. This time, though, the painting would be made in black and white. The canvas would be almost ten feet tall and twenty-one feet long.

Close was not alone among his contemporaries in being interested in the possibilities of large-scale painting, which had come to be seen as one of the chief legacies of the new American art. The Abstract Expressionists had made scale an issue. They belonged to the WPA generation that had learned much about size from Mexican muralists such as Diego Rivera and José Clemente Orozco but embraced it for different reasons. The whole point of Abstract Expressionism, in its mature form, was the sheer breadth of the painterly gestures involved—a generosity of body language as a way of making marks that could not be adequately accommodated on smaller canvases. This is most evident in the case of Jackson Pollock, and the public became aware of it through the widely seen photographs and films of Pollock at work on his drip paintings, in which it is quite clear that he is painting with his entire physical being, carving out space for himself like a fighter or a dancer.

For the generation that followed, the sense of scale found in Abstract Expressionism fit in well with other concerns, such as an interest in the sheer size of the pictorial content encountered in such archetypically American forms of expression as Times

Square billboards and Cinemascope movies. It is often noted that James Rosenquist had experience as a billboard painter before becoming one of the pioneers of Pop art. His feeling for large-scale imagery led to numerous billboard-sized canvases and allowed him to tackle paintings as big as *F-111* (1964–65)—a fragmented blend of pop and military/industrial iconography—which is eighty-six feet long. Few in the sixties tackled work on quite that scale, but the interest in near-billboard size was commonplace, affecting both figurative artists like Rosenquist, Roy Lichtenstein, Andy Warhol, and Alex Katz, and non-figurative painters ranging from Frank Stella and Al Held to Larry Poons and Jules Olitski.

Even in that context, twenty-one-foot-long nudes, especially painted in black-and-white, were not exactly commonplace. Close's reasons for painting the nude on that scale, and with that limited palette, were several.

Historically, if a painter or sculptor produced figures that were significantly larger than life size, they were almost always intended to be seen from a distance, such as those in Michelangelo's Sistine Chapel frescos (or, for that matter, those seen on Times Square billboards). In painting a hugely enlarged figure, Close had something different in mind. He had no objection to the canvas being seen from afar, where the image's proportions could be understood in a conventional way, but he was much more interested in the impact that it would have at close range, where it would be impossible for the viewer to digest the information in the usual way.[4]

It might be said that Close was inviting the viewer to look at a female nude as if at a landscape seen through a panoramic window. Shoulders and breasts become mountains, a surgical scar a crevasse. Or one might compare the experience to watching a Cinemascope movie from the front row of the theater, trying to adapt to the disturbing fact that the giant bodies on screen diminish in perspective as they move away laterally, while expanses of flesh close to the eye are experienced in embarrassing detail, every pore revealed. (In fact, Close has sometimes referred to this painting as his "Cinemascope nude.")

In a real sense, this monumental increase in scale tends to make that most figurative of subjects, the human likeness, less representational and more abstract. Even from a few feet away, it

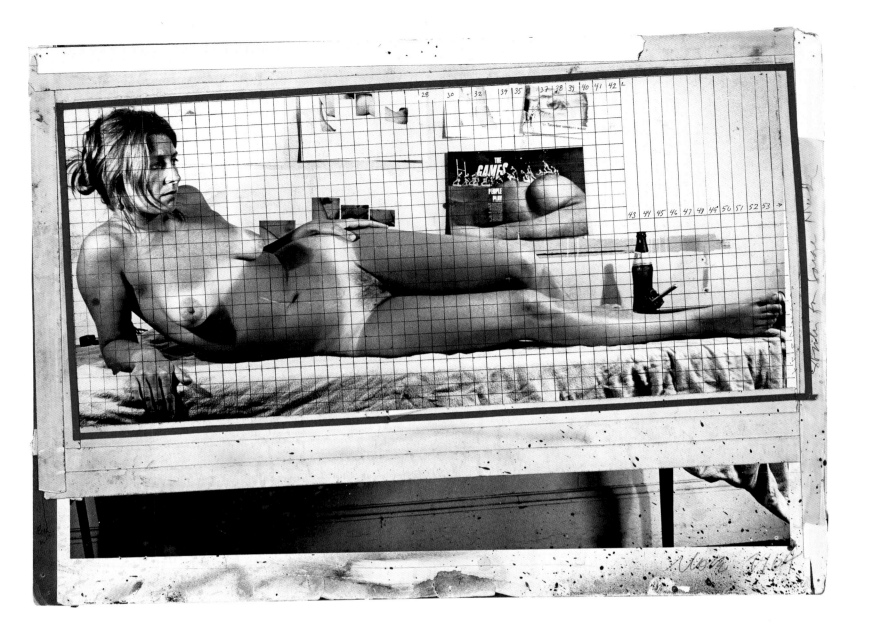

is impossible to take in the whole of *Big Nude* at once, and so the eye scans it, isolates elements, and begins to search for relationships between them. Part of the brain tries to use the magnified information to piece together what we know the naked female body to be. Another part takes elements that have been isolated and reads them in a wholly new way, so that a suntan line might take on the significance of an expressionistic paint stroke in a nude by de Kooning.

The fact that Close's *Big Nude* is rendered in black and white is important in that it helps emphasize the photographic source of the image. This is, after all, not a painting of a reclining nude, but rather a painting of a *photographic likeness* of a reclining nude. This simple fact is crucial to understanding all of Close's work from that point forward.

A live model is three-dimensional, and artists have traditionally found ways to use foreshortening, lighting, virtuoso draftsmanship, and bravura brushwork to reproduce that three-dimensionality and bring the subject to life. A painting made from a photograph is very different. The camera lens has already done the work of reducing three dimensions to a flat representation—producing an illusory likeness that is mechanical yet extremely convincing to the human eye. When an artist reproduces that likeness in paint on canvas, the result is a two-dimensional translation of the preexisting two-dimensional image. In theory, it is possible to reproduce *exactly* the photograph of a nude model in the form of a painting. A painter working from a live model can only approximate, however skillfully, the likeness of what he sees in front of him.

This is not to suggest that making a painting from a photograph of a model is in any sense inherently superior to making a painting from the model in the traditional way. It does mean, however, that both the intention and the result are totally different. When he painted *Big Nude*, Close was creating a handmade reproduction of something that had been produced mechanically.

Despite the heroic scale and considerable ambition involved, there is a deliberate banality about the whole enterprise. The model is attractive enough, yet the way in which she has been photographed is far from idealized, or even flattering. (She can be regarded as decending directly from the frank but un-prettified nudes that go back at least to Manet's *Olympia* a century earlier.) Even the title *Big Nude* emphasizes its deliberate ordinariness.

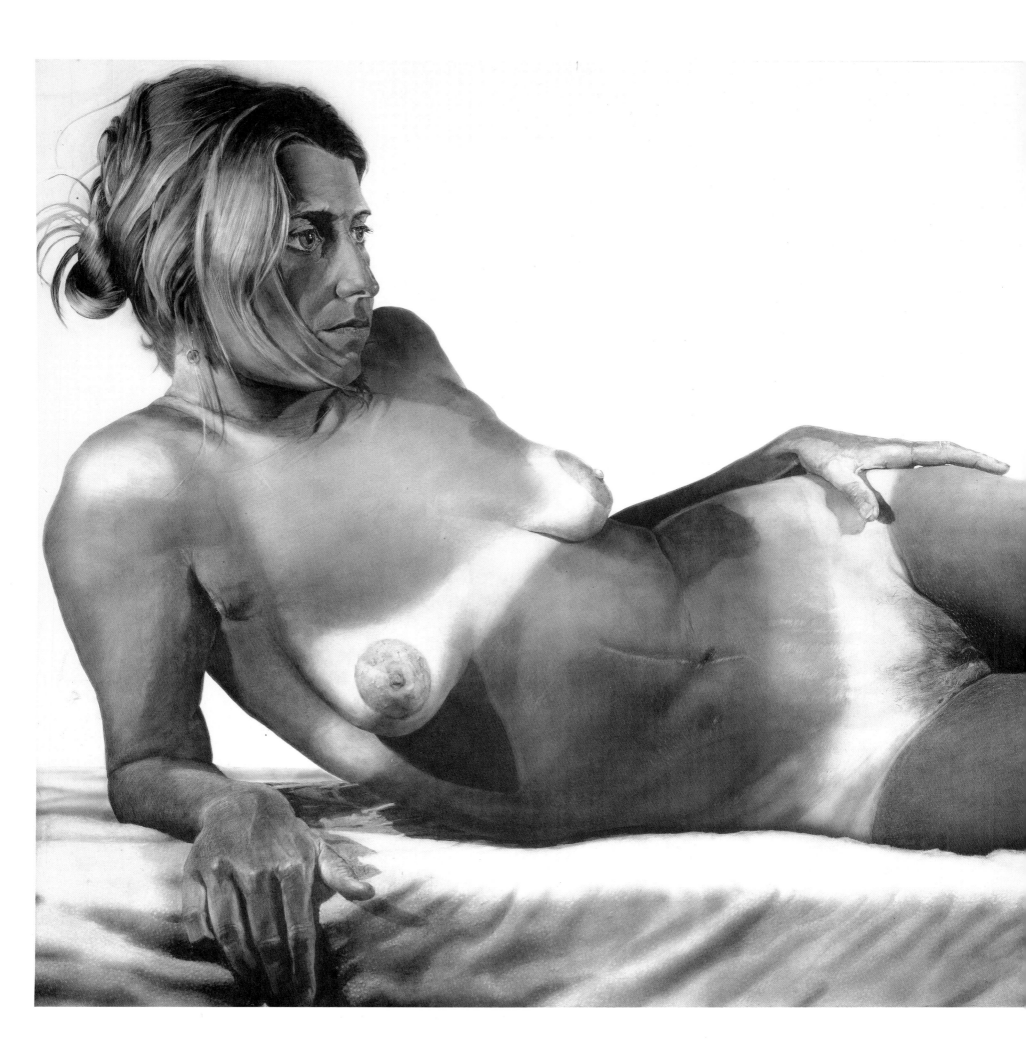

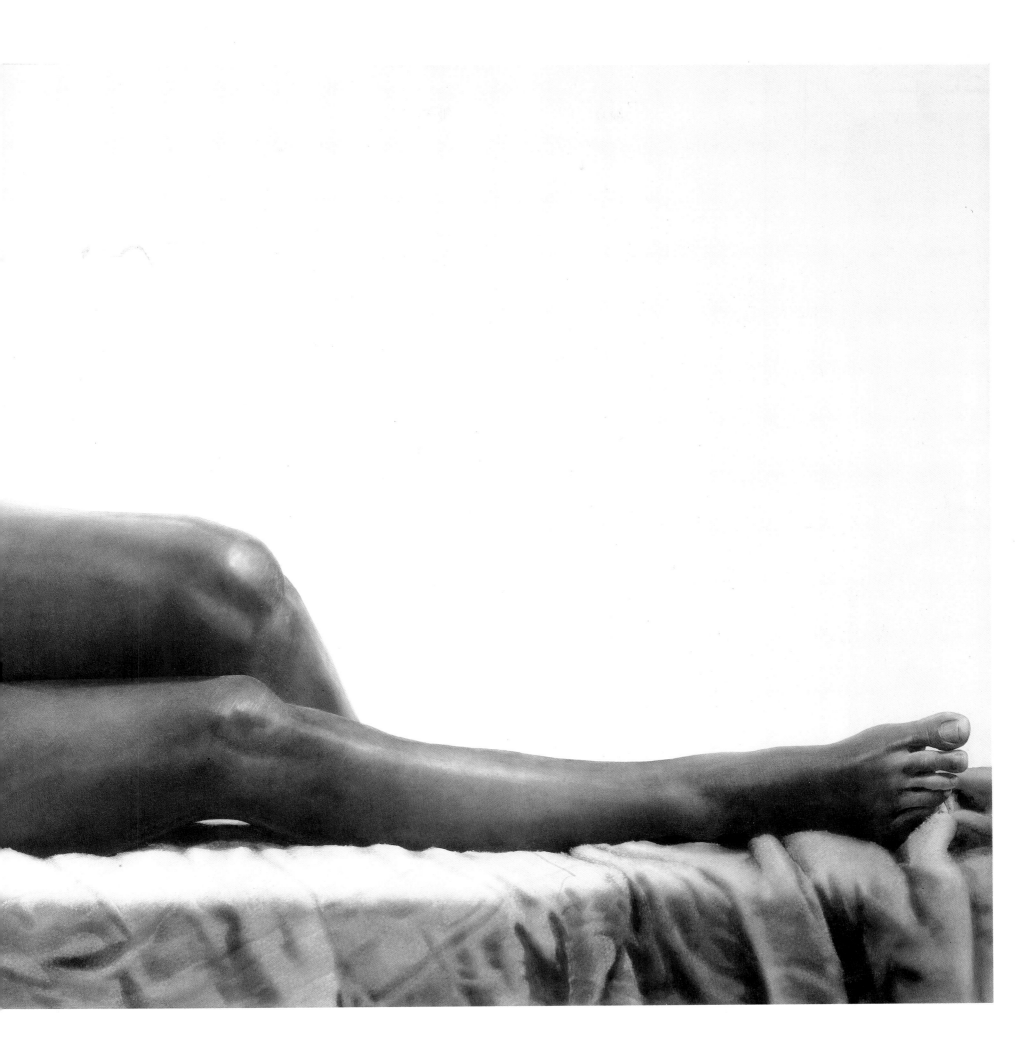

Another artist might have been tempted to call it *Great Nude* or something similar in order to conflate monumentality with intimations of grandeur, but that too would have been contrary to Close's purposes.

In short, *Big Nude* is both ordinary and extraordinary at the same time, and this places it in the long tradition that takes the mundane and raises it to aesthetic heights through the application of an original vision and painterly skill. Artists such as Vermeer, Chardin, Degas, and Picasso come to mind, and Close's level of ambition in creating *Big Nude* makes such comparisons appropriate, even though the painting fell short of the Olympian goals the artist had set himself.

The primary element lacking in *Big Nude* is a fully conceptualized and consistent approach to the process of making a painting of this sort on this scale. As closely as Close tried to approximate the mechanical character of the image, there is something vestigially improvised about the way it was made, a makeshift approach to fabrication that perhaps embodies a last faint hint of nostalgia for gestural painting.

The primed canvas had been squared into a grid to ensure accuracy of copying from the proportionately squared-off photographs, a traditional technique Close would continue to use in future work. The handling of pigment, however, varied in ways that he would soon abandon: he employed brushes, sponges, rags, and an airbrush, among other methods, to lay down paint in thin, transparent layers that would allow the image to retain luminosity. (Because of the cold, he often worked wearing gloves with the fingertips cut off.) He used various kinds of blades and an electric eraser to scrape paint off in order to reveal more of the white ground underneath. The level of technical achievement is impressive, yet the different elements did not quite gel. Close says that he was aiming for an allover effect in which every part of the canvas had equal importance, as in a Pollock drip painting. That didn't happen because the viewer's eye settled, by reflex, too easily on "hot spots" in the painting, such as the breasts and pubic area.

In retrospect, it is apparent that the nude as a genre did not lend itself to the allover ideal. The naked body is so charged with erotic meaning that it's difficult to see it with total objectivity. Another problem was that Close had not yet hit upon a consistent process that would permit him to bring the exact same level of concentration to every square inch of the painting. To do so, he would have to embrace the unglamorous idea of transforming himself into a production-line worker.

. . .

As he worked on *Big Nude*—which he recalls completing in about ten weeks—Close eased into a routine that was typical of the young downtown artists of the sixties, earning his bread and butter teaching at the School of Visual Arts (SVA) on East 23rd Street. (Leslie Close, meanwhile, had transferred to Hunter College, where she studied with artists like Robert Morris and Ralph Humphrey. Her work of the period had a distinct SoHo accent. She would, for example, take plastic place mats—discards from a local loft business—and stuff them with black bristles from the brush factory next door.)

SVA in the late 1960s boasted a faculty made up largely of artists who, though unknown at the time, are today preeminent figures in their various fields, people like Richard Serra, Joseph Kosuth, the late Sol LeWitt, Robert Israel, Malcolm Morley, Barry Le Va, and Joe Zucker, the core members of the faculty being only a few years older than the students. It was one of the downtown nodal points where strongly held ideas and fierce passions intersected, sometimes explosively, spilling over from classrooms into neighboring bars and delicatessens. Politics—predominantly in the form of anger at America over the Vietnam War—was on everybody's mind, and neo-Marxist tendencies were in the air, but for a while it was art itself that was the chief source of passion.

(Lest it seem that the loft crowd was wholly Nietzschean in its concerns and single-mindedness, it's worth remembering that these were the glory days of New York sporting greats like Joe Namath, Willis Read, and Tom Seaver, and in SoHo as elsewhere much time was spent following the fortunes of the Jets, the Knicks, and the Miracle Mets, with the then hapless New York Rangers attracting a particularly headstrong contingent of admirers. In the "miracle year" of 1969, many expeditions from SoHo to Shea Stadium were mounted, and the Mets' World Series victory brought studio activity to a temporary halt. Close, however, was and remains a devout Yankees fan.)

38

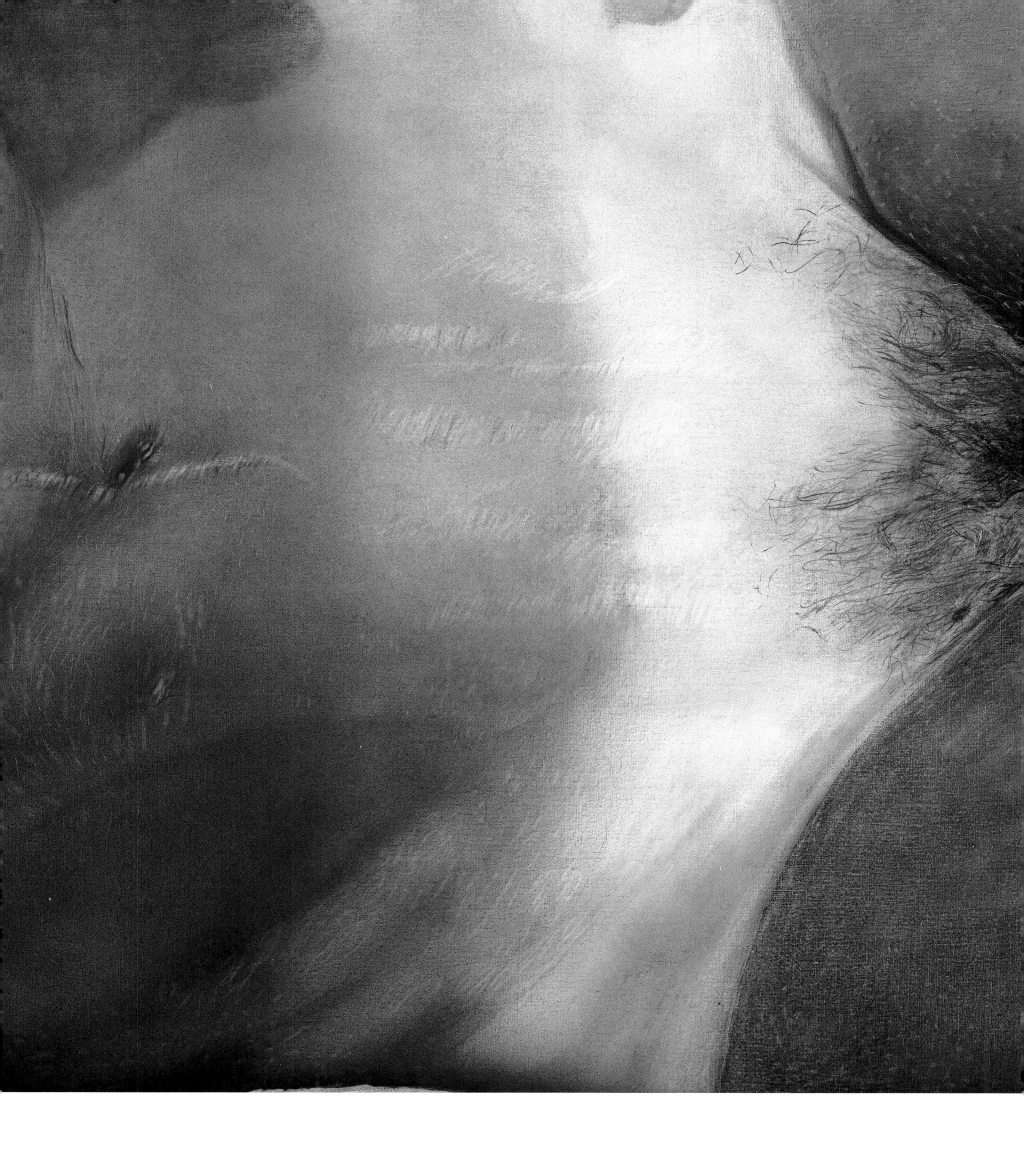

Big Nude (detail), 1967

To an outsider, downtown might have seemed like an urban desert, but settlers soon learned where to find those places where intellectual and aesthetic energy could be exchanged. The first uptown dealer to establish a SoHo outpost was Richard Feigen, who bought a building on Greene Street, just south of Houston, which he used primarily for storage but occasionally opened for exhibitions. Far more significant was the Paula Cooper Gallery, which was established in 1968 in a second-floor loft on Prince Street. Its first show, featuring artists such as Carl Andre, Dan Flavin, Donald Judd, Robert Ryman, Robert Mangold, and Sol LeWitt, was a benefit for the Student Mobilization Committee to End the War in Vietnam. Other early arrivals on the SoHo scene were Ivan Karp's OK Harris Gallery, the first to open on West Broadway, and the Reece Paley Gallery.

Close remembers that he and Leslie would attend some performance or other almost every night of the week—typically something on the order of a dance work in progress at somebody's loft, the bed rolled up and the furniture moved to one side to provide floor space. Many such events were organized by women, including Joan Jonas, Yvonne Rainer, Judy Padow, and Trisha Brown, early proponents of a shift in gender politics that would have a profound effect on the art world. Leslie Close sometimes participated in these events as a dancer. Some of the more ambitious venues evolved into organized cultural entities, a notable example being the still active and influential White Columns Gallery—founded by Gordon Matta-Clark and Jeffrey Lew—which began life as a loft space named 112 Workshop for its Greene Street address.

Then there were the parties. Almost every Saturday night there was a loft party, or often several, and these had a character of their own simply because of the scale of the setting. A gathering in a 3,500-square-foot open-floor industrial space is very different from a gathering in a Greenwich Village brownstone or a Riverside Drive apartment, however commodious. In the mid-sixties, Andy Warhol brought some of the loft party spirit to La Dom (locally called *the* Dom), a venerable Polish social club that became for a while host to the Exploding Plastic Inevitable, Warhol's peripatetic multimedia experiment in extreme entertainment. The Inevitable owed something to the psychedelic shows that had be-

gun in San Francisco a little earlier, but it had a perverse over-the-top New York edge to it that had little to do with the love beads philosophy of the flower children. It was, rather, pure Andy.

• • •

In retrospect, loft pioneers often joke, or even boast, about how difficult it was to find food, prepared or otherwise, in Ur-SoHo. When listening to these stories, the fact that Chinatown, Bleecker Street, and Little Italy were just short strolls away should be taken into account, and there was a Grand Union supermarket just a block north of Houston Street, which was such a staple of SoHo life that Yvonne Rainer named her first dance company for it. If you were adventurous, you could find, within a few blocks of the future SoHo, three stores—one kosher, one Italian, one Chinese—that sold live chickens.

On the southern border of Hell's Hundred Acres, very handy for 27 Greene Street, was the Canal Luncheonette, a great favorite of the Closes who, on those rare occasions when they were flush, went there for egg creams and Chuck's favorite lime rickies. Still, there wasn't much on offer between Houston Street and Canal Street, the two iconic exceptions being Fanelli's Café at Prince and Mercer, and the little grocery store, known simply as "the bodega," at Prince and West Broadway.

The bodega was run by an amiable Puerto Rican who would extend credit to regular customers, and was said to be well informed about upcoming cock fights. Now a magnet for tourists, Fanelli's was then an unpretentious pub, the domain of a diminutive ex-boxer, Mike Fanelli. Its daytime patrons were a comfortable mix of artists and local blue-collar workers who had sustained the place prior to the artists' arrival. During the early evening, the café turned into an artists' bar. Since it was almost next door to Paula Cooper's gallery, it was also a place to hang out before and after readings or performances. Chuck Close was a Fanelli's regular for more than a decade.

• • •

The most important meeting place for the loft dwellers was not in SoHo at all, though it was only a dozen or so blocks away.

40

Located at 213 Park Avenue South, just north of Union Square, max's kansas city (the logo eschewed capital letters) had opened in December of 1965, the brainchild of Mickey Ruskin, who previously had operated The Ninth Circle, a Village bar at one time much patronized by artists.

Max's was destined to become something very special, a place that occupies a unique position in the history of New York social and cultural life as, arguably, the most important institution in the transformation of downtown Manhattan from a loose assemblage of largely rundown neighborhoods into the trendiest part of the city. There was some luck involved in this. Max's happened to be the right place at the right time, but a lot of credit goes to Mickey Ruskin because he was smart enough to see what he had and to make all the right moves. With his beak of a nose, his dark, lank hair, and his gaunt, bemused expression, Mickey was an archetypal urban cowboy, as quirky (perhaps quirkier) than any of his patrons.

Max's eventually became known as a focal point for New York rock music, especially the punk wing, but at the outset it was an artists' hangout, a sixties successor to the nearby Cedar Tavern, where the Abstract Expressionists had downed their Rheingolds and fought the good fight, sometimes with bare knuckles. Along with providing a sense of community, the importance of max's for younger artists was that it was also a powerful symbol of the fact that art had arrived in a big way. People went there to enjoy the art world as theater, to try to channel some of its energy and creativity. The Abstract Expressionists had dissipated America's indifference to home grown art, while artists like Robert Rauschenberg and Jasper Johns had proved that Pollock, de Kooning and Co. were not flashes in the pan. Andy Warhol and the other Pop Artists had captured the public's imagination, and excited media attention as well. The scene had become international: artists, dealers, curators, critics, and collectors arriving from London, Frankfurt, or Tokyo made max's their first stop. New art—and the men and women who made it, sold it, and collected it—had begun to generate the aphrodisiac scent of serious money. Whereas someone as extravagantly gifted as de Kooning had not been able to make a living from his work until he was well into middle age,

it was suddenly almost commonplace for artists in their twenties to be signed by a gallery and to find patrons. Most still depended on their teaching jobs or loft-restoration work—some, like Brice Marden, Sol LeWitt, Robert Ryman, and Joel Shapiro were employed at various times as museum guards or in museum bookstores—but they did not feel that there was anything to prevent them from becoming artists, and uncompromising ones at that.

Chuck Close was never reticent about acknowledging his belief in his own ability. At 27 Greene Street, he was just beginning to find his way beyond the influences that had dominated his student years. In the fall of 1968 he had not yet sold a painting, yet he was comfortable telling me, on my first visit to his studio, that he had no interest in producing work for private collectors. The paintings he was planning to make were meant to be hung in museums and seen by large numbers of people.

· · ·

I recall how, during one of those long nights of intense dialectic at max's, Close threw out the remark, "An artist's style is what he happens to be doing when he is discovered." Like all good aphorisms, this one contains more than a few grains of truth. In Close's own case, however, chance played a minor role. Once he had made the break with gestural painting, he quickly settled

► Frank Stella, **The Marriage of Reason and Squalor, II**, 1959.
Enamel on canvas, 90 3/4 x 13 3/4 in. (230.5 x 337.2 cm).
The Museum of Modern Art, New York

on his initial goal. *Big Nude* was an important first step towards achieving it. One more stride would be all it would take to get him there. As he contemplated that final step, his aim more than ever was to achieve—within the parameters of representational art (and that was the challenge)—an allover, frontal, two-dimensional effect, such as he found in Pollock's drip paintings, but also in certain very different, less overtly emotional works such as Ad Reinhardt's monochrome canvases of the late fifties and early sixties, and the early sixties work of Frank Stella.

Born in 1913, Reinhardt was an almost exact contemporary of Pollock. Trained as an art historian as well as a painter, he brought an intellectual rigor to making art that was the opposite of Pollock's angst-ridden and intuitively physical approach. In reaction to the calligraphic drama of Abstract Expressionism, Reinhardt produced flat, single-color, non-representational paintings that culminated in a series of black-on-black canvases in which simple geometrical forms were evoked by means of paint texture and reflectivity, much as a ground-keeper's roller produces patterns in the mown grass on a playing field (another instance of design that derives from process). The ascetic coolness of Reinhardt's approach appealed to Close at this stage in his development, offering an alternative to gesture—not one that Close was tempted to imitate in terms of imagery (or rejection of imagery) but that nonetheless touched on issues that were becoming of paramount interest to him. One was the potential inherent in meticulous, as opposed to improvisatory, fabrication. In this respect it might be said that Reinhardt's example helped give Close the resolve to break with his artistic surrogate father, de Kooning. Additionally, Reinhardt's work presented an archetypal instance of art that could not be photographed or reproduced satisfactorily, emphasizing how vital it was for his paintings to be seen in the original.

By the late sixties, other artists too—Robert Irwin, for one—were consciously making "non-reproducible" art. (Irwin is reported to have been incensed when *Artforum* placed a photograph of one of his wall-mounted, illuminated discs on its cover.) The novelty of Close's approach was to make paintings so blatantly photographic as to deny the viewer of a reproduction the ability to tell whether he was looking at a reproduction of a painting of a photograph, or a reproduction of the photograph on which the painting was based. Even today, when his work is well known, it is impossible to gauge the size of his portraits from reproductions unless there is supplemental imagery—such as installation shots—to lend scale.

As for Stella, his example was especially potent for young artists in the sixties, because he was one of them, but had already arrived on the scene in a big way. His early paintings are still highly prized, but unless you were there it's difficult to grasp the explosive impact they had at the time. The name Frank Stella was spoken with a certain awe. He was the wunderkind of the decade, and the quality of his work justified any hype to which his career had been subjected.

Born in 1936, Stella was only marginally Close's senior, but his art had already been in the public eye for several years, since 1960 in fact, when, not long after he graduated from Princeton University, a group of his so-called pinstripe paintings was exhibited at The Museum of Modern Art (making him an early example of a very young artist enjoying acclaim straight out of school). Painted in black enamel, and barred with thin stripes of raw canvas as regular as the lines on a legal pad, these works challenged the viewer with the blatancy of their symmetry and frontality. A great European abstractionist such as Piet Mondrian had organized geometrical shapes on canvas in a manner that was not so different from the way that someone might place furniture in a room, looking for interesting ways to articulate space, and for satisfying ways to create a sense of balance between different elements. Stella, by contrast, composed paintings rather as you might apply shingle siding to a Cape Cod saltbox house. If European abstraction was "relational" in character, Stella's form of abstraction was deliberately "nonrelational." It differed from the work of Mondrian, just as the façade of a SoHo cast-iron building, with its structurally determined window arrangements, differs from the façade of a Palladian villa, the elements of which were organized according to aesthetic decisions relating to ideas about harmonious proportion and equilibrium within a classical tradition. I employ the term façade deliberately, because flatness was another important aspect of Stella's early paintings. In a Mondrian, the geometrical shapes set up a figure and ground relationship in which some shapes seem to

jump forward from the background every bit as much as in a conventional still life, or a landscape with a hunting party. In Stella's pinstripe canvases, figure and ground were, to all intents and purposes, one and the same. At first glance, it was difficult to tell if the lighter stripes were on top of a black ground or vice versa.

Close wanted to create paintings that were just as flat and frontal and nonrelational as Stella's abstractions, and as "allover" in composition, while being representational by way of photography. *Big Nude* had taught him that the human body, with all its limbs and appendages and associations, was difficult to treat in this way. It now occurred to him that the head alone, and specifically the face, would be much better suited to his purpose. The shape of the head—seen in full-face portrait format, cropped at the collar bones—fills a conventionally proportioned vertical rectangle of canvas or paper rather completely, making an allover approach more feasible. The very familiar layout of the face—the distribution of eyes, nose, mouth, ears, and so on—provides a fixed set of references that cannot be altered and that therefore constitutes a kind of grid. The body, by contrast, can be arranged in many different ways—made to stand, sit, crouch, with arms folded, perhaps, and with a leg extended or bent at the knee—inviting a "relational" approach to its various parts.

By concentrating on the head, Close would also be able to place an even greater emphasis on the scale of the image. Painted on canvases nine feet high, the portraits he was about to embark on would be seven or eight times as large, by area, as the head of *Big Nude*, thus calling for far more detail.

(Since this was the crucial moment that determined his subject matter for the remainder of his career, it's appropriate to recall Close's prosopagnosia. I believe it would be foolish to suggest that face blindness was his sole reason for choosing this subject matter—as should already be apparent, a number of entirely conscious decisions, informed by the artistic milieu of the time, played into that choice—but there is nothing to suggest that there may not have been a predisposition towards a certain subject matter, as the artist himself believes. More importantly, it may be that the condition gave him the intensity of interest and the degree of patience to deal with the human face in a particular way.)

Whatever its size, the portrait comes loaded with art-historical baggage. Close has said that he was drawn to the subject in part in ornery reaction to Clement Greenberg's assertion that portraiture was the one subject that could no longer be tackled plausibly by artists with any claim to being modernists. In the late 1960s, many younger artists and critics were vocifer-

ously rejecting Greenberg's teachings—a phenomenon dubbed "Clembashing"—just as they were also turning away from the example of the Abstract Expressionist painters he had championed. This was very much a case of sons trying to shake off parental authority, and in fact Greenberg's admittedly dogmatic philosophy still had a great deal of relevance for the artists of Close's generation. In particular, Greenberg's emphasis on the essential flatness of painting—his rejection of illusion—remained a key concept for many younger artists. Traditional portraiture is rooted in illusion, hence Greenberg's assertion that it was antithetical to modernism. As will be seen, however, Close in his portraits would embrace the idea of flatness as fully as any Abstract Expressionist or color field painter, so that, while he was in one sense thumbing his nose at Greenberg, these portraits would not contradict Greenberg's dogma, though certainly they would demonstrate that there was more to the conflict between flatness and illusion than had previously been suspected.

Historically, portraitists have employed carefully selected angles and dramatic lighting to achieve their effects. Close was not interested in exploiting such devices. He wished to take advantage of the near symmetries existing in the face by working from aesthetically neutral frontal photographs such as those that adorn passports and FBI Most Wanted posters, his intention being to present the face as structurally predetermined, like the façades of those SoHo buildings.

That said, a stroll through SoHo provides ample evidence that a great deal of variety is possible within the conventions of the cast-iron idiom. So, of course, do human faces differ enormously despite the fact that everyone possesses a similar underlying armature of bone, muscle, and cartilage. No matter how rigorously objective one might be in setting down someone's features as they appear in a photographed likeness, it would be impossible to ignore the matter of identity, and the sense of a complex being beneath the configuration of descriptive information signifying identity. This dichotomy—the need to create a precise likeness while aiming for an aesthetic ideal that is virtually a form of abstraction—would produce a powerful dynamic tension (to borrow a term from Charles Atlas, a Close namesake who also understood the significance of

size) within the artist's work. Close confronted the challenge boldly by making the first of these paintings a self-portrait. He would even title it *Big Self-Portrait*, though at the time he referred to it, and the paintings that followed, not as "portraits" but as "heads."

• • •

According to Close's telling of the story, there was an element of chance involved in starting out with a self-portrait: he was the only one around at the time. The source of this first self-portrait was a black-and-white photograph made when Close was alone in the studio one day, using a borrowed camera equipped with a cable release. There was an element of trial and error about the shoot. His recollection is that he stripped to the waist because he was still involved with the idea of the nude and thought of the head as a detail of a nude rather than as an independent subject. (This notion carried over to his second large portrait, *Nancy*. Nancy Graves was actually wearing a peasant blouse when she was photographed, but Close painted it out so that in the painting she has bare shoulders.) The fact that he was alone—had no assistant or stand-in—meant that he had to estimate focus and angle as well as he could. He came up with the idea of focusing on a brick wall and then improvised a ruler out of cardboard, measuring the distance from the lens to the wall. He then posed in front of a different wall—one that was plastered, providing a light-colored neutral background—and used the improvised ruler to measure how far from the lens his face should be in order to make the most of a shallow depth of field. He selected a fairly low angle, so that the camera seems to be looking up his nose. There are eleven portrait exposures on the contact sheet in addition to a photograph of the brick wall. The image he selected to work with displayed very explicit shifts in focus—the frames of his glasses being sharp, for example, while his nose is not—the consequence of that shallow depth of field.

To create this first self-portrait, Close worked from two "maquettes"—each an enlargement of the photograph squared off for copying into a grid consisting of 546 squares. The smaller one is attached with masking tape to a sheet of cardboard measuring 18 5/8 by 13 3/8 inches. The other, almost twice as large, is a montage of four different prints (because Close did not have access to

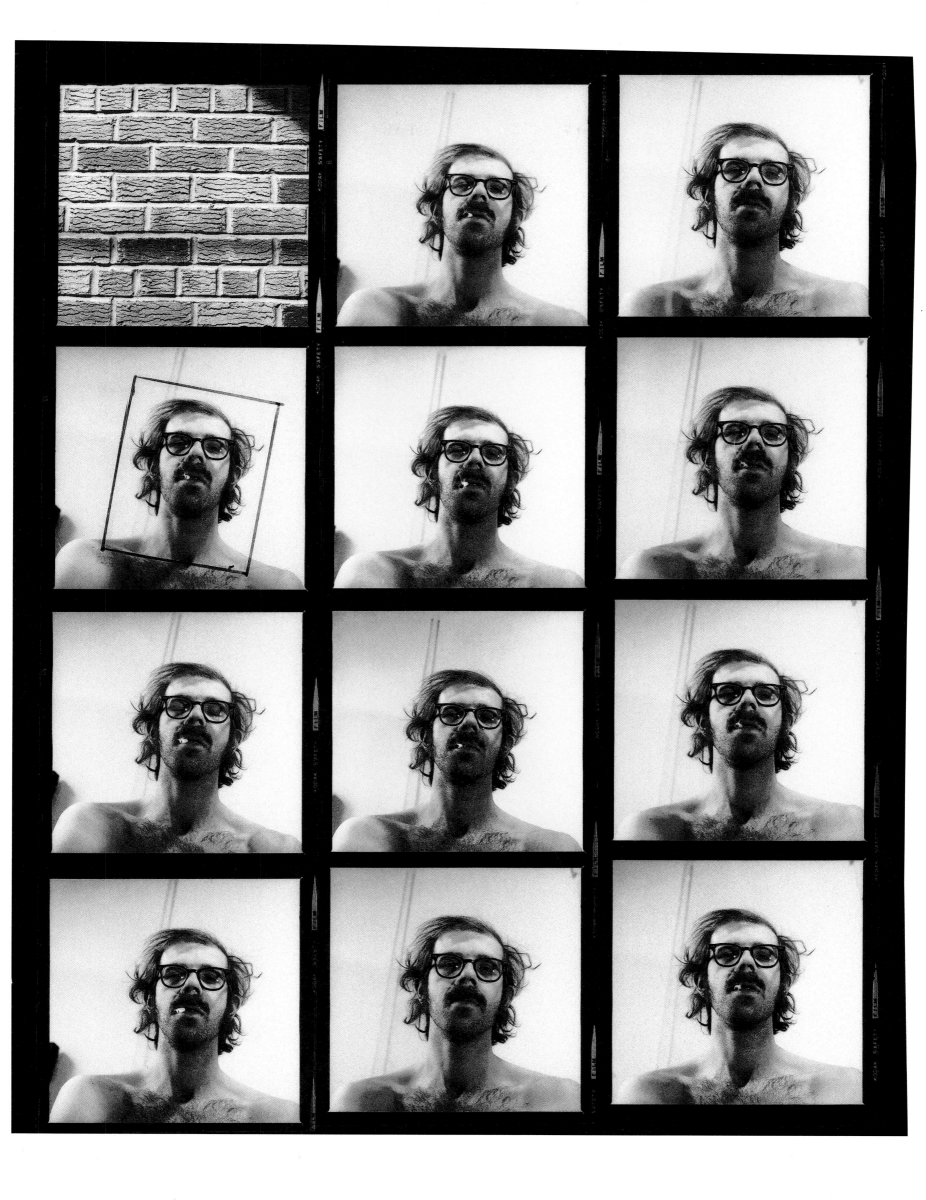

Self-Portrait Maquette, 1968. Photograph, pen and ink, pencil, masking tape, acrylic, wash and blue plastic strips on cardboard, 18 5/8 x 13 3/8 in. (47.9 x 34 cm)

Self-Portrait Maquette, 1968. Four gelatin-silver prints scored with ink, masking tape, and airbrush paint mounted on foamcore, 30 x 24 in. (76.2 x 61 cm)

46

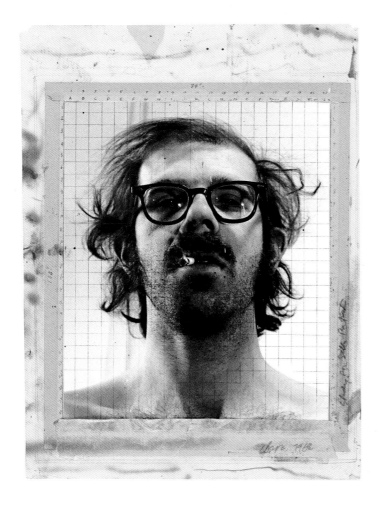

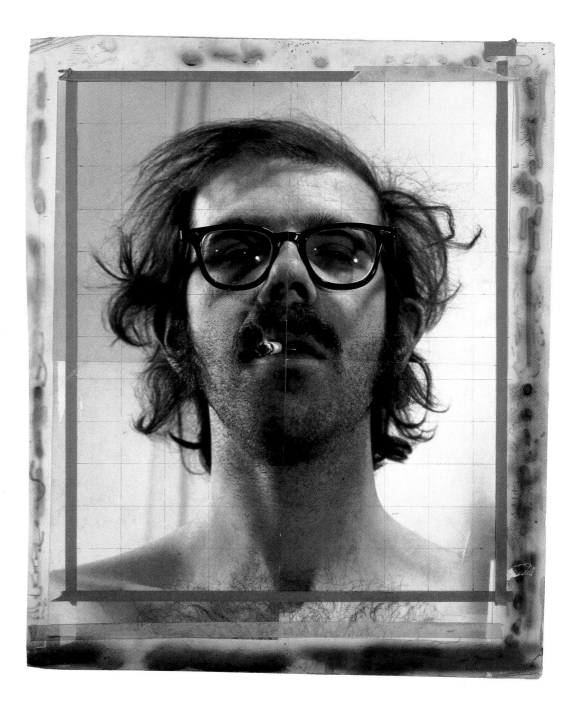

➤ **Big Self-Portrait**, 1968.
Acrylic on canvas, 107 1/2 x 83 1/2 in.
(273 x 212.1 cm)

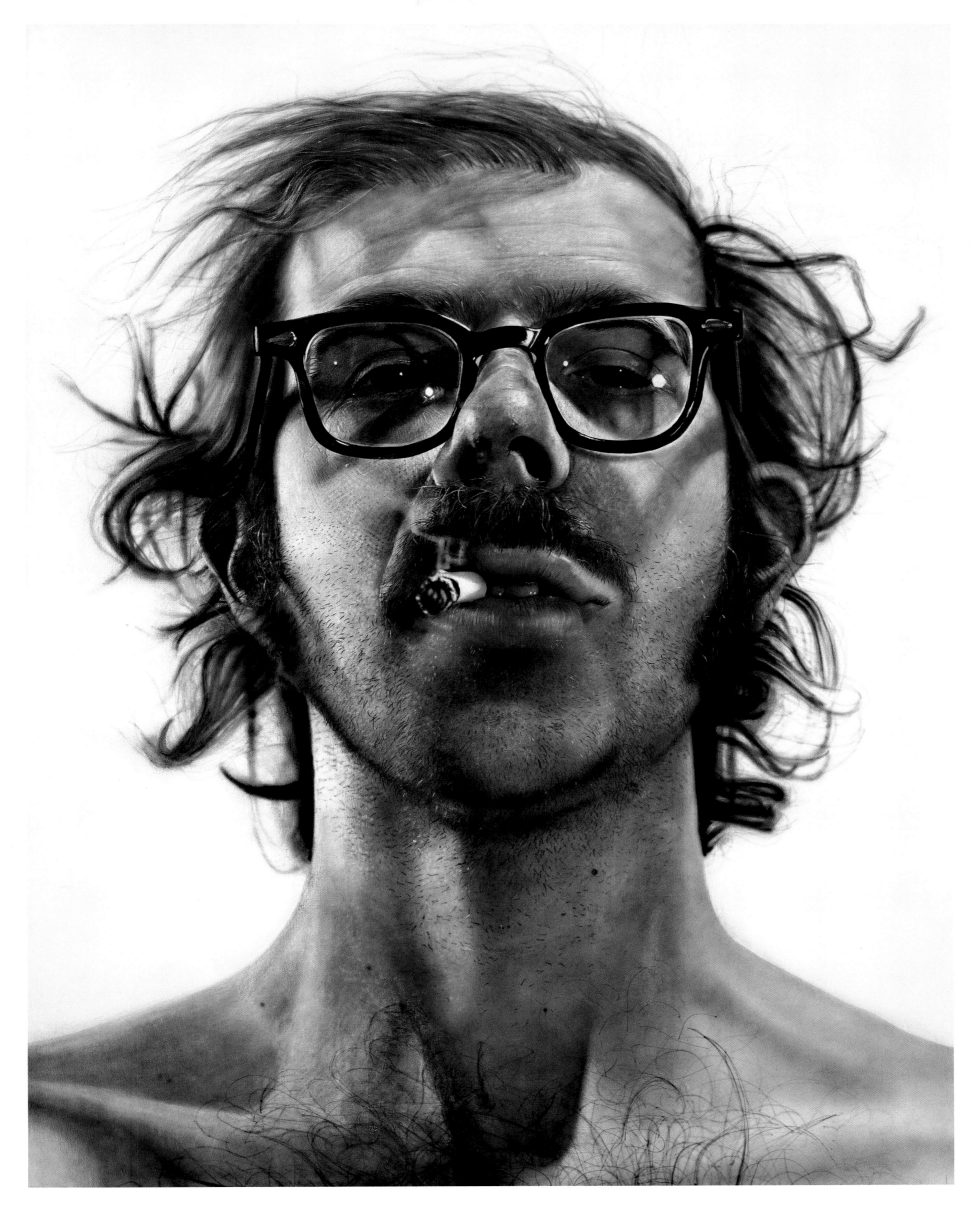

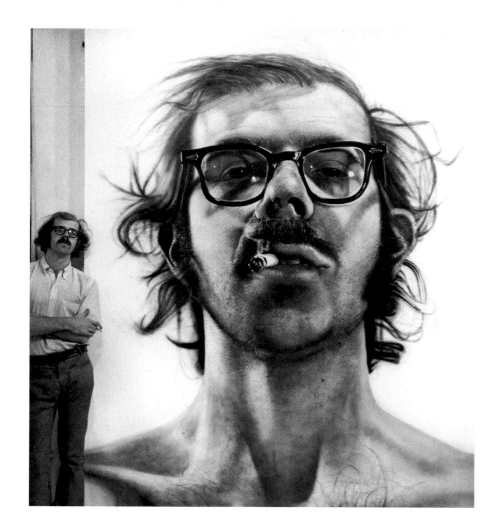

Close's challenge was to match the idea of process to the needs of the highly refined concept of representation with which he had chosen to work. He understood clearly that this meant getting away from, in his words, the "erratic anthology of styles and techniques" that had gone into producing *Big Nude*. On many occasions he has spoken of his need to escape from virtuosity, stating that if you understand what art is about, and you know how to make the appropriate marks on canvas, it's easy to approximate any style. The act of making such paintings can be fun, he says, but when they're finished the results are unsatisfying. In the 1968 *Big Self-Portrait*, he intended to reverse this by adopting a system of working that might be arduous and repetitive but that would produce wholly satisfying results.

The first step was to transfer a pencil version of the photograph to the canvas, making use of the grid to ensure accuracy. (The grid on the canvas was made by using tightly stretched string, rubbed with stalk charcoal, to snap-on lines that could easily be erased so that no trace would be visible through the transparent film of acrylic.) That established, he took an airbrush loaded with diluted acrylic paint and employed it to begin delineating the upper sections of the image, where features are most sharply focused. He then continued to the remainder of the image, employing the same diluted mix of paint and water, slowly increasing the density of the pigment as he built up the darker tones. In the early stages, he experimented with introducing highlights by over-spraying with white paint, but quickly realized that it dried with a bluish tinge that had a deadening effect. To counter this, he restricted himself to creating highlights by removing paint—much as he had when painting the nude—using various tools such as razor blades and an electric eraser so that the white gesso ground would show through.

If this sounds much like the method used by some commercial illustrators and billboard artists, that is superficially true, but in this first monumental head, Close made no concession to slickness of any kind, refusing to indulge in effects that might read well from the sidewalks of Times Square but that would seem rather cursory when viewed from up close. Nor did he indulge himself by giving in to any hint of emphasis on what would normally be thought of as the principal features of the face, those that give it

an enlarger). The smaller of these maquettes was printed slightly dark, so that he could more accurately read the lighter detail, the other was printed slightly light, so that he more accurately read the darker detail.

Curiously, given Close's intention of working from images that were not overly charged with subjective information, this photograph, seen in retrospect, is very much of its period, being characterized by what appears to be a "fuck you" truculence. The artist's hair is long and unkempt, and his moustache and unshaven cheeks contribute to an antiestablishment feeling, as does the half-smoked cigarette dangling from his lips. The lighting is dramatic, so that the frames of his glasses cast shadows around the eyes, and the low angle adds to the mood of the image, which is challenging, verging on threatening. A few strands of chest hair curl into view at the bottom of the image, somehow contributing to the faint sense of menace.

As with *Big Nude*, a black-and-white palette was part of the strategy, emphasizing the photographic origins of the image. A canvas of very fine weave was stretched on a frame nine feet tall and seven feet wide. The canvas was carefully prepared with a dozen coats of gesso, each sanded down before the next was applied. He was then ready to begin painting, and the lessons he had learned from *Big Nude*, along with the thought he had put into the theory of process art, were about to pay off.

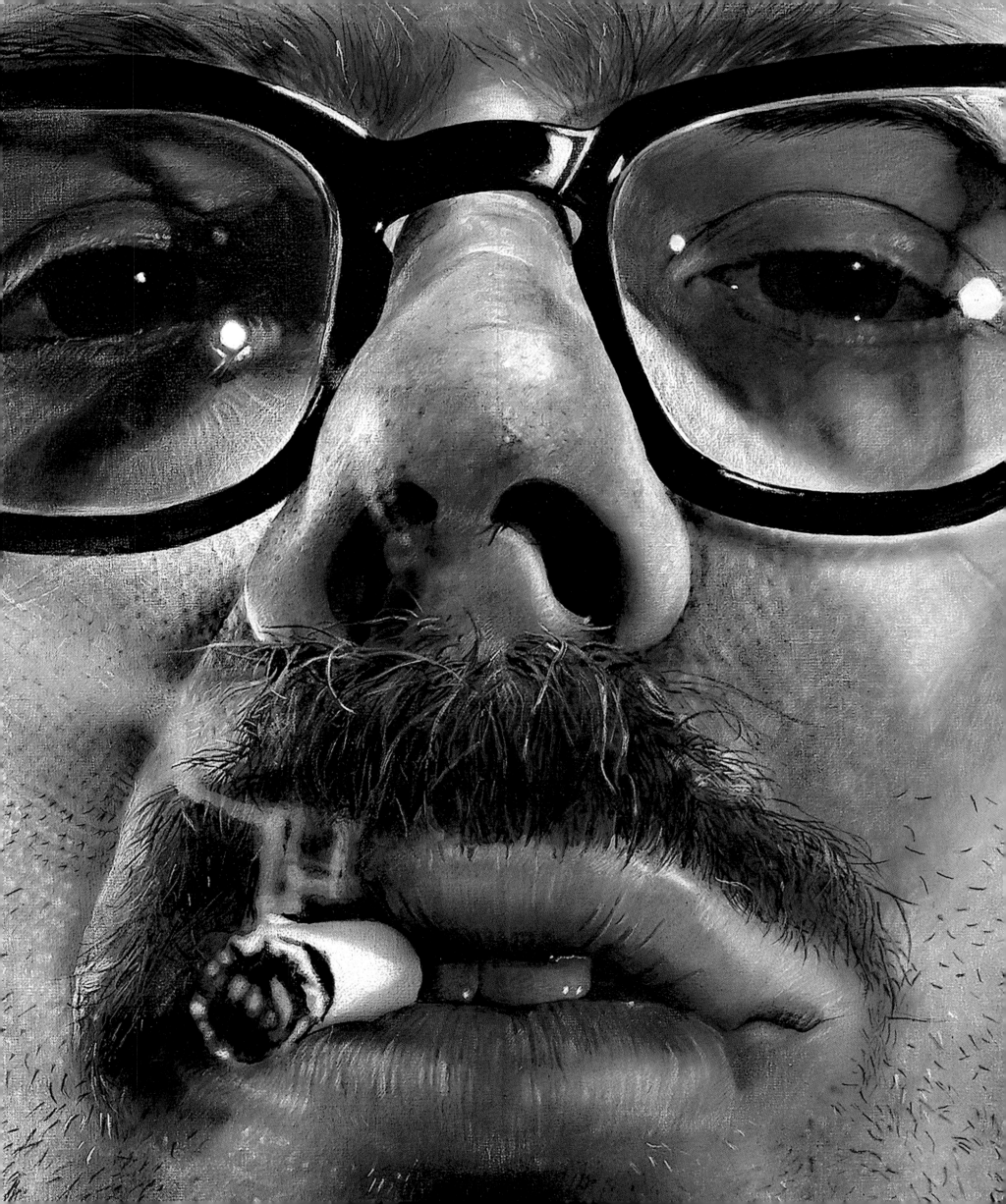

Malcolm Morley, S.S. **Amsterdam in Front
of Rotterdam**, 1966. Acrylic on canvas,
62 x 84 in. (157.5 x 213.4 cm)

character. On the contrary, the rendering of a mole received the same degree of attention as the rendering of the subject's eyes. In this way, the allover concept of composition was accommodated as completely as was feasible, given that a photographed head was the subject.

Big Self-Portrait was designed to be seen from close range, and if the head itself was approximately fifty times life size, by area, so was every detail—every eyelash, every pore. Carefully transliterated from the photograph and magnified, each minute scrap of information took on fresh meaning, much in the way that the wings of an insect take on new meaning when viewed under a microscope. If the viewer steps back from the canvas, however, the photographic derivation of the image becomes very clear, emphasized by the out-of-focus look of some parts—the ears, for example, and much of the hair. Paradoxically, this draws attention to the essential flatness of the painting.

To Close's chagrin, such fidelity to camera-derived illusion would lead to him being considered a leading exponent of the photorealist movement, pioneer members of which, such as Robert

Bechtle, Richard Estes, and Robert Cottingham, began to attract attention a couple of years later, mostly on the West Coast. What these artists had in common with Close was that they used photography to gather information, which was then transferred to canvas or paper. The parallels did not go much beyond that. Typical photorealist paintings were designed to be looked at just like ordinary realist paintings, that is, to be seen as a whole from a normal viewing distance. Popular subject matter included street scenes, cars and motorcycles, supermarket parking lots, commercial signage, and so on. The appeal was to the viewer's sense of everyday contemporaneousness, with everything presented in sharp focus and Kodachrome color.[5] For the most part—Bechtle is a partial exception—these artists were not much interested in representing people, which in itself is enough to distinguish their work from Close's.

To make a direct visual comparison between any group of hardcore photorealist paintings and Close's early portraits is to understand why he responded negatively to the idea of being grouped with these artists. Typical photorealist canvases seek to

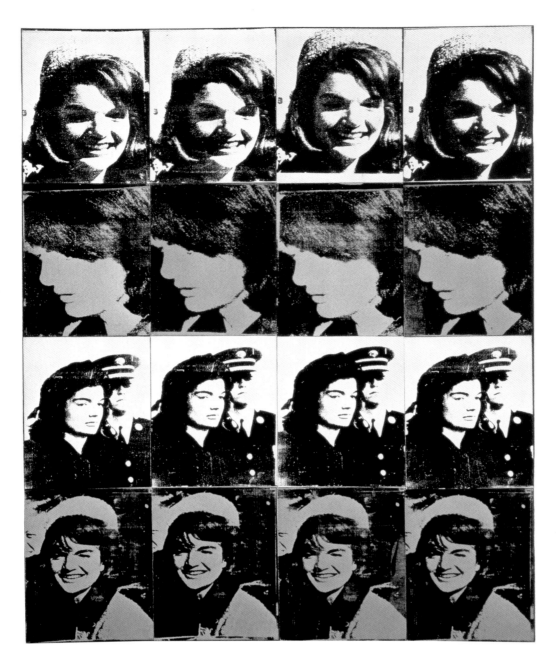

Andy Warhol, 16 Jackies, 1964.
Acrylic, enamel on canvas, 20 x 16 in.
(51 x 40.6 cm) each; 80 3/8 x 64 3/8 in.
(204.2 x 163.5 cm) overall

51

satisfy by directness of representation—by co-opting the look of the snapshot to create a new genre of popular realism, one that to some extent took its impetus from Pop art. Close, on the other hand, borrowed from photography in very different ways, making paintings that are complex, indirect statements about the way in which photography has influenced our way of seeing the world—exploring, for instance, how focal length can be used to enhance, and at the same time undermine, illusion. Above all, photorealists like Estes and Bechtle had no philosophical engagement with the idea of process as a way of creating art. Close's dedication to that idea meant that he had much more in common with New York contemporaries like Richard Serra and Brice Marden, whose work was entirely non-representational. The proof of the pudding is to be found in Close's later paintings and multiples in which he transformed his original camera-based imagery into idioms that remain rooted in photography but that have been radically transfigured by extreme variations in the application of process. Photorealism as a school has shown no such evolution.

A few New York painters were in fact using photographic source imagery in interesting ways. The example of James Rosenquist has already been noted, and, starting in the mid-sixties, Joseph Raffael (then spelling his name Raffaele) produced a series of works that, like some of Rosenquist's paintings, resembled hand-painted photomontages. The artists Close can most usefully be compared with are Malcolm Morley and Andy Warhol. Morley, who taught with Close at SVA, was a Manhattan-based British-born artist who, starting around 1965, made paintings based on commercial reproductions of photographic images, such as postcards and brochure illustrations of cruise ships. This subject matter might seem to link him with the photorealists, but his imagery was loaded with an irony that theirs generally lacked, and his work methods were rigorous in somewhat the same way as Close's. (He used squared-off grids and made his paintings upside down in order to distance himself emotionally from the imagery.) Close and Morley maintained a friendly relationship laced with mutual respect and suspicion.

As for Warhol, his work methods differed radically from Close's, and the fact that he frequently dealt with celebrity icons gave his

Andy Warhol, **Most Wanted Men No. 12, Frank B.**, 1964. | ➤ **Self-Portrait**, 1968.
Silkscreen on gesso on canvas, 48 x 39 in. | Pencil on paper, 29 x 23 in.
(121.9 x 99.1 cm) | (73.7 x 58.4 cm)

were they were manufactured, and in that they were essentially altered—photographically enlarged—Readymades.

If you were an ambitious young artist in the 1960s—whatever your inclinations—Warhol's example was impossible to ignore, if only because he seemed to have unlocked so many possibilities. Half a century earlier, Marcel Duchamp's Readymades had posited the notion than anything could be designated as art. Warhol inherited this idea and carried it to previously unimagined levels. Repeated silk-screened images of soup cans and facsimiles of Brillo boxes could become art if Andy said so. (It was a sign of his incipient celebrity that everyone called him Andy, whether they had met him or not). He could turn brutal photographs of car accidents into instant masterpieces. He could film the Empire State Building from a fixed camera, from dusk to dawn, and create an instant cinematic classic, the significance of which had nothing to do with whether anyone actually sat through the entire eight hours running time, or even watched a single frame. Warhol seemed to have the magic touch. It did not matter if the work was made by him or manufactured by Factory assistants. Technical imperfections were inconsequential, or better still were perceived as part of the Warhol aesthetic (if there could be said to be such a thing). It was enough that the work was unquestionably relevant to the moment.

The entire Warhol phenomenon was swathed in enigma. Was Andy smart, or merely shrewd, or perhaps a new kind of urban naive possessed by intuition preternaturally attuned to the zeitgeist? Was he shallow or perversely profound? Was he some novel kind of idiot savant or an old-fashioned genius? Nobody was sure, but at that time it seemed that he could hardly put a foot wrong, and his impact was all-pervasive. His example was impossible to follow, since no one fully understood where he was coming from or where he was going, but it quickly sank in that after Warhol's arrival on the scene the art world could never be quite the same again, and younger artists like Chuck Close were obliged to rise to the challenge this presented.

In advanced circles, Warhol was so well established by 1967 that Close was careful not to be perceived as borrowing from him, and in any case his taste was inherently very different from the

work a glow of borrowed glamor that was alien to Close, yet there were similarities between Close's heads and Warhol's multiple portraits. Both artists worked with photographic imagery, many of Warhol's subjects cropped at the collarbone like Close's. Earlier in the sixties, Warhol had confronted much the same kinds of concerns that Close did later, searching for ways to combine figuration with post-Pollock American modernism. Warhol's solution to the challenge of process was to use silkscreens, a mechanical procedure that in his hands (or those of his assistants) still left room for expressive gestural touches. (Close talks of Warhol reducing gesture to a single squeegee stroke.) His solution to the problem of composition was often to organize multiple near-identical images into a grid so that an allover effect was achieved.

The Warhol works that most nearly anticipated Close's early portraits were the *Thirteen Most Wanted Men* installed on the outside of Philip Johnson's New York State Pavilion at the 1964 New York World's Fair. These were silkscreened blow-ups of actual "wanted" photographs issued by the New York Police Department. Objections were raised by the Governor's office because so many of the criminals portrayed were of Italian extraction. This caused a political stir, and eventually the panels were obliterated with silver paint. In their original state, they embodied the mug shot ideal that Close spoke of later in reference to his own paintings, but they differed from Close's work both in the way in which they

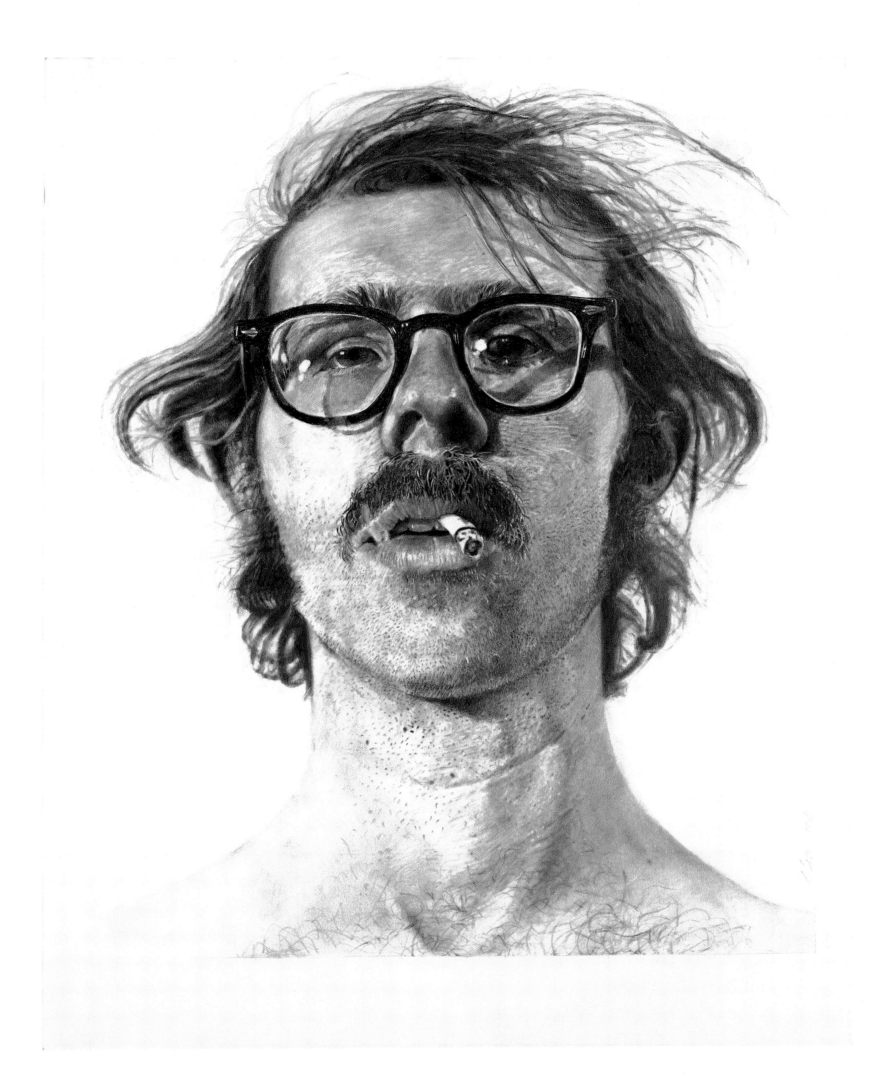

maestro of Camp. Still, he made no bones about his admiration for Warhol, and Leslie Close recalls the afternoon in 1968 when her husband brought home a silk-screened *Marilyn* he had bought for the outrageous price of $350. This led to a tremendous row because they were living hand to mouth and $350 represented more than two months' rent. Leslie can laugh about it today—the Closes still own the painting—but the fact that her husband would make such a reckless purchase at that time of hardship hints at the pervasiveness of Andy Warhol's perceived authority, and Close's response to it.

. . .

No one could accuse Chuck Close of being an artist who launched his career by pandering to easy gratification. At the same time, though, there was and is a great deal of real pleasure to be derived from looking at that first self-portrait, and it goes beyond the simple astonishment that results from seeing a head so enlarged, painted with such astonishing fidelity. In this context, it's instructive to consider the 1968 black-and-white pencil drawing Close made from a similar photographic maquette (to which a cigarette was added by collage). Produced during a later shoot, the image was reversed thanks to a serendipitous darkroom accident and thus presented the artist with the face he saw every day in his bathroom mirror, which very likely had special meaning for him because of his prosopagnosia.

This drawing is twenty-nine inches tall, rather than nine feet, so that although it is larger than life, it is has not been supersized. If the painting is on a scale normally reserved for close-ups of movie stars, or billboards of totalitarian heads of state, this portrait is scaled within the parameters we are accustomed to from visits to galleries and museums, yet it has an astonishing presence because it has been *seen* so intensely.

Close has said that the sheer largeness of the paintings he is best known for does not make him a fan of public art, which he describes as being something you come upon, almost by accident, and are expected to enjoy because a well-meaning benefactor has graciously brought out his checkbook so that the artifact can be installed in some lobby or plaza for the edification of the citizenry. For Close, a great painting is something you seek out and enjoy in

private, like a great book. The privacy of the experience is primal, though afterwards you might want to share your enjoyment and appreciation with like-minded individuals.

The 1968 self-portrait drawing brings this home. Here's an image that is almost intimate in scale but still possesses much of the power of the larger painting. The way it has been manufactured is faithful to the procedures followed in the painting, yet on this scale the results read as superb draftsmanship in a more traditional sense. Respect for those traditional skills is present in *Big Self-Portrait* too, even though the scale and the airbrush technique somewhat confuse the issues. In looking at the whole range of Close's work, it will be found again and again that there is much pleasure to be found in the sheer mastery with which he approaches different variations on the basic process he has remained faithful to. That mastery is already implicit in the 1968 pencil drawing.

. . .

It had taken Close three months of slow, meticulous work to paint the first self-portrait, the strict routine he had imposed on himself finally yielding up something astonishing. As the canvas approached completion, word began to spread in places like max's, Fanelli's, and the School of Visual Arts. Soon friends began to stop by 27 Greene Street to take a look at this astonishing tour de force. Not perhaps quite as refined as the half-dozen heads that would follow, the self-portrait was astonishingly accomplished, and it had that un-fakable look of being an authentic breakthrough painting, a masterpiece in the Renaissance sense of the word, meaning a painting in which a young artist proves himself to be a master. In this case an innovator, too, because Close had produced a painting that was not only spectacular but also a totally original synthesis of challenging, almost dangerous, ideas that only the boldest of his generation would dare to take on.

One of those who came to see the painting was Robert Israel, who visited the studio at the suggestion of Don Nice and was blown away by what he saw. As noted in the introduction, he called me in Minneapolis to tell me that I had to see this amazing painting, and after my subsequent visit to Chuck's studio, I returned to the Walker Art Center with an eight-by-ten-inch photograph of

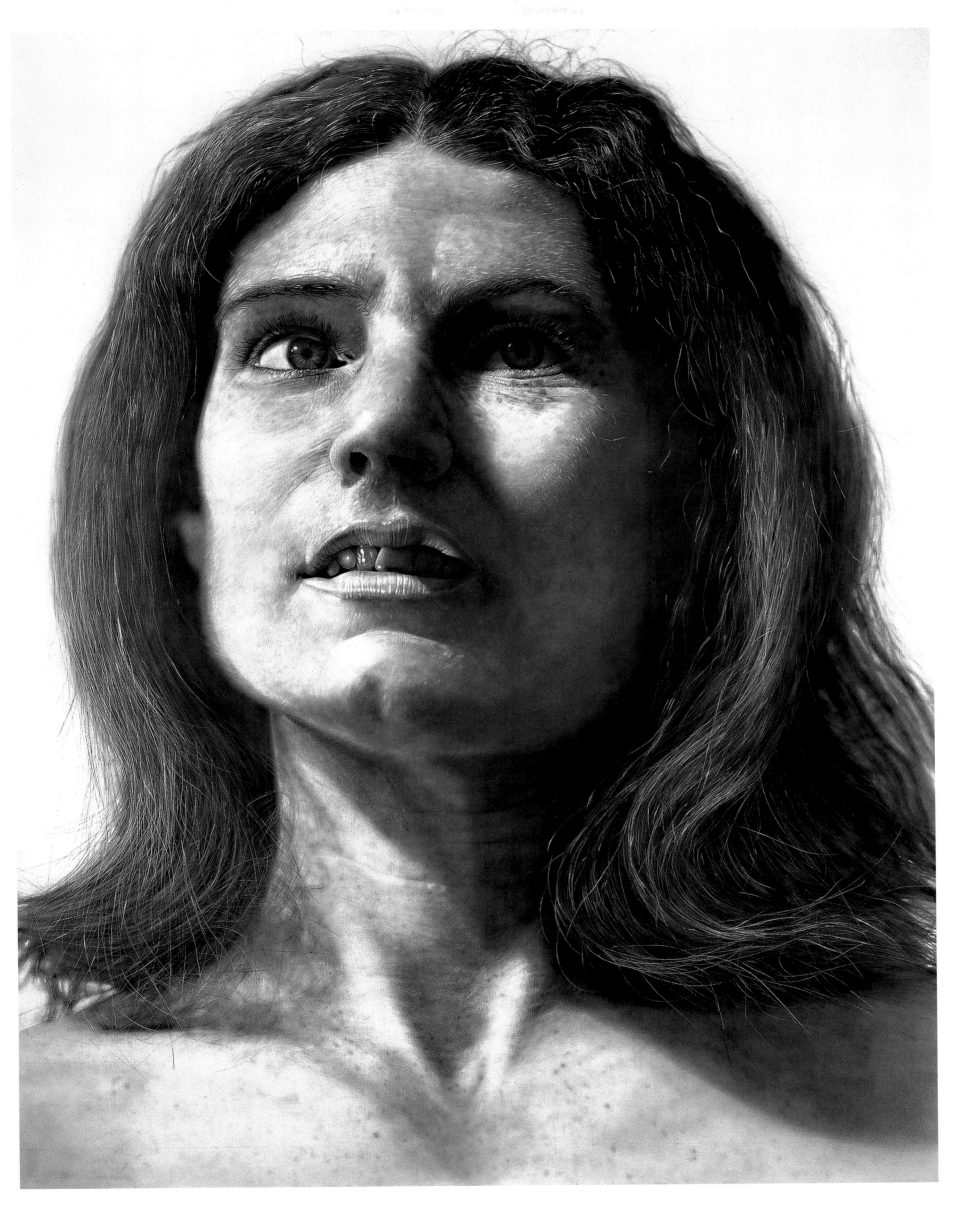

➤ Frank, 1969.
Acrylic on canvas, 108 x 84 in.
(274.3 x 213.4 cm)

Big Self-Portrait, which of course looked exactly like a photograph of a truculent young man with unruly hair, a cigarette dangling from his lips. When I showed it to Martin Friedman, the Walker's director, and other staff members, they gave me askance looks, as if I had jumped the rails. I recall telling Martin, "You have to imagine that when you're standing next to this picture you barely come up to the nostrils." His response was along the lines of "That's not a pleasant thought."

I told Martin that the Walker should buy the painting, and begged him to have it sent out so that he could get a real look at it. (Bob was making the same case by telephone.) Martin balked on the grounds that it would be expensive to crate, ship, and insure a painting that size, and difficult to justify the cost since it was by an unknown artist. On a future visit to New York, however, he agreed to visit Chuck's studio along with Bob. After seeing *Big Self-Portrait* in the original, he authorized shipping the canvas to Minneapolis. This gave board members and other interested parties a chance to get a firsthand look at the painting, and Martin gave me the opportunity to make a presentation to the acquisitions committee. The purchase was agreed to for the asking price of $1,300. Chuck claims it was two years before he saw the money.

Later he told me he had thought long and hard about how he should price this and other early black-and-white paintings. He does not recall quite how he arrived at that precise sum—extremely low even by 1960s standards—but his policy was to keep his prices as reasonable as possible so that the paintings would be affordable to public institutions.

One way this policy paid off was that *Big Self-Portrait* was seen by other Minnesota art world figures with the result that, not long after the Walker's acquisition, another of the black-and-white heads, *Frank* (1969), was acquired by the Minneapolis Institute of Art, and a third was bought by local art dealers Gordon Locksley and George Shea.

• • •

Close was thus able to launch his professional career in exactly the way he had envisioned, by making a sale to an important public institution. By the time he was paid, he had painted a remarkable series of black-and-white heads that included likenesses of New York art world friends Nancy Graves, Richard Serra, Joe Zucker, Philip Glass, Keith Hollingworth, and one of Close's SVA photography students, Frank James. When exhibited, these sitters would be identified only by their first names, a practice that Close continues to this day.

In photographing these subjects, Close inaugurated what would become his normal procedure for photo shoots of all kinds, working with a professional photographer who would serve—to borrow from movie terminology—as the camera operator, while the artist himself filled the roles of director and "cinematographer," making the decisions that determine pose, lighting, exposure, depth of field, and so on. He explains that he never wanted to be stuck with owning cameras and handling the darkroom chores. "That's not what it's about for me."

When directing these early shoots, Close aimed to achieve the mug shot look, though when seen today, not all the images quite match up to FBI standards of full frontal aesthetic nudity. While Serra (p. 58) manages to live up to expectations by coming across with the appearance of someone wanted for questioning in connection with knocking over gas stations and 7-Elevens, Nancy Graves, to whom Serra was married at the time, is presented in a way that now seems almost romantic (p. 55). Viewed—like the initial Close self-portrait—from a relatively low angle, her eyes raised skyward, she is caught in a pose that evokes the Pre-Raphaelites.

Joe Zucker, as painted (p. 59), might pass for a Depression era confidence man (Close remembers him saying he tried to look like a Midwest car salesman). This image bears no resemblance to the Joe Zucker who could have been encountered almost any evening during this period at Fanelli's. That Zucker sported a kind of Harpo Marx–like, dirty-blond Jewish Afro and habitually wore Chicago Blackhawks home-ice jerseys. The Zucker of the portrait has his hair plastered down, not entirely successfully, and is dressed in a white button-down shirt and a tie. The explanation is that he entered into a tacit conspiracy with Close that would ensure that this was not a conventional portraitist's attempt to cap-

pages 58 and 59: Richard, 1969.
Acrylic on canvas, 108 x 84 in.
(274.3 x 213.4 cm)

➤ Joe, 1969.
Acrylic on canvas, 108 x 84 in.
(274.3 x 213.4 cm)

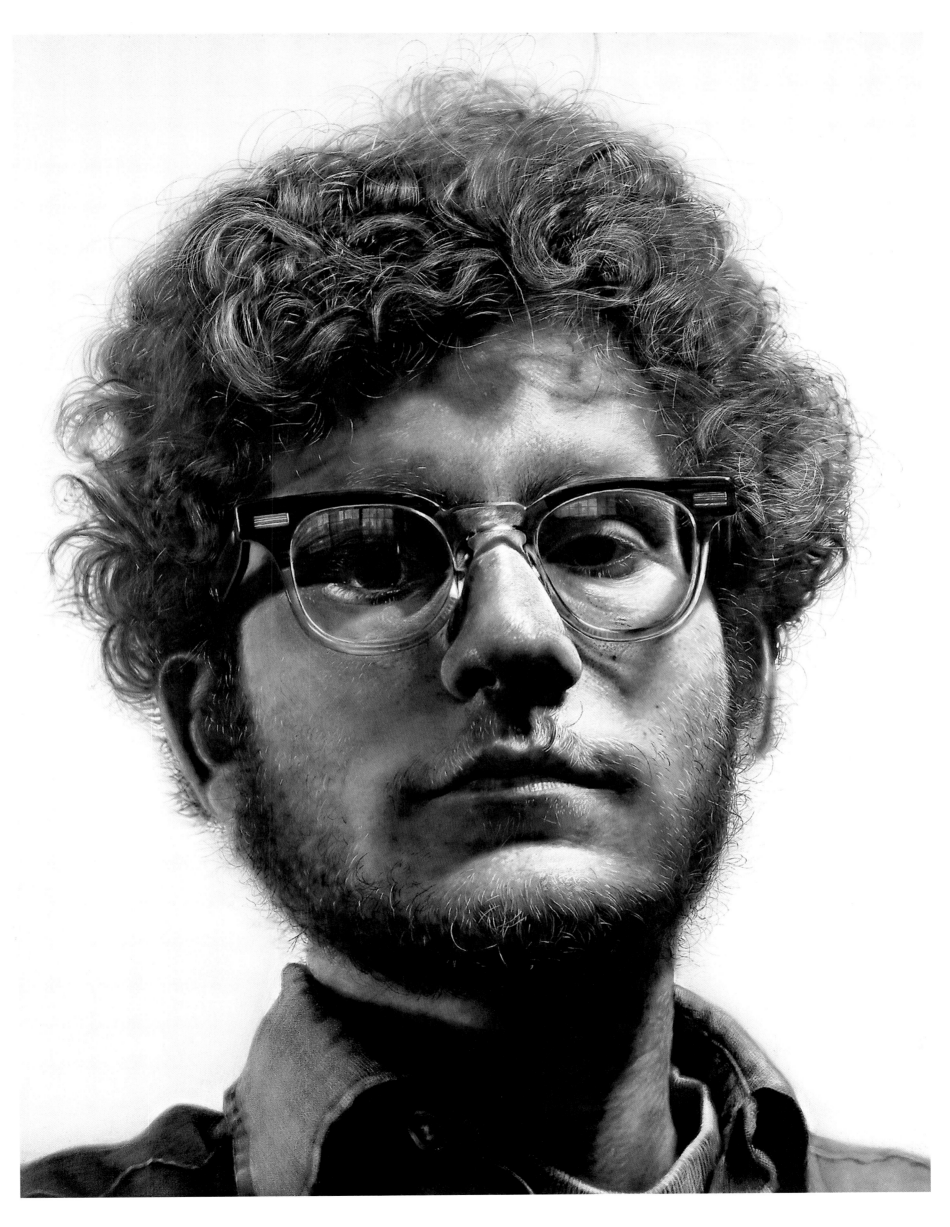

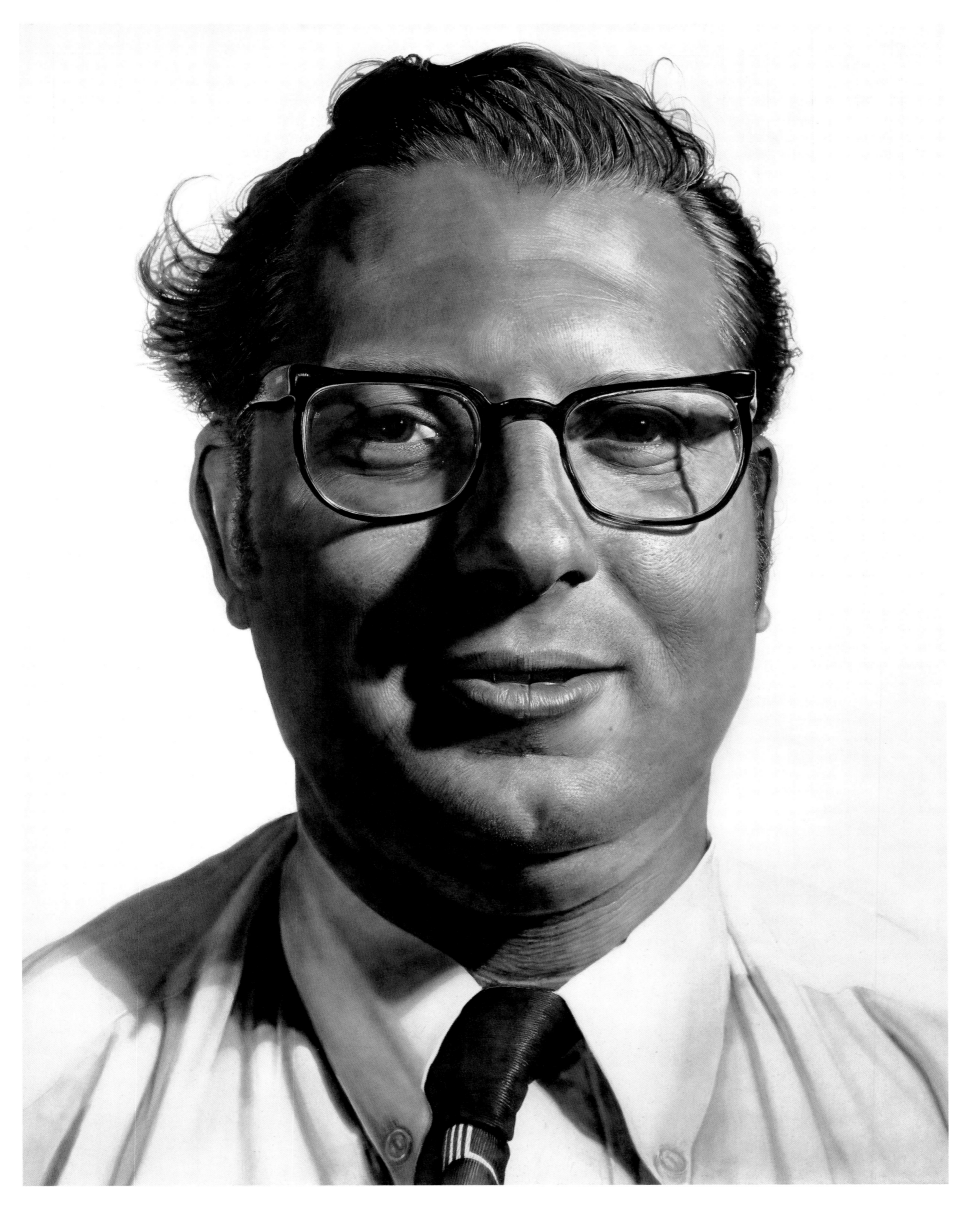

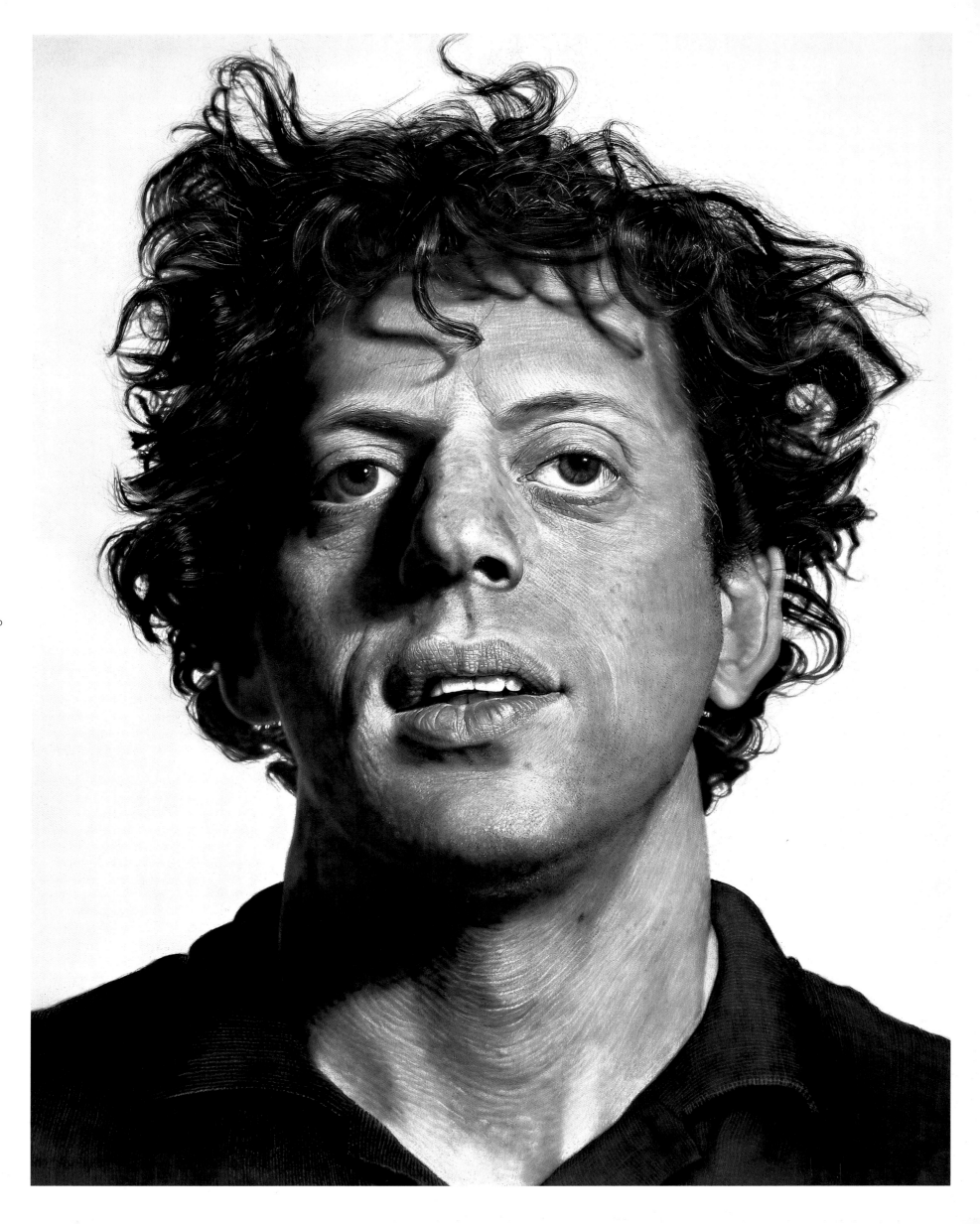

60

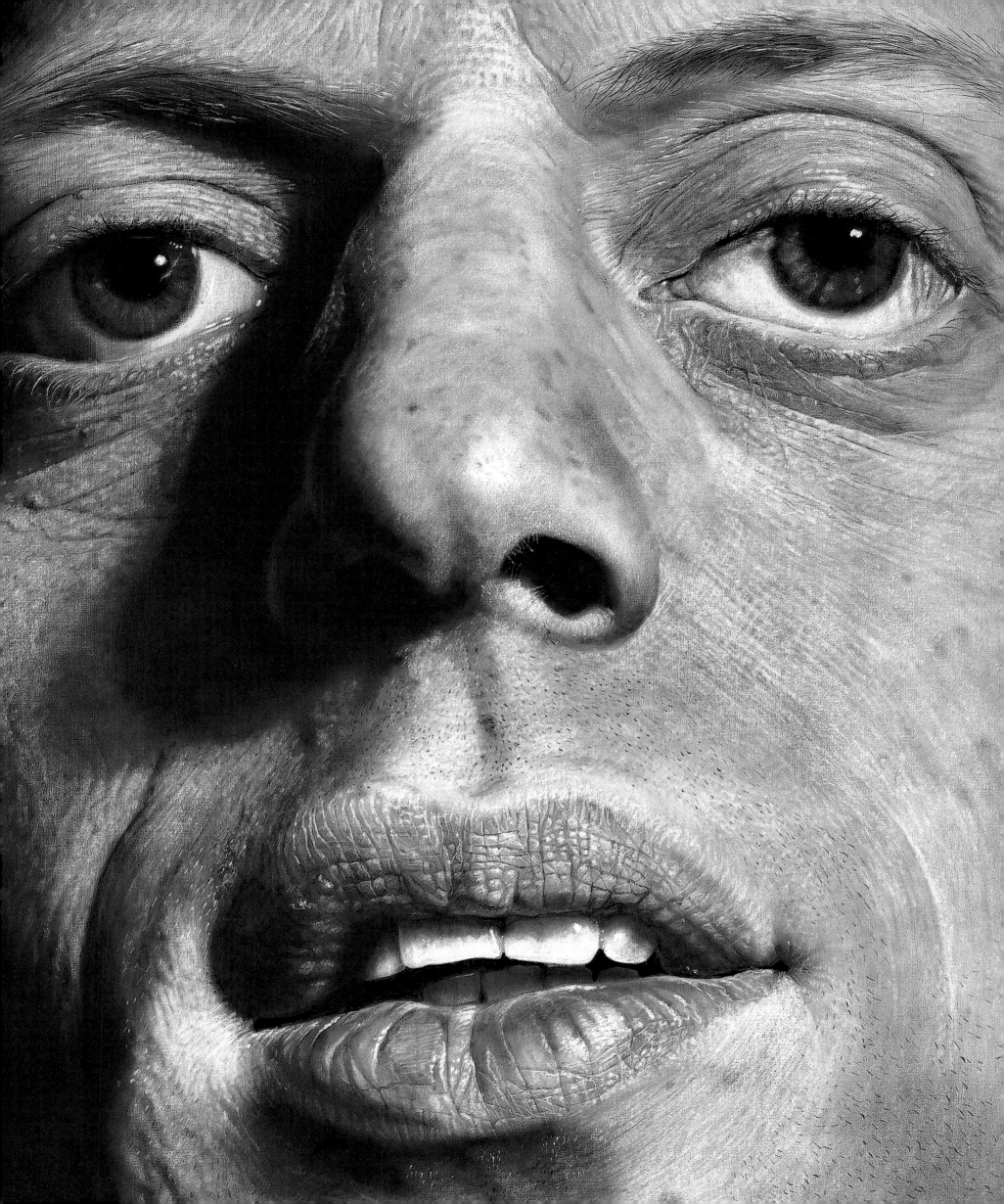

pages 60 and 61: **Phil**, 1969.
Acrylic on canvas, 108 x 84 in.
(274.3 x 213.4 cm)

➤ **Phil** (detail), 1969

➤ Chuck Close working on **Keith**

ture a sitter's "character." This was in fact an illusory Joe Zucker that existed only for the fraction of a second that the camera's shutter was open.

This brings into focus, I believe, the closeness between artist and sitter that was an important factor in the character of these black-and-white canvases. With one partial and special exception, which will be discussed in a later chapter, Close has never accepted a commission to make a painting or drawing (though he has accepted assignments to shoot photographs for magazines). It is crucial to him that the sitter is in some way integral to his life. Zucker was someone he saw on an almost daily basis and with whom he had logged hundreds of hours of discussion on many aspects of art and the making of art—process art in particular—to the extent that Zucker felt that in some way he could actually participate in the conception of the work.

· · ·

Throughout his career, Close has often returned to a given image again and again, rephrasing it in different idioms or different mediums. Of the photographs taken for the black-and-white portraits, the one that Close has gone back to most often has been *Phil*, the likeness of Philip Glass (p. 60). Taken on the same day as the Joe Zucker photograph, this is its opposite in that it shows the Phil Glass you might have run into on West Broadway almost any day in the late sixties. Like both Close and Zucker, Glass was very much involved in process—in his case as a way of generating music— providing an intellectual bond in addition to friendship.

Close makes many photographs of people for his paintings, but only a fraction of them turn out to be images he chooses to work with, and he reports that it's impossible to predict which they'll be. Some images stand out, and he returns to them again and again. *Phil* was an image that he became fascinated with because of "that Medusa hair, those hooded eyes, the lips." It became a challenge for him to take those visual elements and find different ways to represent them—to bring them alive with different kinds of marks.

Phil can be taken as a prototype for the portraits Close would make in the future. The head is presented straight on, with a very shallow depth of field which, when translated to a canvas nine feet

tall, paradoxically produces an almost three-dimensional effect because the tip of the nose and some fronds of Glass's "Medusa" hair are out of focus (just barely in the case of the nose), precipitating a strong sense of dimensional illusion—one that depends on our experience of having learned to read photographs rather than from being fooled into thinking we are in the presence of an actual person. Combined with the hidden grid used to organize the information required to create an illusion, this shallow frontal format (which allows for a maximum payload of information) has provided the basic formula on which Close has built his career.

It was Clement Greenberg's argument that painting differed from other mediums—such as sculpture or theater—because of its essential flatness. The old masters employed illusion to deny that flatness and turn their paintings into stages on which various scenes were portrayed, so that the frames became proscenium arches. By basing his portraits on photographs, Close reversed that idea, using the very pronounced illusion already captured on a flat surface by the camera to reemphasize the flatness of the canvas.

When creating these first black-and-white heads, he was going beyond just making paintings of photographs; to all intents and purposes, he was transforming himself into a photographic enlarger, a piece of optical equipment—a concept that would have delighted the Dadaists. (One thinks of Francis Picabia's 1915 cover art for Alfred Stieglitz's periodical *291*, in which he portrayed Stieglitz as a bellows camera exploded "by fidelity and passion.")

The resulting paintings can be seen as unflattering in the extreme, emphasizing as they do the sitters' flaws, from skin blemishes to poor eyesight. It could be argued, however, that by translating the camera's mechanical objectivity into paint applied to canvas on a monumental scale, Close actually invested his sitters with an heroic dignity, not by portraying them as heroes but by including them in an heroic project.

Initially, at least, this was probably incidental to his agenda.

pages 64 and 65: **Bob**, 1970.
Acrylic on canvas, 108 x 84 in.
(274.3 x 213.4 cm)

➤ **Keith**, 1970.
Acrylic on canvas, 108 1/4 x 84 in.
(275 x 213.4 cm)

pages 66–67: **Keith** (detail), 1970

62

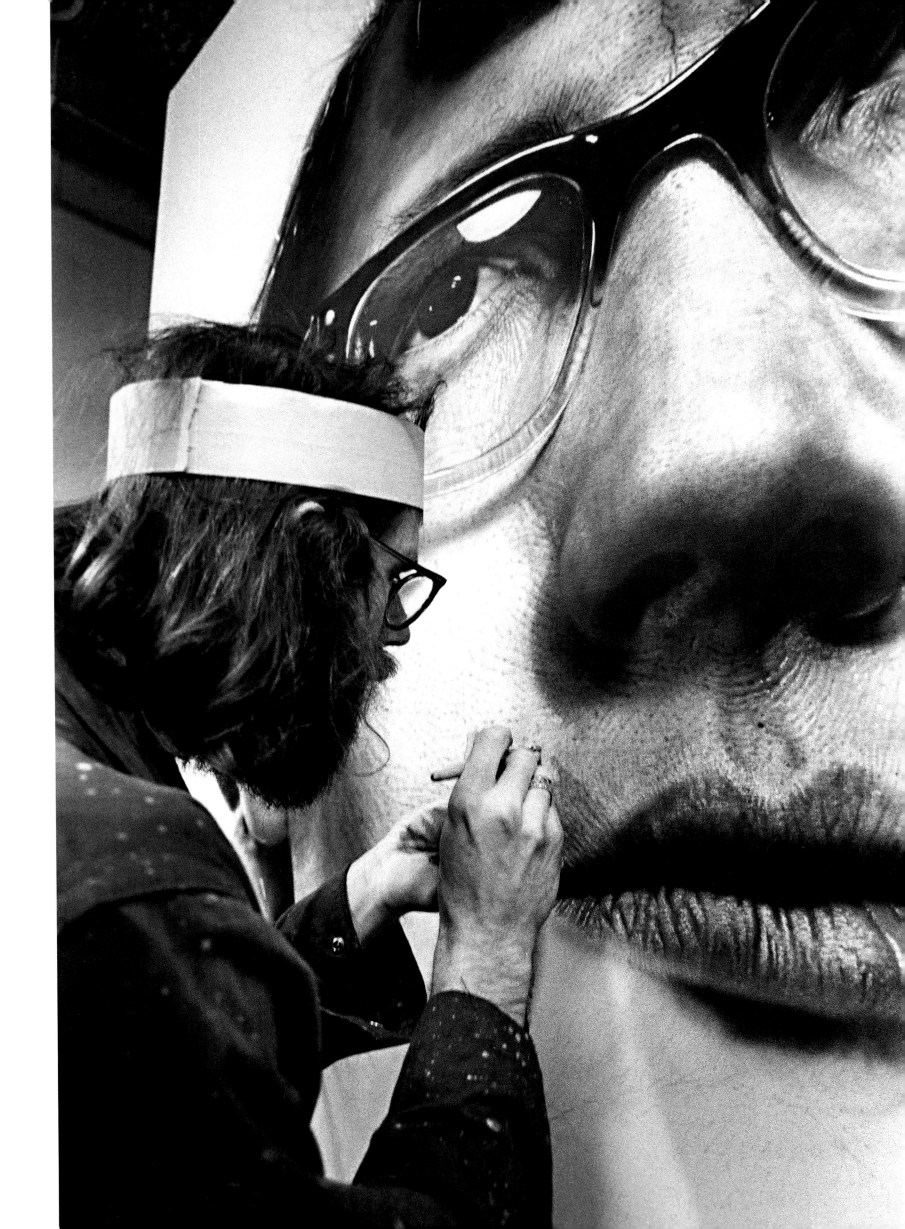

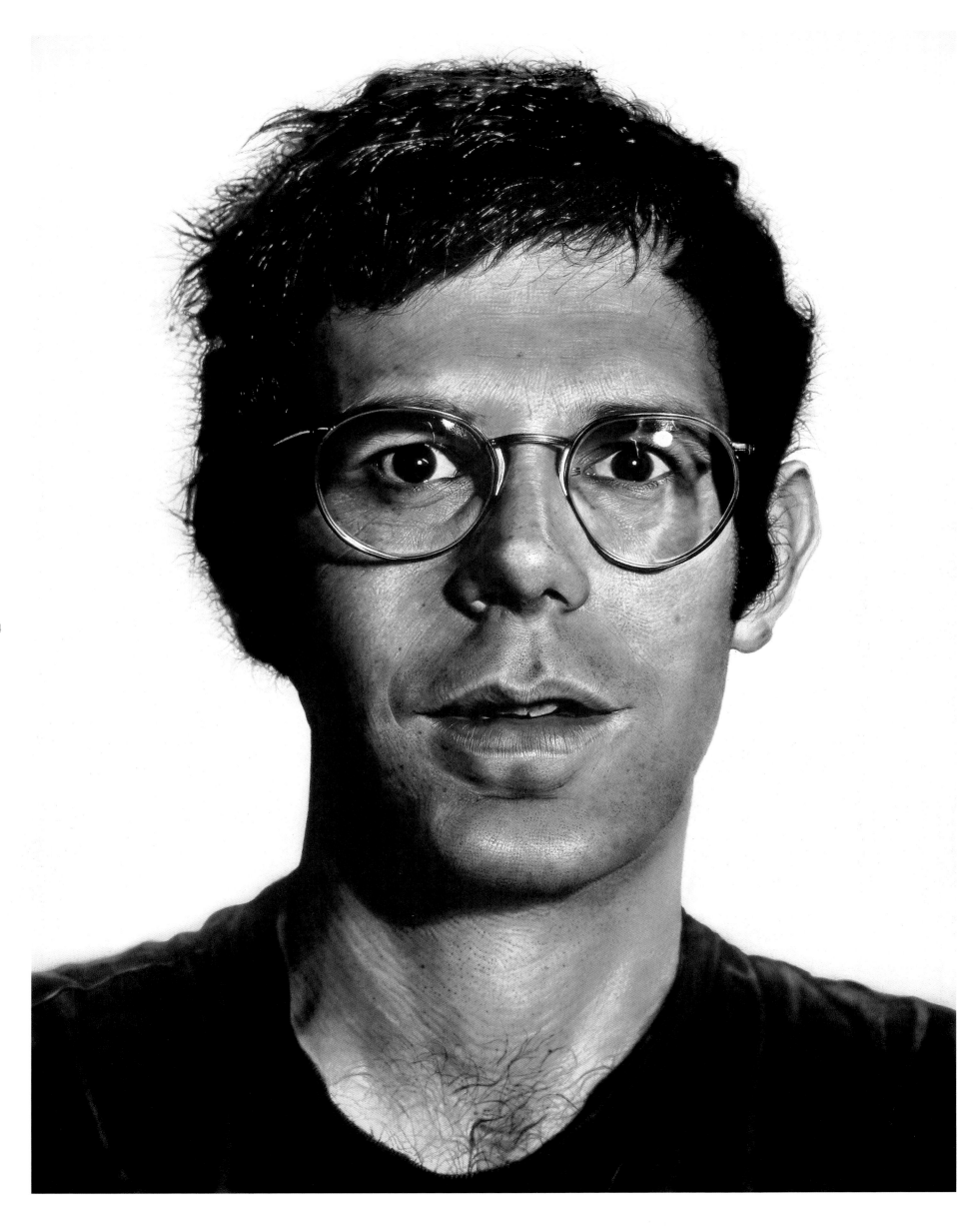

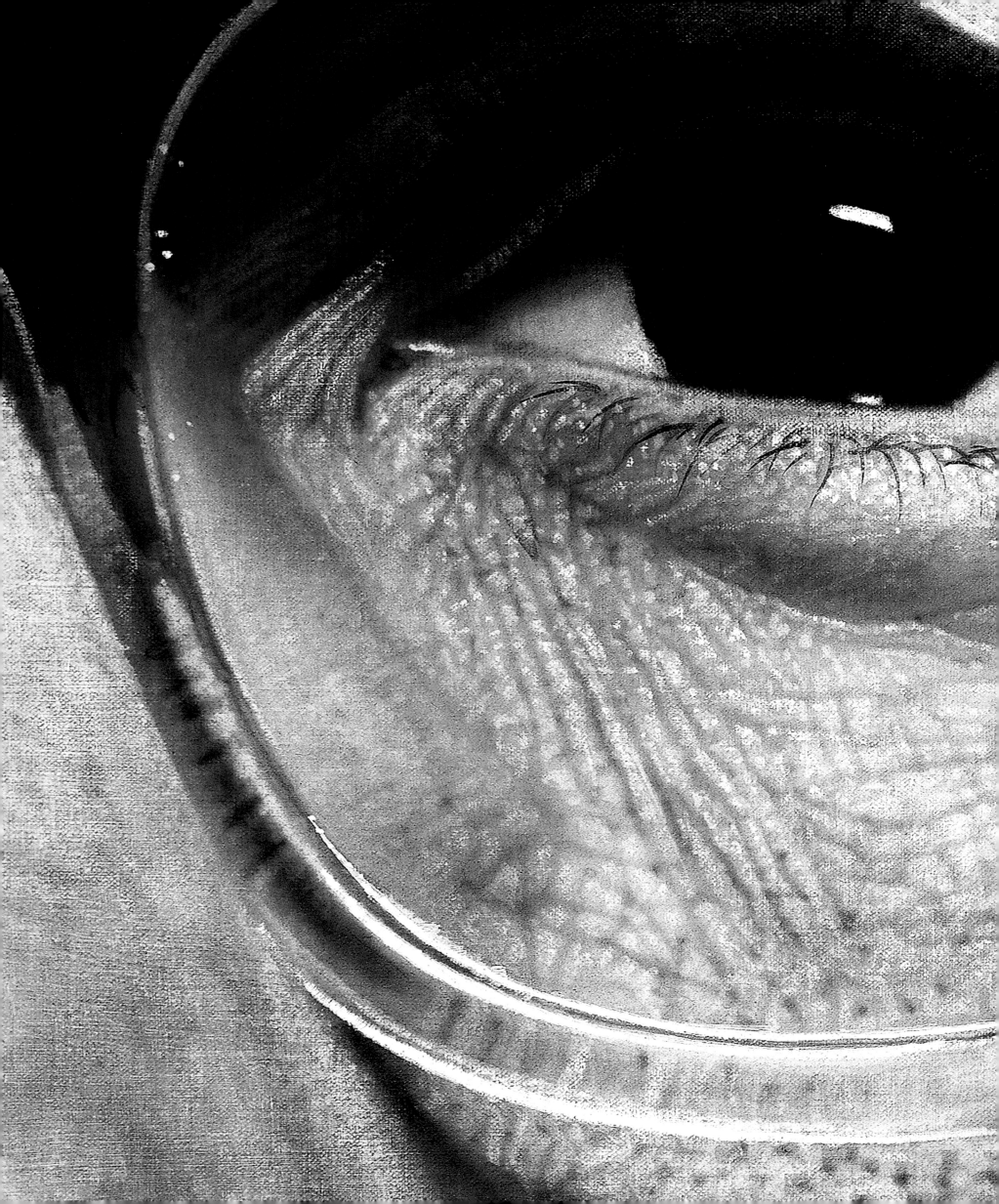

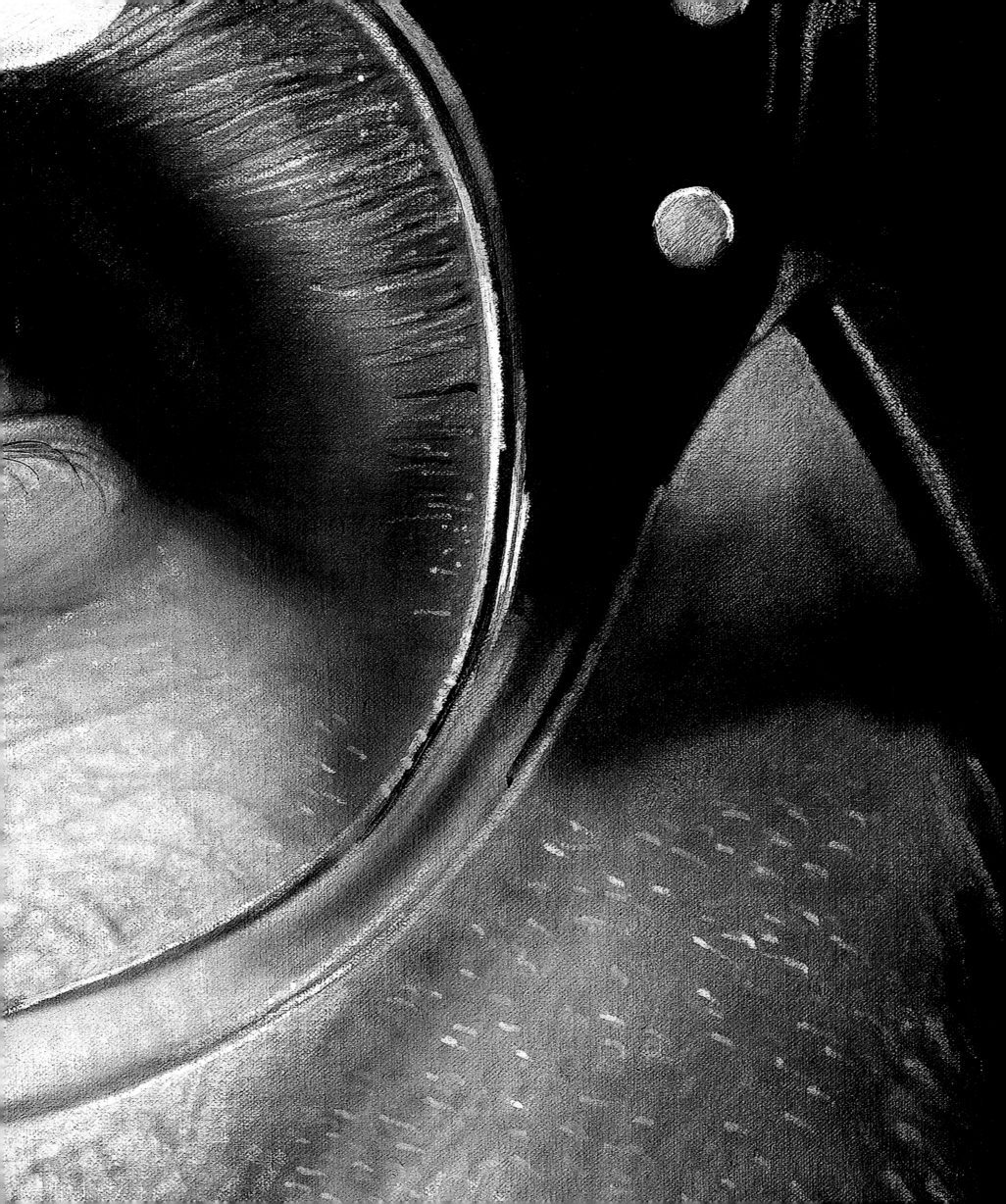

Chapter 3:

EXPERIMENTS IN LIFE AND ART

As the sixties merged into the seventies, there were several important developments in Chuck Close's life and career. In 1969 his work was included for the first time in the Whitney Museum's annual review of American art, and almost simultaneously the museum acquired *Phil* for its permanent collection. A few months earlier, he had begun an association with the Bykert Gallery, first showing there in a group exhibition that May. The following year, he had his first full-scale New York exhibition, at the Bykert, and that summer the Closes were invited to join several other artists and their families in purchasing a loft building at 101 Prince Street, a few blocks north of the space they had been renting.

· · ·

Backed by Frederick J. (Jeff) Byers, a board member of The Museum of Modern Art, the Bykert was directed by Klaus Kertess, who had studied art history at Yale while Close was in the MFA program there, though they did not meet at that time (in fact, Kertess has said he had very little contact with the studio art students). The gallery had opened in September of 1966 in the space at 9 West 57th Street previously occupied by Richard Bellamy's Greene Gallery, an important venue that had served as a springboard for several major artists including Claes Oldenberg, James Rosenquist, and Mark DiSuvero. In some ways, the Bykert came

69

to enjoy the same kind of reputation as the Greene Gallery, being a place where both director and artists were perceived as being at the cutting edge of current trends. There was a difference, however, in that while Bellamy's taste had been decidedly eclectic, taking in both Pop art and the new wave of nonfigurative painting and sculpture, Kertess leaned towards the reductiveness of non-representational artists such as Brice Marden, Ralph Humphreys, and David Novros, who were among the earliest members of his stable. Close was far from an obvious candidate to join them.

Kertess visited Close's Greene Street studio at Marden's suggestion. On that first visit, which occurred towards the end of 1968, Kertess was more impressed by Close's intelligence than by the paintings themselves, telling the artist later that his initial reaction had been, "This person is so smart and articulate, why is he making these weird paintings?" The overt strength of the work began to break down Kertess's resistance, however, and the artist's defense of his approach began to persuade him that this might be more than a one-shot *tour de force*, so he decided to include a Close

painting in a group show to see how well one of these monumental heads would stand up to weeks of daily viewing.

By the time of that exhibition, the Bykert had moved to a space on East 81st Street, recently vacated by the Richard Feigen Gallery. Close's portrait *Frank* shared a room with a poured latex floor piece by Lynda Benglis, who for a while had been the Bykert's part-time secretary. Kertess found that not only did the painting hold up to prolonged viewing, it gained from it. Convinced now, he offered Close a one man show, which opened in February of the following year. This brought together, in the south gallery, three of the black-and-white heads, while a film—produced by Close and titled *Slow Pan for Bob*—was projected in the smaller north gallery. The title of that film succinctly describes its content, the camera panning slowly and systematically over the portrait of Bob Israel.

Before the exhibition opened, Close was interviewed by Cindy Nemser for *Artforum*, the conversation appearing in the issue dated January, 1970, and it was as a result of that interview that the artist officially became known as Chuck Close. Informally he had

Advertisement announcing Chuck Close's first exhibition at
the Bykert Gallery, *Artforum*, March 1970, p. 31

been "Chuck" for more than a decade, but when it came to his pro-
fessional aspirations, he continued to think of himself as Charles
Close, and it was under that name that his work was exhibited
and reviewed on the occasion of the 1969 Bykert group show.[6]
The manuscript of the *Artforum* interview was handed in with
the abbreviation CC used to indicate his responses to Nemser's
questions. Confusion arose when a photograph that was to accom-
pany the interview arrived at the magazine's offices with the label
"Chuck Close," the name by which the student who delivered the
package knew him. An editor assumed that this was the name the
artist chose to go by and so the piece appeared under the title, "An
Interview with Chuck Close." Given *Artforum*'s prestige, it would
have been counter-productive to attempt to revert to Charles,
though to this day Close jokes, half-seriously, that he might have
enjoyed more respect had he been able to hold onto his given
name.

"Chuck" became a last minute substitution for "Charles" in
the advertisement in *Artforum* announcing the Bykert exhibi-

tion. This carefully considered artifact is of further interest in
that it consists of text superimposed on a black-and-white photo-
graph of the artist in front of his portrait of Richard Serra, Close
being out of focus while Serra's partially eclipsed head remains in
focus. (An unused alternate reversed the focal choices.) The im-
age served to give a sense of scale to the painting, while also con-
veying an impression of the importance that camera-based optics
play in Close's work. It further carried the implicit message that
the painting was unreproducible and could be properly experi-
enced only by confronting the original.

· · ·

In the summer of 1970, Close taught at his alma mater, the Univer-
sity of Washington, where he met Mark Greenwold, who was on
the faculty there, and who himself had embarked upon a program
of realist painting utilizing photographic source material.

"I had read the *Artforum* interview," Greenwold recalls, "and
had decided that I hated Chuck's paintings—which I'd seen only in

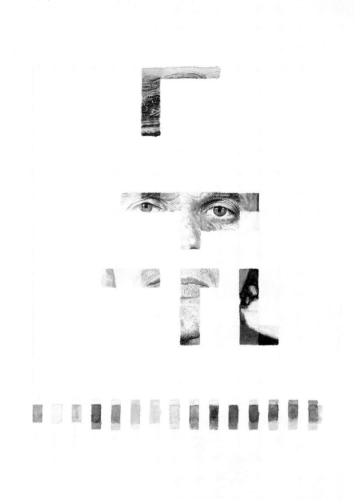

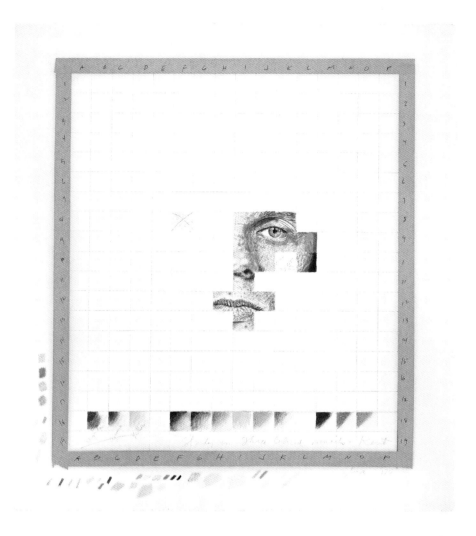

Study for Kent, 1970.
Watercolor on paper, 30 x 22 1/2 in. (76.2 x 57.2 cm)

Small Kent, 1970.
Pencil, colored pencil, and masking tape on paper,
sheet: 24 x 21 1/2 in. (61 x 54.6 cm)

reproduction, of course—and that I didn't much care what he had to say about them. I just didn't like the whole concept."

Greenwold's determination to have as little as possible to do with Close was undermined by the fact that Barbara Harshman, to whom he was married at the time, hit it off with Leslie Close, which inevitably threw the two painters together. The long-range consequence was that Close and Greenwold developed a tight friendship, serving as artistic sounding boards for one another for more than three decades. Greenwold's highly idiosyncratic paintings—snapshots from crowded domestic psychodramas set down with the precision of the early Flemish masters—often feature Close as a character.

Inevitably, that summer in Washington involved contact with Mildred Close, whose hostility towards Leslie (the coincidence of names cannot have helped) was ill-concealed. Close believes that

his mother's character was defined by her determination not to be like her own chronically phobic mother, whose neuroses had helped thwart Mildred's ambitions. Mildred, who was not good at hiding her feelings, saw her son's bride—at that time subject to panic attacks—as exactly the kind of woman he should have avoided (though it seems probable that no one would have measured up to her standards). As for Leslie, she resented being arbitrarily judged. She was also very capable of standing up for herself, so an abrasive relationship was almost guaranteed.

Leslie believes that the friction derived from the simple fact that Chuck had had the temerity to move to the other side of the continent in the first place, and that Mildred blamed her, Leslie, for keeping him there. Chuck, while remaining appreciative of everything his mother had done for him, inevitably sided with his wife when disputes arose. It was in his nature to try to smooth

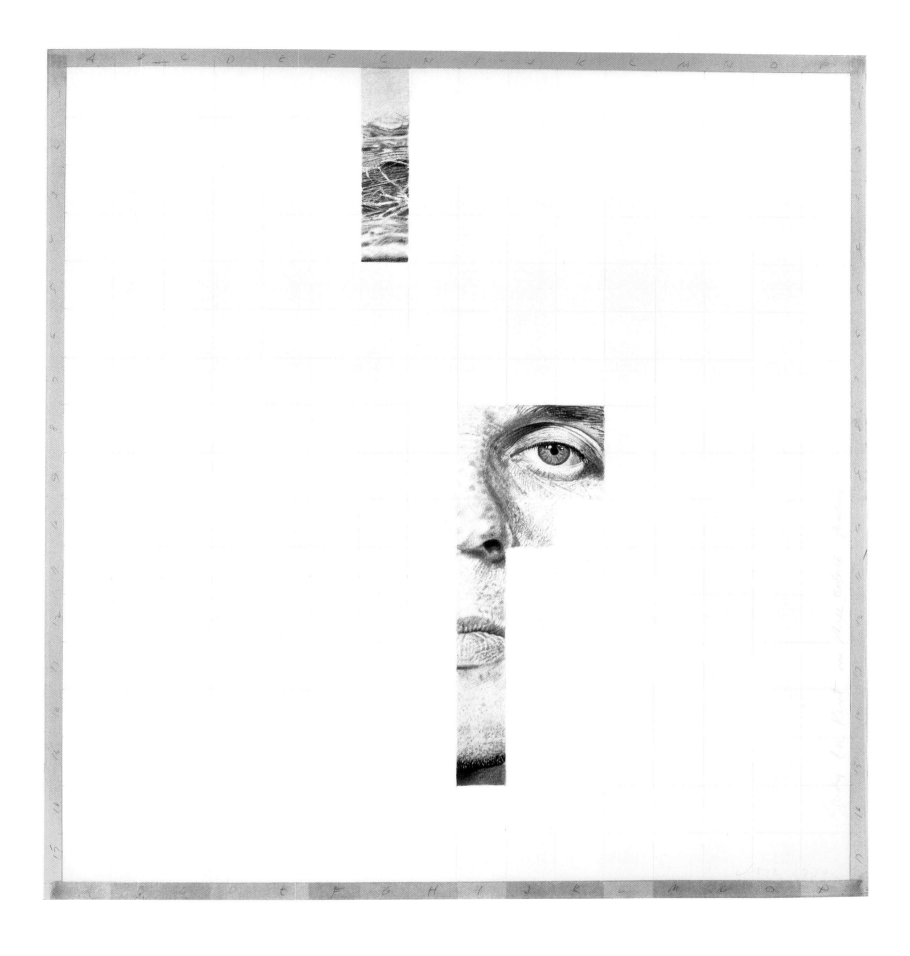

Study for Kent in Three Colored Pencils, 1970.
Colored pencils on paper, 45 x 38 1/2 in.
(114.3 x 97.8 cm)

➤ **Kent**, 1970–71.
Acrylic on canvas, 100 x 90 in.
(254 x 228.6 cm)

things over, but his mother remained obdurate and it became apparent that the situation was likely to worsen.

. . .

Returning from Seattle, the Closes were able to move into their new quarters, a loft space in a building that also housed the studios and homes of other well-known or soon to be well-known artists including Ray Parker, Joe Zucker, and Jack and Sandra Beal. Except for the Closes, all of them had been renting at 101 Prince prior to the forming of a co-operative to purchase the building. The Closes were invited to join the co-op, being offered the empty top floor previously used as a studio by Sandy Beal. The asking price for the entire building was $100,000 and, like everyone else in the co-op, the Closes were required to make a down payment of $5,000. They borrowed this from Leslie's parents, who were repaid almost immediately from the summer's earnings at the University of Washington.

The top floor at 101 Prince had been raw space at its rawest, with battered floors, peeling walls and a sagging tin ceiling. Once again the Closes turned to the SoHo art community to find people to help carry out the necessary renovations. The task of stripping out the old ceiling and replacing it with plaster, for example, was contracted out to Tony Shafrazi, later prominent as a gallery owner representing such artists as Keith Haring and Jean-Michel Basquiat.

The Closes had made the passage from hand-to-mouth garret living—an essential stage in any self-respecting artist's curriculum vitae—to owning their own living space, but it would be a mistake to think that loft life in 1970 was in any sense comparable to what it would become a few years later. This was still living on the edge, in decrepit buildings not zoned for residential use, in an area that at night remained an urban wilderness. A SoHo building for $100,000 might sound like an incredible bargain (and it certainly turned out to be a good investment), but at the time it was a struggle for young artists, largely dependent on part-time teaching positions or casual laboring jobs, to come up with monthly mortgage payments, however modest, in addition to putting food on the table and keeping a studio stocked with expensive art materials.

Even by SoHo standards, 101 Prince Street was a lively building. There was a great deal of socializing among the residents, and the dialogue between Chuck Close and Joe Zucker was especially intense during this period, undoubtedly contributing to the evolution of each artist's thought. Zucker was working on paintings in which images were created, incrementally, from thousands of cotton balls dipped in Rhoplex paint. Superficially, these were as different from Close's paintings of the period as could be imagined. A work such as *Amy Hewes* (1976), in which Zucker's subject is a Mississippi riverboat—the product of a society that had built its wealth on cotton and slavery—takes on political resonance precisely because it is made from balls of cotton. Although there was no surface resemblance between his work and Close's continuous-tone portraits, Zucker's process of assembling those cotton balls was in fact not that far removed from Close's method of breaking down imagery into tonal elements placed according the strictures of a grid. The methodological relationship between Close's work and Zucker's cotton ball paintings became more explicit later, for example in the pulp paper pieces Close made during the following decade, but a fundamental affinity was there from the outset, and the highly charged exchange of ideas between them was fruitful for both artists.

. . .

As soon as he had settled into his new studio, Close began work on a new and ambitious series of paintings. Close felt that he had done all he wanted to with the black-and-white portraits, and for some time had been thinking about what he might do for an encore. He had considered the possibility of changing subject matter—to landscape, for example—but had decided that this would not satisfy his requirements. Instead he settled on the idea of remaining with photo-based portraits, but changed the way in which the pictures were made, though without abandoning the fundamentals of his process-oriented approach.

Before leaving Greene Street, he had begun to think about the possibility of producing photo-imitative paintings in full color in a way that would be consistent with the process he had followed for the black-and-white heads. By then he was fully aware of the work of the photorealists, who were making paintings derived

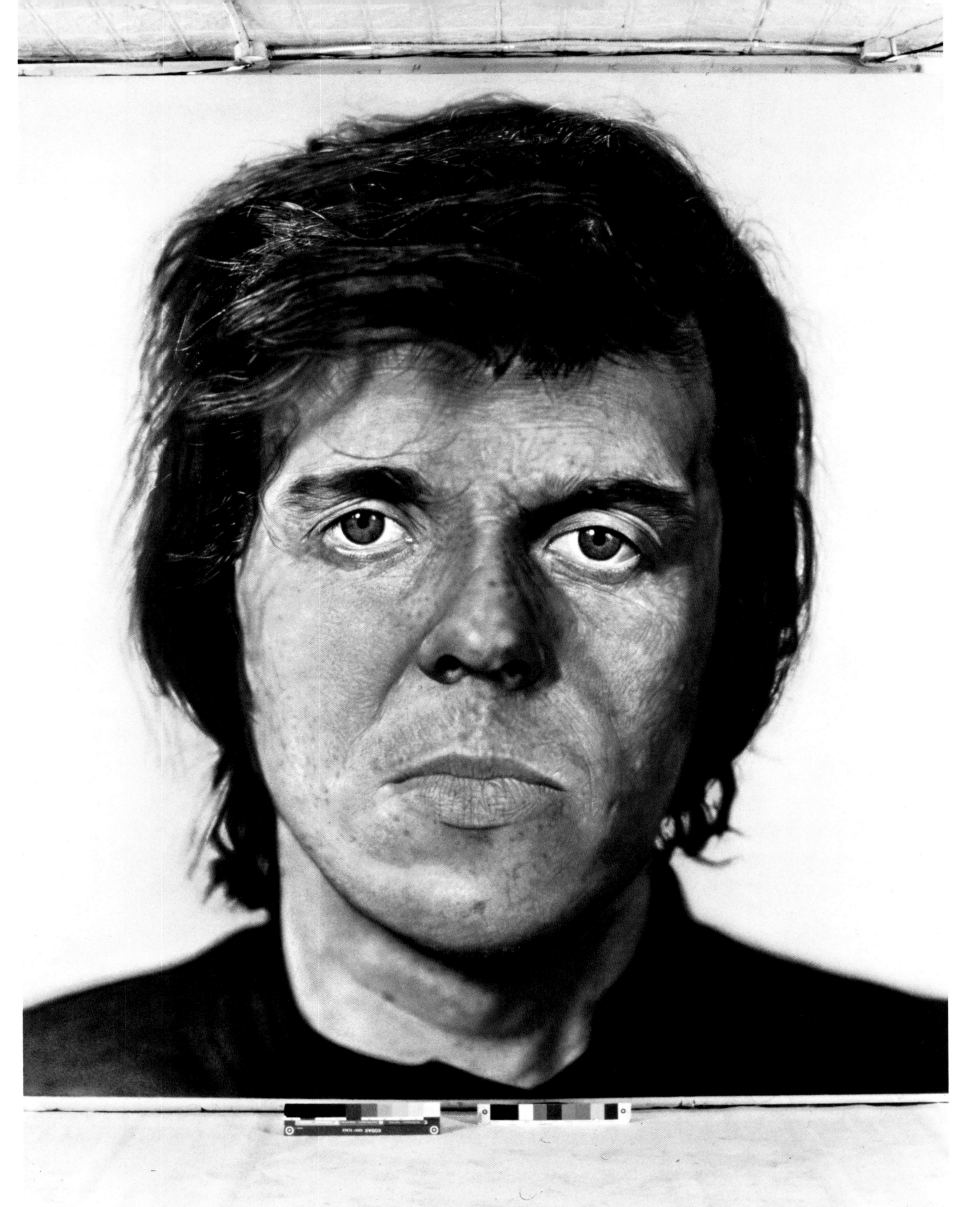

from photographs in much the way that realist paintings had always been made in that colors were pre-mixed on the palette before being applied. (In some cases, the use of airbrush meant that there was no actual palette, but the principle of pre-mixed colors still applied.) Close decided to take a radically different approach.

Before heading for Seattle for his summer teaching job, he had photographed his Yale friend the sculptor Kent Floeter, by then a downtown neighbor. The resulting transparency was sent to a photo lab where it was employed as the basis for magenta, cyan, and yellow color separations, and these in turn were used to make five dye-transfer prints: magenta alone; cyan alone; magenta plus cyan; yellow alone; and magenta plus cyan plus yellow. This last print was, of course, in full color—transparent magenta, cyan, and yellow dyes serving as primary colors, which, when superimposed upon one another, against a white ground, are perceived by the eye as evoking the entire spectrum.

It will be recalled that in making the black-and-white heads Close used only transparent black acrylic paint—no white pigment—relying on the reflective white of the canvas support to provide the lights and highlights. (Even in dark areas, the canvas continues to reflect light, if to a lesser extent, through the film of diluted acrylic). What he proposed to do now was to make a new series of portraits that would be built from three very thin, transparent layers of diluted acrylic color—magenta, cyan, and yellow—brought to life by means of the reflectivity of the white support. He was, in short, planning to reproduce the dye transfer process by hand, on his already established grand scale, using the sequence of actual dye transfers as his guide. Put another way, his ambitious intention was to make three paintings—each as detailed as any of the black-and-white paintings—directly on top of one another. Instead of being mixed on the palette, the color would be mixed by the viewer's eye.

Close took the dye transfers to Seattle that summer and in the small office/studio the college provided for him he made three studies on paper, two of them using colored pencils that approximated magenta, cyan, and yellow, and one using watercolor (pages 72 and 73). Each was made on a white sheet marked into relatively large squares, and in each case only a few of these squares were

completed, since the artist's intention was to see how well the system worked rather than to create a finished work of art. Perhaps the most interesting is the watercolor study, in part because traditional watercolor technique—which builds forms and colors from superimposed transparent washes—has much in common with his proposed method. In this drawing, some squares support a single primary color, while others are layered with two and sometimes three colors, thus providing a useful preview of the process he would be employing. In addition, below the imagery is a color chart made up from the three colors in various combinations; a similar chart appears on one of the colored pencil drawings.

To the best of Close's recollection, this is the only time he made preparatory drawings for a painting. These studies were his first exploratory gestures towards the generation of a new series of portraits every bit as remarkable as the black-and-white heads, and even more labor-intensive. That fall, Close began work on the full scale *Kent* (p. 75), a task that would occupy him well into the next year. Until he got started, he reports, it had never occurred to him that each of these paintings would take three times as long to complete as a black-and-white portrait.

Seen today, when they impress as much as ever, but astonish a little less, the black-and-white portraits have a kind of classical gravity to them, a quality that derives in part from the fact that we perceive them in the context of black-and-white photography, the chromatic constraints of which combine with its long history to invest it with a patina of cultural weight and psychological significance. The impact of the full-color photo-imitative heads would prove to be somewhat different.

A black-and-white photograph of a nude can transform the components of the body into an almost abstract dialogue between intersecting planes rendered in terms of light and shadow, as in the case of works by Edward Weston, for example. Photographed in color, however—and even if composed in the same way—a nude becomes a catalogue of pigmented information in which the flesh tones predominate, conveying sensuality in chromatic terms. In the case of portraits, the contrast is less pronounced, because a likeness is always a prerequisite, but the difference between black-and-white and color remains significant.

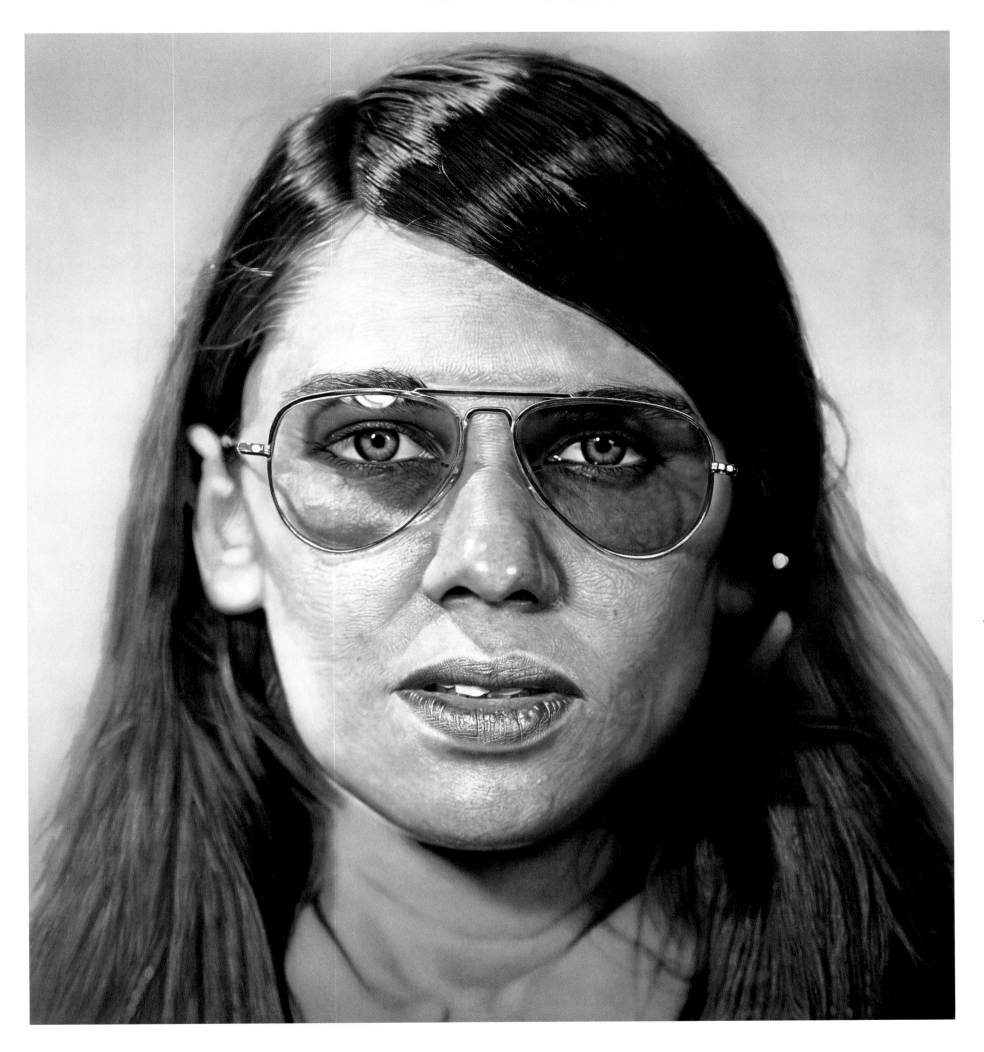

Susan, 1971.
Acrylic on canvas, 100 x 90 in.
(254 x 228.6 cm)

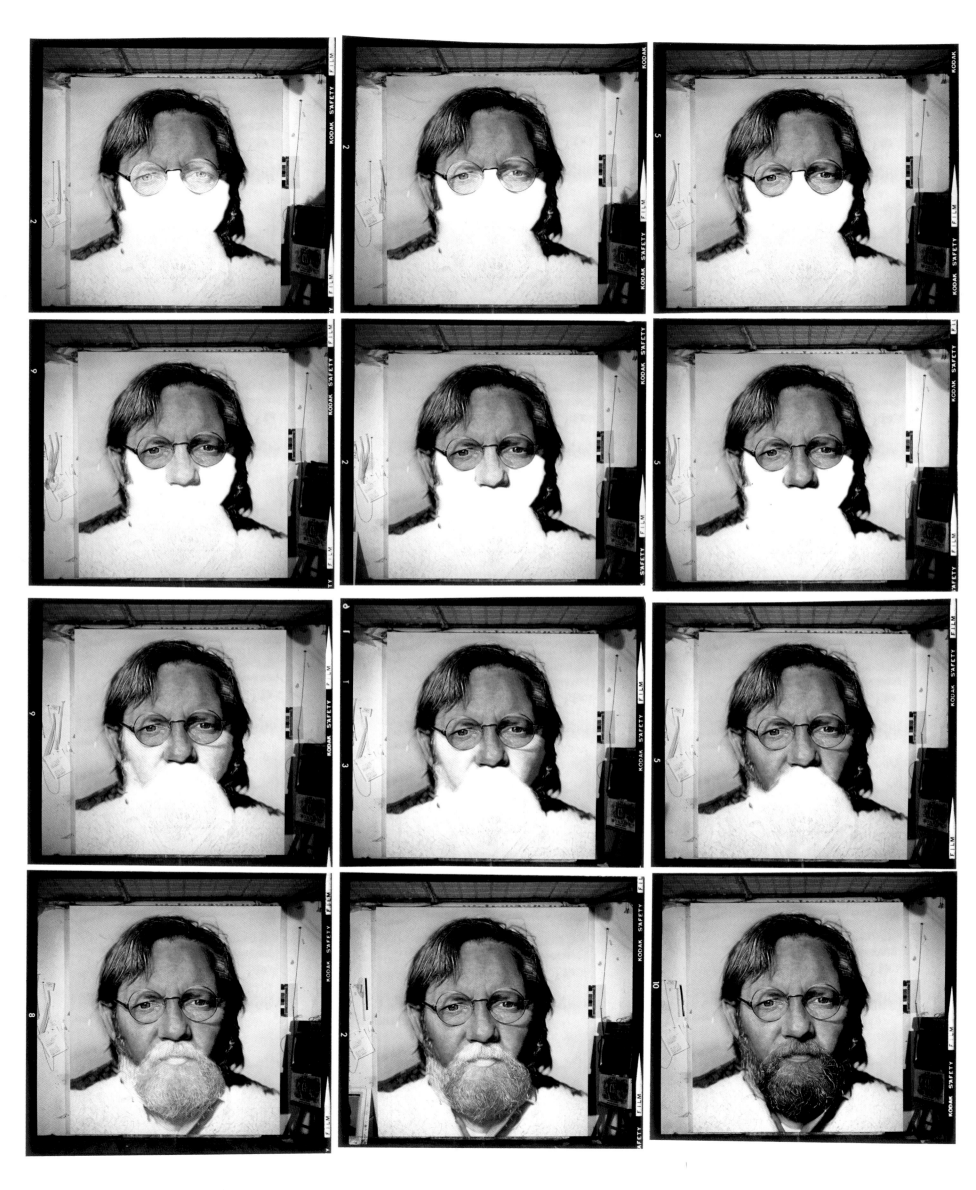

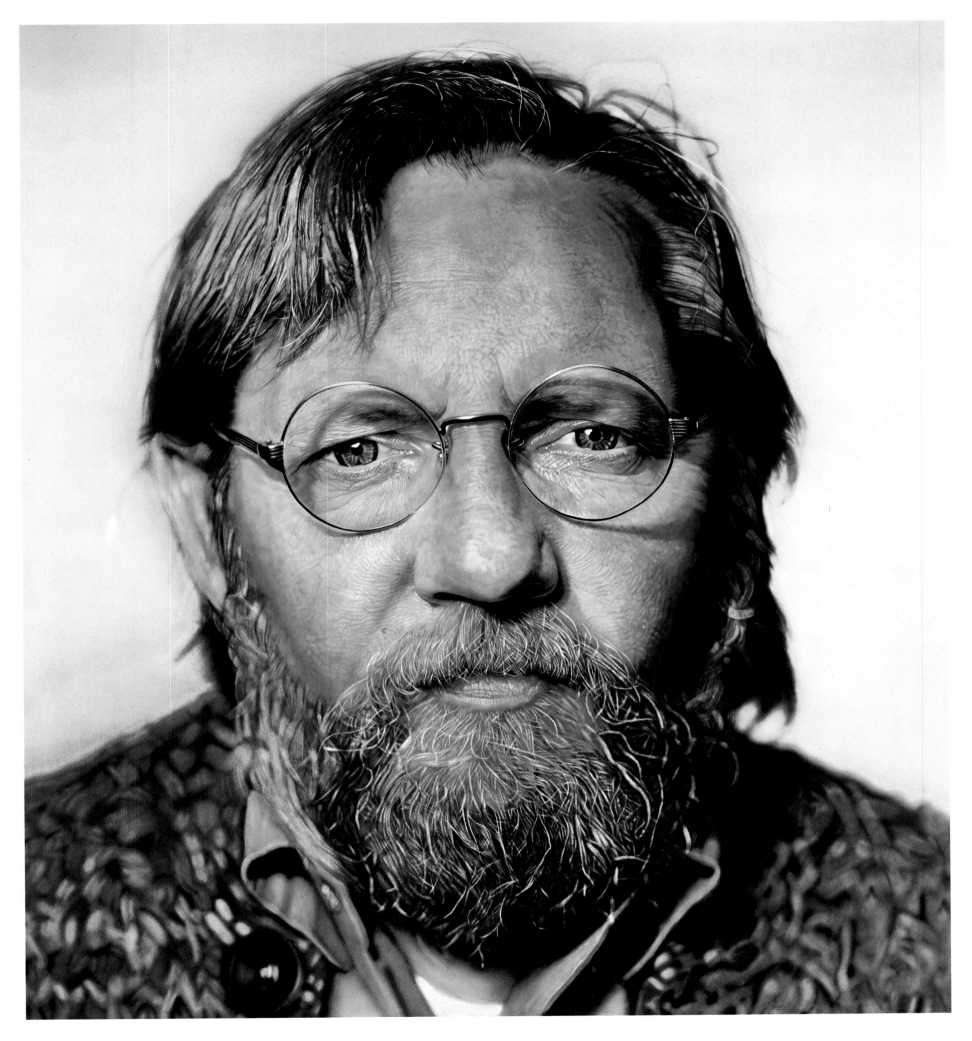

◄ John in progress, 1971–72

John, 1971–72.
Acrylic on canvas, 100 x 90 in.
(254 x 228.6 cm)

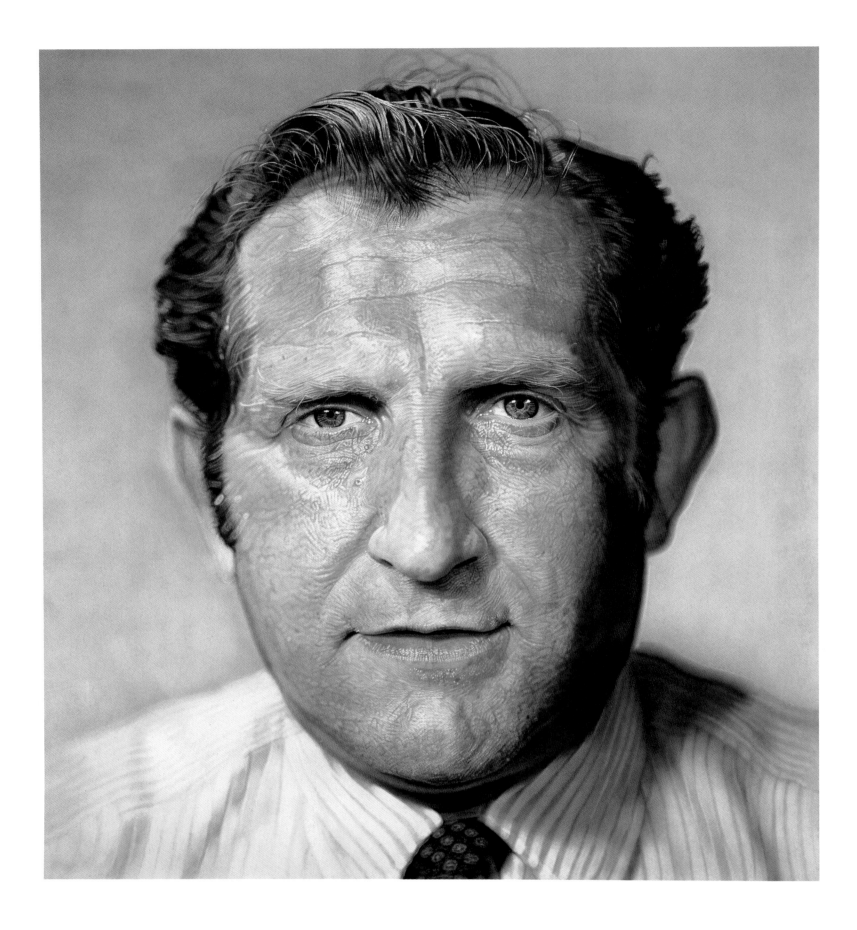

Nat/Watercolor, 1972.
Watercolor on paper mounted on canvas,
67 x 57 in. (170.2 x 144.8 cm)

➤ **Leslie/Watercolor**, 1972–73.
Watercolor on paper mounted on canvas,
72 1/2 x 57 in. (184.2 x 144.8 cm)

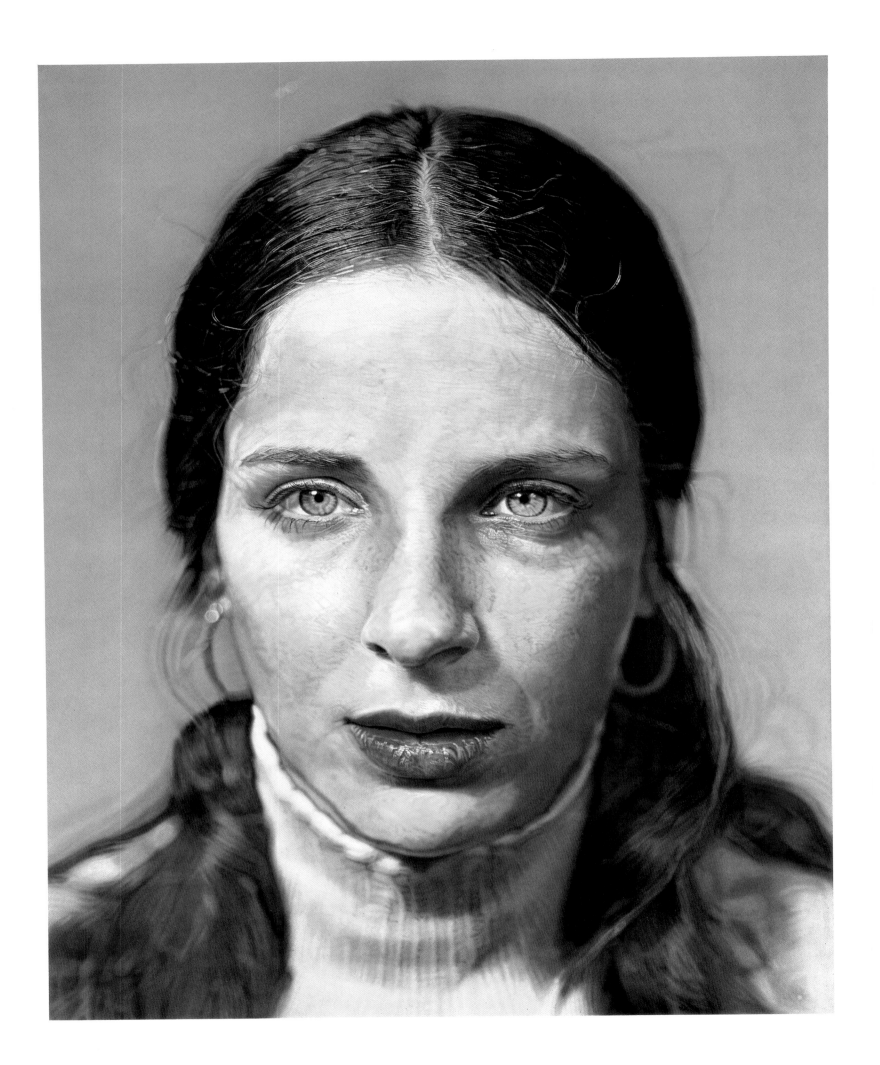

82

As he began work on the first of the three-color portraits, it quickly became apparent that Close's scheme of imitating the dye-transfer process worked well. I was a frequent visitor to the studio at the time and had the opportunity to see how fully chromatic flesh tones began to appear on sections of Kent Floeter's face, as if by magic, though in fact the process could not have been more objective and lacking in reliance upon painterly sorcery. In a sense, this was a return to Chuck Close's childhood infatuation with conjuring tricks. The conjurer appears to be performing magic, but in fact he is deceiving the eye by the application of a carefully thought-out mechanical process. To witness the portrait of Kent evolve over a period of months, seeing it a couple of times a week, was like watching a conjuring trick performed in slow motion.

• • •

The color in this painting, and those that followed in the series, is entirely photographic in character. Still, we are more conscious of the artist's hand in these works than is the case with the black-and-white heads. One reason is that the naturalistic color makes the viewer more aware of the way in which the image has been created. The virtuosity of the black-and-white portraits is cloaked in the *gravitas* of monochrome. The virtuosity of the continuous-tone color portraits is much harder to ignore.

It's interesting, in this regard, to compare the way hair is presented and perceived in the two groups of paintings. There are some virtuoso hair passages in the black-and-white paintings—Joe Zucker's slicked-back coif, for example, is unforgettable—but overwhelmingly the hair reads primarily as dark form against a light background, tending towards the abstraction that is characteristic of black-and-white photography. This is especially the case with the abundant hair of Phil Glass. Every follicle is carefully rendered, but the primary impact is that of its Medusa-like silhouette.

Looking at *Kent* (1970–71), *Susan* (1971; p. 77), *John* (1971–72; p. 79), *Nat* (1972; p. 80), *Leslie* (1973; p. 81), and *Linda* (1975–76; p. 85),[7] one finds fully chromatic treatments of hair (and a beard, too, in the case of *John*) that are no less than spectacular. Its tone and texture and hue and gloss and gyre and tensile qualities become a complex narrative that seems to reveal secrets of the sitter's character and relationship to the gene pool. Standing in front of one of the paintings, you can lose yourself in the hair.

The same is true of the skin, or of the complexities of color in an eye. The black-and-white heads are every bit as detailed, but

one tends to remember them as entities rather than as galaxies of virtuoso passages. The continuous-tone color portraits seem to invite the viewer to become immersed in minutia in a quite different way—if only because in these paintings the iris of an eye, for example, is chromatically differentiated from the adjacent eyelid—and the more one begins to consider how each detail, each effect was achieved, the more one becomes aware of the artist's hand.

Close himself is very clear about the differences between the black-and-white heads and the color portraits:

"The black-and-white heads are in your face. They have no frames to insulate them from the world. They are hierarchical, and that's due to the figure on ground being so emphatic because of the white background. When you turn to the color portraits, the backgrounds are tinted—greenish-gray in some cases, a little warmer in others—which tends to emphasize the allover character of the paintings, because every square inch, even when there seems to be nothing there, is activated by the three layers of color—magenta, cyan, yellow. If the black-and-white paintings are hierarchical, the color portraits are more wallpaper-ish."

He adds that the color portraits possess a sense of depth and distance he describes as "a window effect," by which he means that they induce the illusion of being seen beyond the plane of an imaginary window. The black-and-white heads, by contrast, have the opposite effect, as if they are painted (or maybe projected) on a blind in front of the imaginary window.

. . .

It would be easy to slip into the false supposition that at this stage of his career Close was *simply* attempting to make convincing hand-painted enlargements of photographs. In fact, it's important to remind ourselves that the process he had arrived at in order to achieve this illusion was in reality central to the endeavor, and if the process occasionally shows through the illusion, it serves to bring us closer to the artist's intentions.

One cannot overstate how time-consuming and labor-intensive the large, continuous-tone color portraits proved to be, whether painted in acrylic or in watercolor (as was the case with *Leslie*, and one of two versions of *Nat*). The main cycle, consisting of just over a half dozen paintings, occupied the artist from the fall of 1970 until the second half of 1976—an average of barely one a year, with *Linda*, whose hair proved a special challenge, requiring fourteen months of work. After a break of a couple of years,

➤ Linda, 1975–76.
Acrylic on canvas, 108 x 84 in.
(274.3 x 213.4 cm)

he then painted one last continuous-tone, full-color head, *Mark*—a portrait of Mark Greenwold (p. 87).

The sheer painstaking slowness of the process itself is somehow embodied in the finished paintings, endowing them with a character that might be described as frozen obsession. Close has compared the creation of his works—from all periods—to the way in which a book is accumulated from daily increments of units of information. This is a useful comparison, though the linear nature of a literary text does not involve the author with the necessity of confronting the same page every day, whereas each of Close's incremental paintings is like a lengthy narrative written entirely on a single sheet of paper.

It's a measure of this deliberateness of pace that the years during which these few continuous-tone color portraits were made correspond to a period long enough to see major changes taking place in SoHo and on the New York art scene. The 1970 Kent State shootings had led to an outburst of revolutionary zeal among downtown artists—which Close found himself caught up in—with 101 Prince Street becoming a mecca for radical activity. At that time, some members of the SoHo community believed that art could become a powerful instrument of social and political change. Most soon retreated from the more extreme positions (such as throwing open The Museum of Modern Art to anyone who wished to show there) but the outrage that had erupted in the wake of Kent State had long-term consequences as artists now turned their attention to what seemed like achievable goals. Support was given to museum workers who sought to unionize, and plans were made to draw up innovative contracts that would allow artists to benefit financially from the resale of their work. SoHo's women, Leslie Close included, became very active, forming support groups, staging performance pieces that challenged gender-based stereotypes, and lobbying aggressively for the greater visibility of women artists.

In part because of pressure from groups like the Art Workers Coalition, but also because of a transfusion of blood into the curatorial ranks, museums became less institutionalized, more open, more responsive to artists. The change was apparent in the kind of work they were buying, but even more, perhaps, in the way they began to accommodate experimental music, new dance, and performance art. The kind of things formerly seen only in lofts and at places like Judson Memorial Church now found their way into museums, in New York and elsewhere, with provincial institutions often in the vanguard. Close singles out Suzanne Weil of the Walker Art Center as an example of someone who provided unprecedented opportunities for artists like Philip Glass, Merce Cunningham, John Cage, and Twyla Tharpe, enabling them to reach a much wider audience.

. . .

Downtown bars remained forums where new and not so new ideas were chewed over and occasionally digested, with spots like St. Adrian's, in the Broadway Central Hotel, and Remington's, near Washington Square, gradually taking over from max's kansas city. As the seventies gathered momentum, SoHo proper acquired a new artists' hangout, the Spring Street Bar at Spring and West Broadway.

The area was becoming a magnet for pioneering entrepreneurs as well as artists. An early arrival on Prince Street was Food, the first of the new-wave SoHo restaurants, an inexpensive, artist-owned, co-operative cafeteria that served annoyingly healthy dishes. On Sundays it was ceded to local residents who cooked potluck meals for friends and neighbors. Soon after the Closes' arrival at 101, their stretch of Prince Street also became home to The Cheese Store—direct predecessor to Dean & DeLuca—a harbinger of coming gentrification that at the time was utterly unsuspected. As the decade turned, artists were still fighting for the right to take up legal residence in lofts, which was finally granted in 1971, while SoHo—at last known by that name—was designated an historic area in 1973. By then, the Closes had acquired a blue Volkswagen station wagon, and a black standard poodle, Ruby. On July 15, 1973, Leslie Close gave birth to a daughter, Georgia Molly. Leslie had received her BFA degree, but now her ambitions began to turn in a new direction. Her neighbor Sandra Beal sparked an interest in cultivating begonias, which developed into a passion, and before long the front area of the Closes' loft was filled with exotic blooms. What began as a hobby would evolve into a career.

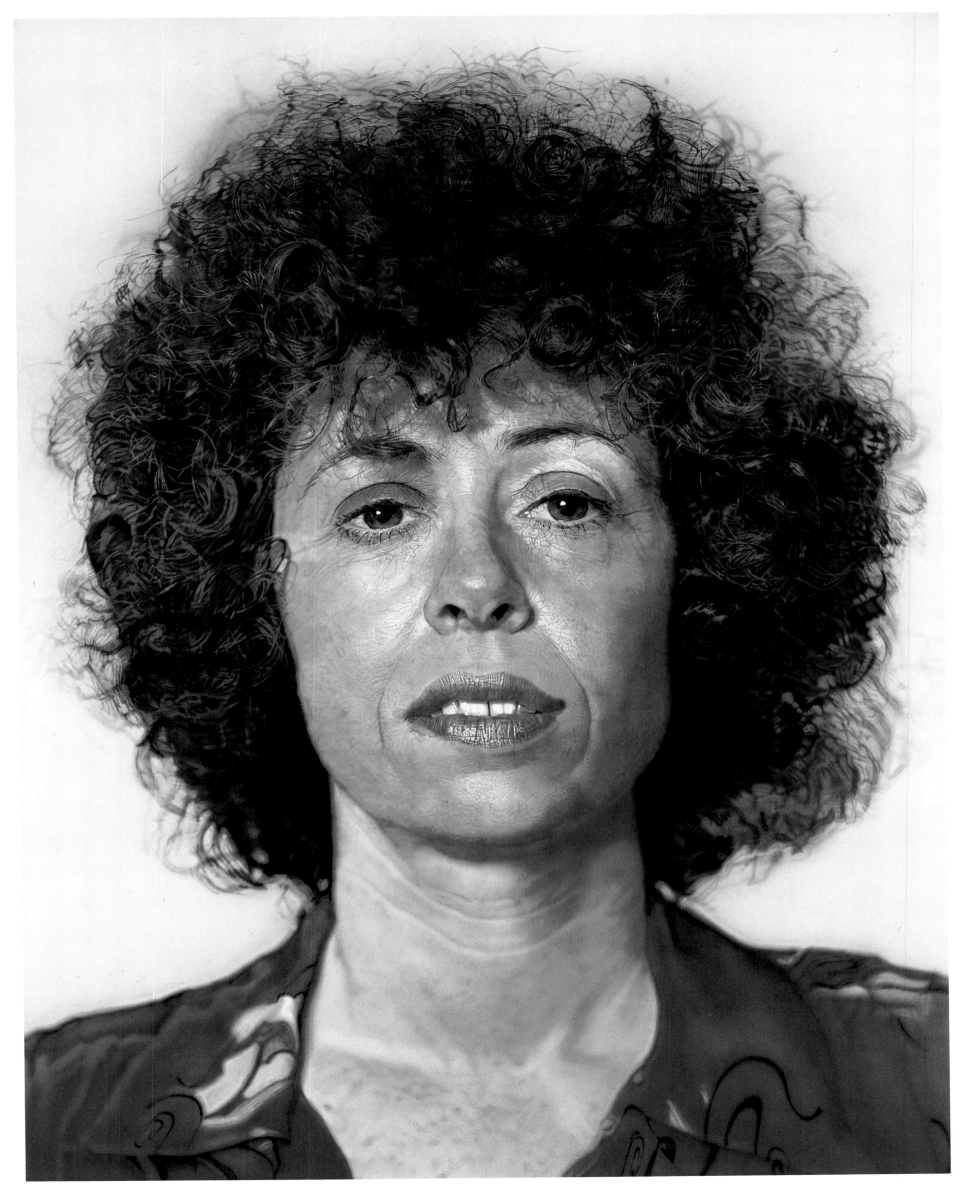

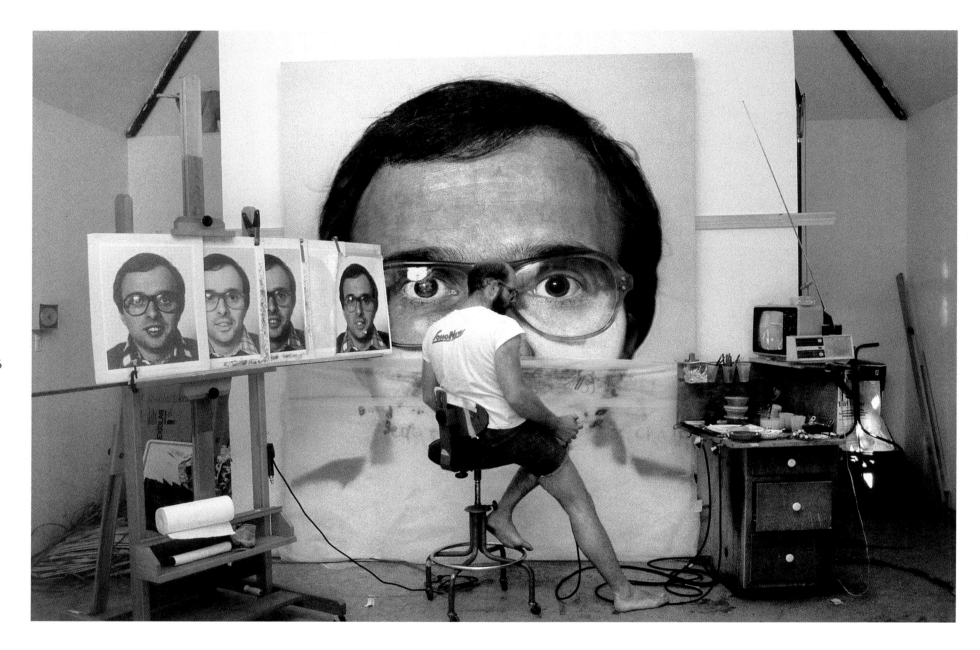

Chuck Close painting **Mark** ➤ **Mark**, 1978-79.
Acrylic on canvas, 108 x 84 in.
(274.3 x 213.4 cm)

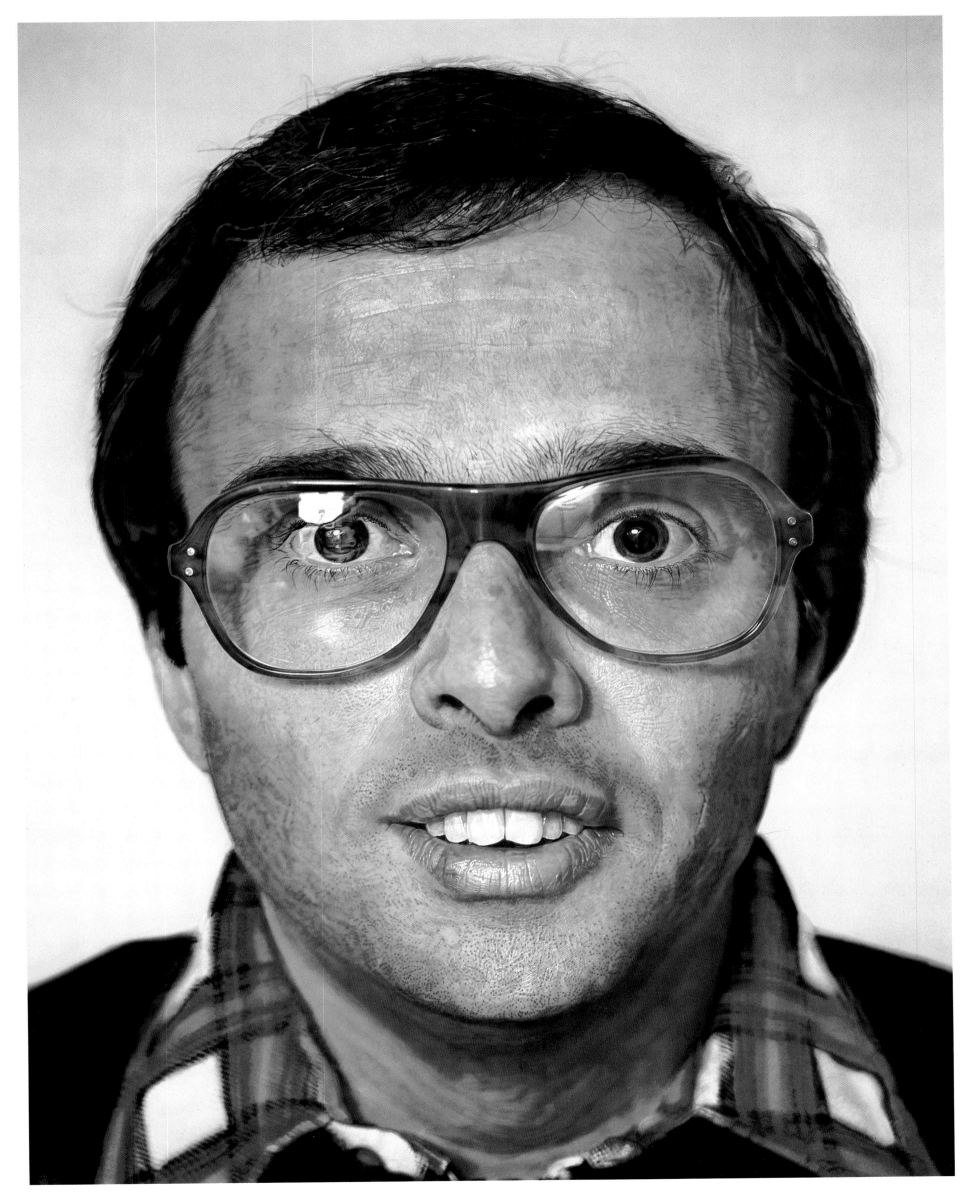

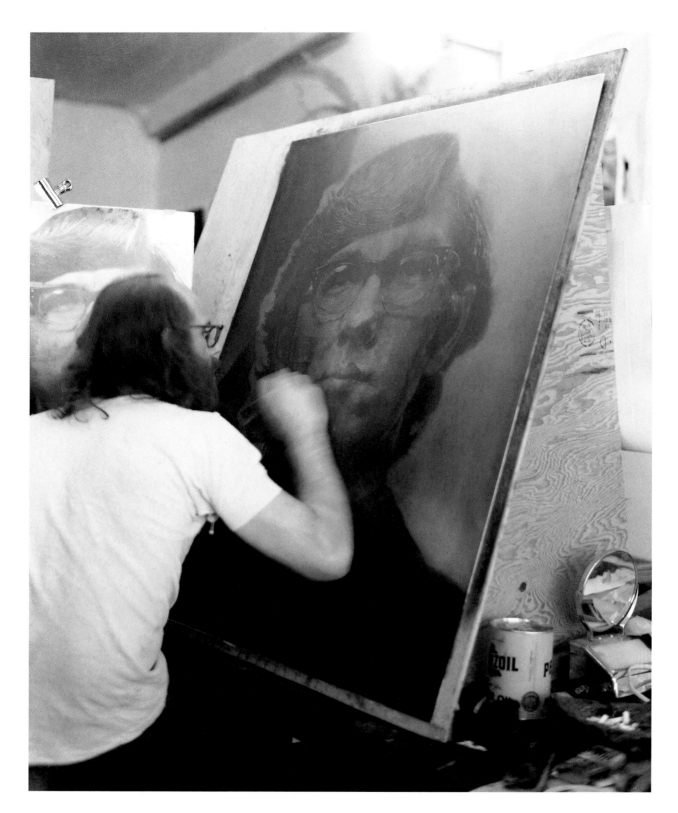

Chuck Close working on **Keith/Mezzotint**
at Crown Point Press, 1972

Close had his third Bykert Gallery exhibition in 1973, having shown the last of the black-and-white heads in 1971. Since then, his work had also been seen at museum shows in Los Angeles, Chicago, Akron, and New York, where The Museum of Modern Art featured him in one of its Projects exhibitions.

If the big continuous-tone color portraits were the most ambitious products of this period, Close had by no means lost his interest in black and white, and in the summer of 1972 he traveled to California to create a work that he considers a landmark in the evolution of his commitment to process. Earlier that year, Robert Feldman of Parasol Press had asked him to think about making a print, giving him a virtual carte blanche. Having a sound basic knowledge of printmaking, Close eagerly accepted the challenge, and announced that he wanted to make a mezzotint—a very large mezzotint. This was no casual proposal since to all intents and purposes the art of creating mezzotints was dead, killed off by photogravure during the nineteenth century. For Close, that was part of the appeal. He wanted to do a mezzotint because no one had done one of any ambition for a hundred years.

Additionally, he was drawn to the technique because, when properly executed, it produces wonderfully rich, velvety black-and-white images. Invented in Holland in the seventeenth century, the mezzotint was occasionally used by major artists—notably Goya—but enjoyed its glory days in England during the eighteenth and early nineteenth centuries when master craftsmen such as Valentine Green and John Raphael Smith employed the medium to make limited edition replicas of works—often portraits—by the Royal Academy stars of the day. There was good reason to suppose, then, that it would lend itself well to replicating photographic imagery.

Green and Smith, and their contemporaries, worked on copper etching plates prepared by being pricked with tens of thousand of tiny holes, this being achieved with a device called a cradle or rocker furnished with tiny cutting teeth. If inked with a very thick ink and run through a printing press, the prepared but otherwise unworked plate would produce a uniform and dense black impression. The printmaker then scraped and burnished his image into the plate, producing areas that would hold progressively less ink or no ink at all, in effect, working from black to white

(the exact opposite of the method used by Close in his black-and-white paintings). In traditional mezzotints, the punctures in the copper were produced in such a way as to create a burr on the surface (caused by displaced metal) which meant that the plate, when printed, cut into the surface of the paper so that the paper absorbed even more ink, adding to the richness of the blacks that could be produced.

This then was the method that Close decided to adapt to his own ends, the image he selected to work with being the 1970 black-and-white portrait of Keith Hollingworth. Arrangements were made for him to collaborate with Kathan Brown of Crown Point Press, which had been producing high quality etchings for a decade, working out of a San Francisco basement. Crown Point had recently moved to a loft in Oakland but was still printing on the modestly-sized press previously installed in the basement. The plate size Close had in mind—the final image would be 51 by 41 1/2 inches—was far larger than anything that could be handled by a standard press of that period, so a new one had to be custom built.

When the school year was over, Close traveled to California and embarked on three months of intense work, much of the time being spent problem-solving, since reviving the mezzotint process and modifying it to accommodate the scale of this print proved far more complex than anyone had imagined. Brown has explained how it would have been impossible to prepare a plate this size using the traditional rocker method.[8] Instead she prepared it using a photo-etching technique that produced three hundred bites per linear inch, but which proved to be extremely difficult to apply evenly to so large a plate. Also, it made the bites without throwing up a burr, which had advantages when it came to proofing (since the burr would have been damaged by the multiple passes required in proofing a print this large) but which proved to be a problem for Close as he worked the copper because, instead of removing burr, his scraping removed actual surface metal, which caused tiny unwanted pits, each ready to sop-up ink, to be uncovered. This was a nuisance that had to be eliminated by burnishing the copper, caving the holes in, and filling them.

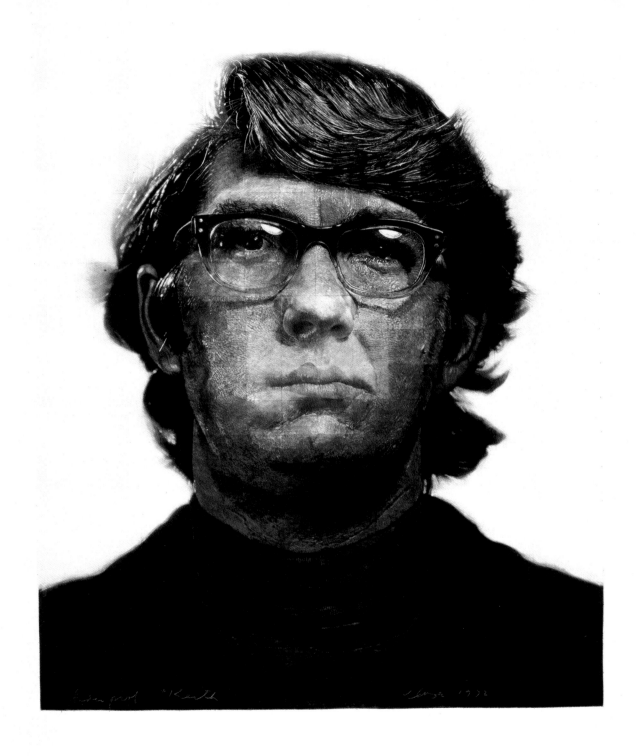

Keith/Mezzotint, 1972.
Mezzotint on paper, sheet: 51 1/2 x 42 in.
(130.8 x 106.7 cm)

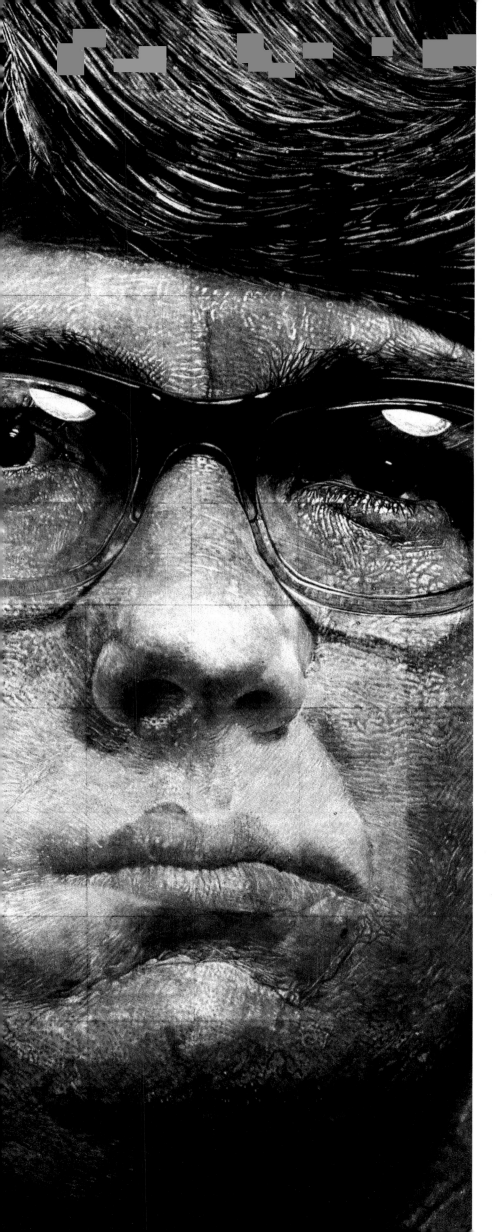

Another problem derived from the fact that Close began by working from the middle of the image, where the details in the maquette are sharpest. This part of the print was proofed so many times that the surface of the plate began to break down. As a result, the central rectangle in the final image, where eyes, nose and mouth are clustered, printed significantly lighter than the rest of the image. This might be seen as a blemish, but it can be more usefully thought of as an inevitable, if unforeseen, by-product of the process.

In the end, the entire plate began to wear down—partly because of problems with the oversize bed of the press—so that just ten satisfactory proofs could be pulled. Those, however, are remarkable examples of ambitious experimental printmaking, fully exploiting the beauty of velvety blacks—in the subject's hair, for example—made available by the mezzotint process.

For Close, this print has added significance because it was the first work in which the incremental method by which the image was created is explicitly revealed. Initially, this occurred by accident: the building blocks of the image—the information contained within each discrete element of the grid upon which the whole was based—did not quite match with one another, so that the image seems to be overlaid with a faint checkerboard pattern, bringing the existence of the grid out into the open. Realizing that this was happening, Close accepted it as evidence of the process, and he began to think about how he might explore and expand the possibilities implicit in this important transitional work.

• • •

In *Keith/Mezzotint*, Close not only allowed the grid to emerge from behind its photographic veil, he also inaugurated another practice that has become a constant in his career, the habit of recycling images in different mediums, using imaginative variations on his basic methodology. Sometimes these reprised images would be based directly on the original photographic maquette, sometimes they would be generated from a painting made from the maquette, rather than the maquette itself, and so on, often through several cross-pollinated generations.

Keith/1,280, 1973.
Ink and pencil on graph paper,
sheet: 22 x 17 in. (55.9 x 43.2 cm)

The original 1970 black-and-white painting *Keith* formed the basis, at various removes, for the mezzotint, a 1975 lithograph in which the head appears four times in different sizes, and two 1981 handmade paper pulp editions. Interspersed with these multiples were a number of drawings, beginning with a 1973 version on graph paper in which the likeness has been built from dots of airbrushed black ink of various densities placed on a grid made up of 320 penciled squares, each of which is further divided into four by the underlying squares of the graph. Though little more than a sketch, this is an early expression of the artist's basic process presented in its naked form, and it led to a long series of black-and-white sprayed dot drawings ranging from snapshot size upwards.

The largest of these, with a canvas support, is the nine-foot tall *Robert/104,072* (1973–74; p. 97) which, like the continuous tone painting *Linda*, took fourteen months to complete. This head is built from what seems like a near infinity of dots (actually the 104,072 of the title), and later in 1974 Close made a series of four smaller drawings on paper in which the same basic image is presented in sizes ranging from postage stamp to a bit larger than a tabloid newspaper, using progressively more

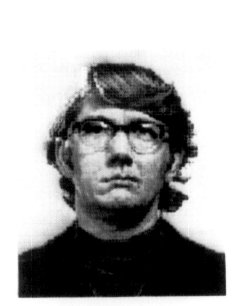

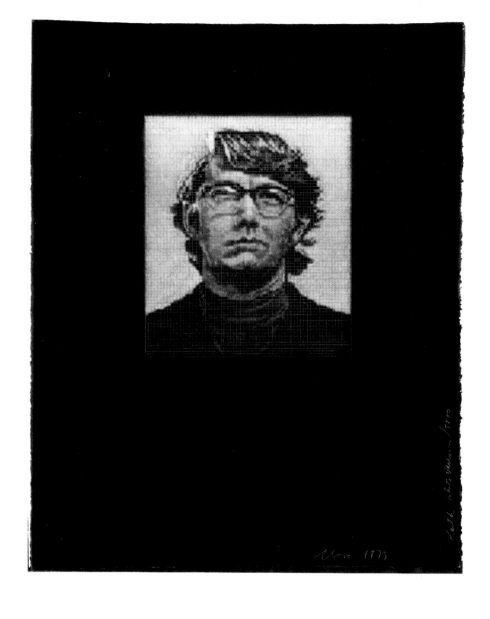

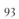

Keith/Three Drawing Set, 1973:
ink on white paper version;
white ink on black paper version;
ink on graphite ground version;
each sheet: 30 x 22 1/2 in.
(76.2 x 57.2 cm)

Robert I/154 · Robert II/616 · Robert III/2,464 · Robert IV/9,856, 1974.
Ink and graphite on paper; each sheet: 30 x 22 in. (76.2 x 55.9 cm)

pages 96 and 97: Chuck Close at work on
Robert/104,072, 1973–74

➤ **Robert**/104,072, 1973–74.
Acrylic on ink with graphite on canvas,
108 x 84 in. (274.3 x 213.4 cm)

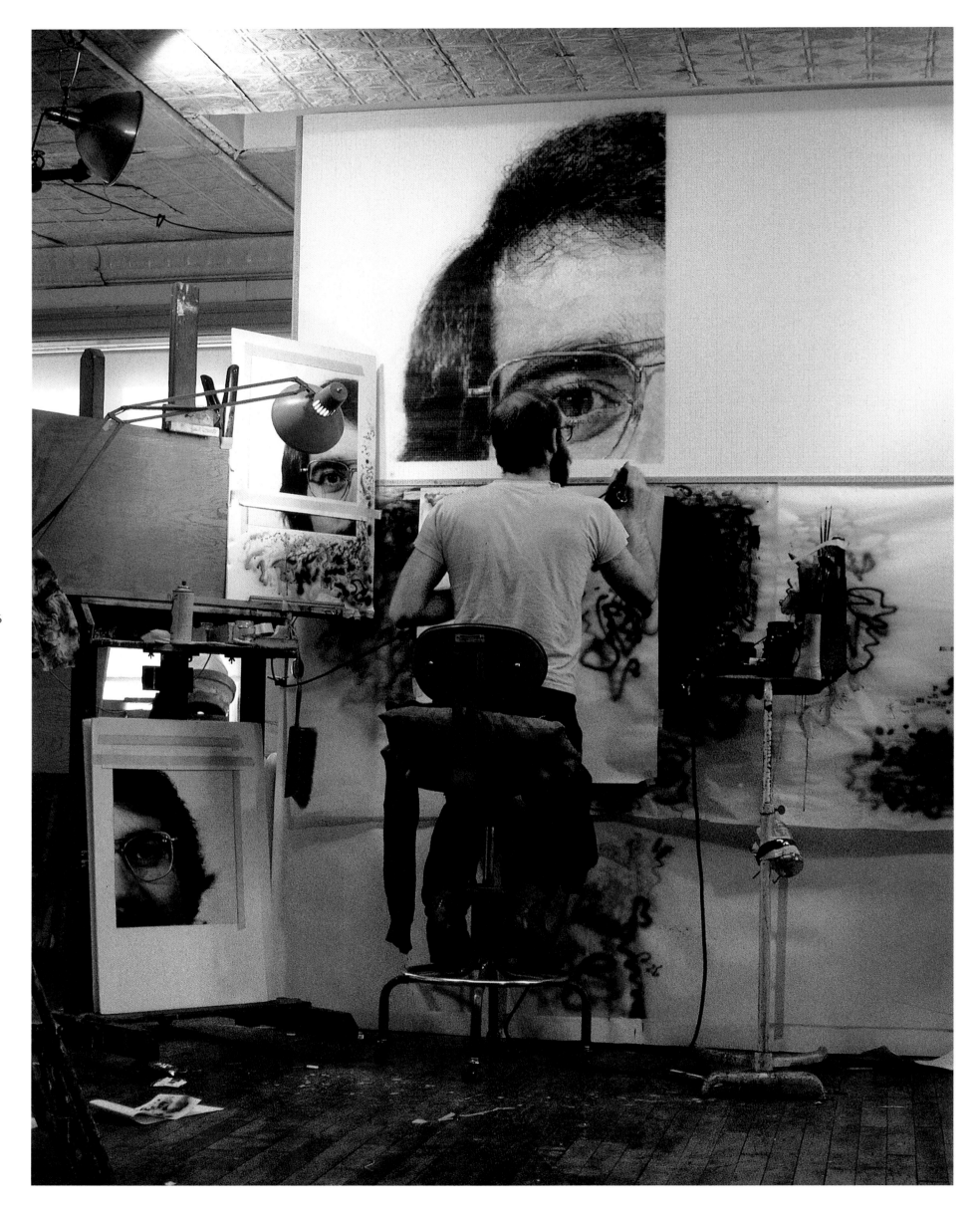

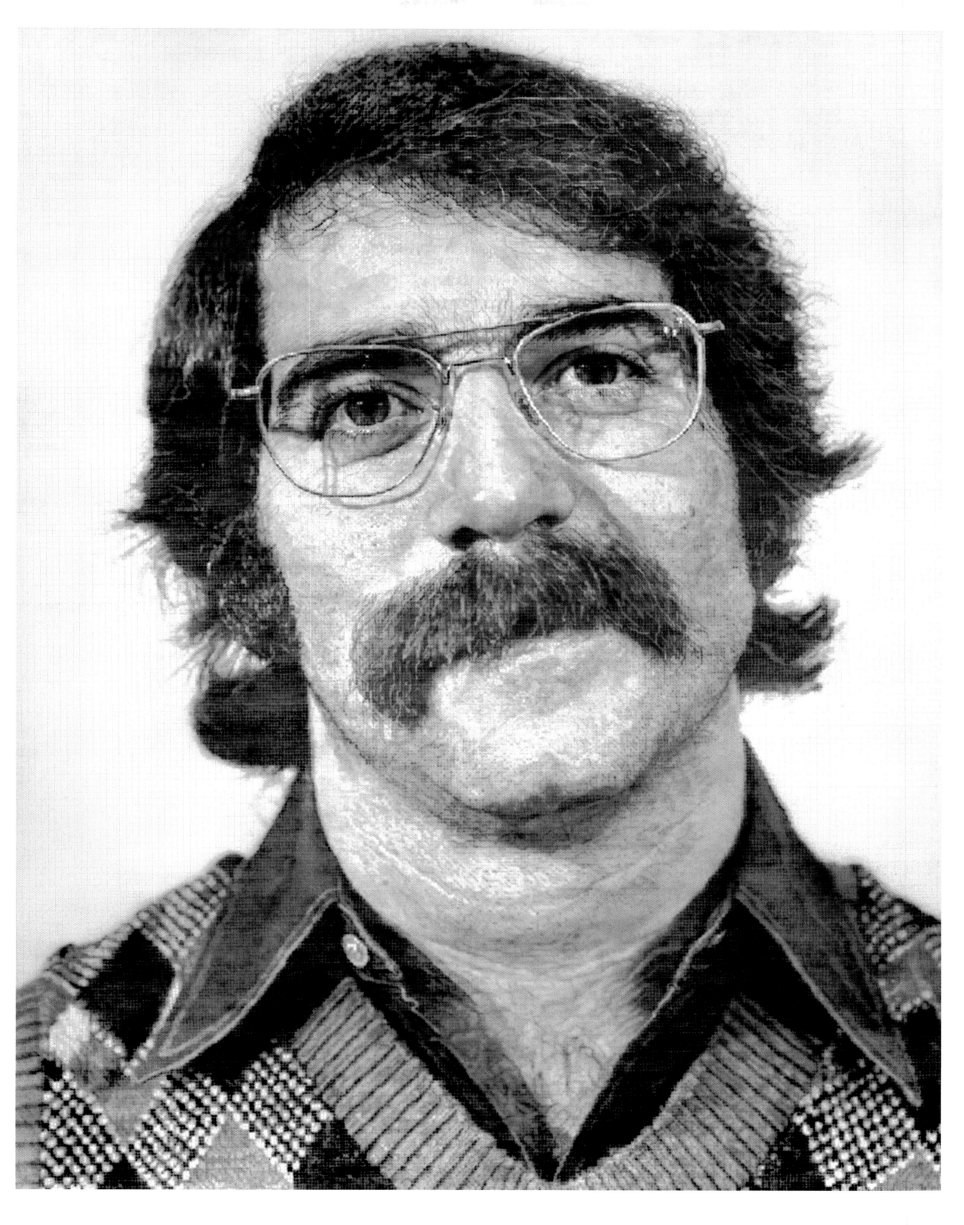

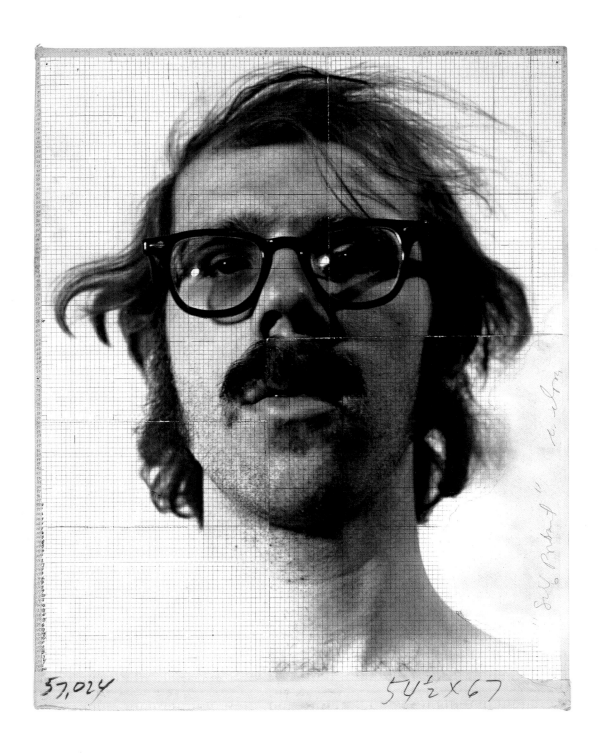

Maquette for **Self-Portrait**, 1975. Black-and-white
Polaroid photograph scored with ink, masking tape
with ink, and acetate, 4 1/2 x 3 1/8 in. (11.4 x 7.9 cm)

➤ **Self-Portrait/58,424**, 1973.
Ink and pencil on paper mounted on canvas,
70 1/2 x 58 in. (179.1 x 147.3 cm)

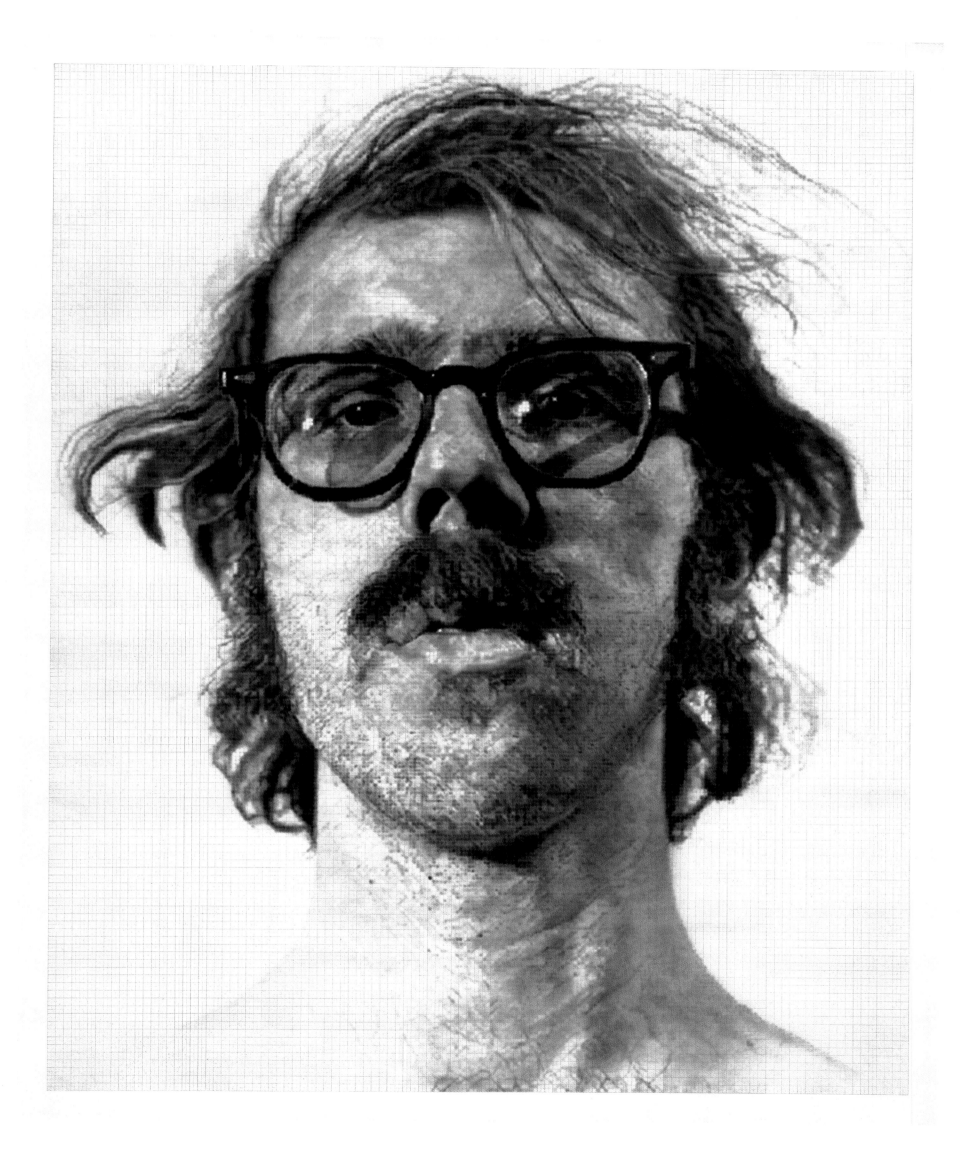

Self-Portrait, 1975.
Ink and pencil on paper,
sheet: 30 x 22 in. (76.2 x 55.9 cm)

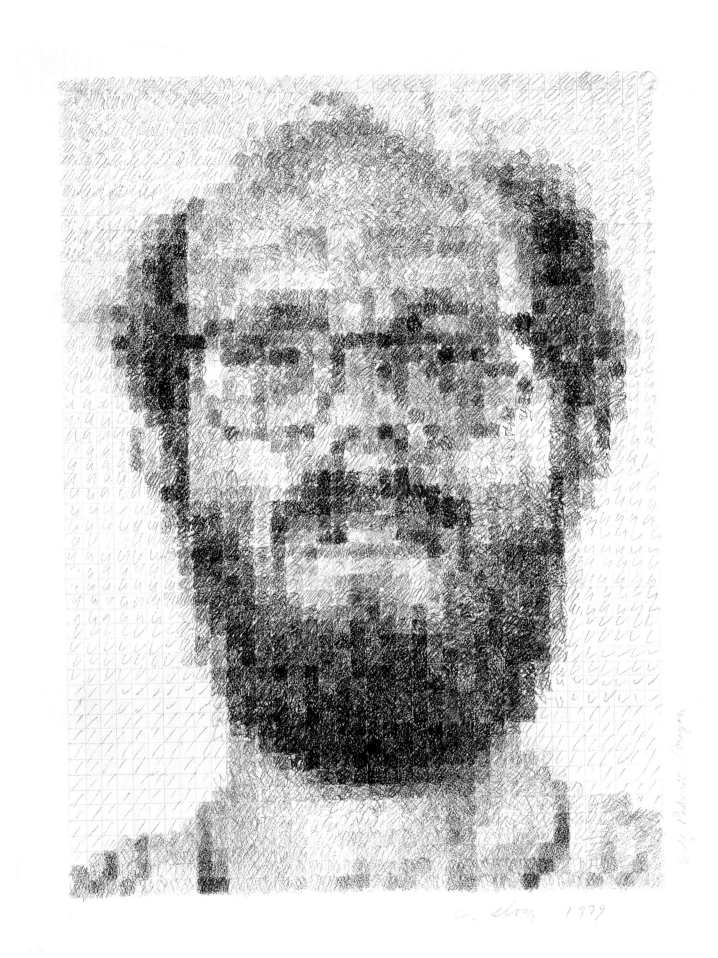

Self-Portrait/Conté Crayon, 1979.
Conté crayon and pencil on paper,
29 1/2 x 22 in. (74.9 x 55.9 cm)

dots as the size increased (pp. 94–95). (The largest contained 9856 squares, the smallest 154.) This followed upon a similar 1973 series based on the 1969–70 painting *Bob*, which reads as an experiment in determining how much information is necessary in order to achieve a likeness. The two larger drawings contain enough information—more than enough in the case of the largest—to present an easily recognizable likeness. The second smallest drawing is marginal in this respect, while the smallest—a blurred constellation of gray blobs—can be identified as a head but is fully recognizable only by reference to the larger drawings.

Drawings such as these inaugurated a series of small ink dot drawings of relatives, friends, and colleagues that Close made over the next couple of years. (The only child was beginning to accumulate an extended family.) In the summer of 1974, the Closes rented an old farmhouse near Garrison, New York, a small town on the

left bank of the Hudson River. There a Graflex camera fitted with a Polaroid back was set up for the purpose of making mug shot–type portraits of visitors, later translated into a rogues' gallery of drawings that made up the core of a dot drawings exhibition that traveled to museums and public galleries in Texas, Oregon, California, Ohio, and Maryland. Dominating the show were the large *Robert* and an ink and graphite on paper self-portrait almost six feet tall based on a grid containing 58,424 squares (p. 99).

This was not the first self-portrait drawing Close had produced. As noted in the previous chapter, in 1968 he had made a smaller graphite drawing based on a flopped photographic maquette. Close notes that the darkroom accident that generated the flopped image serendipitously provided him with an image that was especially familiar because it was what he saw when he looked in the mirror. An alternate maquette photograph from a

Chris, 1974.
Ink and pencil on paper,
30 x 22 in. (76.2 x 55.9 cm)

Don N., 1974.
Ink and graphite on paper,
30 x 22 in. (76.2 x 55.9 cm)

Barbara, 1974.
Ink and graphite on paper,
30 x 22 in. (76.2 x 55.9 cm)

103

different 1968 session, also laterally flopped, provided the basis for the large 1973 dot drawing just mentioned, and the same image later resurfaced in 1980 as a charcoal drawing, loosely rendered to the point of being atmospheric. As with other images produced in series, these—while they can stand alone—gain resonance from being considered side by side. The same applies to another black-and-white self-portrait sequence, rooted in a five-by-four-inch 1975 Polaroid, that by 1983 included two dot drawings—one in white ink on black paper—a loosely-hatched Conté crayon drawing (p. 101), a handmade paper multiple, and a unique pulp paper version. Yet another such sequence evolved out of a 1976 photograph that was used initially as the basis for a very large black-and-white watercolor self-portrait.

This is among a small group of black-and-white, continuous-tone watercolors that included *Klaus* (1976; p. 107) and *Gwynne*

(1982; p. 154), ranging in size from a little over six feet tall to almost seven feet tall. Painted on paper mounted on canvas, these clearly relate to the initial acrylic on canvas series, yet they are quite distinct in character, less hierarchic and more translucent.

By far the most extensive series based on a single image is made up of the variations that have been generated from the original black-and-white head of Phil Glass, painted in 1969. As noted earlier, this image—with its powerful figure-on-ground profile that seems almost expressionistic even in the most photographic of renditions—has taken on an iconic quality as Close has revisited it throughout his career. To take just the decade from 1973 to 1982, *Phil* was reincarnated in the form of dot drawings (several of various sizes and kinds), finger print drawings (three), a watercolor *Phil*, an inkpad print, and several paper pulp originals and editions.

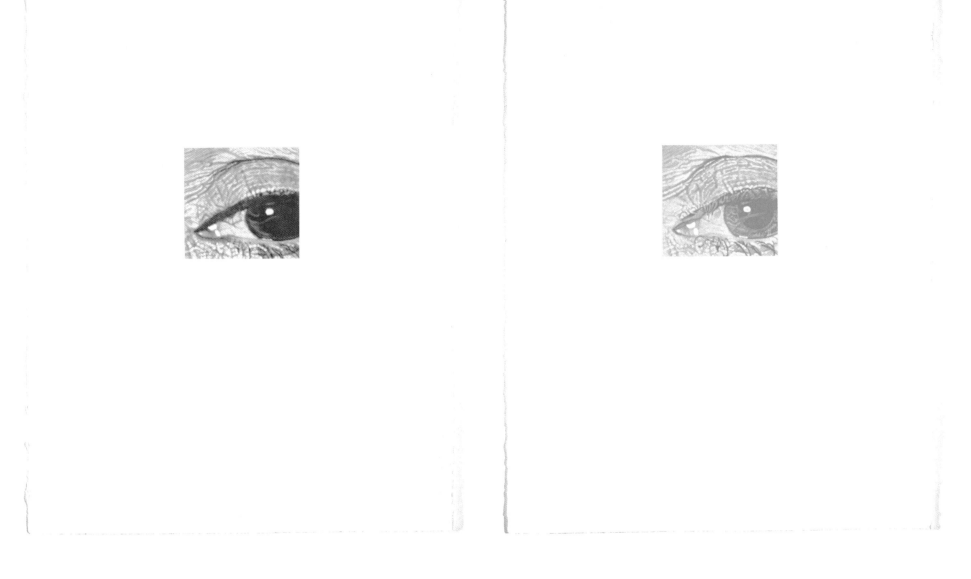

(In 1987, Close told author Lisa Lyons that by exploring images in series, he was not trying to figure out "how many ways there are to skin a cat," but rather was interested in "seeing how subtle shifts in materials, devices, and attitudes can make drastic differences in how the image is perceived."[9])

. . .

Although the 1970s saw much of this exploration of thresholds being carried out in black-and-white, color was not neglected. In particular, the large, continuous-tone color portraits led to a number of experiments employing pastel, watercolor, and colored pencil, for example, pastel versions on watercolor-washed paper, made after *Linda*, *Nat*, *Leslie*, *Susan*, and *Mark*, as well as a self-portrait in the same idiom. (*Linda*, the first in the series, was made on paper very loosely washed with watercolor. Not liking the streakiness of the background, Close cut out the finished image and mounted it on a sheet of unwashed white paper.) These

were dot drawings, but employed a full chromatic range. Working with pastels was the opposite of working with the color separations, since a huge range of virtually opaque colors, with minute variations between different oranges, pinks, or greens, was required to achieve the desired effects.

As will be seen in a later chapter, these pastels proved to be the seeds of an evolutionary process that had far-reaching consequences. Watercolors of *Leslie* and *Mark*, on the other hand, can be seen as backward-looking visual commentaries on the continuous-tone portraits since they are basically demonstrations of how the color separation technique was applied. In *Mark*, for example, the upper part of the image is made up of the three overlaid colors, while in the lower sections first one then two colors are omitted. The *Linda/Eye Series* (1977) is a similar but more explicit presentation of the process, consisting of five watercolors—magenta; cyan; magenta and cyan; yellow; and finally magenta, cyan, and yellow—of a detail from the portrait completed a year earlier.

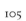

Linda/Eye Series, five drawings, 1977.
Watercolor on paper;
each sheet: 30 x 22 1/2 in. (76.2 x 57.2 cm)

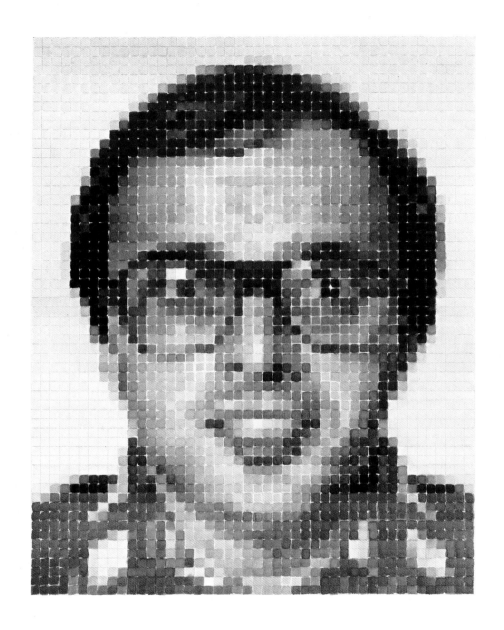

Mark Watercolor/Unfinished, 1978.
Watercolor and graphite on paper,
53 1/2 x 40 1/2 in. (135.9 x 102.9 cm)

➤ **Klaus**, 1976.
Watercolor on paper mounted on canvas,
80 x 58 in. (203.2 x 147.3 cm)

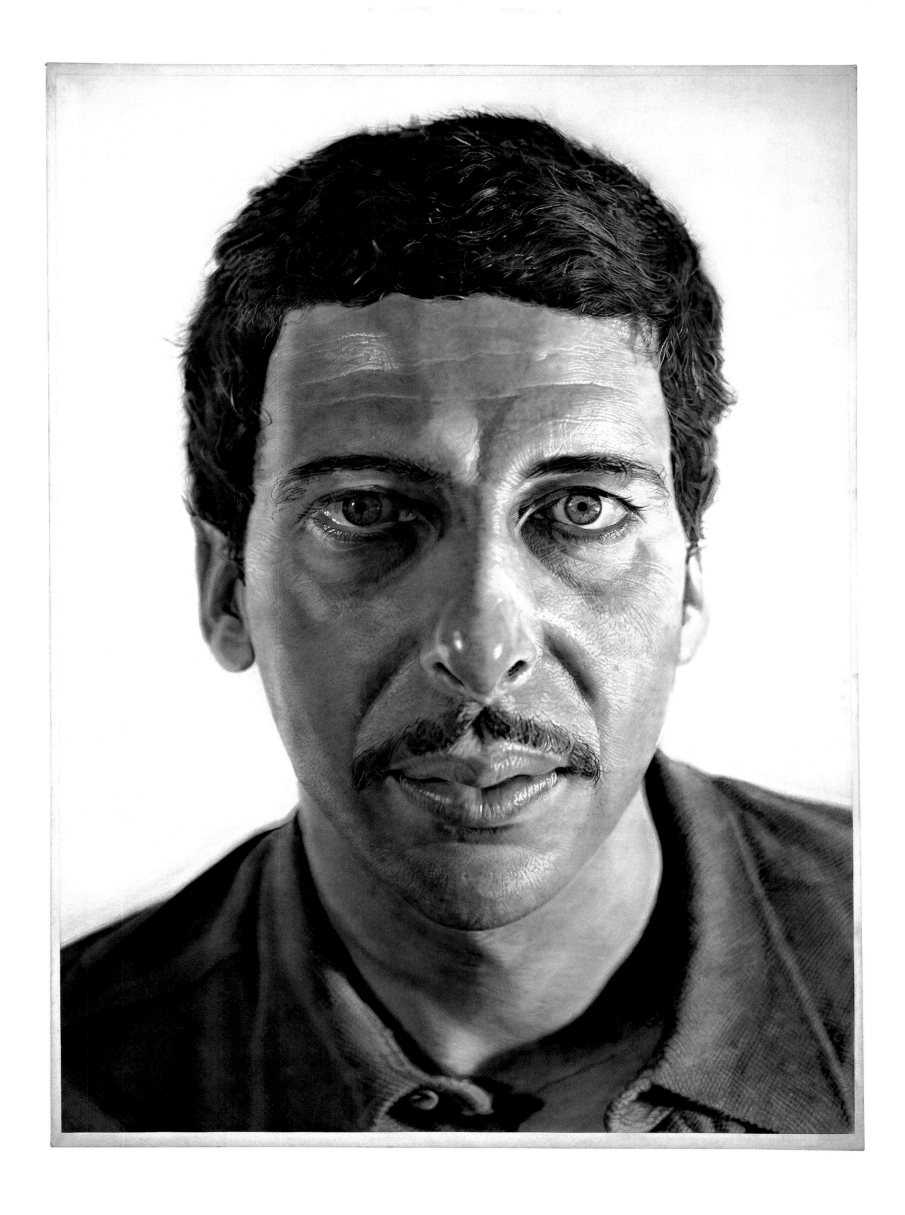

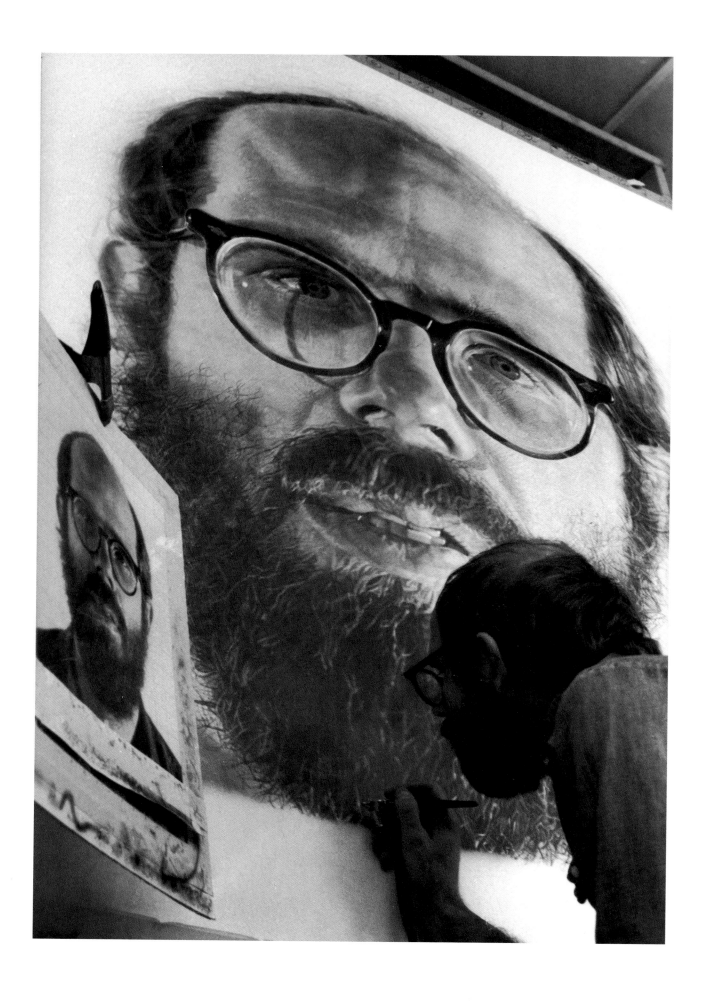

Chuck Close at work on
Self-Portrait/Watercolor, 1976–77

➤ **Self-Portrait/Watercolor**, 1976–77.
Watercolor on paper mounted on canvas,
80 1/2 x 59 in. (205.7 x 149.2 cm)

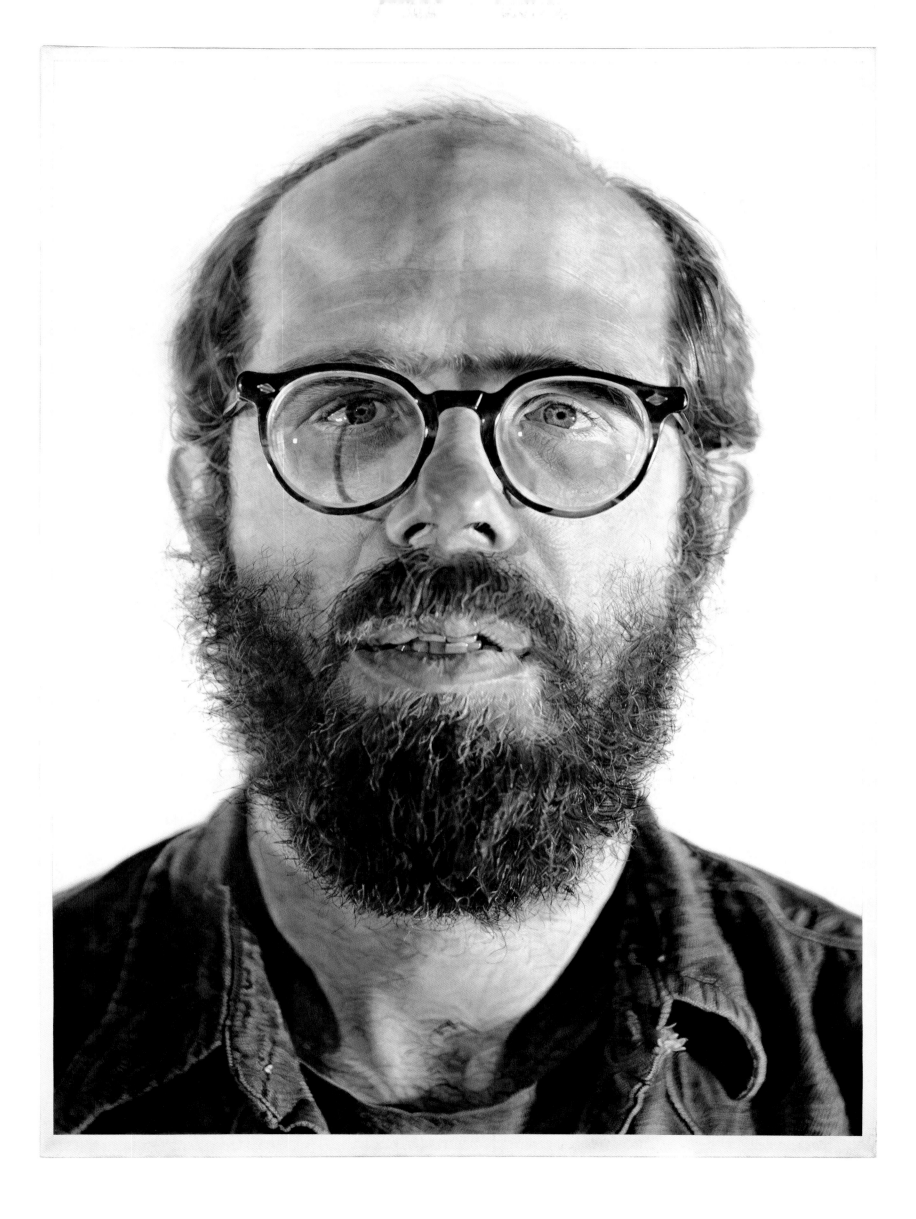

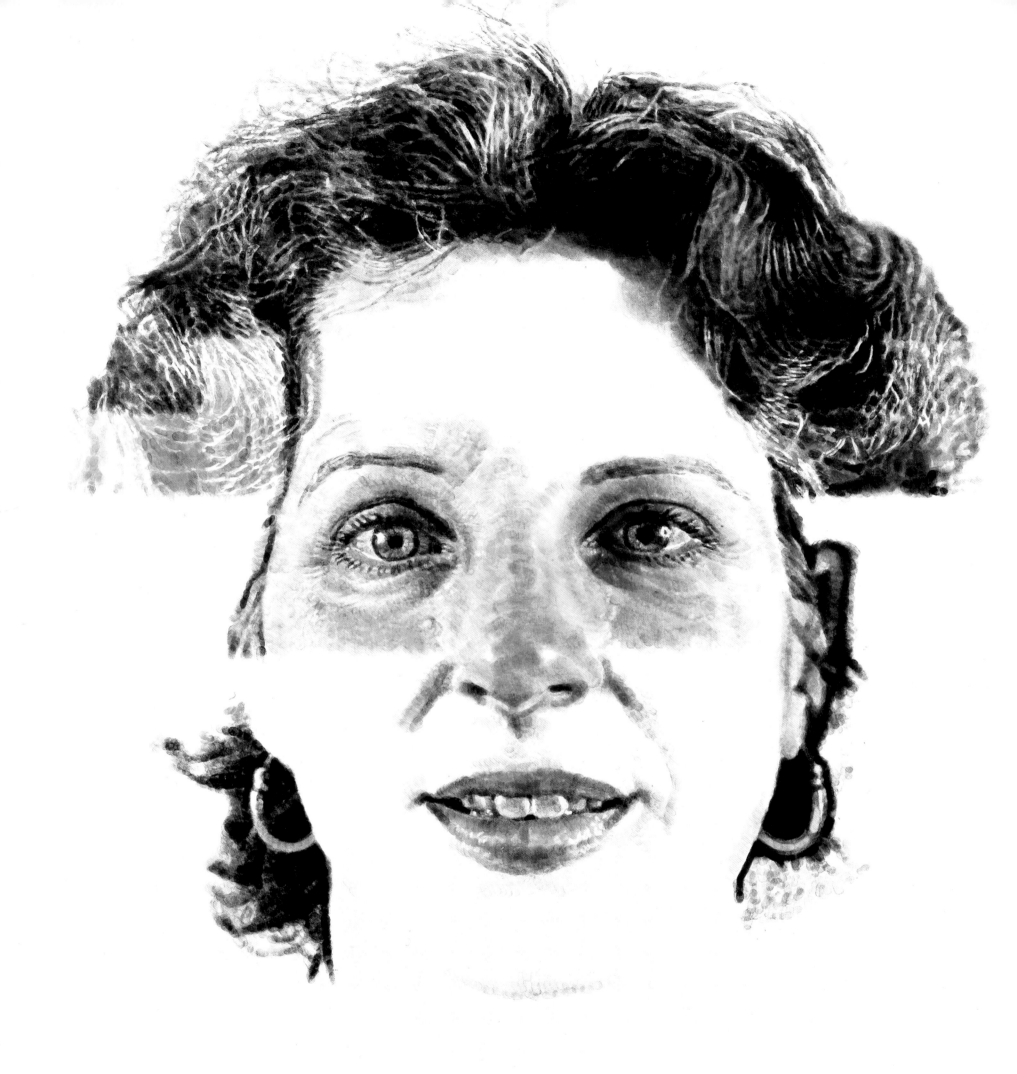

Drawing for Phil/Rubberstamp, 1976.
Ink on paper, 7 5/8 x 6 1/2 in.
(19.4 x 16.5 cm)

Phil, 1980.
Ink and pencil on paper,
29 1/2 x 22 1/4 in. (74.9 x 57.2 cm)

➤ **Phil/Watercolor**, 1977.
Watercolor on paper,
58 x 40 in. (147.3 x 101.6 cm)

114

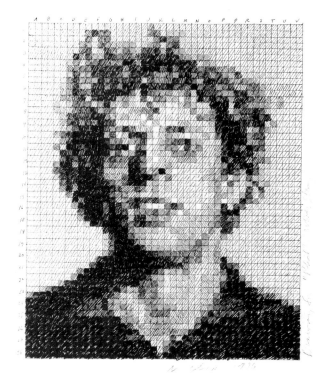

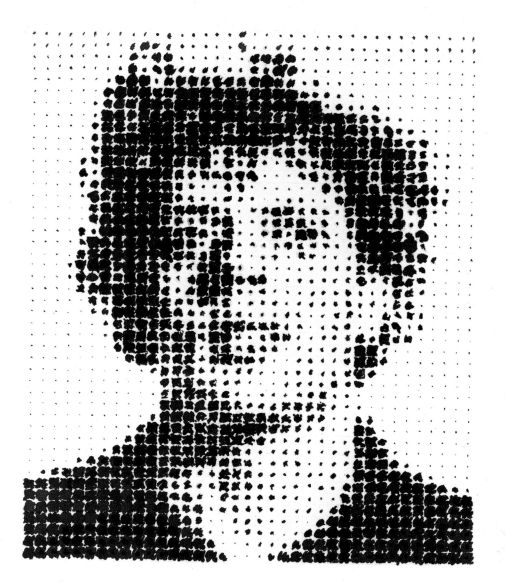

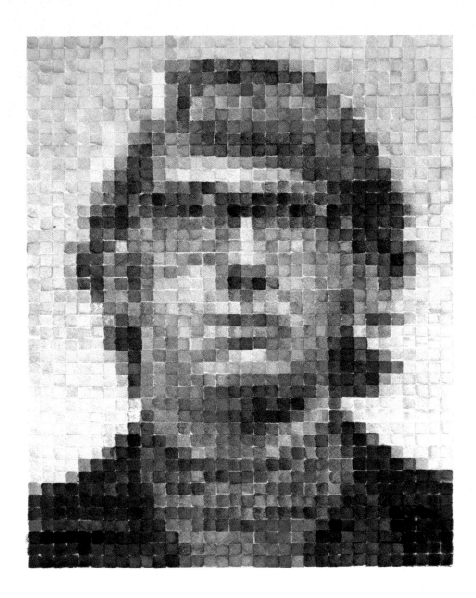

Keith/Square Fingerprint Version, 1979.
Stamp-pad ink on paper,
sheet: 30 x 22 1/4 in. (76.2 x 56.5 cm)

distribution of information he had aimed for from the outset. He had demonstrated that he could satisfy his own demanding standards while, on the one hand, providing more visual information than had ever been applied to the description of the human face, but equally while achieving a likeness with the barest minimum of data.

In 1978 Close began to experiment with a new kind of mark, making dots in a fresh and surprisingly expressive way, using a fingertip as his graphic implement, applying it to a stamp pad and transferring the ink from the pad to a sheet of paper, creating blobs of shifting densities that, when organized, would create a portrait image. His first efforts included versions of *Keith* and *Robert*, made using the usual grid underpinning. In one *Robert* drawing, the fingerprints were applied in a seemingly casual way, sometimes allowed to stray outside the grid lines, while two others were made with the aid of an acetate stencil that produced uniformly shaped marks.

In 1979 Close made the first of several fingerprint versions of *Phil*, culminating in an eight-foot-tall head on canvas. These differed from the ink-pad drawings of *Keith* and *Robert*, and everything else in the artist's oeuvre since the 1968 *Big Self-*

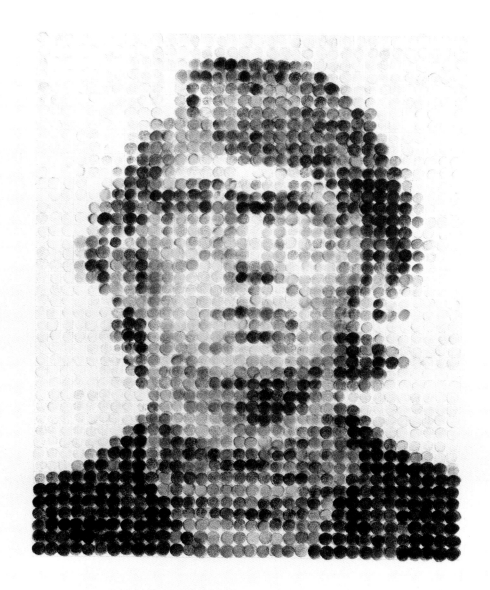

Keith/Round Fingerprint Version, 1979.
Stamp-pad ink on paper,
sheet: 30 x 22 1/8 in. (76.2 x 56.2 cm)

that he painted the last of the big continuous-tone acrylic heads, *Linda* and *Mark*, and the large black-and-white watercolor portraits.

In order to facilitate working on the upper sections of these large paintings, Close now utilized a Big Joe forklift (powerfully emblematic of the artist as self-designated blue-collar worker) to which had been rigged a platform that supported a bench with a plywood back, surfaces for art supplies, and a small black-and-white television set on which he watched—or at least absorbed peripherally—minimally demanding soap operas and game shows, heirs to the radio shows that had sustained him as a child.

During that period came two large self-portrait print editions—one an etching, issued in 1977, made up of crosshatched strokes on a very fine grid, the other, from 1978, a related etching with aquatint, printed in white ink on black paper. In these, as in the drawings of the seventies, Close demonstrated that his version of process could be applied in many ways, creating illusion by systematically applying various kinds of marks to paper, while at the same time retaining the rigor of the overall

Chapter 4:

NEW DIRECTIONS

Soon after Close's 1975 exhibition, the Bykert Gallery closed its doors. By now, the artist's reputation was secure and, after talking to several dealers, he accepted Arne Glimcher's invitation to join the Pace Gallery (now PaceWildenstein), which already represented such notables as Jean Dubuffet, Lucas Samaras, Louise Nevelson, Robert Irwin, and Agnes Martin, as well as the estate of one of Close's heroes, Ad Reinhardt. This initiated an artist/dealer relationship which evolved into a friendship that has lasted for more than thirty years. Close had his first Pace show in the spring of 1977, an exhibition that featured one color-separation continuous-tone portrait–*Linda* (1975–76)–two large black-and-white watercolor heads (*Klaus* and a self-portrait), and smaller supporting works including the pastel version of *Linda*, the five watercolors comprising *Linda/Eye Series*, and a number of black-and-white dot drawings.

That exhibition was at Pace's East 57th Street gallery, in the heart of the long-established midtown gallery belt. By that time, major commercial galleries had arrived in SoHo, transforming the community once and for all. Pioneering dealers like Paula Cooper and Ivan Karp had been joined by a sprinkling of new arrivals, including Holly Solomon and Ronald Feldman, but in the early seventies there came an explosion of activity as a cluster of well-heeled dealers, mostly migrants from 57th Street and Madison Avenue, opened galleries. The center of attention was 420 West Broadway, which became home to gallerists including Leo Castelli, Ileana Sonnabend, André Emmerich, and John Weber (who had taken over Virginia Dwan's highly-regarded stable of artists). On September 25, 1971, when 420 opened for business, there was an endless line waiting for the newly-installed automatic elevator, and the stairways were so packed that the Fire Department threatened to close the building. Out in the street, art fanciers and gawkers spilled from the sidewalks and brought traffic to a halt. They were there to see art (the big hit of the party was Gilbert and George, live at Sonnabend), or else to check out the growing media buzz about SoHo and the downtown scene. They stayed on after dark, trying to shoehorn their way into Food and Fanelli's and the Spring Street Bar. That day, the New York art world made a quantum leap towards becoming an arena for a voyeuristic species of spectator sport in which artists could become superstars far beyond the orbit of Andy Warhol's Factory and the downtown bars.

(Anyone wishing for a glimpse of the area in this transitional phase would do well to rent Paul Mazursky's 1977 film *An Unmarried Woman*, which juxtaposes the new SoHo–the one that came noisily to life on weekends–and the old work-week SoHo, with its decaying loading docks and garbage-strewn sidewalks.)

. . .

In 1975, although still living at 101 Prince Street, Close moved his paints and airbrush to a studio at 89 West Third Street, three blocks north of SoHo in a section of Greenwich Village thick with clubs and restaurants, the building being owned by New York University, where he had been teaching since 1970. It was there

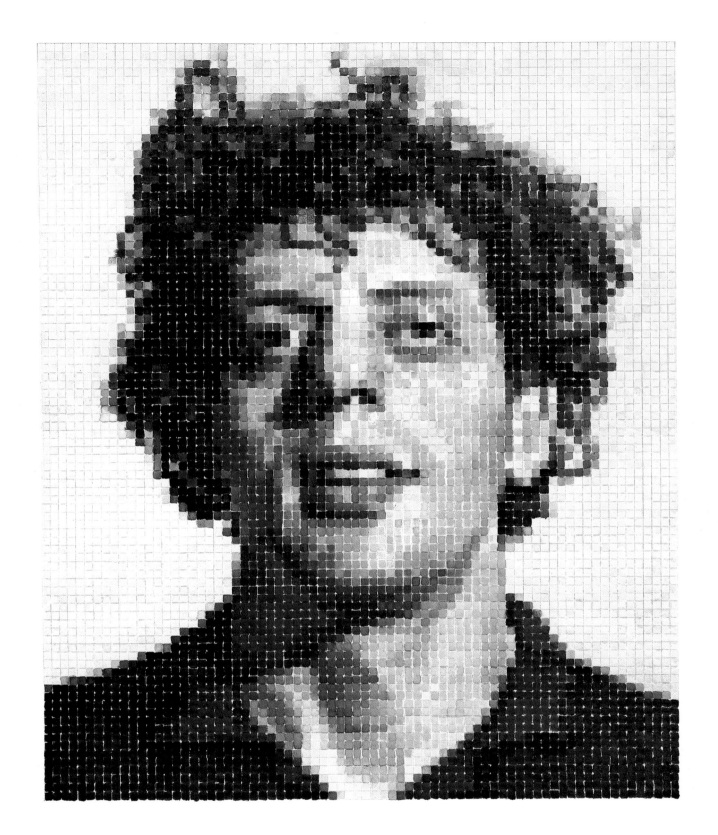

Phil, 1980.
Stamp-pad ink on gray paper,
15 3/4 x 11 1/2 in. (40 x 29.2 cm)

Phil Fingerprint/Random, 1979.
Stamp-pad ink on paper,
40 x 26 in. (101.6 x 66 cm)

➤ **Phil/Fingerprint**, 1980.
Stamp-pad ink on paper,
sheet: 93 x 69 in. (236.2 x 175.3 cm)

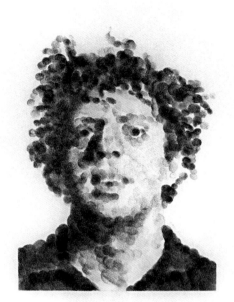

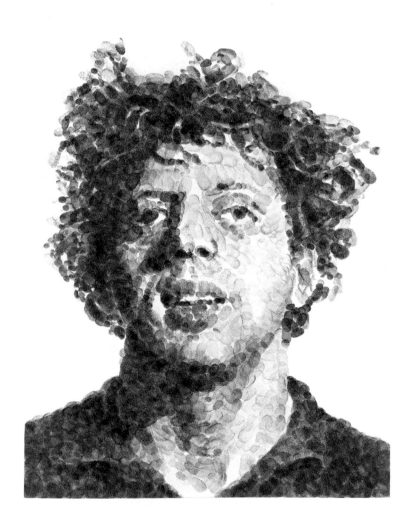

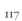

John/Progression, 1983.
Litho ink on paper, 30 x 80 in.
(76.2 x 203.2 cm)

➤ John/Fingerpainting, 1984.
Oil-based ink on canvas, 24 1/2 x 20 1/2 in.
(62.2 x 52.1 cm)

 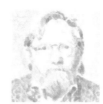

Portrait, in that they were made without reference to the grid. Close had in fact become temporarily disenchanted with the grid— he felt a need to break with its perceived restrictiveness—and saw fingerprint-based imagery as offering another kind of incremental process that could be applied in a less rigid way.

Departing from his previous practice, Close used a projector as an aid to making these and subsequent ink-pad drawings and fingerpaintings. He did not trace from the projected image, as is commonly done by artists wishing to copy photographs, but rather used the projection to establish key points on the paper or canvas support. These coordinates were selected to correspond with, for example, the corner of an eye, the lateral extremity of an ear, and so on. In the case of an average-size drawing, approximately two dozen such co-ordinates might be fixed in this way, and then the drawing would proceed by, in Close's words, "joining the dots," using the key points as a guide. In the case of a larger work, considerably more key points might be necessary.

Although this method still demanded fidelity to the photographic source, it permitted more freedom of execution than had been the case with grid-based works. Using the fingertip as a tool is inherently more personal than using an airbrush (and the combination of fingerprints with mug shots made for an amusing if unintentional conjunction of identification techniques). The den-

sity of the dots making up each of these images was determined by the pressure of the finger on the paper or canvas. Beyond that, shifts in pressure as the fingertip rolled, however imperceptibly, during the making of an impression could give each ink dot[10] a significant inflection—a sense of graphic momentum—which, when combined with the varied inflections of surrounding dots, made possible a degree of tangible expressiveness: a sprightliness not found in earlier grid-based drawings, where the dots have a relatively static quality

By using fingerprints as graphic and tonal markers, Close in effect invented a new form of draftsmanship in the deployment of which he immediately achieved an extraordinary degree of virtuosity. The novelty of the technique, and the level of skill with which it was brought to bear on the task at hand, is evident in the 1979 drawing *Phil Fingerprint/Random* (p. 116). Note, for example, the effectiveness with which chains of nuanced dots are used to evoke strands of hair. (As is so often the case, the hair provides Close with an opportunity to produce passages that seem to have a life of their own.) Note, too, how edges are suggested rather than defined in a way that recalls Cézanne's late watercolors.

Those watercolors are evoked even more strongly in the colored fingerprint drawings and fingerpaintings that Close made in 1983 and 1984, works in which the freestyle (or relatively freestyle)

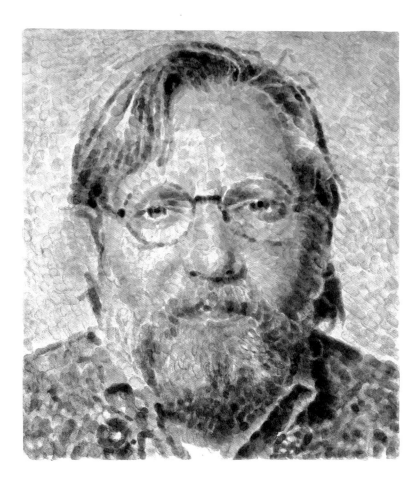

fingertip technique is combined with the three-color separation principal behind the big continuous-tone heads of the 1970s. The head in the smallish—24-by-20-inch—1984 fingerpainting *John* has the quality of Cézanne's rocks and apples, which seem to emerge from light into solidity and dissolve from solidity into light at the same time. An especially fine larger portrait of the artist's daughter, Georgia (p. 124), from the same year, has somewhat the same character, though it's rendered with a degree of detail that makes it less spatially ambiguous, much as Cézanne's oils are less ambiguous than his watercolors.

At all stages in his career, Closes's overall achievement is related to his high level of ambition. Another artist might have been satisfied with the already impressive results found in the inkpad drawings and smaller fingerpaintings. Close, however, capped the series with two works that successfully reached for far more. These were *Fanny/Fingerpainting* (1985), an eight-and-a-half-foot-tall black-and-white likeness of Leslie Close's maternal grandmother—a woman of great presence and character—and *Leslie/Fingerpainting* (1985–86), an equally large color portrait of Leslie herself (following pages).

To describe *Fanny/Fingerpainting* as a mug shot or a mere "head" would be a travesty. By this point in his career, Close had long been able to acknowledge that his efforts to maintain objec-

tivity in his likenesses, while still crucial to his intentions, did not preclude the possibility of the portraits conveying character and emotion. It was no accident, after all, that he continued to paint family and friends, never employing models (the use of which might, in fact, have provided greater emotional distance and hence objectivity), and never accepting commissions. For all the assumed objectivity, then, Close's portraits have always been enriched by an implicit intimacy, and this has never been more so than in the instance of *Fanny*.

The act of painting with the tip of one's finger in itself guarantees a heightened sense of intimacy—skin used to represent skin, Robert Storr has pointed out—a dissolving of the distance between portraitist and subject that a brush, pencil, or any other discrete implement entails. The face evoked in *Fanny* has been shaped by eight decades of life lived fully, not always under the easiest of circumstances. It possesses the kind of nobility that has nothing to do with social position or patrician airs. It is the face of an elderly woman who has earned the respect and love of her family. Brought into that family by marriage, the artist expressed this shared love and respect by the warmth and care with which his finger conjured up every last line etched into the face by time, every fold and pouch brought about by the battle between the decreasing elasticity of flesh and the tug of gravity. Instead of being deplored as

Fanny/Fingerpainting, (detail), 1985

▸Fanny/Fingerpainting, 1985.
Oil-based ink on canvas, 102 x 84 in.
(259.1 x 213.4 cm)

mere evidence of the havoc wrought upon the face by the aging process, each furrow is presented as a marker of maturity, honorably won, and the softness of the subject's flesh is evoked with a gentleness of touch that is itself a tangible expression of affection.

Like all of Close's portraits, the source for this image (rendered this time in oil-based ink on canvas) is a photograph, but in this instance it seems that the artist was able to transcend his self-imposed reliance upon the image captured on film to produce a likeness in which the subject is inescapably a living, breathing presence. With *Fanny*, any vestige of the artist's original commitment to the impersonal application of process had been done in by empathy. This did not mean that his devotion to process had become less valid, however. Rather, it demonstrated that his basic method, once firmly established, was open to flexible interpretation and to the possibility of being invested with strongly subjective emotional content.

Close has made many portraits of his wife, and the large color fingerpainting is perhaps the most remarkable. Like the portrait of Fanny, this painting aspires to the same degree of detail that is found in the continuous-tone portraits, this time though employing an adaptation of the three-color separation method. Because it demands comparison with those continuous-tone images, the ways in which it differs from them tend to be emphasized. Chief among these is that the anonymity of the airbrush is replaced by the intimacy of the fingerprint, so that the painting takes on a warmth and glow that is very different from, for example, the coolness that characterizes the large continuous-tone watercolor of Leslie painted a dozen years earlier.

· · ·

It may seem surprising that the big fingerprint paintings were not especially well received when they were first shown. There was a feeling in some quarters that they were perhaps a trifle gimmicky—that the technique might be fine for small-scale studies but that it was not suitable for works on the scale of *Fanny/Fingerpainting* (which now resides in excellent company in the National Gallery in Washington). The next series of works that

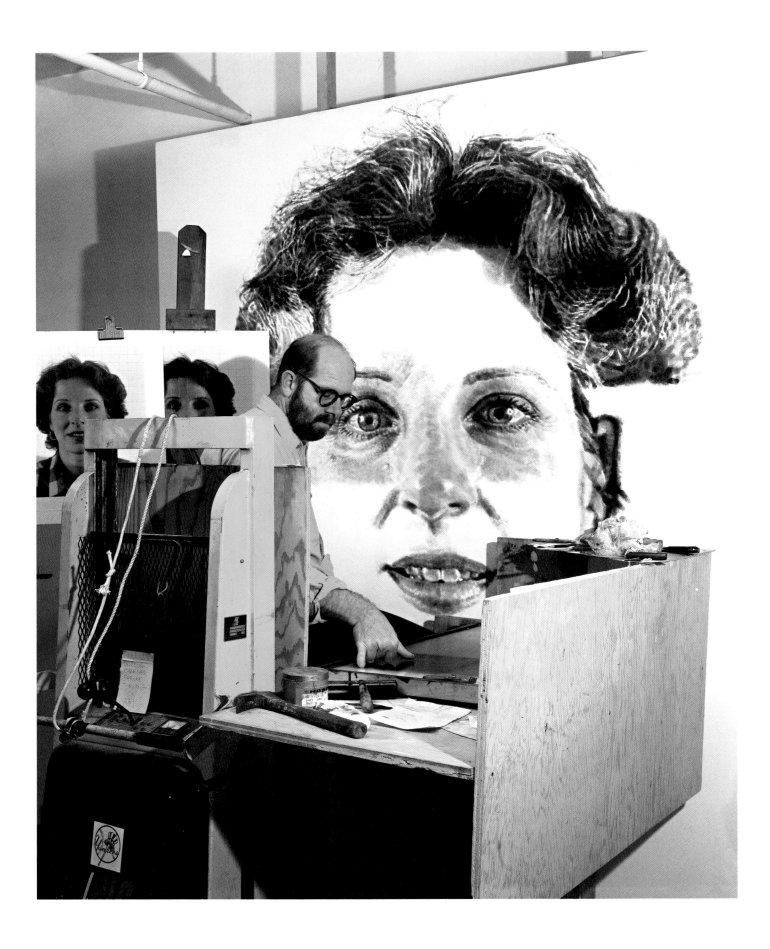

Chuck Close painting **Leslie**, 1985 | ➤ **Leslie/Fingerpainting** (detail), 1985

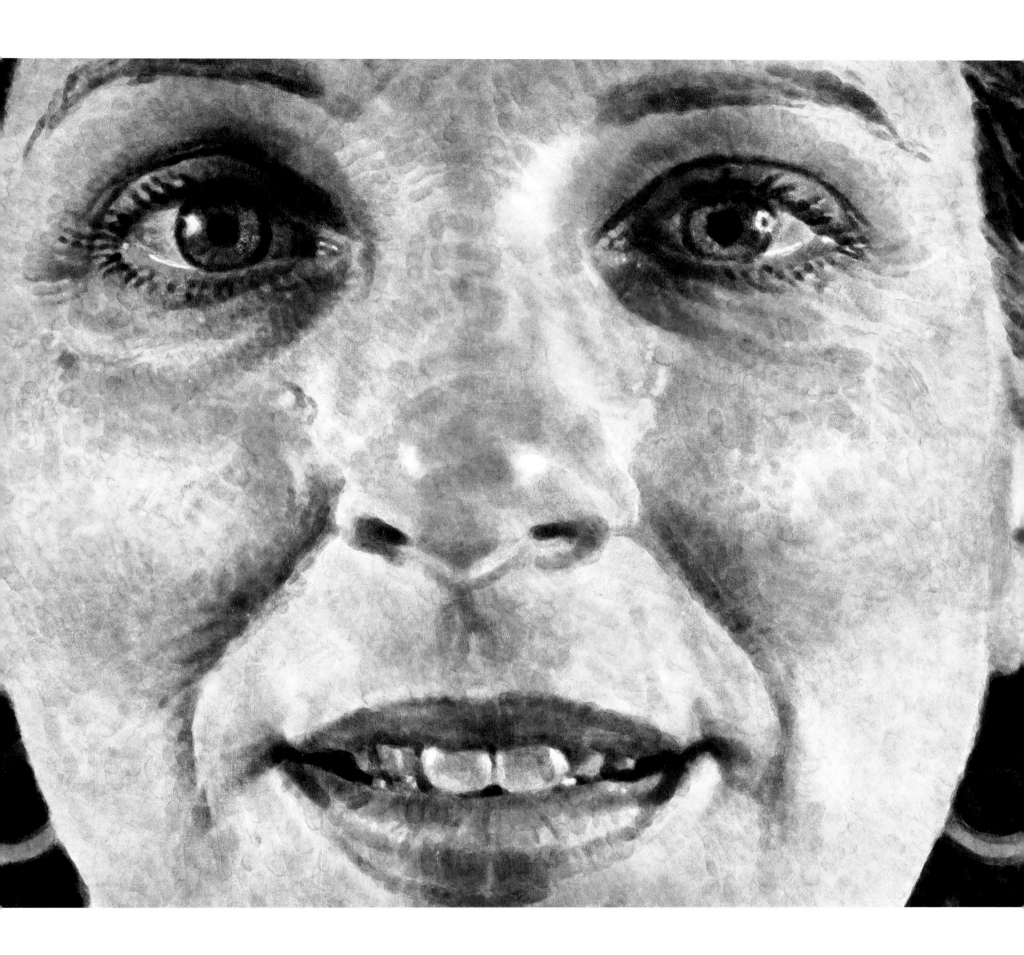

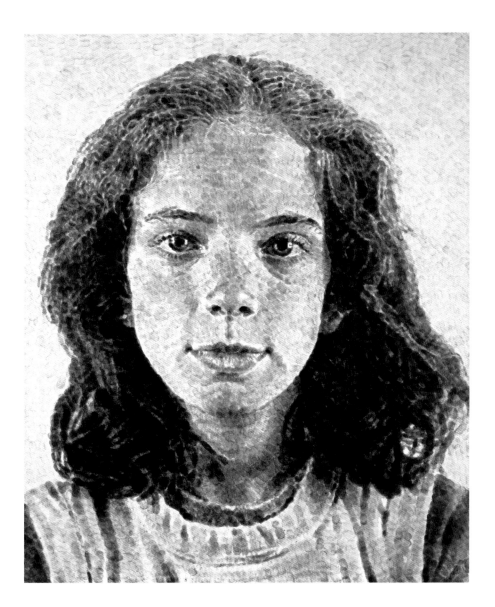

Georgia/Fingerpainting, 1984.
Oil on canvas, 48 x 38 in.
(121.9 x 91.4 cm)

➤ Leslie/Fingerpainting, 1985.
Oil based ink on canvas, 102 x 84 in.
(259.1 x 213.4 cm)

Close embarked on provoked more negativity at the time, though retrospectively they too are highly esteemed.

This was the sequence of pulp paper portraits, both multiples and one-offs, that Close began in 1981. As it happens, Close began to make these highly original works somewhat against his better judgment, explaining that he made them because Joe Wilfer wouldn't let him *not* make them.

Joe Wilfer, who died in 1995 of a brain tumor that may have been induced in part by the chemicals he worked with on a daily basis, was a printer and paper maker who had taught at the University of Wisconsin, in Madison, and had founded the Madison Art Center. In the late 1970s, he was brought east to become director of the Skowhegan School of Art, in Maine. There he managed to step on a number of sensitive toes and was soon released. Desperately wanting to stay on the East Coast, preferably in New York, he began to lobby artists to make editions using pulp paper, having previously had some success in persuading Midwestern artists to produce multiples of that sort. These proposed editions were to be made at the Dieu Donné Papermill, a non-profit shop founded in 1975, located at that time on Crosby Street in Lower Manhattan. One of the artists Wilfer targeted was

Chuck Close, who had been on the Skowhegan board of directors. Close was not enthusiastic, telling him he didn't like the pulp paper pieces he'd seen—too artsy-craftsy. Wilfer didn't give up easily, however, demanding to know what it would take to change Close's mind. Close told him he'd need to work with a whole range of different grays—as many as twenty or thirty calibrated from black to white. Wilfer brought samples. Close told him what was wrong with them. Wilfer made more samples until Close became caught up in the momentum of his enthusiasm, and gradually they arrived at a point that seemed to offer real possibilities. Finally Close agreed to give it a try.

Arrangements were made for Close to begin work at Dieu Donné, and the image he returned to for his first pulp multiple was the one that had yielded the 1970 large black-and-white painting *Keith*, the 1972 *Keith/Mezzotint*, and several other works on paper. The idea was to build the image in much the same way as a black-and-white dot drawing, with wads of tinted pulp taking the place of the dots. Close and Wilfer came up with the concept of structuring the piece by means of a grill normally employed as a light diffuser placed over fluorescent lamp fixtures. Such grills, or gratings, which come in both plastic and metal models (Close

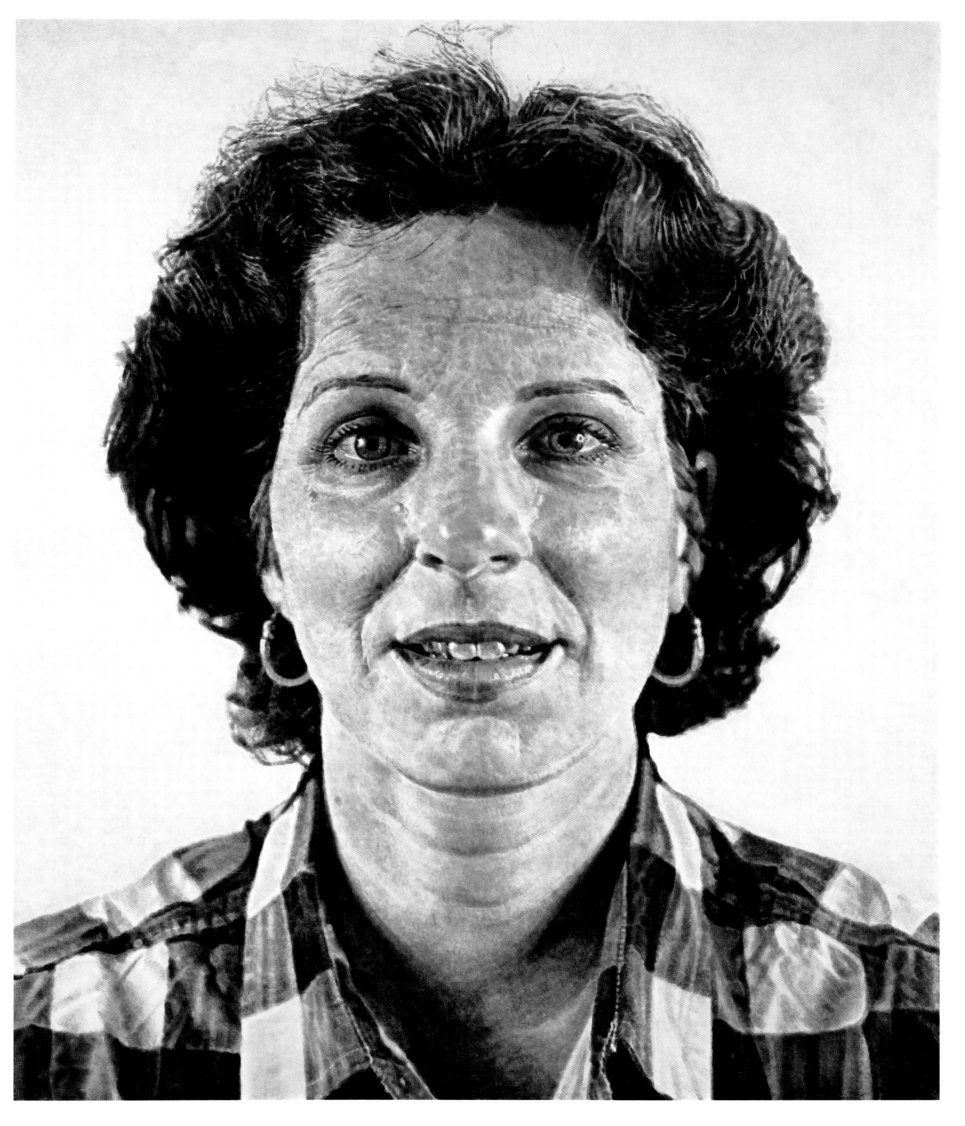

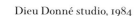

Dieu Donné studio, 1984 | ➤ **Keith II**, 1981. Handmade paper, press dried, each 35 x 26 1/4 in. (88.9 x 66.7 cm)

would make use of both), are in fact readymade grids, meshes of small squares, half an inch deep, into which watery pulp could be injected, one square at a time. As it dried, it would bond to a large sheet of simultaneously drying pulp that became the support for the whole. The structure of the grill insured that there was no bleeding of pulp from one square of the grid into adjacent ones (even though the grill had to be removed while the pulp was still somewhat wet).

One problem that emerged was finding a way to determine the pigmentation and placement of each wad of pulp required to establish the constellation of squares from which the image would be constructed. Close took a watercolor of Keith as his model and matched the tonality of each block of the grid to gradations on a standard Kodak gray scale, which ranges from white to black. This was done by punching holes in the paper on which the gray scale was printed so that it could be placed over the watercolor, enabling the pigment beneath to be seen. (In practice, the standard gray scale did not provide entirely consistent gradation points so that

Close was forced to establish some intermediate readings.) From this systematic analysis, a template could be prepared with each square carefully labeled with a number corresponding to the tonal quality of a given preparation of pulp paper—matched to the gray-scale—which came in semi-liquid form in bottles marked to conform with the numbers. In effect, as Close points out, what he was producing was a very low-tech, handmade, quasi-digitized image.

The system worked well, though not perfectly, so that when the pulp was in place Close would sometimes change the pigmentation of a given wad of paper that did not quite pull its weight in the overall constellation. He also manipulated the still soggy wads to give them texture and a sense of hands-on intervention, so that each example of a given edition was in surface detail different from every other example.

Keith (which as an edition took almost a year of experimentation and work to complete) was the first of these pulp paper multiples, the next being yet another version of *Phil* made using the same grill/grid method, to be followed by another *Robert*. After

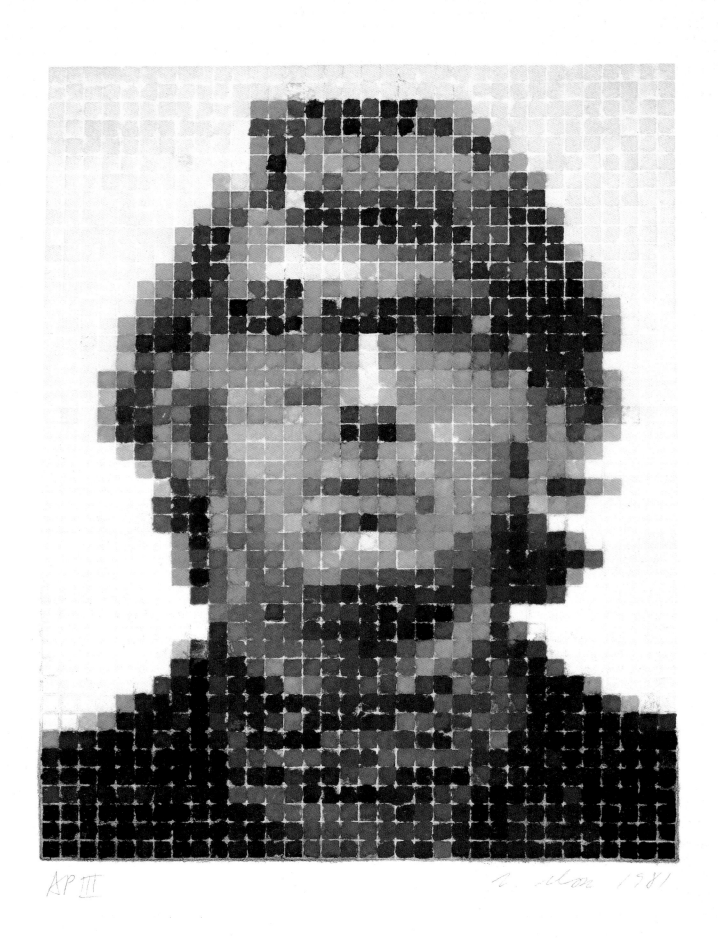

AP III C. Close 1981

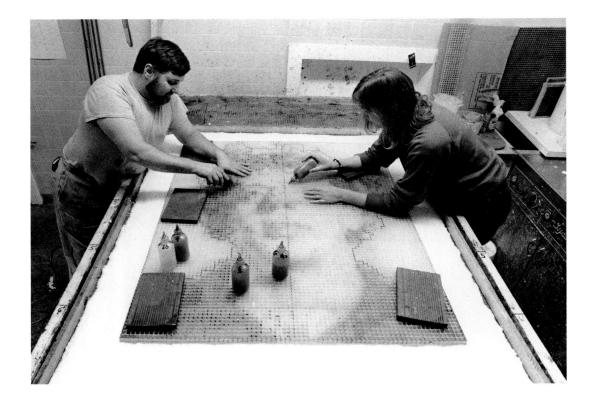

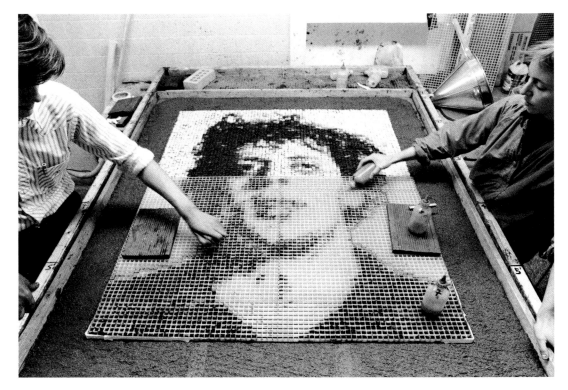

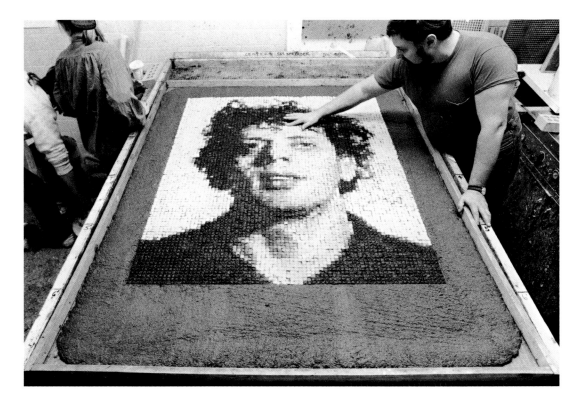

Views of **Phil I** *(top)* and **Phil II** being made,
Dieu Donné studio, 1982

➤ **Phil II**, 1982.
Handmade gray paper, press dried,
64 x 53 1/2 in. (162.6 x 135.9 cm)

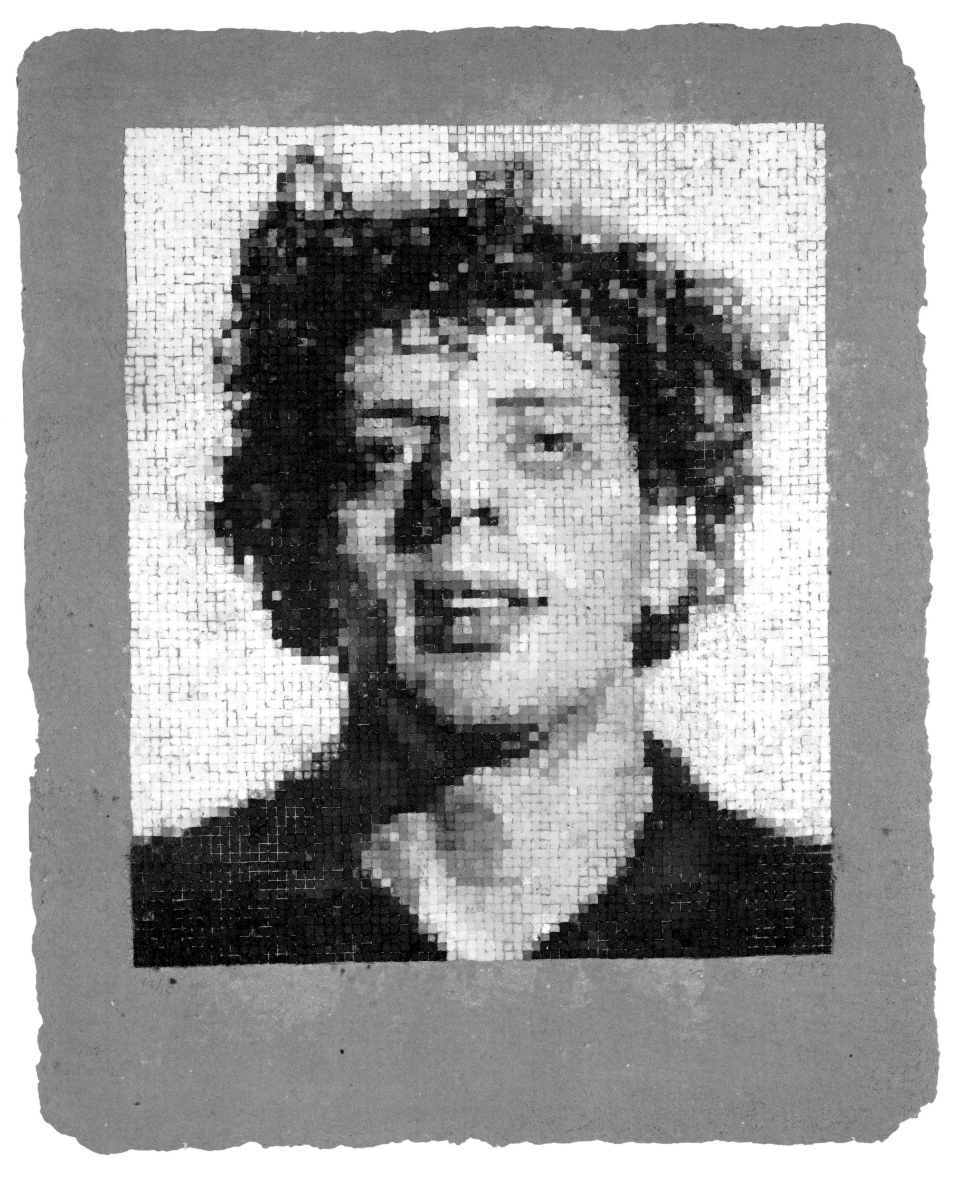

Self-Portrait Manipulated, 1982.
Handmade gray paper in 24 gray values,
air dried, 38 x 30 in. (96.5 x 76.2 cm)

Robert, pulp editions were made under the auspices of Pace Editions in a variety of locations, employing a level of improvised technology that Close has compared with making bathtub gin.[11] Wilfer remained the principal printer, with Ruth Lingen—a former student of Wilfer, who had become his chief assistant—playing a key hands-on role.

Variations on the method produced a 1982 self-portrait that involved a good deal of hand-manipulation, and an un-editioned 1983 self-portrait made with a string grid replacing the mass-produced grill. It is characteristic of Close's devotion to process, and to the inquiring nature of his imagination, that he soon began to invent new ways of using paper pulp. As work progressed on the grid editions, blobs of liquid paper inevitably fell to the floor where they flattened and hardened into what Close has described as "miniature meadow muffins the size of Pringles potato chips,"[12] in the two dozen shades of gray employed in the prints. The artist began to pick up these chips and save them in a cigar box. In spare moments, he would make little heaps of over-

Self-Portrait/String, 1983.
Handmade paper in 24 gray values and string,
37 x 27 in. (94 x 68.6 cm)

lapping paper discs. "The edges of these little chips were beautiful," he recalled, "nat-ural, irregular outside edges formed by gravity, not by artistic decision."[13]Assistants began to produce more of these gravity-generated pulp paper patties, which were collected by tonality into trays, providing Close with an unlikely "palette" that he employed to create collage portraits by gluing the irregularly-shaped chips to a can-vas. Sometimes the canvas was laid on the floor and he worked on it while lying on his stomach on a sledlike device equipped with casters—the reverse, he likes to point out, of Michelangelo working on the ceiling of the Sistine Chapel.

Unique paper pulp heads on canvas such as *Jud* (1982; p. 138) and *Phyllis* (1984; p. 140) resulted from this process. Another image in the series was a 1982 *Georgia*, which prompted Close to create an edition using irregularly shaped wads of pulp paper. In a multiple, these could not be left to gravity, so he made a tracing of the col-lage, which indicated the edges of all the patties, simplifying where necessary. This was passed on to Wilfer who translated the resulting diagram—which resembled a

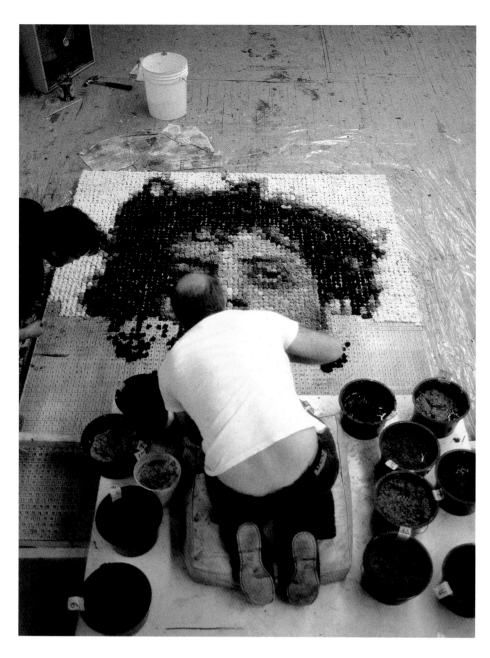

this page:
Views of **Phil**, 1983, in progress

➤ **Phil**, 1983.
Pulp paper on canvas, 92 x 72 in.
(233.7 x 182.9 cm)

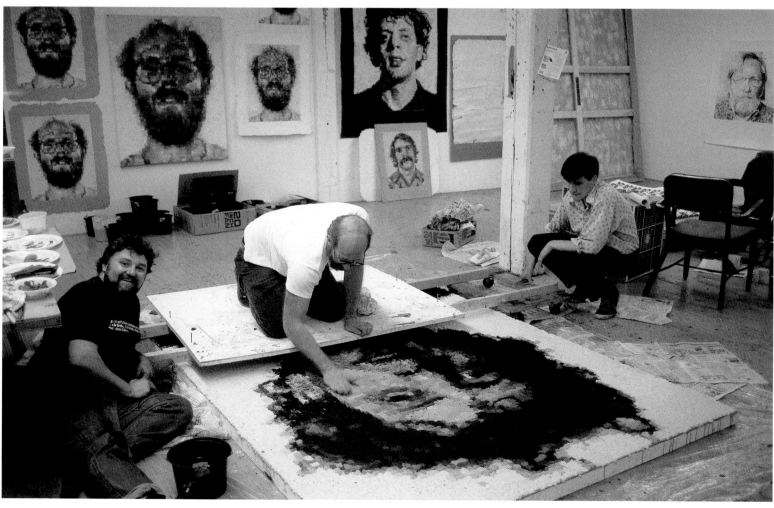

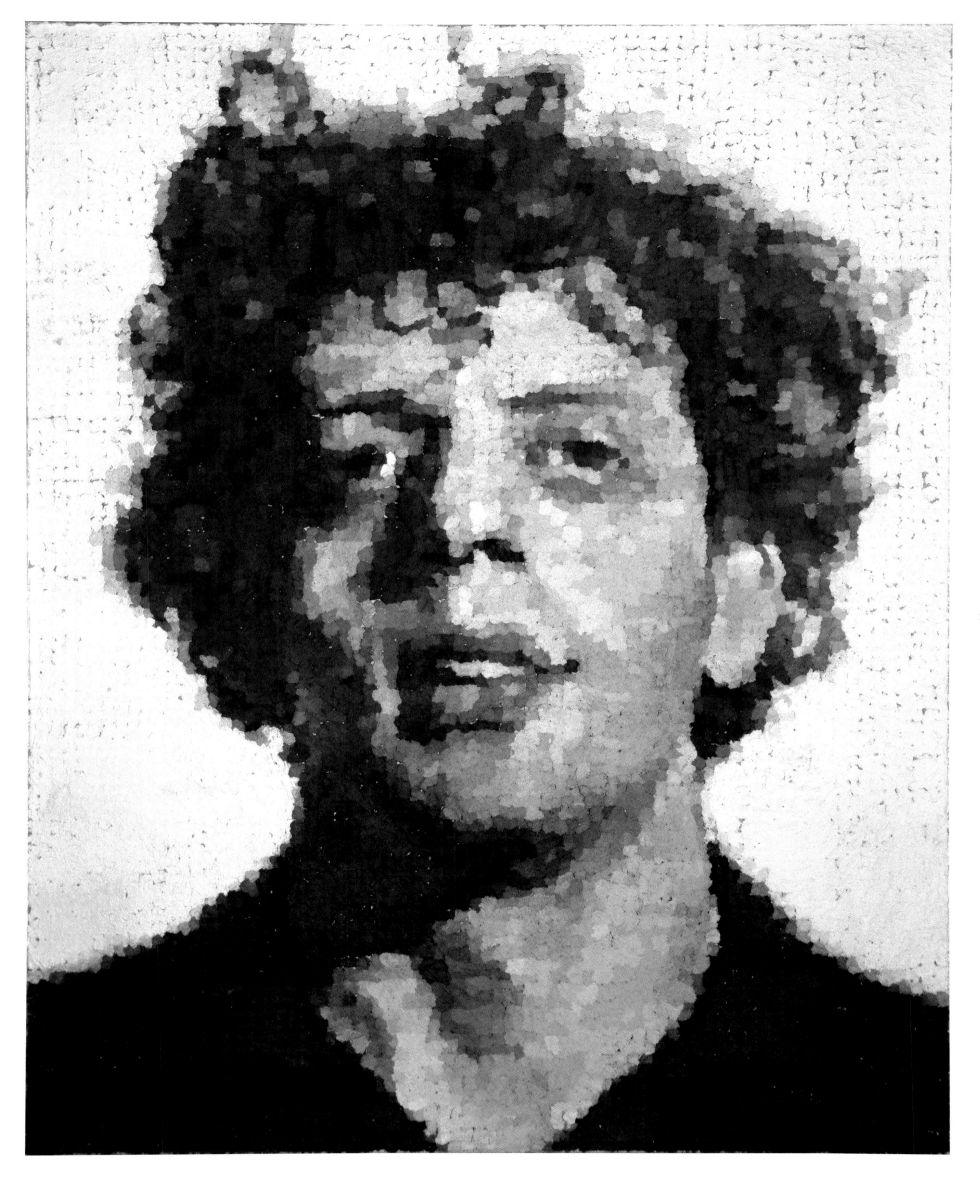

➤ Georgia, 1982.
Pulp paper collage on canvas,
48 x 38 in. (121.9 x 76.2 cm)

paint-by-numbers image—into a stencil-like grill or mold soldered together from bent strips of brass, a process that took four hundred hours (p. 136). The apertures in this grill were assigned grayscale numbers, just as with the earlier grid multiples; pulp was matched to the numbers, and a handmade paper print was produced in an edition of thirty-five.

. . .

During the period in which he was creating the fingerprint images, and the pulp paper pieces—not to mention large black-and-white watercolors, as well as important color dot paintings and drawings that will be discussed in the next chapter—Close also found time to embark on a new career, as a photographer. His work since 1968 had been rooted in photography, but he had never thought of the working photographs of his subjects—the maquettes—as anything but source material, and although he had received a thorough education in the technology of photography, he had never thought of himself as a photographer.

In 1977 Close was given the opportunity to work at the Polaroid Corporation's Cambridge, Massachusetts, research center, using a large format—24-by-20-inch—custom-built Polaroid camera. Nothing came of that, but two years later Kathy Halbreich, then director of the Massachusetts Institute of Technology's Hayden Gallery, invited Close to return to Cambridge to work with the same camera, which Polaroid had now made available to MIT. This time the experiment proved more fruitful.

The big Polaroid was an oversize view camera that had been fitted with a special back designed to carry the instant developing film invented by Dr. Edwin Land in the 1940s. Close accepted Halbreich's invitation, thinking this camera might be ideal for taking photos that could serve as source material for his paint-

ings. In fact, he found that it offered far more than that. The images it produced were characterized by intense natural color and a degree of resolution which, at that size, recalled the unforgiving detail found in Close's large continuous-tone portraits. In addition, Close was stimulated by the immediacy of the process—the fact that he could see the image barely a minute after the shutter was released.

When shooting with standard film, his practice had been to photograph the subject over and over, with perhaps minor variations of exposure, because there was no way of checking the image till it came back from the lab. Working with the big Polaroid was quite different.

"You could see right away what you'd got—instant feedback," he explains, "so for the next shot it was possible to set things up differently, ask for a different expression, or whatever."

Close liked the fact that the subject was also involved in this feedback, that he or she had the opportunity to respond to previous exposures, to participate in a dialogue and become a collaborator.

Among the first pictures he took in 1979 were portraits of family members and fellow artists like Ray Johnson, and originally they were indeed intended as possible maquettes. When Close saw the results, however, it was clear to him that they stood on their own, and, looked at today, these images fit so neatly with the rest of his work that it takes an effort to recall that they were originally intended as a means to an end. Indeed, once Close began to exhibit photographs *as* photographs, it retroactively transformed earlier photo maquettes into quasi-independent works of art that are now avidly collected.

These first Polaroid heads (which include a series of self-portraits shot with an in-your-face close-up lens) are striking enough,

134

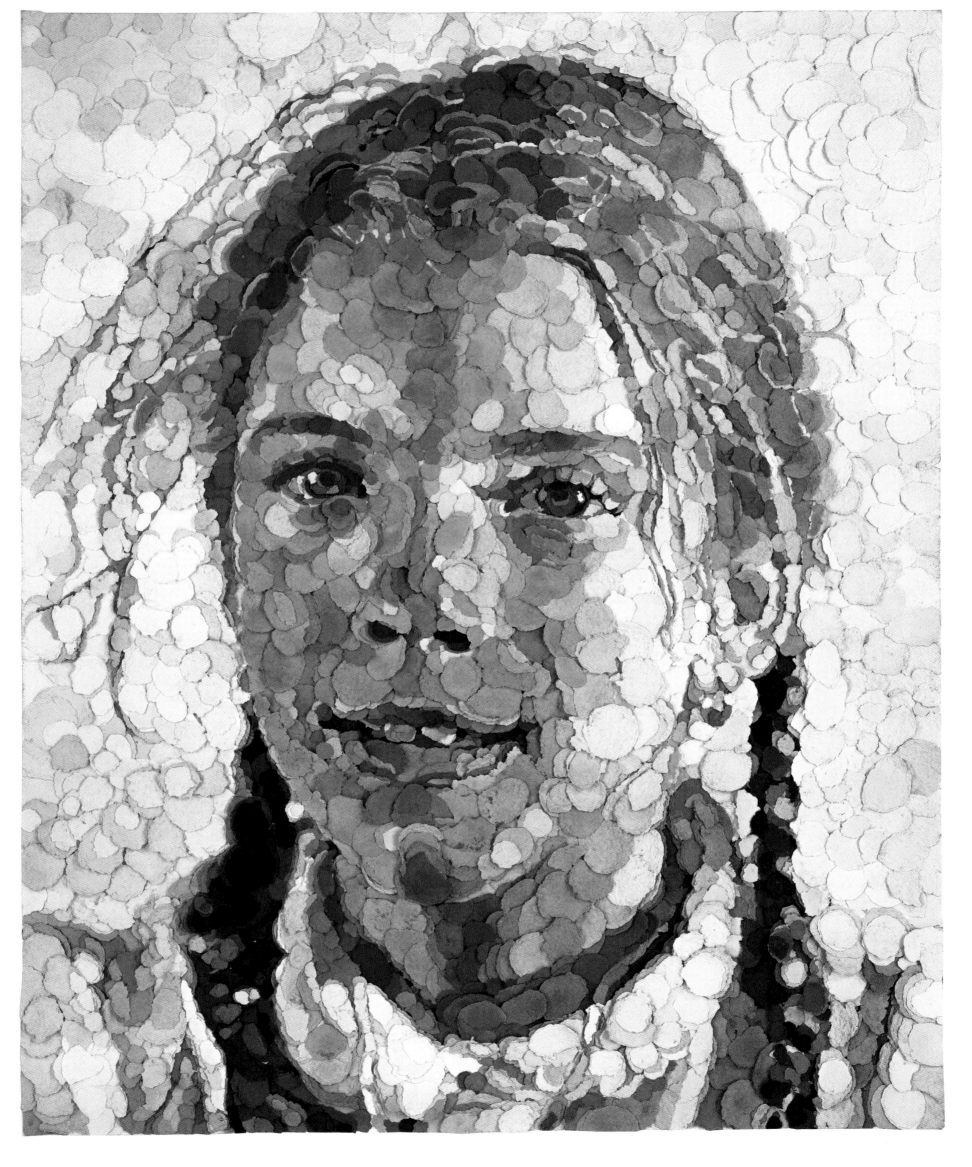

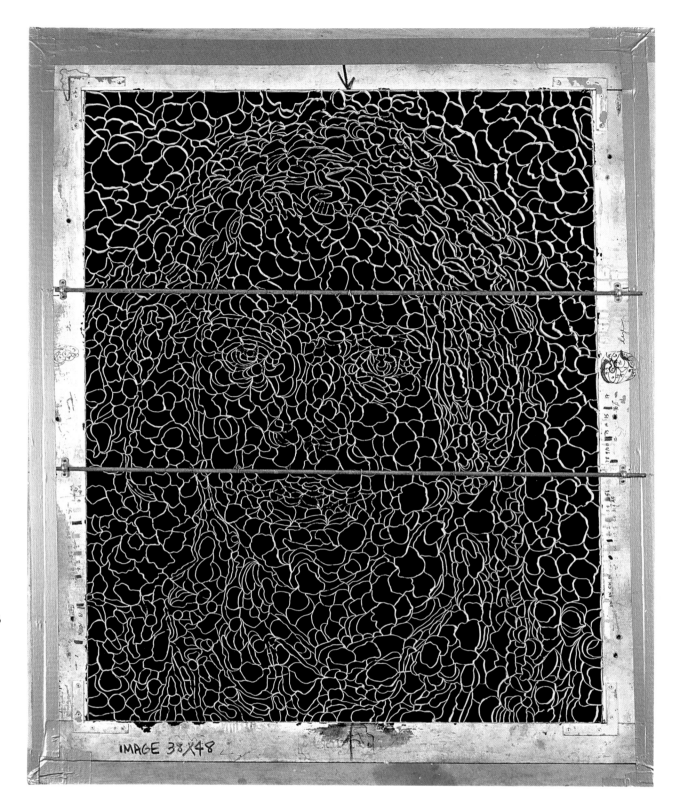

136

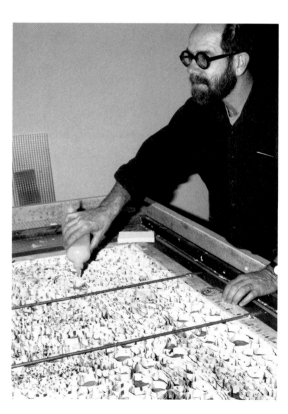

top left: pulp paper grid for **Georgia**, 1984, made by Joe Wilfer; *left:* detail of grid showing grayscale numbers; *above:* Chuck Close injecting paper pulp into the grid

➤ **Georgia**, 1984.
Handmade paper, air dried, 56 x 44 in.
(142.2 x 111.8 cm)

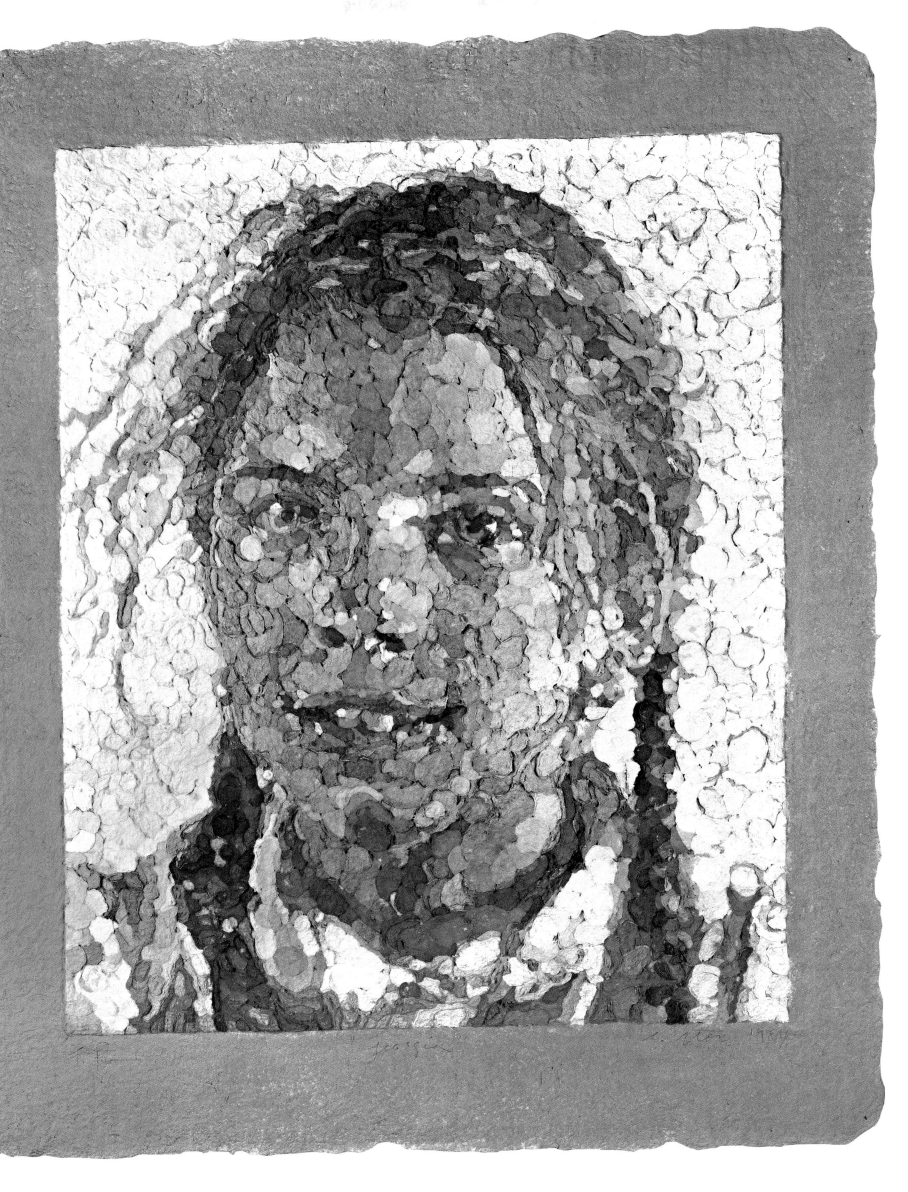

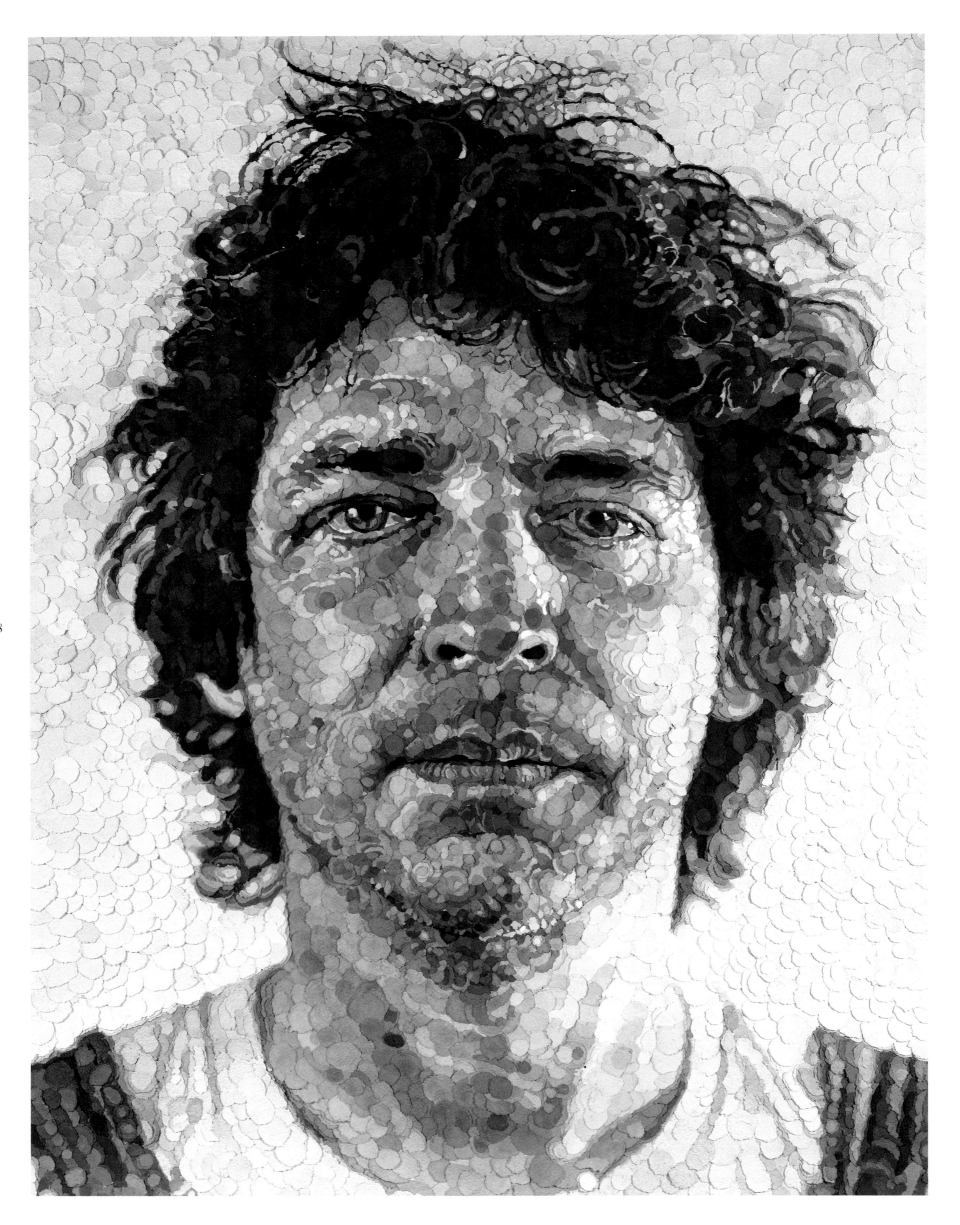

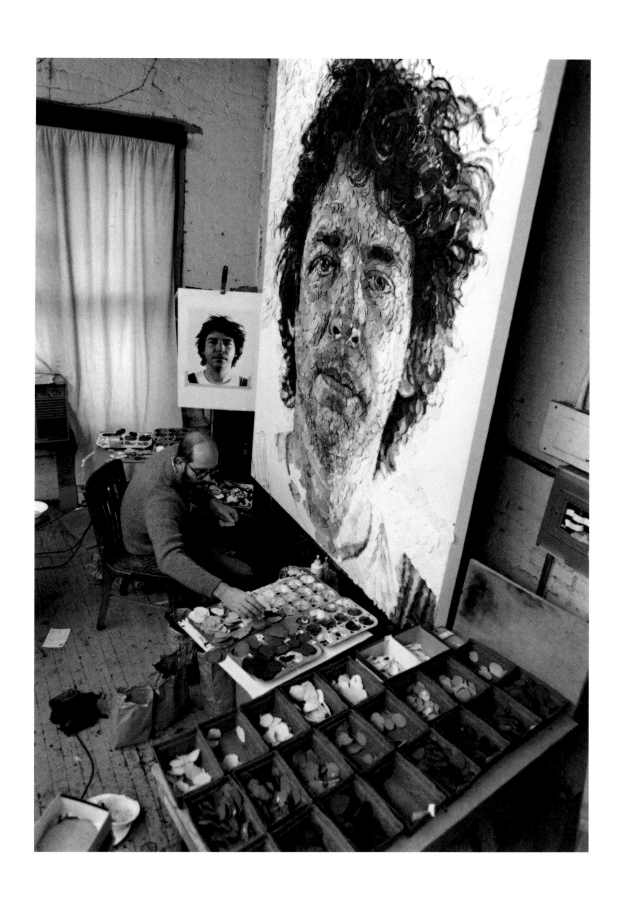

◄ **Jud**, 1982.
Pulp paper collage on canvas,
96 x 72 in. (243.8 x 182.9 cm)

Chuck Close working on **Jud**, 1982

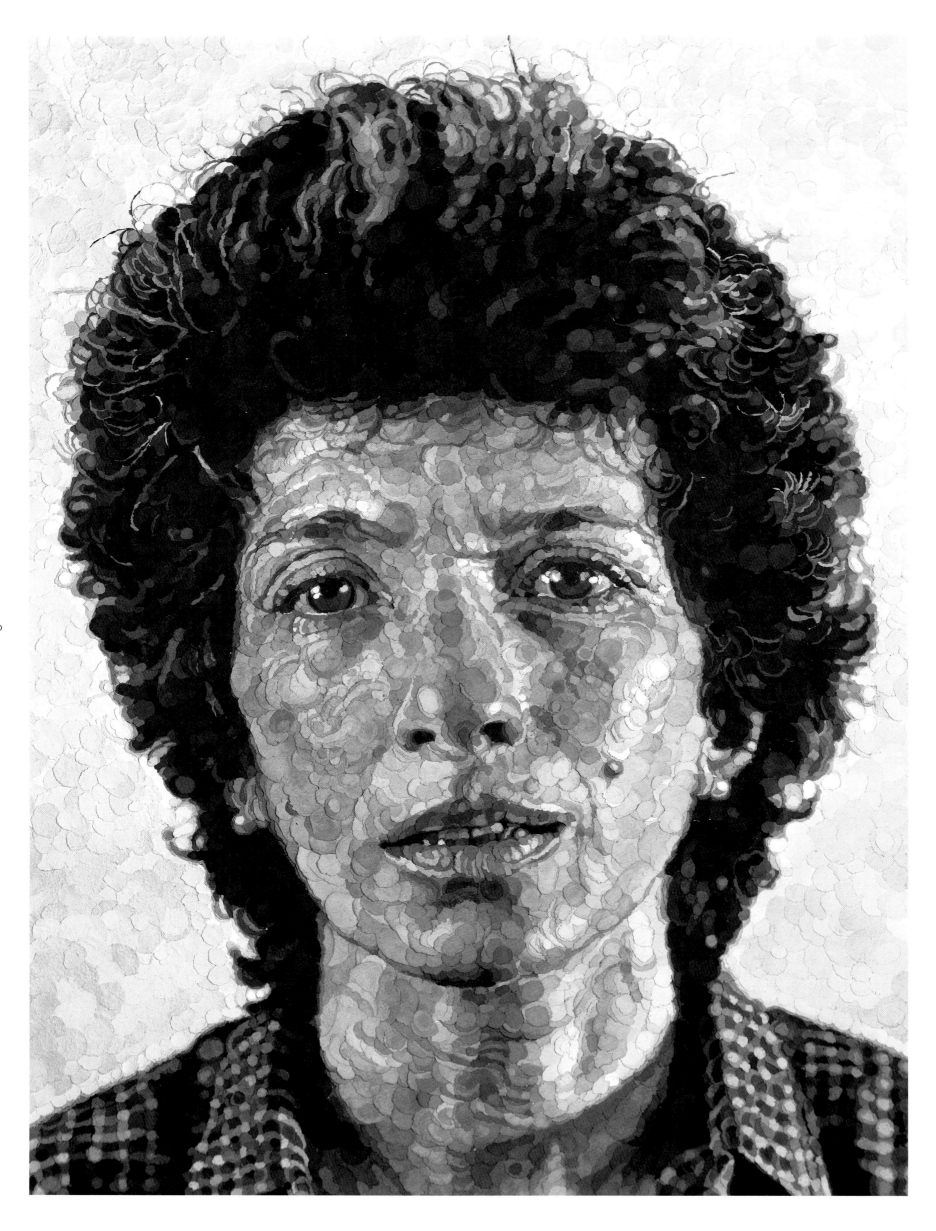

but they were soon surpassed by an extraordinary work, a self-portrait that is arguably a milestone in the history of photography. The title of this 1979 work is *Self-Portrait/Composite/Nine Parts*, which describes the piece succinctly without conveying any of its visual drama.

One respect in which the first Polaroid portraits differed from Close's handmade work was that they were produced in a non-incremental way. How could the grid-based process be applied to photography? The solution Close came up with was characteristically bold. The incremental units would be nine of the 24-by-20-inch Polaroid sheets, each an extreme close-up of part of the artist's face, each separate and distinct but marginally overlapping its neighbors when mounted on the wall in the form of a tick-tack-toe grid, making for a cumulative image with overall dimensions of 83 by 69 inches. Seen today, the piece remains extremely powerful. In 1979 it was positively shocking.

At that time, large-scale photographs—so commonplace in galleries now—were seldom encountered except in the form of advertisements such as the backlit Kodak billboards, then a feature of Grand Central Station's main concourse, which were intended to be seen from a distance. The nine-piece portrait was meant to be seen from close proximity, and the shock value of the scale, combined with the fragmentation of the image and the merciless detail provided by the Polaroid system, was considerable. Fragmentation is particularly shocking when applied to the human face, especially since in this instance the edges of some sheets actually slice through the eyes, metaphorically assaulting the very notion of vision. At the same time, paradoxically, that fragmentation helps to

emphasize the allover quality that Close has sought in all of his work. Each of the nine discrete sheets has an equal role to play in the work's gestalt, so that the camera's mechanically generated illusion, which is aggressively present, is overlaid by, and violently at odds with, a grid structure that is essentially minimalist.

Close's multiple-part Polaroids have sometimes been compared to the composite, multiple perspective Polaroids—dubbed "joiners"—that David Hockney made a little later, between 1982 and 1987. This is unfair to both artists, who arrived at results that were only superficially similar while coming from very different directions.

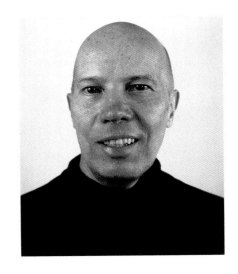

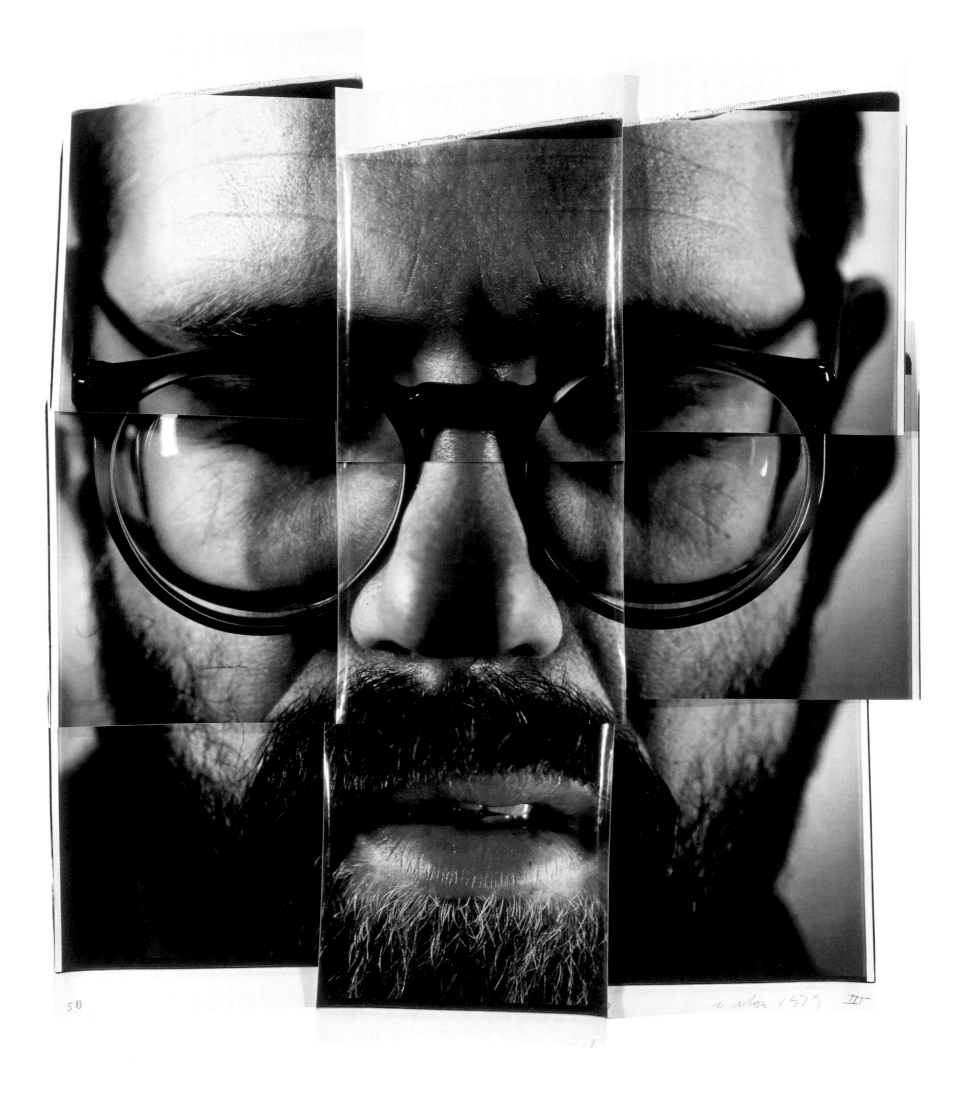

Close's composites are explicitly products of the New York School in its post–Abstract Expressionist, post-Pop phase. Although often identified with Southern California, Hockney's underlying sensibility remains essentially European, and his images can best be understood as an imaginative updating of the Cubist tradition.

As is apparent from their composite photographs, however, both artists agree on challenging the concept of the camera as a reliable recorder of "truth." Close believes that the public's perception of photography (like so much else involving matters of civic trust) was changed forever by the photographic filtering of events surrounding the assassination of John F. Kennedy, and the arrest and reciprocal assassination of Lee Harvey Oswald. Whereas people previously had accepted the truth of the cliché "the camera does not lie," after Dallas some came to believe that photography could be deployed in the service of a massive government-sponsored deception, and even those who did not subscribe to conspiracy theories now placed less faith in photographs as conveyors of definitive truths. In short, the public came to sense what artists, commercial art directors, and intelligence agencies had long understood, that all photographs are subject to interpretation. Central to all of Close's art is his belief that photography is as much about artifice as about recording a morsel of "reality."

. . .

While working with the MIT Polaroid camera, Close was told of an even larger instrument that the Polaroid Corporation had installed just a couple of miles away in the basement of the Museum of Fine Arts, Boston, one that could take 80-by-40-inch instant prints. This had been built on Dr. Land's orders to show off the product in a spectacular way at a shareholder's meeting. After that event, the monster camera had no obvious practical use until it found a home in the museum, where it was utilized for making high-quality images of works of art. Close approached Polaroid, and the company, somewhat reluctantly, gave permission for him to experiment with the camera, which was in fact a room-sized, light-fast box, sixteen feet deep and twelve feet tall and wide, divided into two chambers by a lens board into which a rather basic optical system—lens and bellows—was fitted. The person or object to be photographed would be placed on a platform in a chamber equipped with strobe lights that could produce thirty thousand watt-seconds of flash power. The other chamber was furnished with a focusing screen on which an inverted image of the subject projected by the camera lens could be adjusted. (Sometimes this was done simply by having the model move an inch or two towards or away from the lens.) When focus was achieved, an oversize strip of Polaroid negative film would be lowered in front of the focusing plane, where it was held flat by suction from a simple vacuum device. After final adjustments, the exposure could be made. Often the lens used was from an enlarger rather than a camera, so no mechanical shutter was involved. Instead, a piece of cardboard was held over the lens and removed by hand for a fraction of a second as the strobes flashed.

Along with a couple of technicians, Close would actually be inside the camera for the crucial moments leading up to and during the exposure:

"For a while, you'd be in total darkness. Sometimes I'd wear a night-vision headset like the FBI and the Army use, so I could see what was going on—people moving round like ghosts. Then, when the strobes were triggered, it was amazing. You saw the whole image in an instant—every detail. You could tell if the model had shut her eyes. I mean, you may have known before how a camera worked, but here you were actually inside the damn thing. It was like that Raquel Welch movie where they shrink people to go inside the human body."

Once the exposure had been made, the next task was to spread developing chemicals between the negative and a sheet of printing paper, which then had to be manhandled through a set of rollers that squeezed the layers of the sandwich together, allowing the chemicals to stimulate the Polaroid dye-printing process as paper and negative spilled out onto the floor outside the camera. Ninety seconds later, when the two sheets were pulled apart, the image was revealed.

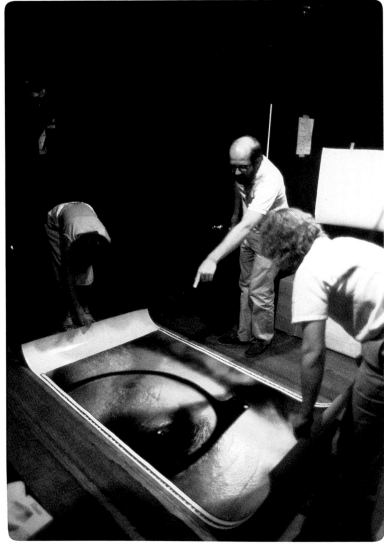

144

Chuck Close creating Self-Portrait/
Composite/Six Parts, 1980

➤ Self-Portrait/Composite, Six Parts, 1980.
Polaroid photographs, overall: 170 x 133 in.
(431.8 x 337.8 cm)

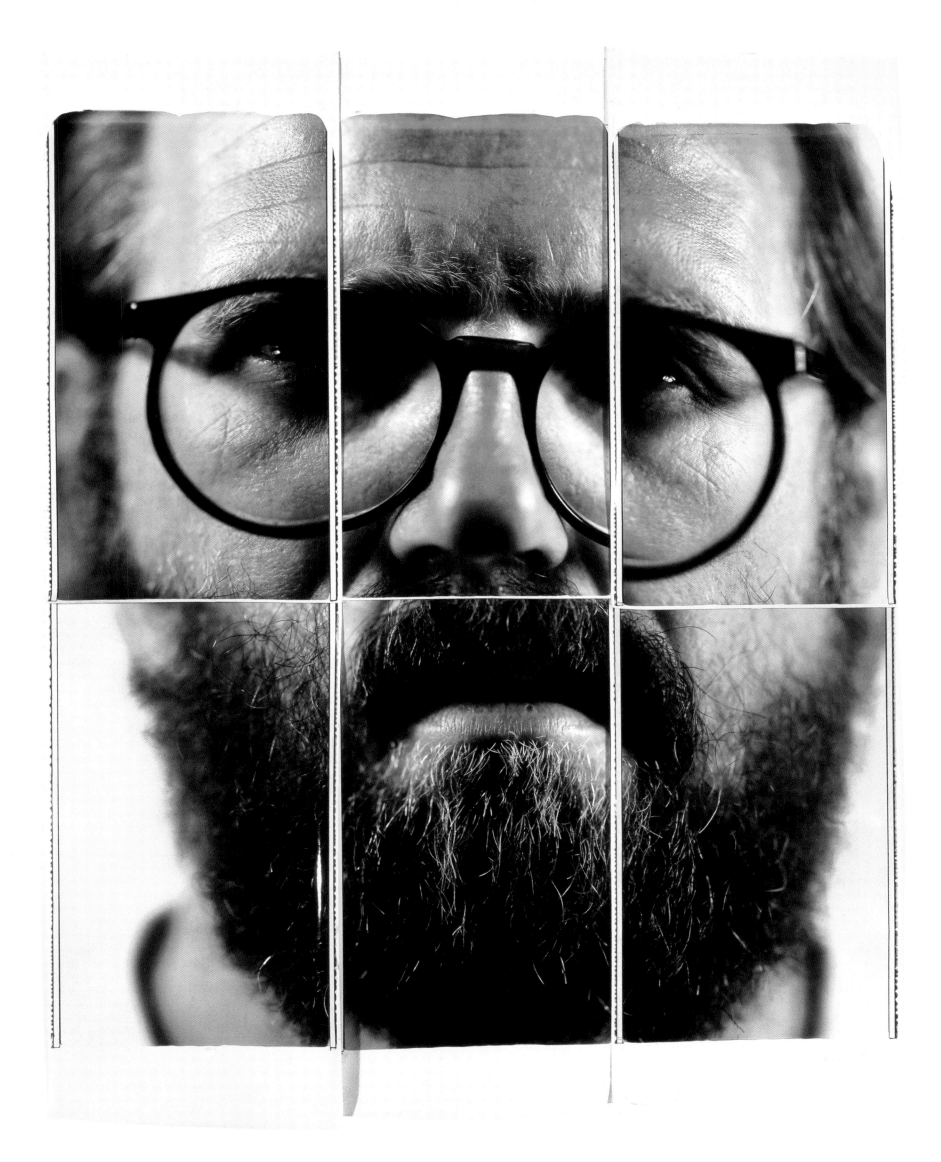

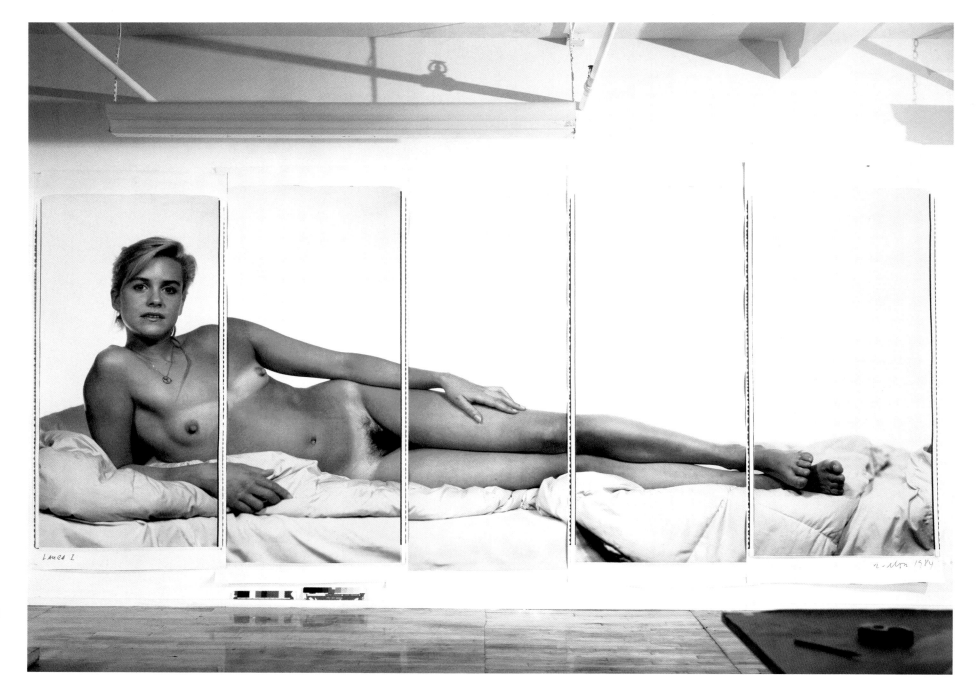

Laura I, 1984.
Polaroid Polacolor II photographs, 102 x 208 in. (215.9 x 528.3 cm)

When first given the opportunity to work with what was then known as the Museum Camera, in 1980, Close made a number of head and shoulder portraits of friends and a gigantic six-panel self-portrait that was an extension of the ideas explored in the nine-sheet self-portrait of the previous year. When he used the Boston camera again in 1984, he departed from his seventeen-year, single-minded devotion to the portrait and produced a series of nudes which also differed from his paintings, drawings, prints, and earlier photographs in that he employed models, both male and female, from outside his immediate social orbit, some of them professional dancers. The images produced included diptychs and triptychs that recorded partial torsos, as well as seventeen-foot-long, five-panel reclining nudes that inevitably recall the big black-and-white nude of 1967–68 (though these Polaroids were in color).

One reason for Close's disappointment with *Big Nude* derived from the fact that the figure's erotic hot spots tended to distract from the uniformity of information that he was aiming for in order to produce a figurative painting possessing the allover quality he saw and admired in the work of artists like Pollock and Stella. If anything, the obtrusion of erotic hotspots is even more characteristic of the 1984 nudes. Breasts, male genitals, and pubic hair, magnified and intensified by the camera, jump out at the viewer. Instead of trying to find a way around this, Close—perhaps because he had developed more confidence in his vision—now insisted on forcing the viewer to confront these hotspots. Peter MacGill recalls that when these nudes were first exhibited at his 57th Street gallery, in January 1985, Close insisted that he build a false wall that would oblige the viewer to encounter the images at close range.

"That was how I saw them," Close says, "so that's how I wanted other people to see them."

Close had never demanded that kind of spatial restriction

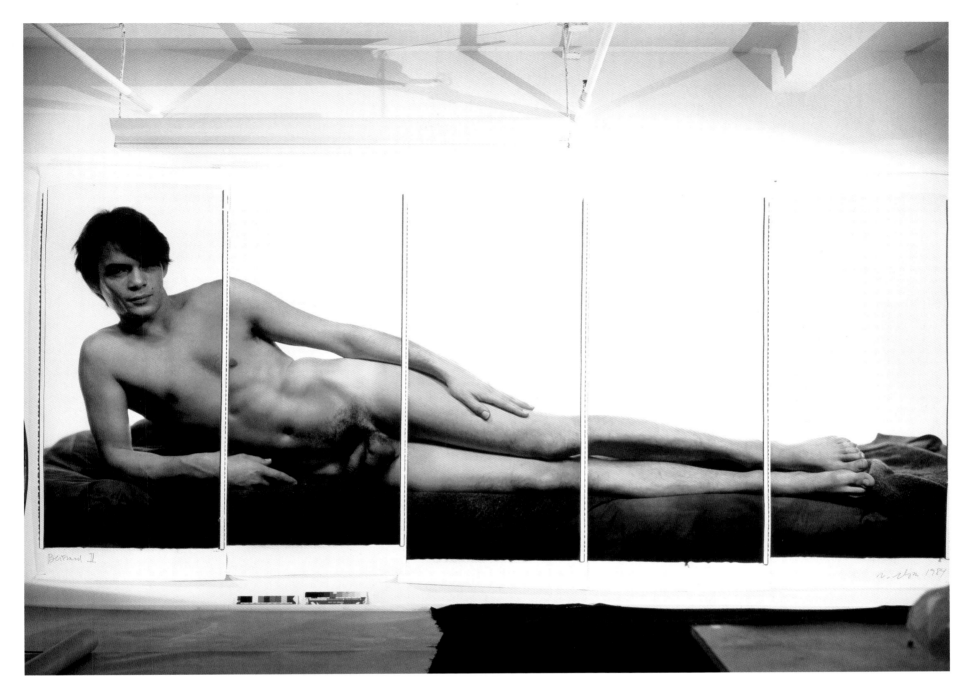

Bertrand II, 1984.
Polaroid Polacolor II photographs, 102 x 208 in. (215.9 x 528.3 cm)

when exhibiting his paintings; at previous shows a viewer could stand back from a given image or walk right up to it—turning himself into a perambulatory zoom lens. Part of the experience of looking at a large Close portrait—especially incremental works such as *Robert/104,072* or *Fanny/Fingerpainting*—is seeing how the information resolves into an image at a certain distance but dissolves into thousands of graphic bits as one approaches more closely. In fact, for the most part Close created these handmade images with his nose a couple of feet from the canvas, seldom studying them from a distance except perhaps when he walked into the studio in the morning or looked at the work with a visitor. In forcing the visitor to the Pace/MacGill Gallery to look at these Polaroid nudes from close range, the artist was both acknowledging that there was no handcrafted illusion involved, and asking the viewer to share something of the experience he was involved with on an everyday basis.

This can be seen as a way of encouraging the thoughtful viewer to reconsider the earlier handmade work, especially, perhaps, the continuous-tone portraits. Most of us have been programmed to think of the creative act as something spontaneous and intuitive. Close's work demonstrates that this can be a very misleading notion. If we put ourselves in his position, and imagine what it is like to spend hundreds of hours looking at a greatly magnified face from very close range, reconstructing it bit by repetitive bit, we can perhaps grasp at least one source of the objectivity that pervades his work, and that has led critics to accuse him of being excessively cold and detached. Close has often remarked that when making self-portraits he sometimes refers to the subject as "him." The same psychological distancing (as opposed to spatial distancing) presumably occurs when he is painting family members and friends, otherwise the months of grinding work, recording each skin blemish, each stray hair, would be intolerable. When the

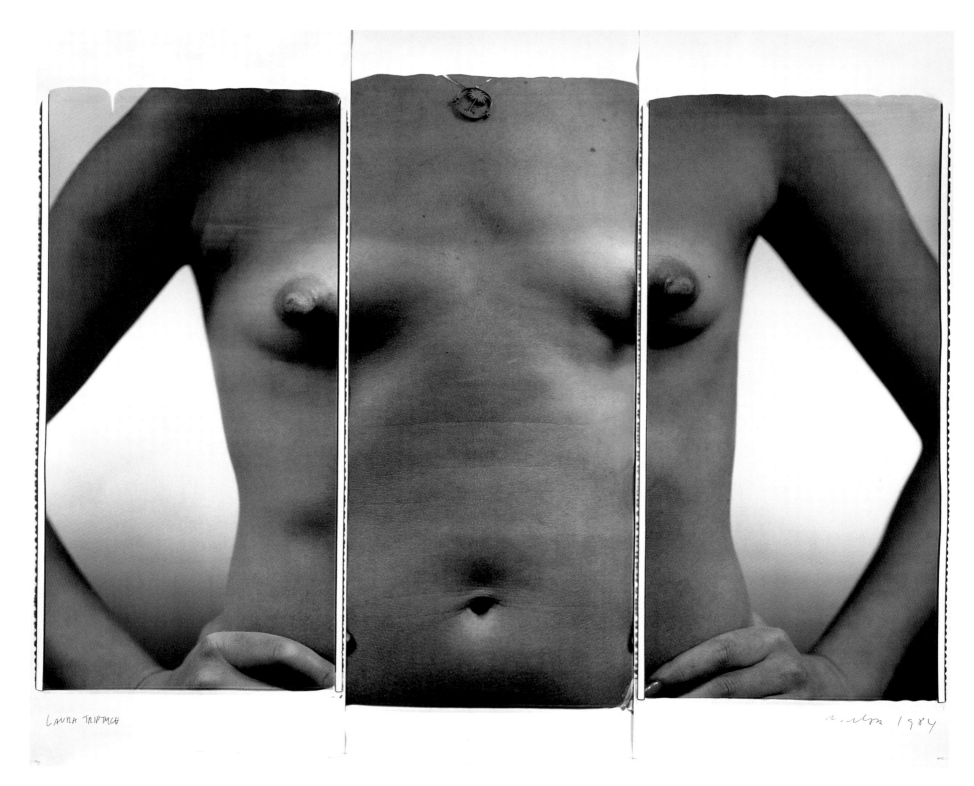

Laura Triptych, 1984.
Polaroid Polacolor II photographs, 102 x 128 in. (215.9 x 325.1 cm)

painting is finished, the person portrayed reemerges, and somehow, as time passes, the sitter's personality seeps back into the meticulously fabricated icon, dissolving the sense of impersonality that was apparent, and perhaps in fact present, when the work was first exhibited. Close's humorous way of summing this up is to tell his subjects, "You may hate your painting now, but come back in twenty years and you'll love it."

Time is a crucial element in Close's work. A Jackson Pollock drip painting is a record of something made rapidly with great energy. A Chuck Close painting is the opposite, being the chronicle of something accrued at a snail's pace and with great patience. This deliberateness continues to inhabit the image after its com-

pletion, as if those hundreds of hours invested by the artist are slowly released, permitting a given image the ability to evolve in the mind of a viewer over time.

Paradoxically, Close was able to use the Polaroid nudes—instant images—as a way of reinforcing the viewers' sense of how he perceived his subjects—putting the gallery-goer into his shoes—thus enabling viewers to grasp the significance of the laborious way in which the handmade images were fabricated. Beyond that, the Polaroids have their own strengths, best seen in the truncated torso diptychs and triptychs which are the most successful, I believe, in achieving a satisfying allover feel, and at the same time forcing the viewer to confront anatomical hotspots, both because these

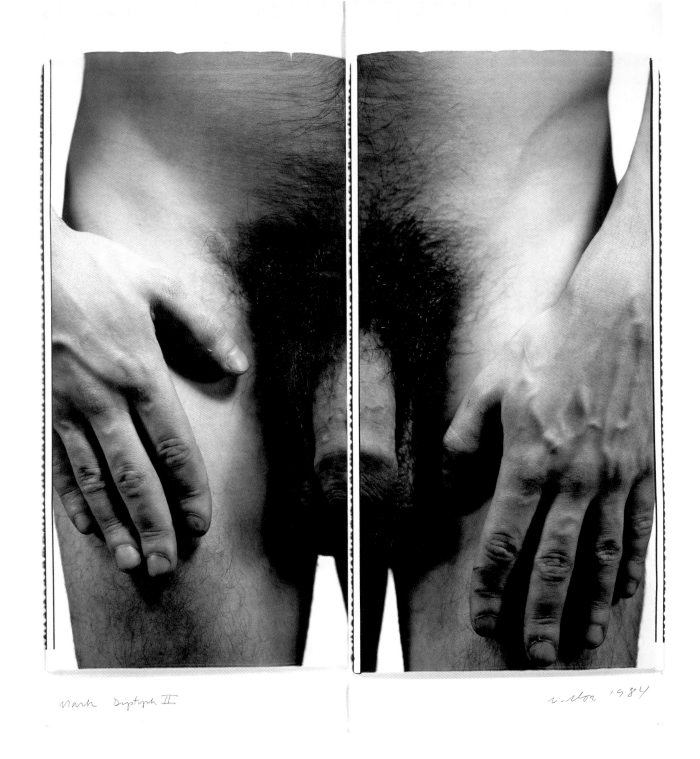

Mark Diptych II

v.Nor 1584

Mark Diptych II, 1984.
Polaroid Polacolor II photographs, each panel: 80 x 40 in. (203.2 x 101.6 cm)

are enormous in relation to the total image, and because they are obliged to play novel compositional roles, as in *Mark Diptych II* in which the subject's penis becomes the fulcrum of the composition.

. . .

The period when the activities discussed in this chapter unfolded was busy in other ways. Close's work had been prominently featured in museums as early as 1971, when the Los Angeles County Museum of Art showed a group of the early heads. In 1980 Martin Friedman and Lisa Lyons organized the first full-scale retrospective of his work at the Walker Art Center in Minneapolis, an exhibition that traveled to St. Louis and Chicago before arriving at New

York's Whitney Museum of American Art in the spring of 1981.

As a result of the publicity surrounding this show, Close was contacted by someone called Martin Close, who proved to be his half-brother. It emerged that Leslie Durward Close had been married and divorced before he wed Mildred Wagner. Other family members had known about this, but Chuck had never been told. A meeting was arranged, but proved to be a disaster. Close found his sibling's political and social attitudes so repellant that there was no further contact between them.

A few months before, Close had found himself caught up in another unhappy family encounter. Relations with his mother—especially between Mildred and Leslie—had not been improved

by Mildred's remarriage to a neighbor, Art Sipprell. When, in the summer of 1980, Chuck, Leslie, and Georgia went to spend a few days at Mildred's home in Lake Stevens, a suburb of Everett, the visit climaxed in a fierce confrontation, nominally provoked by Mildred's disapproval of the way in which Georgia was being raised, though undoubtedly the problems ran much deeper. Chuck exploded, packed up his family, and left.

"[My mother's] hostility towards Leslie made for an intolerable situation," he says, "Back in New York, it reached the point where I would feel sick to my stomach every time the phone rang, in case it was her. I told her we couldn't talk or see each other for a while."

This occurred shortly before the September opening of Close's retrospective at the Walker, which he forbade his mother to attend. Understandably, she took this very badly. Later in the year, there was some movement towards reconciliation, and as a concession, Mildred was invited to the New York opening of the exhibition, scheduled for April of 1981.

On Christmas Eve, 1980–Chuck and Leslie's thirteenth wedding anniversary–Mildred began to suffer chest pains at the Lake Stevens house. Then in her mid-sixties, she had seemed in excellent health. Not long before, she and her husband had sailed their boat to Hawaii in preparation for a proposed around the world voyage. When the pains became severe, Sipprell tried to persuade Mildred to go to an emergency room, but she refused, insisting that she knew what a heart attack felt like and this certainly wasn't one. To prove her point, she stubbornly went out to chop wood, then walked briskly up a steep hill. On her return, she collapsed and was taken to a hospital. Chuck flew out to be at her bedside, but by the time he arrived she was in a coma. On New Year's Eve, she died.

"I still feel terrible that I didn't have a chance to reconcile with her," Close says. "I never felt totally estranged from her–she was my mother. I'm still very conscious of what she did for me when I was a kid, but she was a difficult, stubborn woman and I was very angry at her hostility towards Leslie. It made things impossible. It's very sad, really. I've always been sorry that I never photographed her for a painting."

· · ·

In the early 1980s, SoHo continued to change. More and more galleries opened, occupying larger and larger spaces, and they were joined by other kinds of upscale businesses drawn by the district's shifting demographic profile. In 1984, the Closes moved uptown to an apartment on Central Park West, mostly for the sake of their daughter's schooling. Leslie Close was pregnant again, and on moving day, as furniture was being carried in, she went into labor and was taken to the hospital, where she gave birth to the couple's second daughter, Maggie Sarah.

By this time, Leslie had completed a graduate degree in horticulture, and she had founded and become the first director of the American Gardening and Landscape History Program at Wave Hill Center, in the northwest Bronx. There she initiated an encyclopedic catalogue of materials relating to historical gardens and landscape architecture in America, now housed at the New York Botanical Gardens.

Chuck Close continued to maintain a studio downtown, moving that same year to a space at 75 Spring Street. Here he would turn his attention to a medium that had played little part in his career until that point.

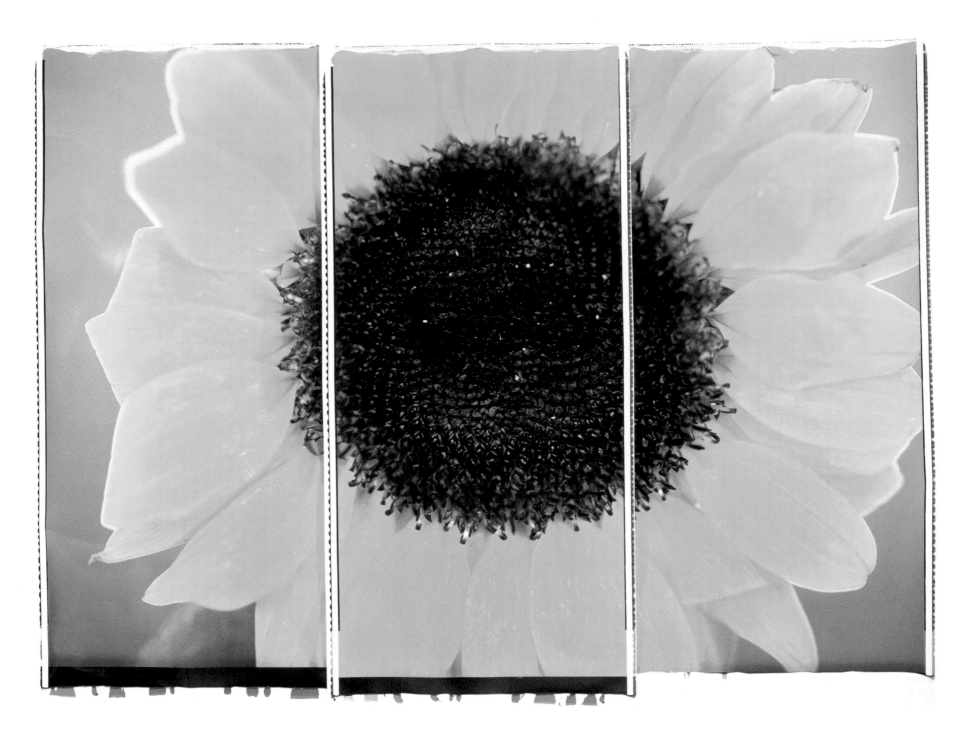

Chapter 5:

PRISMATIC GRIDS

Because of the consistency with which Chuck Close has adhered to his chosen subject matter, it is easy to overlook the complex interplay among his works in different mediums, and among different ways of making marks on canvas or paper, always within the context of adherence to process. To recapitulate, except at the very beginning of his career—the 1970 shift from continuous-tone black-and-white portraits to continuous-tone color portraits—there has never been a straightforward progression in his work, never a case of one idiom being programmatically followed by another, then another, in linear sequence. Starting with the 1972 *Keith/Mezzotint*, cross-fertilization has been the chosen method of propagation, with each technical approach informing every other, and with the artist never definitively abandoning earlier ways of working. The large continuous-tone black-and-white watercolor *Gwynne*, for example, was painted in 1982, a dozen years after the completion of the last of the original black-and-white acrylic cycle, at a time when Close was also occupied with stamp pad images and pulp collages.

The latter half of the 1970s and early 1980s was a particularly rich period of cross-pollination in Close's work, and it is in those years that can be found the beginnings of the idiom that would become central to his career from the late 1980s onward. Ultimately, one could trace it back to the black-and-white dot drawings that followed the 1972 mezzotint, but more particularly it can be seen as being rooted in the pastel portraits mentioned in the previous chapter.

Close had always been attracted to pastel because of its purity and intensity. Pastels are made from powdered pigment, unmixed with any medium, so that the color the artist applies to the paper support is what remains there, unaffected by the kinds of changes that occur during the drying process when working in, say, oil or acrylic. Close's notion was to make fully chromatic dot drawings employing an approach that would be in stark contrast to the way in which the continuous-tone color paintings were made. The latter were created by layering three transparent primary colors, so that the full chromatic range would be reconstituted by the viewer's eye. When it came to the pastels, the artist would produce images built from hundreds of tiny chromatic units, organized according to a tight grid. Again the viewer's eye would be called upon to mix the color, but this time by "reading" the fields of colored dots that constituted the image according to a cumulative process. To achieve this effect, Close would require many different shades and tints of each pigment, literally hundreds of colors in all. It was not until the mid-1970s that he could afford to do this. As Close told Lisa Lyons, working with pastels put him back in touch with the physicality of making art.[14] Having used an airbrush for almost a decade, he had had little direct contact with canvas or paper.

The resulting portraits are surprisingly varied. In the case of *Linda/Pastel* (p. 156), the first in the series, the dots are sometimes kept distinct from their adjacent fellows, though in some areas of the image they are allowed to overlap and blend so that a sense of blurring occurs. Relatively speaking, the distribution of color and tonality is somewhat simplified, adding to the two-dimensional feel of the image, which is in contrast to the sharp focus and illusion of depth found in the large continuous-tone portrait derived from the same photograph. (It should not be forgotten that virtu-

153

ally all of Close's drawings have been made *after* a painting of the subject has been completed. Not studies, they are variants exploring different technical approaches.) *Linda/Pastel* reminds us once again of Close's desire to make portraits having an allover quality that tends to negate the usual dialogue between figure and ground.

In the 1977 *Leslie/Pastel* (p. 157), by contrast, all but a few dots are kept quite distinct from those adjacent to them, and the result is a neater grid and less flattening of the image. The likeness is more naturalistic but has less of an "interpretive" or psychological feel. Much the same could be said of *Susan/Pastel* (1977), *Nat/Pastel* (1978), and the smaller version of *Mark/Pastel* (1977). The larger 1978–79 version of the latter image (p. 158), however—made on a 56-by-44-inch sheet of paper—displays a level of detail and density not found in the other pastel portraits, bringing it closer in mood to its large acrylic sibling. This is partly the result of an increase in both image size and quantity of grid lines, but the handling is subtly different too. Some individual dots have been modified by the superimposition of other, smaller marks. In the area of the lips, for example, a circle of dark pink may be inflected by a touch of lighter pink at the center. Additionally, in some places the flecks of near-white background found at the intersection of grid squares are used to emphasize highlights, helping break down the distinction between figure and ground while increasing the range of descriptive effects that can be achieved.

These devices, especially the use of small dots to modify the larger ones, would prove to be prophetic of the way in which a key branch of Close's art was moving. The next step in this evolution was to be found in the two paintings titled Stanley made in 1980 and 1980–81.

One significant thing about these canvases was Close's use, for the first time in his mature career, of oil paint applied with brushes. He had in fact loved the medium since that first childhood set of oils arrived from Sears, Roebuck, and had used it all through his long de Kooning phase. He had turned to acrylic in the late sixties only because the continuous-tone portraits were made with an airbrush, designed for use with water-based paints. Additionally, giving up oil paint at that point had been symbolic of abandoning the possibly un-American pleasures of traditional painting, an indulgence associated with *ateliers* rather than lofts, in favor of a quasi-industrial process whose finished product was as beautiful and untainted by artsy self-indulgence as a Buick fresh off a Detroit assembly line. The pastels represented a return to enjoyment of the manipulation of pigment for its own sake, and that was perhaps even more the case with the use of oil paint in the portraits of Stanley. To hold a brush once again, and to squeeze sweet-scented, oozing color onto a palette, was a voluptuous pleasure rediscovered.

By comparison with later work, neither version of *Stanley* (pp. 159 and 160) ranks among the most sensual of Close's paintings. The subject was Stanley Rosen, a businessman the artist had met, along with his wife Phyllis (the subject of a pulp portrait), when their children became friendly on the beach at East Hampton. He was photographed looking somewhat formal in a suit and tie, but both the large and the small portrait are rendered with an enjoyment of tactile values that owes nothing to the anti-painterly detachment of the continuous-tone portraits, though it does share a good deal with the hands-on intimacy of the finger-paintings and paper pulp pieces. Conceptually, these first essays in oil paint emerge directly from the pastel drawings, but they provide the added dimension of brushwork. With the continuous-tone portraits, Close's virtuosity, though always implicit in the finished product, is veiled by the anonymity of the execution. In both versions of *Stanley*, we find a record of the artist rediscovering gratification in his own mastery of brushwork.

In the pastels, Close had felt his way towards the subtleties that are possible when building an image from dots of color and inflecting their values by modifying some clusters of dots with smaller touches of color, both complementary and contrasting. In the portraits of Stanley, he took this methodology much further. The paintings were built by laying an evenly-spaced grid of plump, lusciously-pigmented dots over a warm, flesh-tinted ground, then modulating the impact of almost every primary dot with smaller dabs of color in order to build patterns that from a distance would read as highlights and shadow. Especially in the larger painting, an enormous amount of visual information was introduced in order to achieve these effects. Here and there, colors were permitted to spill over the grid lines, and in some areas dots were stretched into

Linda/Pastel, 1977.
Pastel on watercolor-washed paper,
sheet: 29 3/4 x 22 1/8 in. (76.2 x 57.2 cm)

Leslie Pastel, 1977.
Pastel and watercolor on paper,
sheet: 30 x 22 in. (76.2 x 55.9 cm)

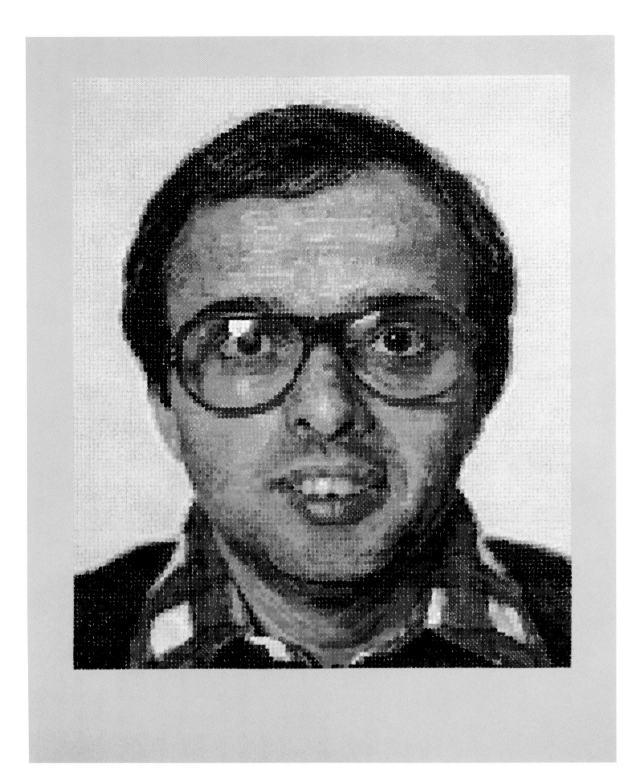

Large Mark Pastel, 1978–79.
Pastel on watercolor, 56 x 44 in.
(142.2 x 111.8 cm)

wiener-shaped directional markers to suggest, for example, hair follicles or the weave of a fabric. Because the squares of the grid were small in relation to the size of the canvas, allowing for a dense texture, the image attained a distinctly photographic sense of "realism" when seen from a distance, almost as if constituted from the half-tone dots used in photo-engraving. Seen close up, however, it dissolved into thousands of tiny nonfigurative elements organized according to a self-sufficient pictorial logic.

· · ·

The far-reaching implications for future work that we now recognize in these paintings would not be acted upon immediately because, as described in the last chapter, it was at this point that Close felt a need to break with the grid. From 1981 to 1986, he was engaged with fingerpaintings, pulp paper works, and photography. In 1986 he returned to the grid for a smallish watercolor and gouache portrait of his wife that was to serve as the basis for a Japanese Ukiyo-e–style woodblock print, to be executed in Kyoto. There

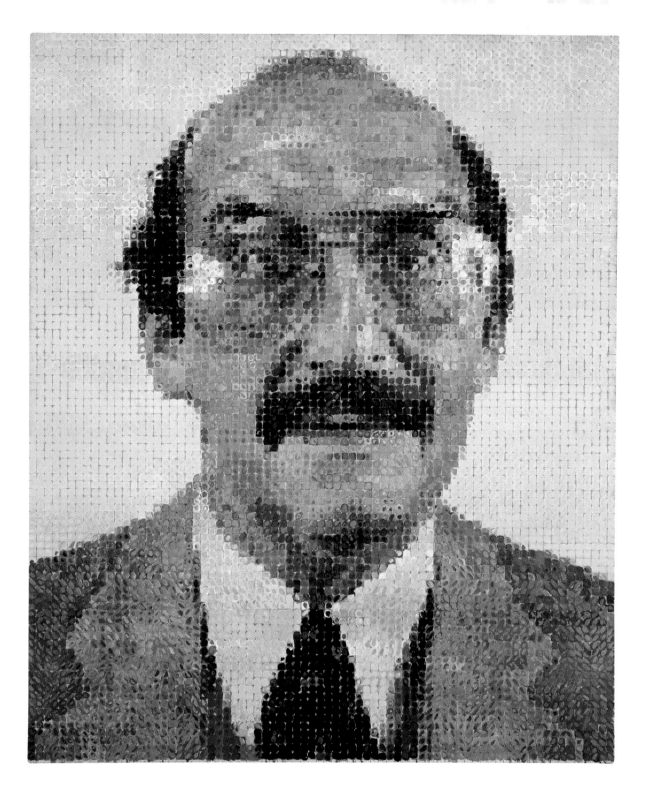

Stanley (Small Version), 1980.
Oil on canvas, 55 x 42 in.
(139.7 x 106.7 cm)

were in fact two watercolor portraits made with this purpose in mind, both derived from the image used for the large and very photographic *Leslie/Fingerpainting*, begun in 1985 and completed in 1986. One of these was a continuous tone image, the other an explicitly gridded version employing a loose adaptation of the modulated dot technique seen in the two *Stanley* paintings. Close took this approach in part with the demands of woodblock printing in mind, but it also represented a conscious return to the rigor of the grid, the artist having exhausted his interest in and patience with the reliance upon a projector necessitated by the process devised for the fingerprint paintings.

Neither the watercolor nor the subsequent woodcut aimed for a high degree of pictorial legibility, instead emphasizing the allover distribution of information inherent in the process. Also in 1986, the technique was refined further in a medium-sized (54 1/2 by 42 1/4 inches) oil-on-canvas self-portrait. In this painting, small circles and somewhat loosely painted diamond and lozenge shapes began to enhance the primary, grid-determined layer of dots, creating a lively surface texture. From a distance, this

pages 160 and 161:
Stanley (Large Version), 1980–81.
Oil on canvas, 101 x 84 in.
(256.5 x 213.4 cm)

Stanley (Large Version)
(detail), 1980–81

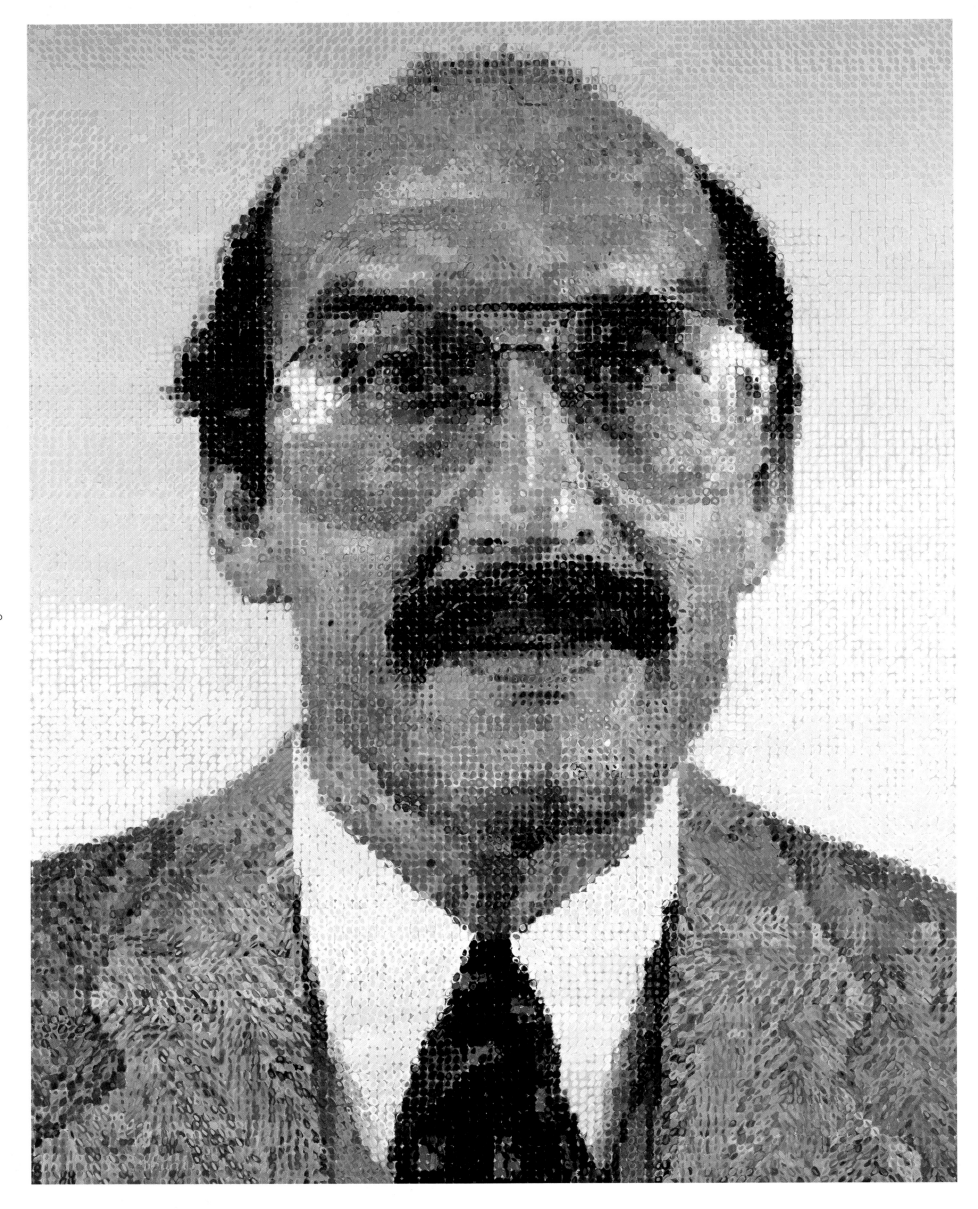

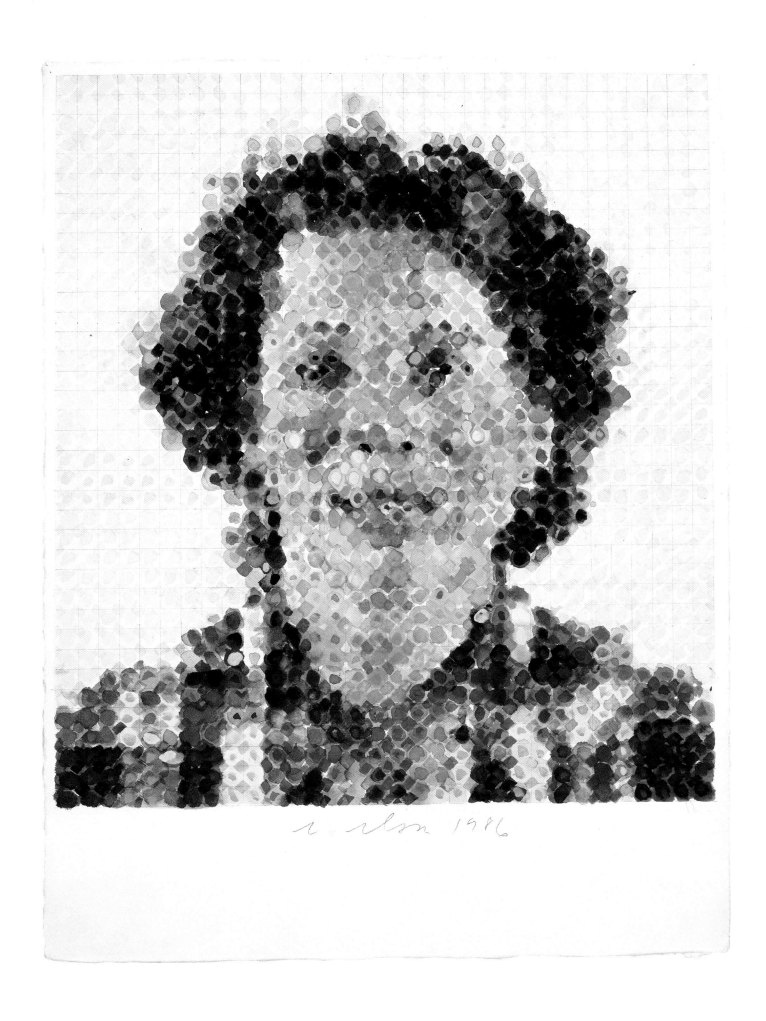

Leslie/Watercolor II, 1986.
Watercolor on paper,
sheet: 30 1/2 x 22 1/4 in. (77.5 x 56.5 cm)

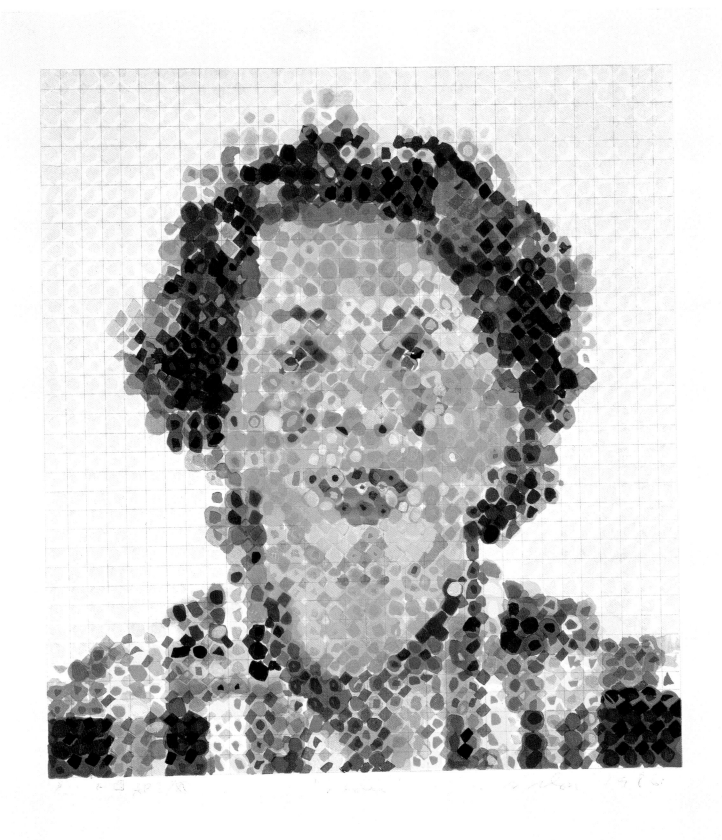

Leslie, 1986.
Woodcut, 32 x 25 1/4 in.
(81.3 x 64.1 cm)

self-portrait read in much the same way as the large pastel *Mark* and the two oils of Stanley, but the constellations of dots had taken on a somewhat more expressive character. The evenness with which the primary dots were distributed in the portraits of Stanley gave way to a grid that is more loosely rendered and peppered with surprises. Colored marks are superimposed upon one another in ways that suggest sections through olives stuffed with pimento, and some brushstrokes—though tiny—become almost gestural. The artist who had formerly suppressed overt expressiveness to create an image that was fully satisfying only when completed had found a way to put explicit pleasure back into the act of painting, and had done so without compromising himself.[15]

The following year, Close painted a larger (72 by 60 inches) self-portrait that can be considered one of the first fully-realized examples of the idiom that has occupied him ever since. Like the two *Stanley* paintings, the 1986 self-portrait was very much a figure-on-ground image, the head silhouetted against a light-colored background. The 1987 self-portrait had much more of an allover character, with a dark background woven from skeins of red and blue paint, further animated in some areas by superimposed dots and dabs of pigment. The paint handling in the facial area is more assured than in the earlier grid paintings, as if Close now knew exactly where he was headed.

Despite the fragmentation, the image still reads photographically when seen from a distance—helped by lighting, much bolder than in the 1986 self-portrait, that creates strong contrasts. As the viewer approaches the canvas, however, the shift to reading the imagery as a collection of abstract notations becomes very pronounced, far more so than was the case in the preceding paintings. In this work, the artist confidently calls on the viewer to fully employ his or her powers of perception as an active—even interactive—element in experiencing the painting, as blobs and flecks and speckles of paint alternately assume and then divest themselves of descriptive roles.

· · ·

That 1987 self-portrait led directly to a new series of oil on canvas portraits that further refined and expanded the method that had evolved from the pastels. At least, in part, the were inspired by a visit Close made to the National Gallery in Washington, D.C., around this time. After leaving the gallery, he began to think about the portraits he had seen that day.

"I was going over them one by one in my head—Holbein, Ingres, Vermeer, and so on—and my thoughts were about the importance of pose, the different angles used in various paintings, the lighting, and especially the eyes. I was struck by the fact that so few of the sitters . . . looked directly at the viewer."

Given his original emphasis on the mug shot, it is hardly surprising that almost all of Close's portraits had featured eyes that looked directly back at the viewer. (The 1968 painting of Nancy Graves—Close's first portrait of anyone other than himself—is entirely uncharacteristic in that she is posed looking skyward. A more interesting exception to the rule is *Leslie/Watercolor* from 1972–73, in which the sitter looks just slightly away from the camera, a common device in traditional portraits.) Now he began thinking about alternatives, and this line of thought would begin to have an impact in the new series.

As we have seen, Close's subjects had always been family and friends, and, inevitably, many of these friends were artists. For this major new group of works, he decided to concentrate entirely on artists, particularly ones who had made something of a specialty of self-portraiture, the chosen subjects being Cindy Sherman, Lucas Samaras, Francesco Clemente, and Alex Katz, artists he thought of as "professional posers." The resulting paintings employed Close's new overtly incremental approach to create works possessing an implacable monumentality equivalent to that found in the continuous-tone portraits. At the same time, the increased flexibility in paint handling that the new approach allowed—even encouraged—permitted the artist to introduce an emotional intensity that was evident in every brush stroke. This visceral feeling had been present in works like *Fanny/Fingerpainting*, but it was now achieved with brushes, a development that opened up new possibilities. In reality, of course, Close's art had always been impassioned, but the openness with which the passion was now expressed—the clear pleasure he was taking in the manipulation of pigment—made this group of works striking in a new way.

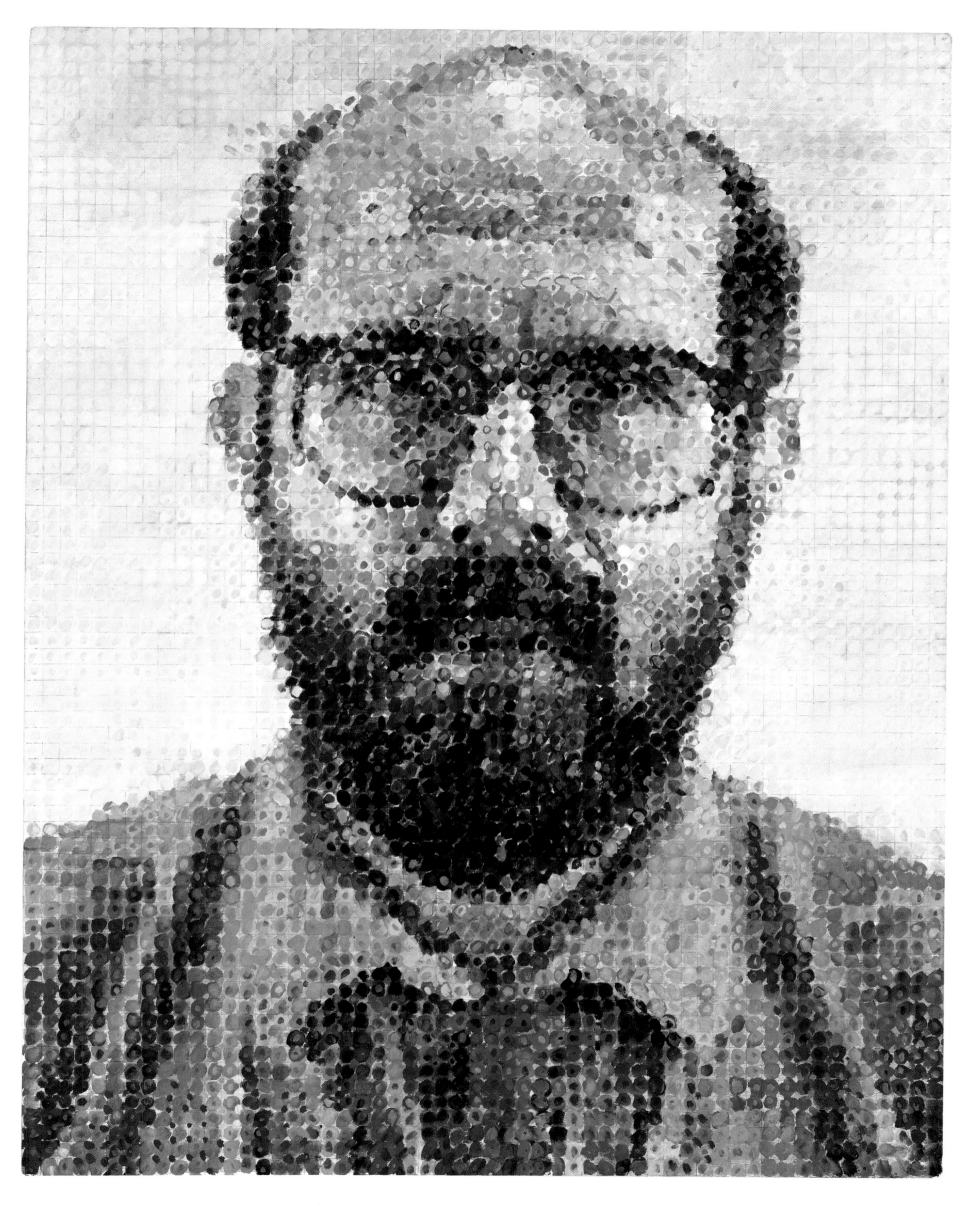

➤ Self-Portrait, 1987.
Oil on canvas, 72 x 60 in.
(182.9 x 152.4 cm)

The nearer the viewer comes to the surface of these paintings, the more the play of pigments ravishes the eye. These are intensely retinal paintings, built from thousands of bits of chromatic information, pointillist at least to the extent that a comparison with the work of Georges Seurat is suggested. (Close in fact dislikes the term "pointillism" as applied to his own work.) But whereas Seurat's system depended—nominally at least—upon the scientific theory of the prismatic division of light into the colors of the spectrum (hence the name "divisionism" that is sometimes applied to it), Close's approach is entirely more pragmatic, though its effect is decidedly prismatic.[16] His own description of his method is strikingly down-to-earth: filling each square of the grid, he has said, is like playing a hole of golf.

By this analogy, Close means that a series of strokes brings him incrementally nearer to his goal. Let's say that an individual square of the grid is set to represent part of the sitter's face, just where the edge of a plane creates a shadow so that flesh begins to shift from light to dark. The underpainting of the square is perhaps cadmium orange (the underlying color is deliberately arbitrary). To come closer to the desired effect, the artist might cover most of the square with a patch of pale blue. That first brushstroke may be compared to the golfer's tee shot, striking the ball as far as possible in the direction of the flag. On the canvas, the patch of blue falls short of achieving the required end result, so a little loop of orange is applied (the approach shot) which begins to establish the basic tonal and chromatic value demanded. It does not yet indicate quite the shift of luminosity needed, however, and so a touch of turquoise is added to one side of the evolving cluster (the chip shot to the green) and offsetting touches of pink and yellow to the square's opposite edge to complete this tiny component of the illusion (the putt is finally sunk). Richly inhabited by blobs and squiggles of color, the square is now ready to fulfill its role in the evolving mosaic, modifying adjacent squares and in turn being modified by them. (To complete the golfing analogy, the larger paintings in this first artists' group were equivalent to playing as many as eight thousand holes, or more than four hundred rounds.)

The method that Close evolved between 1986 and 1988 generated enormously rich broken textures—greens sitting alongside pinks, pinks by purples, purples next to sapphire or cerulean, all in tightly-packed constellations. The paintings produced by this method, which heralded the rebirth of his long-suppressed love of the painterly, constitute a shimmering record of the artist's career-long obsession with process. That was only part of the story, however. As the viewer stepped back from these canvases, those constellations of lenticular dots and Fruit Loop circles began to read as faces with a degree of definition and articulation that was far more convincing than had been the case with the large *Stanley* or even the 1986 self-portrait. For all its fragmented surface, a painting like *Lucas* (1986–87; p. 171), has an intensely photographic presence, with focus, shadow, and highlights fully realized in a way that never allows the viewer to lose sight of the fact that a lens has intervened in the process.

• • •

This group of works broke new ground in other ways too. While some were built on the conventional vertical/horizontal grids Close had favored until then, others employed variants. The two versions of *Francesco* painted at this time, and one version of *Cindy*, employed diagonal grids. This has a subtle yet significant influence on the way the paintings are perceived. There is a gain in dynamism, but a loss of some of the bricks-and-mortar solidity provided by the vertical/horizontal grid. They sit differently on the support, just as a garment cut on the bias hangs differently on the torso.

Versions of *Cindy* and *Lucas* were painted on grids defined by concentric circles and spokes extending from a central hub. Such a grid inevitably has a marked effect on the image represented within it, since the work's compositional energy collects at the center and diminishes rapidly towards the edges of the canvas. *Lucas II* (p. 173), a frontal image, concentrates energy right between the sitter's eyes with startling psychological impact. The progressive lessening of pictorial density as the viewer's eye is drawn centrifugally towards the perimeters makes it seem as if the image is about to fly apart. The portrait evokes thoughts of entropy—the progress

pages 168 and 169: Francesco I, 1987–88.
Oil on canvas, 100 x 84 in.
(254 x 213.4 cm)

➤ Alex, 1987.
Oil on canvas, 100 x 84 in.
(254 x 213.4 cm)

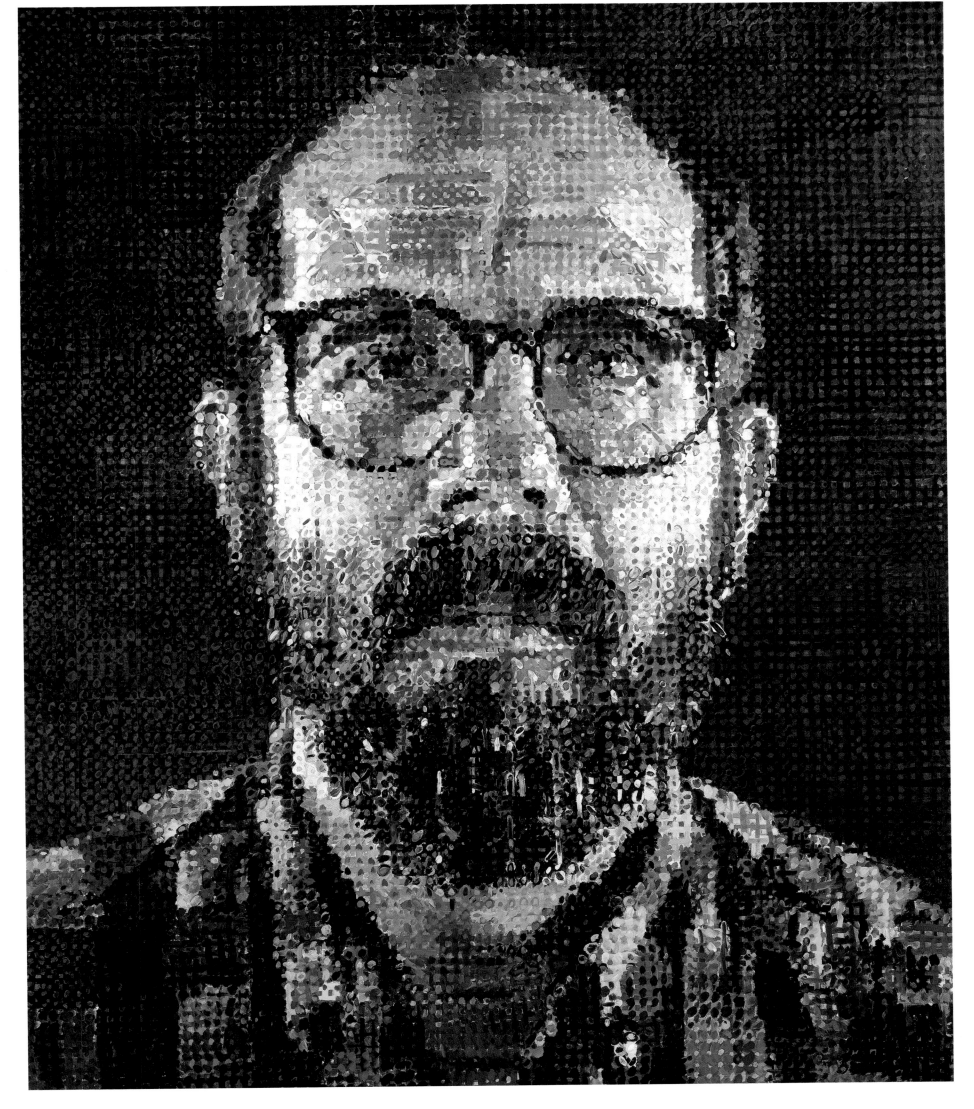

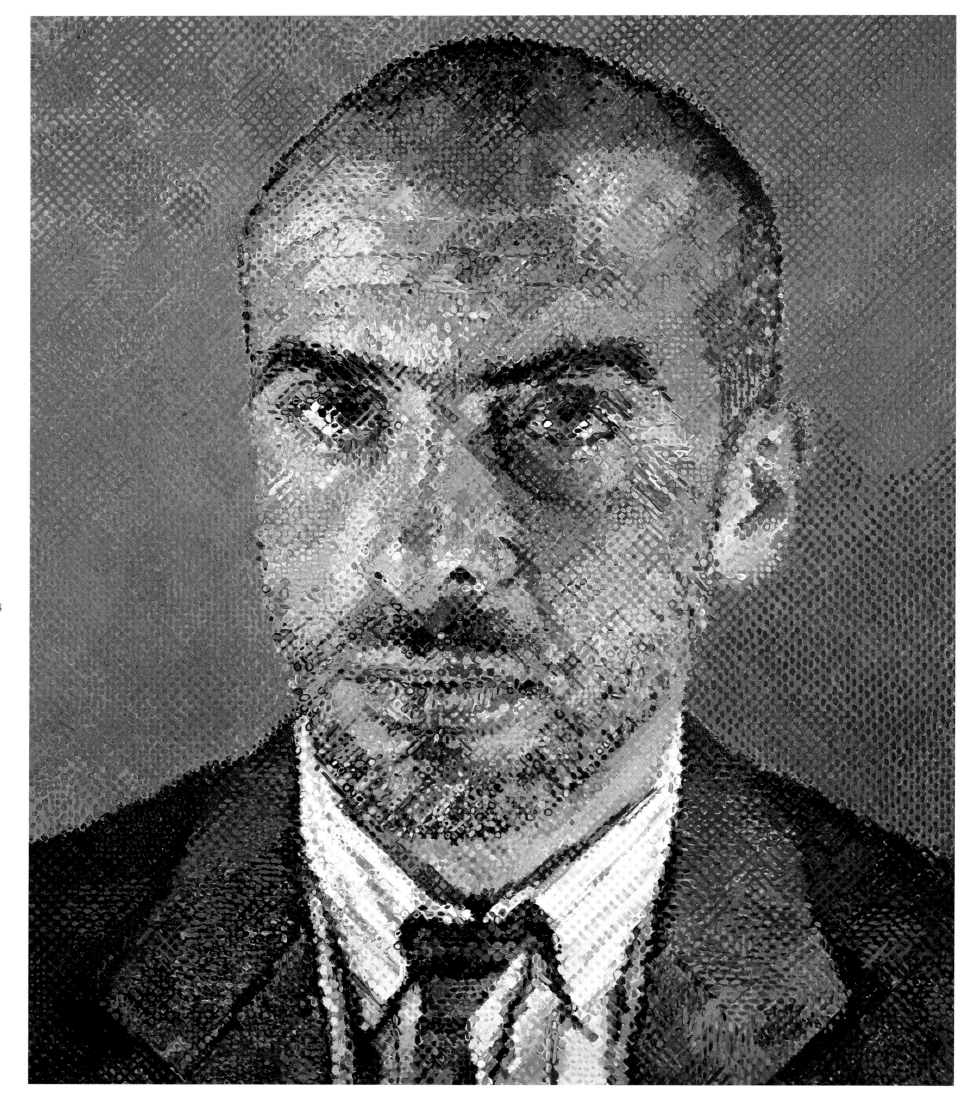

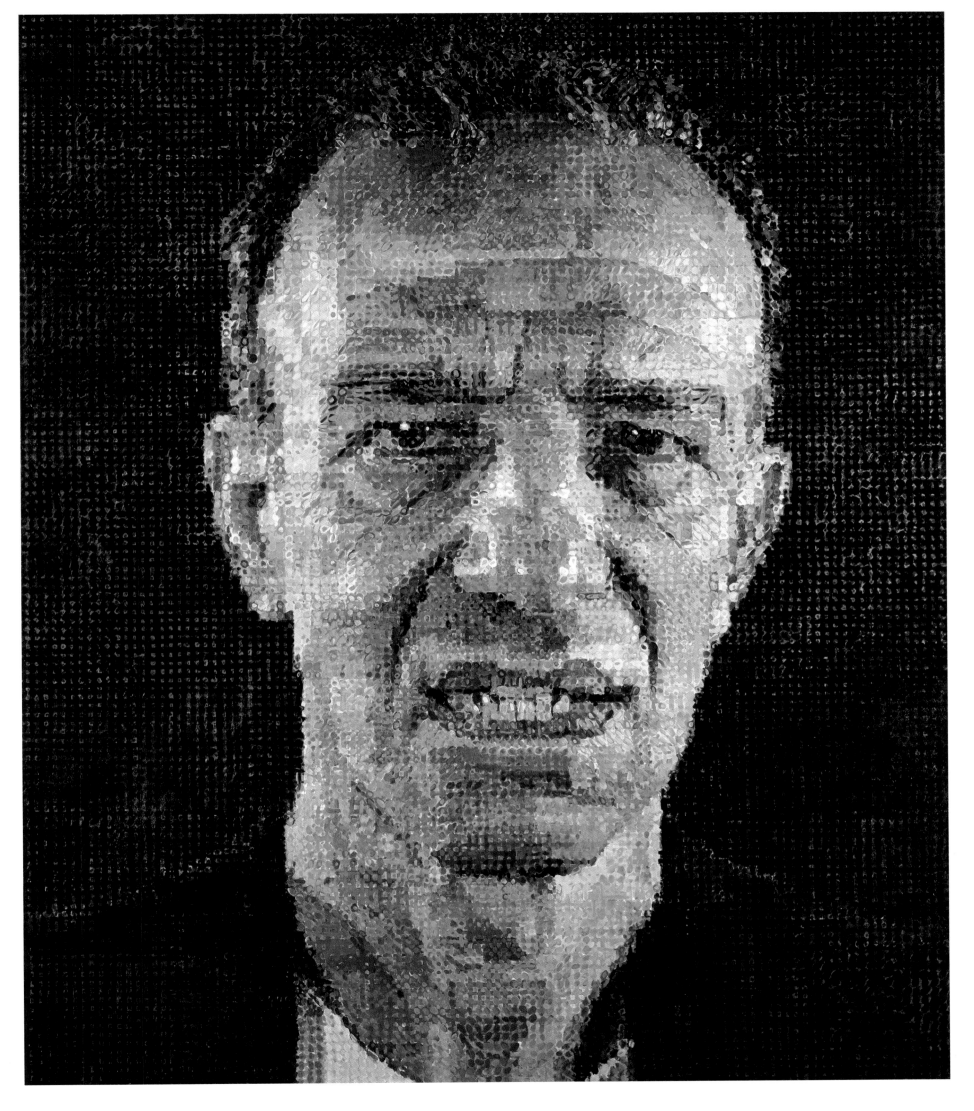

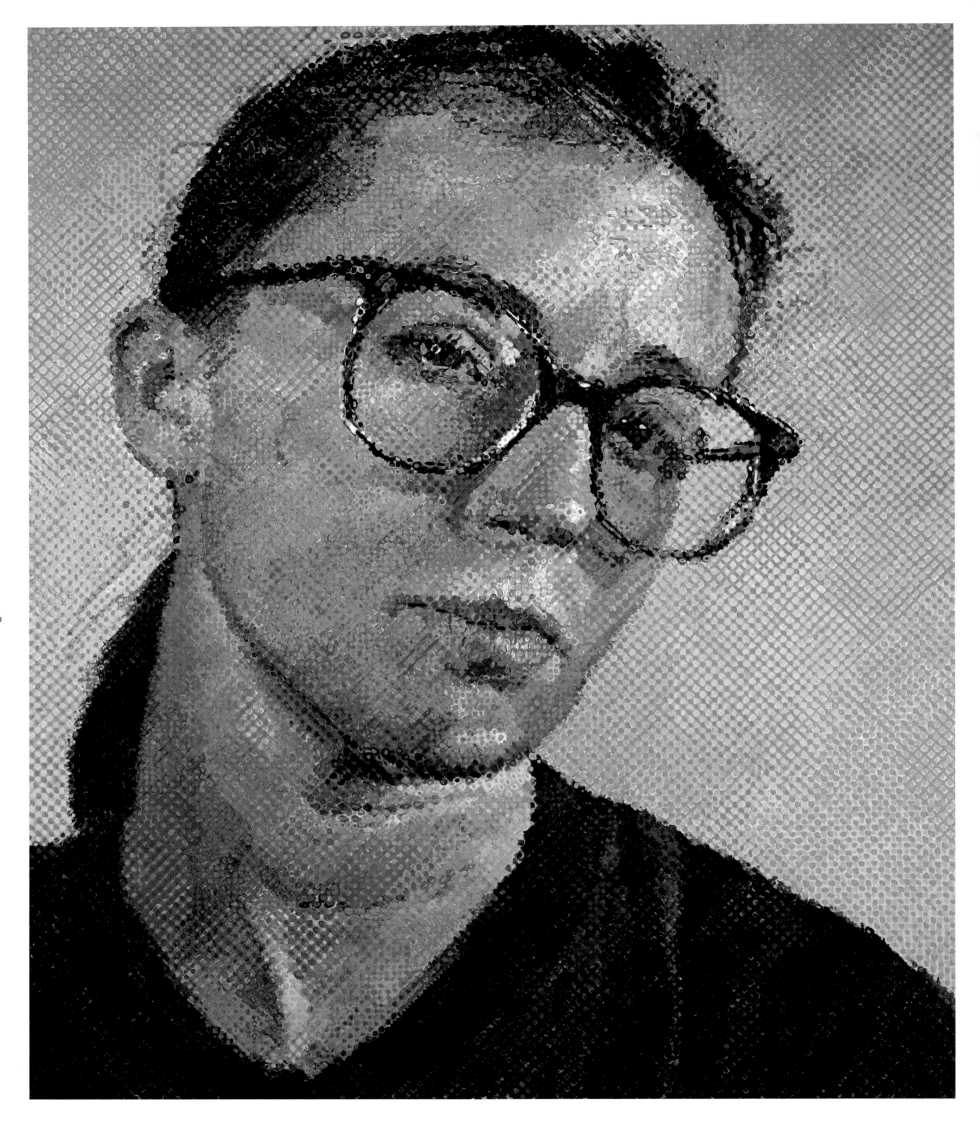

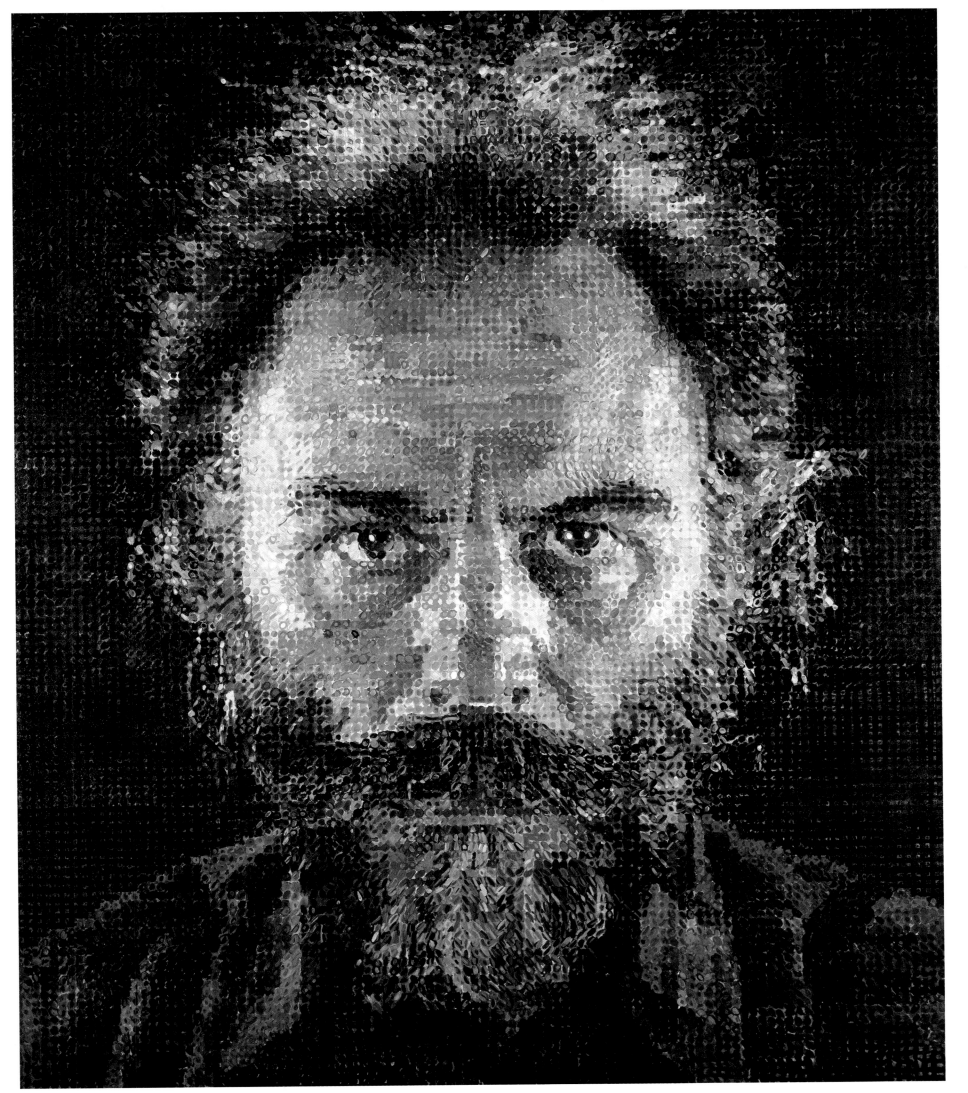

pages 170 and 171: Cindy, 1988.
Oil on canvas, 102 x 84 in.
(259.1 x 213.4 cm)

➤Lucas, 1986–87.
Oil on canvas, 100 x 84 in.
(254 x 213.4 cm)

➤Lucas II, 1987.
Oil on canvas, 36 x 30 in.
(91.4 x 76.2 cm)

of the universe towards chaos—a condition countered only by the fragile ability of the human imagination to give meaningful shape to random events.

The sense of disintegration in *Cindy II* (p. 176), also painted on a circular grid, is less pronounced. One reason for this is that the painting is far larger than *Lucas II*, and the components of the grid are much smaller in proportion to the size of the canvas as a whole. This tends to create a greater sense of unity throughout the picture plane. Also, this painting is one of Close's rare profiles. The fact that the grid is centered on the sitter's right ear lobe, rather than between the eyes, gives it an entirely different psychological slant. A person gazing sideways into space registers very differently from one staring directly at the viewer, especially when the artist's incremental method demands that the viewer work at putting the elements of the likeness together.

The earlier *Cindy* (p. 170) is unusual too in that, in addition to the diagonal grid, it utilizes a three-quarter frontal view with the sitter's head inclined to one side. What it shares with all the paintings in this group, however—and in the end this is more important than experiments with poses and angles—is the fact that it exemplifies Close's new richness of approach to the use of color and his freer way with making marks on canvas. The full effectiveness of this process was perhaps most apparent in a version of *Lucas*—one of the largest paintings in the group, a little over eight feet tall—painted on a conventional vertical/horizontal grid that offers no distraction. With his piercing eyes and his wild hair and beard, Lucas Samaras made an ideal subject for Close's technical approach at this point in its evolution. The use of directional strokes to suggest follicles, pioneered with *Stanley*, is here employed to dramatic effect. Animated by scattered highlights, the sitter's face seems to vibrate with life. Samaras's energized presence thrusts forward out of the dark background in a way that belies Close's emphasis on the two-dimensional picture plane.

The background itself is as alive as any other part of the painting. Its share of the grid is vitalized by thousands of dabs of variegated color, dominated by deep blues but with many flecks of red visible so that one has the impression of a galaxy of dark stars almost, but not quite, blocking out a more distant light source. The color seems to vibrate as in an exercise in optical art by Bridget Riley. By activating the background in this way, combined with the treatment of the head itself, Close reemphasizes his ideal of Pollock-like allover composition, creating a painting that is a kind of prismatic grid, at the same time reinventing chiaroscuro for the age of quantum physics and DNA.

· · ·

The last of this group of portraits to be painted was *Cindy II*. Close declares that the final painting he makes in any particular sequence is in a sense also the first of a new set, since it generally leads him in a new direction. In this instance, the connection to his future work is not immediately obvious, largely because the concentric circle format of the grid is so dominant a feature. Although Close has occasionally employed that format again, it certainly has not been central to his later work.

What makes the painting significant for paintings to come can be understood only on close inspection, a fact that has been overlooked in part because this painting has not been available for public viewing for a number of years. If one takes a photographer's lupe to a transparency or reproduction of this painting, however, and compares its incremental units to those of other paintings in this group, it will be seen that *Cindy II* is significantly looser in its handling—its loops and dabs more gestural and expressive than those found in its immediate predecessors.

This would prove to have a significance far greater than the artist or anyone else could have predicted at the time.

· · ·

In the fall of 1988, these new paintings were exhibited at the Pace Gallery's 57th Street headquarters. Simultaneously, Close had exhibitions of photographs at Pace/McGill and multiples at Pace Editions. (The photographs included some stunning floral images that were in part a response to his wife's career in horticulture.) The reception to all three shows was enthusiastic. The paintings in particular were welcomed as a sign that the artist was back in top form. Chuck Close, it was widely acknowledged, had successfully reinvented himself.

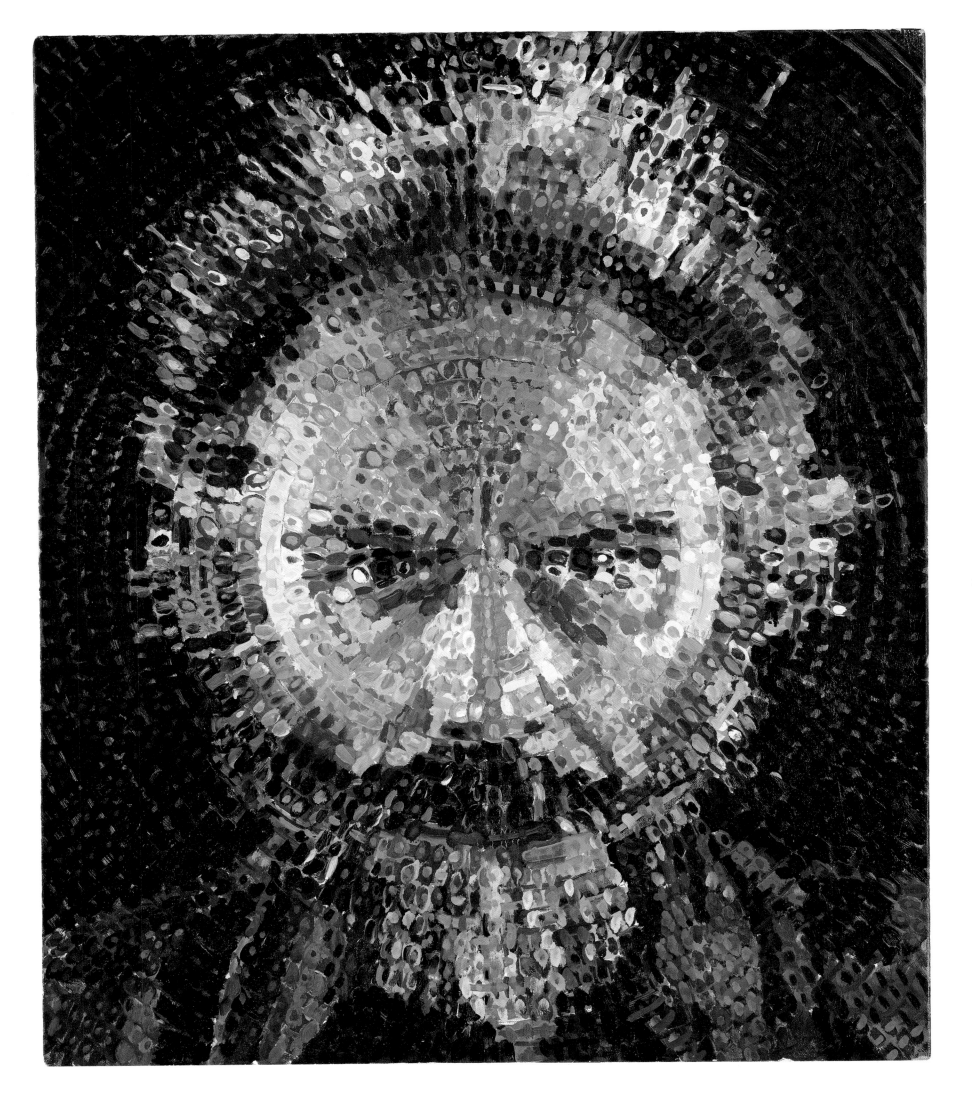

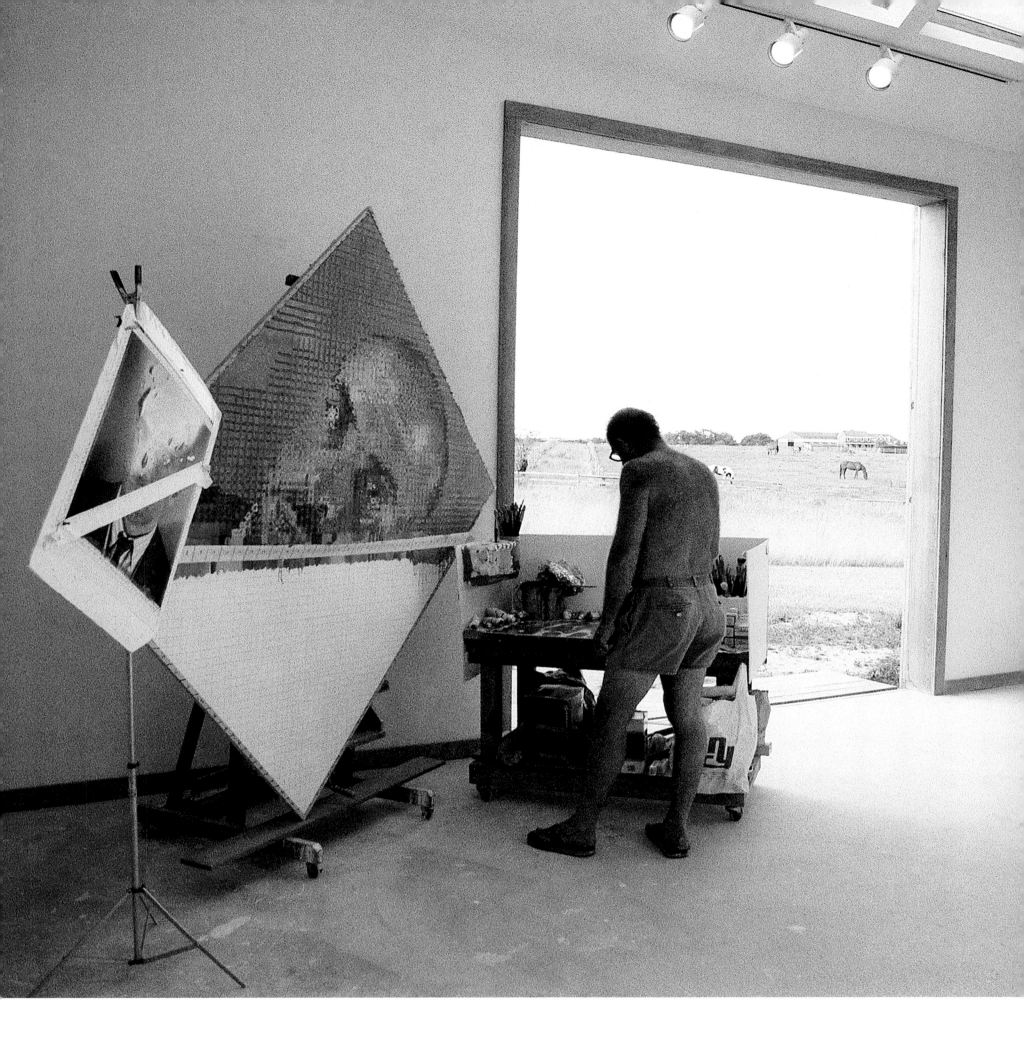

◄ **Francesco II**, 1988.
Oil on canvas, 72 x 60 in.
(182.9 x 152.4 cm)

Chuck Close working on
Francesco II, 1988

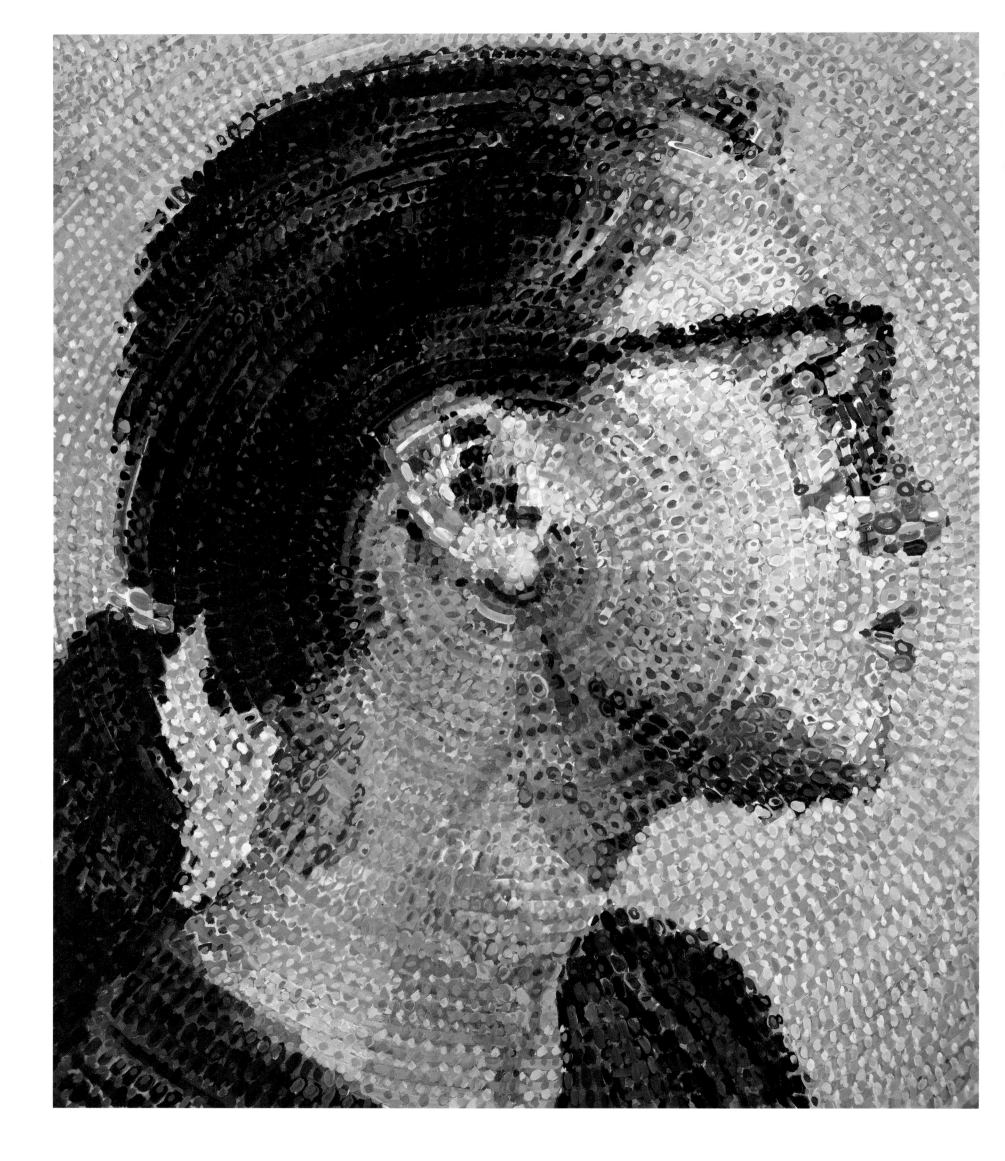

Chapter 6:

THE EVENT

The reception that followed the opening of Close's 1988 Pace exhibition was held in a midtown Chinese restaurant. He was in excellent spirits that night, and he had every reason to be. Three months past his forty-eighth birthday, he seemed to have it all. His work was featured in top public collections, he had had a mid-career retrospective that traveled to major museums around the country, important exhibitions in other American cities, as well as in Europe and Japan, and a dozen one-man shows in New York alone. He had been featured in *Time* and *Newsweek*, and his work had appeared on the cover of every major art magazine. He had earned the respect of his peers and the admiration of the gallery-going public. He had, in short, achieved just about everything that an artist could have hoped for by this point in his career.

Then, on December 7, 1988—Pearl Harbor Day—just six weeks after the three one-man shows had closed, it was all thrown into jeopardy by a catastrophic episode that Close, in retrospect, refers to as the "Event."

The artist had been suffering from what seemed to be a bad cold, accompanied by a cough, which caused breathing difficulties. Mark Greenwold saw him in New Haven a few days before the seventh and remembers that he looked and sounded awful, haggard and pale, and so wracked by the coughing he was doubled over.

According to Close, he had no regular physician at the time, but he did stop by a SoHo clinic, on Spring Street near his studio. His wife remembers things slightly differently, saying that of course he had a doctor, but he refused to go and see him, adding that he used the walk-in clinic because it was more convenient. An antibiotic was prescribed but seemed to have little effect.

"The fact is," says Close, "I was always sick and wheezing and feeling run down. This was worse than usual, but I just took it for granted."

. . .

On the morning of the seventh, he began to experience chest pains and shortness of breath. He might have taken this more seriously except for the fact that it was not the first time he had suffered such symptoms. A dozen years earlier, while still living on Prince Street, he had been woken in the early hours one morning by a crushing pain in the chest. Fatalistically, he waited to see if it would go away, or if he would die, allowing his wife to continue sleeping until the pain diminished.

Why had he not woken her, or attempted to call 911?

"Denial," is his standard explanation when he recalls the incident. "Denial runs in my family."

Once Close finally woke her, that morning, Leslie rushed him to New York University Medical Center, where an EKG was administered, along with other tests. No definitive evidence of a heart attack was found, the doctors saying that too much time had elapsed since the inception of the event, but Close was told that the indications were that he might well be suffering from a serious cardiac condition. He was given nitroglycerine in case of a recurrence of symptoms.

I remember visiting Chuck a day or two later, listening as he gloomily ticked off all the things that he'd have to give up: no more scotch, no more eggs and bacon, no more butter and cheese—worst of all, no more cigarettes. He talked about his father's chronic heart condition, but the denial factor was still at work as he ex-

177

pressed disbelief that he could be suffering from the same kind of problem. At that time there was a great deal of journalistic discussion centering on recently published studies that seemed to show that so-called "Type A" personalities—ambitious and driven, subject to extreme levels of stress because of their need to succeed, or their inability to contemplate failure—were primary candidates for heart problems. Despite plenty of evidence to the contrary, Chuck saw himself as having more of a laid-back personality. This shouldn't be happening to him.

It turned out that he was not alone in believing that he was not a heart attack candidate. Very soon after he suffered the angina symptoms, his case came to the attention of a prominent Chicago heart surgeon who was an art collector, a patron of the painter Jack Beal, who lived in the Closes' building. This doctor knew Chuck and got in touch with him to say that instinct and intuition told him that Chuck was not a candidate for a heart attack. He invited him to Chicago so that he could run further tests. Chuck accepted the invitation, and the testing turned up no evidence of damage to the heart or of coronary disease.

Because of Chuck's medical history, however, the doctor decided to explore the possibility that the angina episode might have been precipitated by myasthenia gravis (MG), a disorder caused by the malfunctioning of biochemical transmissions between the neurological system and the muscular system.[17] This condition—which can be relatively mild or extremely serious—is most often caused by an acquired abnormality of the immune system, but in some cases it appears to have genetic origins. Characterized in its initial phases by muscle fatigue and weakness, the MG diagnosis certainly fit with the neuromuscular vexations that had beset Chuck since childhood. Initial tests for MG were not conclusive, but in the opinion of the Chicago doctor they tended to support the hypothesis.

Returning to New York, Chuck visited two other doctors and had them repeat the tests that had been performed in Chicago. The first testing was also inconclusive, though it indicated that myasthenia gravis was a definite possibility. The doctor who performed the second series of tests rejected the MG diagnosis entirely, and pooh-poohed any connection between the angina pectoris

symptoms and Chuck's childhood neuromuscular afflictions. To this day there has never been a medical consensus on the connection, if any, between those early problems and later angina-like symptoms, including those accompanying the critical event of Pearl Harbor Day, 1988, though Chuck himself firmly believes there must have been some link, and claims that most doctors he has discussed it with agree that there is strong anecdotal evidence for such a connection.

In the years following the initial angina episode, Chuck experienced similar but milder symptoms on a number of occasions, always when he was feeling run-down and under stress. In 1986, while in Japan, he experienced pain severe enough to cause him to check into a hospital in Kyoto. The doctors there found no evidence of a heart attack, but, like the NYU physicians a decade earlier, gave him nitroglycerine in case of a recurrence of the symptoms.

On December 7, 1988, Chuck was in his Central Park West apartment when the chest pains erupted once more. Leslie had left her position at Wave Hill six months earlier to work on writing projects, and she was preparing to leave for her office; Georgia was already in class, and Maggie had been taken to her nursery school. Chuck, recalling that previous episodes of pain had come to nothing and that cardiologists had found no heart damage, persuaded himself that stress and a common cold were at the root of the present bout and decided to tough it out.

"Chuck had refused to deal adequately with the cold," Leslie remembers. "There was a lot of stress at the time. He was pretty anxious about work, and it was that grim, cold, crappy, pre-holiday time of year. There had been these false alarm episodes over the years, and I always felt that the fact that Chuck was reaching the age of his father's death was at the bottom of a lot of his health anxiety. But despite that anxiety—or perhaps because of it—he didn't take his symptoms seriously."

Of this, too, he repeats the mantra, "Denial runs in my family."

Given the circumstances of his mother's death—her refusal to go to the emergency room despite severe angina pains, her instance on chopping wood instead and taking a strenuous walk—this can hardly be questioned.

Eight years after Mildred Close's fatal act of defiance, her son waited until his chest pains subsided and then went about his day's business, which was scheduled to include being interviewed for the public radio show "All Things Considered," and participation as a presenter at the annual awards ceremony of Alliance for the Arts, to be held at Gracie Mansion, the New York City mayor's official residence. Chuck walked across Central Park, and, on East 57th Street, he went into the Fuller Building to visit the Robert Miller Gallery where he looked at flower photographs by Robert Mapplethorpe, thinking that one of these would make a perfect anniversary gift for Leslie. After several more stops, he arrived at National Public Radio's 43rd Street studio to be interviewed by Susan Stanberg, the topic being changes in the character of the art world.

Emerging from the interview, Chuck found that he still had a couple of hours before he was due at Gracie Mansion. On foot once again, in the gathering wintry darkness, he headed for 88th Street and East End Avenue, past the Chrysler Building and Citicorp Center, past the brightly lit storefronts and cafés of the Gold Coast and Yorkville, past the glowing Chanukah candles and blinking Christmas lights. He was still as entranced with New York as he had been when he first visited a quarter of a century earlier, and there were few things he loved more than walking the streets of Manhattan.

This was to be the last time he would ever be able to indulge that passion.

Arriving in the vicinity of Gracie Mansion, he found he was still a little early. By now the cough was really bothering him. He thought a scotch might help and stopped into a neighborhood tavern where he killed a few minutes idly watching a local newscast and feeling vaguely nauseated. He then made his way to Gracie Mansion and was shown into a reception room where hors d'oeuvres were being served. There the chest pains erupted again, far sharper now, and he became concerned enough to request that the order of the program be changed so that he would be the first presenter, other people having been scheduled in front of him.

Chuck was feeling worse by the minute. During the course of the pre-awards gathering, he was approached by Agnes Gund—a prominent collector and a trustee of The Museum of Modern Art (in 1991 she would become its president)—who took the opportunity to ask if he would consider painting her portrait.

"Aggie Gund is a friend," Chuck says, "and I guess I thought she should have known about my policy of not accepting commissions. Because I was feeling so crappy, I snapped her head off, really gave it to her. 'Don't you know I don't that?' We worked it out later—we're better friends than ever now—but at the time she was pretty upset, and I can't blame her because I wasn't very nice."

The ceremony began, and the pain got worse. A discursive speech and prolonged glad-handing by Mayor Ed Koch meant that considerable time passed before Chuck, now the first presenter, was introduced. He managed to read the citation and hand out the award, but instead of returning to his seat on the dais he staggered off stage. Minutes later, still on his own two feet and accompanied by a police officer, he arrived at the emergency room of Doctors Hospital, then located just across East End Avenue from Gracie Mansion, where he received immediate attention. By now the chest pains were excruciating. A cardiac problem was indicated and the staff administered shots of intravenous valium for the pain.

Still fully aware of his surroundings and able to communicate, Chuck had the hospital call Leslie, who was on the point of leaving their apartment en route to the Pace Gallery Christmas party, where he had been scheduled to meet her.

Leslie jumped into a taxi and headed for East End Avenue, not as concerned as she might have been because similar previous episodes had come to nothing. As soon as she arrived at the emergency room, she realized that things were far more serious this time. What made everything especially terrifying was that no one could give her any clear idea of what had happened, let alone exactly what was wrong, though a heart attack still seemed the likeliest explanation. Immediately following a dose of intravenously administered valium, Chuck experienced a violent spasm, his arms and legs thrashing.

"Not an unusual response to pain, or to valium," one nurse told Leslie.

Within minutes Chuck was paralyzed from the neck down but still conscious. Breathing took great effort and his lungs began to flood, a condition that was aggravated by his head cold. Nurses rushed to suction the fluid from his respiratory system. Had he been anywhere else but in a medical facility, he would have suffocated.[18]

Leslie claimed Chuck's possessions, and in his jacket she found an antique brooch Chuck had bought for her earlier that day. Also in the pockets were Polaroid snapshots of two Mapplethorpe photographs which he had been planning to show her so she could choose one for a present. The atmosphere, she recalls, was surreal, compounded by the fact that the ER doctor kept looking at Leslie in a way she found disturbing. Finally he introduced himself—or reintroduced himself, rather. They had been in junior high school together and he had taken her out on her first real date.

Chuck, meanwhile, remained paralyzed from the neck down, but fully aware of everything that was going on. No one could offer a definitive explanation for what had happened, but the ER doctor told Leslie that he believed that the problem was probably neurological, and he advised her to get Chuck to a hospital that could provide a complete workup as soon as possible.

· · ·

Still conscious, Chuck would remain at Doctors Hospital for two days, with Leslie at his side, joined on the ninth by Barbara Harshman, who had traveled from upstate to help in any way she could. It was Barbara's voice, over the phone, that alerted many of Chuck's friends and colleagues to what had happened.

One of the first people Leslie herself had contacted was Chuck's dealer, Arne Glimcher, who responded to her immediate needs by helping her to arrange Chuck's transfer to the intensive care unit at University Hospital, part of the New York University Medical Center complex, stretching south from 34th Street along First Avenue, whose buildings overlook FDR Drive and the East River. This was effected on December 10, a Saturday, and holiday season into the bargain, so another long two days passed before he was seen by specialists. Meanwhile, Chuck had no voluntary movement from the neck down, could breathe only with great difficulty, and had to have his lungs drained every two hours. Only twenty-five percent of each lung was functioning.

Finally, an investigation was initiated to test the neurological damage hypothesis. Two doctors, who specialized in imaging the spine with tiny fiber-optic cameras, carried out a procedure, and afterwards stood with Leslie and her mother in a hallway as they gave the results.

"Their expressions are among the most lasting memories for me of this whole unfolding event," says Leslie. "They looked right in my face and said, '. . . blah, blah, blah—occluded spinal artery—blah, blah—C6, C7—blah, blah—paralysis below C6 . . .' and so on. They waited very quietly, while both my mother and I absorbed this, asked what it meant, etcetera. The grim, professionally sympathetic expressions on their faces told me that this was very, very bad. That was the moment when I realized how really awful this might be."

The essential diagnosis was "spontaneous occlusion of the anterior spinal artery, of unknown genesis." This artery is a key blood vessel in the central nervous system. The type of paralysis Chuck had experienced is most often the result of physical damage to the artery caused by something like a motorcycle accident, but spontaneous occlusion, although somewhat uncommon, was not unheard of, the doctors said, and had probably occurred because of an inherent weakness in that crucial artery. Earlier episodes of angina may have been manifestations of that weakness, though in those instances the walls of the vessel had retained enough resilience to recover. There is some possibility that weeks of continuous and violent coughing may have helped precipitate the final catastrophic collapse.

To counter the secondary swelling of the spinal cord that follows any spinal injury, spontaneous or otherwise, Chuck was given massive injections of steroids. Had these been administered earlier, before the swelling had fully developed, they might have helped. In fact they probably did no good whatsoever, but kept Chuck without sleep for twelve days straight during which time he suffered hallucinations that were liable to occur at any time of the day or night.

"The effect of the steroids," he recalls, "mimics schizophrenia. I would be lying there, flat on my back, unable to move, and I would look at Leslie and say, 'Did you feel that?' 'What?' 'That earthquake . . .' 'There was no earthquake.' 'But I felt the bed shake—I know there was an earthquake.' And then the bed would take off and I'd be hurtling along at tremendous speed—it was like being on some kind of rocket sled out of *Star Wars*, and I'd be zooming through these Germanic, proto-Nazi baronial halls that were right out of paintings by Anselm Kiefer—those long rooms he paints, with pillars and beams and lots of wood grain detail, all rendered in black-and-white, rooms that have a single vanishing point, and I'd be rushing towards that vanishing point, and there'd be a door there—a closed door—and it would seem I was about to smash into it, but at that last minute it would open and I'd be in another of those rooms, and it would happen all over again, one room after another after another. I would be flying a few inches above floor level, always just above those wooden planks disappearing in one-point perspective, and the velocity was tremendous. But it wasn't that scary, somehow. Or, rather, it was scary but in an almost fun sort of way, like being on a roller coaster. And it certainly told me something about Kiefer. The guy really has a bead on some kind of spooky collective psycho-cultural hysteria."

Leslie remembers being told that he was in a state described as Intensive Care Psychosis, having to do with the constant light, the hospital noises, and things of that sort. During this phase, Chuck told her about a foolproof system he had devised to beat the stock market. For a couple of days he repeated this totally incoherent and grandiose scheme to anyone who would listen.

· · ·

Shortly before Christmas, I was able to visit Chuck in the hospital and found him flat on his back in bed, still virtually paralyzed from the neck down. The first thing he asked was, "What's happening with the article?"

Shortly before his three exhibitions opened in the fall of 1988, I had written an essay, for *Art in America*, about the paintings to be shown at Pace Gallery. Despite everything that had happened to him, despite paralysis, Chuck had asked Mark Greenwold to check the latest issue of the magazine and had been upset to learn that the article had not been published yet.

Mark recalls that he called to warn me, so I was aware of Chuck's concern before I got to the hospital, but I remember being astonished by his intensity, which verged on vehemence. I told him that it wasn't surprising that the article hadn't appeared yet, and explained that, in order to avoid the appearance of publishing promotional puff pieces, the magazine's policy was not to print feature articles until some time had passed since exhibitions in commercial galleries had closed. Chuck accepted the explanation, but felt that surely enough time had in fact lapsed. Having returned from Europe a couple of days earlier, I didn't know what the magazine's plans for the piece were. I promised to find out what was happening. (The article was published a couple of months later.)

Chuck said that he envied me being a writer. When I asked why, he replied that if he was a writer he would have no problem being able to continue his career. He would be able to dictate, if necessary, or learn to use a typewriter with something attached to his nose. He went on to talk about his fears that he would never be able to paint again. (Later, Leslie would tell me that, during this period—although Chuck was hopeful of making a full or fairly complete recovery—he often brought up the names of artists he respected, such as Sol LeWitt and Donald Judd, who had other people manufacture their pieces. Mark Greenwold recalls Chuck saying, "I'll spit paint onto the canvas if I have to.")

Only after he had dealt with career issues did he give me an account of what had happened since I had last seen him. He talked about the period of total neck-down paralysis with a combination of horror and humor. "It feels like you're in the ultimate Samuel Beckett play and it's never going to end . . ."

He told me how strong Leslie had been in handling the emergency, how worried he was about Georgia and Maggie's response to what was happening. He also talked about the tremendous support he was receiving from Arne Glimcher. It was thanks to him that Chuck had health insurance sufficient to cover the enormous

expenses involved in responding to the catastrophic event that had overtaken him.

"The gallery's insurance plan," Leslie explains, "provides all the artists with the same coverage that Arne has for himself and his own family. This was and is far from usual in the art world, and without it we would have lost everything—I can't even begin to contemplate how devastating the financial impact would have been."

Foresight and sound planning were far from being the only things Glimcher brought to the situation, however.

"Arne was very much involved from the first," Leslie says. "He visited daily, or if he couldn't be there he phoned. He and Milly [Glimcher] would bring cookies and flowers for the nurses. It seemed they were always looking for excuses to be there, and Arne was an extremely reassuring presence. From the earliest days of the paralysis, he told Chuck that whatever happened we were not to worry about money, that we were family to him, and that with or without paintings to sell we would be okay. He repeated this as often as Chuck needed to hear it—and as often as I needed to hear it.

"Arne gave us that assurance even when we were contemplating the possibility that Chuck would never be able to paint again. He and I told Chuck constantly that art is made more in the head than in the hands. Sometimes Chuck laughed about that, saying that he might have to make art *with* his head since it was the only part of his body that moved.

"Nobody could have been more supportive than Arne and Milly. I'm beyond grateful for everything they did for us."

. . .

As word of Chuck's plight got around in the New York art world, a stream of visitors began to appear at his bedside, and, despite everything, he clearly enjoyed the company and drew strength from it. In one-on-one situations, however—especially when he was alone with Leslie, and the realization of how limited his recovery might be began to sink in—his mood was sometimes bleak as he talked about his future prospects, specifically his anxieties regarding what began to seem like almost insurmountable odds

against him being able to resume his painting career. That was constantly on his mind, but before those concerns could be addressed on anything but a purely speculative level—and as movement slowly returned to parts of his body other than his neck and facial muscles—more basic therapeutic goals had to be achieved. How could Chuck's condition best be treated? What kind of therapy would be most effective, and what degree of rehabilitation was it reasonable to expect?

At this point, Chuck was still flat on his back, unable to elevate himself by even the smallest degree. Whatever therapy was employed, it would have to start from the most basic level. Fiercely determined to stay on top of the situation, Leslie set out to learn as much as she could that would help her make informed decisions. The most pressing was which rehab facility to use. Chuck's doctors were urging her to choose the Howard A. Rusk Institute, NYU Medical Center's own facility, located on the same campus as the hospital.

. . .

Probably nothing can prepare a first time visitor for the spectacle of human tragedy found at an institution like Rusk. Leslie has a vivid recollection of her initial visit.

"A very nice woman—a social worker—offered to take me to see the rehab facility. Mark [Greenwold] was at the hospital that day and I asked him to come with me on the tour. The woman walked us through wards filled with patients with various levels of horrendous brain and spinal cord injury, people strapped into wheelchairs, terrible smells of incontinence, the stunned faces of devastated spouses and children, a surreal aura of catastrophe and horror, all presented to us with cheerful social worker optimism. I remember the lump in my throat growing to the size of a golf ball. When the social worker left and we were finally alone in a corridor, Mark and I looked at each other and we broth broke down and sobbed. Then we pulled ourselves together and talked about how to sell the place to Chuck."

Among the shocks of the tour had been a visit to the physical therapy room, where the facilities seemed incredibly primitive, with patients waiting in line to used weight and pulley devices

that looked as if they belonged in a museum, or maybe a torture chamber. Leslie scouted other rehab facilities, in and around the city, and discovered that similar contraptions, with leather straps and webbing belts, were standard equipment. These rudimentary but proven machines were all that was available to provide the kind of workout that could reawaken vitality in frozen limbs and wasted sinews. If he wanted to be able to feed himself–let alone apply paint to canvas in any meaningful way–Chuck would have to work as hard as a bodybuilder preparing himself for the Mister Universe contest.

It became apparent that Rusk was the most feasible choice. One of its virtues was that it could offer a well-equipped physical conditioning pool–aquatic exercise being a key element in the kind of rehab Chuck would need. Also it was conveniently located so that it would be easy for family and friends to visit. This was especially important where Georgia and Maggie were concerned, since the support offered by their presence was of inestimable value. At Rusk, they could continue to see him daily after school, as they had been doing. Leslie's grueling routine would remain the same: take the kids to school, head for NYU Medical Center (often to do battle with the staff), spend the day there, pick the kids up from school, take them to see their father, take them home, feed them and help them with their homework. Sometimes this would be rounded off with a late trip to the hospital.

"I had to rely tremendously on friends and neighbors, and my parents," she remembers, "especially my mother. To all intents and purposes, she moved in with me for the first several weeks of the disaster."

After a ten-week stay in the hospital, Chuck was moved across the campus to Rusk, where he tried to mentally prepare himself for the battle ahead.

"I couldn't let myself see the horrors that Leslie saw," he explains. "In reality the place was a snake pit, a nightmare full of reminders about how thin the line is between having it all and having nothing. I remember one man you'd see every day, beautifully dressed in a suit and tie, out in a corridor sitting quietly in his wheelchair. I found out he had been a top conservator at the

Metropolitan Museum. This was a man who had done exquisite restoration work on paintings by Goya and Velasquez. He didn't know where he was or who he was.

"But I couldn't think about that kind of thing until much later. I had to concentrate on finding the inner resources I'd need to get through this, and what helped me was the fact that I'd had to learn to deal with the dyslexia when I was a kid. Remembering how I had been able to cope with that gave me strength. I knew how tough this was going to be and I knew I had to stay completely focused.

"The need to find that strength–to get through this thing any way I could–defined my whole experience of Rusk, and still colors my memory of the place. I've shut most of the bad things out. That's why you'll find that my memories of those months are very different from Leslie's. Of course I would get panicked about my career and what was going to happen to my family. Of course I got depressed. But I had to try to find positive things to hang onto, otherwise I was sunk."

• • •

Staying strong and focused was not easy. Challenges to concentrated thought are endemic to a facility like Rusk, where humiliation is a constant companion.

"One thing I quickly learned," Chuck recalls, "was that everything was always done for the staff's convenience, never for the patients'. Say some kind of lab test was scheduled for Monday morning. At nine AM all the patients taking that test, two dozen of us maybe, would be wheeled downstairs on gurneys and lined up in a corridor. You could be left there for hours, lying helpless under a sheet until it was your turn, which might not come till two o'clock. You would miss your physical therapy, miss your lunch. It never seemed to have occurred to anybody that people could be taken down for testing one at a time. It was easier to do it the other way."

Sensitivity, he discovered, was not a strong point of some staff members.

"I'd be in my wheelchair, and Leslie would be pushing it. One of the rehab doctors would come up to us and he'd address himself directly to Leslie, right over my head as if I was unable to speak for myself–as if I couldn't hear him even–and he'd say something

Chuck Close undergoing rehabilitation at Rusk Institute,
with physical therapists Meg Sowarby *(below left and opposite)*
and Tamar Amity *(below right)*

184

like, 'What did he used to do before this happened?' Unbelievable! Certainly some of the patients were totally out of it, but these doctors behaved as if everyone was gaga. You'd think that they'd give these people some sort of training to clue them in."

If some of the Rusk doctors were less than empathic, this was compensated for by the compassion and concern demonstrated by its highly trained and experienced therapists. Meg Sowarby was assigned to be Chuck's physical therapist, along with Tamar Amity, and Phyllis Palsgrove became his occupational therapist. It's fair to say that the art world owes a debt of gratitude to these women. For the next seven months, they would work with Chuck five days a week.

What he was facing up to now—and his family, too—was the knowledge that he would be an "incomplete" quadriplegic; meaning that the best he could hope for was limited movement in all four limbs. The doctors had told him he could expect some improvement in his condition over a period of two years, but beyond the first six or seven months the rate and degree of improvement would begin to diminish rapidly. The hard work of the long weeks at the Institute would be the key to determining to what extent recovery was possible.

One of the first challenges that had to be faced at Rusk was reintroducing him to something most of us take for granted, the

experience of being in an upright position. This was essential to the stabilization of his blood pressure—low blood pressure being a byproduct of spinal cord injury—and to any further physical progress. Close was strapped to a tilt table—basically a board with a central pivot, like a see-saw—and eased, in tiny increments, over a period of weeks, towards a vertical position. Any attempt to increase the angle too rapidly would cause the patient to pass out. As Chuck became accustomed once more to being upright, pool therapy and work with weights and pulleys became possible.

• • •

To an occasional visitor, the bitter realities of the Rusk experience—the hours of boredom and despair, the routine self-torture—were not readily apparent. More often than not, Chuck was able to put on a good show at the end of the day when friends stopped by, especially since he was hungry for art world news and gossip to offset the rest of his routine. His room at Rusk overlooked the East River and the traffic streaming along FDR Drive. Noisy choppers descended to a nearby helicopter pad, so that the atmosphere was rather like something out of the film *M.A.S.H.*

Late in the afternoon, Chuck would sometimes transform himself into a gracious host, inviting friends to pour themselves drinks from the bar he managed to maintain despite the Institute's

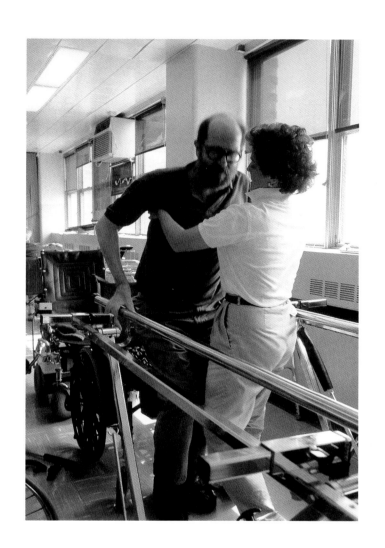

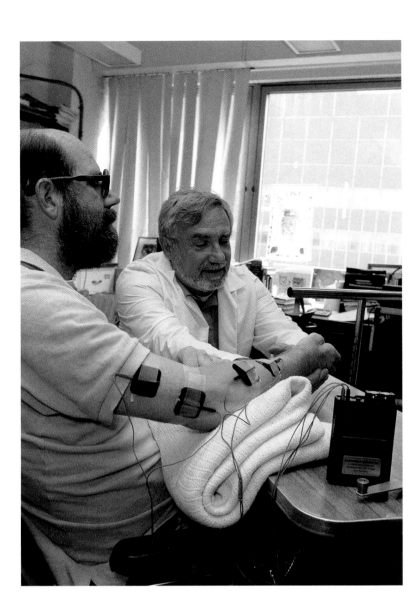

Dr. John Gianutsos instructing Chuck Close in
biofeedback technique at Rusk Institute

Her lasting memories of Rusk center on the horrors that came
with being in that situation: gruesome procedures, depression
and anxiety attacks, constant concern about the pain the children
were feeling, and, on top of those big issues, having to deal with
the everyday annoyances endemic to such places.

"I'd find Chuck in urgent need of attention and suddenly all
the aides would have disappeared, because their shift was about to
end and they didn't want to deal with a problem that would force
them to stay late. It was a nightmare."

. . .

Despite the days of routine misery, hard work in the physical ther-
apy room, along with Leslie's persistence in badgering the staff at
every level, began to pay off. Chuck started to regain some useful
movement in his biceps, but very little in the hands or forearms. If
he was to manipulate a brush, or any other tool, the power would
have to come from the shoulder and upper arm, and he would
have to control movement from his elbow.

As mentioned earlier, when Chuck was at Yale Summer
School, Philip Guston had encouraged his students to make draw-
ings using a long stick dipped into ink, the idea being to chal-
lenge acquired reliance on eye-hand coordination. If Chuck were
to paint again, his hand and forearm would be reduced to serving
much the same function as one of those tree branches. At least he
knew that such a way of working was not out of the question.

Before he could contemplate that possibility, however, he had
to overcome yet another problem. Although his biceps were func-
tioning, he had almost no use of his triceps: there was feeling in
those muscles, but they did not respond normally to neurological
signals. In order to be able to paint, biceps and triceps would have
to work together. Luckily, a research doctor introduced Chuck to a
biofeedback technique that enabled him to regain strength in the
triceps while at the same time teaching them to coordinate with
the biceps once again.

As his physical condition improved, the occupational therapy
dimension of the program became more and more important.

strong disapproval (another *M.A.S.H*-like aspect of the situation.)

Presumably, most visitors suspected that life must be difficult
on either side of the "happy hour." Looking back on those days,
Leslie is painfully conscious of how the mundane realities of a
tragic situation, one that forever changed the Closes' lives, have
come to be cloaked in art world mythologizing, a tendency aggra-
vated by the fact that Chuck was able to overcome his disabilities
and provide the world with an upbeat Hollywood ending. For par-
ticipants in the drama, Leslie in particular, the denouement has
not been so clear-cut.

"A lot has been said and written," she observes, "about those
times at Rusk when there were visitors in the room and Scotch in
the refrigerator. In fact, those moments were the exception, and the
reality of that period was mostly made up of the grinding sameness
of very long, sad days. When friends were there, they put on a good
show of being cheerful for Chuck's benefit, but there were times
when I escorted someone out to the elevator and they would break
down in tears at the shock of seeing him in that condition."

"They're trying to teach you skills that will be useful when you return to the outside world," he explains. "You start off with really basic stuff, like stacking up spools and boxes, which is pretty boring, though it's important in rebuilding muscle strength and coordination. Then they move onto more practical things. One day Phyllis said we were going to practice doing laundry. It took me an eternity just to get a couple of pairs of underpants or something into the washing machine, using a stick and a hook. I told her, 'This is ridiculous. I've never done laundry in my life.' Which wasn't quite true, but my point was that I didn't see doing laundry as a priority, given my limited strength. What was the point? I could hire someone to do that for me. Luckily Phyllis is very smart, so she understood what I was talking about, and Leslie was always on top of things. She badgered the doctors, she worked with Phyllis, she worked with Meg, she got on the case of anyone who might be able to help, or who she thought wasn't doing enough. She guided the whole process."

"I was at the hospital at least six hours a day," Leslie remembers, "so I didn't miss much that was going on. After watching Chuck's first sessions in occupational therapy, I cornered Phyllis in the cafeteria and told her it was absolutely essential that Chuck's therapy used the tools of his trade, not spools and pipe-cleaners, and that his mental health depended on his being able to reassure himself that all was not lost—that he would be able to paint again."

Phyllis agreed, and after that everything was geared towards making art. Leslie paid a visit to the Rusk workshop where adaptive equipment is made and designed. She talked with the man who ran the place and he set about designing and constructing a wheelchair attachment to hold a palette, and adapting an easel so that a wheelchair would fit beneath it.

. . .

The first tentative steps towards a return to painting were taken in the occupational therapy room. Leslie fit a brush loaded with cheap poster paint into a splint, adapted by her and Phyllis from a standard "splint" designed for holding writing implements, and

Chuck attempted to make meaningful marks on a sheet of cardboard. The physical effort involved was enormous, and inevitably the first results were unsatisfying.

"There were tears all round," Leslie recalls.

Gradually, though, the marks on the cardboard did begin to coalesce into something that resembled a painting.

"I was the one crying now," says Chuck. "I told everyone that it was no good, I couldn't do it, but the truth is I was looking for reassurance. I was actually thrilled to see that I was able to put paint onto cardboard, and I wanted people to tell me it was okay."

These first sessions showed that it was worth persevering with the project. The experiment now continued in the art therapy room—a grim, cavernous space overlooking a bleak, windswept courtyard—which was normally used for basket-weaving and other simple therapeutic activities.

"The setting itself was depressing enough," says Chuck, "but what made it worse was the evidence of human misery all around—people's sad efforts to make something with fingers that didn't work properly."

Michael Volanakis, Chuck's long-time studio assistant, brought in art supplies from Spring Street and now an effort to paint in earnest began, with a small canvas installed on the customized easel. This was the beginning of a lonely struggle witnessed by only a handful of people—principally Leslie, Phyllis, Michael, and Barbara Harshman (who continued to travel to and from the city from upstate almost every week for eight months).

There were no overnight miracles, only long hours of pain and frustration, punctuated with frequent moments of despair and occasional glimpses of a possible successful outcome. Everything depended on the encouragement of the small support group and, ironically, upon Chuck's "Type A" personality traits, which made the thought of failure impossible to contemplate.

Slowly a degree of motor control and firmness of touch returned, and the marks on the canvas began to have hints of authority to them. Eventually it became apparent that the belief that Chuck could renew his career was not entirely misplaced.

Chapter 7:

REGENERATION

From the day Chuck Close first held a brush again, and realized he would be able to resume his career, it became crucial for him that he would not be dismissed as a disabled artist.

"I was terrified that that was how people would see me," he says, "and I'm still extremely sensitive about it. Actually I'm an artist who happens to have a disability—and that's all."

This fear, while perfectly understandable, was and is unfounded since, from the first serious painting he undertook while still a patient at Rusk, it was evident that he was going to be able to produce work that needed no asterisk or apology. A limitation that had to be acknowledged was the temporary impossibility of working on the kind of large-scale canvases he was best known for, but that would be overcome before long. In the meantime, he continued to work on the small easel adapted for his use by the Rusk shop, an easel he still sometimes uses, for example when traveling.

At first, Close was limited by a lack of physical strength. To a significant extent, his arm below the elbow remained deadweight: the sheer brawn required to move it came almost entirely from the muscles of his shoulder and upper arm, and at the same time those muscles were required to do much of the work of precisely controlling the handling of the brush in contact with the canvas. (Often he used two hands, and still does, one to steady the other.) The effort and pain involved, not to mention the determination, is almost unimaginable. In Close's mind, there is no doubt that what gave him the strength to succeed was the discipline he had learned as a kid in overcoming his dyslexia.

"Pushing myself to achieve something I really wanted was nothing new. I had been through all that before. The physical side

of it was different, but the resolve and the obstinacy I needed was the same."

The first real post-catastrophe painting was *Alex II* (1989; p. 190), made from an alternate photographic maquette of Alex Katz that had been shot at the same time as the one used for the large 1987 portrait. If Katz, known for his prickly temperament, seemed dyspeptic and even angry in that earlier work, he appears more melancholy in this version. A more important difference, however, is that whereas the first version was executed with highly refined brush marks applied to a fine grid, giving the feel of a tightly-woven silk carpet, the newer one was loosely painted on a more open grid and has more the texture of a Norwegian sweater. Clearly the looseness of the paint handling derived in part from the fact that Close was at an early stage of regaining control of the brush. This is nonetheless a wonderful painting, in no way compromised by the artist's physical condition, or by the circumstances under which it was made. It maintains the essential balance between photo-derived imagery—an iconic head evoked in terms of highlights and shadows—and almost mathematical rigor of execution (however free the paint marks may be) that typifies all of his work.

Prior to his hospitalization, Close had employed many different ways of constructing images, and each—from the continuous-tone airbrushed paintings, to the fingerprint drawings, to the paper pulp pieces—had involved adapting his philosophy of process to changing mediums, some of the them newly minted to give fresh expression to that philosophy. It was continued adherence to the principles of process that would enable Close to revive his career so rapidly. Had he been a painter dependent

189

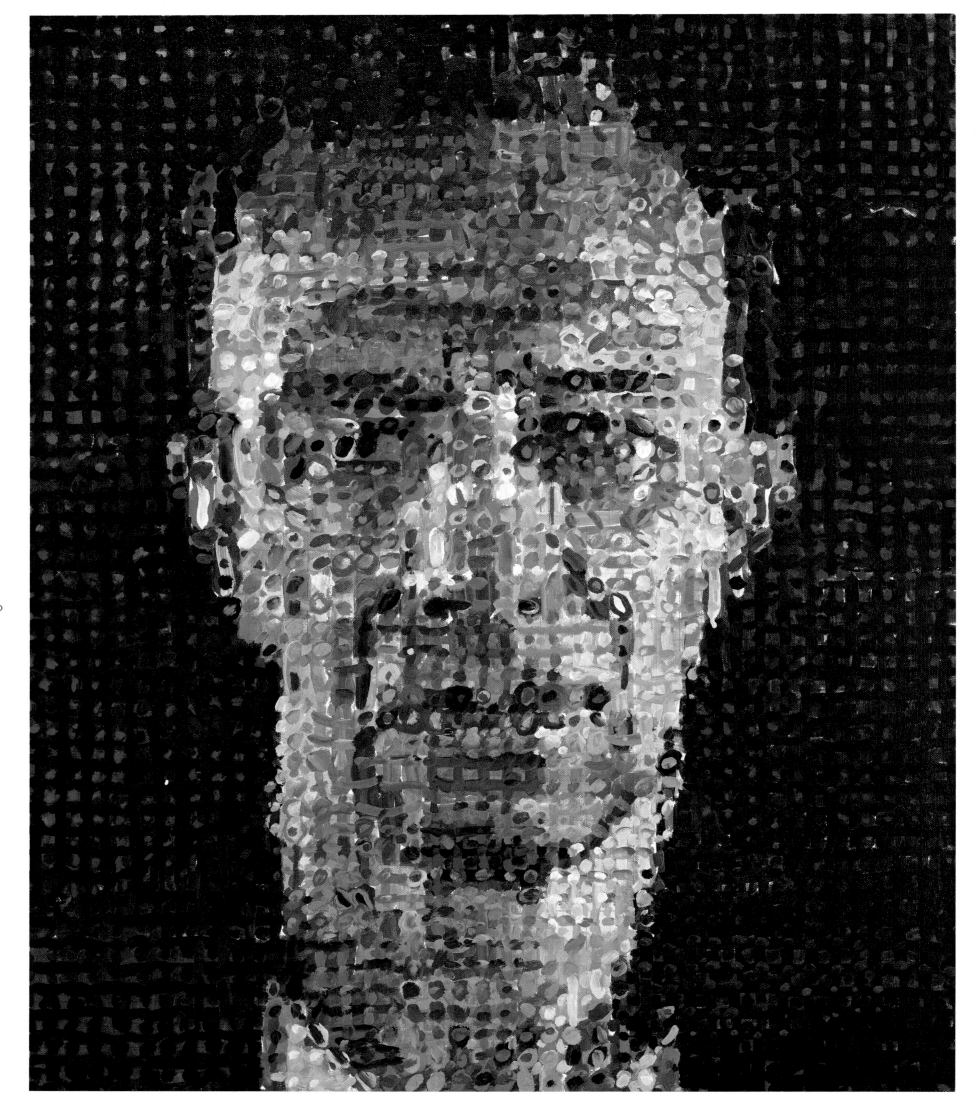

◄ **Alex II**, 1989.
Oil on canvas, 36 x 30 in.
(91.4 x 76.2 cm)

Alex II (detail), 1989

upon bravura gesture or the careful modeling of surfaces (both areas in which he had at one time excelled) he might never have been able to pick up where he had been forced to leave off. On the other hand, the fact that he had been constructing images from small increments applied to a grid meant that he could continue to work in much the way he had when producing the paintings for his 1988 exhibition at Pace. The appearance of the individual increments might change—though in detail of touch and timbre rather than in essential character—but *Alex II* and the paintings that followed demonstrated that continuity from the earlier work was entirely feasible. It is almost as if the artist, while healthy, had anticipated a need for devising a way of working that would stand him in good stead for the future.

Leslie Close makes the point that, prior to the Event, the course of Chuck's career had been determined by sets of self-imposed restrictions that defined each specific process. One group of paintings resulted from using only thinned black acrylic on a white ground, another from adhering strictly to three-color separation methodology, and so on. One consequence of the Event was that a set of restrictions was imposed on him by dramatic circumstances. He has been able to work with that set of restrictions just as he previously worked with the self-imposed ones.

· · ·

Close has strong opinions on the question of continuity.

"Some people imagine that they see something different in the work I did when I started to paint again, but I don't buy that."

If one considers the conceptual similarities that link *Alex I* and *Alex II*, it's easy enough to acknowledge that he has a strong point, and it's not difficult to see why it's vital to the artist to perceive that continuity since it helped validate the work executed after he became a quadriplegic. The process was already established, and there is no loss in quality, or even, in a very real sense, in technical accomplishment. It could be argued, in fact, that the best of the post-1988 paintings are richer than those in the 1988 exhibition.

Is it possible, though, that there *is* some essential difference between the work on either side of the catastrophic event? If we look at *Alex II*, along with the two other paintings completed in

1989–*Janet* and *Elizabeth*–we will find the beginnings of what might be thought of as an almost expressionistic trend that would inflect much of the later *oeuvre*. Factors of control and coordination may have something to do with this, but possibly there is more to it than that, especially since this tendency continued when coordination was fully regained. The 1987 and 1988 paintings had demonstrated a pleasure in the use of oil paint, and had explored in a preliminary way, which retrospectively seems tentative, the use of gesture as a means of generating the incremental signs and ciphers; but by comparison with their post-catastrophe siblings they were for the most part tightly executed. Even in a painting as kinetic as *Lucas II*, which can be seen as a programmatic challenge to pictorial inertia, the marks that animate the grid are rather crisply controlled.

In the post-Event *Alex II* (which is the same size as *Lucas II*), the loops and lozenges of pigment, the bold dabs and dynamic doodles, display an unfettered freedom that belies the physical pain and psychological uncertainty that must have been a constant accompaniment to the making of the painting. What one finds expressed in this treatment, I suggest, is pure pleasure in having overcome extreme adversity–the simple joy of being able to paint again. As one studies the face from close up, it dissolves into a vibrant array of freeform touches of color–coral and crimson, saffron and turquoise, orange and emerald–like a spectacular sunrise reflected on a lake, or the scales of a tropical fish. The touches themselves are no longer slaves to discipline as they were in the majority of paintings for the 1988 exhibition. They do not forget their places in the matrix–their responsibility towards pictorial definition–but they shimmer and burst over gridlines, like dancers who have abandoned the strictures of ballet to join in some barefoot improvisation (without entirely forgetting where they came from). In *Alex II*, Close challenges conventions regarding the kind and quality of information that is required for portraiture, conjuring features out of a carnival of color and gesture that at times threatens to swamp the imagery (look closely at the treatment of the eyes), without ever quite doing so.

Painted in the gloomiest of *ateliers*, this canvas offers passages that are Fauvist in their effervescence, yet its impact is by no means entirely sunny. Katz's brooding features would be enough to ensure this, but beyond that there is something about the way the face, with its bubbles and buttons of bright color, dissolves into the far more somber background, which has the effect of giving the painting a moody gravity despite the exuberance of the handling. This is a work of rich and profound contrasts, both aesthetic and psychological.

As so often in superior paintings, edges are vital to the impact of the image. The closer one comes to this canvas, the more the demarcations between head and background cease to be clearly defined, so that the allover character of the painting asserts itself, each square inch equally worked. The delights of the patchwork constellations of pigment, in which Katz's features appear and vanish, depending upon distance, are set off against fields of darkness that seem to be almost crudely woven–like the raffia work left lying about in the art therapy room–from skeins of solemn color that hover above rather reticent grounds of red and blue.

Close had started making portraits twenty-two years earlier, citing the models of the mug shot and the passport photograph with their implied nonaesthetic objectivity. This first painting to be completed after catastrophic injury is something very different. The artist may not have set out to produce a painting that has a powerful emotional impact–to produce a painting *period* was his goal–but he did so nonetheless. *Alex II* is a modestly-sized work, but one with a great deal of heft, an image that is at the same time optimistic yet informed by Close's face-to-face encounter with despair and possible extinction.

The completed painting was given to Leslie in gratitude.

· · ·

Close remains skeptical of impetuous interpretations of his work, such as the above, saying that what's important to him as he paints is not psychology but following the system, and the system he returned to after the Event was no different from the one he was using before. He points to a direct continuity between *Elizabeth*–the first large painting he made while in a wheelchair–and *Cindy II*, the last painting made prior to the Event. As noted in an earlier chapter, the handling of *Cindy II* is looser than in any of the other

192

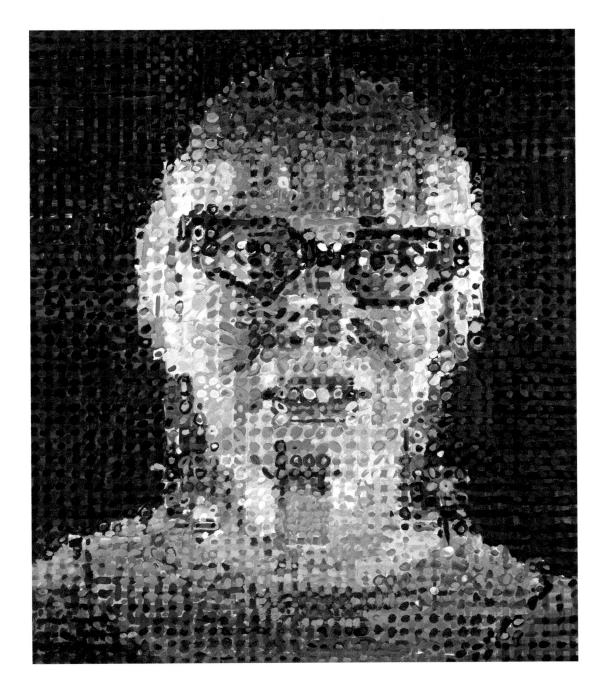

paintings in the 1988 show. The brushstrokes and gestures are very similar to those in *Elizabeth*; there's even a sample of what Close calls "a plaid effect" found quite extensively in *Elizabeth*. (This effect could be seen even earlier in the 1987 *Self-Portrait*.) Close points to this as evidence that he would have been painting exactly the same way whether he had become disabled or not.

A portrait of the painter Elizabeth Murray, *Elizabeth* (1989; p. 195) is six feet tall and constructed on a diagonal grid. Close had been working on another version at the time of his hospitalization, but he started again from scratch when he was able to return to his studio. A six-foot canvas was as large as he could manage at that point; for the upper sections, he worked in his wheelchair, strapped to the platform of his fork lift, often remaining up there all day.

The palette of *Elizabeth* is somewhat unusual for Close, having a distinctly acid cast to parts of the background, and being keyed to especially bright highlights in the facial area, with less reliance on evoking full flesh tones than is typical of the broken-field in-

cremental paintings made either earlier or later. In this painting, Close succeeds in achieving an allover quality as fully as in any canvas he has ever produced. As with *Alex II*, the background has a woven or braided quality—the previously noted "plaid effect"—which extends into the sitter's hair, and even into shadowed planes on the face. This woven texture is broken up with blobs and swirls of pigment that perform a variety of functions, ranging from emphasizing highlights in the hair to giving focus to the eyes, which, as with *Alex II*, are far more fragmented and less graphically literal than was the case with the paintings shown in 1988.

Although plainly photo-derived, this painting threatens to disintegrate into pattern even from some distance, though it does in fact hold together, the essential descriptive information materializing from ribbons of color. On inspection, the individual units that make up the grid are remarkably similar to those to be found in *Cindy II*. The way the components of the image hold together seems somewhat looser, but that is partly a function of the different kind of grid employed.

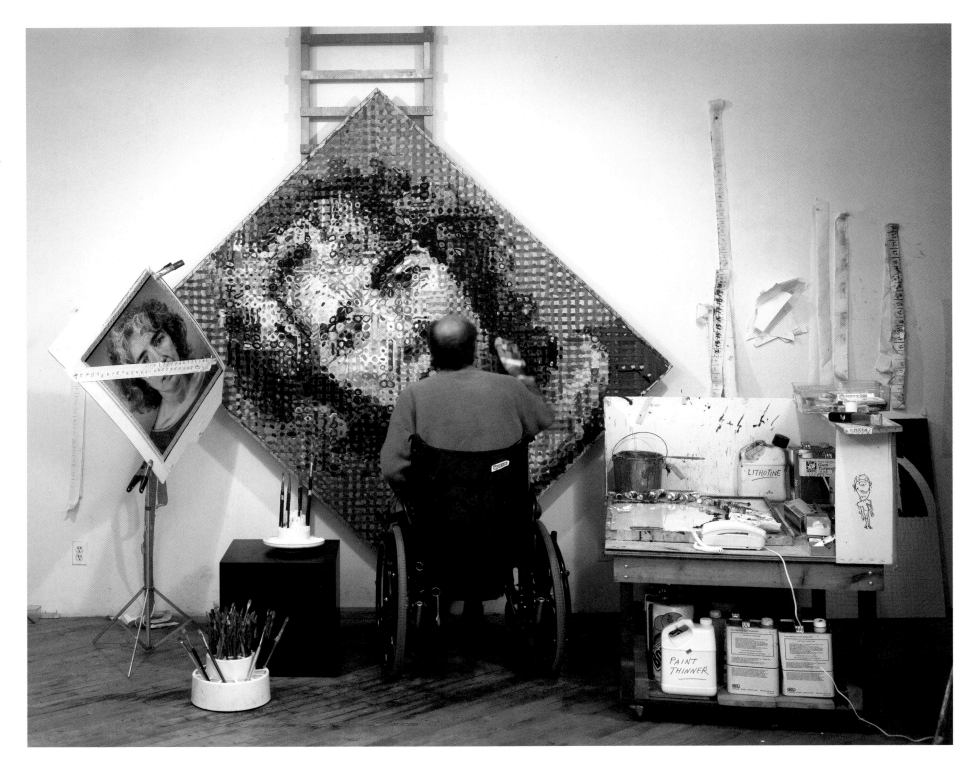

Elizabeth in progress | ➤ Elizabeth, 1989.
Oil on canvas, 72 x 60 in. (182.9 x 152.4 cm)

After seven months in rehab, Chuck returned to his Central Park West apartment, his country house in Bridgehampton, and his Spring Street studio, all three of which had to be refitted to accommodate someone in a wheelchair.

By then, his condition had improved to the point where he could function in the outside world, if not easily. He could stand and even take a few steps with the help of strap-on quad crutches. Using his teeth, he could fit a fork or a paintbrush into a prosthetic splint, and he could get around in a motorized wheelchair, but he still needed a nurse to catheterize him four times a day, something that was never going to change. Outpatient rehab continued for years, but at the time of his release from Rusk, very little further physical improvement could be hoped for. It was more a question

of learning how to maximize the capabilities he had been able to salvage.

Adjusting to home life turned out to be far from easy, and was as difficult or even more so for Leslie and the children. Chuck was still having severe breathing problems; he had choking fits; he fell out of bed and out of the wheelchair; he suffered from horrendous bladder infections that came on without warning, calling for heavy-duty antibiotics that sapped him of his already compromised strength. Circulation problems meant that he had to sleep in a woolen hat and scarf, and he constantly burned his fingers on things like coffee cups, because there was no feeling in them.

Like other caregivers in this situation, Leslie learned that dealing with the patient in the home was far scarier than doing

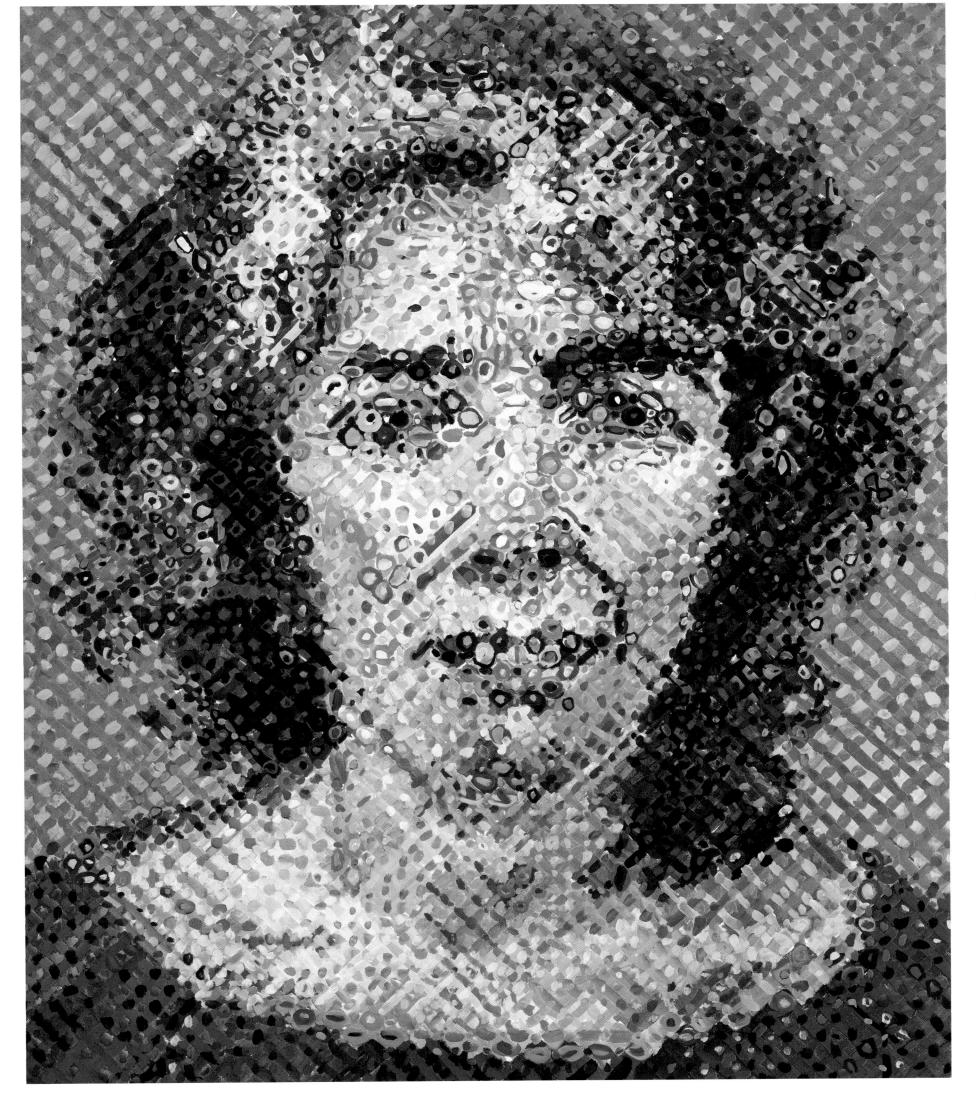

Installation views, **Head-On/The Modern Portrait**, organized by Chuck Close.
The Museum of Modern Art, New York, January–March, 1991

so in the hospital. Luckily she had strong support, notably from a studio assistant named Andy Tirado, who for eighteen months helped her cope with all the physical challenges. One of the hardest things to adjust to was the fact that there was no privacy any more; somebody always had to be there—a nurse, a physical therapist, someone waiting to drive Chuck to the studio. She felt as if she would never be alone again—as if all spontaneity had been drained from their lives.

Chuck recalls the frustration of returning to familiar surroundings without being able to enjoy "normal" activities, especially when it came to interacting with his kids. He felt they were missing out on many things, and hated the fact that when he showed up at their schools in his wheelchair, he wasn't treated like the other parents.

As a quadriplegic," he says, "you face a steep learning curve. You quickly discover that many theaters and movie theaters are not wheelchair-friendly, that there are a lot of places where there are no curb-cuts, all that kind of thing. I learned that there was not a single handicapped parking space in the entire city. Then there's the whole business of dealing with strangers. You still run into people who seem to think that being in a wheelchair is some kind of punishment from God."

He insists, however, that he was extraordinarily lucky, being well-off enough that he could afford to modify his environment to accommodate his physical problems. Additionally, he had tremendous support from the art community, and, most important of all, he was able to continue the activity that gave meaning to his life.

• • •

Close's reintroduction to the public art world came in the form of an Artist's Choice exhibition at The Museum of Modern Art, which he organized at the invitation of Kirk Varnedoe, Chief Curator of

the Department of Painting and Sculpture. *Head On/The Modern Portrait* was installed in a smallish room at the Modern from January to March of 1991, and it was seen again at the Lannan Foundation Gallery in Los Angeles from June to September of that year. It was like no other show that had ever originated at MoMA in that it featured scores of works by dozens of artists, chosen with assistance from four of the museum's departments—Painting and Sculpture, Drawings, Prints and Illustrated Books, and Photography—and installed salon style, which is to say crowded together in layers around the walls of the gallery, many pieces being placed on shelves with very little breathing space between one portrait and the next, and sometimes with mats or frames overlapping—the very opposite of an orthodox contemporary museum installation.

Close's first thought had been to do something rather different and more conventional, namely, to pick fifteen or so of the museum's greatest portraits in order to make the point that there was a

place for the portrait within the modernist tradition. He quickly dismissed this idea on the grounds that the idea of the artist playing connoisseur was not particularly interesting, adding that he'd learned as much from work he didn't like as from work he loved.

Inclusiveness meant spending days in each of the Modern's participating departments going through the collection, sometimes finding works that had not been hung in the public galleries for years, or even decades. The result was a radically eclectic selection of works that included not only obvious examples by the likes of van Gogh, Picasso, Matisse, Duchamp, Man Ray, Diane Arbus, and Max Beckmann, but also dozens of lesser known pieces by artists ranging from Max Pechstein and Jean Crotti to Hugo Erfuth, David Park, Arnulf Rainer, and Ray Johnson.

Close points out that these works came into the museum's collection in many different ways, which gives it a somewhat arbitrary character. Some were purchased, many were donated by

friends of the museum, while others were bequests from artists or their families. In the case of the Ray Johnson work, a small photocopied print labeled "Bill de Kooning," it came into the collection by the back door, having been mailed to MoMA's head librarian, setting up a situation in which the print was routinely entered into the library's catalogue without any curatorial intervention. This was in fact a strategy devised by Close, who had been distressed to find that Johnson was not represented in the collection. It's the one instance in which he bent the rules he had set for himself in making a selection for the show, which otherwise reveled in the often capricious nature of the museum's acquisition history.

In his foreword to the booklet that accompanied the show, Varnedoe made the point that the exhibition, and the installation itself, emphasized the role of the museum as a repository of information—"a data bank"—as opposed to its role as an arbiter of taste. In addition, he pointed out that the installation to a large extent followed the principles that Close employed in his art, namely, constructing an entity from related incremental elements.

Close himself has said that the way he assembled the show related to the way he makes his paintings, explaining that he was trying to share with viewers some of the pleasure that he gets from making art. A key intention of the exhibition was to present works in a jarringly unfamiliar way, with unexpected juxtapositions, so that someone visiting the show might have a fresh experience of works seen many times before.

By the time of the Artist's Choice show, Close's painting career was fully revived. The three 1989 paintings were followed by four completed in 1990, and no fewer than five in 1991, a relatively large number for the artist at any point in his career. The new work had its first public exposure at a large Pace Gallery exhibition, which opened on November 2, 1991, closing on December 7, the second anniversary of his hospitalization. If the Artist's Choice show had reminded people that Close was still active, the Pace show provided ample evidence of his continued ability to make art at the highest level.

Janet (1989; p. 193), a likeness of Close's Yale classmate Janet Fish, is the same size as *Alex II* and very much in the same idiom, though painted with more obvious control as coordination returned, or, more accurately, was relearned. Begun in the art therapy room at Rusk, this painting was completed in the Bridgehampton studio. *Judy* (1990)—the artist Judy Pfaff—displays return of control on a larger scale, while sharing to a degree in the high-keyed palette of *Elizabeth*. The next painting completed was another version of *Alex* that it's tempting to describe as being black-and-white though in fact the image is shot through with blue-grays and earth colors.

Between the 1989 *Alex II* and this 1990 version, one sees steps in the rebuilding of coordination and confidence. The five paintings made during this period all hold up in and of themselves, but they also serve as a record of skills restored and possibilities revisited. In a sense they can be seen as products of the process of recovery, but they are equally a record of the process of rediscovery, and it is that which gives them their special energy.

By the time Close produced *Bill* (1990; p. 201), he was painting with total assurance and with the inflections of touch that mark his mature idiom so far as the prismatic grid paintings are concerned. A likeness of the painter and photographer William Wegman, best known for his carefully staged shots of compliant Weimaraners, this painting is six feet tall and constructed on a relatively open diagonal grid. The Polaroid maquette caught Wegman at an angle somewhere between full and three-quarter face, which is enough to move the image from the mug shot category towards the studio portrait, an important difference in setting up the way the viewer will read the image.

Although every square inch of the canvas has been thoroughly worked, in a way that is expressive of Close's allover painting intentions, there is more of a figure-on-ground effect than is the case with, for example, *Elizabeth*, the background of *Bill* being uniformly dark, the face brightly lit. The hair and features are evoked with a rather varied arsenal of loops and swirls, circles, and ovals

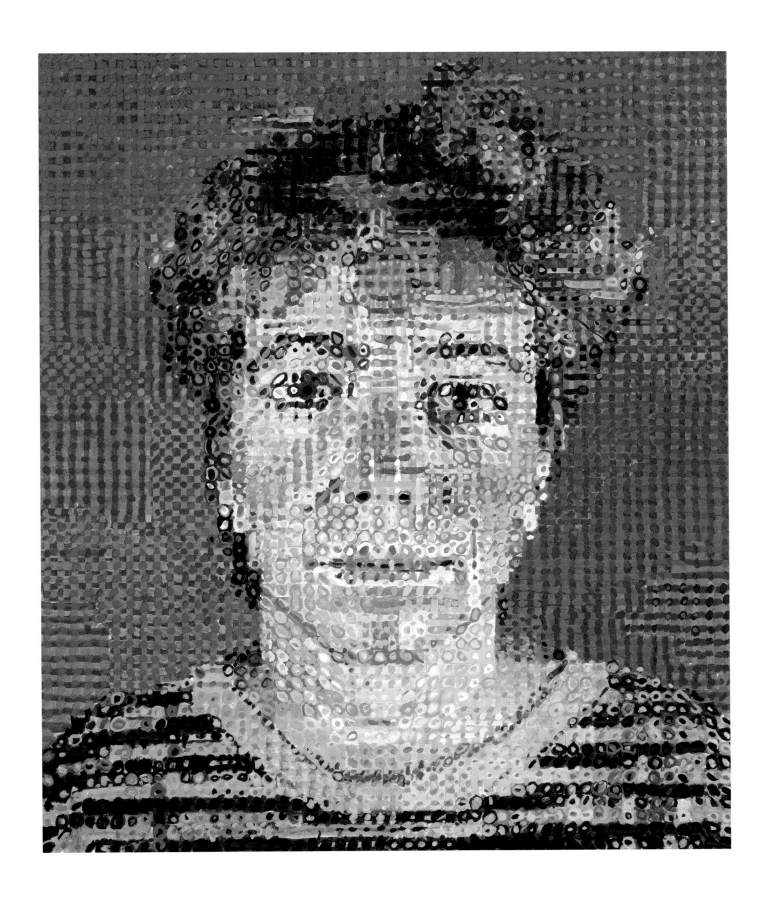

◄ Chuck Close in the exhibition
Head-On/The Modern Portrait, 1991

Judy, 1990.
Oil on canvas, 72 x 60 in.
(182.9 x 152.4 cm)

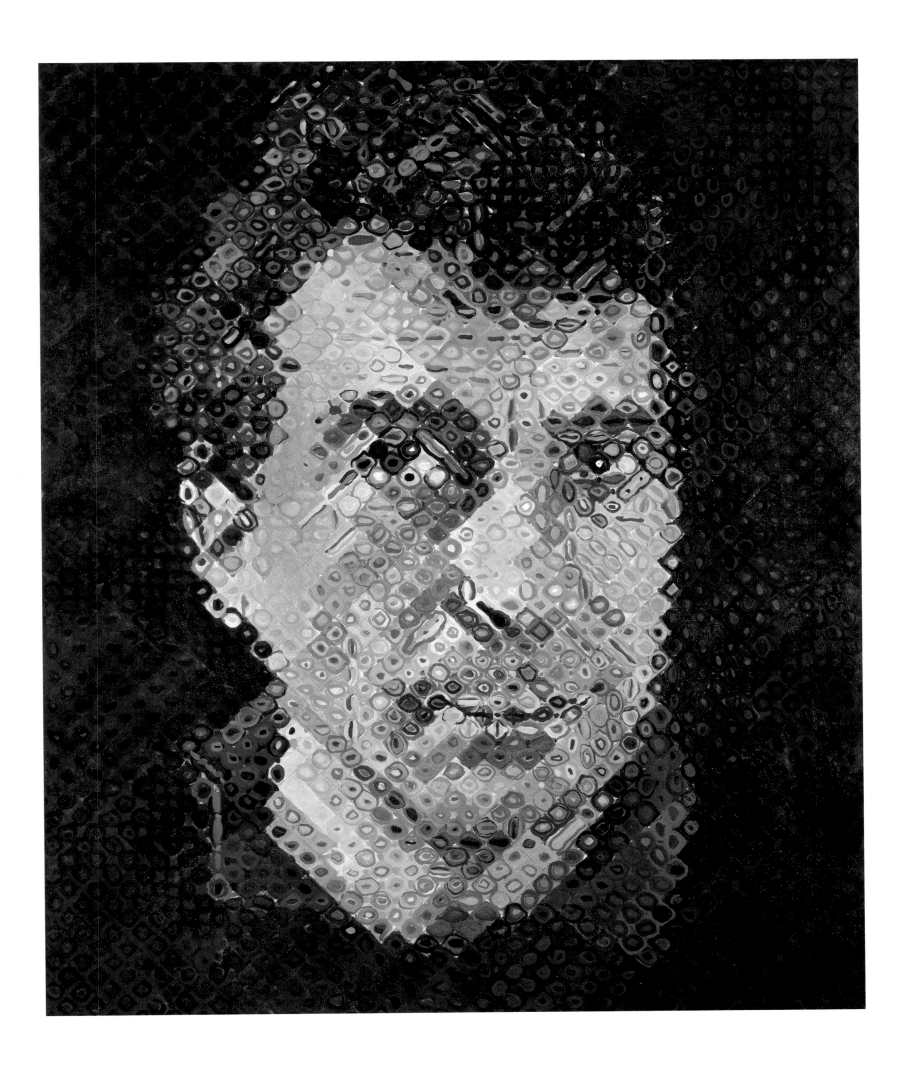

◄ Bill (detail), 1990

Bill, 1990.
Oil on canvas, 72 x 60 in.
(182.9 x 152.4 cm)

and ovoids, some resembling cross-sections through stuffed olives, others like miniature hotdogs seen in profile—with some simple directional marks used at crucial descriptive points. The color is more literal, or perhaps just seems so, than in the transitional post-Event paintings. The flesh tones, utterly convincing from a distance, are in fact made up of many colors, several to each unit of the grid, placed according to the process of incremental color correction that Close had been evolving for a decade at least. Each unit of the grid becomes in effect a tiny but highly expressive non-figurative painting. At first glance, the organization of units can seem almost arbitrary, but if they are inspected closely, it will be found that there is always a definite chromatic relationship between those that are adjacent. If in one square there is a circle of pink over a patch of blue-gray, the same colors, perhaps modified in tint, are likely to be found in neighboring squares, their order of application perhaps inverted. Close has said he works with "families of color," of which he might have a dozen or fifteen organized on his palette at any given time, a system that he evolved prior to the 1988 exhibition.

In the case of *Bill*, most of these miniature paintings are confined within the grid lines, with not much bleeding or overflow. The composite effect is rather like looking at a color photograph through lattice-patterned cut glass, and the diagonal grid dictates that intersections of light and dark—Wegman's left cheek, for example—take on a saw-tooth character reminiscent of the saw-tooth fractals that occur at the edge of forms in some digitally generated imagery. This is something that would be found often in subsequent paintings. It is present in far more exaggerated form in a smaller 1991 painting made from the same photograph of Wegman, a canvas that employs an even more open grid and which experiments, like some early drawings, with limiting the units of description to the point where a likeness is barely discernible.

A 28-by-24-inch painting of Lucas Samaras, made from a black-and-white Polaroid maquette, also investigated the use of minimal information. For the most part, though, the paintings made after the first Wegman portrait up until the fall of 1993, when Close had his second post-Event Pace exhibition, mostly feature a high density of descriptive information, somewhat in the idiom

of the 1988 show, though significantly freer in handling. Early examples of this are *Eric* (1990; p. 205) and *April* (1990–91; p. 206), portraits of the painters Eric Fischl and April Gornik. The level of detail in these images owes a good deal to the size of the paintings themselves, each more than eight feet tall, combined with the use of tight diagonal grids. *Eric* employs the marginally three-quarter view favored for the Wegman paintings (though from the other side). *April* is portrayed full-face, but this could scarcely be described as a mug shot because the lighting, which comes from both sides of the face, is dramatic in the style of a studio portrait. Carefully staged illumination is an important element in all of the prismatic grid paintings because it helps emphasize the photographic way of seeing, which mitigates the fragmentation of the image inherent in the overtly incremental process.

Close painted three very large black, white, and gray images in 1991 and 1992: a new version of *Alex* (p. 209), a self-portrait, and a new version of *Janet* (p. 211). All three of these utilized a vertical/horizontal grid divided into more than 3,000 separate units. These powerful images have some of the gravity of the continuous-tone black-and-white portraits, and a character rather different from the full-color paintings made during the same period. In part this is because they demand that the viewer pay close attention to the graphic aspects of Close's process. In the full-color paintings, the eye is dazzled and seduced by the swirls of pigment that proliferate across the canvas. The black-and-white portraits are cool rather than hot. Loops and ellipses formed in exactly the same way as in the color paintings nonetheless read somewhat differently, more as written characters or ciphers, almost as if the image is made up by accumulating and arranging symbols chosen from the fonts in a printer's pattern book. In the case of the 1991 self-portrait, the characters are perhaps more calligraphic than in the other two black-and-white paintings, but the effect is essentially the same.

In 1992 Close moved to a new ground floor studio, on Bond Street in the NoHo section of downtown Manhattan. Like the Central Park apartment, it was specially fitted to meet the needs of someone forced to live largely in a wheelchair. Until he left the Spring Street studio, he had continued to use the Big Joe forklift to work on the upper sections of large canvases. For his

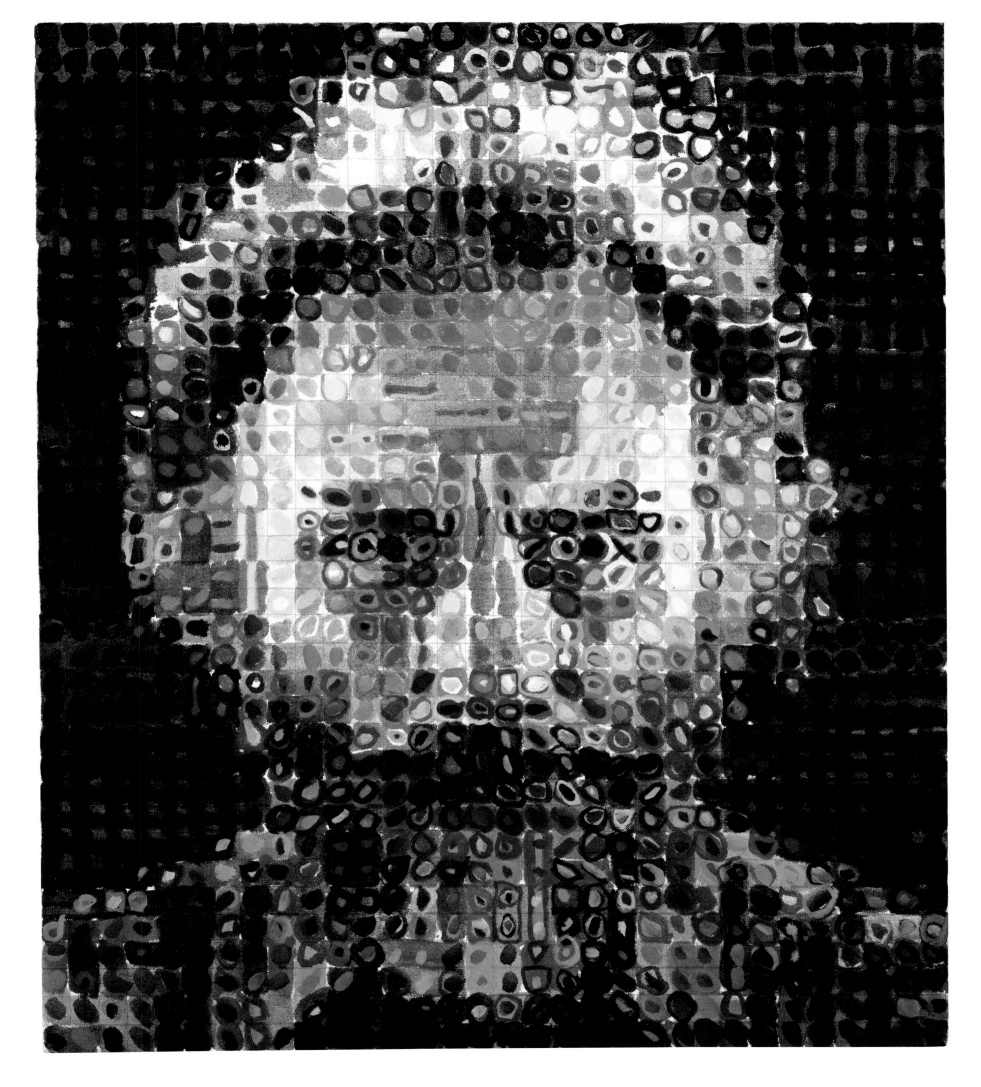

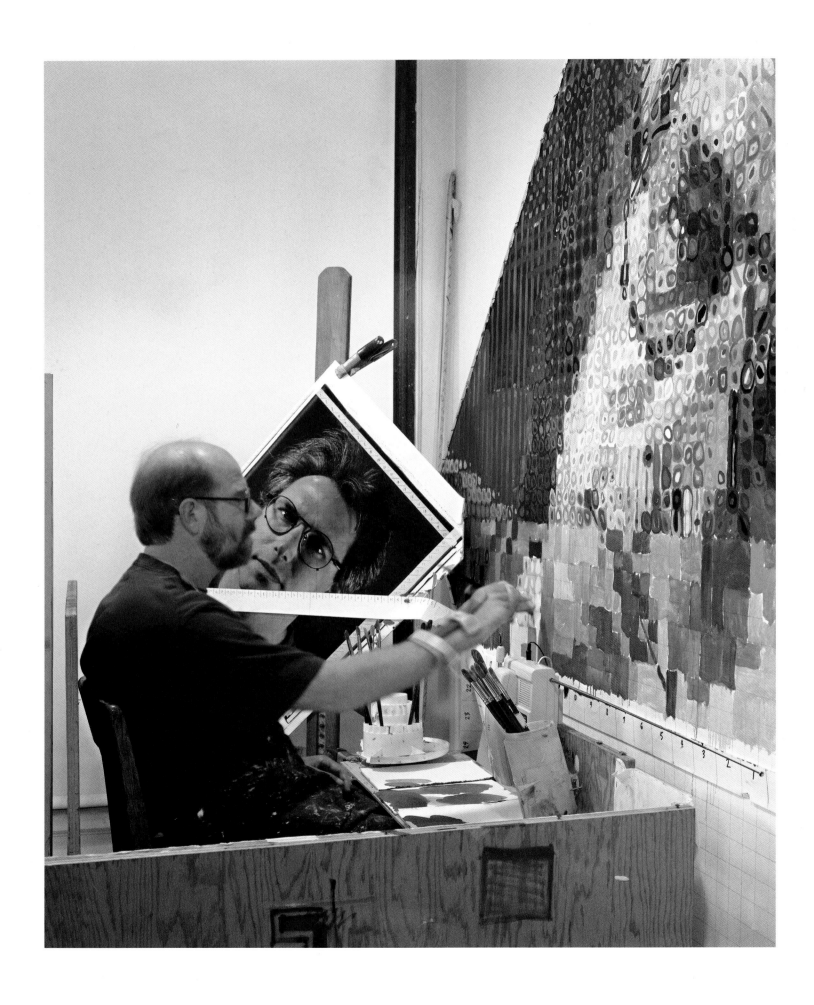

Eric, 1990, in progress ⎪ ➤ Eric, 1990.
Oil on canvas, 100 x 84 in.
(254 x 213.4 cm)

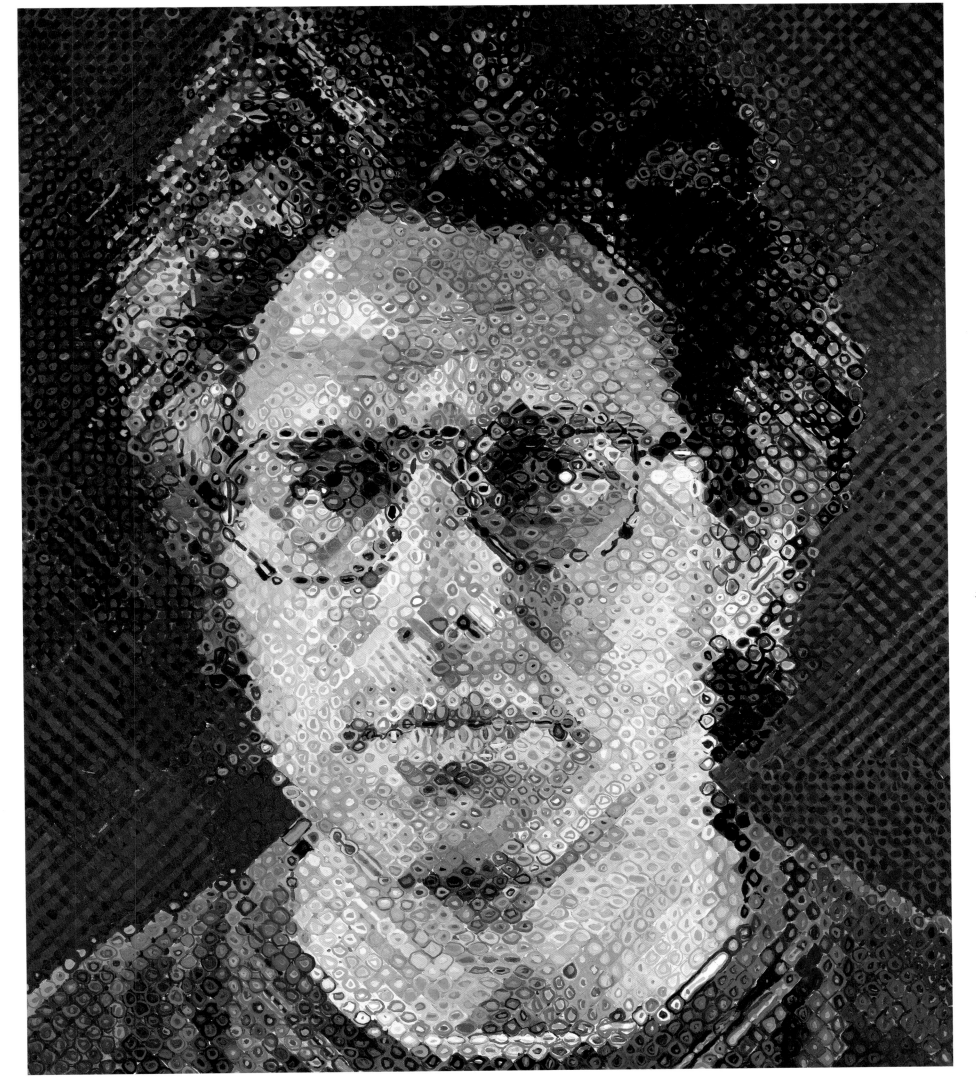

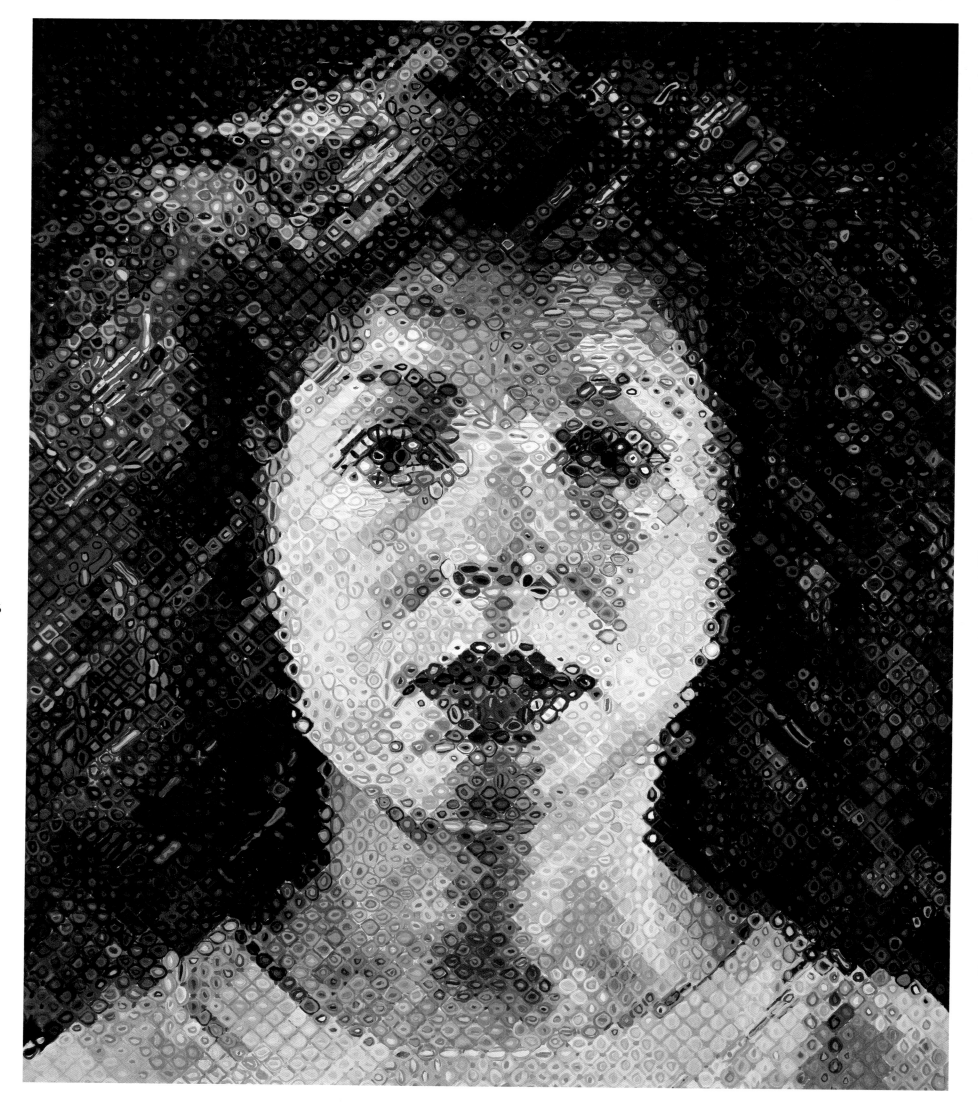

pages 206 and 207: **April**, 1990–91.
Oil on canvas, 100 x 84 in.
(254 x 213.4 cm)

➤ **April** (detail), 1990–91

208

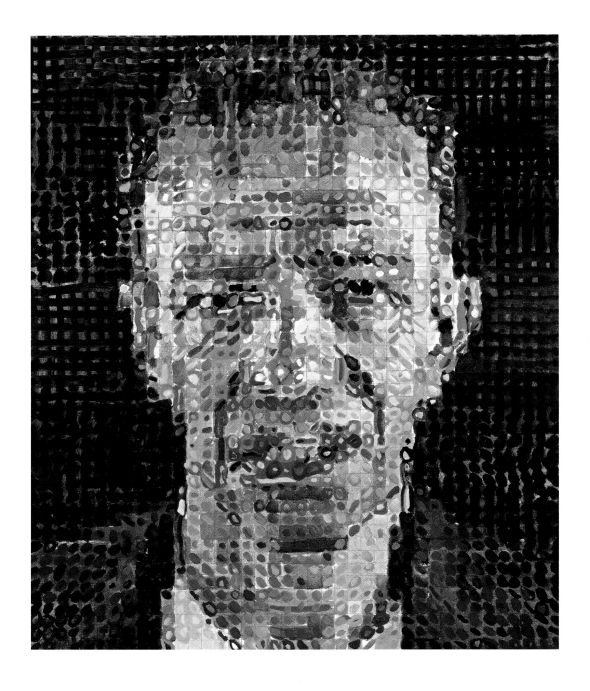

Alex, 1990.
Oil on canvas, 36 x 30 in.
(91.4 x 76.2 cm)

➤ **Alex**, 1991.
Oil on canvas, 100 x 84 in.
(254 x 213.4 cm)

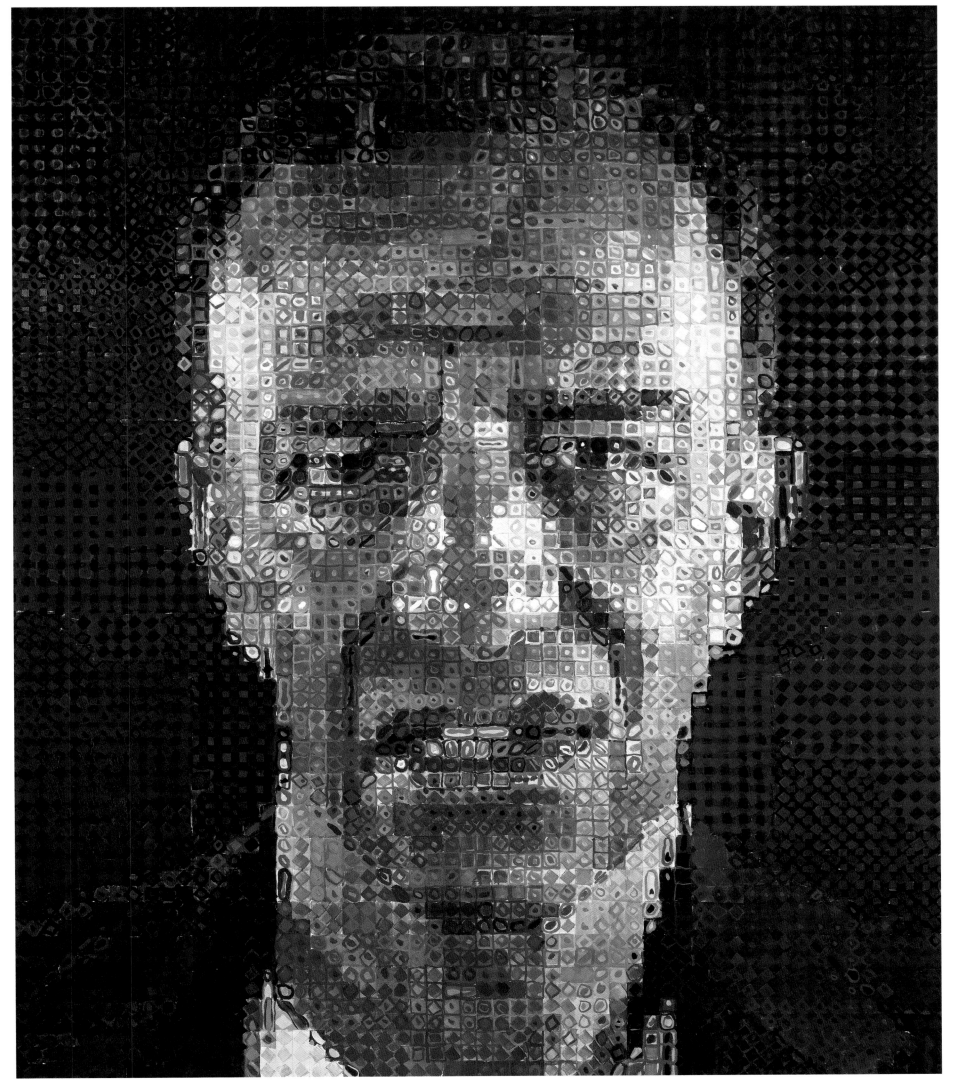

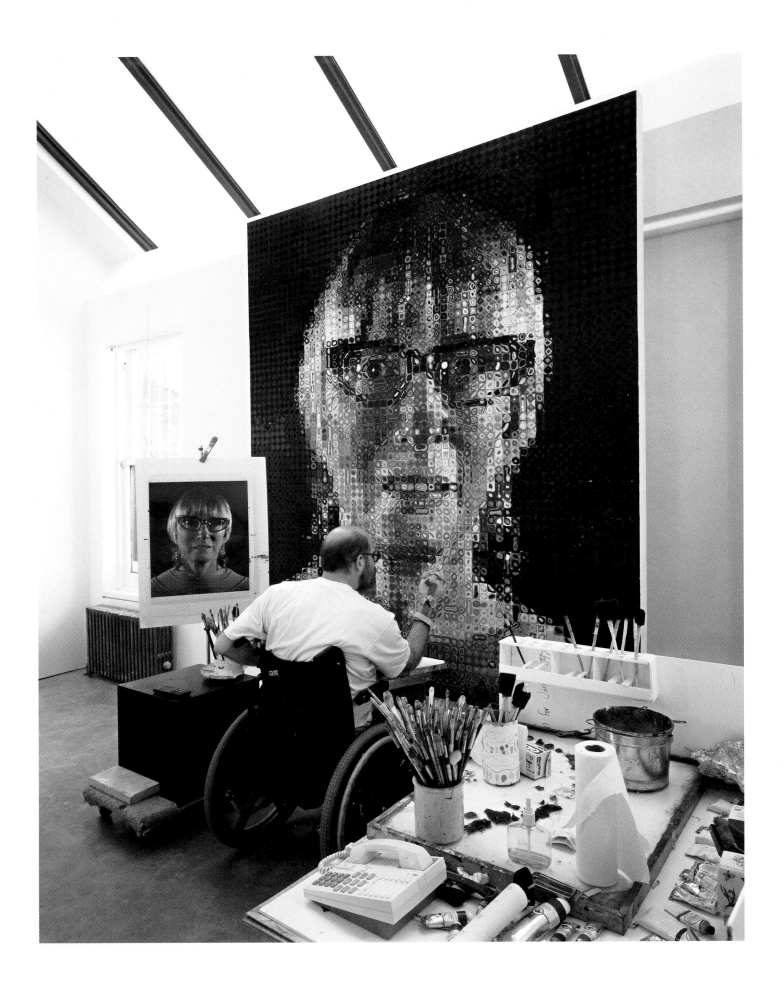

Janet, 1992, in progress ⏐ ➤**Janet**, 1992.
Oil on canvas, 100 x 84 in.
(254 x 213.4 cm)

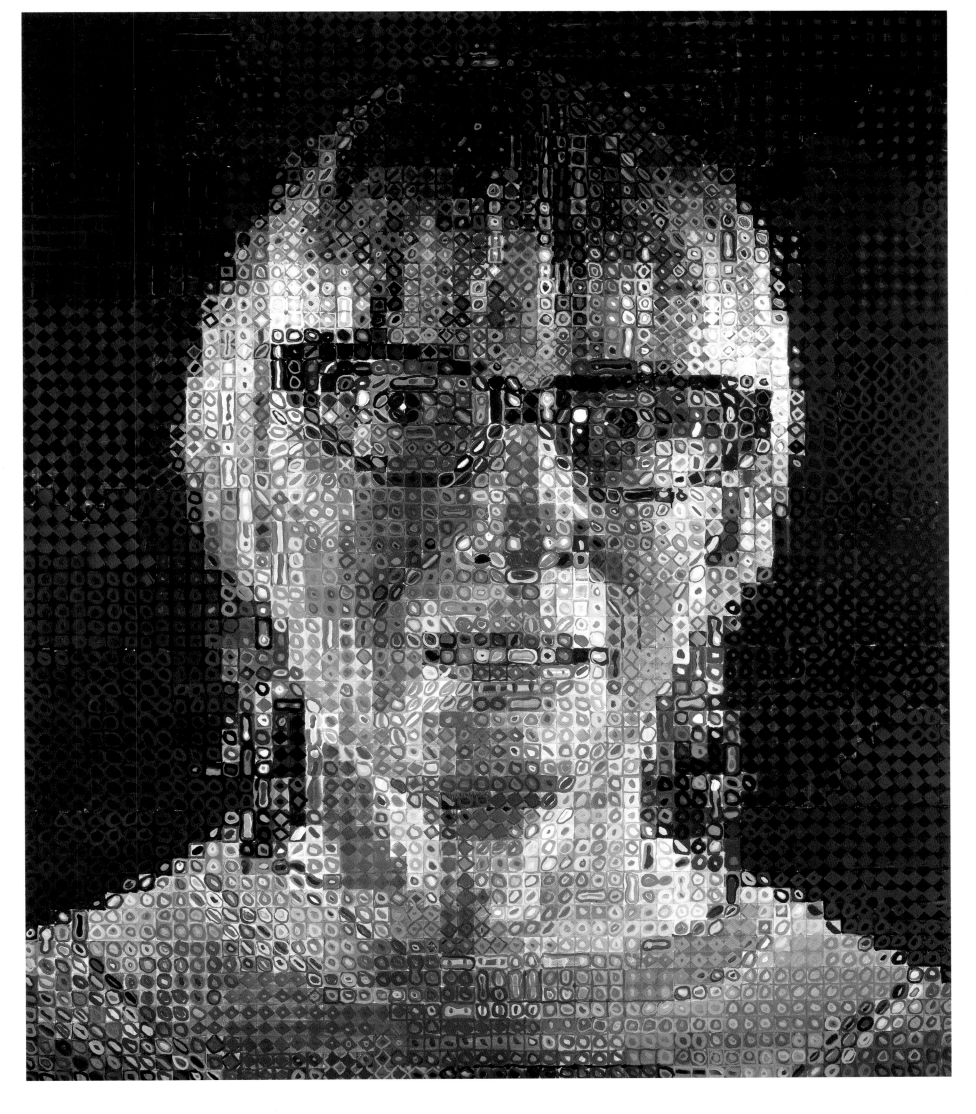

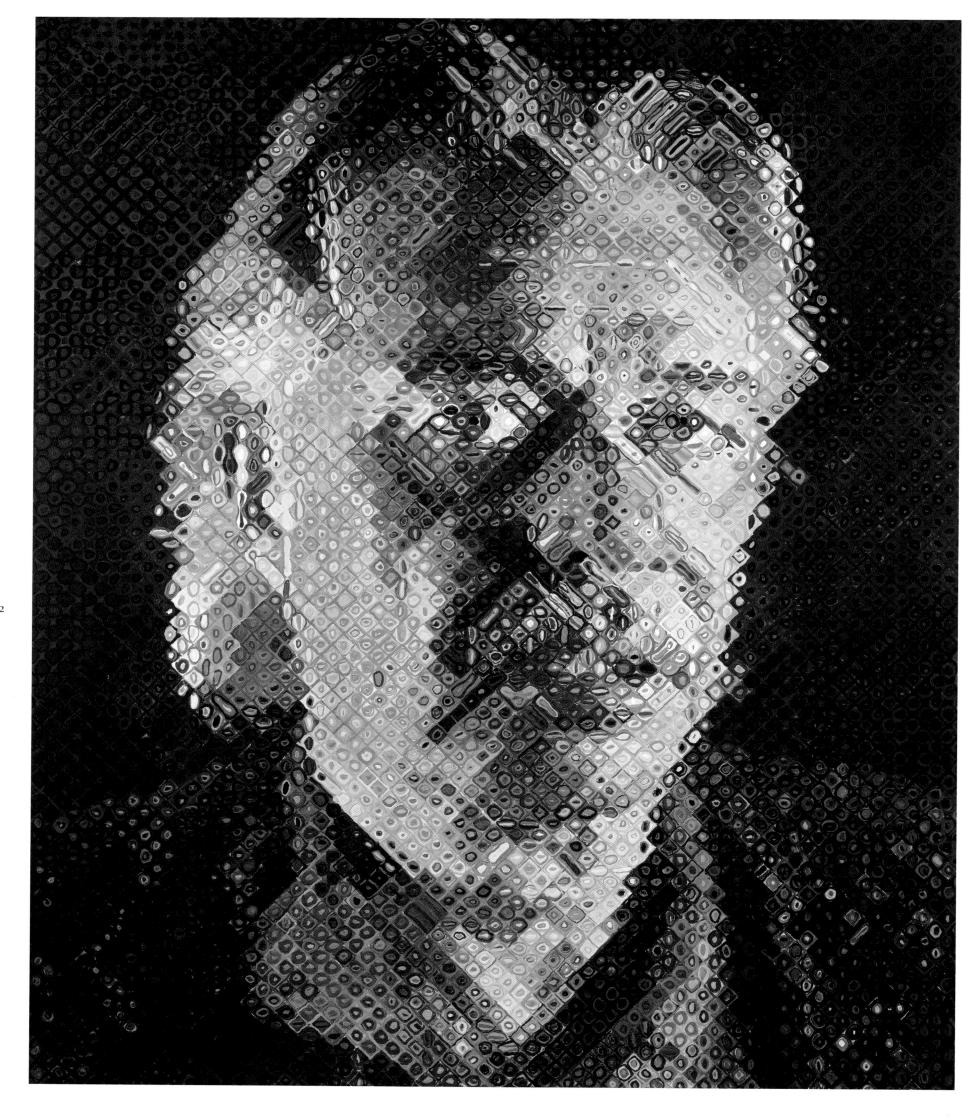

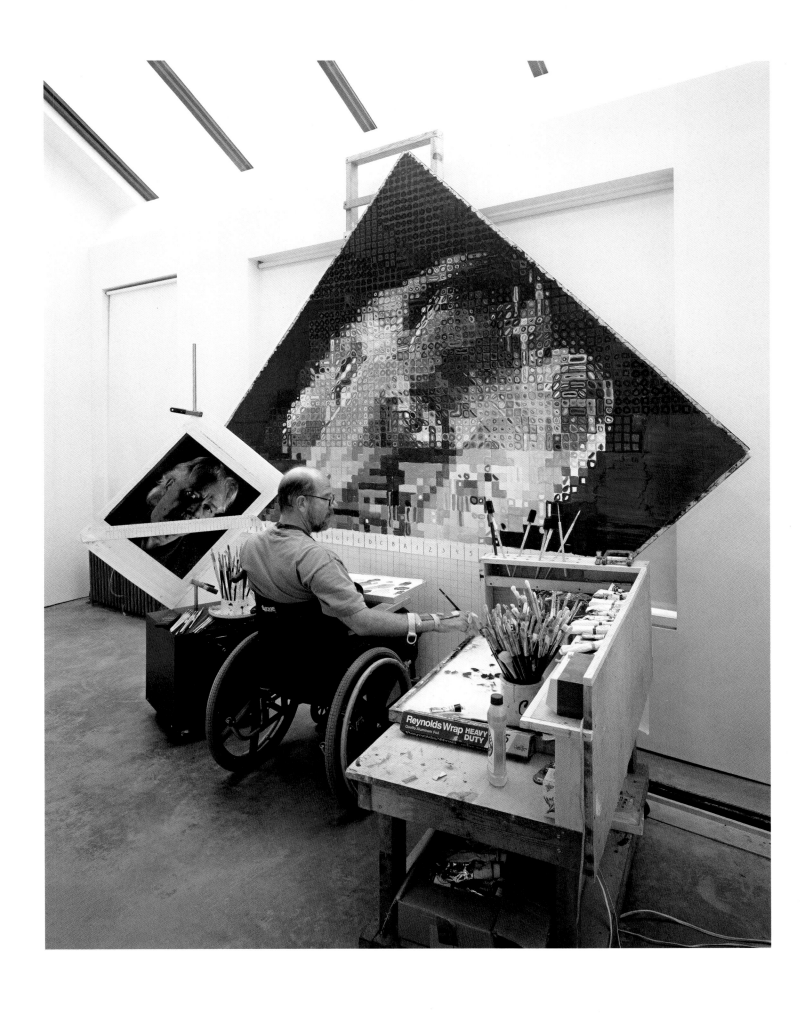

213

◄ **John**, 1992.
Oil on canvas, 100 x 84 in.
(254 x 213.4 cm)

Chuck Close working on **John**, 1992

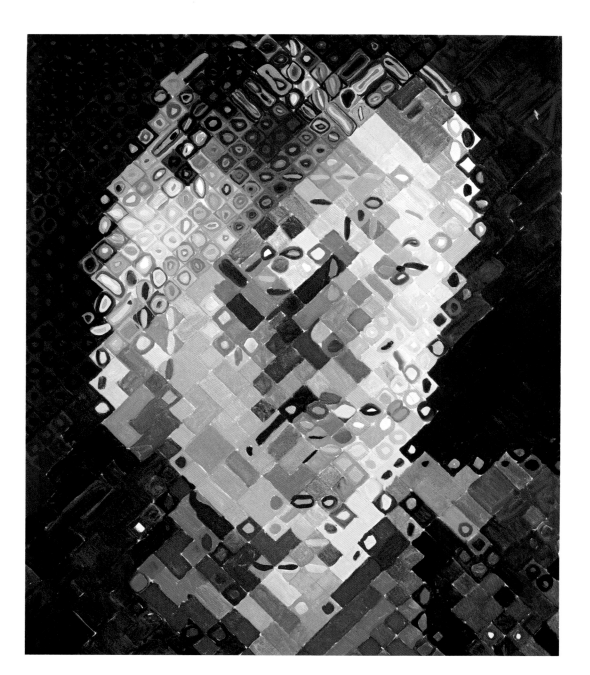

John II, 1993, in progress

Bridgehampton studio, shortly before his hospitalization, he had devised another way of dealing with the same problem, having a slotted pit set into the floor, flush with the wall, into which a painting could be lowered while he worked on its upper sections. (He had first seen such a system, which is extensively used by theatrical scenery painters, in Willem de Kooning's studio.) When he moved to the new space, he installed a basic version of this system, eventually adding motorized tracks that permitted canvases to be raised and lowered and otherwise manipulated mechanically.

One of the first paintings to be made in the Bond Street studio was *John* (1992; p. 212), a portrait of the sculptor John Chamberlain, which holds up as an especially strong example of the artist's prismatic grid idiom. Close has often said that he only paints a small percentage of the people he asks to sit for photographs, and it's easy to see why this particular image caught his fancy. Chamberlain, whose face shows evidence of worldly wear and tear, is caught from the marginally three-quarter angle that was becoming a Close

favorite. He stares into the lens, his features lit as if for a climactic movie close-up, his moustache in itself a graphic statement, his silver hair a reverse silhouette against the deep background. The sitter even thought to wear a chromatically lively shirt and a patterned jacket that offered opportunities for visual grace notes.

If the prismatic grid paintings are considered as a series, it will be seen that there are significant variables from painting to painting in the balance between the way in which clusters of pigment are asked to perform descriptive purposes, and at the same time are permitted to enjoy an independent existence as interlocking abstract elements within a mosaic. Both aspects of this ambiguous existence are always present, and each takes precedence, depending upon what distance they are viewed from. Still, there is a significant difference between, for example, *Alex* (1987), in which the descriptive function is dominant even when seen from quite close range, and *Alex II* (1989), in which the constituents threaten to disintegrate into non-figuration, even when studied from a distance.

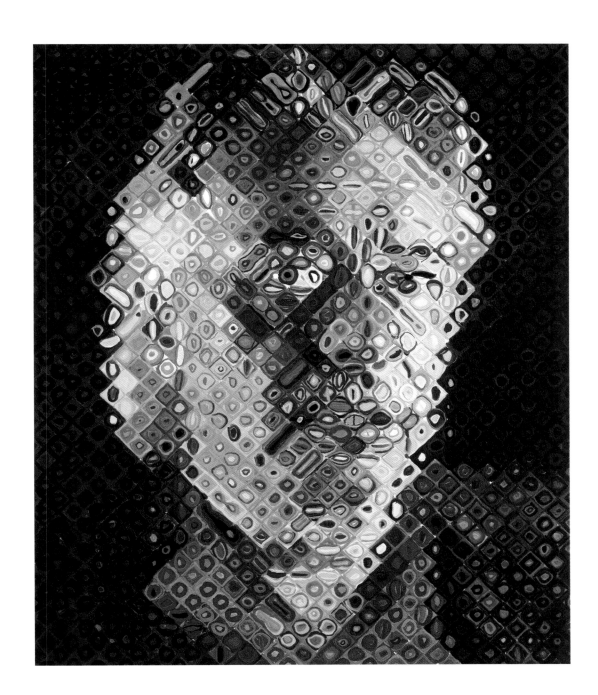

John II, 1993.
Oil on canvas, 72 x 60 in.
(182.9 x 152.4 cm).

In the 1992 *John*, Close arrived at a particularly satisfying balance between the two functions. Circles and dots of bottle green, modified by touches of yellow, white and blue, more than adequately evoke the irises of the subject's eyes (which seem all the more alive because of the fragmentation). It takes very little shift in focus, however, to experience these same circles and dots as elements in an abstract field. The same applies to other areas of the painting—the hair and moustache, for example. This is a painting in which the shift from one kind of visual perception to the other is especially fluid.

Paintings made in 1993 include a large black-and-white portrait of the sculptor Joel Shapiro, another black-and-white self-portrait utilizing a relatively open grid, a smaller and looser painting of John Chamberlain, and a striking portrait of the artist Kiki Smith (p. 218) in which the subject's long, dark hair takes on a life of its own, reading from a distance almost like the bold calligraphy found in the paintings of the Abstract Expressionist Franz Kline,

though in fact it is made up of thousands of individually differentiated units.

· · ·

In 1994 one of the most famous faces in the New York art world, Roy Lichtenstein's, was the subject of two striking portraits, one not quite full face, the other one of Close's rare profiles. Both of these are memorable paintings using graph paper-like grids; the profile—*Roy II*—is especially noteworthy as a bold application of the prismatic grid process (p. 223).

Roy I (p. 222) is a trifle unusual in that it shows the subject with a half smile on his face—not common in Close's work—giving the artist an opportunity to work a little magic with the teeth. The roughly rectangular shapes that represent one tooth are stretched out over two squares, which emphasizes the three-quarter view of the face by introducing a comic book–like, shorthand illusion of foreshortening (certainly appropriate to a portrait of the master of the blown-up comic strip). For the most part this is a fairly straight-

forward painting except for some clever exploitation of the grid to square off the subject's jaw, and for a tendency for Lichtenstein's cheeks to disintegrate into the background, a kind of "edge erosion" that had appeared in a modest form in some earlier paintings.

Both these phenomena are more strikingly apparent in *Roy II*, in which the two are in fact combined. In the mouth and jaw area, the edges of a dozen or so grid squares are emphasized in such a way as to create two thick, dark lines that meet at a right angle, a device that recalls the practices of Cubism in its synthetic phase; these lines divide and separate sections of lips and chin from the rest of the face. Even more pronounced, perhaps—though achieved more loosely—is the way in which morsels of the prow of the subject's prominent nose have been allowed to drift off. These very explicit interruptions of outline have the unexpected effect of making the profile more distinct. At the same time, they do much to emphasize the painting's abstract characteristics.

. . .

The middle to late nineties saw Close painting more artist friends, ranging from Dorothea Rockburne and Lorna Simpson to the veteran painter Paul Cadmus. A 1997 portrait of Robert Rauschenberg (p. 228) is one of several from that period that employs very tight cropping of the face as yet another way of achieving an allover effect. Simultaneously it places an emphasis on the subject's smile, one that is far more explicit than the tentative smile found in *Roy I*.

"I always tell sitters not to smile," Close says, "but when it came to Bob there was no way I could get a picture of him when he was not smiling. He was the exact opposite of Jasper Johns, who makes a thing of not smiling for the camera."

The Rauschenberg painting is also amusing for the way in which the treatment of the eyes evokes a pair of hearts, a piece of presumably unintended symbolism that fits well with Rauschenberg's smile and genial personality.

The period also saw new self-portraits, including a tightly cropped 1997 version (p. 232), and an even more tightly cropped

version painted the previous year. In 1995 Close made a pair of black-and-white self-portraits that, more than any he had painted in years, can be seen as a return to the mug shot ideal (pp. 230 and 231). Full-face and profile, the maquettes for these paintings present the artist in unflattering likenesses worthy of any FBI Most Wanted list. The paintings themselves are equally unflattering, but they are brought to life by the liveliness of the handling.

. . .

By the time Close was making these paintings, his reputation stood higher than it ever had and more than one New York museum was vying to stage a new retrospective exhibition. Initially it appeared that the Metropolitan Museum of Art would be the venue for the show, but the artist withdrew on the grounds that the museum was proposing to give him only half the space he felt had been promised, and also planned to trim the size of the catalogue. Instead, The Museum of Modern Art took on the Close retrospective. It ran there from February 26 to May 26, 1998, before traveling to the Museum of Contemporary Art in Chicago, the Hirshhorn Museum and Sculpture Garden in Washington, D.C., the Seattle Museum of Art, and the Hayward Gallery in London.

In his essay for the catalogue, Robert Storr, who organized the exhibition, addressed the primacy of process in Close's art, saying of Close and his peers, "The gamble they have taken is that the unique products of programmatic artistic choices will defy generalities and exceed any foreseeable result . . . Close has spent the last thirty years pushing representation to its limits. In the process he has won his aesthetic wager many times over."[19]

Inevitably, Storr also touched on what Chuck Close had had to overcome in terms of catastrophic injury. Many of those present at the gala opening for the exhibition had visited him in the hospital or in rehab less than a decade earlier. The contrast between the grim corridors of Rusk and the hallowed precincts of MoMA was something that was palpably on people's minds, and must have had a special significance for Leslie, Georgia, and Maggie Close.

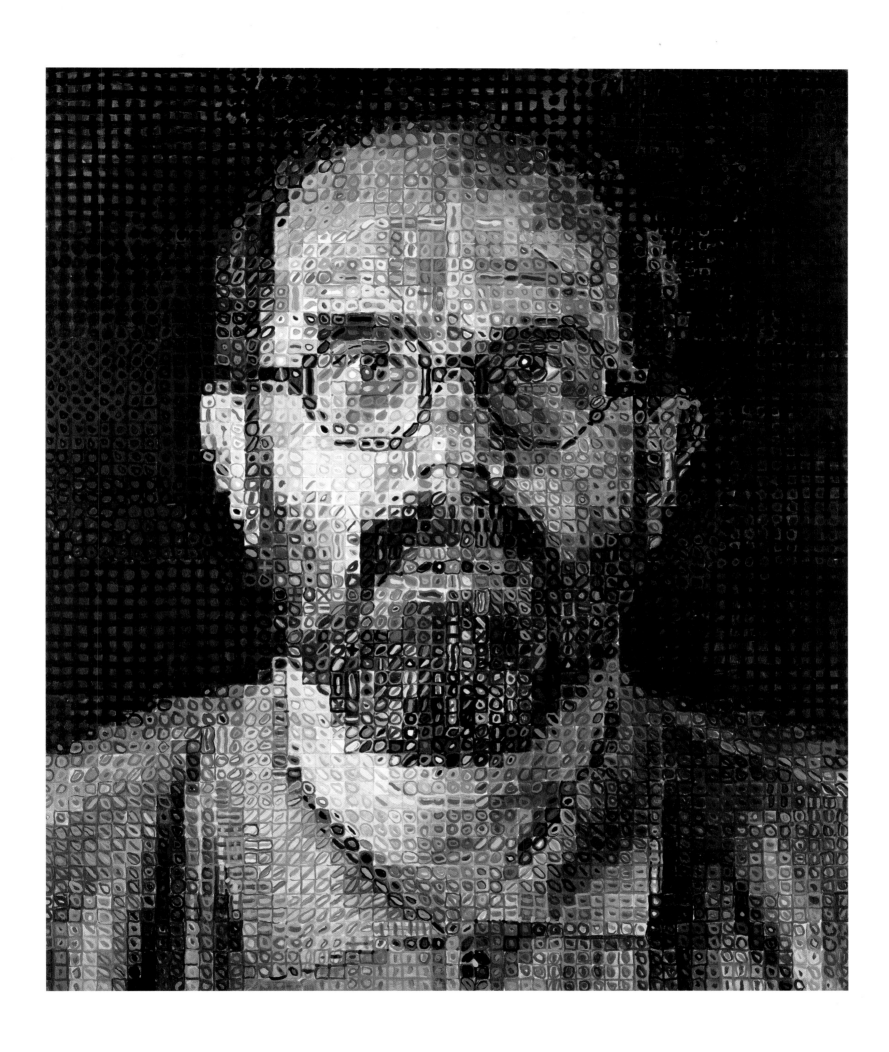

Self-Portrait, 1993.
Oil on canvas, 72 x 60 in.
(182.9 x 152.4 cm)

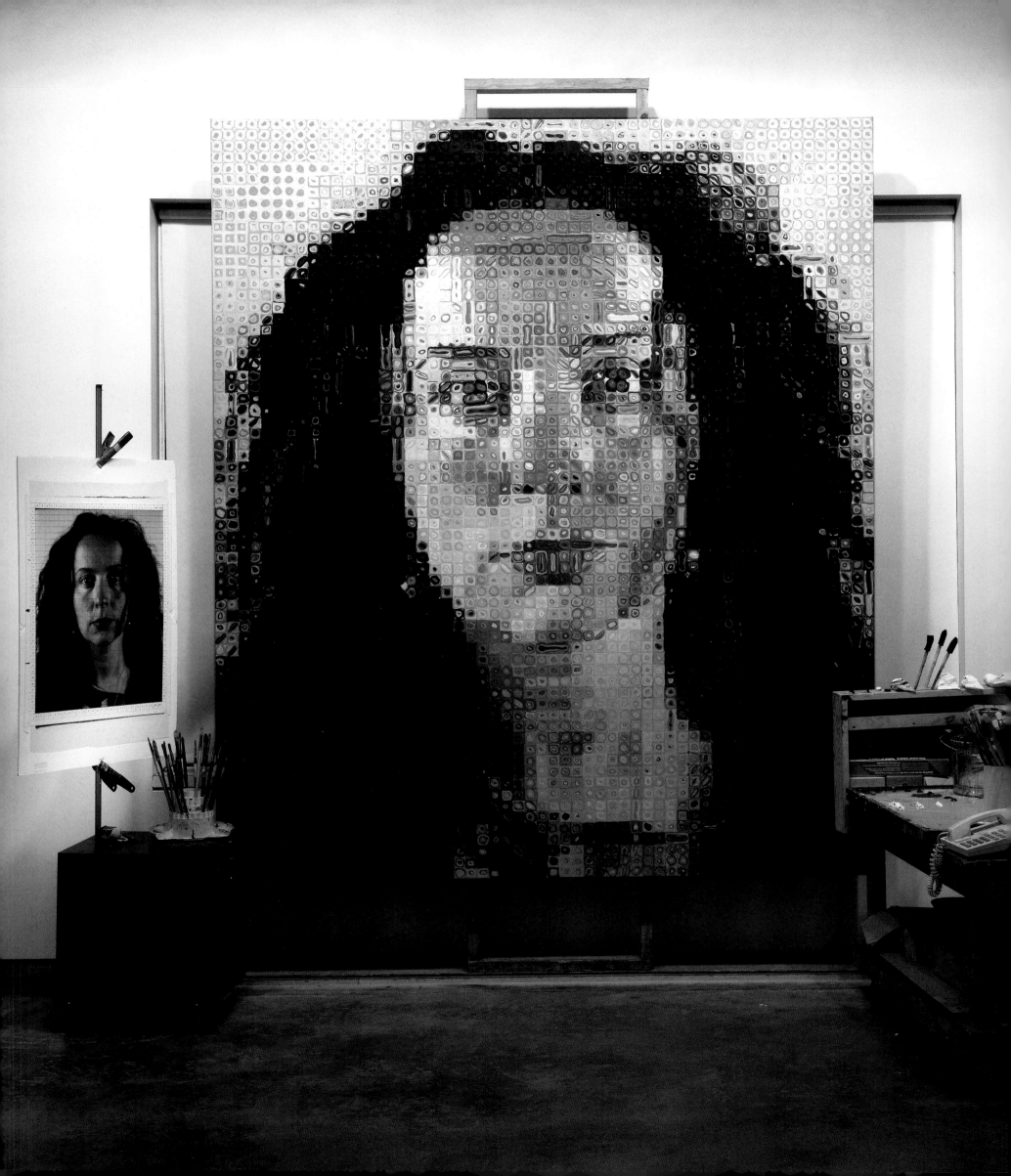

Kiki (detail), 1993

◄ **Kiki**, 1993 (studio view).
Oil on canvas, 100 x 84 in.
(254 x 213.4 cm)

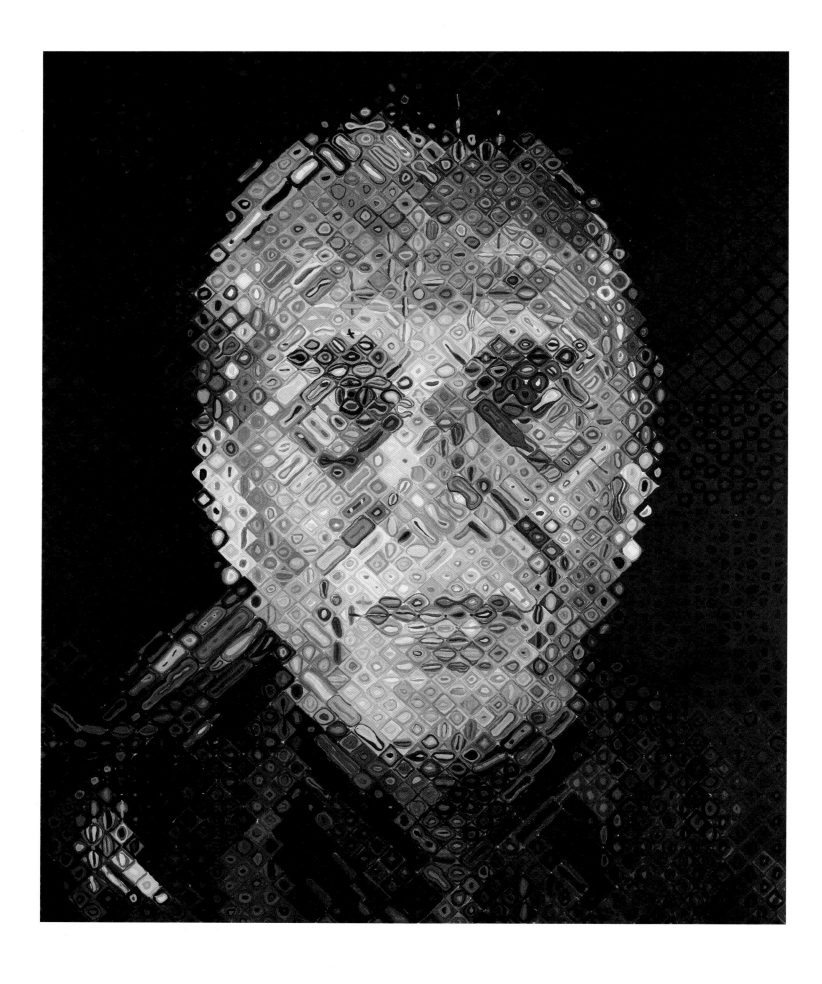

Paul, 1994.
Oil on canvas, 102 x 84 in.
(259.1 x 213.4 cm)

➤ **Paul III**, 1996, in progress

studio view: **Roy II**, 1994.
Oil on canvas, 102 x 84 in.
(259.1 x 213.4 cm)

Roy I, 1994.
Oil on canvas, 102 x 84 in.
(259.1 x 213.4 cm)

➤ **Roy II**, 1994.
Oil on canvas, 102 x 84 in.
(259.1 x 213.4 cm)

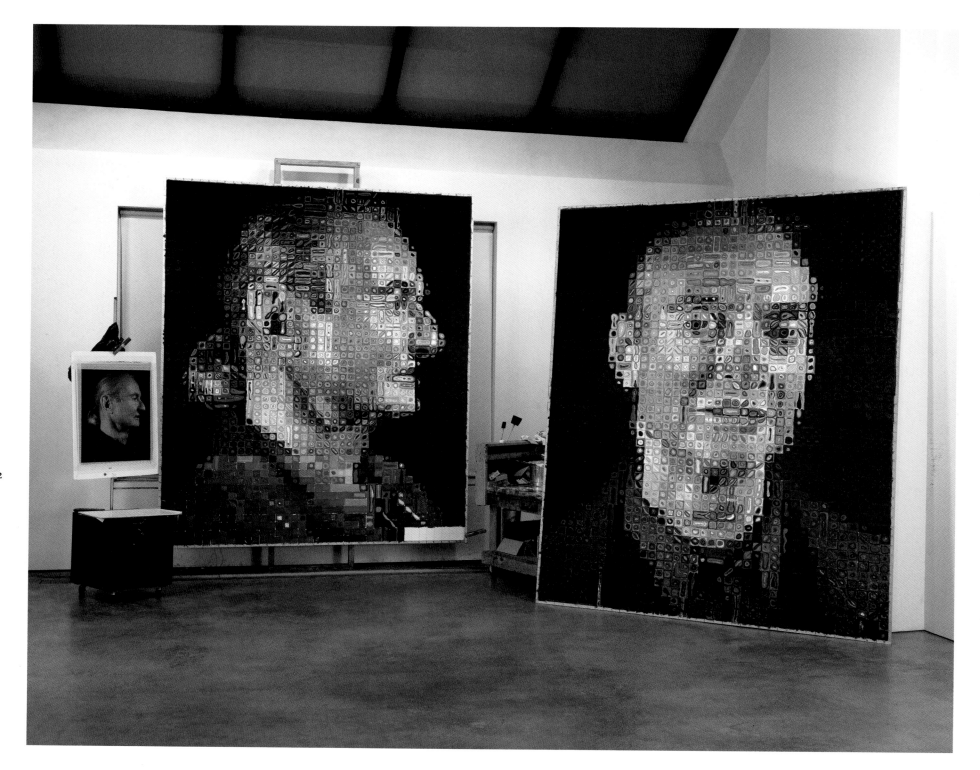

pages 224–225: **Roy II**, 1994 (detail)

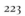

223

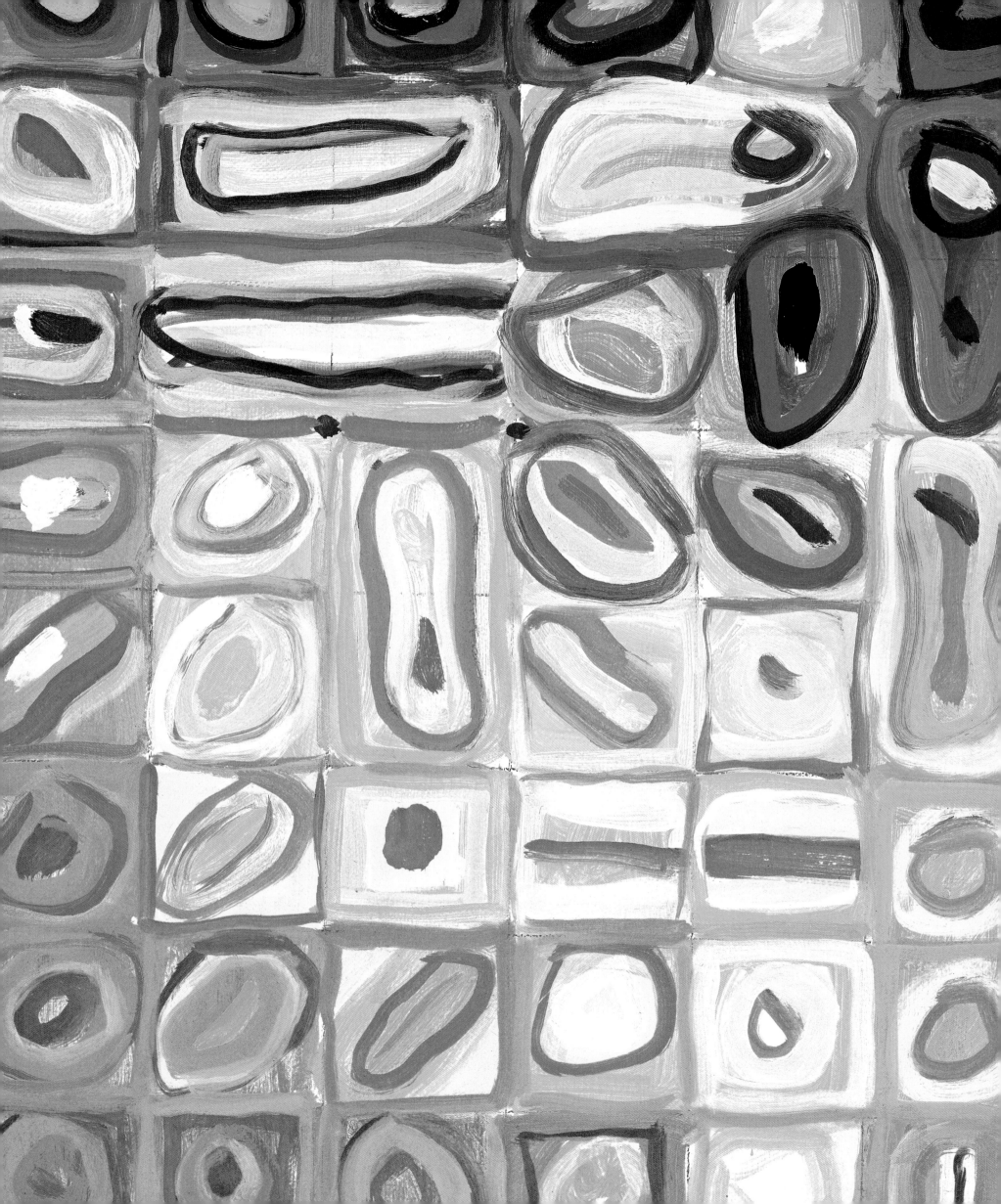

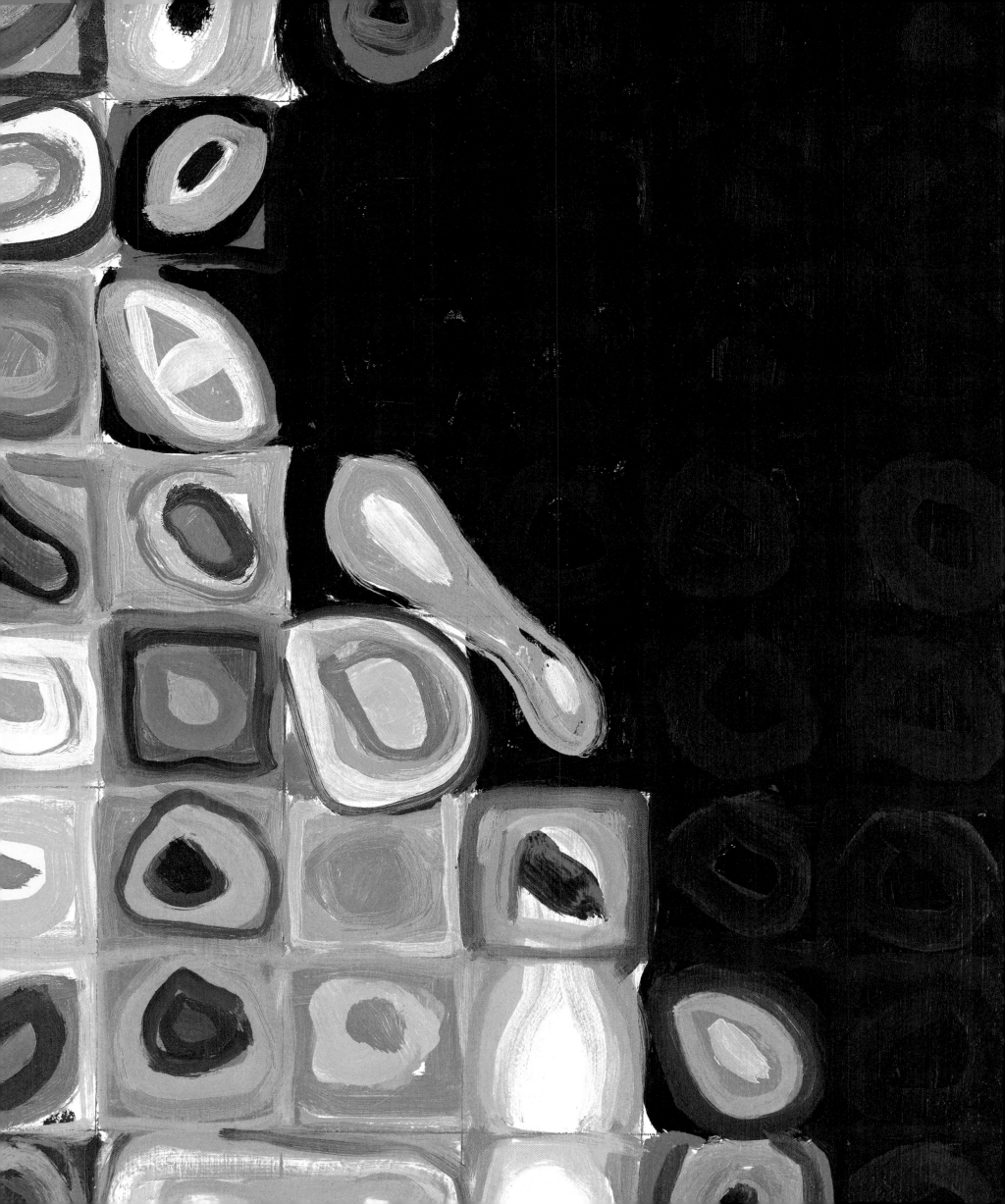

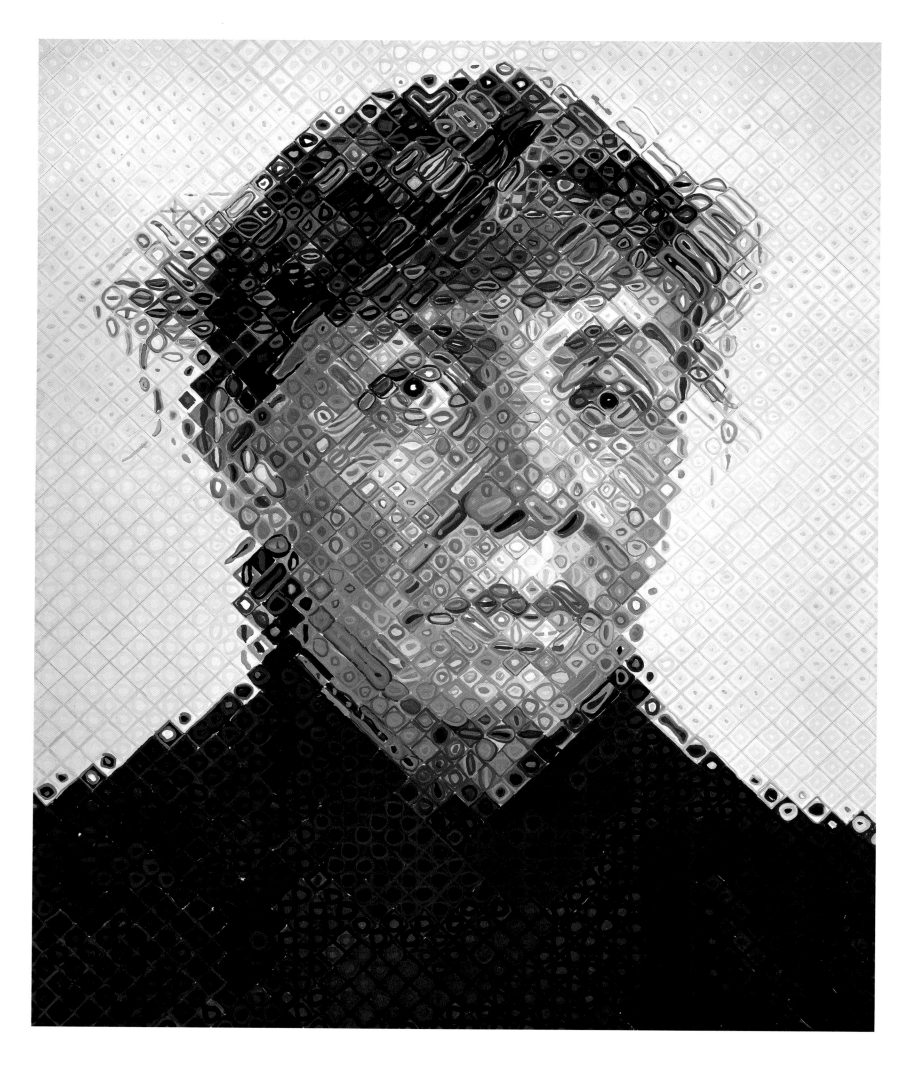

Dorothea, 1995.
Oil on canvas, 102 x 84 in.
(259.1 x 213.4 cm)

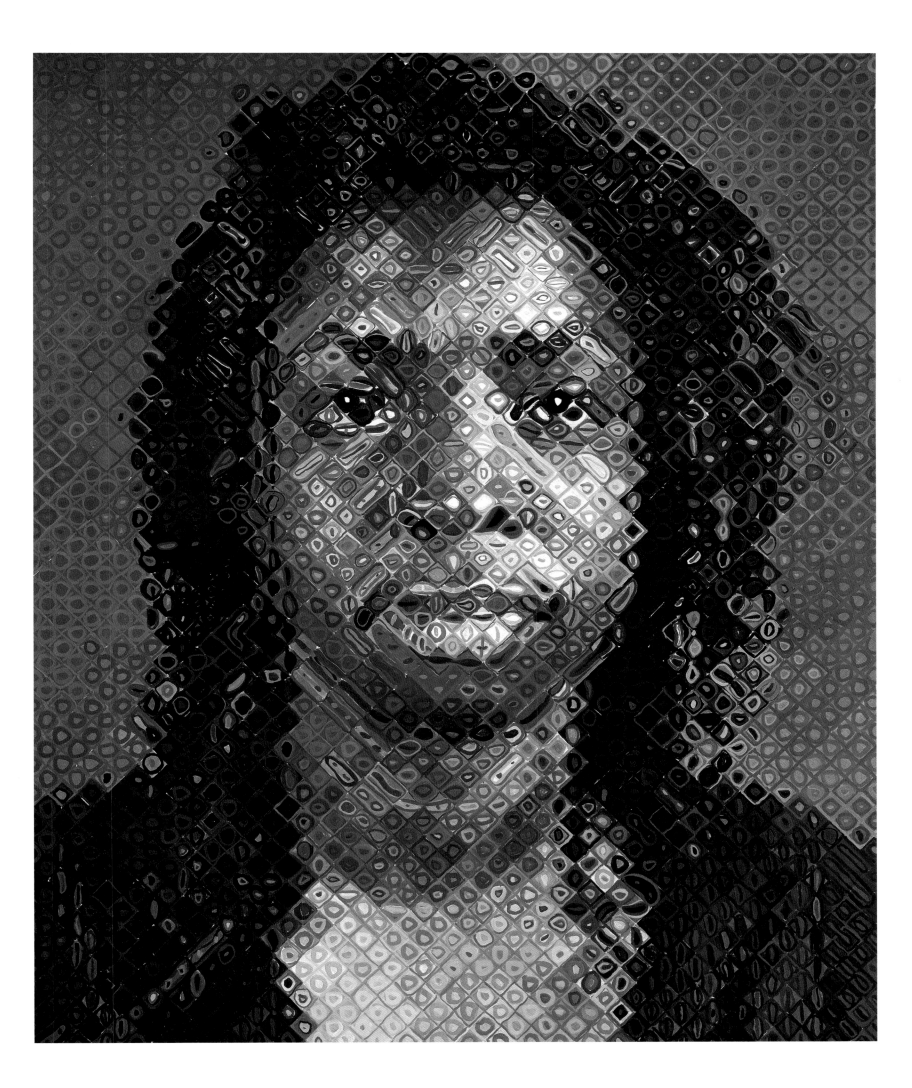

Lorna, 1995.

Oil on canvas, 102 x 84 in.

(259.1 x 213.4 cm)

228

◄ Robert, 1997.
Oil on canvas, 102 x 84 in.
(259.1 x 213.4 cm)

Georgia, 1996.
Oil on canvas, 30 x 24 in.
(76.2 x 61 cm)

229

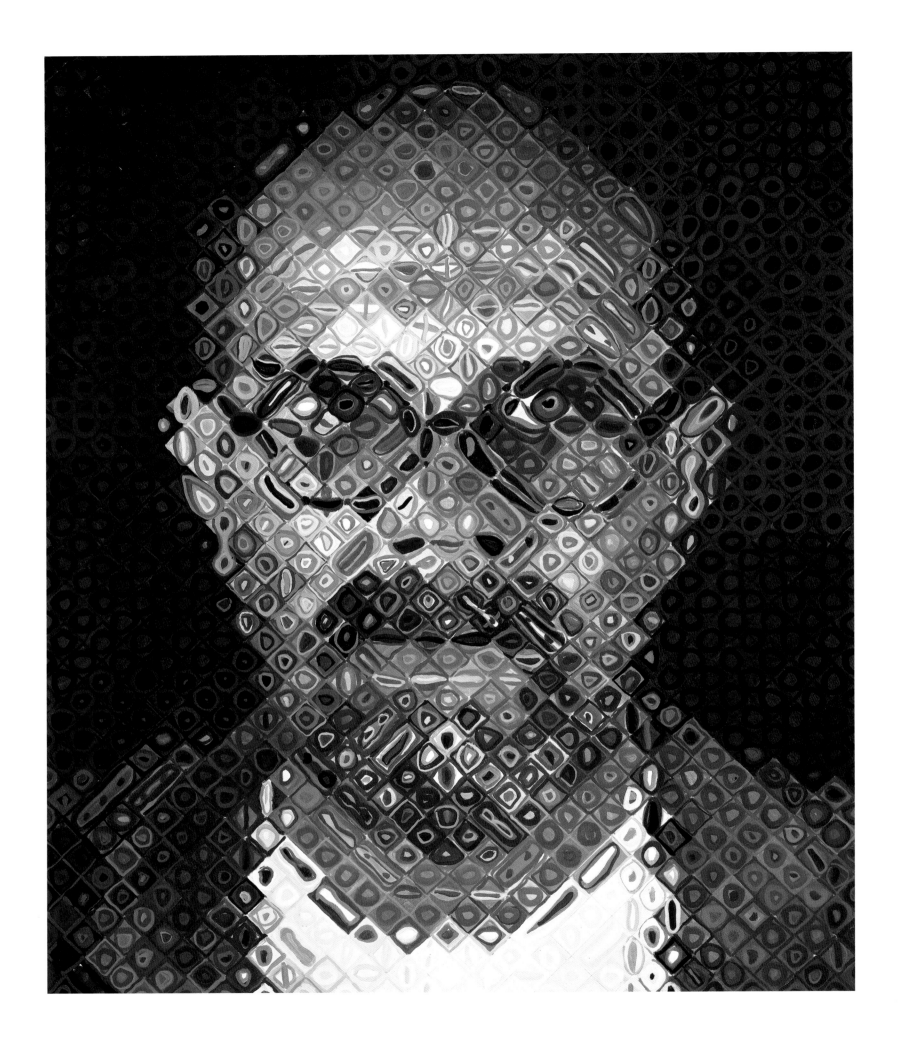

230

Self-Portrait I, 1995.
Oil on canvas, 72 x 60 in.
(182.9 x 152.4 cm)

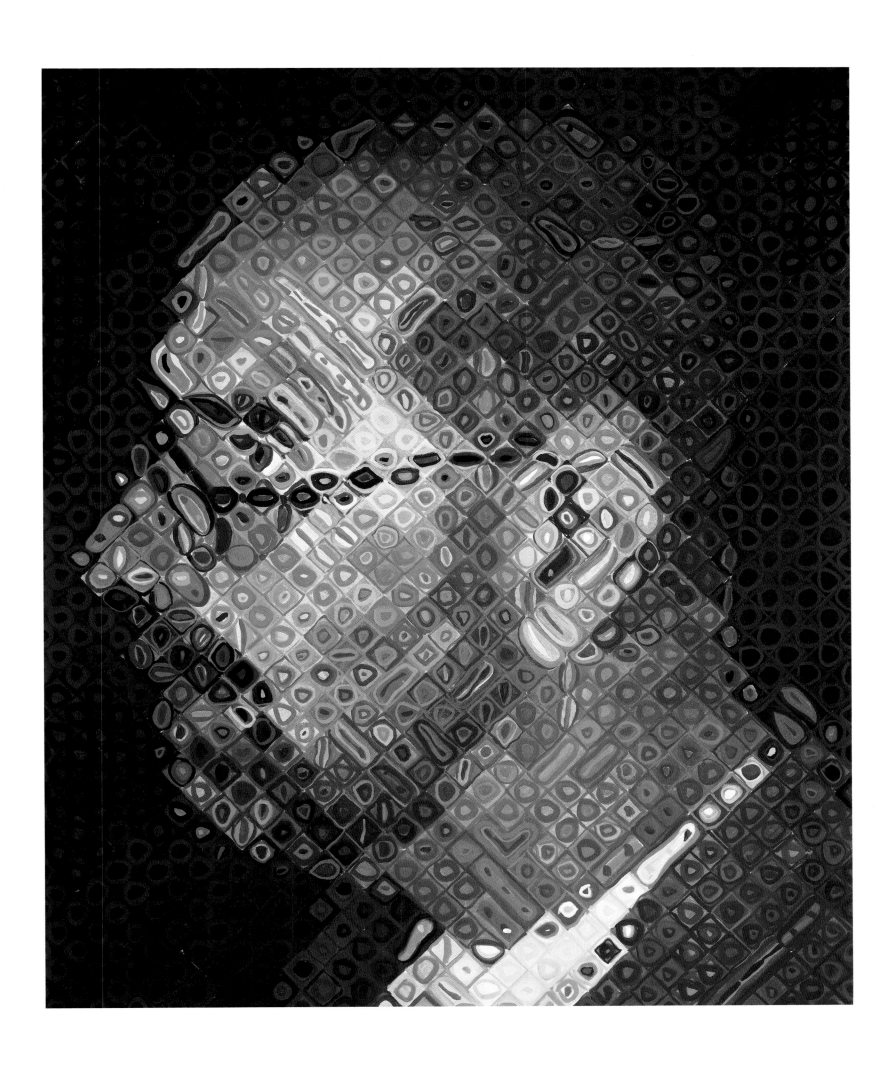

Self-Portrait II, 1995.
Oil on canvas, 72 x 60 in.
(182.9 x 152.4 cm)

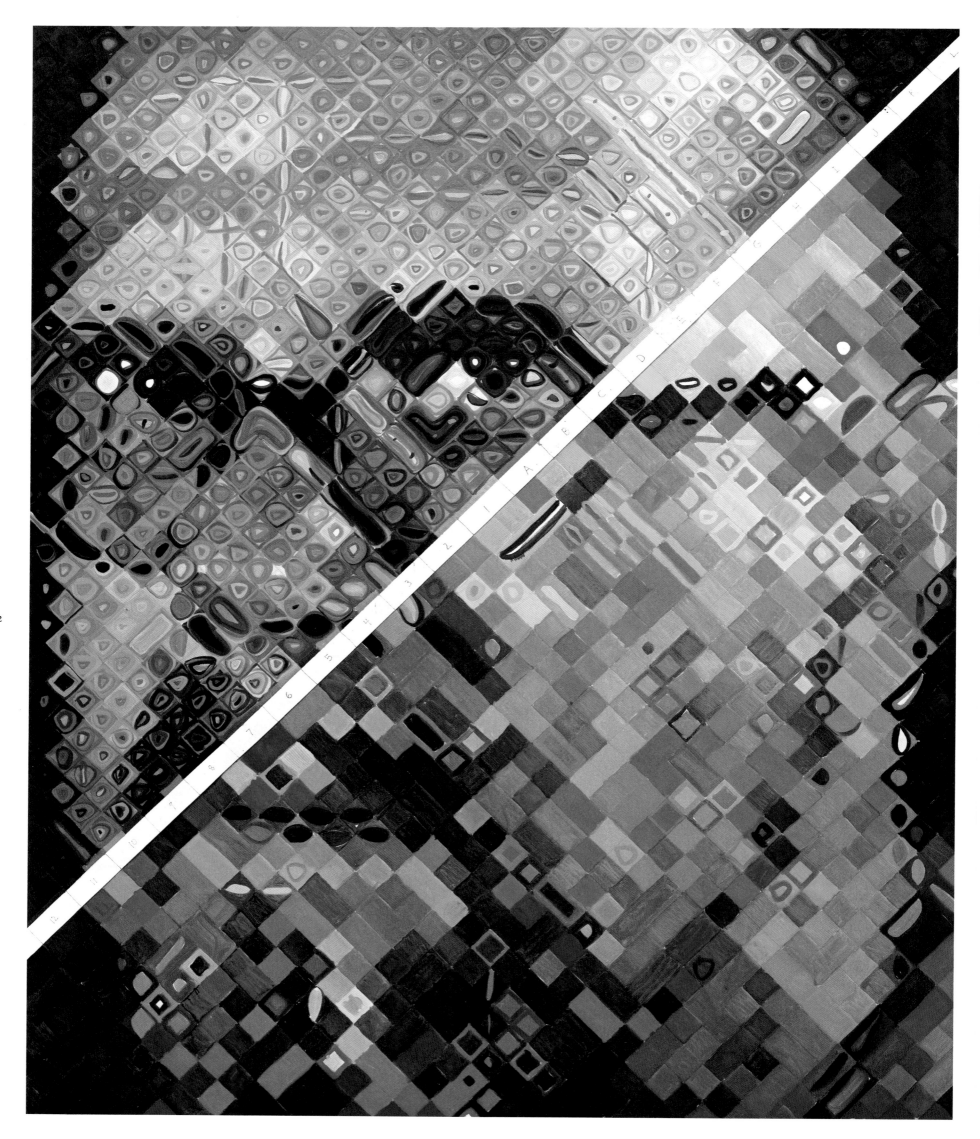

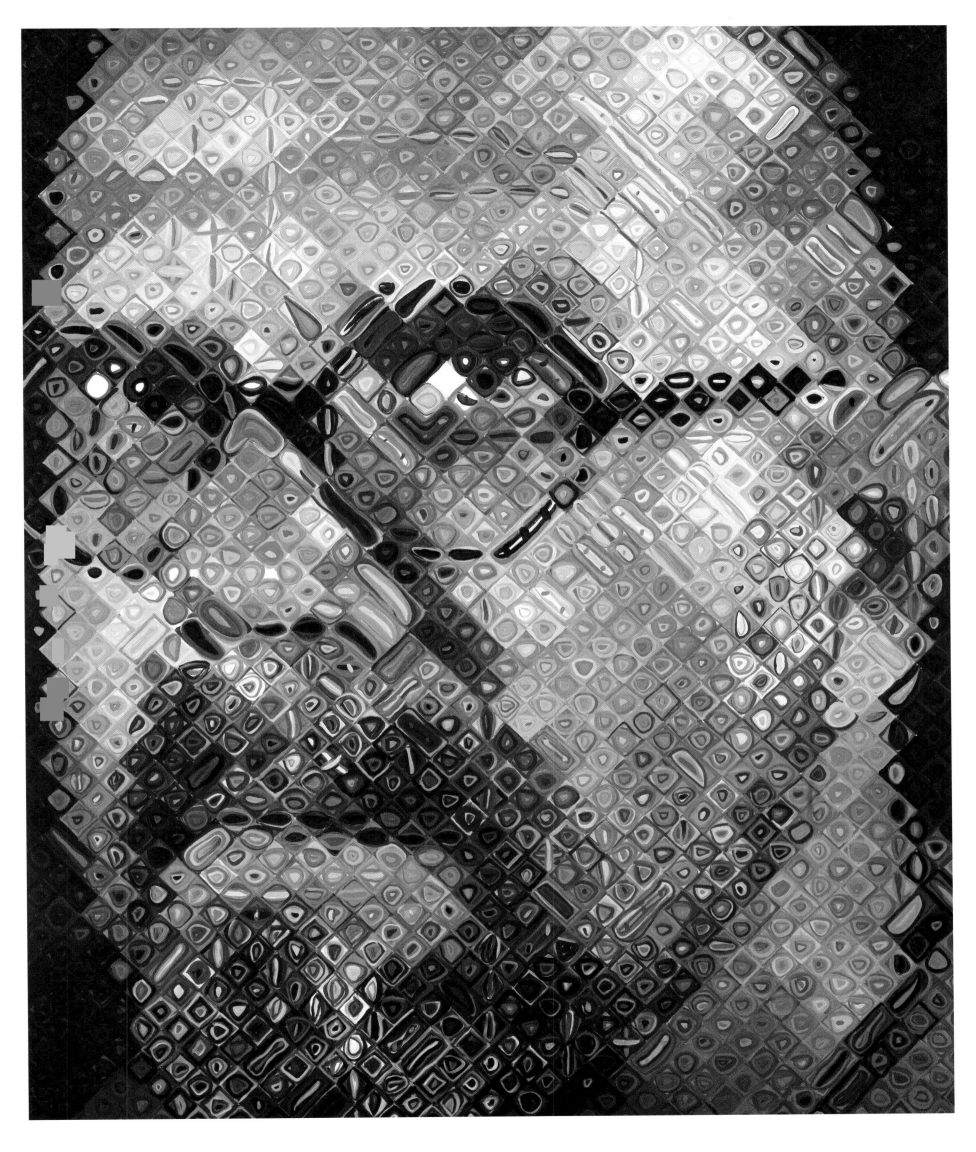

233

pages 225 and 226: **Self-Portrait** (1997) in progress

➤ **Self-Portrait**, 1997.
Oil on canvas, 102 x 84 in.
(259.1 x 213.4 cm)

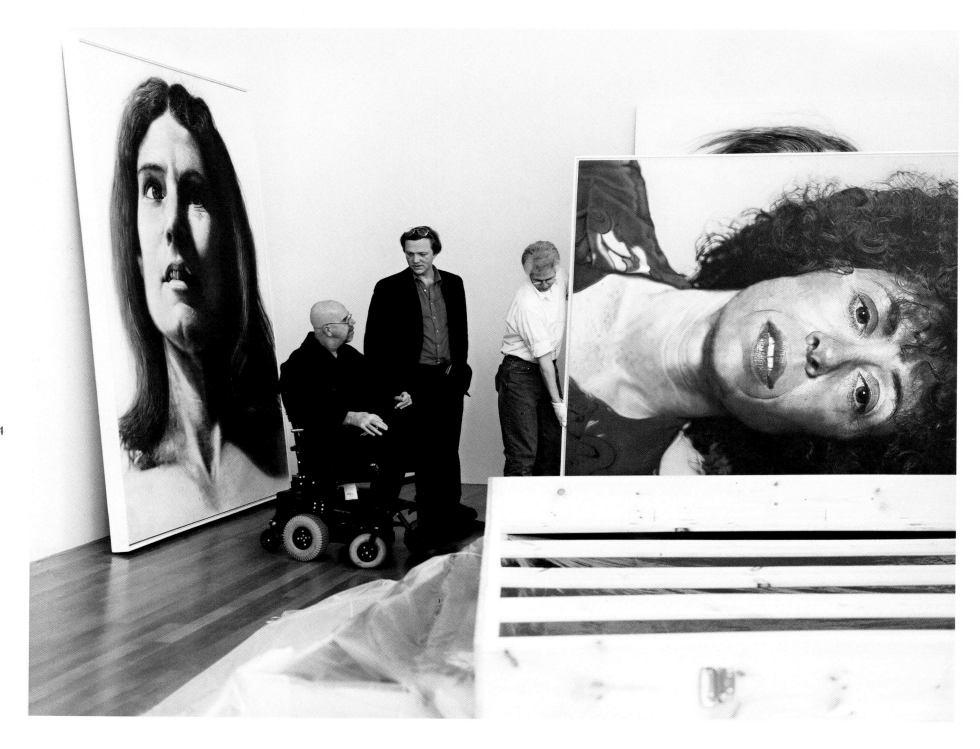

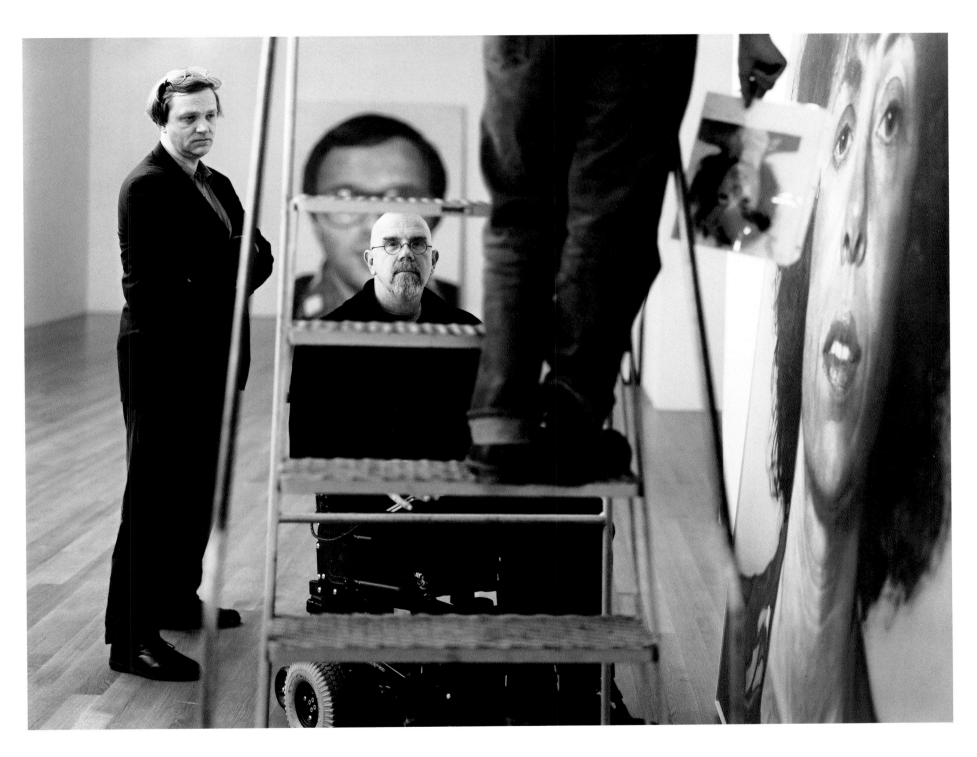

235

Chuck Close and Robert Storr supervising the installation of
"Chuck Close: A Retrospective," at The Museum of Modern Art,
New York, 1998. Photographs by Tina Barney

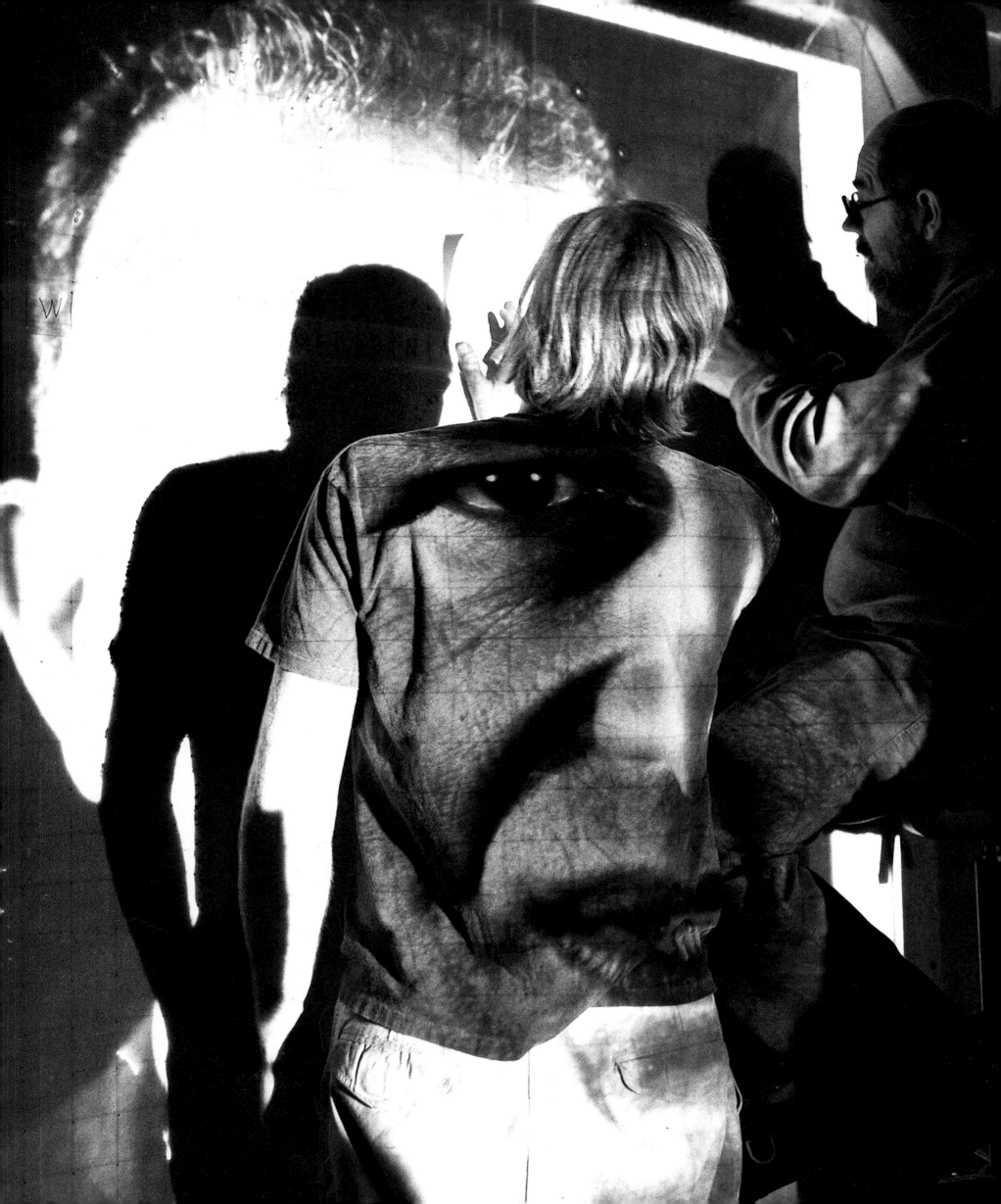

Chapter 8:

PROCESS AND PRAGMATISM

Many painters make prints that are essentially peripheral to their primary concern of working with paint on canvas, seeing them perhaps as a way of making their imagery available to a wider audience. Chuck Close, by contrast, embraces printmaking as an activity integral to his overall program of producing art by different methods while remaining faithful to both his subject matter and to his reliance upon process as a way of generating imagery. In recent decades, only a handful of major artists—Jasper Johns is the example that springs most readily to mind—have articulated their ambitions as effectively by means of multiples, and Close is perhaps alone in the range of techniques he has embraced.

Prior to his hospitalization, he had resurrected an obsolete form of printmaking (the mezzotint), made traditional etchings and woodblock prints, and invented new forms and sub-categories such as pulp paper multiples and fingerprint lithography. Since his hospitalization, he has remained just as protean, producing soft-ground scribble etchings, spitbite etchings, relief prints, linoleum cuts, silkscreens, and two kinds of woodblock prints. Even when he is working with traditional media, he has a habit of devising new approaches that derive from his obsessive need to understand and rethink the technology he is employing.

His ability, both intuitive and intellectual, to grasp print technologies was already apparent in his student days at Yale. On one occasion while he was there, art historian Egbert Haverkamp-Begemann handed out the assignment of figuring how the printmaker Hercules Seghers (circa 1590–1645) was able to produce etchings that look like aquatints, a process not invented until after the Dutchman's death. Close approached the problem by practical experimentation. The aquatint method produces a granulated texture, the result of the printmaker working through an acid-resistant ground, like a conventional etching ground but evenly loaded with a powdery substance, usually rosin dust. Rather than approaching his task from a theoretical viewpoint, Close asked himself, "How would *I* get that effect without the aquatint ground?" He knew that Seghers's etchings came out in small editions, and that provided a clue. It suggested that the copper plates had been submitted to some pretty rough treatment that made them break down quickly. It occurred to Close that the Dutchman might have saturated his plate with acid till its corrosive action began to pit the copper, creating a grainy, aquatint-like texture. When he tried this, he found that he was able to approximate Seghers's effects. It was not conclusive proof that the Dutchman had used this method, but it certainly made for a plausible thesis, and it demonstrated that Close had an innate grasp of the medium, as would prove to be the case with other methods of printmaking.

· · ·

Close's first excursion into printmaking, after emerging from rehab, was a group of three linoleum-cut self-portraits, made using the reduction block method invented by Picasso. Picasso had become frustrated at the way printers had difficulty maintaining accurate registration when working with multiple blocks and

237

multiple passes, each pass with a different color ink. He hit on the idea of fastening a single block of linoleum firmly to a table, then carving the first layer of imagery to be printed—everything in the image that is to register in yellow, say. When this was done with, that layer would be physically removed (with a blade) and the next, to be registered in blue perhaps, could be carved on the renewed surface, and so on for as many layers of color and imagery as were needed.

The process is subtractive rather than cumulative. Its one major disadvantage is that if anything goes wrong it's almost impossible to fix without starting from scratch, and all the sheets partially printed at that point have to be scrapped.

Close had used the technique before becoming a quadriplegic, for example in the seven-step, black, white, and gray reduction linocut *Lucas* (1988). Now, to compensate for his loss of grip and motor control, he had to work with a very fine electric rotary cutter instead of the more direct tools—an electric chisel, for example—that he used for *Lucas*. This resulted in the blocks having a somewhat different, in some ways more delicate, character. The important thing, though, was that he had proved to himself that he could still make the kind of kind of cuts required for lino prints, woodblock prints, and similar forms of relief print, just as he could still use a paintbrush. The exact way of using the tools might have changed, but the resulting cuts produced marks on paper that enabled the artist to build images the way he always had, without any compromise.

Emboldened by this, he began to plan a very large and ambitious linocut in collaboration with Joe Wilfer, the printmaker who had persuaded him to work with pulp paper a decade earlier. This proved to be a problem-plagued project that almost became a total disaster.

The pictorial source for this print was a black-and-white photographic maquette of Alex Katz, made in 1987. In February of 1991, time was booked at Tandem Press, in Wisconsin, one of the few places that had a press large enough to handle the job (the resulting print would be 79 3/8 by 60 3/8 inches). Close and Wilfer had arranged to take delivery of a large roll of so-called battleship linoleum, a form of floor covering that is used aboard naval vessels. Made with linseed oil and sawdust on a canvas backing, this material comes in a neutral gray and, to quote Close, "it cuts like butter." Unfortunately, before it reached Tandem Press's studio floor, the linoleum was speared by a forklift and rendered unusable. Because the time assigned to the project was just nine days, and a crew was ready to go to work, there was no way of replacing the battleship linoleum. Instead, vinyl flooring was obtained from a local store and mounted on Plexiglas. The likeness of Alex Katz was projected onto that and Close set to work, the intention being *not* to evoke the subject's face by means of a patterned grid, as in the later paintings, but rather to render it without overt signs of a matrix, almost in the manner of the continuous-tone portraits, allowing for the fact that the tools used to cut the block would demand an emphasis on texture so that the face would take on a leathery quality. The problem was that the electric tools Close was hoping to work with were extremely difficult to handle on the hard vinyl surface. After a brief period of experiment, he was forced to conclude that he did not have the strength to control them.

The solution arrived at was for Close to draw on the vinyl with a Sharpie pen for eight hours at a stretch, with assistants then taking over to carve for eight hours. Since everyone's carving has its own distinctive calligraphy, it was necessary to rotate people every fifteen minutes, to even things out. When carving was complete for the day, printing would begin, and this method made it possible for one color (specifically one shade of gray) to be printed in each twenty-four hour period.

Another problem that had arisen was that the custom-made paper, ordered from Japan at great expense, proved entirely un-

238

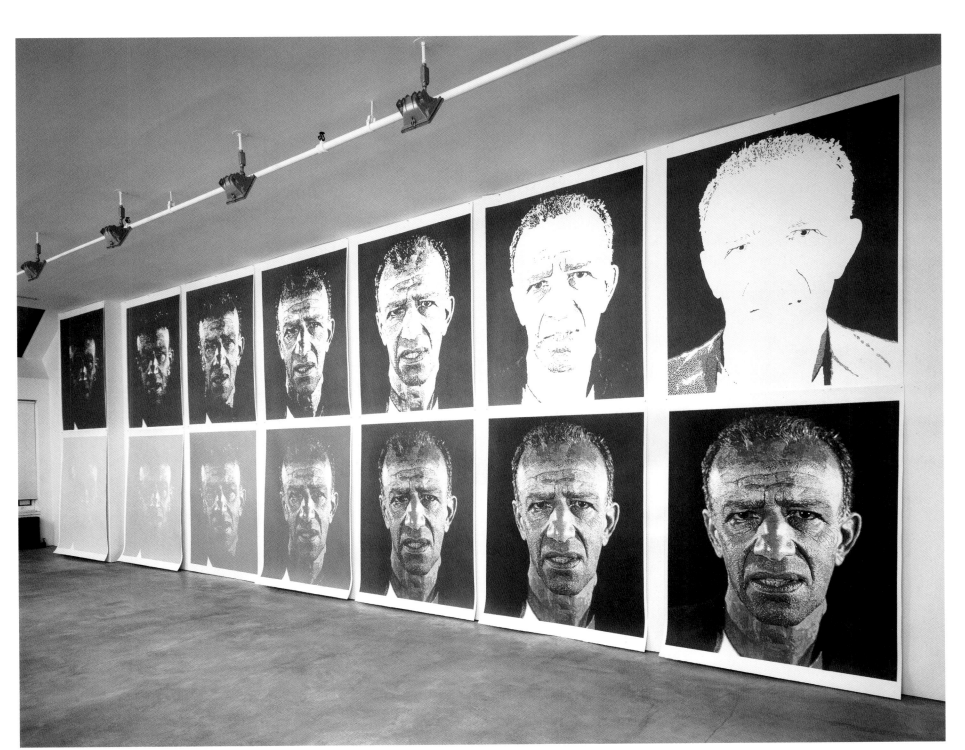

► Alex/Reduction Print, 1993.
Silkscreen, 79 3/8 x 60 3/8 in. (201.6 x 153.4 cm)

following page: detail

satisfactory, bearing no resemblance to the samples that had been provided. (Some sheets had a seam down the middle.) It became apparent to Close that he was not going to be content with the quality of the end product and since, as noted, reduction block printing is a subtractive process in which the blocks for previous layers cease to exist once used, there is no way of going back to fix things. There was in fact nothing wrong with the blocks themselves, so the team went ahead with printing, and at the end of printing each color, had the block re-inked with black ink which was then printed onto Mylar, so that a record would exist of every stage.

Close likes to say, of printmaking in general, "Something always goes wrong, and there's always a solution." In this case, the solution turned out to be rather straightforward, though conceptually bold. Screen prints are made by transferring images on Mylar to fine mesh "screens" that have been rendered light-sensitive by being coated with an emulsion, a process that produces a form of stencil. Ink is forced through these stencil-screens, onto paper or some other support, by means of a squeegee. A simple image can be created from a single screen, but more complex images involve many screens and many passes using different colored inks.

It would be possible, then, to take the Mylars printed in Wisconsin, transform them into screens, and print from those screens. This task was given to Brand X, a New York workshop, and they were able to produce a handsome edition that is, in effect, a hybrid of screen printing and reduction block printing. If Close had set out from the beginning to make a screen print, it would have been different, because the appearance of *Alex/Reduction Block* remained almost totally determined by the process of carving involved in creating the linocut.

Close points to this as an example of how his application of process—while it is central to his working method—is not inflexible.

"An uncompromising process artist would have gone with the woodblocks on the flawed paper, whatever the imperfections.

That would have been true to the process—and it's actually what Joe Wilfer wanted to do. I will stay with the process all the way *only* if it gives me the results that I want. I'm not a purist. The quality of the end product is what I'm interested in."

• • •

Prior to making the pragmatic decision that resulted in production of this hybrid, Close had never had any interest in making screen prints, thinking of them as suitable for posters, commercial reproductions, and for the kind of art that draws directly upon mass market imagery—he quotes the examples of Roy Lichtenstein and Andy Warhol—but certainly not for his own work. The experience with *Alex*, however, convinced him that he had underestimated the potential of the medium. Silkscreen printing, as it had evolved by the mid-nineties, was capable of subtleties he had not realized were possible:

Alex in fact helped launch a continuing relationship with the Brand X studio, where over the next several years he produced a number of editions, working with master craftsmen including Robert Blanton, Thomas Little, and John Stauber. The first of these, issued in 1995, derived from his 1991 oil on canvas self-portrait. Although not as large as the painting, this is still a very large print (64 1/2 by 54 inches) that presented the printmakers with a considerable technical challenge. At first glance, this is a black-and-white image, but on closer inspection it proves to be made up of many different colors—from pale flesh tones to rich blue-blacks—in a variety of different densities, shades, and tints. In fact, this is an eighty-color silkscreen, each color requiring a different drawing on Mylar and a fresh screen. (To be more precise, the same screen is reused, but between passes one stencil is erased and replaced by the next.)

This image was based closely on the existing painting, one made up of tens of thousands of pieces of calligraphic informa-

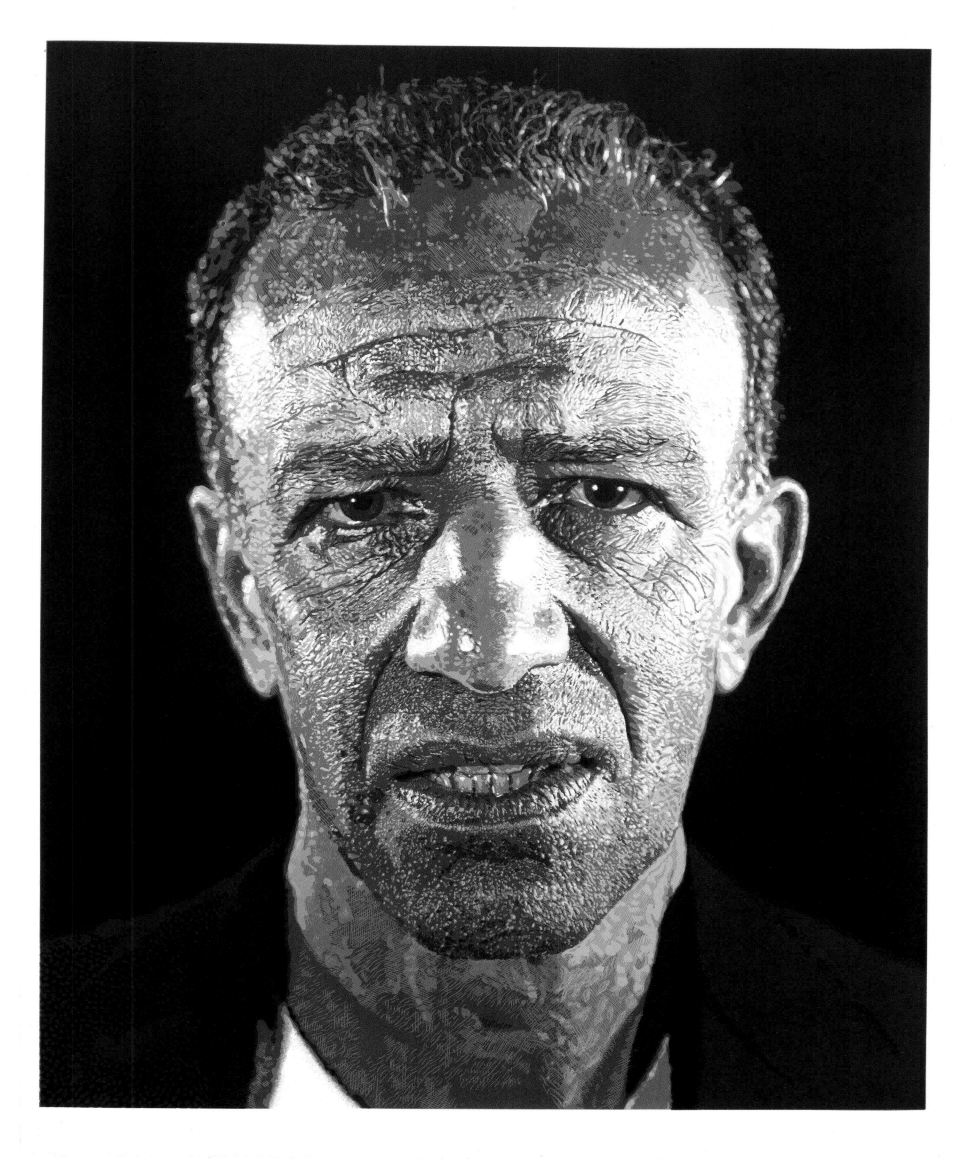

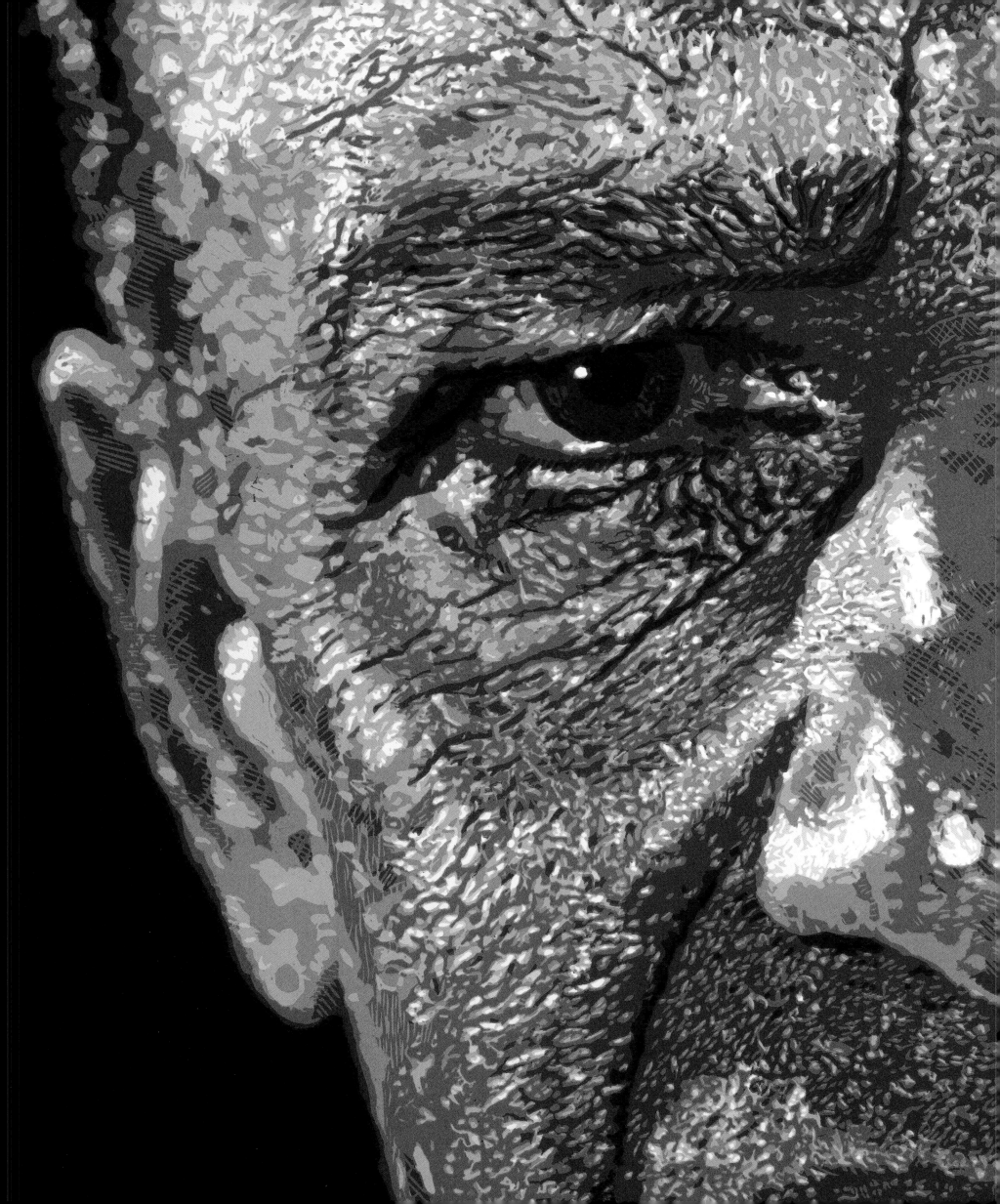

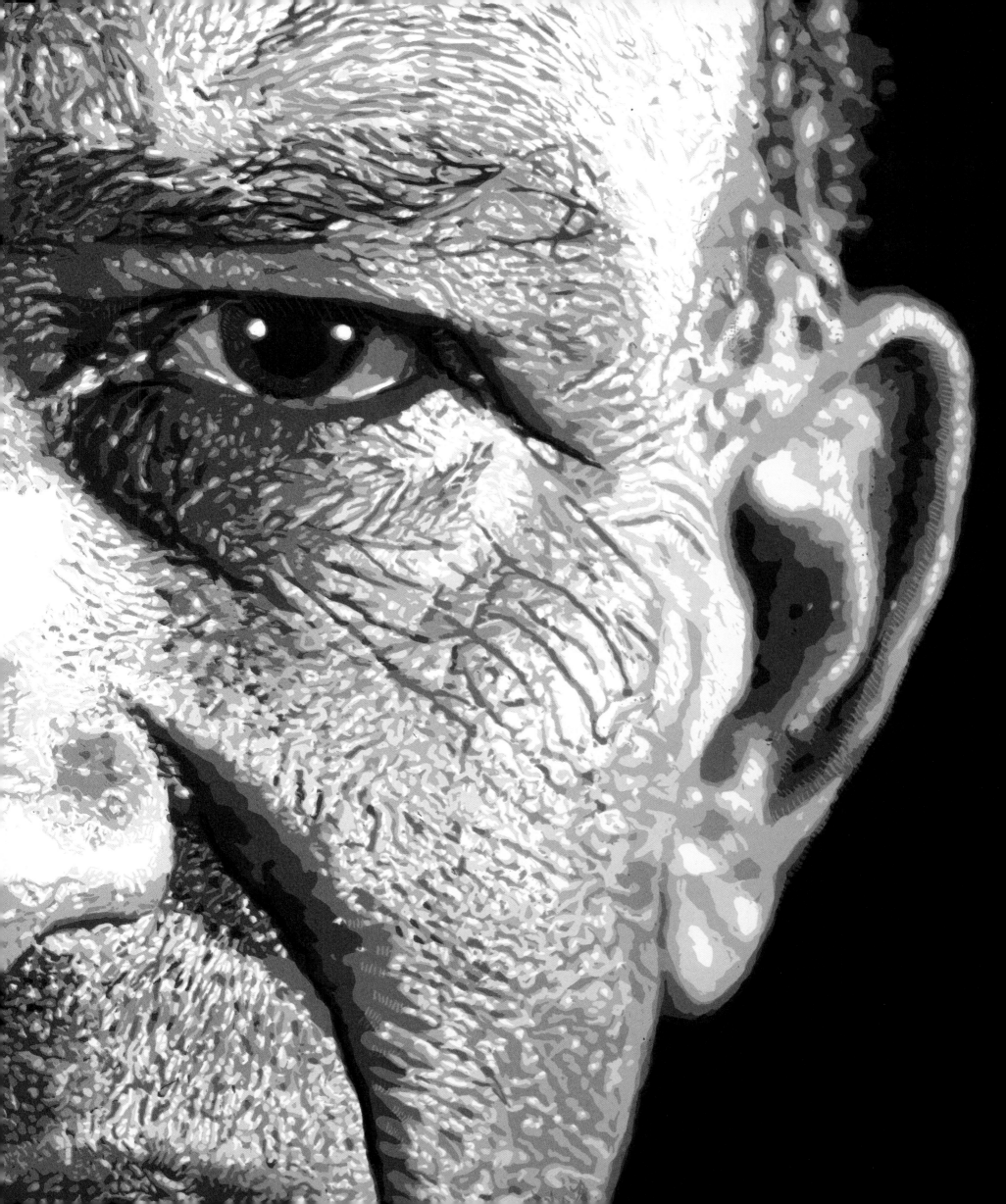

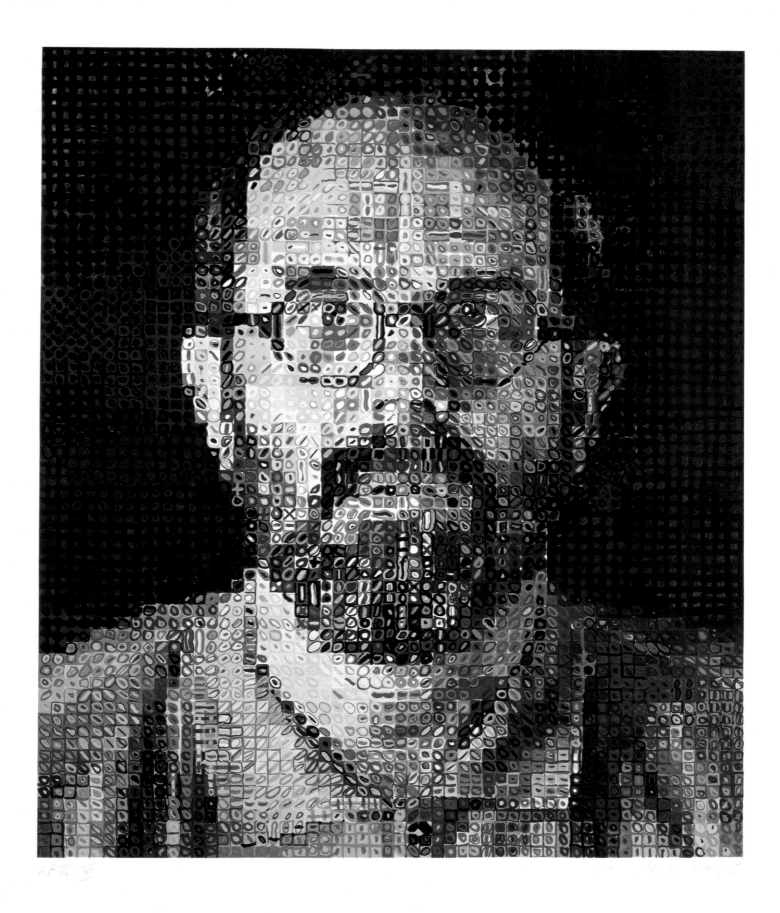

Self-Portrait, 1995.
80-color silkscreen, 64 1/2 x 54 in.
(163.8 x 137.3 cm)

➤ **Self-Portrait** (detail), 1995

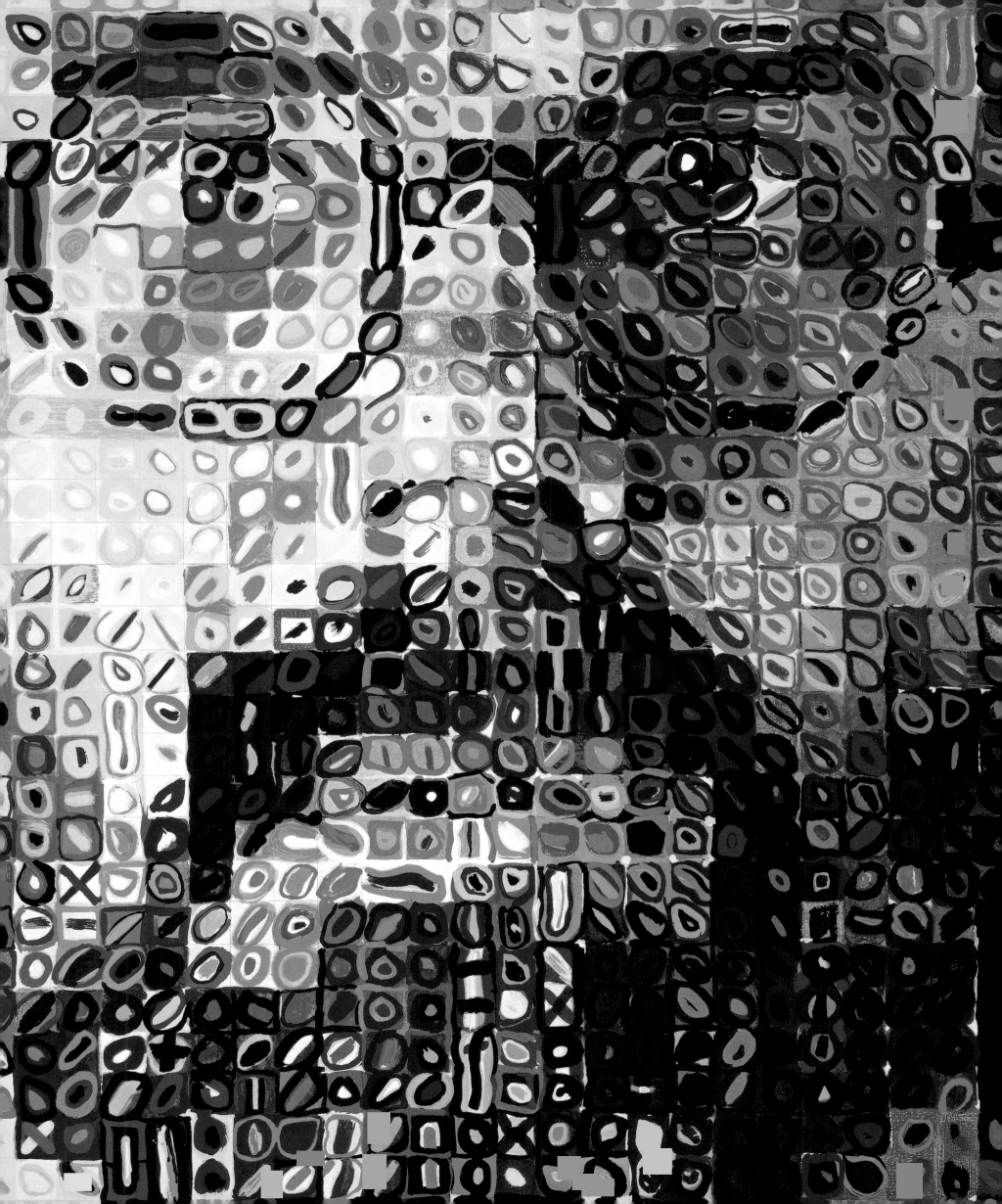

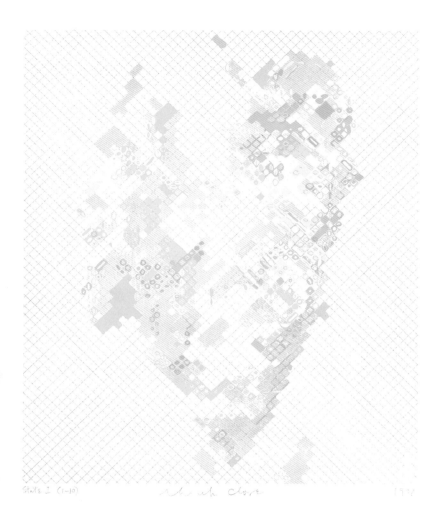

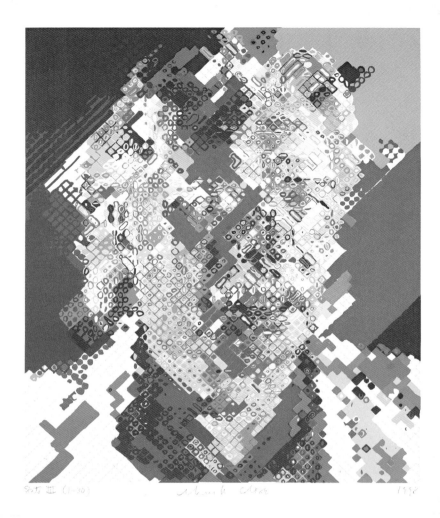

246

tion, meaning that every square of the grid that underlies the painting had to be reproduced as convincingly as possible. Each loop and swirl had to be translated by hand onto Mylar (a challenge taken on by Tom Little) in such a way as to capture the essence of Close's brushstrokes, even though the spontaneity of the gesture was not available to the silkscreen artist. To make things more complicated, the whole process had to be planned in terms of working from light to dark, from warm to cool, and for the most part from transparent to opaque. The printers began by estimating the number of colors required, breaking them down into thirty light, thirty medium, and thirty dark. This careful preparation enabled them to approximate the process that had been employed to realize the painting, though in a way that was necessarily modified by the requirements of the medium, thus giving the image a distinctive quality of its own. In the final stages, when the image in its entirety was rather fully developed, a process of correction came into play, much like the adjustments involved in the final

stages of producing one of the illuminated grid paintings. Just as Close might modify a wedge of oily darkness with a lighter dab of translucent glaze, so the printers might achieve similar results, under his supervision, by adding touches of transparent ink.

Subsequent screen print editions have included highly chromatic images such as *John* (1998), which employed 126 colors, *Self-Portrait* (2000), utilizing a modest 111 colors, and *Lyle* (2002; p. 250), which called for 149 colors (and hence 149 Mylars, 149 screens). Each of these derives directly from a preexisting painting, which in part accounts for the scale (all three are more than five feet tall). When a print derives directly from a large painting, Close explains, it's important to him that they have the same quality of bigness so that they retain the same kind of impact, and also so that the bits of information from which the image is built can dissolve into abstract detail when the print is viewed from close up.

Images such as *John* and *Lyle* were enormously difficult to conceptualize from a printmaker's point of view. In working with

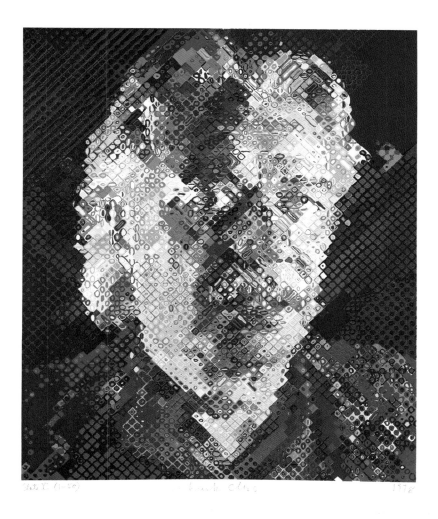

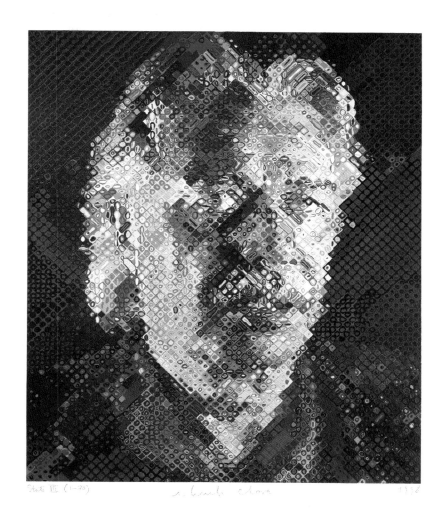

Close, the printmakers gradually evolved a pragmatic approach that modified the logical system which, for example, suggests that it makes sense to work from light to dark. In the case of *John*, both lights and darks were established early on so that there would be clearly defined points of reference to work with. The method that was arrived at to some extent mimicked the way Close works on his paintings, a systematic but far from rigid approach in which constant adjustments result in a richness that could not be arrived at by pedantic adherence to rigor for its own sake. Since they were working from an existing model, the printmakers could not adopt this approach in its entirety, but the extent to which they could understand and empathize with Close's methods ensured that the prints would retain much of the vibrancy of the paintings.

All of this involved the Brand X team in working with the artist at every stage and in every detail. With screen prints, where the artist cedes more hands-on control than is the case with, say, an etching, a key part of the collaboration takes the form of verbal interchange. That is also the case with traditional Japanese woodblock prints—of the sort made familiar through the work of ukiyo-e artists such as Utamaro, Hokusai, and Hiroshige.

This process involves complex interaction and trust between artist, wood engraver, and printer. In the West, we are familiar only with the names of the artists who designed the prints, but in Japan the printers themselves are considered artists/craftsmen of the highest order, as Chuck Close discovered in 1986 when he and Kathan Brown of Crown Point Press went to Kyoto to work on his first Japanese woodblock, *Leslie* (see p. 163). Before arriving, he had sent a gouache to the master printer, Tadashi Toda, as a working guide. When Close stepped into the print shop for the first time, he was shocked to discover that Toda had not only begun work on the project but was interpreting it according to his own inclinations. This was normal practice for a Japanese printer as highly regarded as Toda. Close, however, had no intention of losing control of the project and so was forced to enter into an elaborate dialogue,

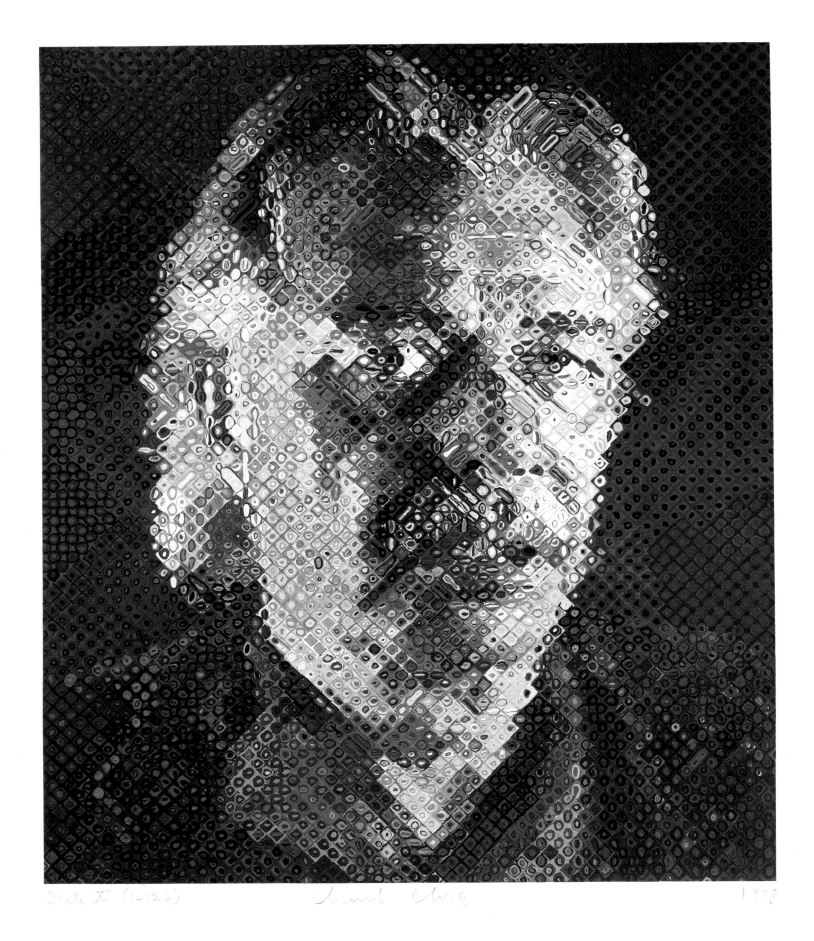

248

State I (1-126) Senate Close 1992

made difficult by cultural differences and the lack of a common language. Luckily he was able to turn to Hidekatsu Takada, a Japanese-trained printer who had spent half his life in California. He was able to translate Close's instructions in such a way—larded with carefully worded honorifics—as not to offend Toda's sense of etiquette and professional pride.

"This turned out to be a good experience," Close says, "because it taught me how printmaking can be a collaborative activity."

Since the early 1990s, Close has made more Japanese-style woodblock prints, though always working in America, with printers such as Yasu Shibata who was his collaborator on *Emma* (2000; p. 254), an especially complex 113-color print that utilized 27 very large blocks, each measuring 44 by 36 inches (see pp. 252–53). Because of the registration problems involved in printing on damp paper (paper's constituent tissues expand and contract according to moisture content) ukiyo-e prints were traditionally quite small. Working on this scale, then, was a challenge, but once again the size was important to Close because he wanted to approximate as nearly as possible the scale of the painting (in this case 72 by 60 inches).

Shibata began by spending time in front of the painting, and went so far as to mix some of his colors—as many as practical—on the spot. Back in his workshop, with a large transparency and a photograph for reference, he began to carve the blocks. The complexity of the subject, with its grid of fragmented shapes and colors, forced him to work largely by trial and error, pulling proofs from an early stage in order to discover how the colors would interact and what order they should be printed in, taking into account such considerations as transparency and opacity. (As noted earlier, the logic of working from light to dark does not always apply to Close's imagery.)

When this procedure had reached the stage of a third proof, in which nineteen blocks and eighty-eight colors had been used, the dialogue between artist and printer began in earnest, with Close specifying the changes he required, and Shibata experimenting with ways of making the necessary corrections, starting fresh with a new proof each time, applying ink to the blocks with special bamboo and horsehair brushes, and printing each block by hand, using a tool known as a baren.[20] The result was a tour de force that took more than a year and a half to complete. The painting that was its source had taken just three months.

. . .

European woodcuts differ from their Japanese cousins in that they are made with dense, oil-based inks rather than translucent, water-based inks, in which regard they are closer in material character to oil-paintings than are the ukiyo-e–style prints. Because of this, when Karl Hecksher collaborated with Close on a European woodblock version of *Lucas* (1993; p. 257), he was able to follow very systematically the procedures Close had used in making the painting *Lucas II*. As noted in an earlier chapter, when working on the prismatic grid paintings, Close begins by laying down arbitrary fields of color that provide him with a starting point that is to all intents and purposes the opposite of conventional underpainting in that it does very little to define form. The artist is simply giving himself something other than a blank canvas as a starting point, but this initial random distribution of color does have some impact on the final chromatic makeup of the painting because it influences the choices of color that follow as swirls of pigment are superimposed. Each dab of paint modifies what is already there, and glimpses of underpainting will be visible in the finished work (just as white linen highlights might be allowed to show through in a more conventional work). Given the character of the inks he was using, Hecksher was able to begin to build his image in much the same way.

Lucas II (p. 173) is the portrait of Lucas Samaras that utilizes a grid based on concentric circles. This dictated setting down that

249

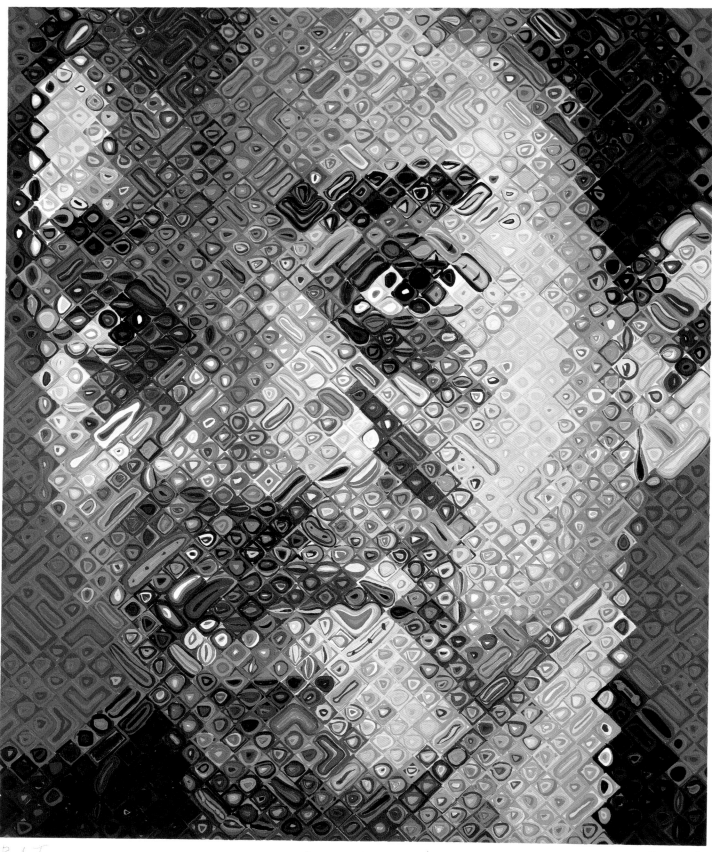

250

BAT *Chuck Close* 2003.

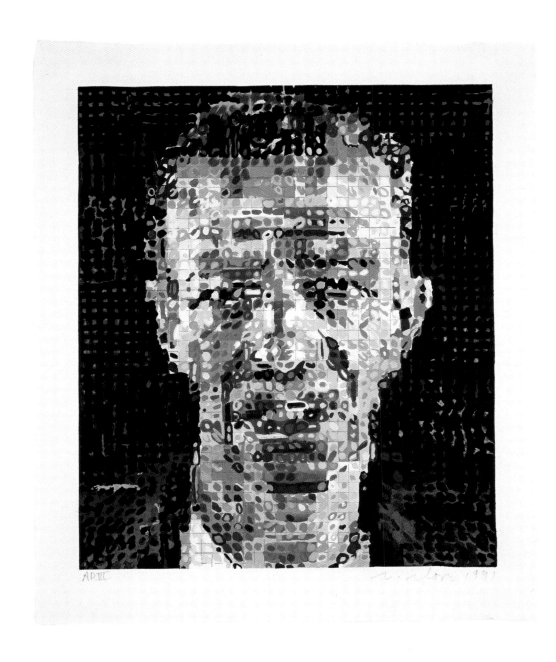

◂ Lyle, 2003.
149-color silkscreen, 65 1/2 x 53 7/8 in.
(165.7 x 136.5 cm)

Alex, 1991.
95-color 47 Japanese-style woodcut, 28 x 23 1/2 in.
(71.1 x 59.1 cm)

Emma, 2002. Woodcut blocks 1, 8, 15, 20.
Maple plywood, each: 36 x 44 in. (91.4 x 111.8 cm)

252

253

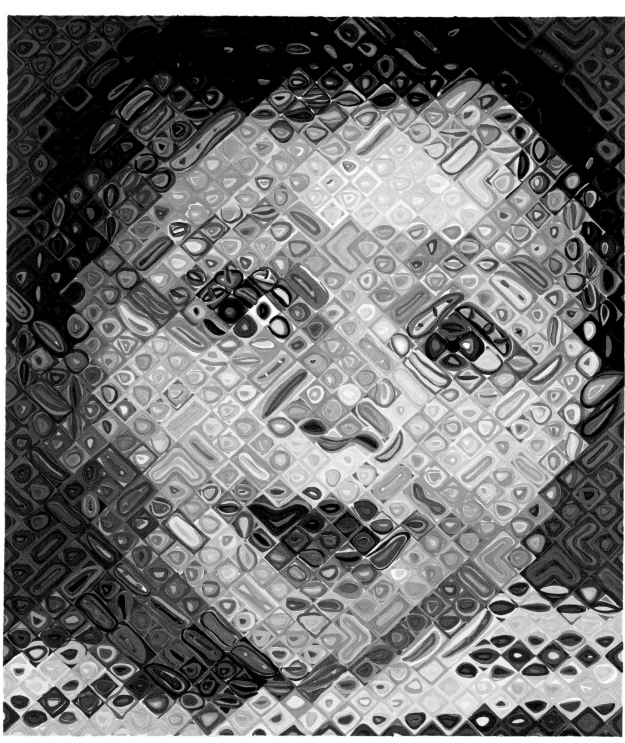

254

23/55 *Chuck Close* 2007

◄ Emma, 2002.
123-color Japanese woodcut,
43 x 35 in. (109.2 x 88.9 cm)

first layer of random colors in irregular pie-shaped wedges around the center point. To match this procedure, Hecksher created a block that Close describes as "a kind of jigsaw form." This featured cut-out shapes designed to plug into a motherboard (p. 256). Each shape could be removed and inked individually, then plugged back into the matrix. This technique allowed the printer to lay down interlocking areas of flat color that served as the ground upon which other levels of the image, printed from other blocks, could be overlaid. As is clearly apparent from the finished image, many blocks were involved. As with the Japanese woodcut Emma, this version of Lucas would take a year and a half to proof and edition, all printing being done by hand, without use of a press.

. . .

Relief prints, such as the varieties of woodblock, are very different in character from intaglio prints such as etchings and engravings. With relief prints, the image is created by inking and printing the raised part of the block; what has been cut away does not register. With intaglio prints, the reverse is true. The surface of the plate (usually copper or zinc) does not print. Instead, ink is held in the furrows that have been cut or bitten by acid into the metal, so that what is transferred to the paper support has somewhat the quality of a line drawing or, in the case of a variant such as mezzotint, a halftone character. Often different intaglio methods are combined in a single image.

As described in Chapter 3, Close's first serious foray into printmaking was the large Keith/Mezzotint (p. 90). In 1988 he made his first spitbite etching, an intaglio process he has since returned to on a couple of occasions. This is a variant on the more familiar aquatint method that involves dusting a plate with powdered rosin, then heating the rosin so that it melts into beads that adhere to the plate. When the plate is exposed to acid, the acid etches the metal around each bead of rosin, providing the necessary bitten texture to hold ink, which will print as a rather even tone, if properly done. For a standard aquatint, areas of the plate are stopped out with varnish. The acid will not etch these areas, which will remain white when the plate is printed.

In the case of a spitbite etching, instead of stopping-out and then exposing the whole plate to an acid bath, the acid is applied to the aquatint ground with a brush. The term spitbite derives from the fact that the nitric acid is actually diluted with saliva. Close's 1988 outing with the method was a self-portrait made in collaboration with Aldo Crommelynck, who had worked extensively with both Picasso and Matisse. Close discovered that he was able to use spitbite to manage much the same effect as he had achieved using an airbrush to make black-and-white drawings back in the seventies, building the image on a grid from dots of various densities. In this case, the densities would be determined, according to the same gray scale used in some of the paper-pulp pieces, by the length of time the acid was allowed to bite into the area defining a given dot. For the lightest tones, the acid would be allowed to work for just a split second (timed with a metronome) before it had to be blotted off the plate (using baby diapers because of their absorbency). For darker tones, the acid might be left in place for several minutes.

In 1995 and 1997, Close employed the same basic method, in collaboration with the printers of Spring Street Workshop, in New York, to make Phil/Spitbite (p. 261) and Self-Portrait/Spitbite (White on Black). For the latter, sheets for the edition were first of all printed solid black from an aquatint plate, and then the spitbite plates were printed in white, an unusual approach that derived from drawings he had made in the seventies and eighties.

This habit of returning to his previous work as inspiration for new projects remains a constant in Close's evolution. It is not so much a self-conscious device as an openness towards drawing upon memory and experience in an organic way. Interesting ideas have a habit of taking root, even when initially they may have led to

255

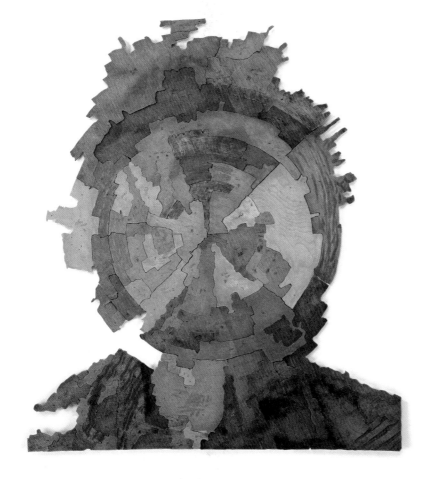

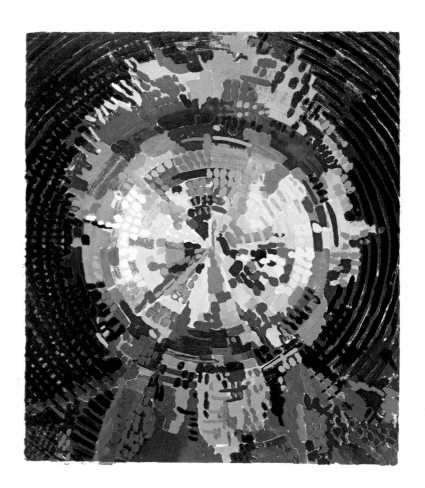

➤ **Lucas/Woodcut**, 1993.
Woodcut with pochoir, 46 1/2 x 36 in.
(118.1 x 91.4 cm). Edition of 50

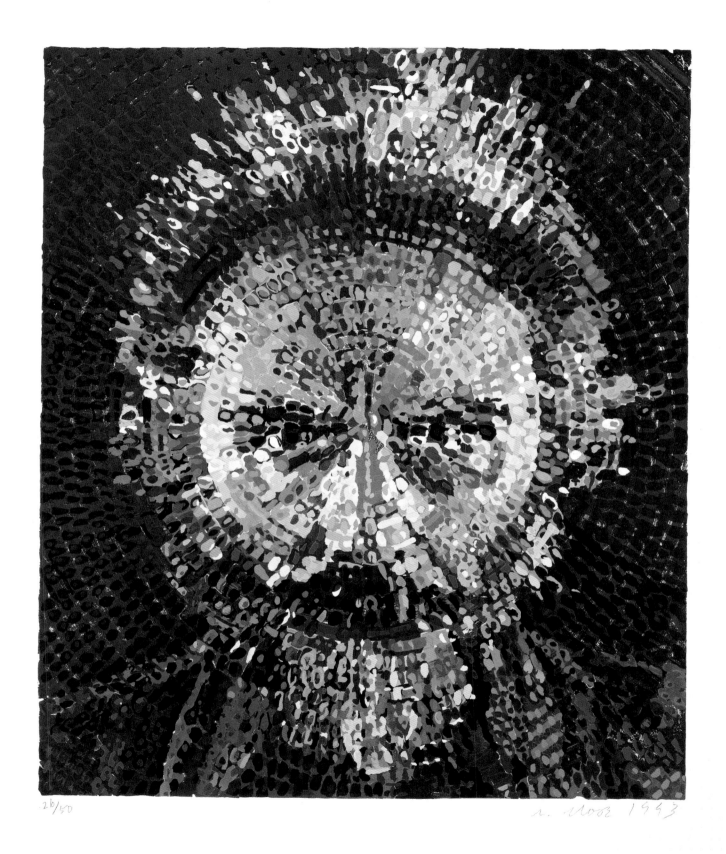

26/60 v. Moos 1993

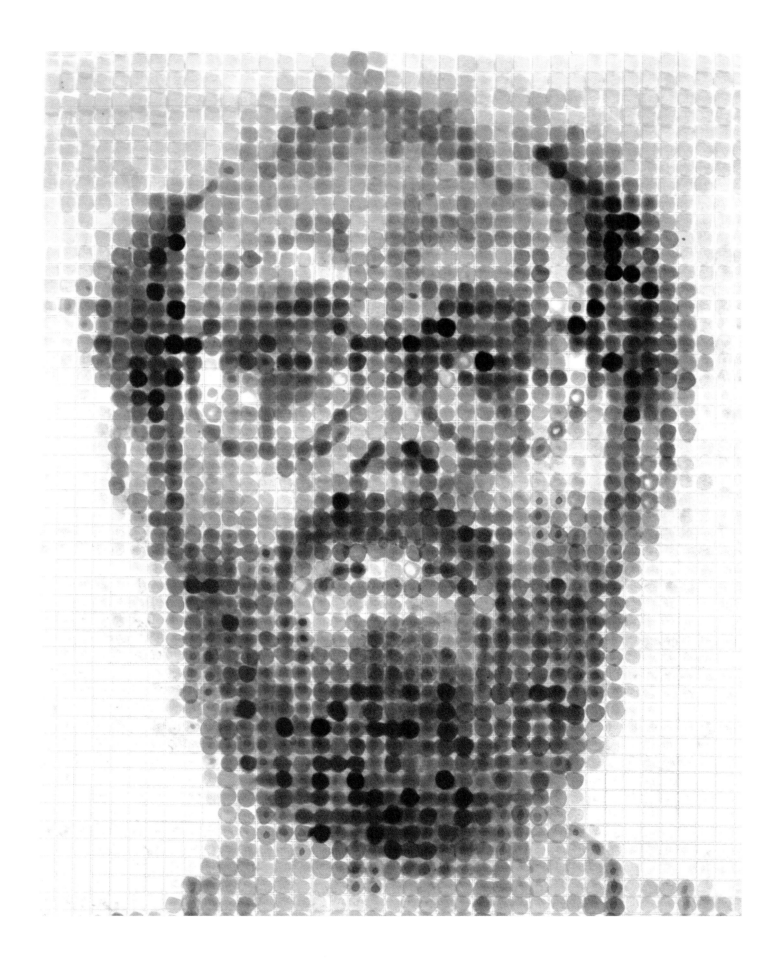

Self-Portrait (detail), 1988.
Spitbite etching, 20 1/2 x 15 5/8 in.
(52.1 x 40 cm)

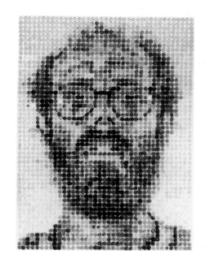

Self-Portrait, 1992.
Etching, 19 1/2 x 15 1/2 in.
(49.5 x 39.4 cm)

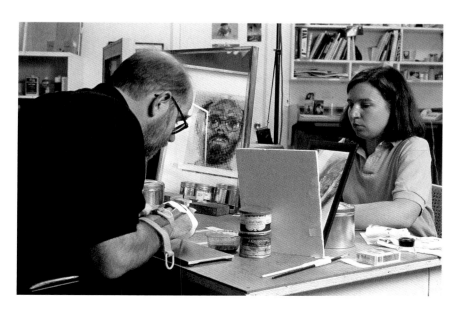

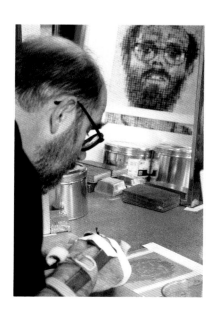

Chuck Close working on
Self-Portrait, 1992

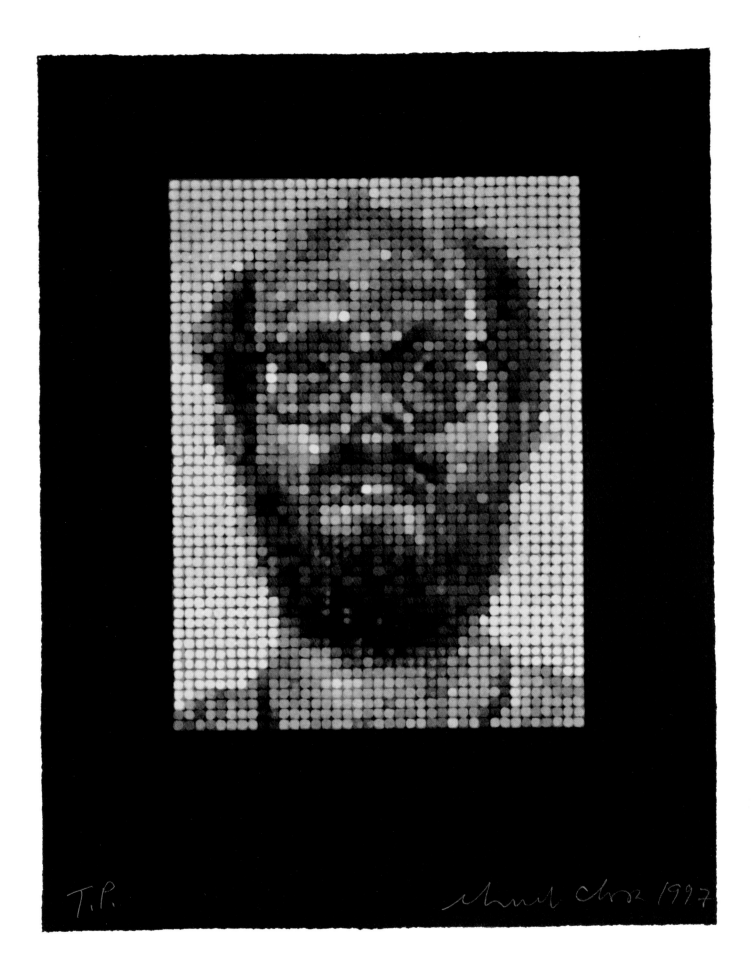

T.P. Chuck Close 1997

Self-Portrait/Spitbite/White on Black, 1997.
Spitbite aquatint, 20 1/2 x 15 3/4 in.
(52.1 x 40 cm)

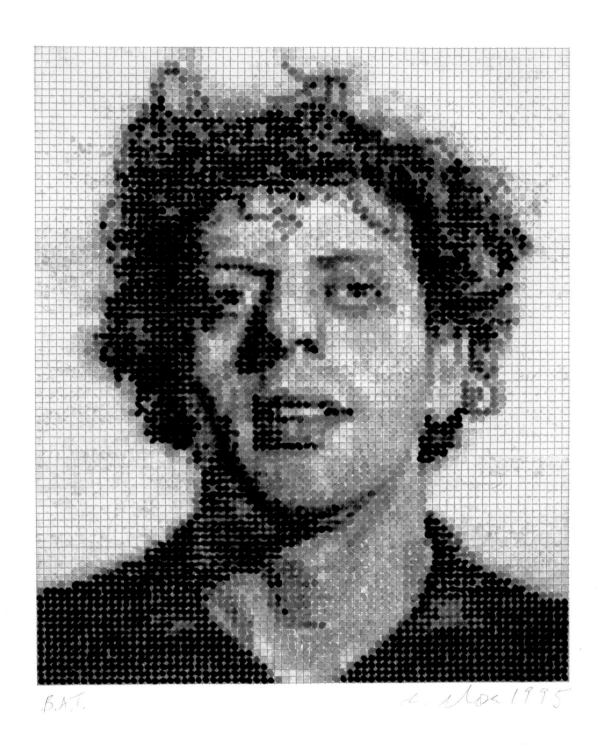

B.A.T. C. Close 1995

Phil/Spitbite, 1995.
Spitbite etching, 28 x 20 in.
(71.1 x 50.8 cm)

Self-Portrait/Scribble/Etching Portfolio, 2000.
12 states, each displaying a single color from final etching print,
18 1/4 x 15 1/4 in. (46.4 x 38.7 cm)

Self-Portrait/Scribble/Etching Portfolio Progressive, 2000.
12 states, each displaying a progressive state from portfolio of 12 progressives,
12 states, and 1 final signed print, 18 1/4 x 15 1/4 in. (46.4 x 38.7 cm)

 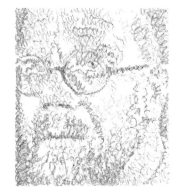 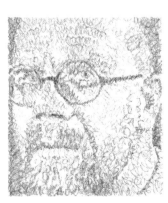

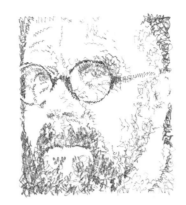

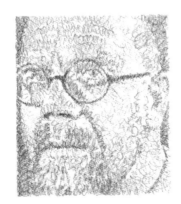
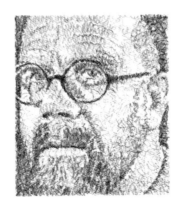
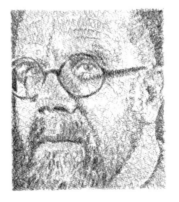
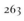

Self-Portrait/Scribble/Etching Portfolio, 2000.
(continued from previous pages)

264

Self-Portrait/Scribble/Etching Portfolio, 2000.
(continued from previous pages)

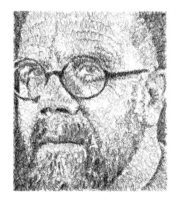 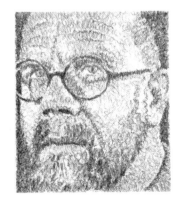 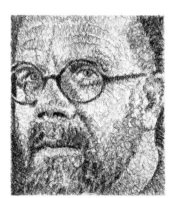

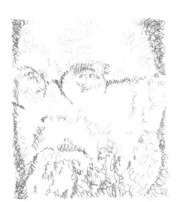

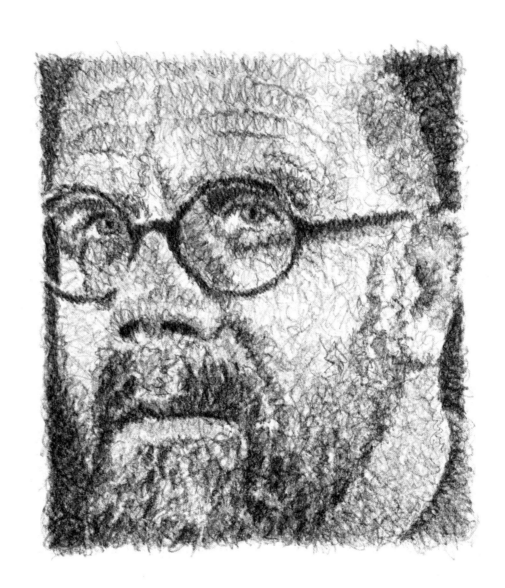

9/15 Chuck Close 2000

◄ Self-Portrait/Scribble/Etching Portfolio Final Print, 2000.
Final signed print from portfolio of 12 states and 12 progressives,
18 1/4 x 15 1/4 in. (46.4 x 38.7 cm)

unsatisfactory results. Back in the early 1970s, when he was working on the continuous-tone color paintings, Close began to think about the possibility of making prints using the same principal of three-color separation. At the time, he experimented with this idea at the Tyler School of Art in Philadelphia. It didn't work, but the idea kept popping back into his head. In the late nineties, he made a collaborative Exquisite Corpse drawing, his contribution being the head. He created the image with overlaid red, orange, green, and purple lines. Liking the results, he was prompted to adapt the technique to printmaking.

Close discussed his idea with Bill Hall and Julia D'Amario of Pace Editions, and the results included *Self-Portrait* (2001), a smallish soft-ground etching, *Lyle* (2000), and a suite of soft-ground self-portrait etchings, also published in 2000 (pp. 262–65). Issued in an edition of fifteen, the latter consists of a set of twenty-five prints, of which twelve are single-color proofs printed from the twelve individual plates used, twelve are progressives showing how these plates were combined cumulatively to create the final image, and one is a signed finished print. All of these images are built from free-form squiggles, leading Close to describe them as scribble etchings.

A soft-ground etching begins with a plate (or plates) that has been coated with a waxy, semi-soft kind of acid-resistant ground. A sheet of paper is placed over this and the artist draws on the paper with a pencil, crayon, or some other tool. When the paper is removed, it picks up the ground beneath the marks the artist has made, and the plate is then bitten with acid in the usual way. The advantage of this method is that it can be used to produce lines that are soft and grainy, so that the print appears very much like a pencil or crayon drawing. Close's notion was to make a number of these "drawings"—a dozen in the case of the self-portrait suite, in different colors that, when printed on top of one another, would produce something approximating a full-color effect. Three pri-

mary colors alone would not have achieved the desired results, so that secondary colors and black were also used. As in the case of the reduction block prints, Close departed from his normal practice by making the drawings from projections of the images rather than from a grid (which self-evidently would not have worked for the scribble images). In the case of the self-portrait suite, the plates were created rather quickly, but the process of proofing and editioning was carried out over a period of two and a half years.

. . .

Shortly after the scribble etching suite, Close returned to working with handmade paper for *Self-Portrait/Pulp* (2001), a large (57 1/2 by 40 inches) full-face likeness issued in an edition of 35. This was based on, and elaborated from, a much smaller reduction linoleum-cut self-portrait from 1997 in which the image was evoked from what appears to be circular dabs of white and graded tints of gray applied to a black ground (though in fact, given the reduction process, black was the last color applied).

To produce the pulp version, it was first necessary to create a brass grill, similar to the one made by Joe Wilfer for the 1984 pulp edition of *Georgia*, though less elaborate (see p. 136). (Close's chief collaborator on the 2001 project was Ruth Lingen, who had been Wilfer's trusted assistant and became his successor. She has worked with Close on a number of editions.) The new grill was used to produce a schematic version of the head employing a range of grays married to a black pulp ground. Then stencils cut from plastic sheeting were used to place blobs of pulp (by means of cake-decorating tools), prepared in the same range of grays, to create a powerful image in which the detail is established by means of a simulated stipple effect.

. . .

One reason why prints are so central to Close's career is the fact that all printmaking techniques are about process. Whether the

268

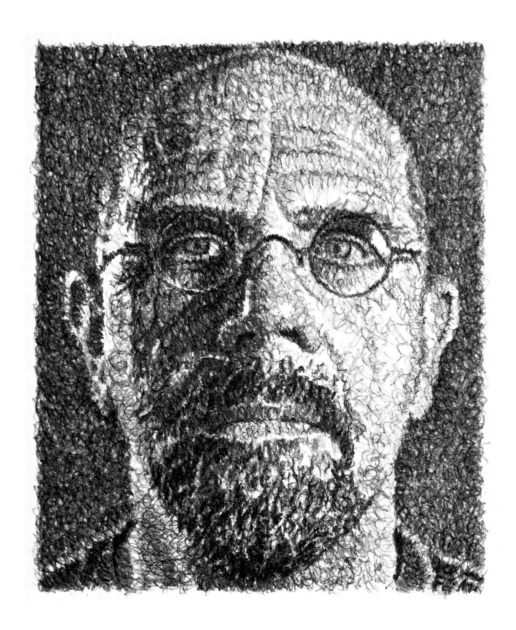

60/60 Chuck Close 2001

Self-Portrait/Scribble/Etching, 2001.
Softground etching from nine plates, 18 1/4 x 15 1/4 in.
(46.4 x 38.7 cm)

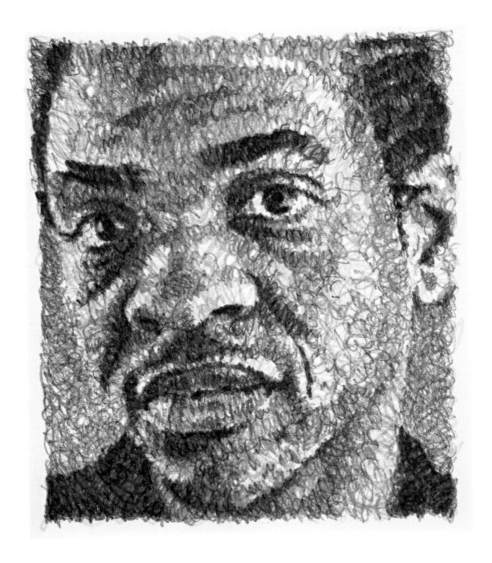

56/60 Chuck Close 2000

Lyle, 2000.
8-color, soft-ground etching, 18 1/4 x 15 1/4 in.
(46.4 x 38.7 cm)

270

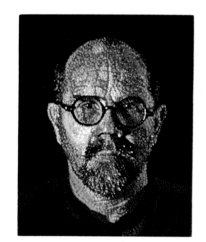

Self-Portrait I (Dots), 1997.
Reduction linoleum cut, 24 x 18 in.
(61 x 45.7 cm)

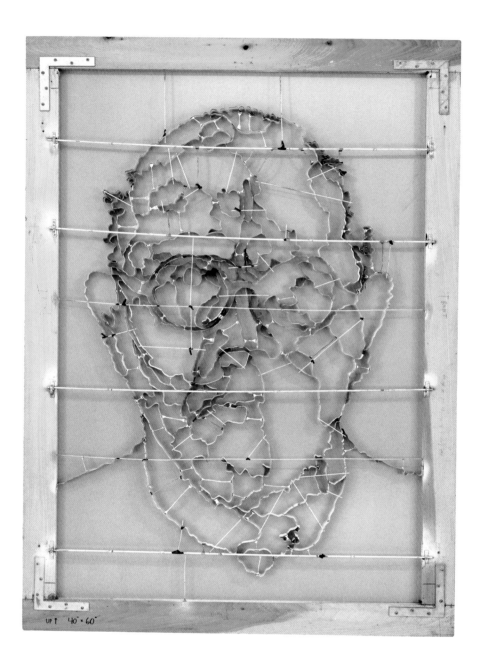

Self-Portrait-Pulp brass shim, 2001

➤ Self-Portrait/Pulp in progress

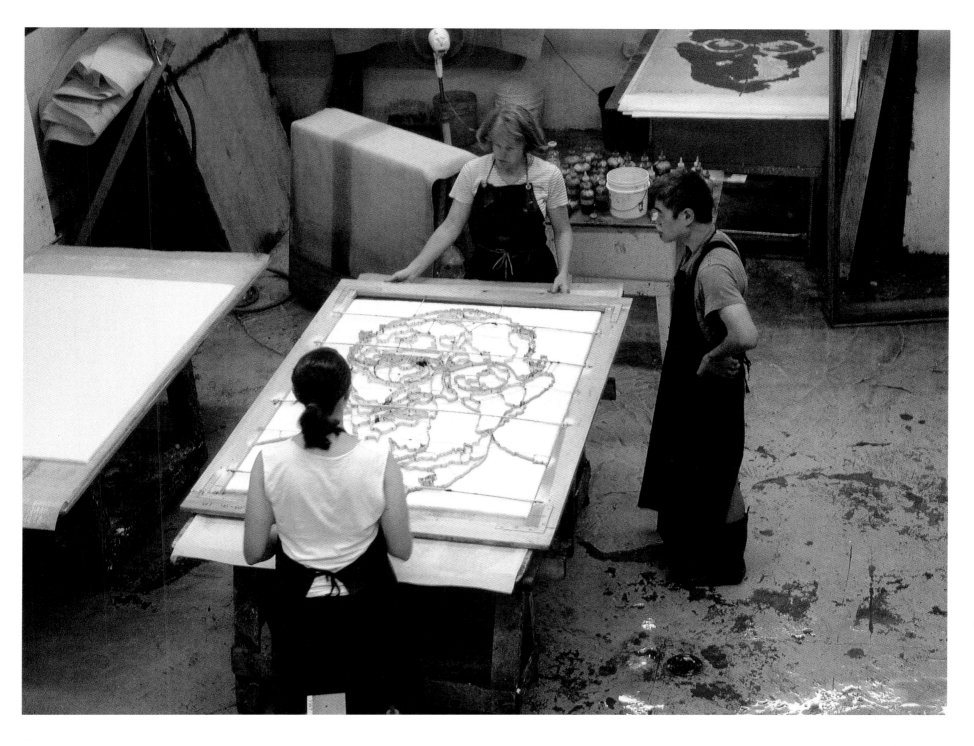

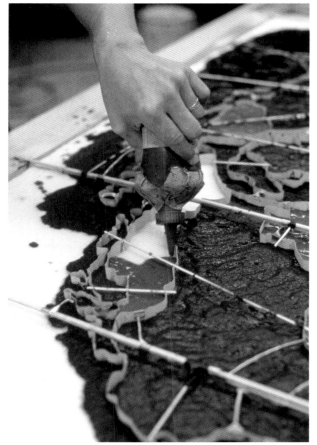

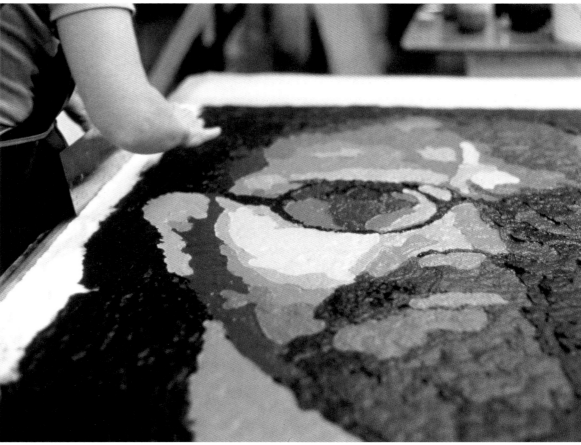

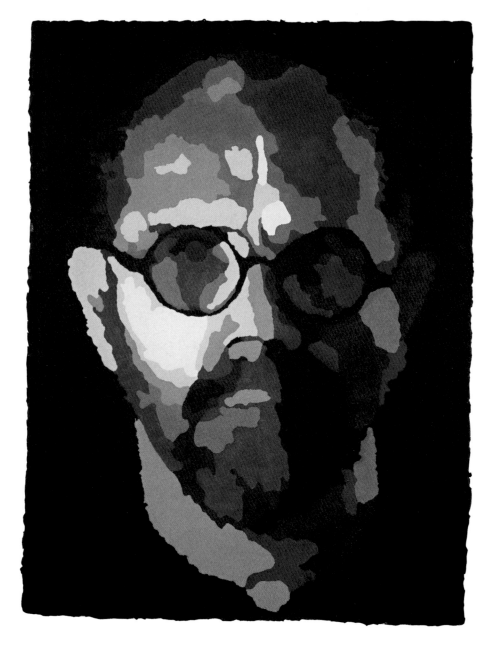
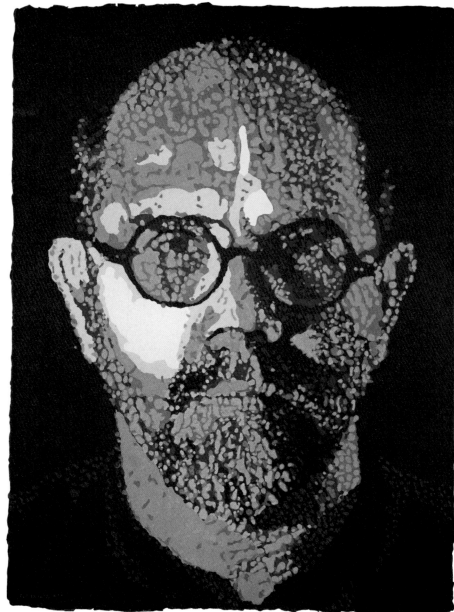

272

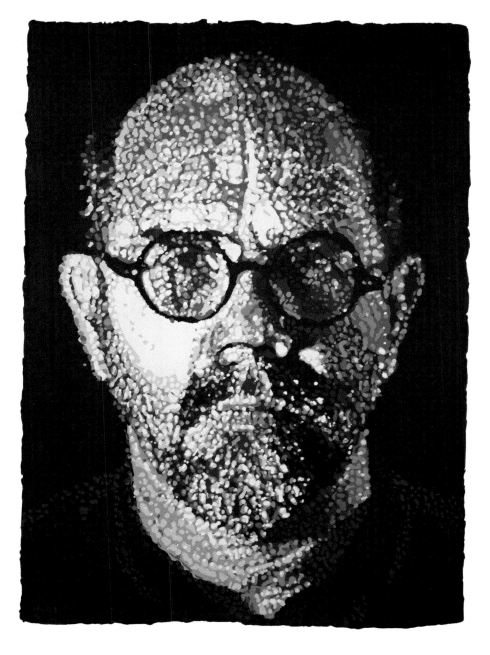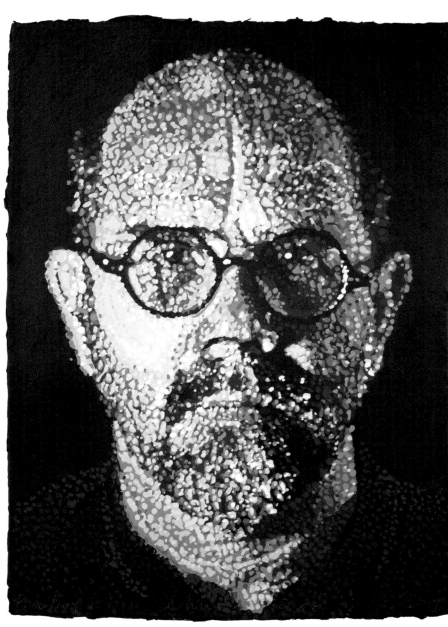

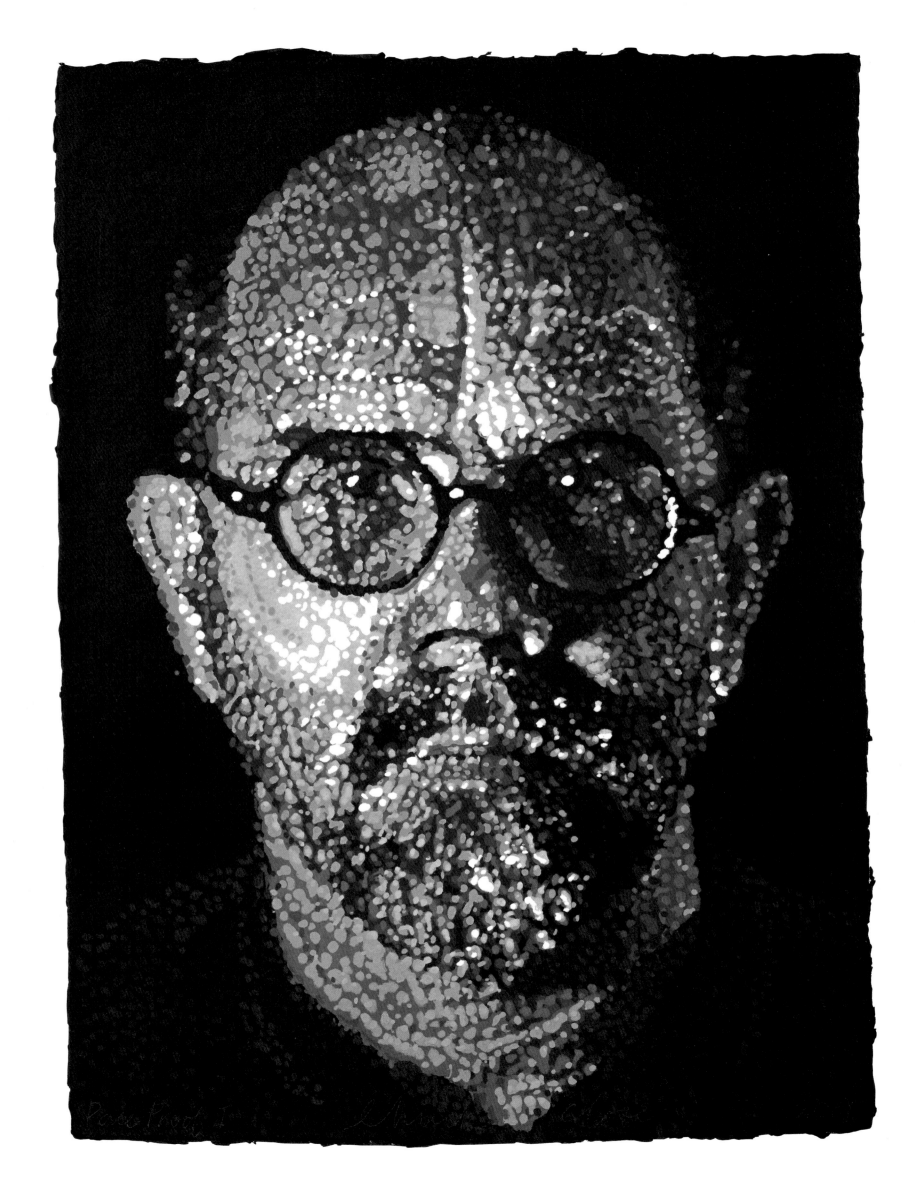

◄ Self-Portrait/Pulp, 2001.
Stenciled handmade paper pulp in 11 grays,
57 1/2 x 40 in. (146.1 x 101.6 cm)

medium is intaglio printing, relief printing, stencil printing, or planographic printing (such as lithography), there is always a definite procedure involved. Certain tasks must be performed in a certain order; a logic must be adhered to. Innovation and improvisation are possible, but always within parameters defined by a system.

System and process remains essential to all of Close's work—he says he wants to give a viewer the ability to enjoy seeing how something is made—but never in a pedantic way, as is very apparent in his approach to producing prints. It is in this area, in fact, when there are times where he finds that process has limitations, as is clear in the case of the reduction block linoleum-cut version of *Alex* that, because of the problems encountered, was transformed into a screen print.

When it comes to printmaking, the facts of life involved in collaboration, the ability to make full use of the talents of others (and their experience with a specific process), are always accompanied by a set of potential variables. The artist must be firmly in charge of the project, but he must be able to do so while remaining fully open to the creative contributions of his collaborators, especially when the collaborator is someone as inventive as, for example, Joe Wilfer. Close works effectively within the parameters this situation calls for because he is a very social person, able to communicate easily with his collaborators, and respond positively to their input, while never losing sight of his ultimate goal.

He begins a project having already earned respect, not only for his existing body of work but also by making initial demands that give notice of his intention to challenge the craftsmen he will be dealing with to push their abilities to the limit. "I want to make the largest mezzotint ever made," he will say, or, "We're going to make a woodcut that will require more than a hundred blocks." This immediately sets up a relationship in which everyone has to be on their mettle.

Close's entire career in printmaking is a story of high ambition and high achievement. One outcome of this is perhaps the most successful print show ever, the exhibition "Chuck Close: Process and Collaboration," organized by Terrie Sultan of the Blaffer Art Gallery at the University of Houston, where it made its debut in 2003. From there it traveled to the Metropolitan Museum of Art in New York, the first stop on a tour of museums and public galleries that at the time of writing extends indefinitely, with new venues still being added. Not just a selection of finished prints, this retrospective, supported by an informative catalogue,[21] illustrates the relationship between process and achievement in a way that an exhibition of paintings and drawings never could. By seeing sequential proofs, and sets of progressives (much as Close himself did when studying Rembrandt etchings at Yale), the viewer is able to grasp exactly how Close goes about creating works of art, and not only prints, because the presentation also makes it possible to deduce how his paintings are made.

275

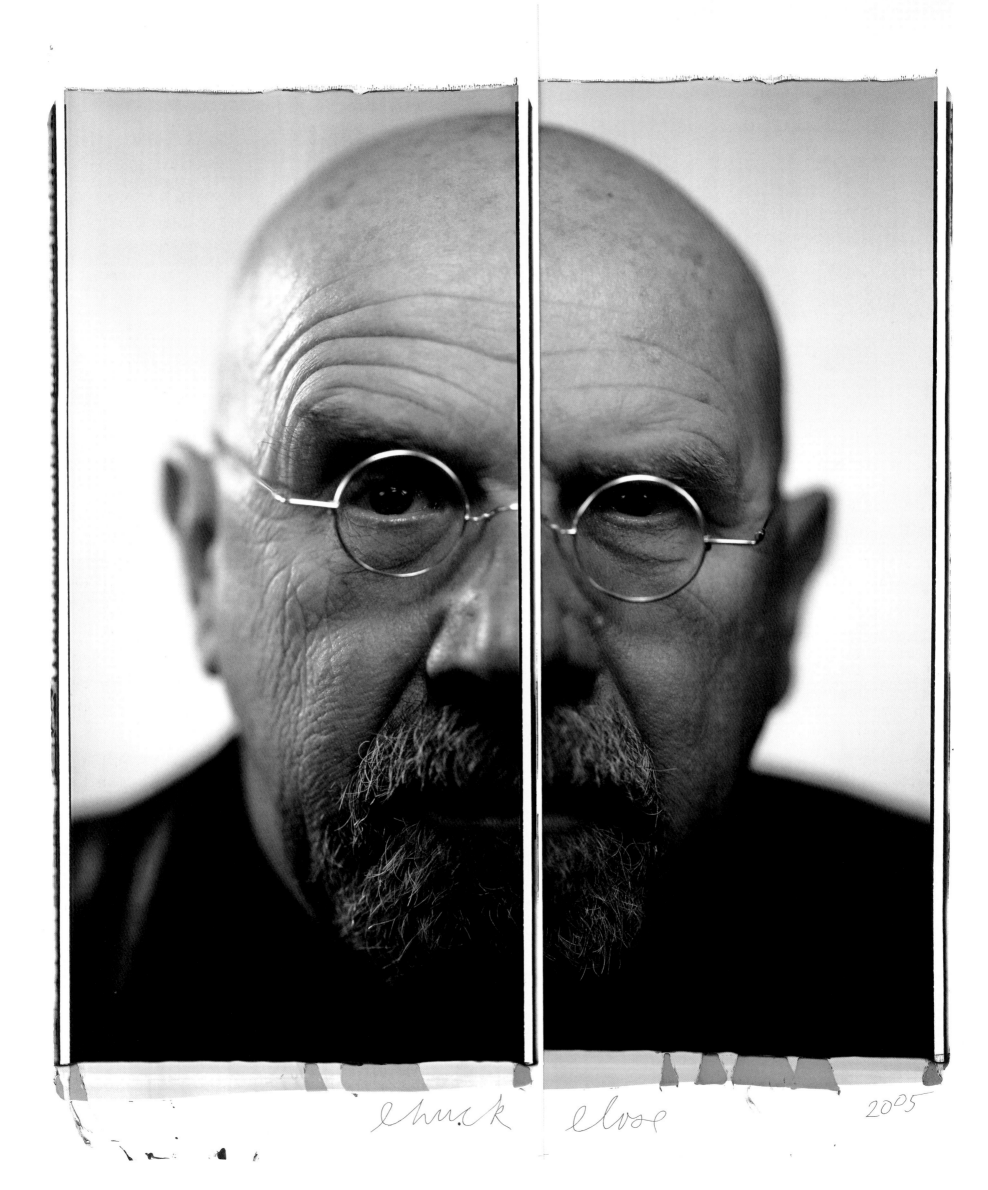

chuck close 2005

◄ Self-Portrait/Diptych, 2005.
Two color Polaroid photographs mounted on aluminum,
overall: 103 x 80 in. (261.6 x 203.2 cm)

Chapter 9:

PITILESS BEAUTY

In the past two decades, Chuck Close's involvement with photography has become more varied in scope, both from the point of view of the technology he has employed—most notably his successful experiments in producing modern daguerreotypes—and of the range of projects he has undertaken.

One constant has been his use, since the 1980s, of the large-format Polaroid camera to produce the images on which his paintings are based. Starting with the photographs made for the portraits included in the 1988 Pace Gallery exhibition, these differ stylistically from Close's early maquettes, both the gelatin silver black-and-white prints and the dye-transfer prints. This is especially true of the way they are lit, which is very relevant to the change in character of the paintings themselves. In the photos of the 1960s, and 70s—made for the continuous-tone heads—the lighting of the subject tends to be harsh and unflattering: sometimes flat, sometimes angled so as to produce heavy shadow on one side of the face.

In describing how he went about setting up the shots for these early maquettes, Close talks of deliberately doing everything a portrait photographer is not supposed to do. That was part of the mug shot aesthetic, and it went back to the maquette for the first self-portrait: the awkward angle, the reflections on the lenses of the glasses, the harsh shadows cast by their frames. That same unflattering lighting is also characteristic of the early Polaroids, starting with the first examples taken at MIT. As for working with the room-sized Museum Camera, it would have been difficult to avoid harsh lighting since exposures depended upon banks of strobe lights exploding in the subject's face.

Beginning with the maquettes made for the 1988 show, however, the character of the lighting in Close's Polaroids becomes much more considered, or rather is considered in a different way. As noted earlier, Close had decided to assemble for that show a group of paintings of artists he described as "professional posers." Mug shot lighting applied to someone like Lucas Samaras or Francesco Clemente might have yielded a good painting, but it would have been a lost opportunity. For another reason, too, carefully articulated lighting was a necessity for all the prismatic grid paintings since it helps remind the viewer of the photographic source of images that are simultaneously being subjected to systematic fragmentation.

When shooting subjects for maquettes, Close makes a number of exposures and in some cases several will prove interesting. Images not selected as the source for a painting might still enjoy a life as photographs in their own right. Such examples relate directly to his paintings in the same way as Polaroid portraits made in the 1980s, but in the 1990s he began to make portrait photographs that fall into a different category. Since the nudes and flowers of the previous decade, he had looked on photography as an opportunity to relax somewhat and play by a different set of rules, selecting subjects that he would never choose for paintings. Now he decided that, when working with the camera, he could also allow himself to make portraits intended for purposes that had nothing to do with his everyday studio activities.

Early examples of this are the black-and-white Polaroids of Bill Clinton made in 1996, intended to raise money for the President's reelection campaign. (That plan was aborted when a White House

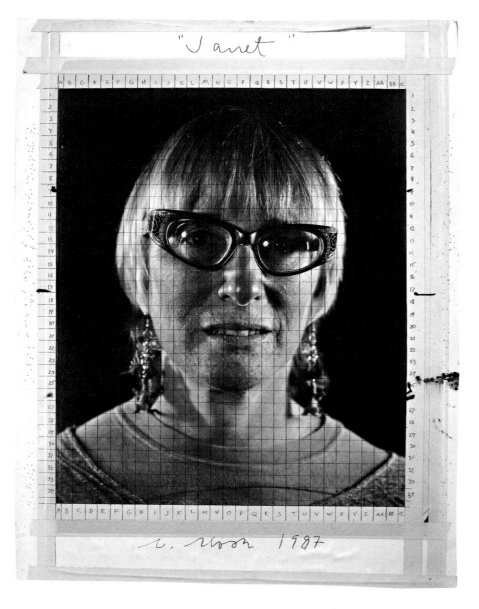

Janet (maquette), 1987.
Polaroid photograph, tape and ink, mounted to foamcore,
overall: 34 3/8 x 25 in. (87.2 x 63.5 cm)

Lucas (maquette), 1990.
Polaroid photograph, tape and ink, mounted to foamcore,
overall: 34 3/8 x 25 in. (87.2 x 63.5 cm)

lawyer pointed out that since the pictures had been shot in the Oval Office, they couldn't be used for fundraising as long as the President was in office.)

Where photography is concerned, Close is prepared to modify his rules, if only to a limited extent. He remains firm about not accepting private portrait commissions, but is willing to take on appropriate assignments from publications he feels comfortable working with. Thus he has photographed Senator Hillary Clinton for the *New York Times Magazine*, the editors of which have also commissioned him to tackle subjects such as Broadway actors and actresses, and popular singers.

When taking such pictures he employs what he calls the "beauty lens," which, if it does not flatter, is not excessively cruel. For non-commercial portraits he more often employs a far less forgiving extreme close-up lens that can produce an illusion of sucking the sitter's face towards the camera, making the nose

seem bulbous while narrowing the skull and consigning the ears to deep space. He habitually employs such a lens when shooting self-portraits, and a good example is an 88-by-68 inch color digital inkjet version produced in 1999, so exaggerated as to be virtually a caricature. Seen alongside a more conventionally proportioned black-and-white self-portrait from the same year—the same size but assembled from four separate inkjet prints—the Mannerist exaggeration of the former is quite obvious.

In 2005 Close revisited the possibilities inherent in multi-panel Polaroid self-portraits, first explored so dramatically with the 1979 *Self-Portrait/Composite/Nine Parts*. Like the six-part composite self-portrait made in 1980, the new self-portraits were shot using the room-sized Polaroid Museum Camera, by then relocated to New York. *Self-Portrait Diptych* (2005; p. 276) is large—103 by 80 inches—and relatively straightforward, with a single dividing line running vertically just to the right of the bridge of the subject's

Bill, 1996.
Two Polaroid photographs, each 26 1/2 x 22 in.
(67.3 x 55.9 cm)

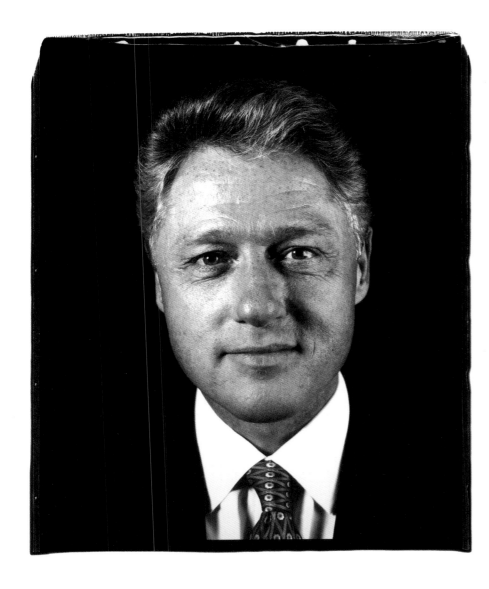

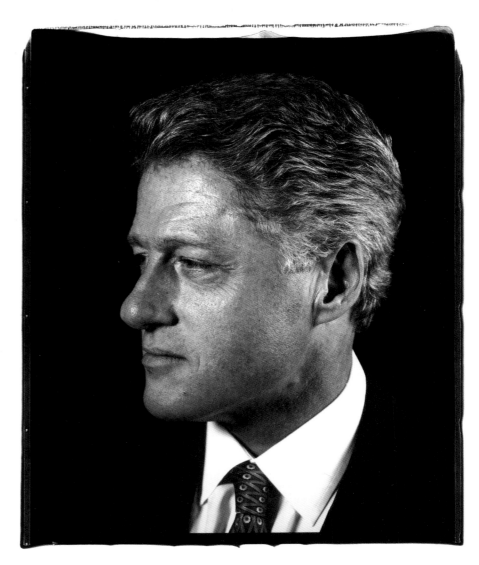

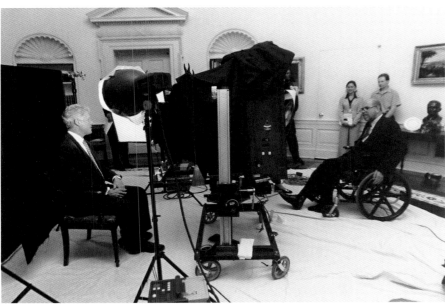

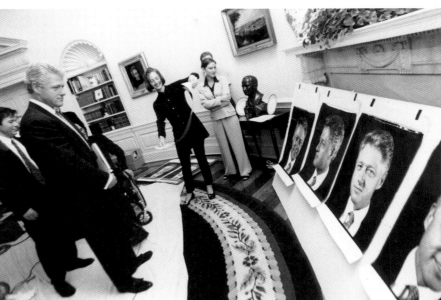

Chuck Close photographing Bill Clinton
in the White House, 1996.

Julie, 1997.
Polaroid photograph, 24 x 20 in.
(61 x 50.8 cm)

Willem, 1997.
Polaroid photograph, 24 x 20 in.
(61 x 50.8 cm)

Judy, 1997.
Polaroid photograph, 24 x 20 in.
(61 x 50.8 cm)

➤ Self-Portrait/Composite/Six Parts, 2005.
Six color Polaroid photographs,
overall: 183 x 122 in. (464.8 x 309.9 cm)

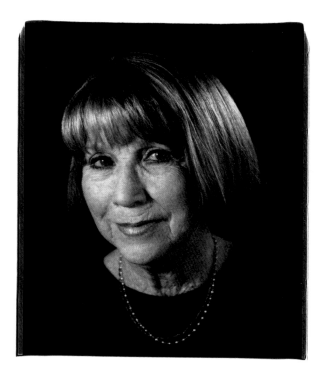

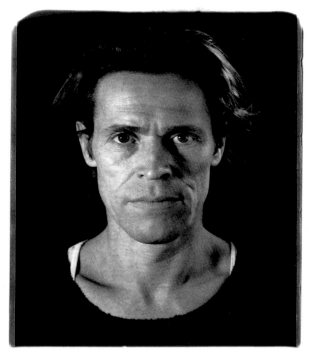

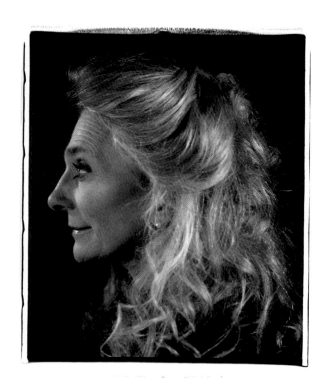

280

nose (as seen from the camera's viewpoint), with the right-hand panel significantly narrower than the left-hand. This asymmetry gives the composite image a character that is faintly disturbing, yet at the same time refreshing.

Self-Portrait/Composite/Six Parts (2005) is huge—more than fifteen feet high. Nothing could be quite as shocking as the 1979 nine part self-portrait, in which the radical fragmentation of the face—it seems to belong to someone who has been blinded with a red-hot poker—is made still more sinister by disfiguring shadow and savage cropping at top and bottom. The more sober 2005 composite is still quite radical, though, its six-panel format accentuating the effect achieved with the extreme close-up lens. The head is distorted to approximately the shape of a football, and the out-of-focus ears seem to be an end zone away; meanwhile, the mountainous nose juts forward aggressively, threatening to poke through the picture plane, or at least stretch it out of shape.

Here the tug of war between two-dimensionality and photographic illusion is as explicit as in any of the paintings, perhaps even more so. Taken together, these two 2005 composites can be seen as another expression of Close's distrust of photography as a provider of a true record of the real world. Although the artist is clearly recognizable in both images, in one he is seen as a man

with an almost circular face, in the other as someone with an elongated skull. Reality is somewhere in between.

. . .

Close has often expressed his dislike of being termed a realist painter, pointing out that he is just as interested in artifice as in realism. This applies equally to his photography, as is implicit in the daguerreotypes he began producing in 1999, this being a medium that combines a striking ability to convey pictorial information with great intensity and an elusive, shimmering surface quality that makes the image seem like something conjured up by an illusionist. Certainly it offers much to interest both the painter who once lavished his attention on representing pores and pockmarks, and the onetime child magician.

A century and a half after it went out of fashion, the daguerreotype is typically seen as being representative of a certain era—the 1840s and 1850s—after which the technology was superceded by other photographic systems that were more versatile, less fussy, easier to view, and that permitted multiple reproductions of the image captured by the camera lens. There was very little evolution within the daguerreotype's original period of popularity, and the surviving plates (millions were made) are looked on mostly as

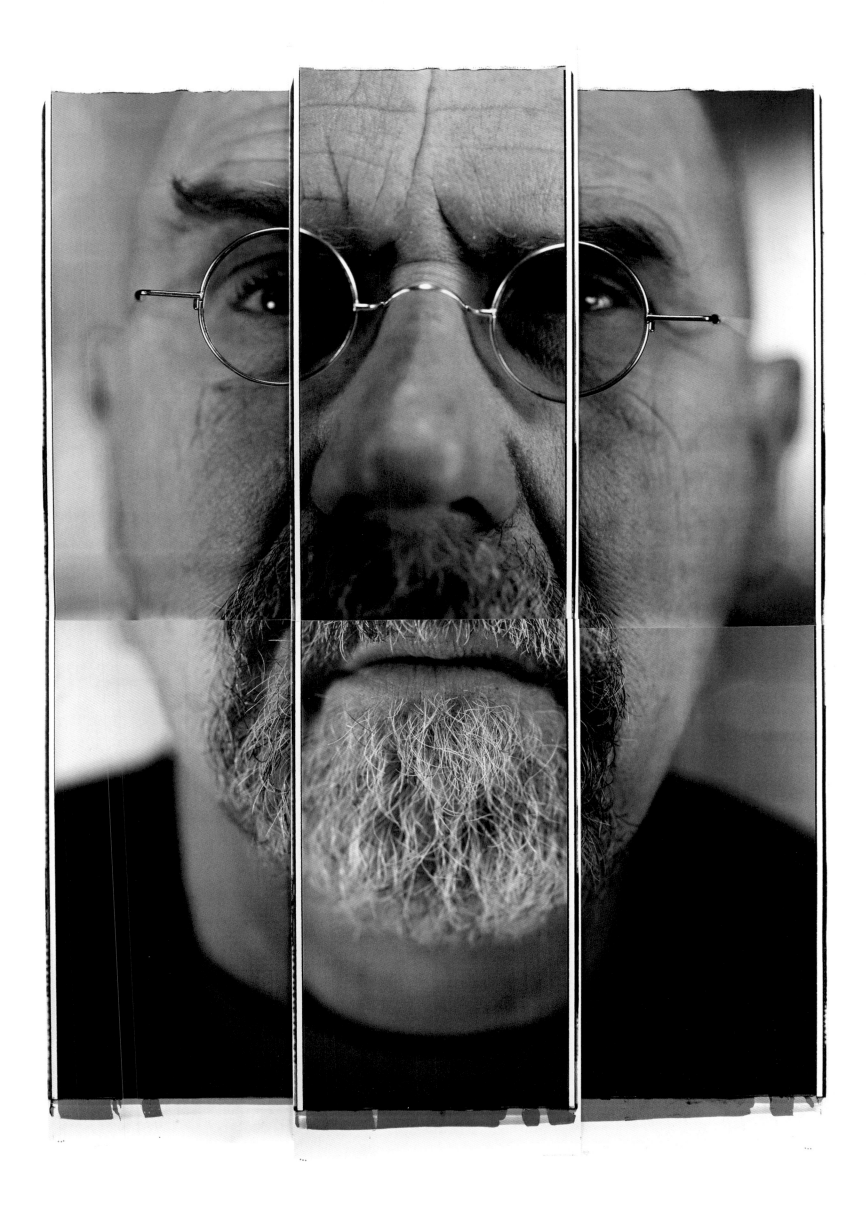

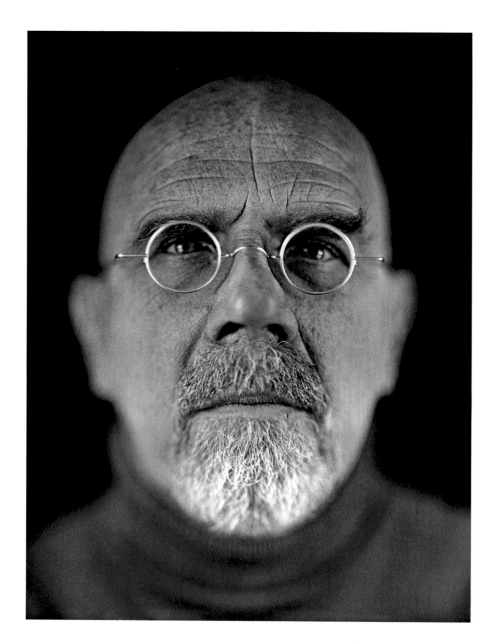

Self-Portrait, 2002.
Daguerreotype, 8 1/2 x 6 1/2 in.
(21.6 x 16.5 cm)

opposite spread, left to right:
Robert, 2001.
Daguerreotype, 8 1/2 x 6 1/2 in.
(21.6 x 16.5 cm)

Phil, 2001.
Daguerreotype, 8 1/2 x 6 1/2 in.
(21.6 x 16.5 cm)

curiosities that help define that moment in time. In fact, even the most ordinary daguerreotype is worthy of attention because of the system's remarkable qualities, including an ability to convey visual information with matchless clarity.

The daguerreotype was launched to astonishment and acclaim in 1839 by Louis-Jacques-Mandé Daguerre, already famous as an artist specializing in painted dioramas. He had developed the system in collaboration with another artist-inventor, Nicéphore Niépce, whose crucial contributions Daguerre managed to minimize thanks to the fact that Niépce had died six years earlier. The labor-intensive technology involved was very much of the period. It began with a sheet of copper coated with silver. That silvered plate had to be buffed until it was as reflective as a mirror, then placed in a container into which bromine and iodine fumes were introduced, rendering the plate sensitive to light. That plate was then exposed in the camera, using a very wide aperture, and developed using highly toxic mercury vapors. This rendered a unique and fragile image that sat on the mirrored surface of the plate. The mirror effect meant that the image had to be viewed from an angle, but it gave that image an almost hallucinatory charac-

ter, and the definition was stunning. The method's shortcomings included the fact that very long exposures were required, which somewhat limited the subject matter. Primarily the system was used for portrait photography, the sitter's head being held steady with a clamp so that movement did not ruin the image.

The opportunity for Close to explore the daguerreotype came about in 1997 when Colin Westerbeck, then a curator of photography at the Art Institute of Chicago, asked the artist if he would be interested in working with Grant Romer of Eastman House. The project was facilitated by a grant from the Lannan Foundation, and some small self-portraits resulted, shot in a makeshift studio, with Close supervising the creative decisions while Romer handled the technical details and operated the camera, a modified Hasselblad. The results were interesting but flawed, lacking the kind of consistency that would be required if the project were to be pursued further.

A couple of years went by before Close decided to take another shot at mastering the medium, using the residue of the Lannan Foundation money assigned to the experiment. This time he entered into a collaboration with Jerry Spagnoli, a photographer who

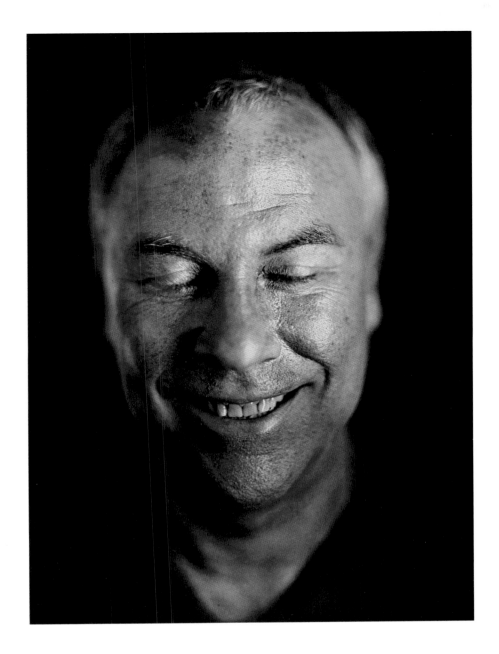

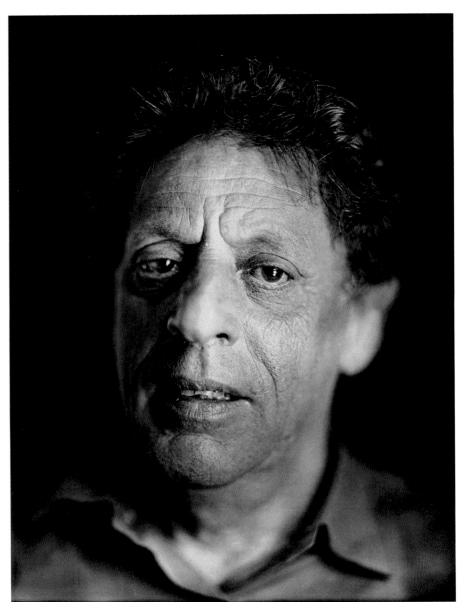

already had a good deal of experience with the daguerreotype, and who had figured out ways to remove much of the uncertainty from the process, though there were still problems to be ironed out.

At first they worked with natural light and long exposures, just as the daguerreotype operators did back in the nineteenth century. From the outset, though, Close was determined to avoid a phony antiquarian look, finding the medium intriguing because he believed the technology was capable of producing results that would enable him to do something that related to his other work.

The first efforts were all self-portraits, Close saying that he preferred not to subject anyone else to the discomfort until the system had been debugged. The key breakthrough came when he decided to do away with natural light and replace it with banks of strobe lights, working in much the way that he worked when shooting the earliest Polaroids. In part at least this came about because he wanted to use the daguerreotype system to shoot nudes, and that presented a very specific problem. Long exposures in natural light were okay for portraits, because the head could be held in place with a hidden clamp. When it came to shooting a bare chest, however, there was no way for the subject to suppress breathing for

long enough to allow a clean exposure. Strobes would do away with that problem, and it soon became apparent that they would also give the image a look that was entirely modern, without in any way losing the unique qualities that made the medium so appealing.

Looking at Close's portrait daguerreotypes, one is immediately struck by similarities between these images and the large black-and-white paintings of the 1967 to 1970 period. There is, for example, the same emphasis on focus, even more exaggerated in the case of the daguerreotypes because the polished surface seems to somehow emphasize the extremely shallow depth of field. There is also the same confrontational character—literally an in-your-face quality—and the same almost frightening level of detail, with every pore revealed. This too is more exaggerated in the daguerreotypes, if only because many of the sitters are rather older than the subjects of the black-and-white paintings, who were then in their twenties or early thirties. Some young faces do appear on the silvered plates, but most are significantly marked by the passage of time. A sense of this can be obtained by comparing the daguerreotype of Phillip Glass made in 2001 with his portrait painted thirty-two years earlier.

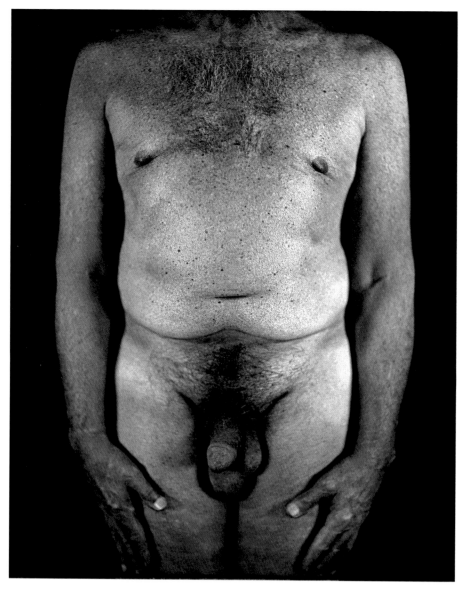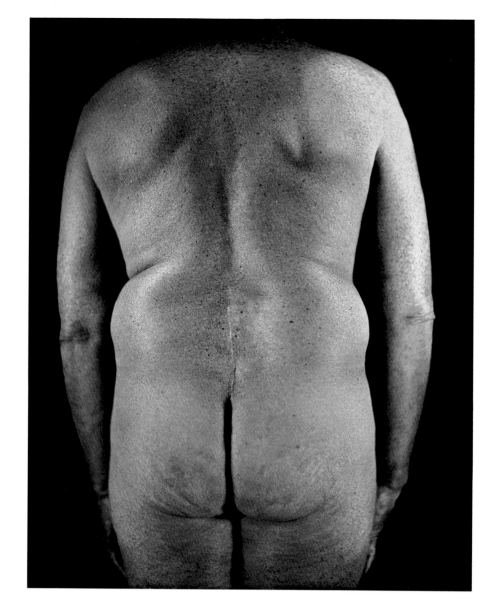

Untitled Torso Diptych, 2000
Two daguerreotypes, each 8 1/2 x 6 1/2 in. (21.6 x 16.5 cm)

The most obvious dissimilarity between the daguerreotypes and the big black-and-white heads is the enormous difference in scale. The painted heads were nine feet tall, while the biggest of Close's daguerreotypes are just 8 1/2 by 6 1/2 inches, the largest size used for classic nineteenth-century plates.

Close points out that, although best known for his oversize paintings, he has always been equally interested in making small-scale images. When it comes to daguerreotypes, he particularly likes the intimacy of the viewing experience—the fact that you pick one up and look at it the way you would pick up a book, which was in fact the preferred way of viewing them in Victorian times. People would keep them in velvet sleeves, treating them as precious objects, almost as icons.

A major difference between Close's daguerreotype portraits and their Victorian ancestors is the range from which they are shot, which combines with the use of strobe lights to produce images that are very much of the twenty-first century. In pictures from the daguerreotype era, one finds full-length portraits, three-quarter-length portraits, and head and shoulder shots, but the ex-

treme close-range exposure that Close favors was almost unheard of. For one thing, the Victorian photographers took their example from the painted portraits of the time. For another, the extreme close-up would have been difficult to achieve convincingly using natural light.

Close has made the occasional half-length daguerreotype portrait, such as *Olivier* (2001), but more typically, the image consists of the head itself, with a glimpse of shirt and collar, much as in the painted heads. Because of the shallow depth of field, the sitter's neck is generally out of focus, so that the head seems to float against the background, emphasizing a "dimensional, holographic" effect that Close has talked of in this connection (he in fact posed for a series of four self-portrait holograms in 1997). This is very much the case with the series of self-portraits, taken from different angles, made in 2001. In these, the artist wore a dark V-neck sweater over a white tee shirt. The sweater blended into the background so that the head seems to be floating in space, supported only by the neck, which slides out of focus. From some angles, the ears seem to dissolve, and from others it is Close's shaved skull that loses definition

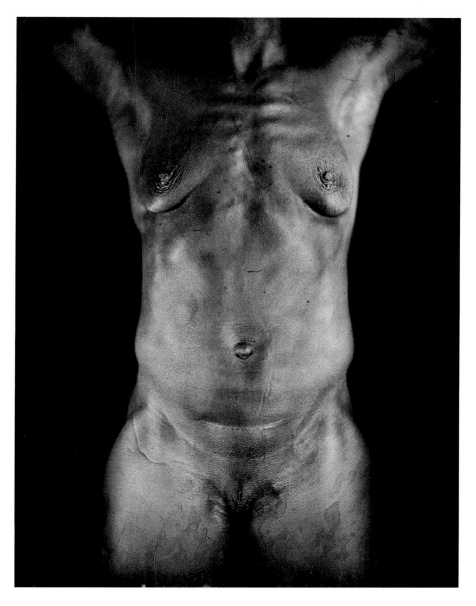

Untitled Torso Diptych, 2000
Two daguerreotypes, each 8 1/2 x 6 1/2 in. (21.6 x 16.5 cm)

at the edges. The effect is decidedly spectral, a little like the ecto-plasm photographs faked by nineteenth-century mediums, and this reading is heightened by the daguerreotype's reflective qual-ity and its tendency to flip from positive to negative.

At the same time, though, it's difficult to imagine that images could seem more concrete than these daguerreotype portraits, a characteristic that Close has learned to emphasize by the use of illumination verging on the brutal. Occasionally, a sitter's expres-sion betrays the fact that he is posed twelve inches from banks of strobes that produce a thirty-thousand-watt-second burst of light. One version of *Robert* (2001) captures the subject—Robert Wilson—with his eyes closed and a grin on his face as he reacts to the blind-ing flash. Normally, Close selects only exposures that show the subject with eyes fully open (and reflecting the strobes). In these images—captured with an 8-by-10-inch Deardorff view camera fit-ted with a 219 mm lens with a 3.5-inch opening—what gives away the power of the light source is the astonishingly high definition of skin texture in the areas of the image that are totally in focus. Moles, freckles, lines, wrinkles, and other blemishes are pitilessly

recorded, and yet the effect of these portraits is not cruel. On the contrary, they have a unique beauty that comes from the ruthless veracity involved.

. . .

Close's daguerreotype self-portraits can be taken as typifying his daguerreotype portraits as a whole, but they also take on an ad-ditional cargo of self-scrutiny that is, to a greater or lesser extent, present in all of his self-portraiture. The artist asserts that his ap-proach to making a likeness is free of any conscious contamina-tion by psychological concerns. When he paints a portrait, he is, after all, reproducing a photograph. When the photograph itself is being taken, however, he is dealing directly with its subject—they are in a room together involved in a common endeavor—and he has said about Polaroids and daguerreotypes that he thrives on the fact that the technology allows both him *and* the sitter to see al-most immediate results. That way each can react to the image and indulge in exchanges of a sort that frequently leads to adjustments in camera position, lighting, pose, and expression before the next exposure is made. This interchange between photographer and

Self-Portrait (2006) being woven
on an electronic Jacquard loom | ➤ Self-Portrait, 2006.
Jacquard tapestry, 103 x 79 in.
(261.6 x 200.7 cm)

subject, with all it implies from a human standpoint, plays a real part in determining the final result. And when the artist turns the camera on himself, he becomes engaged in a dialogue with himself that is a factor in shaping the resulting image.

The group of five self-portraits mentioned above was preceded by a less dramatic group of three made in 1999. That set consists of one image of the artist looking straight ahead flanked by two three-quarter-angle images facing inward but still looking at the camera lens, creating a slightly sinister effect. These images are interesting in that they predate Close's use of strobes in the daguerreotype studio and employ natural light from one side, supplemented by reflected light from the other. The contrast with the strobe-lit 2001 group is striking.

A 2001 self-portrait that shows Close peering out over his glasses is typical of the in-your-face strobe-lit daguerreotypes. A 2004 likeness finds him captured almost head-on, though his shoulders are at a slight angle, and smiling broadly. In everyday life, Close has an infectious smile, which he uses freely, but to see him smiling in one of his self-portraits is almost shocking. It is all the more effective because the strobes and the shallow depth of field isolate the smile beneath a hedgerow of moustache and a tumescent nose. Eyes, nose, and beaming mouth seem to float in front of the rest of the image, which is diffused and ghostly, creating an effect evocative of Lewis Carroll's Cheshire Cat.

. . .

The daguerreotype nudes that Chuck Close began to produce in 2000 are characterized by the same pitiless beauty as the portraits. These differ from the Polaroid nudes he had made back in the 1980s in that instead of using dancers and professional models, he persuaded friends and acquaintances to pose for him. When shooting those 1980s nudes, he had talked of sparing his friends the

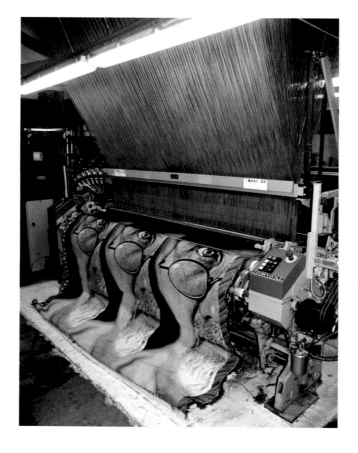

embarrassment of taking their clothes off. Now he reversed that policy, saying that times had changed and he had fun convincing people he knew that they should serve as nude models. More significantly, this was a way of guaranteeing himself subjects who did not match up to fashionable ideals of youth and beauty. In some instances, the unblinking focus on seasoned flesh recalls the work of the late John Coplans, who took uncompromising photographs of his own aging body, and perhaps even that of Hannah Wilke, who photographed first her mother and then herself during the terminal stages of cancer. Close does not go as far as these artists, but the acknowledgment of mortality is a crucial aspect of his daguerreotype nudes.

"I've watched people at the gallery looking at the nudes," he says, "and I find it interesting that they don't spend the most time in front of the beautiful bodies. Even the young ones seem to be more involved with the bodies that show signs of wear and tear, the ones that show evidence of having been lived in."

Although he persuaded friends to stand naked in front of those banks of strobes, he did spare them to the extent of not showing their faces. Like the best of his Polaroid nudes, these images make the most of the tension that can be set up between representation at its most literal and abstraction at its most ambitious. And like those Polaroids, they are far removed from the "abstract" nudes of photographers like Edward Weston and Bill Brandt in that they avoid all compositional artifice, depending instead on the basic symmetry of the body when seen from a full-frontal or rear view.

. . .

A unique offshoot of Close's daguerreotypes has been a series of Jacquard tapestries, produced in collaboration with Donald Farnsworth of Magnolia Editions, in Oakland, California. Close had produced tapestries before, and a single rug, working at long

286

distance with a manufacturer in China. The tapestries produced with Magnolia Editions, however, are altogether more substantial.

The Jacquard loom is a nineteenth-century invention that revolutionized weaving, both by its mechanical efficiency and its ability to reproduce very complex imagery. The tapestries produced by Magnolia, which are woven at a small, family-owned mill in Belgium, combine the traditional virtues of Jacquard weaving with digital technology. In the old days, looms were programmed by means of punched cards—not unlike those used to program early computers—which had to be created by hand, an exacting, time-consuming, and tedious process. The modern computer permits the loom to be programmed from a scanned image. This is not a wholly mechanical process, however, since the digital information can be modified by the artist at every stage in the process, permitting him to retain extensive control over the product as it evolves.

Close's first collaborative effort with Magnolia was a tapestry based on a black-and-white Polaroid, but, as interpreted by the Jacquard loom, the image lacked the refinement he was looking for, the edges of the forms being too "hard." When Close switched to creating tapestries based on his daguerreotypes, however, the results were both astonishing and entirely successful. The Jacquard loom proved capable of reproducing the full intricacy of the information recorded by the daguerreotype process, even when an image was blown-up from 8 1/2 to 103 inches tall, almost the same size as Close's early black-and-white paintings. The sheen of the archival cotton threads, from which the image is woven, and the depth of texture they provide, makes for a richness of surface that has far more in common with the elusive nature of the daguerreotype than might be expected. Although, at a glance, the portrait tap-

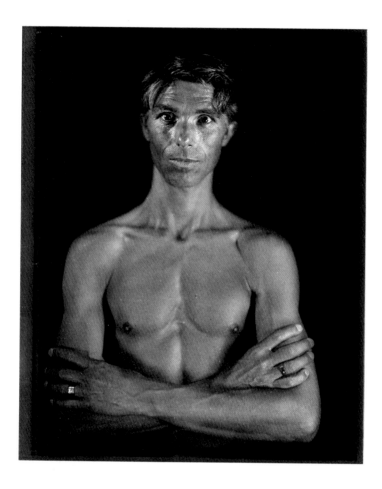

estries appear to be black-and-white, each is in fact woven from more than a hundred colors, and this too recalls the characteristic presence of a daguerreotype image, which is permeated with both reflected highlights and a residue of chemical hues.

A tapestry is the ultimate in incremental image-building, and Close says that he feels that, in many ways, the medium is as much like painting as anything other than painting could be. "First, I see two-foot-wide test strips, then a series of full-size tests. At each stage, I have unbelievable control over, for example, the transitions. If twenty grays don't give me a satisfactory transition from dark to light, then we might try forty."

Such transitions are crucial to capturing the shifts in focus found in the source daguerreotypes, and the ability of the Jacquard loom to reproduce such shifts is one of the characteristics of the process that Close finds most rewarding. At the time of writing, his involvement with Magnolia Editions has yielded one self-portrait, ten other portraits, and one sunflower tapestry.

• • •

The portrait tapestries effectively illustrate Chuck Close's approach to making art, both intuitive and intellectual, which is to innovate by using a modern form of imaging—photography—as the starting point for re-exploring traditional methods of image-making, some of which, like weaving (or painting, for that matter), have been around since prehistoric times.

I have repeatedly emphasized the incremental (and time-consuming) nature of Close's picture-making, which contrasts utterly with the ability of the camera to capture an image at a single gulp. His art is suffused with a kind of aesthetic and ethical tension between the instantaneous and the labor-intensive. The subjects of

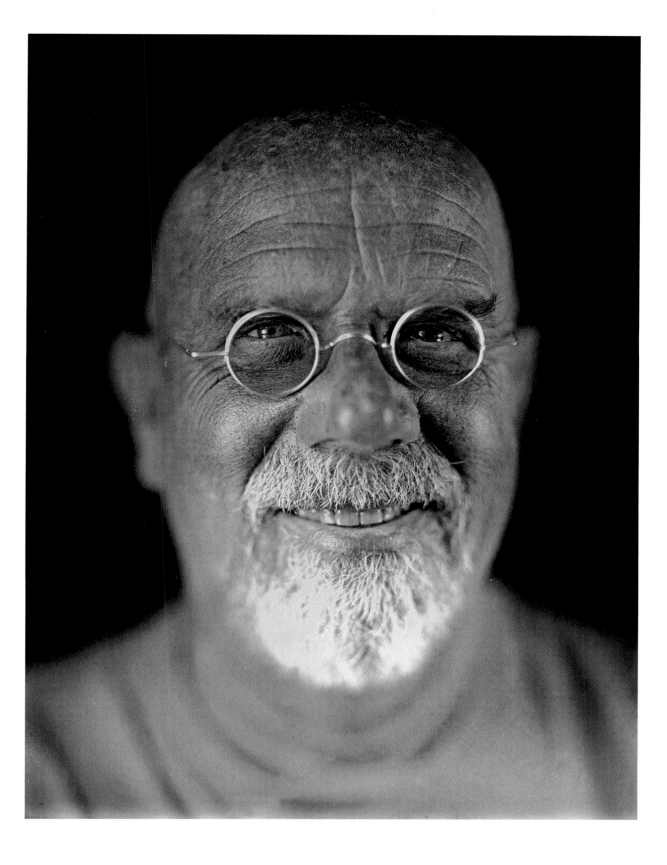

Self-Portrait, 2004.
Daguerreotype, 8 1/2 x 6 1/2 in. (21.6 x 16.5 cm)

his portraits are captured by the camera as they once appeared for a fraction of a second. Reconstituting a facsimile of that moment—sometimes years later—involves the artist, and his collaborators, in months of concentrated work. When Close takes photographs, he does so from the perspective of someone who has a unique understanding of what it takes to reconstitute a photographic image manually.

Throughout Close's *oeuvre*, painting and photography feed off one another, yet each body of work stands on its own. The daguerreotypes alone constitute a substantial and original contribution to recent photography, and I believe that *Self-Portrait/Composite/Nine Parts* is one of the seminal photographs of the final quarter of the twentieth century. Then again, it could be argued that the 1967-68 *Big Self-Portrait* is one of the seminal photographs of the third quarter of the twentieth century. It just happens to have been processed and enlarged by hand with the help of an airbrush.

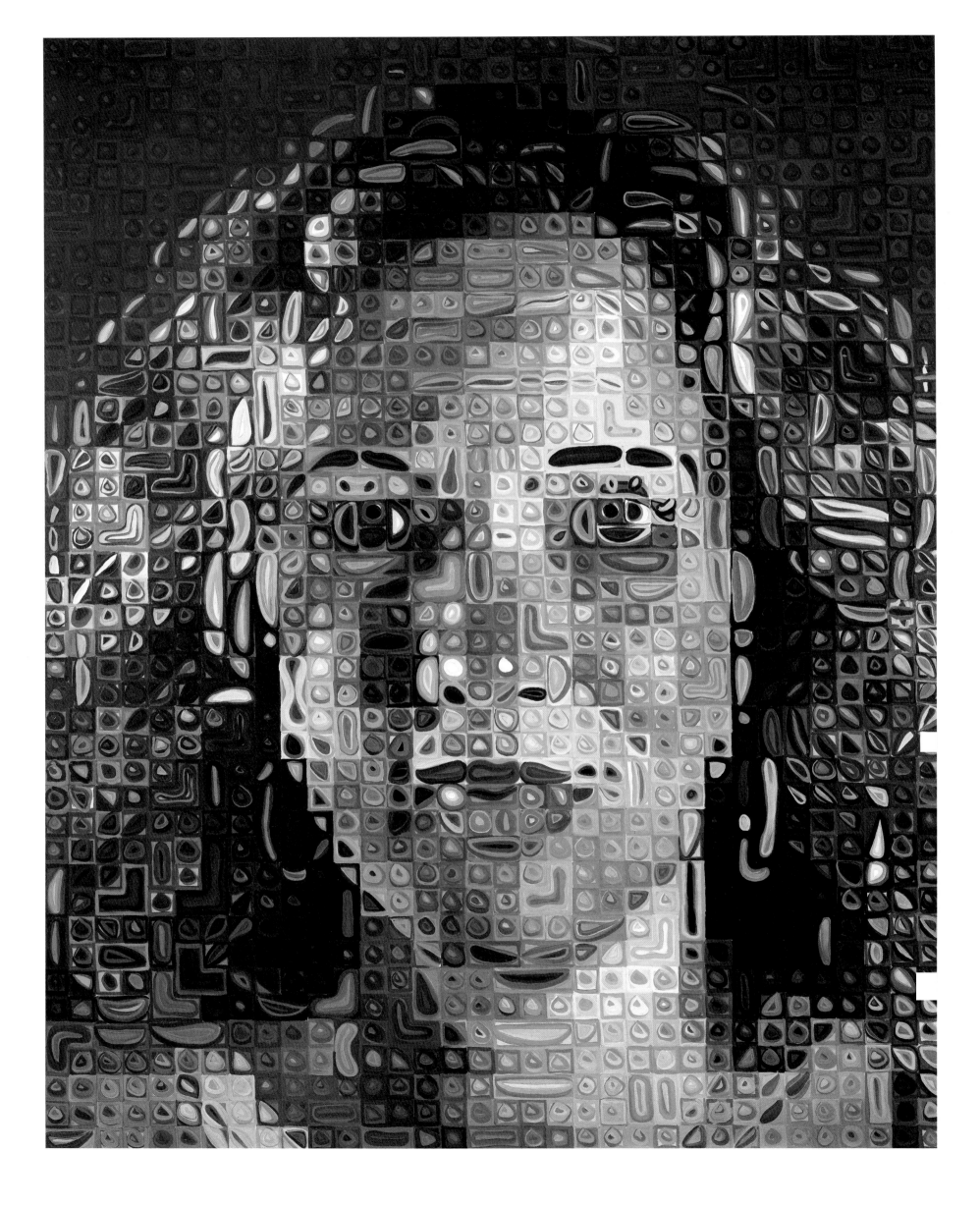

Chapter 10:

CONCLUSIONS

At the beginning of his essay for the catalogue of Chuck Close's 1998 MoMA retrospective, Kirk Varnedoe compared the pugnaciously punk 1967 black-and-white *Big Self-Portrait* with a more recent likeness in which the artist is seen as a prosperous, solid citizen who is courted by collectors and receives invitations to the White House.[22] There is nothing particularly new about this passage from bohemianism to the establishment. It is a journey that has been made by many successful artists, in all fields.

Picasso, to give one example, moved on from the ramshackle surroundings of the Bateau Lavoir to the glittering world represented by Maxim's and lavish balls in the *hotels particuliers* of the Avenue de la Grande Armée. This did not mean that old friends, old haunts, or old habits were abandoned. Most importantly, there was always the studio as a refuge. In the studio, the rules never change.

Chuck Close now sits on the board of the Whitney Museum of American Art, is a formidable advocate for cultural causes, has had a fellowship named for him by the American Academy in Rome, and participates in scores of civic activities. The studio, however, is always there as his refuge, the place where he is completely comfortable, where he is visited by old friends, and where he carries on the activities that define him.

In Close's case, the idea of the studio as refuge is manifested in a variety of locations. In recent years, most of Close's painting has been done in his smaller Bridgehampton studio, set in a spectacular garden—created by Leslie Close—that is itself a work of art. For the most part, the Bond Street studio now serves as a busy nerve center for scores of peripheral activities. It is here that works are

cataloged, proofs of prints and posters are subjected to scrutiny, daguerreotypes are lined up for inspection, letters are dictated, transparencies are filed and stored, and audiences with friends, collectors, and curators are conducted. It's not uncommon to arrive at the studio to find a film or television crew setting up, or to discover the artist huddled with a journalist armed with a recording device, or scribbling in a notebook.

While in the city, however, Close spends a good deal of his time in other studios, working on a print, perhaps, or setting the lighting for a series of photographs. The impression he gives is of unceasing activity, as he conducts a conversation with a visitor, simultaneously takes phone calls, yells out instructions to an assistant, then zooms off in his motorized wheelchair, looking for a missing catalogue. Lunch might be eaten on the fly—a sandwich sent in from a nearby café—though visitors are just as likely to be swept off to a favorite local bistro for a leisurely meal filled with lively conversation. Except for the occasional dropped telephone, Close's physical impairments hardly seem to slow him. In reality, though, there are still constraints. At four o'clock every day, a nurse will arrive at the studio. There are times too—though less frequent than before—when fierce infections flair up, or antibiotics drain his energy.

"All I can do when I feel that shitty," he says, "is paint. When I'm painting, I can forget the worst of it."

· · ·

The distance between that first self-portrait and recent examples may seem huge at first glance, but in reality the threads of logic

291

Self-Portrait (maquette), 2001.
Color Polaroid with artist's tape mounted on foamcore,
33 1/4 x 22 in. (84.5 x 55.9 cm)

➤ Self-Portrait, 2001.
Oil on canvas, 108 x 84 in.
(274.3 x 213.4 cm)

292

that join them are apparent enough when they are viewed thoughtfully. An unusual opportunity to do that occurred in 2005 when the Walker Art Center in Minneapolis (appropriately enough, given its role in launching his career) organized a retrospective of almost all of Close's self-portraits to that date, in every medium, paintings, prints, drawings, photographs, holograms—eighty-five works in all.

The impact of the show was overwhelming, not only to visitors but also to the artist himself, who of course had never seen all these images together before. At a preview of the exhibition's installation prior to its run at the San Francisco Museum of Modern Art,[23] he at one point fled the fourth floor galleries, loudly complaining, "I can't stand it—God, I must be so egocentric, painting myself so many times . . . All these faces! I'm getting out of here!" Five minutes later, he was back in front of a large 1973 black-and-white dot drawing, studying it intently, as if for the first time—as if looking at the likeness of someone the artist could refer to as "him."

What gave this exhibition its singular impact was precisely the fact that it was the same face, portrayed over and over again, and with so much variety of treatment. Hung to emphasize chronology, it permitted the viewer to see how that particular face had evolved

from punk to person of substance, and how that reflected an evolution of society as a whole during the same period, as Varnedoe suggested in his 1998 essay.

• • •

The self-portrait exhibition included noteworthy paintings made in the years following the Museum of Modern Art retrospective. Two large color self-portraits are striking because of their uncompromising frontality, being painted from Polaroid maquettes that in some respects recall the mug shot aesthetic of the early heads, though these likenesses are devoid of the "attitude" found in the early self-portraits, and seem almost remote. The first—nine feet tall and painted in 2000–1—uses a diagonal grid and has a monumental solidity that is not typically characteristic of the heads painted "on the bias." This owes something, I believe, to the graphic boldness of the incremental units that make up this particular likeness: the pupils and irises of the eyes are like miniature Jasper Johns target paintings seen through a distorting lens. Highlights and shadows are decisively delineated and help give the painting a vertical thrust. It has a columnar strength as well, which is owed to the fact that the maquette was shot with the ex-

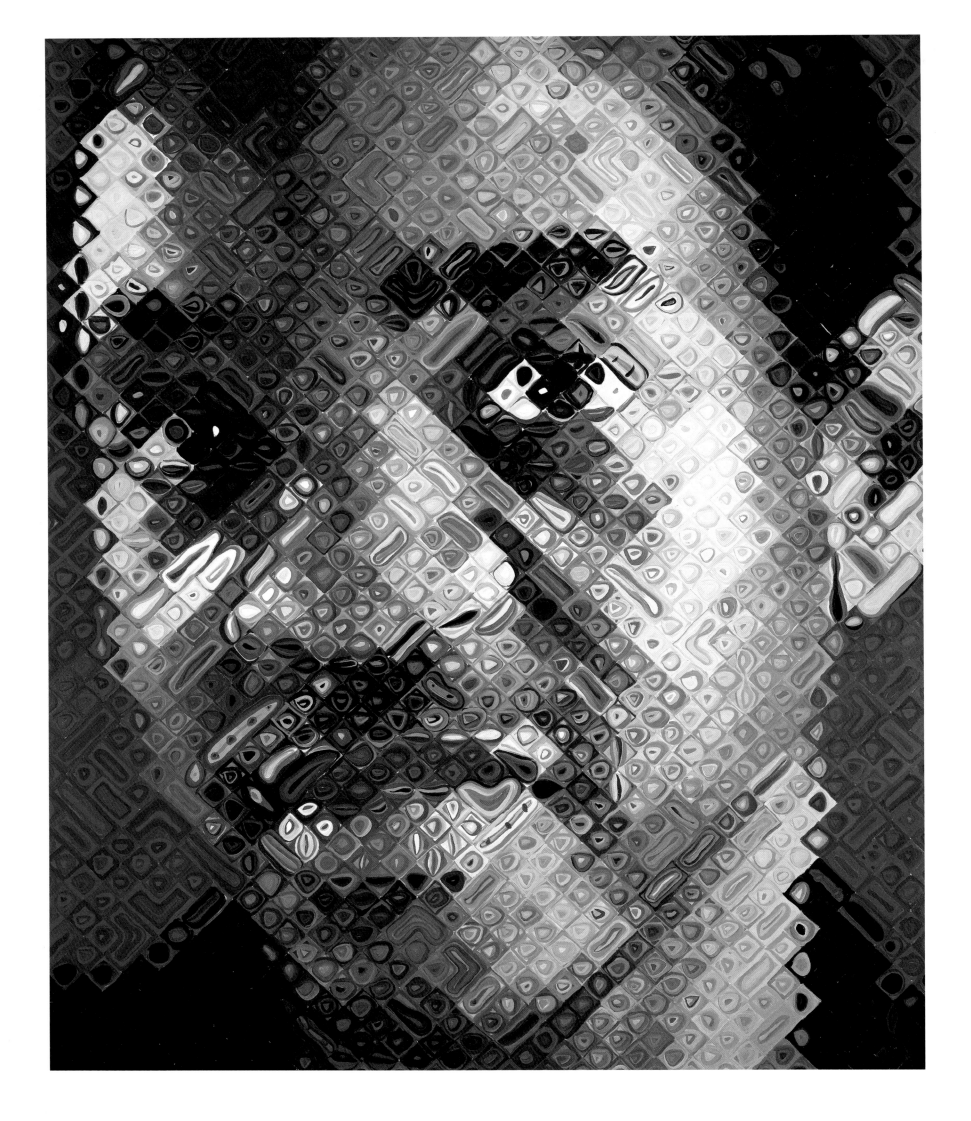

Lyle, 1999.
Oil on canvas, 102 x 84 in.
(259.1 x 213.4 cm)

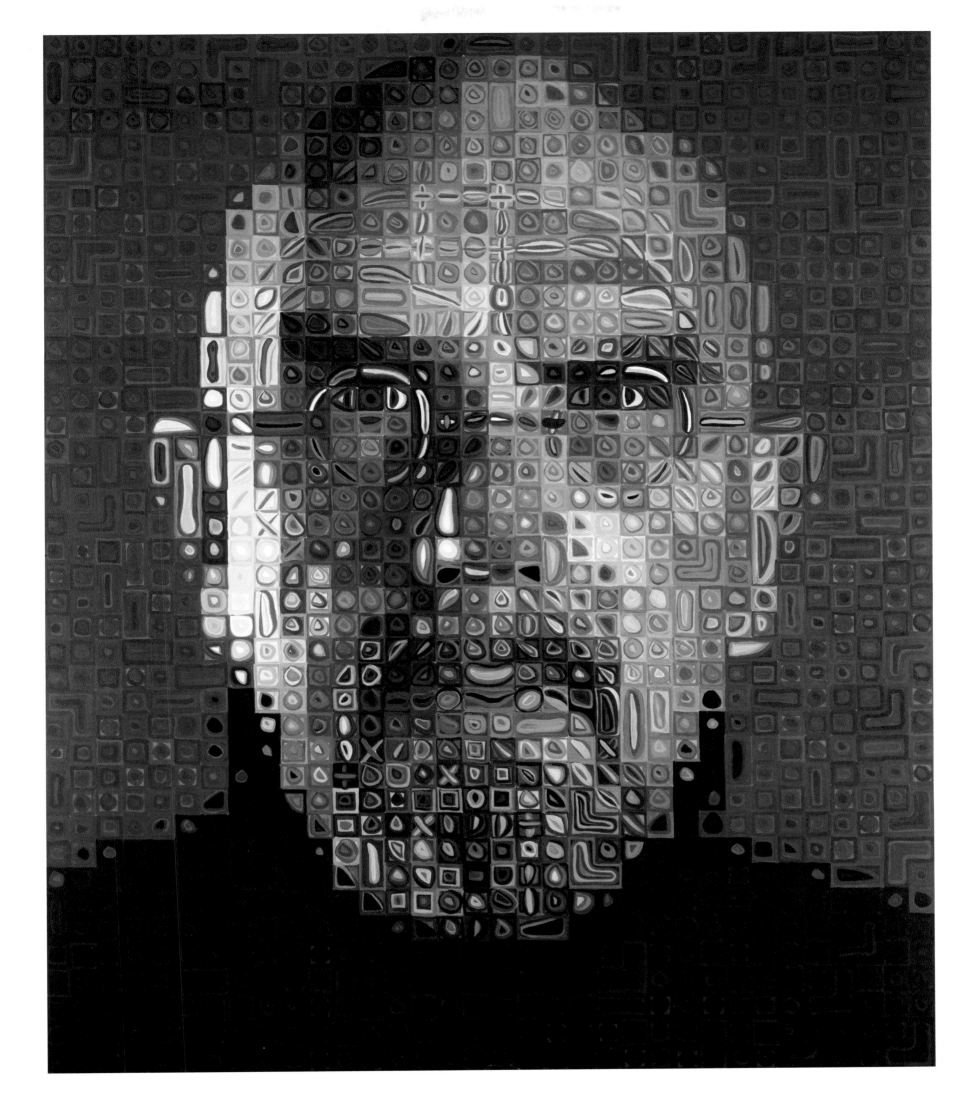

Self-Portrait, 2004–5.
Oil on canvas, 102 x 84 in.
(259.1 x 213.4 cm)

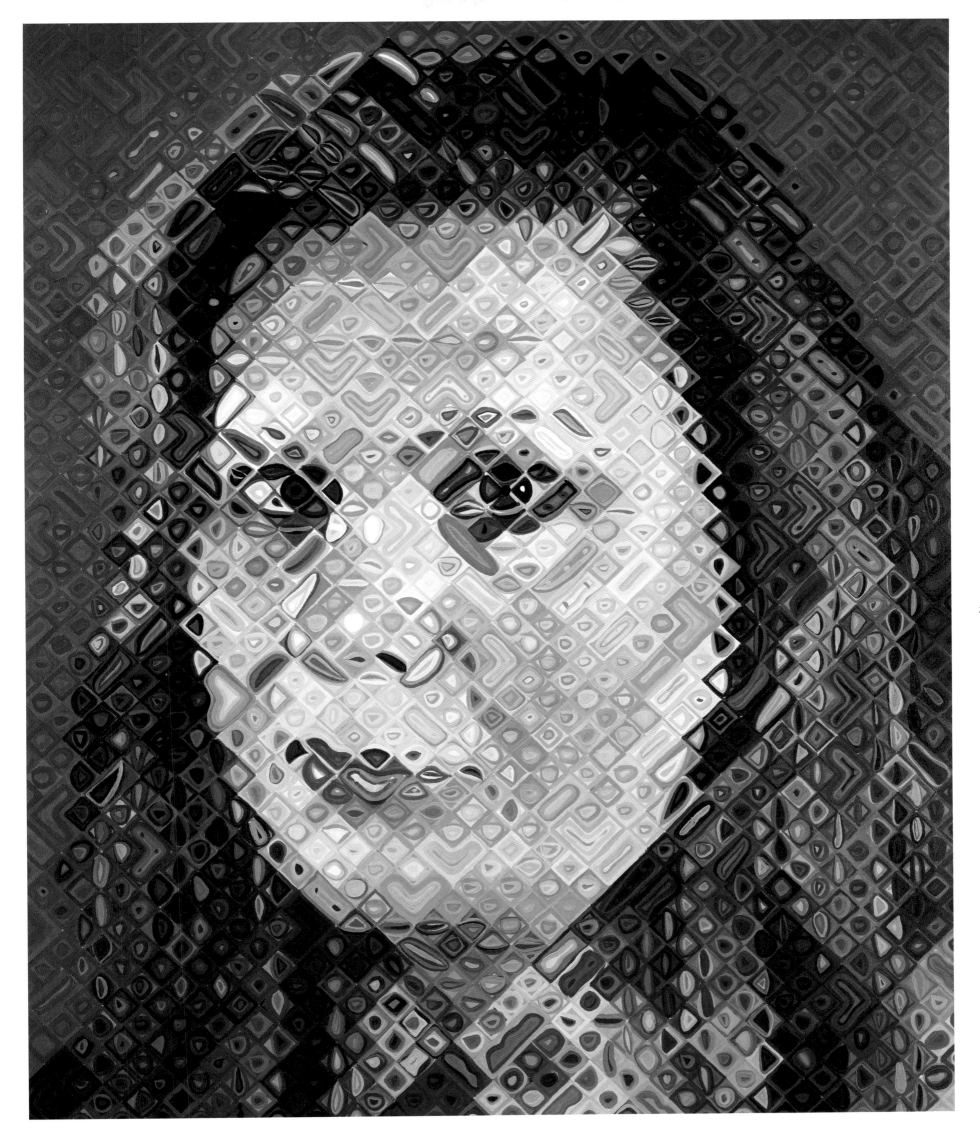

pages 296 and 297: **Robert II**, 2001.
Oil on canvas, 108 x 84 in.
(274.3 x 213.4 cm)

▶ Lisa, 2002.
Oil on canvas, 102 x 84 in.
(259.1 x 213.4 cm)

▶ Self-Portrait, 2005.
Oil on canvas, 108 3/4 x 84 in.
(276.2 x 213.4 cm)

treme close-up lens discussed in the previous chapter, rendering the artist's head narrow and bullet like, hardly wider than the neck that supports it.

The second of these paintings—102 by 86 inches and painted in 2004–5—is structured on a vertical/horizontal grid. Close's face is lit in somewhat the same way as in the preceding self-portrait, but the head is not cropped quite as tightly, nor has it been quite so elongated by the lens, making for an image that is less monumental (though still substantial). Rather, this painting is extremely elegant in a manner that recalls the portraits of Hans Holbein: indeed, the bearded face that peers out through circular glasses might belong to some humanist contemporary of Erasmus and Sir Thomas More. When he sat for the maquette photograph, Close was wearing a black turtleneck sweater, and if the painting is seen from a distance, this garment becomes a surrogate for the black, fur-trimmed robes worn by sixteenth-century scholars. (From close range, the apparent field of black dissolves into subtle swirls of subdued color.) Fragmentation makes this an entirely modern portrait, of course, and once again the incremental units are boldly handled, even more so than in the 2000–1 canvas.

In fact, this later portrait was created soon after Close had taken a brief hiatus from painting, having felt that he was in a rut. (During that vacation from the easel, he made ink drawings that he found unsatisfactory and he destroyed them.) It was painted with an enthusiasm that the artist had not displayed in some time, and this is reflected in its freshness and directness of handling. A splendidly unfussy painting, it breaks down into units that have the graphic clarity that is more commonly found in his black-and-white portraits. As always, representation merges with abstraction, but in addition, abstraction fragments into a sea of symbols, with clusters of marks resembling multiplication and division signs appearing among circles within circles and squares within squares.

Between those two remarkable color paintings came two black-and-white self-portraits that, as it happens, relied less than usual on constellations of marks resembling graphic symbols, and more upon exploring the limits of the looseness of handling that could be practiced without abandoning the grid (though the smaller of this pair does employ plus and multiplication signs). These paintings do not offer easy gratification, but they are good examples of how Close is always elbowing fresh space for himself, ensuring that his method does not fossilize into a formula.

In 2005 Close painted a large color self-portrait for an exhibition at the National Portrait Gallery in London. The image was organized on a diagonal matrix and derived from a maquette that presented the subject at the acute three-quarter angle that he has now employed on a number of occasions. This painting makes a point about the prismatic grid images and the way in which they mimic photographic reality despite the decidedly non-photographic character of the incremental elements. When he was photographed for this portrait, Close had been spending time in the sun, with the result that he was tanned and his nose had become red and shiny. This is fully evoked in the finished painting despite the fact that the skin tones are as usual achieved by juxtaposing tints and shades of many different pigments. As in so much of his work, the artist relies on the viewer's eye to assemble the image, right down to an accurate illusion of the appearance of sunburned flesh.

· · ·

During those same years, Close continued to make portraits of fellow artists, his subjects including Lyle Ashton Harris, Cecily Brown, more versions of Paul Cadmus, Inka Essenhigh, Andres Serrano, and dancer/choreographer Merce Cunningham. One painting that he is particularly satisfied with is his likeness of Lynda Benglis, whose work had been featured alongside his at the first group show he participated in at the Bykert Gallery back in 1969.

Lynda was completed just before the 2004–5 *Self-Portrait*, immediately after Close's short hiatus. Like that painting, this one is hung on a relatively open grid and it too has been painted very directly, displaying a freshness and spontaneity that suggests the artist required little time tinkering and making adjustments. The individual units are less ideographic than is the case with the self-portrait, but they are crisp and clean, with elongated shapes commonly filling two or even three squares.

Along with these recent artist portraits, there have also been portraits of family members, and one of a friend. Among the for-

298

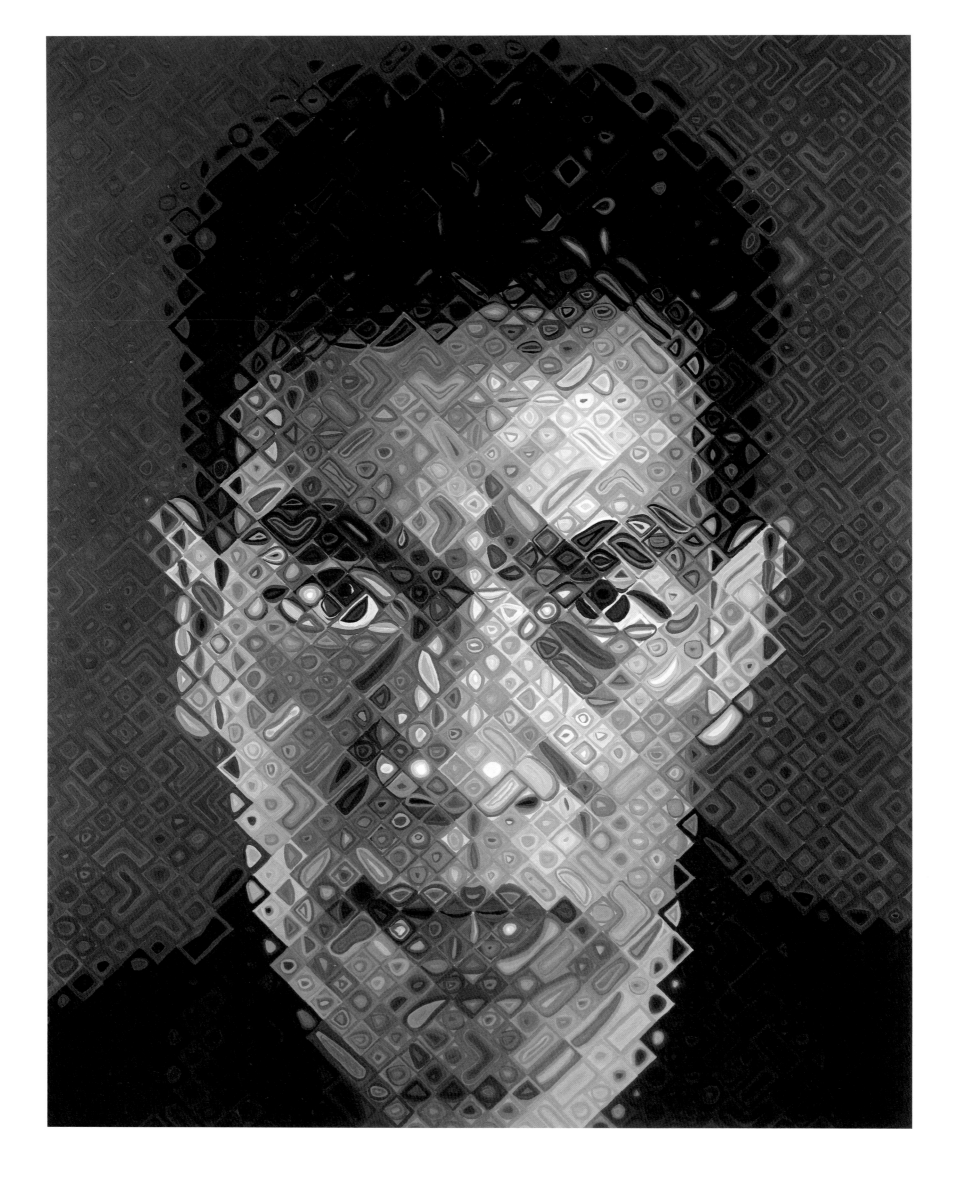

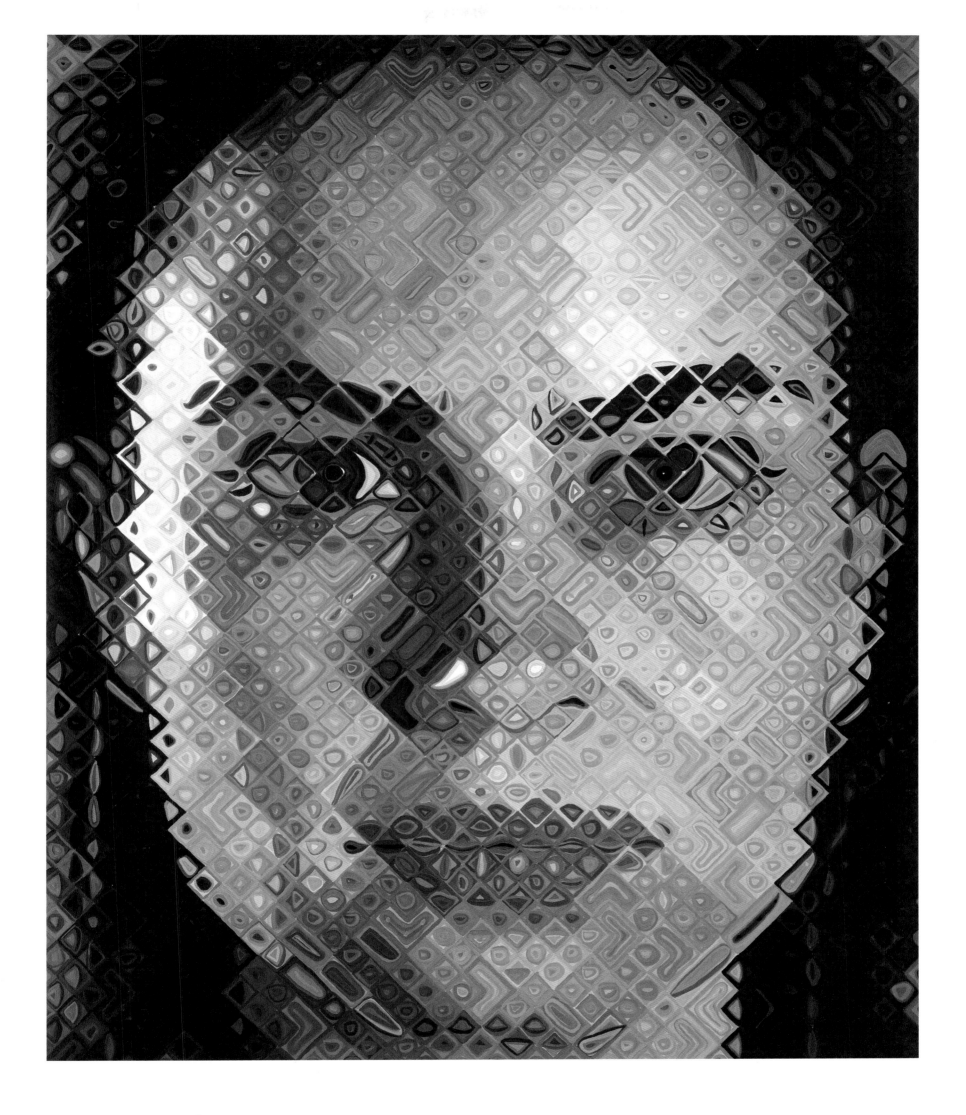

◂ Andres, 2003.
Oil on canvas, 108 1/2 x 84 in.
(289.6 x 213.4 cm)

Inka, 2003.
Oil on canvas, 102 x 84 in.
(259.1 x 213.4 cm)

◄ **Merce**, 2005.
Oil on canvas, 108 1/2 x 84 in.
(259.1 x 213.4 cm)

pages 304 and 305: **Lynda**, 2004.
Oil on canvas, 108 1/2 x 84 in.
(289.6 x 213.4 cm)

► **Lynda** (detail), 2004

mer are a painting of his niece Emma, an infant at the time she was photographed. This painting, made in 2000, has an appropriately childlike character, with the treatment of the eyes having a postmodernist, cartoonlike quality.

In 2002 came a new likeness of the artist's wife which, like *Emma*, utilizes a diagonal grid. In this incarnation, Leslie's face, tightly cropped, is turned towards the viewer in such a way that her head is tilted at an angle to her shoulders. The background is reduced to narrow parentheses of darkness that allow Close's all-over intentions to be fully expressed. The lighting of the face is difficult to interpret, making this one of the least explicitly photographic of Close's recent portraits. There is a liquid aspect to the way in which the features are evoked, with fluid shapes overflowing the grid lines as one patch of color seems to spill into the next. As in the case of *Emma*, there is something cartoonish about the treatment of the eyes, and the handling of the lips is extremely sensual, incorporating a pair of brightly colored hearts.

Herb (2004) is something of a departure, at least in the work of the past couple of decades, in that it portrays neither an artist nor a family member, but a friend. Stylistically, this painting is in many ways the opposite of the 2002 *Leslie* in that the photographic derivation is very explicit, and the treatment is mosaic-like rather than fluid. At the same time, this painting has a distinctive individuality within the sequence of prismatic grid paintings in that the distribution of chromatic marks across the entire surface of the canvas is especially evenly handled. There are some places where marks flow from one square to the next, but these instances are few in number. Essentially, this is a painting in which the structure of the diagonal grid has been allowed to fully express itself.

In an earlier chapter I noted the echo of cubist method that makes an appearance in the 1994 canvas *Roy II*. In the case of *Herb*, there is no specific cubist allusion, but this painting does make use of the grid to "geometricize" the image. As one looks at the face, it becomes apparent that it splinters into diamonds, trapezoids, and triangles—W shapes, too—that delineate features (the eyebrows, for example), and define planes. Each eye is centered in a loosely knit diamond—made up of perhaps one hundred grid units—representing shadow. Were this all, the whole thing might be rather simplis-

tic, but in fact, the colorization and calligraphy of these units is so subtly achieved that the geometry is not quite fixed. Glance away from the painting for a second, then glance back, and it seems that the edges of the diamonds have shifted. This gives the painting a very animated character despite its resemblance to a mosaic.

• • •

If *Herb* (a lawyer by profession) was a departure from recent practice in terms of choice of subject, then the 2006 portrait of President Bill Clinton is a far greater anomaly. As mentioned in the last chapter, Close has photographed Clinton in the past, but his rules regarding who he paints remain far stricter than his rules for photography. From the beginning it has been his policy never to accept a commission. Until the Clinton painting, the nearest he had come to doing so was his 1997–98 portrait of Jasper Johns, painted at the behest of a Canadian businessman, Ian M. Cumming, and presented by Cumming to the National Portrait Gallery in Washington, D.C. Close felt he could undertake that assignment because Johns is an artist he knows and admires, so that this was a painting that he might have made without being commissioned. He saw it, in fact, as an opportunity.

It was Cumming once again who raised the possibility of making a portrait of President Clinton, to be presented to a national institution. This time Close, an admirer of the former President, was more hesitant. Although he had met Clinton on a number of occasions, he would not presume to describe him as a close friend; and the fact that the former President plays the saxophone does not make him an artist. In the end, Close decided that, given the subject, he could not refuse the commission, but he imposed one condition. He would make the painting on the understanding that if it did not come up to his standards, or if he simply didn't like it, he would have the right to destroy it.

There were reasons for his caution. To paint an art world celebrity like Jasper Johns is one thing, but to paint the likeness of someone who for eight years was the most powerful man in the world presents all kinds of potential pitfalls. Chuck Close has never been accused of indulging in flattery in the way he portrays his subjects, yet the concept of pictorial puffery has over the centuries become

303

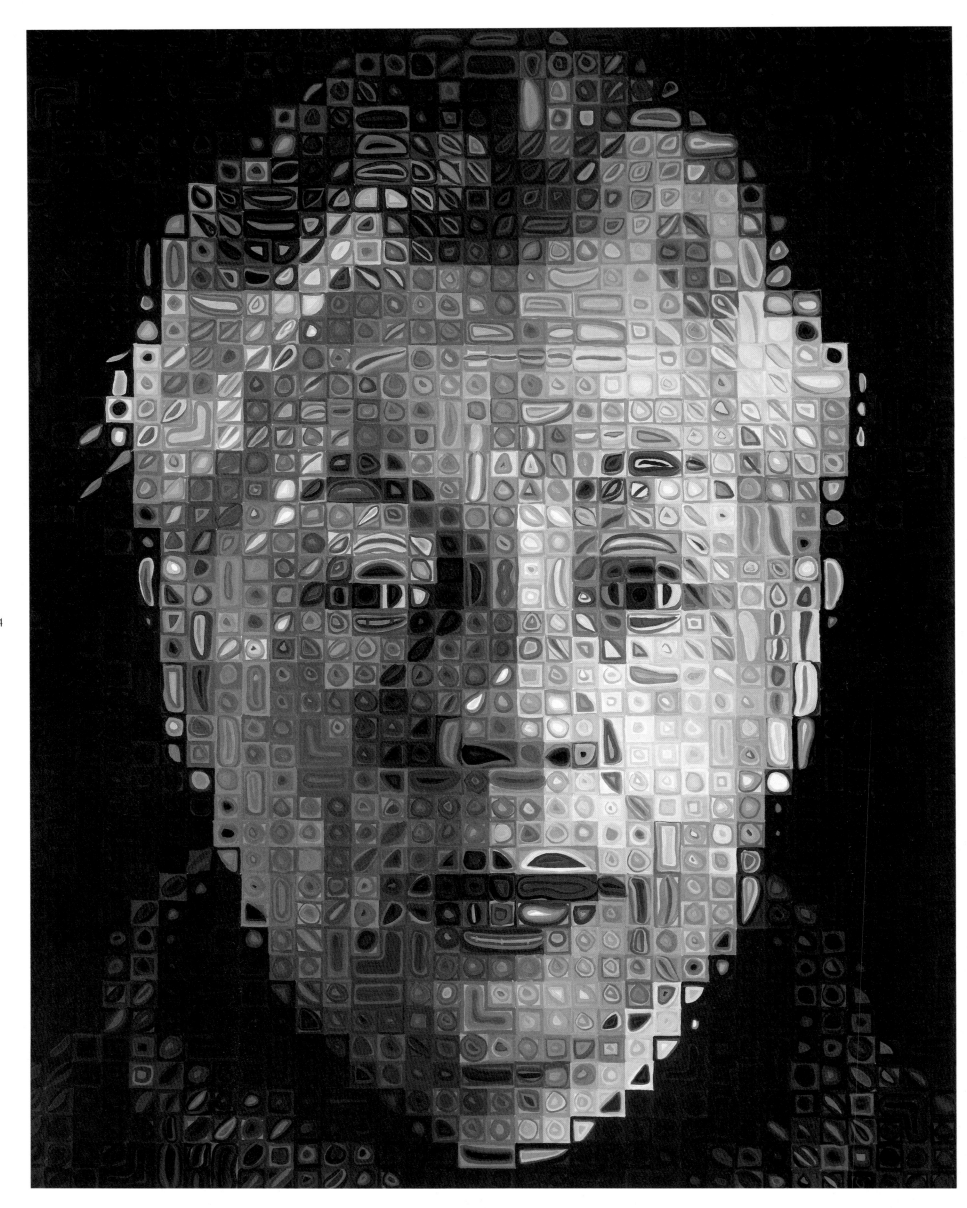

◄ **Maggie**, 2005–6. Emma, 2000.

Oil on canvas. 102 x 84 in. Oil on canvas, 72 x 60 in.

(259 x 213 cm) (182.9 x 152.4 cm)

308

Herb, 2003–4.
Oil on canvas, 102 x 84 1/4 in.
(259.1 x 214 cm)

➤ Herb (detail), 2003–4

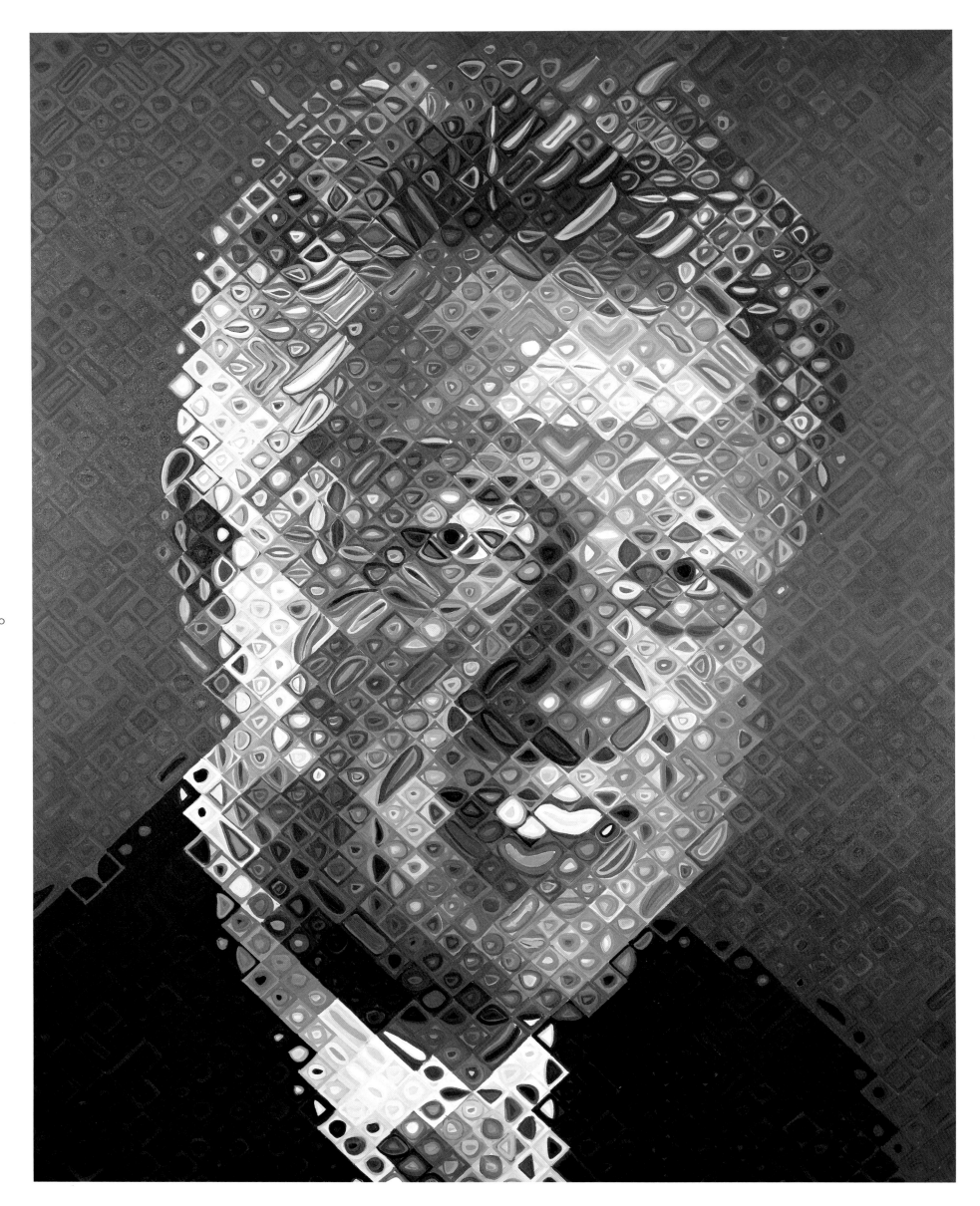

so attached to portraits of powerful men that viewers might read it into the painting even if it were not there. One way of avoiding this would be to go out of one's way *not* to flatter. Lucien Freud's recent portrait of Queen Elizabeth of England might be taken as an example of that approach (though in Freud's case the refusal to flatter is habitual). The idea of being *deliberately* unflattering, though, is as alien to Close as its opposite.

Having agreed to make a portrait of Clinton, then, he went about painting it just as he would have painted any other. As things turned out, Close was happy with the finished work, which is neither flattering nor unflattering, though he did remark to a studio visitor, "Bill's going to hate it."

· · ·

One thing that has characterized Chuck Close's career as a whole is an astonishing level of industriousness. Given that it takes him months to make a single painting—over a year in some instances—his output is surprisingly large. This is to a considerable extent a result of the fact that he explores multiple possibilities at the same time. While working on a given painting three or four days a week (never starting a new one till the last is finished), he is likely to be simultaneously supervising the proofing of a suite of prints, or planning sittings for a new group of daguerreotypes. Close is not one to wait for inspiration to strike. From early in his career he has tended to work regular office hours.

This in itself is an expression of art as process, the theme that runs through his career. For all of his success, and for all of the unwanted drama that transformed his life, Close remains the same artist who moved into the freezing loft at 27 Greene Street in 1967. (His present studio is just a few blocks away.) He continues to manufacture objects using incremental processes not dissimilar to those used by the sweatshop workers who toiled in that space before him, with manual repetition a principal ingredient. His work differs from theirs in that the end product is hung on museum walls, and that he gets to enjoy the full benefit of his labors. He is free to revel in the pleasure of making something the old-fashioned way—by hand. Even in his collaborations with printmakers, which inevitably involve some technology, he likes to be as hands-on and

pragmatic as possible, often overcoming problems by coming up with solutions that he describes, with satisfaction, as "low-tech."

Close jokes that he has been in the art world long enough to see painting pronounced dead several times. To paraphrase Mark Twain, he feels that news of its demise has been greatly exaggerated. No one could be more devoted to painting as an activity than Close, and I believe it's fair to say that he takes more delight in it today than ever. That he does so may have something to do with the kind of paintings he has been making during the past two decades, which allow free rein to his gifts for inventive brushwork and juicy color. The fact that he is able to make paintings at all, given the disaster of his paralysis, is itself a source of continuing satisfaction.

This does not mean that he is entirely without regrets at the loss of dexterity. He tells of an afternoon at the Metropolitan Museum of Art, a few years ago, during which a melancholy realization set in.

"I wandered into the galleries where the early Flemish masters are hung—Robert Campin, van Eyck, van der Weyden, Petrus Christus, Memling—wonderful artists. And I realized that the painters I love the most—Vermeer, too—did these small, highly detailed, delicate paintings that are so perfectly rendered you almost can't see how they were made. The very opposite of what I was doing. And it hit me that physically I would never be able to do anything like that again, even if I wanted to."

These are the words of someone who feels that he once possessed the gifts to use a paintbrush to set down absolutely anything that he chose to, as he chose to. This casts an interesting light on his devotion to process. As Leslie Close pointed out, her husband, prior to becoming a quadriplegic, habitually confronted himself with self-imposed difficulties and limitations that determined the way in which he achieved his ends in any given set of works. This certainly helped emphasize the idea of process as the means to an end, but it also suggests that one reason for Close turning to process was as a way of keeping his own virtuosity in check. Another, of course—given the incremental character of that process—was a response to his dyslexia.

Coming to artistic maturity in New York in 1967 was very different from earning the right to be called a master in Flanders in

311

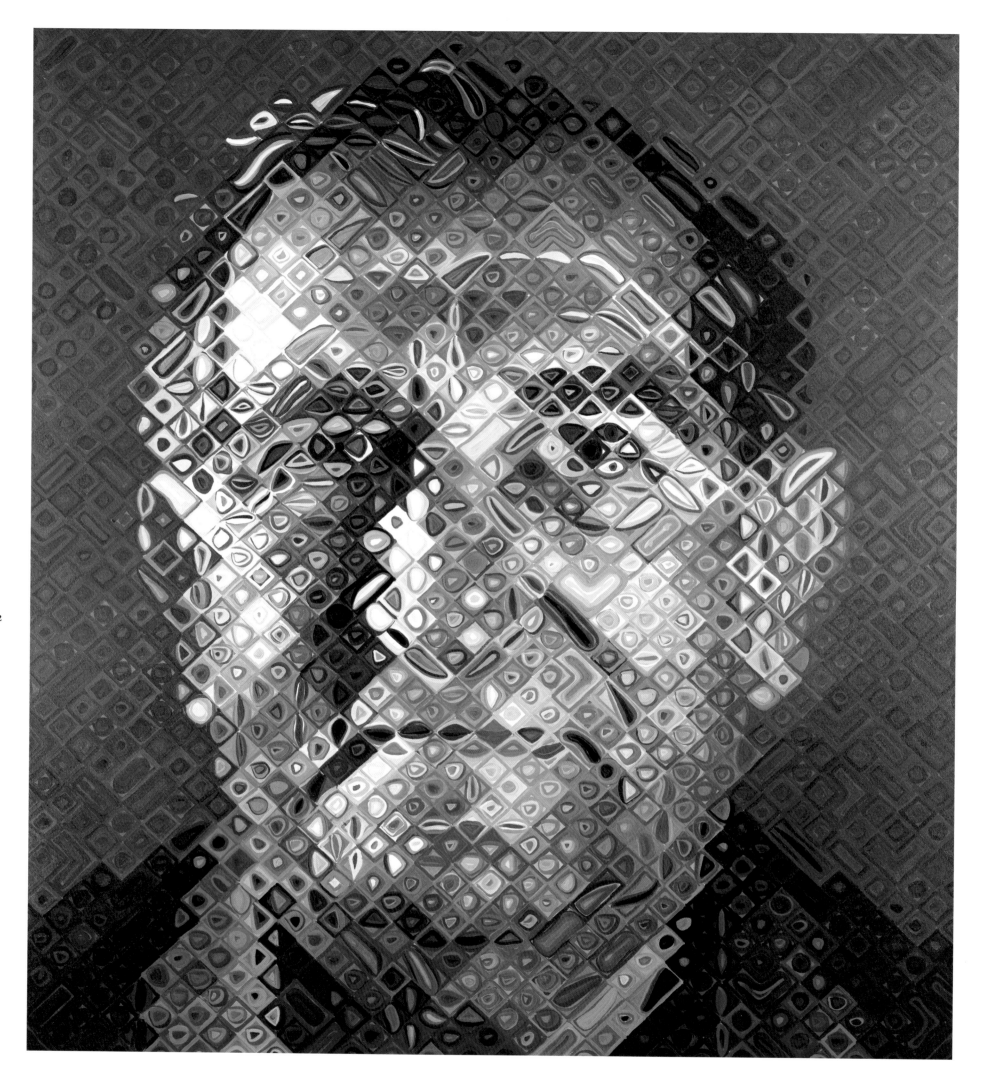

Nat, 2005–6.
Oil on canvas, 102 x 96 in.
(259.1 x 243.8 cm)

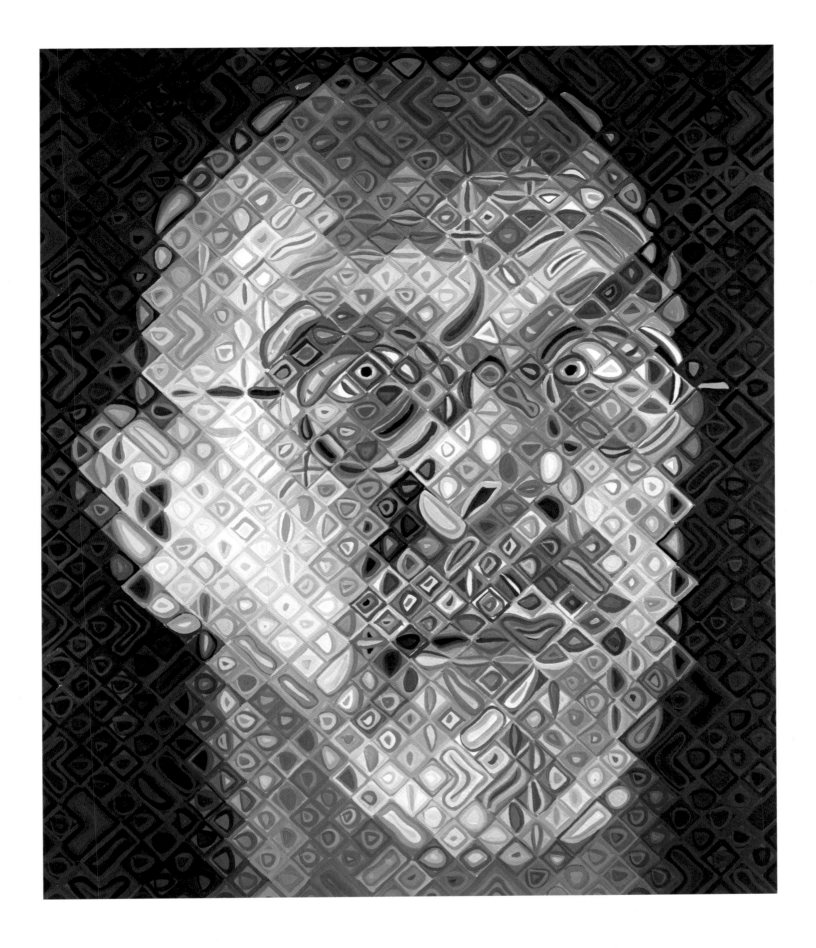

Self-Portrait, 2002–3.

Oil on canvas, 72 x 60 in.

(182.9 x 152.4 cm)

► Self-Portrait, 2007.
Oil on canvas. 72 x 60 in.
(183 x 152.5 cm)

the first half of the fifteenth century, though that era too was one of radical change. The Flemish artists of that period were building upon the pictorial naturalism that had emerged in the work of miniaturists like the Limbourg Brothers, and doing so in the context of new discoveries regarding perspective and optics.[24] Those were exciting times for artists, but everything pointed in a single direction—towards the perfection of illusionism.

In 1967, by contrast, a number of paths could be taken. Color field painting was still a strong presence, while nonfigurative painters were experimenting with the possibilities inherent in shaped and extended canvases. Minimalism was in its heyday, and conceptualism was on the rise. Even someone who made the choice of going with process art could choose any of several directions, since the process selected would determine the outcome. The art produced by Richard Serra is very different from that of Sol LeWitt, and neither resembles the art made by Chuck Close, though all three have much in common in terms of underlying principles.

What makes Close's work so different from that of his fellow process artists is the fact that he was able to match this latter-day New York art world philosophy to the concerns that had occupied the talents of those fifteenth-century painters in cities like Bruges and Louvain, the exploration of illusion. That was something that had fascinated him since he analyzed those covers of *Time* and the *Saturday Evening Post* through his grandmother's magnifying glass. This paid off when he realized how, by turning to the mechanical illusion created by the camera, he could resolve the apparent conflict between illusionism and the obsession with flatness that had gripped advanced artists since Pollock's allover drip paintings had transformed their perception of what painting could be.

In his continuous-tone paintings of the sixties and seventies, Close achieved an astonishing breakthrough by making deadpan blowups of photographic images of individual heads in which he utterly rejected the painterly while assiduously reproducing the apparition of reality captured by the camera. Flatness and illusionism were wed, and the brilliance with which Close rendered these early portraits allowed him to move on to other ways of fabricating images in which the tension between photographic "reality" and the flatness of the canvas, the struggle between the chimerical quality of illusion and the concreteness of abstraction, is always the dominant dynamic. This has culminated in the prismatic grid paintings in which the incremental massing of tiny, variegated abstract elements still, thanks to some extraordinary sleight of hand, reads as illusion produced by a lens.

Chuck Close's achievement has been to revisit the discovery of illusionism found in those Flemish masters, and to rethink it in terms of modernism. (This is especially apropos if one is prepared to accept the controversial notion that artists were making use of the camera obscura six centuries ago.) In a very real sense, his work encompasses the arc of western art from van Eyck to de Kooning, Pollock, and Johns. It is the product of total immersion in that world, to the point where his mind contains an image bank that embodies André Malraux's notion of the museum without walls. The images themselves do not, of course, find their way into his paintings. What is manifested there is his immense curiosity about, and understanding of, the way in which those images were made, and why. Without ever taking the form of imitation, that fund of knowledge is implicit in everything he does.

Chuck Close's portraits are not the kind of paintings that you look at casually, thinking, "That's rather good." They grab your attention because of their monumental scale, then hold it because each of them contains so much information, and each bit of information is constantly transforming every other bit of information, shifting from description to abstraction as the viewer's position changes. Many early modernists—Wassily Kandinsky, for example—talked of making paintings that had the fluidity of music, and its freedom from imitation. Seen from close up, Close's prismatic grid paintings come as near to being visual music as anything one can imagine, each dab and swirl of paint a note in a vast sea of orchestral texture. Yet from a slight distance, this chromatic texture shapes up into something more thematic, peppered with pictorial leitmotifs. A few more steps back and the themes organize themselves into description of the most sophisticated kind.

· · ·

No one looks at a painting with the intensity of the artist who made it. Chuck Close's paintings, however, are made in such a

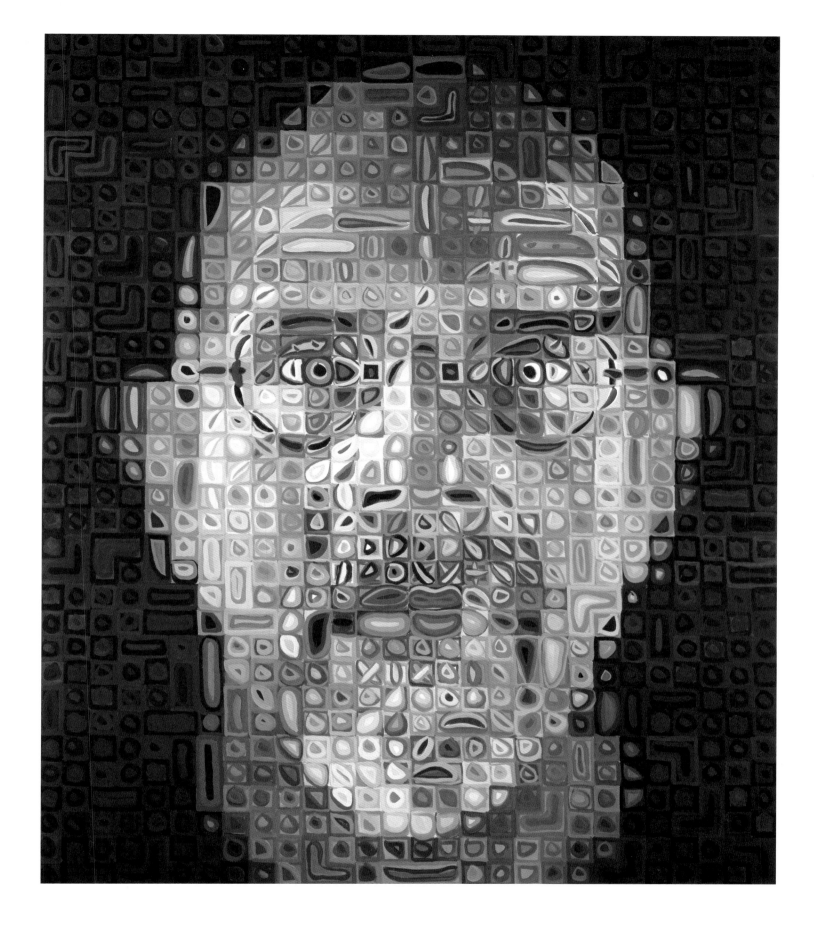

way—and this again is a function of process, and especially its incremental aspect—that they challenge anyone who encounters them to at least *attempt* that kind of intensity. (I am reminded of James Joyce's statement that his ideal reader would be one who devoted a lifetime to studying his books.) This is what gives them such a hold on the viewer. They do not readily yield up their secrets, and yet one hungers to uncover those secrets. It's possible to visit these portraits again and again and discover something new each time (or rather it's impossible not to find something new).

Looking at them, in short, demands active involvement in the way they were made, as well as enjoyment of the finished product. In the case of the prismatic grid paintings, this characteristic is immediately apparent, but it's equally true of the continuous-tone portraits precisely because the method of fabricating them has been so perfectly concealed.

It's my respectful hope that this book will be read and reread for clues as to how these paintings, and Chuck Close's other multi-faceted works of art, might be read and reread.

NOTES

1. As a senior in high school, Close applied to the Walt Disney Studio with the idea of becoming an animator. When he learned of the drudgery involved in the apprenticeship, and the low pay, he thought better of the idea.

2. From the transcript of a conversation between Alden Mason and Lamar Harrington, taped January 13, 1984, part of an oral history commissioned by the Smithsonian Institution Archives of American Art.

3. In 1995 the University of Massachusetts, Amherst, awarded Close an honorary doctorate.

4. In her 2005 book *Art and the Power of Placement*, Victoria Newhouse points out that Pollock's large drip paintings first made a major public impact when seen at the Betty Parsons Gallery, a relatively modest space that forced viewers into an unusually intimate relationship with the artist's wall-size canvases.

5. In Germany, at about the same time, Gerhard Richter was making paintings from black-and-white photographs that can be seen as having a definite relationship with Close's heads. Neither artist was aware of the other's work until later, however. In California, in 1968, Vija Celmins—who had attended Yale Summer School with Close—began making rigorously disciplined pencil drawings of black-and-white photographs of the ocean, and these too had something in common with Close's paintings at a philosophical level.

6. Reviews appeared in *Arts* and *Artforum*, by Cindy Nemser and Emily Wasserman respectively.

7. Along with Kent Floeter and Leslie Close, the subjects are Susan Zucker, John Roy, Nat Rose (Leslie's father), and Linda Rosenkrantz.

8. Kathan Brown in conversation with Chuck Close and Terrie Sultan, *Chuck Close Prints: Process and Collaboration*, Princeton, 2003, p. 49.

9. Lisa Lyons and Robert Storr, *Chuck Close*, Rizzoli International Publications, 1987, p. 92.

10. Although Close began by using the ink found on pads intended for use with rubber stamps, he later made fingertip portraits using lithographer's ink and oil-based inks. He had been warned that the ink-pad ink was likely to be somewhat impermanent, and something in its chemical makeup was causing his fingers to become numb.

11. Close and Pace Editions worked with Dieu Donné again for an ambitious 1992 self-portrait.

12. Terrie Sultan, Richard Schiff, et al., *Chuck Close Prints: Process and Collaboration*, Princeton University Press, 2003, p. 66. The catalogue for a traveling exhibition originating at the Blaffer Gallery, the art museum of the University of Houston, this publication provides a detailed introduction to Close's work in prints and multiples.

13. Ibid.

14. Lisa Lyons and Robert Storr, *Chuck Close*, Rizzoli, 1987, p 36

15. Close emphasizes that he never found the daily chores of picture-making—however mechanical they might seem—anything but pleasurable.

16. Thorough as always, Close made a study of Seurat's methods, traveling to Chicago to spend time in front of *A Sunday on La Grande Jatte–1884* (1884–86). He concluded that Seurat was far from consistent in applying scientific principles.

17. The biochemical agent concerned is acetylcholine (ACh), which causes and controls muscle activity by transmitting nerve impulses across synapses.

18. Serious respiratory problems would continue for months because Close's diaphragm was partially paralyzed, so that his cough was very weak and "unproductive."

19. Robert Storr et al, *Chuck Close*, the Museum of Modern Art, New York, 1998, p. 25

20. The hand-pulled printing method involves laying a sheet of paper over the block, then rubbing the back of the paper with the baren—which typically is about a foot long and comes in various shapes—so that the ink is transferred smoothly to the support.

21. Terrie Sultan et al, *Chuck Close Prints: Process and Collaboration*, Princeton University Press, 2003

22. Robert Storr et al., *Chuck Close*, The Museum of Modern Art, New York, 1998, p. 61

23. In addition to Minneapolis and San Francisco, the exhibition traveled to the High Museum of Art, in Atlanta, and the Albright-Knox Gallery in Buffalo, New York.

24. Chuck Close has long believed that European masters, beginning in the fifteenth century, made use of the camera obscura and similar optical devices. He has been a strong defender of the theories expressed by David Hockney in his book *Secret Knowledge: Rediscovering the Lost Techniques of the Old Masters* (2001).

EXHIBITIONS

Exhibitions accompanied by an important catalogue are indicated with an asterisk.

SOLO EXHIBITIONS

1967
"Charles Close," University of Massachusetts Art Gallery, Amherst, Mass., January 8–February 1.

1970
"Chuck Close," Bykert Gallery, New York, February 28–March 28.

1971
* "Chuck Close: Recent Work," Los Angeles County Museum of Art, Los Angeles, September 21–November 14.

"Chuck Close: Recent Work," Bykert Gallery, New York, December 4–January 5, 1972.

1972
* "Chuck Close," Museum of Contemporary Art, Chicago, February 5–March 19.

1973
"Project 11: Chuck Close," The Museum of Modern Art, New York, January 11–February 25.

"Chuck Close, Collector's Exhibition," Akron Art Museum, Akron, March 31–May 6.

"Chuck Close: Recent Work," Bykert Gallery, New York, October 20–November 15.

1975
"Chuck Close: Keith," Mint Museum of Art, Charlotte, N.C., January 5–February 2. Traveled under different exhibition titles to Ball State University Art Gallery, Muncie, Ind.; Phoenix Art Museum, Phoenix, June 1–29; The Minneapolis Institute of Arts, July 18–August 31.

"Chuck Close," Bykert Gallery, New York, April 5–24.

* "Chuck Close: Dot Drawings 1973–1975," Laguna Gloria Art Museum, Austin, June 17–July 20. Traveled to Texas Gallery, Houston, July 22–August 16; Art Museum of South Texas, Corpus Christi, August 19–September 20; San Francisco Museum of Modern Art, December 10–January 25, 1976; The Contemporary Arts Center, Cincinnati, February 22–March 5, 1976.

"Chuck Close: Drawings and Paintings," The Portland Center for the Visual Arts, September 26–October 26.

1976
"Chuck Close," Baltimore Museum of Art, April 6–May 30.

1977
* "Chuck Close: Recent Work," The Pace Gallery, New York, April 30–June 4.

"Chuck Close, Matrix 35," Wadsworth Atheneum, Hartford, November 1–January 29, 1978.

1979
"Focusing on Faces," Hayden Gallery, Cambridge, Mass., January 17–20.

"Chuck Close: Copie/Conforme?," Musée national d'art moderne, Centre Georges Pompidou, Paris, April 18–June 11.

* "Chuck Close," Kunstraum München, Munich, June 28–July 21.

* "Chuck Close: Recent Work," The Pace Gallery, New York, October 26–November 24.

1980
* "Close Portraits," The Walker Art Center, Minneapolis, September 28–November 16. Traveled to St. Louis Art Museum, December 5–January 25, 1981; Museum of Contemporary Art, Chicago, February 6–March 29, 1981; Whitney Museum of American Art, New York, April 14–June 21, 1981.

1982
"Chuck Close: Matrix/Berkeley 50," University Art Museum, Berkeley, March 3–May 5.

"Chuck Close: Polaroid Portraits," California Museum of Photography, University of California, Riverside, May 14–July 31.

"Chuck Close: Paperworks," Richard Gray Gallery, Chicago, September–October 1982. Traveled to John Stoller Gallery, Minneapolis, October–November; Jacksonville Art Museum, Jacksonville, Fla., December 10–January 19, 1983; Greenberg Gallery, St. Louis, September–October 1983.

1983
* "Chuck Close: Recent Work," The Pace Gallery, New York, February 25–March 26.

1984
* "Chuck Close: Handmade Paper Editions," Herbert Palmer Gallery, Los Angeles, February 4–March 16. Traveled to Spokane Center of Art, Cheney, Wash., April 5–May 12; Milwaukee Art Museum, June 1–September 30; N.I.U. Art Gallery, Northern Illinois University, DeKalb, September 25–October; Columbia Museum of Art, Columbia, S.C., November 18–January 1985.

1985
"Chuck Close: Photographs," Pace/MacGill Gallery, New York, January 12–February 16.

* "Chuck Close: Works on Paper," Contemporary Arts Museum, Houston, February 9–April 21.

* "Exhibition of Chuck Close," Fuji Television Gallery, Tokyo, March 1–30.

"Chuck Close: Large Scale Photographs," Fraenkel Gallery, San Francisco, June 26–July 27.

1986
"Chuck Close: Maquettes," Pace/MacGill Gallery, New York, January 9–February 15.

"Chuck Close: New Etchings," Pace Editions, New York, February 21–March 22.

* "Chuck Close: Recent Work," The Pace Gallery, New York, February 21–March 22.

1987
"Chuck Close: Photographs," Aldrich Museum of Contemporary Art, Ridgefield, Conn., March 1–May 10.

* "Chuck Close: Drawings, 1974–1986," The Pace Gallery, New York, June 19–July 24.

"Chuck Close–Large Scale Self-Portraits," Pace/MacGill Gallery, New York, October 15–November 28.

1988
"Chuck Close: Prints and Photographs," Pace Editions, New York, September 23–October 22.

* "Chuck Close, New Paintings," The Pace Gallery, New York, September 23–October 22.

"Chuck Close: A Survey," Pace/MacGill Gallery, New York, September 23–October 22.

"Chuck Close: Photographs," Fendrick Gallery, Washington, DC., November 1–December 3.

"Works on Paper by Chuck Close," Tomasulo Gallery, Union County College, Cranford, N.J., December 2–December 23.

1989
* "Chuck Close," The Art Institute of Chicago, February 4–April 16. Traveled to The Friends of Photography, Ansel Adams Center, San Francisco, November 8–January 7, 1990.

* "Chuck Close Editions: A Catalogue Raisonné and Exhibition," The Butler Institute of American Art, Youngstown, Ohio, September 17–November 26.

"Chuck Close: Works on Paper from the Collection of Sherry Hope Mallin," Aldrich Museum of Contemporary Art, Ridgefield, Conn., October 29–February 25, 1990.

1991
* "Chuck Close: Up Close," Guild Hall Museum, East Hampton, N.Y., June 15–July 28.

"Chuck Close Editions," University Art Museum, University of Southwestern Louisiana, Lafayette, September 7–October 24.

"Chuck Close: Large Color Photographs," William Twigg-Smith Gallery, The Contemporary Museum, Honolulu, September 10–November 17.

* "Chuck Close: Recent Paintings," The Pace Gallery, New York, November 2–December 7.

"Chuck Close," The Art Institute of Boston, November 8–December 18.

1993
"Chuck Close Editions," Pace Editions, New York, March 20–30.

"Chuck Close: Lucas Rug," A/D Gallery, New York, April 1–June 3.

"Chuck Close: Portraits," Virginia Museum of Fine Arts, Richmond, July 21–October 31.

"A Print Project by Chuck Close," The Museum of Modern Art, New York, July 24–September 28.

* "Chuck Close Recent Paintings," The Pace Gallery, New York, October 22–November 27.

1994
* "Chuck Close: Retrospektive," Staatliche Kunsthalle, Baden-Baden, April 10–June 22. Traveled to Kunstbau Lenbachhaus, Munich, July 13–September 11.

* "Chuck Close: Visible and Invisible Portraits," Kaohsiung Museum of Fine Arts, Taiwan, June.

"Chuck Close: 8 peintures récentes," Fondation Cartier pour l'art contemporain, Paris, September 24–October 23.

1995
"Chuck Close: The Graphics," Dean Jensen Gallery, Milwaukee, January 20–March 4.

"Chuck Close Recent Editions: Alex–Chuck–Lucas," Pace Editions, New York, March 10–April 13.

* "Chuck Close: Recent Paintings," PaceWildenstein, Los Angeles, September 28–October 28. Traveled to Pace-Wildenstein, New York, December 2–January 6, 1996.

"Chuck Close: Alex/Reduction Block," Lannan Foundation, Los Angeles, September 30–January 7, 1996.

1996
* "Affinities: Chuck Close and Tom Friedman," The Art Institute of Chicago, April 27–July 28.

"A Salute to Chuck Close," Archives of American Art, Smithsonian Institution, New York, October 8–January 6, 1997.

"Chuck Close: Large Scale Black and White Photographs," PaceWildenstein/MacGill, New York, October 24–November 23.

1997
"Chuck Close: Large Scale Black and White Photographs," PaceWildenstein, Los Angeles, January 24–March 1.

"Chuck Close 'Large Format Polaroids,'" Galerie Daniel Blau, Munich, March 7–April 26.

"Chuck Close/Paul Cadmus: In Dialogue," Philadelphia Museum of Art, April 5–June 1.

"Chuck Close," Henry Art Gallery, Seattle, May 30–June 22.

1998
"Close's Subject: Part Portrait/Part Process," The Museum of Modern Art, New York, February 26–May 26.

"Chuck Close: Self-Portraits," Weinstein Gallery, Minneapolis, March 14–April 11.

"Chuck Close: Prints 1978–1997," Georg Kargl Gallery, Vienna, September 10–30.

"Chuck Close: Prints," Virginia Lynch Gallery, Tiverton, R.I., September 27–October 25.

* "Chuck Close: A Retrospective," The Museum of Modern Art, New York, February 25–June 2. Traveled to Museum of Contemporary Art, Chicago, June 20—September 13; Hirshhorn Museum and Sculpture Garden, Washington, DC., October 15–January 10, 1999; The Seattle Art Museum, February 18–May 9, 1999; The Hayward Gallery, London, July 22–September 19, 1999.

1999
"Photographs by Chuck Close," White Cube, London, July 23–September 4.

2000
"Chuck Close: Portraits and Nudes," Pace/MacGill Gallery, New York, March 16–April 22.

* "Chuck Close: Recent Paintings," PaceWildenstein Gallery, New York, March 17–April 29.

"Chuck Close: Recent Prints at Pace Prints," Pace Prints, New York, April 8–May 6.

"Chuck Close: Paperworks at Dieu Donné Papermill," Dieu Donné Papermill, New York, April 22–June 3.

"Chuck Close: A Painting of Agnes/ Prints and Drawings," The University of New Mexico, The Harwood Museum, Taos, May 7–July 9.

"Chuck Close: Daguerreotypes and Iris Prints," Galerie Daniel Blau, Munich, September 8–October 28.

"Chuck Close: Self Portraits," David Adamson Gallery, Washington, DC., September 16–October 21.

"Chuck Close Photographic Works," The Butler Institute of American Art, Youngstown, Ohio, September 24–November 26.

"Chuck Close," Worcester Art Museum, Worcester, Mass., December 9–March 29, 2001.

2001
"Chuck Close Self-Portraits 1967–2001," Fraenkel Gallery, San Francisco, March 8–April 28.

2002
Exhibition at Pace/Prints, New York, February 20–March 9.

"Chuck Close: Ritratti," The American Academy in Rome, February 22–April 21.

"Chuck Close Prints," The Neuberger Museum of Art, Purchase, N.Y., September 29–December 29.

"Chuck Close: New Editions, "Pace/Prints," New York, November 1–January 10, 2003.

"Chuck Close: Daguerreotypes," Pace/MacGill, New York, November 15–January 11, 2003.

* "Chuck Close: New Paintings," PaceWildenstein Gallery, New York, November 15–January 11, 2003.

2003
"New Paintings," White Cube, London, January 30–March 1.

"Daguerreotype to Digital," Texas Gallery, Houston, September 13–October 11.

* "Chuck Close Prints: Process and Collaboration," Blaffer Gallery, the Art Museum of the University of Houston, September 13–November 23. Traveled to Metropolitan Museum of Art, New York, January 13–April 18, 2004; Miami Art Museum, May 14–August 22, 2004; Knoxville Museum of Art, Knoxville, Tenn., October 29, 2004–March 27, 2005; Mint Museum of Art, Charlotte, N.C., April 16–August 7, 2005; Addison Gallery of American Art, Andover, Mass., September 13–November 23, 2005; Modern Art Museum of Fort Worth, April 9–June 25, 2006; Madison Museum of Contemporary Art, Madison, Wis., July 30–October 8, 2006; Orange County Museum of Art, Costa Mesa, Calif., January 28–April 22, 2007; Boise Art Museum, Boise, Idaho, May 12–August 12, 2007; Portland Art Museum, Portland, Ore., October 6, 2007–January 6, 2008.

2004
"Chuck Close: Drawings, Photographs, Prints," Craig Starr Associates, New York, January 15–January 31.

"Chuck Close: Prints and Process," William H. Van Every Gallery, Davidson College, Davidson, N.C., January 22–February 27.

2005
"Chuck Close: Face to Face," Jerald Melberg Gallery, Charlotte, N.C., April 23–May 28.

* "Chuck Close: Recent Paintings," PaceWildenstein Gallery, New York, May 10–June 18.

* "Chuck Close: Self-Portraits 1968–2005," Walker Art Center, Minneapolis, July 24–October 16; San Francisco Museum of Modern Art, November 19–February 21, 2006; The High Art Museum, Atlanta, March 25–July 9, 2006; The Albright-Knox Art Gallery, Buffalo, July 22–October 22, 2006.

2006
"Chuck Close," Galerie Xippas, Athens, June 28–October 30.

* "A Couple of Ways of Doing Something," Aperture Foundation, New York, November 10–January 4, 2007.

2007
"Chuck Close: Pinturas, 1968/2006," Museo Nacional Centro de Arte Reina Sofia, Madrid, February 6–May 7; Ludwig Forum für internationale Kunst, Aachen, Germany, May 25–September 2

"Chuck Close," Galerie Xippas, Paris, February 24–April 7.

GROUP EXHIBITIONS

1969
"Lynda Benglis, Chuck Close, David Paul, Richard Van Buren," Bykert Gallery, New York, May 20–June 20.

* "1969 Annual Exhibition of Contemporary American Paintings," Whitney Museum of American Art, New York, December 16–February 1, 1970.

1970
* "22 Realists," Whitney Museum of American Art, New York, February 10–March 29.

"Klischee und Antiklischee," Neue Galerie der Stadt Aachen, West Germany, March–April.

"Three Young Americans," Allen Memorial Art Museum, Oberlin College, Ohio, April 17–May 12.

1971
* "Prospect '71, Projection," Städtische Kunsthalle, Düsseldorf, October 8–17.

"Recent Vanguard Exhibition," Art Gallery of Ontario, December 18–January 9, 1972.

1972
"Eight New York Painters," Berkeley Museum, University of California.

* "Annual Exhibition, Contemporary American Painting," Whitney Museum of American Art, New York, January 25–March 19.

* "Colossal Scale," Sidney Janis Gallery, New York, March 9–April 1.

* "Painting and Sculpture Today, 1972," Indianapolis Museum of Art, April 26–June 4.

* "Kunst um 1970–Art around 1970: Sammlung Ludwig in Aachen," Neue Galerie der Stadt Aachen, West Germany, June.

"Crown Point Press at the San Francisco Art Institute," Emmanuel Walker Gallery, San Francisco, September 1–October 1.

* "Documenta 5," Fredericianum, Kassel, West Germany, June 30–October 8.

* "Hyperréalistes américains," Galerie des Quatre Mouvements, Paris, October 25–November 25.

* "Amerikanischer Fotorealismus," Württembergischer Kunstverein, Stuttgart, November 16–December 26. Traveled to Frankfurter Kunstverein, Frankfurt, January 6–February 18; Kunst und Museumverein Wuppertal, West Germany, February 25–April 8.

"Eighteenth National Print Exhibition," Brooklyn Museum of Art, November 22–February 4, 1973. Traveled to California Palace of the Legion of Honor, March 24–June 17, 1973.

* "Realism Now," The New York Cultural Center, December 6, 1972–January 7, 1973.

1973
"Aachen International 70–74," Edinburgh Festival, Royal Scottish Academy, Edinburgh.

"Art conceptuel et hyperréaliste," Ludwig Collection, Musée d'art moderne de la ville de Paris.

"Ein grosses Jahrzehnt amerikanischer Kunst: Sammlung Peter Ludwig Köln/Aachen," Kunstmuseum Luzern, Lucerne.

"Ekstrem Realisme," Louisiana Museum, Humlebaek, Denmark.

"Realism Now," Katonah Gallery, Katonah, N.Y..

"Young American Artists." Traveled to Denmark, Norway, Sweden, and West Germany, January–October.

* "Combattimento per un'immagine," Galleria civica d'arte moderna, Turin, March–April.

"Photo-Realism: Paintings, Sculpture and Prints from the Ludwig Collection and Others," Serpentine Gallery, London, April 4–May 6.

"The Emerging Real," Storm King Art Center, Mountainville, N.Y., Part I: April 7–July 15; Part II: July 28–October 28.

"Ruhr Festival Exhibition," Stadtische Kunsthalle, Recklinghausen, West Germany, May 4–June 17.

"Grands Maîtres hyperréalistes américains," Galerie des Quatre Mouvements, Paris, May 23–June 15. Traveled to 4e Salon international d'art, Basel, June 20–25.

* "American Drawings 1963–1973," Whitney Museum of American Art, New York, May 25–July 22.

* "American Art–Third Quarter Century," Seattle Art Museum, August 22–October 14.

* "The Super-Realist Vision," DeCordova and Dana Museum, Lincoln, Mass., October 7–December 9.

* "Gray Is the Color: An Exhibition of Grisaille Painting, XIIIth–XXth Centuries," Rice Museum, Rice University, Houston, October 19–January 19, 1974.

"One Hundred Master Drawings from New England Private Collections," organized by Hopkins Center Galleries, Dartmouth

College, Hanover, N.H. Traveled to Wadsworth Atheneum, Hartford, September 5–October 14; Hopkins Center Galleries, Dartmouth College, October 26–December 3; The Museum of Fine Arts, Boston, December 14–January 25, 1974.

"Kunst nach Wirklichkeit: Ein neuer Realismus in Amerika und in Europa," Kunstverein Hannover, Hanover, West Germany, December 9–January 27, 1974.

* "Hyperréalisme," Galerie Isy Brachot, Brussels, December 14–February 9, 1974.

1974
Exhibition, Palazzo Reale, Milan.

* "Projekts '74 (Kunst bleibt Kunst)," Wallraf-Richartz Museum, Cologne.

* "Selections of Realistic Painting from the Ludwig Collection," Groninger Museum voor Stad en Lande, Groningen, The Netherlands.

* "ARS '74," Ateneum, The Fine Arts Academy of Finland, Helsinki, February 15–March 31. Traveled to Tampereen Nykytaiteen Museo, Tampere, Finland, April 10–May 12.

* "Hyperréalistes américains, réalistes européens," Centre national d'art contemporain, Paris, February 15–March 25.

"I potesi di Casa Esistenziale Ico Parisi," Galerie Germain, Paris, February 19–March 19.

* "Three Realists: Close, Estes, Raffael," Worcester Art Museum, Worcester, Mass., February 27–April 7.

* "25 Years of Janis, Part 2," Sidney Janis Gallery, New York, March 13–April 13.

* "11th Tokyo Biennale 1974," Tokyo, May 10–30.

* "Kijken naar de werkelijkheid," Museum Boymans-van Beuningen, Rotterdam, June 1–August 18.

* "Art 5 '74," Basel, June 19–24.

* "Amerikaans Fotorealisme: Grafiek," Hedenaagse Kunst, Utrecht, The Netherlands, June 8–August 4. Traveled to Palais des beaux arts, Brussels, September–October.

"New Portraits," Whitney Museum of American Art, Downtown Branch, New York, November 7–December 12.

1975
"Selections from the Collection of Herbert and Dorothy Vogel," Clocktower, New York.

* "Portrait Painting 1970–75," Allan Frumkin Gallery, New York, January 7–31.

* "34th Biennial Exhibition of Contemporary American Painting," Corcoran Gallery of Art, Washington DC., February 22–April 6.

* "Painting, Drawing, and Sculpture of the 60s and 70s from the Dorothy and Herbert Vogel Collection," Institute of Contemporary Art, University of Pennsylvania, Philadelphia, October 7–November 18. Traveled to The Contemporary Arts Center, Cincinnati, December 17–February 15, 1976.

* "Recent American Etching," Davison Art Center, Wesleyan University, Middletown, Conn., October 10–November 23. Traveled to National Collection of Fine Arts, Smithsonian Institution, Washington DC., January 21–March 27, 1976.

"The Portrait/1975," Boston University Art Gallery, School for the Arts, December 2–21.

1976
"Soho," Akademie der Kunst, Berlin.

* "Drawing Now, 1955–75," The Museum of Modern Art, New York, January 21–March 21. Traveled to Edinburgh

College of Art; Kunsthaus Zürich, October 9–November 14; Kunsthalle Baden-Baden, November 24–January 16, 1977; Graphische Sammlung Albertina, Vienna, January 28–March 6, 1977; Sonjia Henie–Niels Onstad Museum, Oslo, March 17–April 24, 1977; The Tel Aviv Museum, May–June 1977.

* "The Photographer and the Artist," Sidney Janis Gallery, New York, February 7–March 6.

* "Seventy-Second American Exhibition," Art Institute of Chicago, March 13–May 9.

"Aspects of Realism," Stratford Art Gallery, Stratford, Ontario, June 8–September 5; Vancouver Centennial Museum, September 16–October 17; Glenbow Alberta Institute, Calgary, Alberta, October 28–November 28; Mendel Art Gallery, Saskatoon, Saskatchewan, December 10–January 9, 1977; Winnipeg Art Gallery, Manitoba, January 20–February 20, 1977; Edmonton Art Gallery, Alberta, March 1–April 1, 1977; Memorial University Art Gallery, St. John's, Newfoundland, April 14–May 14, 1977; Confederation Art Gallery, Charlottetown, Prince Edward Island, May 26–June 26, 1977; Musée d'art contemporain, Montreal, July 7–August 7, 1977.

* "Three Decades of American Art Selected by the Whitney Museum of American Art," Seibu Museum of Art, Tokyo, June 18–July 20.

* "Drawing Today in New York," Tulane University, New Orleans, September 2–23; Rice University, Houston, October 8–November 19; Southern Methodist University, Dallas, January 10–February 16, 1977; University of Texas at Austin, February 27–March 11, 1977; Oklahoma Arts Center, Oklahoma City, April 15–May 15, 1977; Dayton Art Institute, Dayton, Ohio, June 3–August 21, 1977.

* "American Artists: A New Decade," organized for the Fort Worth Art Museum. Exhibited at the Detroit Institute of Arts, July 30–September 19.

* "Amerikanischer Druckgraphik von 1945 bis heute," Nationalgalerie, Berlin, September 4–November 11. Traveled to Kunsthalle zu Kiel, West Germany, November 7–December 30.

* "Richard Artschwager, Chuck Close, Joe Zucker," Daniel Weinberg Gallery, San Francisco, September 14–October 22. Traveled to La Jolla Museum of Contemporary Art, November 5–December 5; Memorial Union Art Gallery, University of California at Davis, January 5–28, 1977.

* "Modern Portraits: The Self and Others," Wildenstein Gallery, New York, October 20–November 28. Organized by Columbia University.

"American Master Drawings and Watercolors," Whitney Museum of American Art, New York, November 23–January 23, 1977.

1977
* "Illusion and Reality," Australian National Gallery, Canberra; Western Australian Art Gallery, Perth; Queensland Art Gallery, Brisbane; Art Gallery of New South Wales, Sydney; Art Gallery of South Australia, Adelaide; National Gallery of Victoria, Melbourne; Tasmanian Museum and Art Gallery, Hobart, Australia.

* "1977 Biennial Exhibition," Whitney Museum of American Art, New York, February 19–April 3.

"New Realism: Modern Art Form," Boise Gallery of Art, Boise, Idaho, April 14–May 29.

"Works on Paper," Galerie de Gestlo, Hamburg, May 27–July 10.

* "Paris–New York," Musée national d'art moderne, Centre Georges Pompidou, Paris, June 1–September 19.

* "Documenta 6," Museum Fridericianum, Kassel, June 24–October 10.

"New York Now," Amherst College, Amherst, Mass., fall.

"Twentieth Century American Art from Friends' Collections," Whitney Museum of American Art, New York, September.

* "American Drawings, 1927–77," Minnesota Museum of Art, St. Paul, September 6–October 29.

* "1967–1977: Ten Years: The Museum of Contemporary Art: A View of the Decade," Museum of Contemporary Art, Chicago, September 10–November 10.

* "Works from the Collection of Dorothy and Herbert Vogel," University of Michigan Museum of Art, Ann Arbor, November 11–January 1, 1978.

* "Critics Choice," Joe and Emily Lowe Art Gallery, Syracuse University, New York, November 12–December 11. Traveled to Munson-Williams-Proctor Institute Museum of Art, Utica, N.Y., January 1–30, 1978.

"Representations of America." Organized by The Metropolitan Museum of Art, New York. Traveled to Pushkin Museum, Moscow, December 15–February 15, 1978; The Hermitage, Leningrad, March 15–May 15, 1978; Palace of Art, Minsk, Russia, June 15–August 15, 1978.

1978
"Old Friends and New Faces: The Permanent Collection Featuring Recent Acquisitions," The Johnson Gallery, Middlebury College, Middlebury, Vt., February 11–March 11.

"Contemporary Drawing/New York," UCSB Art Museum, University of California at Santa Barbara, February 22–March 26.

"Collage 1978," Goddard Riverside Community Center, New York, April 21–May 3.

* "Eight Artists," Philadelphia Museum of Art, April 29–June 25.

"Aspects of Realism: Artist of the Region," Guild Hall, East Hampton, N.Y., July 22–August 13.

* "20th Century American Drawings: Five Years of Acquisitions," Whitney Museum of American Art, New York, July 28–October 1.

"Point," Philadelphia College of Art, November 20–December 15.

"The Mechanized Image." Organized by Karen Amiel, Arts Council of Great Britain. Traveled to City Museum and Art Gallery, Portsmouth; Graves Art Gallery, Sheffield; Camden Arts Centre, London; Hatton Art Gallery, Newcastle; Aberdeen Art Gallery and Museum, Aberdeen, Scotland.

* "Late Twentieth-Century Art." Organized by The Sydney and Frances Lewis Foundation. Anderson Gallery, Virginia Commonwealth University, Richmond, December 5–January 8, 1979.

* "American Painting of the 1970s," Albright-Knox Gallery, Buffalo, December 9–January 14, 1979. Traveled to Newport Harbor Art Museum, Newport Beach, Calif., February 3–March 18, 1979; The Oakland Museum, Oakland, April 10–May 20, 1979; Cincinnati Art Museum, July 6–August 26, 1979; Art Museum of South Texas, Corpus Christi, September 9–October 21, 1979.

* "Grids: Format & Image in 20th Century Art," The Pace Gallery, New York, December 16–January 20, 1979. Traveled to Akron Art Museum, March 24–May 6, 1979.

1979
"Black and White Are Colors: Paintings of the 1950s–1970s," Galleries of the Claremont Colleges, Claremont, Calif. Traveled to Montgomery Art Gallery, Pomona College, Pomona, Calif.; Lang Art Gallery, Scripps College, Claremont, Calif.

"Documents, Drawings, and Collages: Fifty American Works on Paper from the Collection of Mr. and Mrs. Stephen D. Paine," Williams College Art Museum, Williamstown, Mass.. Traveled

to Toledo Museum of Art; John and Mable Ringling Museum of Art, Sarasota, Fla.; Fogg Art Museum, Harvard University, Cambridge, Mass.

"Drawings about Drawings Today," Ackland Art Museum, University of North Carolina, Chapel Hill, January 1–March 11.

"Images of the Self," Hampshire College Art Gallery, Hampshire, Mass., February 2–March 14.

* "1979 Biennial Exhibition," Whitney Museum of American Art, New York, February 14–April 1.

"America Now: Young America, Painters of the '70s." Organized by the New Museum of the International Communication Agency. Traveled to Eastern Europe, spring 1979.

* "Copie conforme?" Centre Georges Pompidou, Musée national d'art moderne, Paris, April 18–June 11.

"The Altered Photograph: 24 Walls, 24 Curators," P.S. 1, Long Island City, April 22–June 10.

"As We See Ourselves: Artists' Self-Portraits," Heckscher Museum, Huntington, N.Y., June 22–August 5.

"The Decade in Review: Selections from the 1970s," Whitney Museum of American Art, New York, June 19–September 2.

"Print Publishing in America." Organized by the United States Information Agency. Exhibition traveled to United States Embassies, October 1979–October 1980.

* "20 x 24/Light," Light Gallery, New York, October 4–27. Traveled to Philadelphia College of Art, April 1980.

"Realist Space," C. W. Post Art Gallery, School of the Arts, Greenvale, N.Y., October 19–December 14.

"Artists by Artists," Whitney Museum of American Art, Downtown Branch, New York, October 25–November 28.

"Reflections of Realism," The Albuquerque Museum, November 4, 1979–January 27.

"American Paintings of the Seventies," Krannert Art Museum, Champaign, Ill., November 11–January 1, 1980.

1980
"Ten American Artists from Pace," Wildenstein and Co. Gallery, London.

"First Person Singular: Recent Self-Portraiture," Pratt Manhattan Center Gallery, New York, February 2–March 1. Traveled to Pratt Institute Gallery, Brooklyn, March 5–April 1.

* "Printed Art: A View of Two Decades," The Museum of Modern Art, New York, February 13–April 1.

* "American Painting of the Sixties and Seventies," Montgomery Museum of Art, Montgomery, Ala., April 4–May 25. Traveled to Joslyn Art Museum, Omaha; Museum of Fine Arts, St. Petersburg, Fla.; Columbus Museum of Art, Columbus, Ohio, 1981; Colorado Springs Fine Art Center, Colorado Springs, 1981; Sierra Nevada Museum of Art, Reno, 1981.

"American Realism of the Twentieth Century," Morris Museum of Arts and Sciences, Morristown, N.J., April 14–June 1.

"American Portrait Drawings," National Portrait Gallery, Washington, DC., May 1–August 3.

"Aspects of the 70s: Directions in Realism," Danforth Museum, Framingham, Mass., May 17–August 24.

* "The Figurative Tradition and the Whitney Museum of American Art: Paintings and Sculpture from the Permanent Collection," Whitney Museum of American Art, New York, June 25–September 28.

"Portrait Real and Imagined," Guild Hall Museum, East Hampton, N.Y., August 23–September 21.

* "The Morton G. Neumann Family Collection," The National Gallery of Art, Washington DC., August 31–December 31.

"American Figure Painting 1950–1980," The Chrysler Museum, Norfolk, Va., October 17–November 30.

1981
* "20 Artists: Yale School of Art 1950–1970," Yale University Art Gallery, New Haven, January 29–March 29.

"Drawings from Georgia Collections: 19th and 20th Century," The High Museum of Art, Atlanta, May 14–June 28.

* "Inside/Out: Self Beyond Likeness," Sullivan Gallery, Newport Harbor Art Museum, Newport Beach, Calif., May 22–July 12. Traveled to Portland Art Museum, September 8–October 18; Joslyn Art Museum, Omaha, February 13–April 4, 1982.

* "Photographer as Printmaker: 140 Years of Photographic Printmaking." Organized by The Arts Council of Great Britain. Traveled to Museum and Art Gallery, Leicester, September 16–October 18; The Cooper Gallery, Barnsley, December 19–January 17, 1982; Castle Museum, Nottingham, January 30–February 28, 1982; The Photographer's Gallery, London, March 11–April 11, 1982; Ferens Art Gallery, Hull, August 5–30, 1982; Talbot Rice Centre, Edinburgh, October 28–November 28, 1982.

* "Super Realism from the Morton G. Neumann Family Collection," Kalamazoo Institute of the Arts, Kalamazoo, Mich., September 1–November 1. Traveled to The Art Center, Inc., South Bend, Ind., November 22–January 3, 1982; Springfield Art Museum, Springfield, Mich., January 16–February 28, 1982; Dartmouth College Museum and Galleries, Hanover, N.H., March 19–May 2, 1982; DeCordova and Dana Museum, Lincoln, Mass., May 9–June 20, 1982; Des Moines Art Center, July 6–August 15, 1982.

"The Image in American Painting and Sculpture 1950–1980," The Akron Art Museum, September 12–November 8.

* "Contemporary American Realism Since 1960," Pennsylvania Academy of Fine Arts, Philadelphia, September 18–December 13. Traveled to Virginia Museum, Richmond, February 1–March 28, 1982; Oakland Museum, May 6–July 25, 1982; Gulbenkian Foundation, Lisbon, September 10–October 24, 1982; Salas de Exposiciones de Belles Artes, Madrid, November 17–December 27, 1982; Kunsthalle, Nuremberg, February 11–April 10, 1983.

"Seven Photorealists from New York Collections," Solomon R. Guggenheim Museum, New York, October 6–November 8.

* "American Prints: Process and Proofs," Whitney Museum of American Art, New York, November 25–January 24, 1982.

* "Instant Photography," Stedelijk Museum, Amsterdam, December 4–January 17, 1982.

1982
* "Photo-Realisme: Dix Ans après," Galerie Isy Brachot, Paris, January 13–March 6.

"Art of Our Time," High Museum of Art, Atlanta, January 23–March 7.

* "Surveying the Seventies," Whitney Museum of American Art, Fairfield County Branch, Fairfield, Conn., February 12–March 31.

"The Human Figure in Contemporary American Art," Contemporary Arts Center, New Orleans, March 5–April 4.

* "Momentbild: Künstlerphotographie," Kestner-Gesellschaft, Hanover, March 5–April 18.

"New American Graphics 2: An Exhibition of Contemporary American Prints," Madison Art Center, University of Wisconsin, Madison, March 13–April 25. Traveled to Crossman Gallery, University of Wisconsin, Whitewater, September 20–October 15; Alaska State Museum, Juneau, February 1–March 1, 1983; Visual Arts Center of Alaska,

Anchorage, March 15–April 12, 1983; Alaska Association for the Arts, Fairbanks, April 26–May 31, 1983; El Paso Museum of Art, July 2–July 30, 1983; Visual Arts Gallery, Hayes, Kan., September 15–October 20, 1983; Amarillo Art Center, Amarillo, Tex., November 2–December 11, 1983; Colorado Gallery of the Arts, Littleton, Col., January 13–February 17, 1984; Concord College, Athens, West Va., March 9–April 13, 1984; Art Center, Inc., South Bend, Ind., May 20–June 17, 1984; Humboldt Cultural Center, Eureka, Calif., August 5–September 9, 1984.

"The Pace Gallery at Asher/Faure," Asher/Faure Gallery, Los Angeles, March 13–April 10.

"Paper Transformed," Turman Gallery, Indiana State University, Terre Haute, March 19–April 15.

"Great Big Drawings," Hayden Gallery, Massachusetts Institute of Technology, Cambridge, Mass., April 3–May 2.

"Making Paper," American Craft Museum, New York, May 20–September 26. Traveled to Cleveland Institute of Art, December 10–January 7, 1983; One SeaGate of Owens Illinois, Toledo, Ohio, January 17–March 15, 1983; Columbus Museum of Art, March 27–May 22, 1983; Tucson Museum of Art, June 25–August 9, 1983; Greenville County Museum of Art, Greenville, S.C., September 11–November 13, 1983; Huntsville Museum of Art, Huntsville, Ala., January 30–March 5, 1984; Southeast Arkansas Art Center, Pine Bluff, March 19–April 30, 1984; Colorado Springs Fine Arts Center, Colorado Springs, Colo., May 19–July 8, 1984; Wustum Museum of Fine Arts, Racine, Wis., August 5–September 30, 1984; Leigh Yawkey Woodson Art Museum, Wausau, Wis., October 31–December 9, 1984.

"Homo Sapiens: The Many Images," The Aldrich Museum of Contemporary Art, Ridgefield, Conn., May.

"Late 20th Century Art," Worcester Art Museum, Worcester, Mass., September 10–October 31.

"New Portraits Behind Faces," Dayton Art Institute Experiencenter, Dayton, Ohio, October 19–February 6, 1983.

"Black & White," Leo Castelli Gallery, New York, December 29–February 9, 1983.

1983
"Subjective Vision: The Lucinda Bunnen Collection of Photographs," High Museum of Art, Atlanta.

"Faces Since the '50s: A Generation of American Portraiture," Center Gallery, Bucknell University, Lewisburg, Penna., March 11–April 17.

"Drawings 1974–1984," Hirshhorn Museum and Sculpture Garden, Washington DC., March 15–May 13.

"Photographic Visions by Martha Alf, Chuck Close, Robert Cumming, David Hockney, Robert Rauschenberg, Ed Ruscha," Los Angeles Center for Photographic Studies, September 19–October 16.

"Drawings by Contemporary American Figurative Artists," Maryland Institute, College of Art, Meyerhoff Gallery, Baltimore, September 26–November 4.

"New Work, New York," Newcastle Polytechnic Gallery, Newcastle-upon-Tyne, Eng., October 8–November 4. Traveled to Harrowgate Gallery, Harrowgate, Eng.

"Self-Portraits," Linda Farris Gallery, Seattle, August 4–September 11. Traveled to Los Angeles Municipal Art Gallery, October 18–November 13.

"American Super-Realism from the Morton G. Neumann Family Collection," Terra Museum of American Art, Evanston, Ill., November 4–December 7.

* "The First Show: Painting and Sculpture from Eight Collections, 1940–1980," The Museum of Contemporary Art, Los Angeles, November 20–February 19, 1984.

1984

"The New Portrait," The Institute for Art and Urban Resources, Long Island City, New York, NY April 15–June 10.

"Art of the States: Works from a Santa Barbara Collection," The Santa Barbara Museum of Art, June 22–August 26.

"The Modern Art of the Print: Selections from the Collection of Lois and Michael Torf," Williams College Art Museum, Williamstown, Mass., May 5–July 16. Traveled to Museum of Fine Arts, Boston, August 1–October 4.

"Drawings by Contemporary American Figurative Artists," Meyeroff Gallery, Maryland Institute, College of Art, Baltimore, September 26–November 4.

"Viewpoint: the Artist as Photographer," Summit Art Center, Summit, N.J., November 4–December 30.

* "American Art Since 1970: Paintings, Sculpture and Drawings from the Collection of the Whitney Museum of American Art." Organized by the Whitney Museum of American Art. Traveled to La Jolla Museum of Contemporary Art, La Jolla, Calif., March 10–April 22; Museo Tamayo, Mexico City, May 17–July 29; North Carolina Museum of Art, Raleigh, September 29–November 25; Sheldon Memorial Art Gallery, University of Nebraska, Lincoln, January 12–March 3, 1985; Center for the Fine Arts, Miami, March 30–May 26, 1985.

1985

"Self-Portrait Today," The Museum of Modern Art, Saitama, Japan.

* "L'Autoportrait à l'âge de la photographie: peintres et photographes en dialogue avec leur propre image," Musée cantonal de beaux-arts, Lausanne, January 18–March 24. Traveled to Württembergischer Kunstverein, Stuttgart, April 11–June 9; Akademie der Kunst, Berlin, September 1–October 6; Blaffer Gallery, the Art Museum of the University of Houston, March 2–30, 1986; San Antonio Travel Park Plaza, in connection with the Texas Sesquicentennial, San Antonio, April 12–27, 1986.

"American Realism: The Precise Image," Isetan Museum of Art, Tokyo, July 25–August 19. Traveled to Daimaru Museum, Osaka, November 7–December 12.

"Workshop Experiments: Clay, Paper, Fabric, Glass," Brattleboro Museum and Art Center, Vt., October 18–December 8.

* "American Realism: Twentieth Century Drawings and Watercolors from the Glenn C. Janss Collection," San Francisco Museum of Modern Art, November 7–January 12, 1986. Traveled to De Cordova and Dana Museum and Park, Lincoln, Mass., February 13–April 6, 1986; Archer M. Huntington Art Gallery, University of Texas, Austin, July 31–September 21, 1986; Mary and Leigh Block Gallery, Northwestern University, Evanston, October 23–December 14, 1986; Williams College Museum of Art, Williamstown, Mass., January 15–March 8, 1987; Akron Art Museum, April 9–May 31, 1987; Madison Art Center, Madison, Wis., July 26–September 20, 1987.

"Self-Portrait: The Photographer's Persona, 1840–1985," The Museum of Modern Art, New York, November 7–January 7, 1986.

"Nude, Naked, Stripped," Hayden Gallery, Massachusetts Institute of Technology, Cambridge, Mass., December 13–February 2, 1986.

1986

"An American Renaissance: Painting and Sculpture Since 1940," Museum of Art, Fort Lauderdale, Fla., January 12–March 30.

"The Real Big Picture," The Queens Museum, New York, January 17–March 19.

"Public and Private: American Prints Today, The 24th National Print Exhibition," The Brooklyn Museum of Art, New York, February 7–May 5. Traveled to Flint Institute of Arts, Flint, Mich., July 28–September 7; Rhode Island School of Design,

Providence, September 29–November 9; Museum of Art, Carnegie Institute, Pittsburgh, December 1–January 11, 1987; Walker Art Center, Minneapolis, February 1–March 22, 1987.

"New Etchings," Pace Editions, New York, February 21–March 22.

"Group Portrait Show," Martina Hamilton Gallery, New York, April 21–June 3.

"Painting and Sculpture Today–1986," Indianapolis Museum of Art, Indianapolis, June 24–August 24.

* "The Changing Likeness: Twentieth-Century Portrait Drawings," Whitney Museum of American Art at Phillip Morris, New York, June 27–September 4 .

"Big and Small," Israel Museum, Jerusalem, summer.

"Philadelphia Collects Art Since 1940," Philadelphia Museum of Art, September–November.

"50 Years Modern Color Photography, 1936–1986," Photokina, World's Fair of Imaging Systems, Cologne, September 3–9.

"Drawings from the Collection of Dorothy and Herbert Vogel," The University of Arkansas at Little Rock, September 7–November 16. Traveled to Moody Gallery of Art, The University of Alabama, Tuscaloosa, February 2–27, 1987; Pennsylvania State University Museum of Art, University Park, Penna., March 15–May 10, 1987.

"Contemporary Works from The Pace Gallery," Moody Gallery of Art, University of Alabama, Tuscaloosa, October 5–November 7.

"70s into 80s," Museum of Fine Arts, Boston, Mass., October 22–February 8, 1987.

"American Paintings from the Museum Collection," The Parrish Art Museum, Southampton, N.Y., October 26–November 30.

"Viewpoint: The Artist as Photographer," Summit Art Center, Summit, N.J., November 4–December 30.

"Structured Vision: Collage and Sequential Photography," Boise Gallery of Art, Boise, Idaho, November 25–January 4, 1987. Traveled to Whatcom Museum of History and Art, Bellingham, Wash., March 27–May 15, 1987; Cheney Cowles Memorial Museum, Eastern Washington State Historical Society, Spokane, September 11–October 11, 1987; University Gallery, Sonoma State University, Rohnert Park, Calif., November 5–December 13, 1987.

1987

"American Drawings and Watercolors of the Twentieth Century, Selections from The Whitney Museum of American Art," The Whitney Museum of American Art, New York.

"American Traditions in Watercolor," The Worcester Art Museum, Worcester, Mass..

"Contemporary Works on Paper," Vivian Horan Fine Art, New York.

"The Monumental Image," Art Gallery, Sonoma State University, Sonoma, Calif..

"Post-war Paintings from Brandeis University," Rose Art Museum, Brandeis University, Waltham, Mass.

* "This Is Not a Photograph: Twenty Years of Large Scale Photography, 1966–1986," The John and Mable Ringling Museum of Art, Sarasota, March 7–May 31. Traveled to The Akron Art Museum, Akron, Ohio, October 31–January 10, 1988; The Chrysler Museum, Norfolk, Va., February 26–May 1, 1988.

"Faces," Crown Point Press, San Francisco, March 19–May 9.

"Director's Choice," Tampa Museum of Art, April 19–June 14.

"American Art Today: The Portrait," The Art Museum at Florida International University, Miami, May 8–June 3.

* "20th Century Drawings from the Whitney Museum of American Art," National Gallery of Art, Washington, DC., May 21–September 7. Traveled to The Cleveland Museum of Art, September 30–November 8; Achenbach Foundation, California Palace of the Legion of Honor, San Francisco, March 5–June 5, 1988; Arkansas Art Center, Little Rock, June 30–August 28, 1988; Whitney Museum of American Art, Fairfield County, Stamford, Conn., November 18, 1988–January 18, 1989; Whitney Museum of American Art at the Equitable Center, New York, February 3–April 1, 1989.

* "Photography and Art: Interactions since 1946," Los Angeles County Museum of Art, June 4–August 30; Museum of Art, Fort Lauderdale, October 15–January 24, 1988; The Queens Museum, Flushing, N.Y., February 13–April 3, 1988; Des Moines Art Center, May 6–June 26, 1988.

* "Portrayals," International Center of Photography/Midtown, New York, June 12–July 18. Traveled to Herron Gallery, Indianapolis Center for Contemporary Art, November 21–December 19.

"Assemblage/Collage," Maris Art Gallery, Westfield State College, Westfield, Mass., September 25–October 31. Traveled to The Lamont Gallery, Phillips Exeter Academy, Exeter, N.H., November 13–December 13; Berkshire Artisans Community Arts Center, Pittsfield, Mass., April 4–30, 1988; Dongnang Gallery, Seoul Institute of the Arts, September 16–October 2, 1988; Nesto Gallery, Milton Academy, Milton, Mass., December 8, 1988–January 20, 1989; Herter Art Gallery, University of Massachusetts, Amherst, Mass., February 6–27, 1989.

"The Anderson Collection: Two Decades of American Graphics, 1967–1987. Prints, Monotypes, Works on Paper," Stanford University, Palo Alto, Calif., September 29–January 3, 1988.

"The Instant Image, An Exhibition of Works by the Major Artists in Photography," Rockland Center for the Arts, West Nyack, N.Y., November 15–December 13.

"Legacy of Light," International Center of Photography, New York, November 20–January 8, 1988. Traveled to the DeCordova and Dana Museum and Park, Lincoln, Mass., May 28–July 31, 1988.

1988

"Artschwager: His Peers and Persuasion 1963–1988," Daniel Weinberg Gallery, Los Angeles.

"Made in the 60s: Painting and Sculpture from the Permanent Collection of the Whitney," Whitney Museum of American Art, Downtown Branch at Federal Reserve Plaza, New York.

"Selections 4," Photokina 88, Cologne. Traveled to Musée de l'Elysée, Lausanne; Victoria and Albert Museum, London; Hamburger Kunsthalle, Hamburg; Museo de Arte Contemporáneo de Caracas, Venezuela.

"Self as Subject," Katonah Gallery, Katonah, N.Y., January 24–March 6.

"Perspective of 20th Century Paintings," Nagoya City Art Museum, Japan, March 23–June 19.

* "1988, The World of Art Today," Milwaukee Art Museum, May 6–August 28.

"Life Like," Lorence Monk Gallery, New York, June 4–June 25.

"Fifty-Second National Midyear Exhibition," The Butler Institute of American Art, Youngstown, Ohio, June 26–August 21.

"The Instant Likeness: Polaroid Portraits," The National Portrait Gallery, Washington, DC., August 27–December 4. "Aldo Crommelynck, Master Prints with American Artists," Whitney Museum of American Art at the Equitable Center, New York, August 31–November 7.

"Drawing on the East End: 1940–1988," The Parrish Art Museum, Southampton, September 18–November 13.

"Altered Images," The Penson Gallery, New York, November 15–December 10.

* "Three Decades; The Oliver Hoffmann Collection," Museum of Contemporary Art, Chicago, December 17–February 5, 1989.

* "Identity: Representations of the Self," Whitney Museum of American Art, Federal Reserve Plaza Branch, New York, December 14–February 10, 1989.

1989

"The Face," The Arkansas Arts Center, Little Rock.

"Twentieth-Century Painting and Sculpture: Selections for the Tenth Anniversary of the East Building," National Gallery of Art, Washington, DC..

"Field and Frame: Meyer Shapiro's Semiotics of Painting," New York Studio School, New York, April 7–May 13.

"The Indomitable Spirit," Blum Hellman Gallery, Santa Monica, Calif., May 19–June 9.

"Contemporary Art from the Chase Manhattan Bank Collection," The Yokohama Museum of Art, Yokohama, Japan, June 18–October 1.

"Art in Place," Whitney Museum of American Art, New York, July 7–October 29.

"Robert Bechtle, Chuck Close, Robert Cottingham, Malcolm Morley, Sigmar Polke," Pat Hearn Gallery, New York, September 16–October 7.

"Seattle: Before and After," Center for Contemporary Art, Seattle, October 5–November 27.

* "Image World-Art and Media Culture," Whitney Museum of American Art, New York, November 8–February 18, 1990.

* "On the Art of Fixing a Shadow: 150 Years of Photography," National Gallery of Art, Washington, DC., May 7–July 30. Traveled to The Art Institute of Chicago, September 16–November 26; Los Angeles County Museum of Art, December 21–February 25, 1990.

"First Impressions," Walker Art Center, Minneapolis, June 4–September 10. Traveled to Laguna Gloria Art Museum, Austin, December 2–January 21, 1990; Baltimore Museum of Art, February 25–April 2, 1990; Neuberger Museum, State University of New York at Purchase, Purchase, N.Y., June 27–Sept. 23, 1990.

1990

"Prints of the Eighties," Pratt Manhattan Gallery, New York, January 13–February 17. Traveled to Guild Hall Museum, East Hampton, N.Y., June 17–July 29.

"Je est un autre," Galeria Comicos, Lisbon, February–March.

* "The 20th Anniversary," Fuji Television Gallery, Tokyo, April 2–26.

* "Portrait of an American Gallery," Galerie Isy Brachot, Brussels, April 19–June 23.

"Figuring the Body," The Museum of Fine Arts, Boston, July 28–October 28.

"Heads," BlumHelman Gallery, New York, September 5–22.

"Square," Nohra Haime Gallery, New York, September 5–29.

"Monochrome/Polychrome: Contemporary Realist Drawings," Florida State University Gallery and Museum, Tallahassee, Fla., October 26–November 21, 1990.

"Contemporary Woodblock Prints," Jersey City Museum, December 6–March 3, 1991.

1991

"Contemporary Woodblock Prints from Crown Point Press," Edison Community College, Fort Meyers, Fla.

"Fantasies, Fables and Fabrications: Photo-Works from the 1980s," Boston University Art Gallery, Boston, Mass.

* "Artist's Choice–Chuck Close: Head-On/The Modern Portrait," The Museum of Modern Art, New York, January 10–March 19. Traveled to Lannan Foundation, Los Angeles, June 25–September 7.

"Image & Likeness: Figurative Works from the Permanent Collection," Whitney Museum of American Art, Downtown at Federal Reserve Plaza, New York, January 23–March 20.

"The Unique Print," The Pace Gallery, New York, January 25–February 23.

"Large Scale Works on Paper," John Berggruen Gallery, San Francisco, February 21–March 16.

"Louisiana: The New Graphics Wing," Louisiana Museum of Modern Art, Humleback, Denmark, March 3–31.

"Academy-Institute Invitational Exhibition of Painting and Sculpture," American Academy and Institute of Arts and Letters, New York, March 5–30.

"Portraits," Linda Cathcart Gallery, Santa Monica, Calif., May.

* "1991 Biennial Exhibition," Whitney Museum of American Art, New York, April 2–June 30.

"In Sharp Focus: Super-Realism," Nassau County Museum of Art, Roslyn Harbor, N.Y., April 14–July 7.

"Portraits on Paper," Robert Miller Gallery, New York, June 25–August 2.

"Vito Acconci, John Baldessari, Jennifer Bartlett, Chuck Close" Paula Cooper Gallery, New York, September 7–28.

* "Departures: Photography 1923–1990," Organized by Independent Curators Incorporated, New York. Traveled to Iris & B. Gerald Cantor Art Gallery, College of Holy Cross, Worcester, Mass., September 12–October 20; Denver Art Museum, January 25–March 22, 1992; Joslyn Art Museum, Omaha, April 9–May 31, 1992; Pittsburgh Center for the Arts, July 5–August 23, 1992; The Goldie Paley Gallery, Moore College of Art and Design, Philadelphia, September 5–October 11, 1992; Telfair Academy of Arts and Sciences, Inc., Savannah, Ga., January 5–February 21, 1993.

"Graphicstudio: Contemporary Art from the Collaborative Workshop at the University of South Florida," National Gallery of Art, Washington, D.C., September 15–January 5, 1992.

"The Portrait Tradition: Master Printmakers," Pace Prints, New York, October 25–November 30.

"Accent on Paper: 15 Years at Dieu Donné Papermill," Lintas Worldwide, New York, October 2–January 10, 1992.

* "American Realism and Figurative Art: 1952–1990," Organized by Japan Association of Art Museums. Traveled to The Miyagi Museum of Art Sendai, Miyagi, November 1–December 23; Sogo Museum of Art, Yokohama, January 29–February 16, 1992; Tokushima Modern Art Museum, Tokushima, February 22–March 29, 1992; The Museum of Modern Art, Shiga, April 4–May 17, 1992; Kochi Prefecture Museum of Folk Art, Kochi, May 23–June 17, 1992.

"Six Takes on Photo-Realism," Whitney Museum of American Art at Champion, Stamford, Conn., November 15–January 25, 1992.

"Past/Present: Photographs from the Collection of the Museum of Fine Arts, Houston," The Museum of Fine Arts, Houston, December 8–February 9, 1992.

"The Language of Flowers," Paul Kasmin Gallery, New York, December 12–January 16, 1992.

1992
"Portraits, Plots, and Places: The Permanent Collection Revisited," Walker Art Center, Minneapolis.

* "Arte Americana 1930–1970," Lingotto, S.r.l., Turin, January 8–March 31.

* "Psycho," KunstHalle, New York, April 2–May 9.

"Passions & Cultures: Selected Works from the Rivendell Collection, 1967–1991," Richard and Marieluise Black Center for Curatorial Studies and Art in Contemporary Culture, Bard College, Annandale-on-Hudson, N.Y., April 4–December 1993.

* "À visage découvert," Fondation Cartier pour l'art contemporain, Jouy-en Josas, France, June 18–October 4.

* "Le Portrait dans l'art contemporain, 1945–1992" Musée d'art moderne et d'art contemporain, Nice, July 3–September 27.

"The Language of Flowers," Paul Kasmin Gallery, New York, December 12–January 16, 1993.

1993
"I Am the Enunciator," Thread Waxing Space, New York, January 9–February 27.

* "Photoplay: Works from the Chase Manhattan Collection," Center for the Arts, Miami, January 10–February 21. Traveled to Museo Amparo, Pueblo, Mexico; Museo de Arte Contemporaneo de Monterrey, Mexico; Centro Cultural Consolidado, Caracas; Mass.SP/Museo de Arte de São Paolo, Brazil; Museo Nacional de Bellas Artes, Buenos Aires; Museo Bellas Artes, Santiago.

"Exploring Scale in Contemporary Art," Laguna Gloria Art Museum, Austin, January 23–March 4.

* "Autoportraits contemporains: Here's Looking at Me," Espace Lyonnais d'art contemporain, Lyon, January 29–April 30, 1993.

* "American Color Woodcuts: Bounty from the Block, 1890s–1900s," Elvehjem Museum of Art, University of Wisconsin, Madison, Wis., January 30–April 4.

"A New Installation of Photography from the Collection and Recent Acquisitions," The Museum of Modern Art, New York, February.

"Paul Cadmus: The Artist as Subject," Midtown Payson Gallery, New York, February 4–March 6.

"Contemporary Realist Watercolor," Sewall Art Gallery, Rice University, Houston, February 25–April 10.

"First Sightings: Recent Modern & Contemporary Acquisitions," Denver Art Museum, April–November.

"Up Close: Contemporary Art from the Mallin Collection," Herbert F. Johnson Museum of Art, Cornell University, Ithaca, N.Y., April 2–June 3.

"Passions & Cultures: Selected Works from the Rivendell Collection, 1967–1991," Richard and Marieluise Black Center for Curatorial Studies and Art in Contemporary Culture, Bard College, Annandale-on-Hudson, N.Y., April 4–December 22.

* "Yale Collects Yale," Yale University Art Gallery, New Haven, April 30–July 31.

* "Heads and Portraits: Drawings from Pierro de Cosimo to Jasper Johns," Jason McCoy, Inc., New York, May 6–June 12.

"45th Venice Biennial," Venice, June 13–October 10.

"Art Works," International Center of Photography, New York, July 2–September 26.

"Personal Imagery: Chicago/New York," Phyllis Kind Gallery, New York, September 18–October 30.

* "The Return of the Cadavre Exquis," The Drawing Center, New York, November 6–December 18. Traveled to the Corcoran Gallery of Art, Washington, D.C., February 5–April 10, 1994; Fundacion para el arte contemporaneo, Mexico City; Santa Monica Museum of Art, Santa Monica, July 7–

September 5, 1994; Forum for Contemporary Art, St. Louis, September 30–November 12, 1994; American Center, Paris, December 1994–January, 1995.

* "The Portrait Now," National Portrait Gallery, London, November, 19–February 6, 1994.

1994
"Block/Plate/Stone: What a Print Is," Katonah Museum of Art, Katonah, N.Y., March 13–May 15; Traveled to Davidson Art Center, Wesleyan University, Middletown, Conn., March 28–June 4, 1995.

* "30 Years-Art in the Present Tense: The Aldrich's Curatorial History, 1964–1994," The Aldrich Museum of Contemporary Art, Ridgefield, Conn., May 15–September 17.

"Facing the Past: Nineteenth-Century Portraits from the Collection of the Pennsylvania Academy of the Fine Arts," The Frick Art and Historical Center, Pittsburgh, May 27–June 24, 1994.

* "From Minimal to Conceptual Art: Works from the Dorothy and Herbert Vogel Collection," National Gallery of Art, Washington, D.C., May 29–November 27; Tel Aviv Museum of Art, July–August 1998.

"Visible Means of Support," Wadsworth Atheneum, Hartford, June–November.

"The Assertive Image: Artists of the Eighties," selections from the Eli Broad Family Foundation, University of California at Los Angeles, June 6–October 9.

"Against All Odds: The Healing Powers of Art," The Ueno Royal Museum and the Hakone Open Air Museum, Tokyo, June 9–July 30.

* "Face-Off: The Portrait in Recent Art," Institute of Contemporary Art, University of Pennsylvania, Philadelphia, September 9–October 30. Traveled to Joslyn Art Museum, Omaha, January 28–March 19, 1995; Weatherspoon Art Gallery, University of North Carolina, Greensboro, April 9–May 28, 1995.

"Master Prints from the Collection of The Butler Institute of American Art," The Butler Institute of American Art, Youngstown, Ohio, September 9–October 19.

"Democratic Vistas: 150 Years of American Art from Regional Collections," University Art Museum, State University of New York, Albany, September 24–November 13.

"Humanism and Technology: The Human Figure in Industrial Society," Seoul International Art Festival, National Museum of Contemporary Art, Seoul, December 16–January 14, 1995.

1995
* "Made In America: Ten Centuries of American Art," organized jointly by The Carnegie Museum of Art, Pittsburgh; The Minneapolis Institute of Arts; The Nelson-Atkins Museum of Art, Kansas City; The St. Louis Art Museum; and The Toledo Museum of Art.

"Matrix's 201 Birthday Bash!" Wadsworth Atheneum, Hartford.

"A.R.T. Press: Prints and Multiples," Betsy Senior Gallery, New York, January 12–February 4.

Group Exhibition, Daniel Weinberg Gallery, San Francisco, March 18–April 22.

"Me," Dru Arstark Gallery, New York, March 25–May 6.

"Touchstones from The Graphicstudio and Limestone Press/ Hine Editions," The Boca Raton Museum of Art, Boca Raton, Fla., April 28–May 30.

"One Vocabulary: Its Permutations and the Possibilites Therefrom, Part One: Daniel Buren, Chuck Close," Barbara Krakow Gallery, Boston, May 29–August 15.

Group Exhibition, Retretti Art Center, Punkaharju, Finland, May 23–August 27.

"Large Bodies," Pace/MacGill Gallery, New York, June 29–September 1.

"Art Works: The PaineWebber Collection of Contemporary Masters," The Minneapolis Institute of Arts, June 30–September 15, 1995. Traveled to Museum of Fine Arts, Boston, March 14–June 9, 1996; San Diego Museum of Art, October 13, 1996–January 5, 1997; Center for the Fine Arts, Miami, March 13–May 25, 1997.

"Our Century," Museum Ludwig, Cologne, July 8–October 8.

* "46th Venice Biennial: Identity and Alterity, Figures of the Body, 1895/1995," Palazzo Grassi and Palazzo Ducale, Venice, June10–October 15.

"25 Americans: Painting in the 90s," Milwaukee Art Museum, September 8–November 5.

* "Beyond the Borders: The First Kwangju International Biennale, International Exhibition of Contemporary Art," Kwangju, Korea, September 20–November 20.

* "1995 Carnegie International," The Carnegie Museum of Art, Pittsburgh, November 5–February 18, 1996.

"Facts and Figures: Selections from the Lannan Foundation Collection," Lannan Foundation, Los Angeles, October 22–February 26, 1996.

"Printmaking in America: Collaborative Prints and Presses 1960–1990," Mary and Leigh Block Gallery, Northwestern University, Evanston, Ill., September 22–December 3. Traveled to The Jane Vorhees Zimmerli Art Museum, Rutgers, New Brunswick, N.J., April 23–June 18; The Museum of Visual Arts, Houston, January 23–April 23, 1996; National Museum of American Art, Smithsonian Institution, Washington, D.C., May 10–August 4, 1996.

* "Face Value: American Portraits," The Parrish Art Museum, Southampton, N.Y., July 22–September 3. Traveled to Wexner Center for the Arts, The Ohio State University, Columbus, March 5–April 21, 1996; Tampa Museum of Art, July 14–September 8, 1996.

1996
"Narcissism: Artists Reflect Themselves," California Center for the Arts Museum, Escondido, February 4–May 26.

"Master Printers and Master Pieces," Kaohsiung Museum of Fine Arts, Taiwan, February 16–June 2.

"New in the 90s," Katonah Museum of Art, Katonah, N.Y., March 31–April 21.

"Fractured Fairy Tales, Art in the Age of Categorical Disintegration," SoHo at Duke, Duke University Museum of Art, Durham, N.C., April 12–May 25.

"Interstices: The A(a)rtist, A(a)rt and the A(a)udience," Duke University, Durham, N.C., April 12–May 25.

* "Thinking Print: Books to Billboards, 1980–1995," The Museum of Modern Art, New York, June 19–September 10.

"A Decade of Giving: The Apollo Society," The Toledo Museum of Art, September 8–December 1.

"Landfall Press: Twenty-Five Years of Printmaking," The Milwaukee Art Museum, September 13–November 10. Traveled to Chicago Cultural Center, March 15–May 18, 1997; Davenport Museum of Art, Davenport, Iowa, September 14–November 17, 1997; Springfield Museum of Art, Springfield, Ohio, March 13–May 9, 1998.

"Collection Highlights: 1945 to the Present," Seattle Art Museum, October–May 1997.

"Chuck Close, Jim Dine, Louise Nevelson," Concordia College, Bronxville, N.Y., October 14–November 17.

"Hidden in Plain Sight: Illusion and the Real in Recent Art," Los Angeles County Museum of Art, October 27–January 12, 1997.

"Portraits," James Graham & Sons, New York, November 7–December 21.

"Some Recent Acquisitions," The Museum of Modern Art, New York, November 15–January 2, 1997.

"Celmins, Close, Salle Works on Paper," Department of Visual and Environmental Studies, Harvard University, Cambridge, December 7–29.

* "Painting into Photography/Photography into Painting," Museum of Contemporary Art, Miami, December 20–February 16, 1997.

1997

"One Collection, 13 Curators: Selections from the Rivendell Collection of Late 20th Century Art," Center for Curatorial Studies, Bard College, Annandale-on-Hudson, New York, February 8–23.

* "Birth of the Cool," Deichtorhallen, Hamburg, February 13–May 11. Traveled to Kunsthaus, Zurich, June 18–September 7.

* "The Age of Modernism–Art in the 20th Century." Organized by the Zeitgeist-Gesellschaft. Martin-Gropius-Bau, Berlin, May 7–July 27.

"Porträt im 20. Jahrhundert," Raab Galerie, Berlin, May 8–June 2.

"Seattle Collects Paintings," Seattle Art Museum, May 22–September 7.

* "The Hirshhorn Collects: Recent Acquisitions," The Hirshhorn Museum and Sculpture Garden, Washington, D.C., June 4–September 7.

"In-Form," Bravin Post Lee Gallery, New York, June 4–July 19.

* "Twenty-Five Years at Crown Point Press: Making Prints, Doing Art," National Gallery of Art, Washington, D.C., June 8–September 1. Traveled to the Fine Arts Museums of San Francisco, California Palace of the Legion of Honor, October 4–January 4, 1998.

* "Views from Abroad: European Perspectives on American Art 3: The Tate Gallery Selects: American Realities," Whitney Museum of American Art, New York, July 10–October 5.

"About Face: Artists' Portraits in Photography," Fogg Art Museum, Harvard University Art Museum, Cambridge, July 19–October 19.

"Painting Project," Basilico Fine Arts and Lehmann Maupin, New York, September 11–October 11.

"Faces and Figures," Nassau County Museum of Art, Roslyn Harbor, N.Y., September 21–January 4, 1998.

"Photorealists," Exhibit A Gallery, Savannah College of Art and Design, Savannah, Ga., October 2–November 25.

"Concept/Image/Object: Recent Gifts for the Lannan Foundation," The Art Institute of Chicago, December 6–May 7, 1998.

1998

"PAPER +: Works on Dieu Donné Paper," The Gallery at Dieu Donné Papermill, New York, April 18–May 29.

"Then and Now and Later: Art Since 1945 at Yale," Yale University Art Gallery, New Haven, February 10–July.

"East Hampton Seen and Scene," Guild Hall, East Hampton, N.Y., June 27–July 26.

* "Photoimage: Printmaking 60s to 90s," The Museum of Fine Arts, Boston, July 7–September 27. Traveled to the Des Moines Art Center.

"Dreams for the Next Century," Parrish Art Museum, Southampton, N.Y., August 9–September 6.

"Artists in Collaboration with Art Resources Transfer, New York," The Vedanta Gallery, Chicago, September 4–October 9.

"The Promise of Photography–The DG Bank Collection," Hara Museum of Contemporary Art, Tokyo, October–January, 1999. Travelled to Kestner Gesellschaft, Hanover, March–May 1999; Centre national de la photographie, Paris, June–August 1999; Akademie der Künste, Berlin, January 1999–March 2000; Schirn Kunsthalle, Frankfurt am Main, January–March 2001.

"Photoplay: Works from the Chase Manhattan Collection," George Eastman House, Rochester, N.Y., October 23–January 31, 1999.

"The Risk of Existence," Phyllis Kind Gallery, New York, November 7–December 31.

"Photography's Multiple Roles: Art, Document, Market, Science," The Museum of Contemporary Photography, Columbia College, Chicago, November 14–January 9, 1999.

"Postcards on Photography: Photorealism and the Reproduction," Cambridge Darkroom Gallery, Cambridge, Eng., December 13–February 7, 1999.

1999

"New Modernism for a New Millennium: Works by Contemporary Artists from the Logan Collection," Limn Gallery, San Francisco, January 22–March 7.

"Art at Work: Forty Years of the Chase Manhattan Collection," The Museum of Fine Arts, Houston, and the Contemporary Arts Museum, Houston, March 3–May 2. Traveled to The Queens Museum of Art, May 23–October 1.

"The Way We Are Now," The Art Directors Club, New York, March 4–30.

"Recent Prints," Betsy Senior Gallery, New York, April 17–June 5.

"Scale Matters: Mega vs. Mini," Norton Museum of Art, West Palm Beach, Fla., April 28–October 10.

"Mastering the Millennium: Art of the Americas," The Art Museum of the Americas, Organization of American States and The World Bank, Washington, D.C., May 9–August 9.

"Innovation/Imagination: 50 Years of Polaroid Photography," The Friends of Photography–Ansel Adams Center, San Francisco, May 11–July18. Exhibition traveled in the United States and Mexico for four years.

"Outward Bound: American Art at the Turn of the Twenty-first Century," Meridian International Center, Washington, D.C., May 20–June 28. Traveled to Museum of Fine Arts, Hanoi; Museum of Fine Arts, Ho Chi Minh City; Painting Institute, Shanghai; Working People's Cultural Palace, Beijing; Singapore Museum of Art; CIPTA Gallery, Jakarta Art Center, Indonesia.

"Face à face: L'Estampes contemporaines," Galerie Mansart, Bibliothèque nationale de France, Paris, May 28–July 25.

"Face to Face: From Cézanne to Cyberspace," Fondation Beyeler, Basel, May 30–September 15.

"The Nude in Contemporary Art," The Aldridge Museum of Contemporary Art, Ridgefield, Conn., June 6–September 12.

"Changing Faces: Contemporary Portraiture," Jim Kempner Fine Art, New York, June 12–July 17.

"Drawn from Artists Collections," The Drawing Center, New York, April 24–June 12. Traveled to the Hammer Museum of Art, University of California at Los Angeles, July 13–September 26.

"As American as . . . 100 Works from the Parrish Art Museum," The Parrish Art Museum, Southampton, N.Y., August 17–September 19.

"Mostra Rio Gravura." Exhibited in several municipal venues within the city of Rio de Janeiro, Brazil, September and October 1999.

"North American Engraving Today: Three Exponents," Galeria IBEU, Institute Brasil-Estados Unidos, Copacabana, Brazil, August 24–September. Traveled to Galeria IBEU, Madureira, Brazil, September 30–October 29.

"The Self, Absorbed," Bellevue Art Museum, Bellevue, Wash., September 4–November 7.

"Art in Our Time: 1950 to the Present," Walker Art Center, Minneapolis, September 5, 1999–2001.

"The American Century: Art and Culture, Part II, 1950–2000," Whitney Museum of American Art, New York, September 26–February 13, 2000.

"Ghost in the Shell: Photography and the Human Soul, 1850–2000," Los Angeles County Museum of Art, October 16–January 17, 2000.

"The Artist and the Camera: Degas to Picasso," San Francisco Museum of Modern Art, October 2–January 4, 2000. Traveled to Dallas Museum of Fine Art, February 1–May 7, 2000; Fundació del Museo Guggenheim, Bilbao, Spain, June 12–September 10, 2000.

"The Century of the Body: Photoworks 1900–1999," Culturgest-Gestão de Espaços, Lisbon, October 6–December 19. Traveled to Musée de l'Elysée, Lausanne, Switzerland, February–December, 2000.

2000

"Van Gogh: Face to Face," The Detroit Institute of Arts, March 12–June 4. Traveled to Museum of Fine Arts, Boston, July 2–September 24; Philadelphia Museum of Art, October 22–January 14, 2001.

"Kwangju Biennale 2000," Kwangju Biennale Foundation, Kwangju, Korea, March 29–June 7.

"La Beauté," Papal Palace, Avignon, France, May 2–September 17.

"A Century Homage to Vincent van Gogh," Institute van Gogh, Auvers-sur-Oise, France, May 20–September 20.

"The Figure: Another Side of Modernism," Newhouse Center for Contemporary Art, Snug Harbor Cultural Center, Staten Island, N.Y., June 4–January 15, 2001.

"'Photography and Art,' A Developmental Dialogue: Firth, Beato, Warhol, Close," Galerie Daniel Blau, Munich, at Art Basel, Basel, Switzerland, June 21–26.

"Face to Face: Twentieth Century Portraits," Westmoreland Museum of American Art, Greensburg, Penna., August 6–October 22.

"The Persistence of Photography in American Portraiture," Yale University Art Gallery, New Haven, August 22–November 26.

"About Faces," Fraenkel Gallery, San Francisco, September 7–October 28.

"American Perspectives: Photographs from the Polaroid Collection," Tokyo Metropolitan Museum of Photography, September 12–November 12; Museum (EKI) KYOTO, February 17–March 14, 2001; Takamatsu City Museum of Art, June 1–July 1, 2001; Museum of Contemporary Art, Sapporo, July 21–September 2, 2001.

"Prints," Senior & Shopmaker Gallery, New York, September 22–November 4.

"Collection of Osaka City Museum of Modern Art: Photograph/Painting/Plane: Various Visions," Osaka City Museum of Modern Art, September 23–November 5.

"Open Ends," The Museum of Modern Art, New York, September 28–January 30, 2001.

"Celebrating Modern Art: The Anderson Collection," San Francisco Museum of Modern Art, October 4–January 15, 2001.

"Portraits of the Presidents: The National Portrait Gallery." Organized by the National Portrait Gallery, Smithsonian Institution, Washington, D.C. Traveled to George Bush Presidential Library and Museum, College Station, Tex., October 6–January 15, 2001; Harry S. Truman Library and Museum, Independence, Mo., February 16–May 20, 2001; Gerald R. Ford Presidential Museum, Grand Rapids, N.Y., June 22–September 23, 2001; Ronald Reagan Presidential Library and Museum, Simi Valley, Calif., October 26, 2001–January 21, 2002; Memphis Brooks Museum of Art, Memphis, Tenn., February 22–May 19, 2002; North Carolina Museum of History, Raleigh, N.C., June 21–September 15, 2002; Virginia Historical Society, Richmond, October 18, 2002–January 12, 2003.

"An American Focus: The Anderson Graphics Art Collection," California Palace of the Legion of Honor, San Francisco, October 7–December 31, 2000. Traveled to Palm Springs Desert Museum, Palm Springs, Calif., January 17–March 21, 2001; Albuquerque Museum of Art, Albuquerque, October 7, 2001–January 6, 2002.

"Chorus of Light: Photographs from the Collection of Elton John," High Museum of Art, Atlanta, November 4–January 28, 2001.

"The 46th Biennial: Media/Metaphor: New Stories in Contemporary Art," Corcoran Gallery of Art, Washington, DC., December 9–March 5, 2001.

2001

"Is Seeing Believing? The Real, the Surreal, the Unreal in Contemporary Photography," North Carolina Museum of Art, Raleigh, January 14–April 1. Traveled to Cummer Museum of Art and Gardens, Jacksonville, Fla., April 22–July 8.

"The Sight of Music," New York Historical Society, New York, January 16–June 17.

"About Faces," C&M Arts, New York, in association with Fraenkel Gallery, San Francisco, January 18–March 10.

"Under Pressure: Prints from Two Palms Press," Lyman Allyn Museum of Art at Connecticut College, New London, February 2–April 1. Traveled to Schick Art Gallery, Skidmore College, Saratoga Springs, N.Y., July 12–September 16; Meadows Museum, Southern Methodist University, Dallas, October 22–December 8; University Gallery, University of Massachusetts at Amherst, Mass., February 2–March 15, 2002; Kent State University Art, Kent, Ohio, September 4–September 28, 2002.

"Prints and Multiples," Senior & Shopmaker Gallery, New York, February 20–March 31.

"About Face: Selections from the Department of Prints and Illustrated Books," The Museum of Modern Art, New York, March 21–June 5.

"Self-Made Men," D. C. Moore Gallery, New York, April 4–May 5.

"Collaborations with *Parkett*: 1984 to Now," The Museum of Modern Art, New York, April 5–June 5.

"Still Lifes & Portraits/Portretten & Stilleven," Rijksmuseum, Amsterdam, April 7–June 24.

"A Century of American Woodcuts," Jane Haslem Gallery, Washington, D.C., June 1–August 15.

"Digital Printmaking Now," Brooklyn Museum of Art, New York, June 21–September 2.

"Pop! Painting and Sculpture from the Collection," Saint Louis Art Museum, June 29–September 16.

"No Big Pictures, Summer Show 2001," Pace/MacGill Gallery, New York, July 5–August 31.

"American Perspectives: Photographs from the Polaroid Collection," Museum of Contemporary Art, Sapporo, Japan, July 21–September 2.

"From Rags to Riches: 25 Years of Paper Art from Dieu Donné Papermill," Kresge Art Museum, Michigan State University, East Lansing, September 4–October 28. Traveled to Maryland Institute College of Art, November 9–December 16; Beach Museum of Art, Kansas State University, Manhattan, Kan., April 2–June 30, 2002; Heckscher Museum of Art, Huntington, N.Y., November 23, 2002–January 27, 2003; Milwaukee Art Museum, April 11–June 22, 2003.

"ABBILD. Recent Portraiture and Depiction," Landesmuseum Joanneum, Graz, Austria, October 5–December 16.

"Tele(visions)," Kunsthalle, Vienna, October–January 2002.

"Reisen ins Ich: Künstler/Selbst/Bild: Journeys into the Self: Artists' Self-Images," Sammlung Essl, Vienna, October 10–March 2, 2002.

2002
"What's Going On: Prints, Drawings and Photographs from the 1970s." Davidson Art Gallery, Wesleyan University, Middletown, Conn., February 3–March 8.

"Walk Around Time," Walker Art Center, Minneapolis, April 4–February 8, 2003.

"Eye Contact: Modern American Portrait Drawings from the National Portrait Gallery," Amon Carter Museum, Fort Worth, May 25–August 25. Traveled to Elmhurst Art Museum, Elmhurst, Ill., October 4–January 5, 2003; Naples Museum of Art, Naples, Fla., February 14–May 11, 2003.

"Painting on the Move: An Exhibition in Three Parts: After Reality–Realism and Current Painting," Kunsthalle Basel, May 26–September 8.

"Art/33/Basel," Georg Kargl, Basel, June 12–17.

"The Antiquarian Avant-Garde," Sarah Morthland Gallery, New York, June 13–August 10.

"Art Downtown," 48 Wall Street, New York, June 14–September 15.

"Visions from America: Photographs from the Whitney Museum of American Art," Whitney Museum of American Art, New York, June 27–September 22.

"Photographic Impulse: Selections from the Joseph and Elaine Monsen Collection," Henry Art Gallery, University of Washington, Seattle, July 13–August.

"To Be Looked At: Painting and Sculpture from the Collection," MOMA QNS, New York, July 2002–September 6, 2004.

"An American Legacy: A Gift to New York," Whitney Museum of American Art, New York, October 24–January 26, 2003.

"Life Death Love Hate Pleasure Pain: Selected Works from the MCA," Museum of Contemporary Art, Chicago, November 16–April 20, 2003.

2003
"Come Forward: Emerging Art In Texas," Dallas Museum of Art, February 23–May 11.

"Retrospectacle: 25 Years of Collecting Modern and Contemporary Art Photography, Part II," Denver Art Museum, March 10–August 3.

"Both Sides of the Street: Celebrating the Corcoran's Photography Collection," Corcoran Gallery of Art, Washington, D.C., April 12–July 28.

"Family Ties," Peabody Essex Museum, Salem, Mass., June 12–September 21.

"Pittura/Painting: From Rauschenberg to Murakami, 1964–2003," La Biennale di Venezia, Museo Correr, Venice, June 15–November 2.

"Les Hyperréalismes USA, 1965–1975," Musee d'art moderne et contemporain de Strasbourg, France, June 27–October 5.

"The Eye Club," Fraenkel Gallery, San Francisco, September 4–November 29.

"Global Village: The 1960s." Montreal Museum of Fine Arts, October 2–January 18, 2004.

"Exhibiting Signs of Age," Berkeley Art Museum, University of California, Berkeley, October 8–January 18, 2004.

"Imagination–On Perception in Art," Landesmuseum Joanneum, Steiermark, Austria, October 25–January 18, 2004.

"Drawing Modern: Works from the Agnes Gund Collection," Cleveland Museum of Art, October 26–January 1, 2004.

"Atomic Time: Pure Science and Seduction," Corcoran Gallery of Art, Washington, DC., November 1–January 26, 2004.

"Supernova: Art from the 1990s from the Logan Collection," San Francisco Museum of Modern Art, December 13–May 23, 2004.

2004
"An International Legacy: Selections from Carnegie Museum of Art," Nevada Museum of Art, Reno, January 9–April 4.

"Ideal and Reality," Galleria d'Arte Moderna, Bologna, January 17–May 9.

"Inside Out: Portrait Photographs from the Permanent Collection," Whitney Museum of American Art, New York, February 7–May 23.

"Likeness: Portraits of Artists by Other Artists," Logan Galleries, California College of Arts, Wattis Institute, San Francisco, February 27–May 8. Traveled to McColl Center for Visual Art, Charlotte, N.C., September 3–November 6; Institute of Contemporary Art, Boston, January 19–May 1, 2005; Dalhousie University Art Gallery, Halifax, Nova Scotia, May 26–July 31, 2005; University Art Museum, California State University at Long Beach, Calif., August 30–October 30, 2005; Illingworth Kerr Gallery, Alberta College of Art and Design, Calgary, Alberta, January 12–February 26, 2006; Contemporary Art Center of Virginia, Virginia Beach, March 23–May 12, 2006.

"Pop Art & Minimalismus: The Serial Attitude," Albertina Museum, Vienna, March 8–August 29.

"The Modernist Debate: American Artistic Discourse, 1955–1980," Circulo de Bellas Artes, Madrid, April 2–May 30.

"Off the Wall: Selections from the JPMorgan Chase Collection." Bruce Museum, Greenwich, Conn., May 15–September 12.

"Speaking with Hands: Photographs from the Buhl Collection," Solomon R. Guggenheim Museum, New York, June 4–September 8.

"Matisse to Freud: A Critic's Choice: The Alexander Walker Bequest," The British Museum, London, June 15–January 9, 2005.

"Smart Collecting, Acquisitions 1990–2004: Celebrating the Thirtieth Anniversary of David and Alfred Smart Museum of Art," The David and Alfred Smart Museum of Art, University of Chicago, July 8–September 5.

"Moi! Autoritratti del XX secolo," Galleria degli Uffizi, Florence, September 18–January 9, 2005. Traveled to Musée de Luxembourg, Paris, March 31–July 25, 2004.

"Perspectives @ 25: A Quarter Century of New Art in Houston," Contemporary Arts Museum, Houston, November 16–January 9, 2005.

2005
"Contemporary Voices: Works from the UBS Art Collection," Museum of Modern Art, New York, February 1–April 25. Traveled to Fondation Beyeler, Basel, November 26–March 19, 2006.

"Logical Conclusions: 40 Years of Rule-Based Art," Pace-Wildenstein Gallery, New York, February 18–March 26.

"Double Take: Photorealism from the 60s and 70s," The Rose Art Museum, Brandeis University, Waltham, Mass., May 19–July 31.

"The Artist Turns to the Book," The Getty Research Institute Exhibition Gallery, Los Angeles, May 24–September 11.

"The History of Photography–How Photography Changed People's Viewpoint," Tokyo Metropolitan Museum of Photography, September 17–November 6.

"The Figurative Impulse: Works from the UBS Art Collection," Museo del Arte de Puerto Rico, San Juan, September 23–January 8, 2006.

"In Private Hands: 200 Years of American Painting." Pennsylvania Academy of Fine Arts, Philadelphia, October 1–January 8, 2006.

"Self-Portrait: Renaissance to Contemporary," National Portrait Gallery, London, October 20–January 29, 2006. Traveled to Art Gallery of New South Wales, Sydney, February 17–May 14, 2006.

"Fine Art Works and Japanese Waka Poems," The Tokushima Modern Art Museum, Tokushima, Japan, November 12–December 18.

"From Darkroom to Digital: Photographic Variations," The Art Institute of Chicago, Chicago, November 19–February 26, 2006.

"Pollock to Pop: America's Brush with Dali," The Salvador Dali Museum, St. Petersburg, December 9–April 23, 2006.

2006
"Le Mouvement des images," Le Musee national d'art moderne–Centre Georges Pompidou, Paris, April 5–January 29, 2007.

"The Expanded Eye: Stalking the Unseen," Kunsthaus Zurich, June 16–September 3.

"Full House: Views of the Whitney's Collection at 75," Whitney Museum of American Art, New York, June 29–September 3.

"JOY POP! POP ART 1960s–2000s," Seiji Togo Memorial Sompo Japan Museum of Art, Tokyo, July 8–September 3.

"New York New York: Fifty Years of Art, Architecture, Photography, Film and Video," Grimaldi Forum, Monaco, July 14–September 10.

"Eretica: Transcendenza e profano nell'arte contemporanea," Civica galleria d'arte moderna, Palermo, August 1–September 20.

"Self/Image: American Portraiture from Copley to Close," Reynolda House Museum of American Art, Winston-Salem, N.C., August 30–December 30.

"Cities in Transition, Photography: Chuck Close, Mitch Epstein, Dayanita Singh," Madison Square Park, New York, September 19–November 10.

"Portrait/Homage/Embodiment," The Pulitzer Foundation for the Arts, St. Louis, November 3–June 30, 2007.

"Lewitt x 2: Sol Lewitt: Structure and Line, Selections from the Lewitt Collection," Madison Museum of Contemporary Art, Madison, Wis., November 5–January 14; Miami Art Museum, Miami, February 9–June 3, 2007; Weatherspoon Art Museum, September 9, 2007–January 18, 2008; Austin Museum of Art, Austin, May 24–August 17, 2008.

2007
"Mr. President," University Art Museum, State University at Albany, January 18–April 1.

"Matisse to Freud, a Critic's Choice: The Alexander Walker Bequest," New Walk Museum & Art Gallery, New Walk, Leicester, Eng., January 27–March 18.

"Chuck Close, Franz Gertsch," Max Lang Gallery, New York, February 23–March 24.

"The Missing Peace: Artists Consider the Dalai Lama," The Rubin Museum of Art, New York, March 9–September 3.

323

BIBLIOGRAPHY

Monographs and Exhibition Catalogues

1971
Chuck Close: Recent Work. Los Angeles: Los Angeles County Museum of Art, 1971. Text by Gail R. Scott.

1972
Chuck Close. Chicago: Museum of Contemporary Art, 1972. Text by Dennis Adrian.

1975
Chuck Close: Dot Drawings, 1973–1975. Austin: Laguna Gloria Art Museum, 1975. Text by Christopher Finch.

1977
Chuck Close: Recent Work. New York: The Pace Gallery, 1977.

1979
Chuck Close. Munich: Kunstraum München, 1979. Text by Hermann Kern.

Chuck Close. Recent Work. New York: The Pace Gallery, 1979. Text by Kim Levin, reprinted from *Arts Magazine*, June 1978.

Close, Chuck. *Keith/Six Drawings/1979*. New York: Lapp Princess Press, 1979.

1980
Close Portraits. Minneapolis: Walker Art Center, 1980. Texts by Martin Friedman and Lisa Lyons.

1983
Chuck Close. New York: The Pace Gallery, 1983. Text by John Perreault.

1984
Chuck Close: Handmade Paper Editions. Los Angeles: Herbert Palmer Gallery, 1984. Text by Richard H. Solomon.

1985
Chuck Close: Works on Paper. Houston: Contemporary Arts Museum, 1985. Text by Edmund P. Pillsbury.

Exhibition of Chuck Close. Tokyo: Fuji Television Gallery, 1985. Text by Lisa Lyons.

1986
Chuck Close: Recent Work. New York: The Pace Gallery, 1986. Dialogue between Arnold Glimcher and Chuck Close.

1987
Chuck Close: Drawings 1974–1986. New York: The Pace Gallery, 1987.

Lyons, Lisa, and Robert Storr. *Chuck Close*. New York: Rizzoli, 1987.

1988
Chuck Close, New Paintings. New York: The Pace Gallery, 1988. Text by Klaus Kertess.

1989
Chuck Close. Chicago: The Art Institute of Chicago in collaboration with The Friends of Photography, San Francisco, 1989. Text by Colin Westerbeck.

Chuck Close Editions: A Catalogue Raisonné and Exhibition. Youngstown, Ohio: The Butler Institute of American Art, 1989. Introduction by Louis A. Zona; essay by Jim Pernotto.

1991
Chuck Close: Recent Paintings. New York: The Pace Gallery, 1991. Text by Peter Schjeldahl.

Chuck Close: Up Close. East Hampton, New York: Guild Hall of East Hampton, 1991. Foreword by Joy L. Gordon; text by Colin Westerbeck.

1993
Chuck Close: Recent Works. New York: The Pace Gallery, 1993. Text by Arthur C. Danto.

1994
Chuck Close: 8 peintures récentes. Paris: Fondation Cartier pour l'art contemporain, 1994.

Chuck Close: Retrospektive. Baden-Baden: Staatliche Kunsthalle; and Stuttgart: Edition Cantz, 1994. Texts by Jochen Poetter, Helmut Friedel, Robert Storr, and Margit Franziska Brehm.

1995
Chuck Close: Recent Paintings. Beverly Hills and New York: PaceWildenstein, 1995. Text by John Yau.

Guare, John. *Chuck Close: Life and Work 1988–1995*. New York: Thames and Hudson, 1995.

1996
Affinities: Chuck Close and Tom Friedman. Chicago: The Art Institute of Chicago, 1996. Text by Madeleine Grynsztejn.

1997
The Portraits Speak: Chuck Close in Conversation with 27 of His Subjects. Introduction by Dave Hickey; edited by Joanne Kesten; conceived, developed, and produced by William Bartman. New York: A.R.T. Press, 1997.

1998
Greenberg, Jan, and Sandra Jordan. *Chuck Close Up Close*. New York: DK Publishing, 1998.

Storr, Robert, with essays by Kirk Varnedoe and Deborah Wye. *Chuck Close*. New York: The Museum of Modern Art, 1998.

Wye, Deborah. *Close's Subject: Part Portrait/Part Process*. New York: The Museum of Modern Art, 1998.

2000
Chuck Close: Daguerreotypien. Munich: Galerie Daniel Blau, 2000. Interview by James Hofmaier.

Chuck Close: The Photographic Works. Youngstown, Ohio: The Butler Institute of American Art, 2000. Text by Edward Lucie-Smith; interview by Louis A. Zona.

Chuck Close: Recent Paintings. New York: PaceWildenstein Gallery, 2000. Text by Richard Shiff.

2002
Chuck Close: Recent Works. New York: PaceWildenstein Gallery, 2002. Text by Kirk Varnedoe.

Chuck Close: Daguerreotypes. Milan: Alberico Cetti Serbelloni Editore, 2002. Edited by Demetrio Paparoni; foreword by Philip Glass; with a conversation between Chuck Close, Timothy Greenfield-Sanders, and Jerry Spagnoli.

2003
Sultan, Terrie, with an essay by Richard Shiff. *Chuck Close Prints: Process and Collaboration*. Princeton: Princeton University Press, 2003.

2005
Chuck Close/Franz Gertsch. Berlin: Galerie Haas & Fuchs, 2005.

Chuck Close: Recent Paintings. New York: PaceWildenstein Gallery, 2005. Text by Robert Rosenblum.

Engberg, Siri, with essays by Madeleine Grynsztejn and Douglas R. Nickel. *Chuck Close: Self-Portraits, 1967–2005*. San Francisco: San Francisco Museum of Modern Art; Minneapolis: Walker Art Center, 2005.

Friedman, Martin. *Close Reading: Chuck Close and the Art of the Self-Portrait*. New York: Harry N. Abrams, 2005.

2006
Holman, Bob, and Chuck Close. *A Couple of Ways of Doing Something*. New York: Aperture, 2006.

2007
Chuck Close: Pinturas, 1968/2006. Madrid: Museo Nacional Centro de Arte Reina Sofía, 2007. Texts by Robert Storr and Klaus Kertess; with a dialogue between Chuck Close and Richard Shiff.

Books

1969
Lucie-Smith, Edward. *Late Modern: The Visual Arts Since 1945*. New York: Praeger Publishers, 1969.

1971
Dempsey, Michael. *The Year's Art 1969–70: Europe and the U.S.A.* New York: G. P. Putnam's Sons, 1971.

Thomas, Karin. *Bis heute: Stilgeschichte der bildenden Kunst im 20. Jahrhundert*. Cologne: DuMont Schauberg, 1971.

1972
Coke, Van Deren. *The Painter and the Photograph: From Delacroix to Warhol*. Albuquerque: University of New Mexico Press, 1972.

Hunter, Sam. *American Art of the 20th Century*. New York: Harry N. Abrams, Inc., 1972.

Kulterman, Udo. *New Realism*. New York: New York Graphic Society, 1972.

Nakov, B. Andrei. *XX Siècle; Panorama 72*. New York: Tudor Publishing Company, 1972.

Rose, Barbara. *American Art since 1900*. New York: Praeger Publishers, 1972.

1973
John Wilmerding, ed. *The Genius of American Painting*. New York: William Morrow and Co., 1973.

Brachot, Isy, ed. *Hyperréalisme*. Brussels: F. Van Buggenhoudt, 1973.

Chase, Linda. *Grands Musées No. 2/L'Hyperréalisme américain: Peintures et sculptures*. Rev. ed. Paris: Filipacchi, 1973.

Robinson, Franklin W. *One Hundred Master Drawings from New England Private Collections*. Hanover, N. H.: The University Press of New England, 1973.

Sager, Peter. *Neue Formen des Realismus*. Cologne: DuMont Schauberg, 1973.

1974
Carucci, Beniamino, ed. "Spazio dedicato a Charles Close," in *I potesi per una casa esistenziale*. Trans. Barbara Radice. Rome, 1974.

Calamandrei, Mauro, with photographs by Gianfranco Gorgoni. *ART USA: Arte e vita dell'America d'oggi*. Milan: Fratelli Fabbri Editori, 1974.

Cotler, Sheldon, ed. *Photography Year/1974 Edition*. New York: Time-Life Books, 1974.

Mussa, Italo. *L'Iperrealismo: Il vero piu vero del vero*. Rome: Romana Libri Alfabeto, 1974.

Read, Herbert. *A Concise History of Modern Painting*. New York: Praeger Publishers, 1974.

1975
Battcock, Gregory, ed. *Super Realism: A Critical Anthology*. New York: E. P. Dutton, 1975.

Daval, Jean-Luc, ed. *Art Actuel/Skira Annuel 75: Skira Annuel No. 1*. Geneva: Skira, 1975.

Hobbs, Jack A. *Art in Context*. New York: Harcourt Brace Jovanovich, 1975.

Popper, Frank. *Art: Action and Participation*. New York: New York University Press, 1975.

Rose, Barbara. *American Art since 1900*. Rev. ed. New York: Praeger Publishers, 1975.

Rose, Barbara, ed. *Readings in American Art: 1900–1975*. Rev. ed. New York: Praeger Publishers, 1975.

Walker, John A. *Art since Pop*. London: Thames and Hudson, 1975.

1976
Castleman, Riva. *Prints of the 20th Century: A History*. New York: Museum of Modern Art; London: Thames and Hudson, 1976.

Honish, Dieter, and Jens Christian Jensen. *Amerikanische Kunst von 1945 bis heute*. Cologne: DuMont, 1976.

Hunter, Sam, and John Jacobus. *Modern Art: From Post-Impressionism to the Present: Painting, Sculpture, and Architecture*. New York: Harry N. Abrams, 1976.

Johnson, Ellen. *Modern Art and the Object*. New York: Harper & Row, 1976.

Kulterman, Udo. *The New Painting*. Rev. ed. Colorado: Westview Press, 1976.

Lipman, Jean, and Helen M. Franc. *Bright Stars: American Painting and Sculpture Since 1776*. New York: E. P. Dutton & Co., 1976.

Lucie-Smith, Edward. *Super Realism*. Oxford: Phaidon, 1976.

Stebbins, Theodore E., Jr. *American Master Drawings and Watercolors: A History of Works on Paper from Colonial Times to the Present*. New York: Harper & Row in association with the Drawing Society, 1976.

Wilmerding, John. *American Art*. New York: Penguin Books, 1976.

1977
Arnason, H. H. *History of Modern Art*. Rev. ed. New York: Harry N. Abrams, 1977.

Becker, Wolfgang, intro. *Art for the Museum Since 1945*. 2nd ed. Vol. 2. Aachen, West Germany: The Neue Gallery, 1977.

Bevlin, Marjorie E. *Design through Discovery*. 3rd ed. New York: Holt, Reinhart and Winston, 1977.

Billeter, Erika. *Malerei und Photographie im Dialog von 1840 bis heute*. Bern: Benteli, 1977.

Brommer, Gerald F., and George Horn. *Art in Your World*. Worcester, Mass.: Davis Publications, 1977.

Cummings, Paul. *Dictionary of Contemporary American Artists*. 3rd ed. New York: St. Martin's Press, 1977.

Daval, Jean-Luc. *Skira Annuel No. 4/Art Actuel '78*. Geneva: Editions d'Albert Skira, 1977.

Donson, Theodore B. *Prints and the Print Market*. New York: Thomas Crowell, 1977.

Emanuel, Muriel, and Sharon Harris et al., *Contemporary Artists*. New York: St. Martin's Press, 1977.

Lucie-Smith, Edward. *Art Now: From Abstract Expressionism to Superrealism*. New York: William Morrow and Co., 1977.

Rattemeyer, Volker. *Kunst und Medien: Materialien zur Documenta 6*. Kassel, West Germany: Stadtzeitung Verlag, 1977.

Rose, Barbara, and Jules D. Prown. *American Painting*. New York: Skira, Rizzoli, 1977.

Selleck, Jack. *Looking at Faces*. Worcester, Mass.: Davis Publications, 1977.

Thomas, Karin, and Gerd de Vries. *DuMont's Kunstler Lexikon: Von 1945 bis zur Gegenwart*. Cologne: DuMont, 1977.

1978
Distel, Herbert. *The Museum of Drawers*. Zurich: Kunsthaus Zürich, 1978.

Mathey, Francois. *American Realism*. Geneva: Editions d'Art Albert Skira, 1978.

Naylor, Colin, and Genesis P. Orridge. *Contemporary Artists*. Calne, Eng.: Hilmarton Manor Press, 1978.

Saff, Donald, and Deli Sacilotto. *Printmaking: History and Process*. New York: Holt, Rinehart and Winston, 1978.

Vyverberg, Henry. *The Living Tradition: Art, Music and Ideas in the Modern Western World*. New York: Harcourt, Brace and Jovanovich, 1978.

1979

Alloway, Lawrence. *Great Drawings of All Time: The Twentieth Century*. New York: Shorewood Fine Books, 1979.

Baigell, Mathew. *Dictionary of American Art*. New York: Harper and Row, 1979.

Brown, Milton W., et al. *American Art: Painting, Sculpture, Architecture, Decorative Arts, Photography*. New York: Harry N. Abrams,1979.

Castleman, Riva. *Prints of the 20th Century: A History*. New York: Holt, Rinehart and Winston, 1979.

Chaet, Bernard. *An Artists' Notebook: Techniques and Materials*. New York: Holt, Reinhart and Winston, 1979.

Lucie-Smith, Edward. *Super Realism*. Oxford: Phaidon, 1979.

Warner, Malcolm. *Portrait Painting*. New York: Phaidon, 1979.

1980

Arthur, John. *Realist Drawings and Watercolors: Contemporary Works on Paper*. Boston: New York Graphic Arts Society/ Little, Brown and Co., 1980.

Betti, Claudia, and Teel Sale. *Drawing: A Contemporary Approach*. New York: Holt, Rinehart and Winston, with Capital City Press, Vt., 1980.

Butler, Christopher. *After the Wake: An Essay on the Contemporary Avant-Garde*. Oxford: Clarendon Press, 1980.

Canaday, John. *What is Art? An Introduction to Painting, Sculpture, and Architecture*. New York: Alfred A. Knopf, 1980.

Daval, Jean-Luc, ed. *Art Actuel/Skira Annuel 80/ Skira Annuel No. 6*. Geneva: Skira, 1980.

Goodrum, Charles A. *Treasures of the Library of Congress*. New York: Harry N. Abrams,1980.

Hill, Patricia, and Roberta K. Tarbell. *The Figurative Tradition and the Whitney Museum of American Art*. New York: the Whitney Museum of American Art in association with University of Delaware Press, 1980.

Hobbs, Jack A. *Art in Context*. 2nd ed. New York: Harcourt Brace Jovanovich, 1980.

Johnson, Una E. *American Prints and Printmakers*. New York: Doubleday and Co., 1980.

Lindey, Christine. *Superrealist Painting and Sculpture*. New York: William Morrow and Co., 1980.

Lucie-Smith, Edward. *Art in the Seventies*. Ithaca: Cornell University Press, 1980.

Meisel, Louis K. *Photorealism*. New York: Harry N. Abrams, 1980.

1981

Armstrong, Tom. *Amerikanische Malerei 1930-1980*. Munich: Prestel, 1981.

Brommer, Gerald F. *Discovering Art History*. Worcester, Mass.: Davis Publications, 1981.

Cummings, Paul. *Twentieth-Century Drawings: Selections from the Whitney Museum of American Art*. New York: Whitney Museum of American Art, 1981.

Elsen, Albert E. *Purposes of Art*. 4th ed. New York: CBS College Publishers, 1981.

Gabay, Neil. *Modern Painters: An Art Appreciation*. Akron: Nina Books, 1981.

Goodyear, Frank H., Jr. *Contemporary American Realism since 1960*. New York: New York Graphic Society, 1981.

Huyghe, Rene, ed. *Larousse Encyclopedia of Modern Art from 1880 to the Present Day*. New York: Excalibur Books, 1981.

Melot, Michael, Antony Griffiths, and Richard S. Field. *Prints: History of an Art*. New York: Skira/Rizzoli, 1981.

Piper, David, ed. *The Random House Library of Paintings and Sculpture*. Vol. 1. New York: Random House, 1981.

Sachs, Samuel. *Favorite Paintings from the Minneapolis Institute of Arts*. New York: Abbeville Press, 1981.

Selz, Peter. *Art in Our Times: A Pictorial History 1890–1980*. New York: Harry N. Abrams, 1981.

Vogt, Paul. *Contemporary Painting*. New York: Harry N. Abrams, 1981.

Wise, Kelly, ed. *Portrait: Theory*. New York: Lustrum, 1981.

1982

Bujese, Arlene, ed. *Twenty-five Artists*. Foreword by Thomas M. Messer. Frederick, Md.: University Publications of America, 1982.

Daval, Jean-Luc, ed. *Photography: History of an Art*. New York: Rizzoli, 1982.

Goldstein, Nathan. *One Hundred American and European Drawings: A Portfolio*. Englewood Cliffs, N.J.: Prentice Hall, 1982.

Herrmanns, Ralf. *Varför New York?* Stockholm: AB Wilken, 1982.

Johnson, Ellen H. *American Artists on Art from 1940 to 1980*. New York: Harper & Row, 1982.

Mendelowitz, Daniel. *Mendelowitz's Guide to Drawing*. 3rd ed. Revised by Duane A. Wakeham. New York: CBS College Publishing; Holt, Rinehart and Winston, 1982.

Mollison, James, and Laura Murray, eds. *Australian National Gallery: An Introduction*. Canberra: Australian National Gallery, 1982.

Ronte, Dieter. *Museum moderner Kunst Wien*. Braunschweig, West Germany: Georg Westermann, 1982

Vaizey, Marina. *The Artist as Photographer*. New York: Holt, Rinehart and Winston, 1982.

1983

Arthur, John. *Realists at Work*. New York: Watson-Guptill, 1983.

Emanuel, Muriel, et al., eds. *Contemporary Artists*. 2nd ed. New York: St. Martin's Press, 1983.

Kaplan, Ellen. *Prints: A Collector's Guide*. New York: Coward-McCann,1983.

Martin, Judy. *The Complete Guide to Airbrushing Technique and Materials*. New Jersey: Chartwell Books, 1983.

Naef, Weston. *New Trends from the Gallery of World Photography Series*. Japan: Shueisha Publishing, 1983.

1984

Armstrong, Tom, foreword; Richard Marshall, essay. *American Art since 1970: Painting, Sculpture and Drawing from the Collection of the Whitney Museum of American Art*. New York: Whitney Museum of American Art, 1984.

Baigell, Matthew. *A Concise History of American Painting and Sculpture*. New York: Harper and Row, 1984.

Lee, Marshall, ed. *Art at Work: The Chase Manhattan Collection*. New York: E. P. Dutton, 1984.

Art of Our Time, The Saatchi Collection. Vol. 4. New York: Rizzoli, 1984. Essay by Kim Levin.

Lucie-Smith, Edward. *Movements in Art since 1945*. Rev. ed. New York: Thames and Hudson, 1984.

Markowski, Eugene, D. *Image and Illusion*. Englewood Cliffs, N.J.: Prentice Hall, 1984.

Oldenburg, Richard E., preface; Sam Hunter, essay. *The Museum of Modern Art: The History of the Collection*. New York: Harry N. Abrams, 1984.

Piper, David, ed. *Looking at Art*. New York: Random House, 1984.

Robins, Corinne. *The Pluralist Era: American Arts, 1968–1981*. New York: Harper & Row, 1984.

Rosenblum, Naomi. *A World History of Photography*. New York: Abbeville, 1984.

Russell, Stella Pandell. *Art in the World*. 2nd ed. New York: CBS College Publishing, 1984.

Vitz, Paul, and Arnold Glimcher. *Modern Art and Modern Science: The Parallel Analysis of Vision*. New York: Praeger Publishers, 1984.

Watrous, James. *A Century of American Printmaking 1880–1980*. Madison, Wis.: University of Wisconsin Press, 1984.

1985

Adrian, Dennis. *Sight Out of Mind: Essays and Criticism on Art*. Ann Arbor: UMI Research Press, 1985.

Billeter, Erika. *Das Selbstportrait*. Lausanne: Musée cantonal des beaux-arts, 1985.

Feldman, Edmund Burke. *Thinking about Art*. Englewood Cliffs, N.J.: Prentice Hall, 1985.

Gorgoni, Gianfranco. *Beyond the Canvas: Artists of the Seventies and Eighties*. New York: Rizzoli, 1985.

Hertz, Richard. *Theories of Contemporary Art*. Englewood Cliffs, N.J.: Prentice Hall, 1985.

Hunter, Sam, and John Jacobus. *Modern Art: Painting, Sculpture, Architecture*. 2nd ed. New York: Harry N. Abrams, 1985.

Kramer, Hilton. *The Revenge of the Philistines: Art and Culture, 1972–1984*. New York: The Free Press, 1985.

Krantz, Les. *American Art Galleries and Illustrated Guide to Their Art and Artists*. New York: Facts on File Publishers, 1985.

——. *American Artists: An Illustrated Survey of Leading Contemporary Americans*. Chicago: Krantz Company Publishers, 1985.

Kraus, Rosalind. *The Originality of the Avant-Garde and Other Modernist Myths*. Cambridge: The MIT Press, 1985.

Lucie-Smith, Edward. *American Art Now*. New York: William Morrow and Co., 1985

——. *Movements in Art since 1945*. Rev. ed. New York: Thames & Hudson, 1985.

Pelfrey, Robert, and Mary Hall-Pelfrey. *Art and Mass Media*. New York: Harper and Row, 1985.

Simms, Patterson. *The Whitney Museum of American Art: Selected Works from the Permanent Collection*. New York: W. W. Norton & Co., in association with the Whitney Museum of American Art, 1985.

1986

Arnason, H. H. *History of Modern Art: Painting, Sculpture, Architecture*. 3rd ed. New York: Harry N. Abrams, 1986.

Bowman, Russell, intro., and Cynthia Holly. *Milwaukee Art Museum Guide to the Permanent Collection*. Milwaukee: Milwaukee Art Museum, 1986.

Fischl, Eric, and Jerry Saltz, eds. *Sketchbook with Voices*. New York: Alfred van der Marck Editions, 1986.

Finch, Christopher. *American Watercolors*. New York: Abbeville, 1986.

Marshall, Richard, and Robert Mapplethorpe. *50 New York Artists*. San Francisco: Chronicle Books, 1986.

Martin, Alvin. *American Realism: Twentieth Century Drawings and Watercolors*. New York: Harry N. Abrams in association with the San Francisco Museum of Art, 1986.

Piper, David. *The Illustrated Library of Art*. New York: Portland House, 1986.

Rose, Barbara. *American Painting: The Twentieth Century*. New York: Rizzoli, 1986.

Stein, Harvey, photographs; Elaine King, essay. *Artists Observed*. New York: Harry N. Abrams, 1986.

1987

Crane, Diane. *The Transformation of the Avant Garde: The New York Art World 1945–1985*. Chicago: The University of Chicago Press, 1987.

Faulkner, Ray, with Edwin Ziegfeld and Howard Smagula. *Art Today*. 6th ed. New York: Holt Reinhardt and Winston, 1987.

Grundberg, Andy, and Kathleen McCarthy Gauss. *Photography and Art: Interactions Since 1946*. New York: Abbeville, 1987.

Hoy, Ann H. *Fabrications: Staged, Altered, and Appropriated Photographs*. New York: Abbeville, 1987.

Sullivan, Constance, ed. *Legacy of Light*. New York: Alfred A. Knopf, 1987.

Weiermair, Peter. *Das verborgene Bild*. Vienna: Ariadne, 1987.

1988

Finch, Christopher. *Twentieth Century Watercolors*. New York: Abbeville, 1988.

Harvey, Steven, et al. *Smith Kline & French Research and Development Art Collection*. Upper Merion, Penna.: Smith Kline & French Laboratories, 1988.

Legg, Alicia, ed., with Mary Beth Smalley. *Painting and Sculpture in the Museum of Modern Art*. New York: The Museum of Modern Art, 1988.

Levin, Kim. *Beyond Modernism, Essays on the Art from the 70's and 80's*. New York: Harper & Row, 1988.

Sandler, Irving. *American Art of the 1960's*. New York: Harper & Row, 1988.

1989

Bishop, Margaret. *Young Artists: Visual Arts Activities for Young Artists at Home and at School*. Annandale, Australia: Piper Press, 1989.

Landau, Terry. *About Faces*. New York: Anchor Books Doubleday, 1989.

Ward, John L. *American Realist Painting 1945–1980*. Michigan: UMI Research Press, 1989.

1990

Cooper, Emmanuel. *Fully Exposed: The Male Nude in Photography.* London: Unwin Hyman, 1990.

Friedman, Martin, intro. *Walker Art Center: Paintings and Sculpture from the Collection.* New York: Rizzoli International Inc., in conjunction with the Walker Art Center, Minneapolis, 1990.

Goddard, Donald. *American Painting.* Hugh Lauter Levin Assoc., 1990.

Schwartz, Sanford. *Artists and Writers.* New York: Yarrow, 1990.

Wax, Carol. *The Mezzotint: History and Technique.* New York: Harry N. Abrams,1990.

1991

Hoffman, Katherine. *Explorations: The Visual Arts since 1945.* New York: Harper Collins, 1991.

Wheeler, Daniel. *Art since Mid-Century: 1945 to the Present.* New York: Vendome, 1991.

Yenawine, Philip. *How to Look at Modern Art.* New York: Harry N. Abrams, 1991.

1992

Gotz, Stephan. *American Artists in Their New York Studios.* Stuttgart: Daco-Verlag Gunter Blase, 1992.

Lloyd, Michael, and Michael Desmond. *European and American Paintings and Sculpture 1870–1970 in the Australian National Gallery.* Canberra: Australian National Gallery, 1992.

Seitz, William. *Art in the Age of Aquarius 1955–1970.* Washington, DC.: Smithsonian Institution Press, 1992.

Strickland, Carol. *The Annotated Mona Lisa: A Crash Course from Prehistoric to Post-Modern.* Kansas City: Universal Press Syndicate, 1992.

1993

Halle, David. *Inside Culture.* Chicago: University of Chicago Press, 1993.

Jeffri, Joan, ed. *The Painter Speaks: Artists Discuss Their Experiences and Careers.* New York: Columbia University and Greenwood Press, Westport, Conn., 1993.

Kismaric, Carole, ed. *Art Works: Teenagers and Artists Collaborate on the 20" x 24" Camera.* New York: Art Works/ The Education Project, 1993.

Meisel, Louis K. *Photorealism Since 1980.* New York: Harry N. Abrams, 1993.

Mendelowitz, Daniel M. *A Guide to Drawing.* 5th ed. Orlando: Harcourt Brace Jovanovich College Publishers, 1993.

Smith, Jean Kennedy, and George Plimpton. *Chronicles of Courage: Very Special Artists.* New York: Random House, 1993.

Smith, Ray. *The DK School: An Introduction to Acrylics.* London: Dorling Kindersley, 1993.

Whipple, Enez. *Guild Hall of East Hampton: An Adventure in the Arts, the First 60 Years.* New York: Harry N. Abrams, 1993.

1994

Craven, Wayne. *American Art: History and Culture.* New York: Harry N. Abrams, 1994.

Diamonstein, Barbaralee. *Inside the Art World: Conversations with Barbaralee Diamonstein.* New York: Rizzoli, 1994.

Ewing, William E. *The Body: Photographs of the Human Form.* San Francisco: Chronicle, 1994.

Lucie-Smith, Edward. *American Realism.* London: Thames and Hudson, 1994.

Rose, Ted. *Discovering Drawing.* Worcester, Mass.: Davis Publications, 1994.

Schneider Adams, Laurie. *A History of Western Art.* New York: Harry N. Abrams,1994

1995

Babbitt, Sherry, ed., and Ann Temkin. *Philadelphia Museum of Art: Handbook of the Collections.* Philadelphia: Philadelphia Museum of Art, 1995.

Johnson, Brooks, ed. *Photography Speaks II: From the Chrysler Museum Collection: 70 Photographers on Their Art.* New York: Aperture; Norfolk, Va.: Chrysler Museum of Art, 1995.

Johnson, Kathryn C. *Made in America: 10 Centuries in American Art.* New York: Hudson Hills, 1995.

Lauer, David, and Stephen Pentak. *Design Basics.* Florida: Harcourt Brace & Company, 1995.

Le Thorel, Edward. *Dictionary of Contemporary Artists.* Paris: Bordas, 1995.

Lucie-Smith, Edward. *ARTODAY.* New York: Phaidon, 1995.

——. *Visual Arts in the Twentieth Century.* New York: Harry N. Abrams,1996

Walther, Ingo, ed. *Malerei der Welt.* 2 vols. Cologne: Benedikt Taschen, 1995.

Wilson, Janet. *National Museum of American Art.* Washington, DC.: Smithsonian Institution, 1995.

1996

Barnes, Rachel, et al. *The 20th Century Art Book.* London: Phaidon, 1996.

Bijutsu Shupan-Sha, Ltd. *New Materials Guide.* Tokyo: BBS, 1996.

Brown, Kathan. *Ink, Paper, Metal, Wood: Painters and Sculptors At Crown Point Press.* San Francisco: Chronicle, 1996.

Demetrion, James T., intro. *Hirshhorn Museum and Sculpture Garden: 150 Works of Art.* Washington, DC.: Hirshhorn Museum and Sculpture Garden, 1996.

Hickey, Dave, intro. *Between Artists: Chuck Close Interviews Vija Celmins.* Los Angeles: ART Press,1996.

Piras, Sebastian, photographs; David Ross, foreword; Paul Brach, intro. *Artists Exposed.* Nuoro, It.: Ilisso, 1996.

Ross, Mairi, Jennifer Barger, and Jean Lawlor Cohen. *Friends of Art and Preservation in Embassies Tenth Anniversary.* Washington, DC: Friends of Art and Preservation in Embassies, 1996.

Seidner, David. *The Face of Contemporary Art.* Munich: Gina Kehayoff, 1996.

Stiles, Kristine, and Peter Selz, eds. *Theories and Documents of Contemporary Art: A Sourcebook of Artists' Writings.* Berkeley: University of California Press, 1996.

Sussler, Betsy, ed., with Suzan Sherman and Ronalde Shavers. *BOMB Speak Art!* New York: G+B Arts International/New Art Publications, 1997

Sweetkind, Irene S., ed. *Master Paintings from The Butler Institute of American Art.* New York: Harry N. Abrams, in association with The Butler Institute of America, 1996.

Tansey, Richard G., and Fred S. Kleiner, eds. *Gardner's Art through the Ages.* New York: Harcourt Brace College Publishers, 1996.

Weintraub, Linda, with Arthur Danto and Thomas McEvilley. *Art on the Edge and Over: Searching for Art's Meaning in Contemporary Society, 1970s–1990s.* Litchfield, Conn.: Art Insights, Inc., 1996.

1997

Betty, Claudia, and Teel Sale. *Drawing: A Contemporary Approach.* Norwalk, Conn.: Harcourt Brace College Publishers, 1997.

Woodall, Joanna, ed. and intro. *Portraiture: Facing the Subject.* Manchester: Manchester University Press, 1997.

1998

American Photography 14/1998. New York: D.A.P., 1998.

Bass, Jacquelynn, preface; with essays by Constance Lewallen, Michael Auping, et al. *Matrix/Berkeley: 20 Years.* Berkeley: University of California Press, 1998.

Gilbert, Rita. *Living With Art.* 4th ed. New York: McGraw Hill Companies, 1998.

Kimmelman, Michael. *Portraits: Talking with Artists at the Met, the Modern, the Louvre and Elsewhere.* New York: Random House, 1998.

Kultermann, Udo, ed., and Anthony Quinn, foreword. *St. James Modern Masterpieces.* Detroit: Visible Ink Press, 1998.

The Marie Walsh Sharpe Art Foundation and The Judith Rothschild Foundation. *Visual Artists Guide to Estate Planning.* Colorado Springs: The Marie Walsh Sharpe Art Foundation, 1998.

Ross, David A., with Adam D. Weinberg and Beth Venn. *American Art of the Twentieth Century: Treasures of the Whitney Museum of American Art.* New York: Whitney Museum of American Art, 1998.

Updike, John, foreword. *Centennial Portfolio: Fifty Original Prints by Members of the American Academy of Arts and Letters in Celebration of Its Centennial.* New York: American Academy of Arts and Letters, 1998.

Walther, Ingo F., ed. *Art of the 20th Century. Vol. 1: Painting.* Cologne: Taschen, 1998.

1999

Davis, Keith F. *An American Century of Photography: From Dry-Plate to Digital: The Hallmark Photographic Collection.* 2nd ed. New York: Hallmark Cards; Harry N. Abrams, 1999.

Dolphin, Laurie, ed.; Stokes Howell, intro.; Chuck Close, foreword; John Bigelow Taylor, photographs. *Evidence: The Art of Candy Jernigan.* San Francisco: Chronicle, 1999.

Expression and Appreciation of Art. Tokyo: Kairyudo Publishing Co., 1999.

Face to Face to Cyberspace. Ostfildern-Ruit, Germany: Hatje Cantz; Basel: Fondation Beyeler, 1999. With contributions by Ernst Beyeler.

Goldstein, Nathan. *Figure Drawing: The Structure, Anatomy, and Expressive Design of Human Form.* 5th ed. Upper Saddle River, N.J.: Prentice Hall, 1999.

Gruen, John Jonas; John Spring, foreword. *Facing the Artist,* New York: Prestel, 1999.

Hollander, Anne, Diane Johnson, et al. *Reflections in a Glass Eye: Works from the International Center of Photography.* New York: Bulfinch Press and International Center of Photography, 1999.

Hitchcock, Barbara, and Deborah Klochko, introductions; Deborah Martin Kao, essay. *Innovation/Imagination: 50 Years of Polaroid Photography.* New York: Harry N. Abrams; The Friends of Photography, 1999.

Kozitka, Laura J., and Susan Rossen, eds.; James N. Wood, intro. *Master Paintings in The Art Institute of Chicago.* Rev. ed. Chicago: The Art Institute of Chicago, 1999.

De Kunst van de 20ste Eeuw (The 20th Century Art Book). Belgium: TOTH Phaidon, 1999.

Mulligan, Therese, and David Wooters, eds.. *Photography: From 1839 to Today.* Rochester, N.Y.: George Eastman House; Cologne: Taschen, 1999.

Spaulding, Karen Lee, ed. *Masterworks at the Albright-Knox Gallery.* New York: Hudson Hills, 1999.

Seidner, David. *Artists at Work: Inside the Studios of Today's Most Celebrated Artists.* New York: Rizzoli, 1999.

Tobler, Jay, ed. *The American Art Book.* London: Phaidon, 1999.

Walther, Ingo F., ed. *Masterpieces of Western Art: A History of Art in 900 Individual Studies from the Gothic to the Present Day. Part II: Contemporary Painting: New Movements in Painting since 1945, from Pollock to Baselitz.* Cologne: Taschen, 1999.

2000

Barrett, Terry. *Criticizing Art: Understanding the Contemporary.* 2nd ed. Mountain View, Calif.: Mayfield Publishing, 2000.

Bell, Julian, intro. *Five Hundred Self-Portraits.* London: Phaidon, 2000.

Bernard, Laura. *Certificat d'aptitude professionnelle: Photographe Basquiat, Fleischer, Nadar, van Gogh.* Mont-Saint-Aignan: Centre national d'enseignement à distance, 2000.

Danto, Arthur C. *The Madonna of the Future: Essays in a Pluralistic Art World.* New York: Farrar, Straus and Giroux, 2000.

Fineberg, Jonathan. *Art since 1940: Strategies of Being.* 2nd Edition. New York: Harry N. Abrams, 2000.

MoMA Highlights: 325 Works from The Museum of Modern Art, New York. 2nd ed. New York: The Museum of Modern Art, 2000.

Gatto, Joseph A., Albert W. Porter, and Jack Selleck. *Exploring Visual Design: The Elements and Principles.* 3rd ed. Worcester, Mass.: Davis Publications, 2000.

Grace, Trudy. *Paper Trail: Prints, Drawings, and Watercolors in the National Academy of Design.* New York: National Academy of Design, 2000.

Guasch Ferrer, Ana Ma. *Del postminimalismo a lo multicultural, 1968–1995.* Madrid: Alianza Editorial, 2000.

Harrison, William B., foreword. *Art at Work: Forty Years of The Chase Manhattan Collection.* New York: The Chase Manhattan Bank, 2000.

Hitchcock, Barbara, ed.; Andy Grundberg, intro. *Emerging Bodies: Nudes from the Polaroid Collections.* New York and Zurich: Edition Stemmle, 2000.

Hunter, Sam, John Jacobus, and Daniel Wheeler. *Modern Art: Painting, Sculpture, Architecture.* 3rd ed. New York: Harry N. Abrams, 2000.

Kirsh, Andrea, and Levenson S. Rustin. *Seeing through Paintings: Physical Examination in Art Historical Studies.* New Haven and London: Yale University Press, 2000.

Langmuir, Erika, and Norbert Lynton. *The Yale Dictionary of Art & Antiques.* New Haven: Yale University Press, 2000.

Lauer, David A., and Stephen Pentak. *Design Basics,* 5th ed. Orlando: Harcourt Brace, 2000.

Mishory, Alec. *Art History: An Introduction.* Tel Aviv: Open University of Israel, 2000.

Newman, Amy. *Challenging Art: ARTFORUM 1962–1974.* New York: Soho Press, 2000.

Perl, Jed. *Eyewitness: Report from an Art World in Crisis.* New York: Basic Books, 2000.

Platzker, David, and Elizabeth Wyckoff. *Hard Pressed: 600 Years of Prints and Process.* New York: Hudson Hills, 2000.

326

Prendeville, Brendan. *Realism in 20th Century Painting.* New York and London: Thames & Hudson, 2000.

Shukan Bijutsukan (The Weekly Museum), Tokyo: Shogakukan, 2000.

Temkin, Ann, et al. *Twentieth Century Painting and Sculpture in the Philadelphia Museum of Art.* Philadelphia: The Philadelphia Museum, 2000.

2001

Anderson, Maxwell L., intro. *Whitney–American Visionaries: Selections from the Whitney Museum of American Art.* New York: Harry N. Abrams, 2001.

Becker, Wolfgang. *Streit Lust: For Argument's Sake.* Cologne: Wienand, 2001.

Bocola, Sandro. *Timelines–The Art of Modernism 1870–2000.* Cologne: Taschen, 2001.

Brenson, Michael. *Visionaries and Outcasts: The NEA, Congress, and the Place of the Visual Artist in America.* New York: The New Press, 2001.

Fichner-Rathus, Lois. *Understanding Art.* Orlando: Harcourt College Publishers, 2001.

Gibson, Robin, and Norbert Lynton, intro. *Painting the Century: 101 Portrait Masterpieces 1900–2000.* London: National Portrait Gallery, 2001.

Glimcher, Milly, ed., with Arne Glimcher. *Adventures in Art: 40 Years at Pace.* Milan: Leonardo International, 2001.

Greenberg, Jan. *Heart to Heart: New Poems Inspired by Twentieth-Century American Art.* New York: Harry N. Abrams, 2001.

Kahan, Mitchell D., Barbara Tannenbaum, and Jeffrey Grove. *Akron Art Museum, Art Since 1850: An Introduction to the Collection.* Akron: Akron Art Museum, 2001.

Landmuir, Erika, and Norbert Lynton. *The Yale Dictionary of Art and Artists.* New Haven, Conn.: Yale University Press, 2001.

Lauder, Jo Carole, and Ann L. Gund, foreword. *Gift to the Nation.* Washington D.C.,: FAPE, 2001.

Leddick, David. *Male Nudes.* New York: Taschen, 2001.

Leddick, David. *Male Nude Now: New Visions for the 21st Century.* New York: Universe Publishing/Rizzoli, 2001.

Powell, Earl A., foreword. *National Gallery of Art: Master Paintings from the Collection.* Washington, D.C.: National Gallery of Art, 2004.

Ocvirk, Otto, et al. *Art Fundamentals: Theory and Practice.* New York: McGraw Hill Companies, 2001.

Pakesch, Peter. *Abbild: Recent Portraiture and Depiction.* Vienna and New York: Springer, 2001.

Paparoni, Demetrio, and Francesco Clemente, intro. *Timothy Greenfield-Sanders.* Milan: Alberico Cetti Serbelloni, 2001.

Smith, Terry. *Impossible Presence: Surface and Screen in the Photogenic Era.* Sydney: Power Institute, 2001.

2002

Anderson, Maxwell L. *An American Legacy: A Gift to New York.* New York: Whitney Museum of American Art, 2002.

Beyer, Andreas. *Das Porträt in der Malerei.* Munich: Hirmer, 2002.

Blake, Randolph, and Robert Sekuler. *Perception.* New York: McGraw-Hill Companies, 2002.

Demers, Owen. *Texturing and Painting.* Indianapolis: New Riders, 2002.

Getlein, Mark. *Gilbert's Living with Art.* New York: McGraw-Hill Companies, 2002.

Herbert, Martin L. "Grids in Art." In *The Designer and the Grid.* Brighton, Eng.: Rotovision, 2002.

Mishory, Alec. *Art History: An Introduction.* Tel Aviv: Open University of Israel, 2002.

Mulligan, Therese, and David Wooters, eds.. *1000 Photo Icons.* Rochester, N.Y.: George Eastman House; Cologne: Taschen, 2002.

Ocvirk, Otto, et al. *Art Fundamentals: Theory and Practice.* New York: McGraw-Hill Companies, 2002.

Rexer, Lyle. *Photography's Antiquarian Avant-Garde.* 2002.

Schneider Adams, Laurie. *Art across Time.* New York: McGraw-Hill Companies, 2002.

Sekuler, Robert, and Randolph Blake. *Perception.* 4th ed. New York: McGraw Hill, 2002.

Tatehata, Akira. *The Concise History of Western Art.* Tokyo: Bijutsu Shuppan-Sha, 2002.

2003

Beyer, Andreas. *Portraits: A History.* New York: Harry N. Abrams, 2003.

Campany, David. *Art and Photography.* London: Phaidon, 2003.

Kleiner, Fred S., Christin J. Mamiya, and Richard G. Tansey. *Gardner's Art through the Ages: The Western Perspective.* Little Rock, Ark.: Wadsworth, 2003.

Pipes, Alan. *Foundations of Art and Design.* London: Laurence King, 2003.

Taylor, Mark C. *The Moment of Complexity: Emerging Network Culture.* Chicago: The University of Chicago Press, 2003.

2004

Aimone, Steven. *Design! A Lively Guide to Design Basics for Artists and Craftspeople.* New York: Lark Books, 2004.

Bersson, Robert. *Responding to Art: Form, Content and Context.* New York: McGraw Hill Companies, 2004.

Cempellini, Leda. *L'iperrealismo "fotografico" americano in pittura: risonanze storiche nella East e nella West Coast.* [American Photographic Hyperrealism: Historical Resonances from the East to the West Coast.] Italy: Padua University Press, 2004.

Dickens, Rosie. *The Usborne Introduction to Modern Art.* London: Usborne Publishing, 2004.

Elderfield, John. *Modern: Painting and Sculpture 1880 to the Present at The Museum of Modern Art.* New York: The Museum of Modern Art, 2004 .

Johnson, Brooks, comp. *Photography Speaks: 150 Photographers on Their Art.* New York: Aperture, 2004.

Lauer, David, and Stephen Pentak. *Design Basics.* 6th ed. Little Rock, Ark.: Wadsworth Publishing, 2004.

Schama, Simon. *Hang-Ups: Essays on Paintings.* London: BBC Books, BBC Worldwide Ltd, 2004.

West, Shearer. *Portraiture.* Oxford: Oxford University Press, 2004.

Wye, Deborah. *Artists and Prints: Masterworks from The Museum of Modern Art.* New York: The Museum of Modern Art, 2004.

2005

El arte en los museos del mundo. Barcelona: Thema Equipo Editorial, 2005.

Beech, Marty, et al. *Visual Arts for Students with Disabilities: Accommodations and Modifications.* Learning Systems Institute Florida State University, 2005.

Blake, Randolph, and Robert Sekuler. *Perception.* 5th ed. San Francisco: McGraw Hill, 2005.

Bleicher, Steven. *Contemporary Color Theory and Use.* Clifton Park, N.Y.: Thomas/Delmar Learning, 2005.

Brommer, Gerald F. *Discovering Art History.* 4th ed. Worcester, Mass.: Davis Publications, 2005.

Carpenter, Elizabeth, and Joan Rothfuss. *Bits and Pieces Put Together to Present a Semblance of a Whole: Walker Art Center Collections.* Minneapolis: The Walker Art Center, 2005.

Chuck Close: A Flipbook. Minneapolis: Walker Art Center; Berkeley: Fliptomania, 2005.

Crist, Steve. *The Polaroid Book: Selections from the Polaroid Collections of Photography.* Cologne: Taschen, 2005.

Cumming, Robert. *Art: Eyewitness Companions.* London: DK Publishing, 2005.

Dickins, Rosie. *The Usborne Book of Art: Internet Linked.* 3rd ed. London: Usborne Publishing, 2005.

Feisner, Edith Anderson. *Colour: How to Use Colour in Art and Design.* 2nd ed. London: Laurence King, 2005.

Getlein, Mark. *Gilbert's Living with Art.* 7th ed. New York: McGraw Hill Companies, 2005.

High Museum of Art Collection Handbook. Atlanta: High Museum of Art, 2005

Jasper, Caroline. *Powercolor: Master Color Concepts for All Media.* New York: Watson-Guptill, 2005.

Lewis, Richard W. *Absolut Sequel: The Absolut Advertising Story Continues.* Hong Kong: Periplus Editions, 2005.

Masterworks of Modern Art from The Museum of Modern Art. New York: Scala Vision, 2005.

Ocvirk, Otto, et al. *Art Fundamentals: Theory and Practice.* 10th ed. San Francisco: McGraw Hill Higher Education, 2005.

Paparoni, Demetrio. *L'arte contemporanea e il suo metodo.* Padua: Neri Pozza, 2005.

Richer, Francesca, and Matthew Rosenzweig, eds. *No. 1: First Works by 362 Artists.* New York: D.A.P., 2005.

Schneider Adams, Laurie. *A History of Western Art.* 4th ed. New York: McGraw-Hill Companies, 2005.

Soutif, Daniel. *L'Art du XXe siècle 1939–2002.* Paris: Citadelles & Mazenod, 2005.

Techno/Sublime. Boulder: CU Art Museum/University of Colorado at Boulder, 2005.

Yale University: Profiles in Leadership. New Haven: Yale University Press, 2005.

2006

Brown, Kathan. *Magical Secrets about Thinking Creatively: The Art of Etching and the Truth of Life.* San Francisco: Crown Point Press, 2006.

Buser, Thomas. *Experiencing Art around Us.* 2nd ed. Belmont, Calif.: Thomson Wadsworth, 2006.

Dantzic, Cynthia Maris. *100 New York Painters.* Atglen, Pa.: Shiffer Publications, 2006.

Engberg, Siri, et al. *Kiki Smith: A Gathering, 1980–2005.* Minneapolis: Walker Art Center, 2006.

Hopwood, Graham. *Handbook of Art.* 2nd ed. Marrickville, Australia: Science Press, 2006.

Hume, Helen D. *Printmaking Today, Ideas, Projects and Techniques.* New York: Watson-Guptill, 2006.

The Kirk Varnedoe Collection. Savannah: Telfair Museum of Art, 2006.

Lindemann, Adam. *Collecting Contemporary.* Cologne: Taschen, 2006.

McQuade, Donald, and Christine McQuade. *Seeing and Writing.* 3rd ed. Boston: Bedford/St. Martins, 2006.

Mullins, Charlotte. *Painting People: State of the Art.* London: Thames and Hudson, 2006

Ocvirk, Otto G., et al. *Art Fundamentals: Theory and Practice.* 10th ed. New York: Mc Graw Hill, 2006.

Stewart, Mary. *Launching the Imagination.* 2nd ed. New York: McGraw-Hill Companies, 2006.

Swanson, Dean, and Martin Friedman. *Lewitt x 2: Structure and Line, Selections from the Lewitt Collection.* Madison: Madison Museum of Contemporary Art, 2006.

Yale: Landmarks and Leaders. New Haven: Yale University, 2006.

Zelanski, Paul, and Mary Pat Fisher. *Color.* Upper Saddle River, N.J.: Prentice Hall, 2006.

2007

Brommer, Gerald F. *Discovering Art History.* 4th ed. Worcester, Mass.: Davis Publications,2007.

Elements of Literature. Austin: Holt, Rhinehart and Winston, 2007.

Focal Encyclopedia of Photography. 4th ed. Burlington, Mass.: Focal Press, 2007.

Mendelowitz, Daniel M., David L. Faber, and Duane A. Wakeham. *A Guide to Drawing.* 7th ed. Belmont, Calif.: Thomson Wadsworth, 2007.

Meyers, Morton, MD. *Happy Accidents: Serendipity in Modern Medical Breakthroughs.* New York: Arcade Publishing, 2007.

Schneider Adams, Laurie. *Art across Time.* 3rd ed. New York: McGraw Hill, 2007.

2008

Getlein, Mark. *Gilbert's Living with Art.* 8th ed. New York: McGraw Hill, 2008.

INTERVIEWS AND ARTIST'S STATEMENTS

1970

Nemser, Cindy. "An Interview with Chuck Close." *Artforum* 8, no. 5 (January 1970): 51–55.

1972

Chase, Linda, and Ted McBurnett. "The Photo Realists: 12 Interviews." *Art in America* 60, no. 6 (November–December 1972): 76–77.

Kurtz, Bruce. "Documenta 6: A Critical Preview." *Arts Magazine* 46, no. 8 (summer 1972): 41.

1975

Henry, Gerritt. "The Artist and the Face: A Modern American Sampling." *Art in America* 63, no. 1 (January–February 1975): 41.

1976

"The Art of Portraiture in the Words of Four New York Artists." *New York Times,* October 31, 1976.

1977

Glueck, Grace. "The 20th Century Artists Most Admired by Other Artists." *ARTnews* 76, no. 9 (November 1977): 78–103.

327

1978

Harshman, Barbara. "An Interview with Chuck Close." *Arts Magazine* 52, no. 10 (June 1978): 142–45.

Shapiro, Michael. "Changing Variables: Chuck Close and His Prints." *Print Collectors Newsletter* 9, no. 3 (July–August 1978): 69–73.

1979

Diamonstein, Barbaralee. "Chuck Close." In *Inside New York's Art World.* New York: Rizzoli, 1979.

"Phil: Six Images." *The Paris Review* 21, no. 75 (spring 1979): 107–114.

1981

Close, Charles. Transcribed lecture in *Excellence: The Pursuit, the Commitment, the Achievement.* Washington, DC.: LTV Corporation, 1981.

1982

DeLoach, Douglass. "Up Close: An Interview with Chuck Close." *Art Papers* 6, no. 2 (March–April 1982): 2–3.

1984

[Sandback, Amy, and Ingrid Sischy]. "A Progression by Chuck Close: Who's Afraid of Photography?" *Artforum* 22, no. 9 (May 1984): 54–55.

1986

Close, Chuck. "New York in the Eighties: A Symposium." *New Criterion,* special issue (summer 1986): 12–14.

"Dialogue: Arnold Glimcher with Chuck Close." In *Chuck Close: Recent Work.* New York: The Pace Gallery, 1986.

1987

Close, Chuck. "Leslie." *Art in America* 75, no. 2 (February 1987): 55.

Smecchia, Muni de. "Artisti nel loro studio: Chuck Close." *Vogue Italia,* no. 446 (April 1987), 144–47, 201, 204.

Varnedoe, Kirk. "An Interview with Chuck Close." *World Art,* no. 1 (1987): 32–37.

1991

Artist's Choice–Chuck Close: Head On/The Modern Portrait. New York: The Museum of Modern Art, 1991. Foreword by Kirk Varnedoe and Artist's Statement by Chuck Close.

Watson, Simon. "A Conversation between Simon Watson, Dennis Kardon, and Chuck Close." *Balcon* (Madrid), 1991, 156–60.

1992

Close, Chuck. "Artist Pages: Janet." *American Art* 6, no. 2 (spring 1992): 58–59.

———. "Chuck Close: *Self-Portrait Composite, Sixteen Parts,* 1987." *Aperture,* no. 129 (fall 1992): 24–25.

Golz, Stephan. "Chuck Close." In *American Artists in Their New York Studios: Conversations about the Creation of Contemporary Art.* Cambridge: Center for Conservation and Technical Studies, Harvard University Art Museums; and Stuttgart: Daco-Verlag Gunter Blaise, 1992.

1993

Close, Chuck and Michael Auping. "Face to Face: Portraits from the Collection of the Metropolitan Museum of Art." *Artforum* 32, no. 2 (October 1993): 66–71.

———. "He Called Me Chuck." *Artforum* 32, no. 1 (September 1993): 122–23.

Smith, Jean Kennedy, and George Plimpton. "Chuck Close." In *Chronicles of Courage.* New York: Random House, 1993.

Van Wyck, Bronson. "Interview: Chuck Close." *Yale Literary Magazine* 5, nos. 2–3 (autumn–spring 1993–94): 44–49.

1994

Close, Chuck. "Interview With Kiki Smith." *Bomb,* no. 49 (fall 1994): 38–45.

Diamonstein, Barbaralee. "Chuck Close." In *Inside the Art World: Conversations with Barbaralee Diamonstein.* New York: Rizzoli, 1994.

Gardner, Paul. "Light, Canvas, Action: When Artists Go to the Movies." *ARTnews* 93, no. 10 (December 1994): 129.

1995

Close, Chuck. "Critical Reflections, Adam Gopnik." *Artforum* 33, no. 8 (April 1995): 76.

———. "Golf War." In "Returned to Sender, Remembering Ray Johnson." *Artforum* 33, no. 8 (April 1995): 73, 111.

Guare, John. "Close Encounters of an Incredible Kind." *Interview,* November 1995, 80–83.

1996

"Vija Celmins Interviewed by Chuck Close, 1992." In *Between Artists: Twelve Contemporary American Artists Interview Twelve Contemporary American Artists.* Los Angeles: A.R.T. Press, 1996.

1997

Sussler, Betsy; A. M. Homes, intro. *Speak Art! The Best of Bomb Magazine's Interviews with Artists.* G&B Arts International, 1997.

Temkin, Ann, intro. *Chuck Close/Paul Cadmus: In Dialogue.* Philadelphia: Philadelphia Museum of Art, 1997.

1998

Adams, Brooks; photographs by Tina Barney. "Close Encountered: Brooks Adams talks with Chuck Close and Robert Storr." *Artforum* 36, no. 8 (April 1998): 90–98, 135.

Close, Chuck, artist/board member statement. *5000 Artists Return to Artists Space: 25 Years.* New York: Artists Space, 1998.

Huebner, Jeff. "A Conversation with Chuck Close." *Chicago Tribune,* July 5, 1998.

Wiens, Ann. "Headshot: Interview with Chuck Close." *New Art Examiner* 26, no. 1 (September 1998): 38–41.

2000

Close, Chuck. "My New York, Places that Changed Us. Chuck Close: At Max's Kansas City, Art Was Better than Money—and It Was Worth Fighting For." *New York,* December 18–25, 2000, 93.

Close, Chuck, and Bice Curiger. "Putting English on the Stroke: Chuck Close in Conversation with Bice Curiger, August 21, 2000, Bridgehampton, New York." *Parkett* no. 60 (December 2000): 56–65.

Close, Chuck, and Elizabeth Peyton. "About Face: Chuck Close in Conversation with Elizabeth Peyton, October 3, 2000, New York City." *Parkett* no. 60 (December 2000): 28–34.

2003

Close, Chuck. "Here and Abroad." Interview. *Departures,* March–April 2003, 54.

———. "OK! The Kate Moss Portfolio." *W,* September 2003, 414–21.

2004

Henry, Clare. "A Little Help from His Friends." Interview with Chuck Close. *Financial Times* (London), January 21, 2004, 10.

Close, Chuck. "A People's Democratic Platform." *The Nation,* August 29, 2004, 24.

———. "Was war Ihr wichtigstes Erlebnis mit der Kunst in den letzten 25 Jahren?" *Art: Das Kunst Magazin,* no. 11 (November 2004): 144–47.

Gross, Terry. "The Way People Look." In Terry Gross, *All I Did Was Ask: Conversations With Writers, Actors, Musicians and Artists.* New York: Hyperion, 2004.

Richards, Judith Olch, ed. *Inside the Studio: Two Decades of Talks with Artists in New York.* New York: Independent Curators International, 2004.

Ruiz, Cristina. "The best thing is never to sell to Saatchi in the first place." Interview with Chuck Close. *The Art Newspaper,* January 2004, 35.

2005

Close, Chuck. "Laurie Anderson." *Interview,* March 2005, 92–93.

"A Conversation with Chuck Close and Robert Lazzarini." In Brad Thomas, *Untitled: Robert Lazzarini Works on Paper.* Davidson, N.C.: Van Every/Smith Galleries, Davidson College, 2006.

2006

Close, Chuck. "Chuck Close on *Erasmus of Rotterdam, 1523.*" *Tate Etc.,* autumn 2006, 67.

———. "Delighting in the Debased." *Time,* May 8, 2006, 170.

———. "The Great Illusionist." *Financial Times,* September 26, 2006, 14.

———. "Hindsight, Foresight." *Art Review* 4, no. 2 (February 2006): 114.

ARTICLES AND REVIEWS

1969

Nemser, Cindy. "Reviews in the Galleries." *Arts Magazine* 43, no. 8 (summer 1969): 58.

Wasserman, Emily. "Group Show/Bykert Gallery." *Artforum* 8, no. 1 (September 1969): 69.

1970

Davis, Douglas. "Art: Return of the Real." *Newsweek,* February 23, 1970, 105.

Marandel, J. Patrice. "New York." *Art International* 14, no. 5 (May 20, 1970): 86.

Nemser, Cindy. "Presenting Charles Close." *Art in America* 58, no. 1 (January–February 1970): 98–101.

Perreault, John. "Art: Get Back." *Village Voice,* February 19, 1970, 14–15, 17.

———. "Dining In." *Village Voice,* March 12, 1970, 16, 18.

Ratcliff, Carter. "22 Realists Exhibit at the Whitney." *Art International* 14, no. 4 (April 1970): 67–71.

Spear, Athena. "Reflections on the Work of Charles Close, Ron Cooper, and Neil Jenny, and Other Contemporary Artists: Three Young Americans at Oberlin." *Arts Magazine* 44, no. 7 (May 1970): 44–47.

1971

Kramer, Hilton. "Art Season; A New Realism Emerges." *New York Times,* December 21, 1971.

———. "Stealing the Modernist Fire." *New York Times,* December 26, 1971.

Seldis, Henry J. "Art Review: Chuck Close Work Shown." *Los Angeles Times,* October 4, 1971.

Szeemann, Harold. "Documenta 5: Entretien avec Harold Szeemann." *L'Art vivant,* no. 25 (November 1971): 4–7.

1972

Ammann, Jean-Christophe. "Realismus." *Flash Art,* no. 32–34 (May–July 1972): 50–52.

Davis, Douglas. "Nosing Out Reality." *Newsweek,* August 14, 1972, 58.

Dyckes, William. "A One-Print Show by Chuck Close at MoMA." *Arts Magazine* 47, no. 3 (December 1972/January 1973): 73.

Elderfeld, John. "The Whitney Annual." *Art in America* 60, no. 3 (May–June 1972): 27–29.

Hahn, Otto. "La Nouvelle Coqueluche: L'Hyperréalisme." *L'Express,* October 30–November 5, 1972, 102.

Hughes, Robert. "The Realist as Corn God." *Time,* January 31, 1972, 50–55.

Nakov, Andrei B. "Sharp Focus Realism: Le Retour de l'image." *XX Siècle* 37, no. 38 (June 1972): 166–68.

Nemser, Cindy. "The Close Up Vision–Representational Art–Part II." *Arts Magazine* 46, no. 7, (May 1972): 44–48.

Pozzi, Lucio. "I Super Realisti USA" *Bolaffi arte* 3, no. 18 (March 1972): 54–61.

Rose, Barbara. "Real, Realer, Realist." *New York,* January 31, 1972, 50.

Seitz, William C. "The Real and the Artificial: Painting of the New Environment." *Art in America* 60, no. 6 (November/December 1972): 58–72.

1973

Brunelle, Al. "Reviews: Chuck Close at MoMA." *ARTnews* 72, no. 4 (April 1973): 73.

Canaday, John. "Art: Miro's Joy and Verve/Chuck Close." *New York Times,* October 27, 1973.

Davis, Douglas. "Art Without Limits." *Newsweek,* December 24, 1973, 68–74.

Levin, Kim. "The Newest Realism: A Synthetic Slice of Life." *Opus International,* nos. 44–45 (June 1973): 28–37.

Mellow, James R. "'Largest' Mezzotint by Close Shown." *New York Times,* January 13, 1973.

Melville, Robert. "The Photograph as Subject." *Architectural Review* 153, no. 915 (May 1973): 329–33.

Nochlin, Linda. "The Realist Criminal and the Abstract Law." Parts 1, 2. *Art in America* 61, nos. 5, 6 (September–October, November–December, 1973): 54–61, 96–103.

Perreault, John. "A New Turn of the Screw: Drawings by Chuck Close." *Village Voice,* November 1, 1973, 34.

Restany, Pierre. "Sharp Focus: La Continuité réaliste d'une vision américaine." *Domus,* no. 525 (August 1973), 9–13.

Stiteman, Paul. "New York Galleries: Chuck Close [at] Bykert." *Arts Magazine* 48, no. 3 (December 1973): 60.

1974

Coleman, A. D. "From Today Painting is Dead." *Camera 35,* 18, no. 5 (July 1974): 34, 36–37, 78.

Dyckes, William. "The Photo as Subject: The Paintings and Drawings of Chuck Close." *Arts Magazine* 48, no. 5 (February 1974): 28–33. Reprinted in Battcock, Gregory, ed., *Super Realism: A Critical Anthology.* New York: Dutton, 1975.

Hughes, Robert. "An Omnivorous and Literal Dependence." *Arts Magazine* 48, no. 9 (June 1974): 24–29.

1975

Bourdon, David. "American Painting Regains Its Vital Signs." *The Village Voice,* March 17, 1975, 88.

deAk, Edit. "Photographic Realism." *Art-Rite/Painting,* no. 9 (spring 1975): 14–15.

Derfner, Phyllis. "New York: Chuck Close." *Art International* 19, no. 6 (June 15, 1975): 67.

Henry, Gerrit. "Artist and the Face; A Modern American Sampling." *Art in America* 63, no. 1 (January–February 1975): 34–41.

Kramer, Hilton. "Art: Chuck Close." *New York Times*, April 26, 1975.

Wallach, Amei. "Portrait Painting Is Alive and Well." Part 2. *Newsday*, January 26, 1975.

Zimmer, William. "Art Reviews: Chuck Close." *Arts Magazine* 49, no. 10 (June 1975): 8–9.

1976

Chase, Linda. "Photo-Realism: Post-Modernist Illusionism." *Art International* 20, nos. 3–4 (March–April 1976): 14–27.

Kramer, Hilton. "Art: the Fascination of Portraits." *New York Times*, October 22, 1976.

1977

Bourdon, David. "Time Means Nothing to a Realist." *Village Voice*, May 16, 1977, 75.

Cavaliere, Barbara. "Arts Reviews: Chuck Close." *Arts Magazine* 52, no. 1 (September 1977): 22.

French-Frazier, Nina. "New York Reviews: Chuck Close." *ARTnews* 76, no. 8 (October 1977): 130.

Hess, Thomas B. "Up Close with Richard and Philip and Nancy and Klaus." *New York*, May 30, 1977, 95–97.

Hughes, Robert. "Blowing Up the Closeup." *Time*, May 23, 1977, 92.

Russell, John. "Art: Big Heads by Chuck Close." *New York Times*, May 6, 1977.

Stevens, Mark. "Close Up Close." *Newsweek*, May 23, 1977, 68.

1978

Levin, Kim. "Chuck Close: Decoding the Image." *Arts Magazine* 52, no. 10 (June 1978): 146–149 and cover. Reprinted in *Chuck Close: Recent Work*, exhibition catalogue, The Pace Gallery, New York, October 26–November 24, 1979, and in *Copie Conforme?* exhibition catalogue, Centre George Pompidou, Musée National d'Art Moderne, Paris, April 18–June 11, 1979.

Ratcliff, Carter. "Making It in the Art World: A Climber's Guide." *New York*, November 27, 1978, 61–67.

1979

Harshman, Barbara. "Grids." *Arts Magazine*, vol. 53, no. 6 (February 1979): 4.

Kramer, Hilton. "Chuck Close–In Flight from the Realist Impulse." *The New York Times*, November 4, 1979.

Perreault, John. "Post-Photorealism." *The Soho Weekly News*, November 22, 1979, 19.

Schmidt, Doris. "Malerei–wie gedruckt. Zur ersten europäischen Ausstellung von Chuck Close im Kunstraum München." *Süddeutsche Zeitung*, July 11, 1979.

1980

Cavaliere, Barbara. "Art Reviews: Chuck Close." *Arts Magazine* 54, no. 6 (February 1980): 33.

Diamonstein, Barbaralee. "Chuck Close: 'I'm Some Kind of a Slow Motion Cornball.'" *ARTnews* 79, no. 6 (summer 1980): 112–116.

Kertess, Klaus. "Figuring It Out." *Artforum* 119, no. 3 (November 1980): 30–35.

Simon, Joan. "Close Encounters." *Art in America* 68, no. 2 (February 1980): 81–83.

1981

Appelo, Tim. "Too Close for Comfort." *Pacific Northwest*, December 1981, 32–34.

Artner, Alan G. "Close Encounters at the MCA: No Longer Radical or Realistic." *Chicago Tribune*, February 15, 1981.

Bourdon, David. "Art. Chuck Close: Portraits. The Saint Louis Art Museum." *Vogue*, January 1981, 27, 30.

Casademont, Joan. "'Close Portraits' Whitney Museum of American Art." *Artforum* 20, no. 2 (October 1981): 74.

Glueck, Grace. "Artist Chuck Close: 'I Wanted to Make Images That Knock Your Socks Off!'" *New York Times*, June 10, 1981.

Hughes, Robert. "Close, Closer, Closest." *Time*, April 27, 1981, 60.

Kramer, Hilton. "Portraiture: The Living Art." *Bazaar*, March 1981, 14, 26, 28.

———. "Chuck Close's Break with Photography." *New York Times*, April 19, 1981.

Larson, Kay. "Art: Chuck Close." *New York*, May 11, 1981, 74–75.

———. "Dead End Realism." *New York*, October 26, 1981, 94–95.

Levin, Kim, and Fred W. McDarrah. "Close-Ups." *Village Voice*, April 22–28, 1981, 64–65.

Perreault, John. "Encounters of the Close Kind." *Soho Weekly News*, April 29, 1981, 45.

Schjeldahl, Peter. "Realism on the Comeback Trail." *Village Voice*, November 11–17, 1981, 77.

Wallach, Amei. "Looking Closer at Chuck Close." *Newsday*, April 19, 1981, 17–18.

Wilson, William. "The Chilly Charms of Close." Part 6. *Los Angeles Times*, June 8, 1981,.

1982

Ackerman, Jennifer. "Agressive Image, Painterly Gestures: Looking at Some Close-Ups." *Yale Alumni Magazine and Journal* 45, no. 8 (June 1982): 42–45.

1983

Baker, Kenneth. "Leaving His Fingerprints." *Christian Science Monitor*, August 12, 1983, 20.

Danoff, I. Michael. "Chuck Close's *Linda*." *Arts Magazine* 57, no. 5 (January 1983): 110–11.

Larson, Kay. "Art: Chuck Close at Pace." *New York*, March 21, 1983, 59–60.

Moritz, Charles, ed. "Chuck Close." In *Current Biography* 44, no. 7 (July 1983): 9–12.

Raynor, Vivien. "Art: Chuck Close with Friends as Models." *New York Times*, March 4, 1983.

1985

Grundberg, Andy. "Chuck Close at Pace/MacGill." *Art in America* 73, no. 5 (May 1985): 174–75.

Hagen, Charles. "Chuck Close/Pace/Macgill." *Artforum* 23, no. 8 (April 1985): 96–97.

1986

Close, Chuck. "New York in the Eighties: A Symposium." *New Criterion* 4, special issue (summer 1986): 12–14.

Grundberg, Andy. "A Big Show That's About Something Larger Than Size." *New York Times*, February 23, 1986.

Poirier, Maurice. "Chuck Close at Pace." *ARTnews* 85, no. 5 (May 1986): 127.

Raynor, Vivien. "Chuck Close at Pace." *New York Times*, February 28, 1986.

1987

Johnson, Ken. "Photographs by Chuck Close." *Arts Magazine* 61, no. 9 (May 1987): 20–23.

Pradel, Jean-Louis. "Jean-Olivier Hucleux, Chuck Close: Les Réalités improbables." *Art Press*, no. 120 (December 1987): 34–37.

Steiner, Wendy. "Postmodernist Portraits." *Art Journal* 46, no. 3 (fall 1987): 173–77.

1988

Grundberg, Andy. "Blurring the Lines–Dots?–Between Camera and Brush." *New York Times*, October 16, 1988.

Kimmelman, Michael. "Chuck Close at Pace Gallery." *New York Times*, October 7, 1988.

Lewis, Jo Ann. "Chuck Close's True Grid." *Washington Post*, November 5, 1988.

Lyon, Christopher. "Chuck Close at Pace and Pace/MacGill." *ARTnews* 87, no. 10 (December 1988): 143, 145.

1989

Nesbitt, Lois. "Chuck Close at Pace Gallery and Pace Prints." *Artforum* 27, no. 5 (January 1989): 110.

Westfall, Stephen. "Chuck Close." *Flash Art*, no. 144 (January/February 1989): 119.

1990

Speiser, Irene. "Gesprach mit Chuck Close: Eine Welt intimer Einzelheiten." *Photographie*, no. 9 (September 1990): 50–52.

1991

Johnson, Ken. "Chuck Close at MoMA." *Art in America* 79, no. 5 (May 1991): 167–68.

Kimmelman, Michael. "Chuck Close Browses and Assembles an Exhibition." *New York Times*, January 18, 1991.

Knight, Christopher. "Face to Face with Faces in 'Head-On.'" *Los Angeles Times*, June 26, 1991.

Larson, Kay. "Close Encounter." *New York*, December 2, 1991, 148–49.

Newhall, Edith. "Close to The Edge." *New York*, April 15, 1991, 38–46.

Schjeldahl, Peter. "Those Eyes . . . Head On/The Modern Portrait." *Village Voice*, February 5, 1991, 85.

Smith, Roberta. "In Portraits on a Grand Scale, Chuck Close Moves On." *New York Times*, November 8, 1991.

Wallach, Amei. "Close Encounters at MoMA." *New York Newsday*, January 27, 1991.

———. "The Will to Paint." *New York Newsday*, April 21, 1991.

———. "How Can You Tell A Franz Gertsch from a Chuck Close?" *Parkett*, no. 28 (June 1991): 44–46.

Wise, Kelly. "Vibrant Selection of Close's Work." *Boston Globe*, December 4, 1991, 46.

1992

Ament, Deloris Tarzan. "He Lost His Hands, but Not His Art." *Seattle Times/Seattle Post-Intelligencer*, October 4, 1992.

Auping, Michael. "Chuck Close: The Ironies of *Janet*," *Albright-Knox Art Gallery Calendar*, December 1992, 1, 3.

Decter, Joshua. "New York in Review." *Arts Magazine* 66, no. 6 (February 1992): 78–80.

Gardner, Paul. "'Making the Impossible Possible.'" *ARTnews* 91, no. 5 (May 1992): 94–99.

Gopnik, Adam. "The Art World: Close Up." *New Yorker*, February 24, 1992, 76–78.

Princenthal, Nancy. "Chuck Close at Pace." *Art in America* 80, no. 3 (March 1992): 114–15.

1993

Danto, Arthur C. "Close Quarters." *Elle Decor*, February/March 1993, 98–107.

De Ferrari, Gabriella. "Close Encountered." *Mirabella*, November 1993, 78–80.

Glueck, Grace. "Habit-Forming Close-Ups; Playpen-Style Post-Structuralism." *New York Observer*, November 22, 1993, 24.

Kimmelman, Michael. "Art in Review: Chuck Close." *New York Times*, November 5, 1993.

Malcolm, Daniel R. "Print Project by Chuck Close." *Print Collector's Newsletter* 24 (November–December 1993): 178.

Tanaka, Hiroko. "Chuck Close: An Artist of Wonder." *Asahi Shimbun Weekly AERA* (Japan), December 20, 1993, 46.

Wallach, Amei. "Close Builds to a Dazzling Solution." *New York Newsday*, October 29, 1993.

1994

Breyer, Heinrich. "Folgenreiche Kleinodien, mittelalterliche Buchmalerei aus dem Kloster Seeon." *Feuilleton*, no. 160 (July 14, 1994): 12.

Gookin, Kirby. "Reviews: Chuck Close." *Artforum* 32, no. 7 (March 1994): 84–85.

Holert, Tom. "Die Porträtmaschine. Vom Fotorealismus zu leuchtenden Farbfeldeon: Chuck Close." *Vogue* (Germany), April 1994, 108, 110.

Lingeman, Susanne. "Chuck Close: Porträts sind seine Romane." *Arte das Kunstmagazin* (Germany), no. 4 (April 1994): 54–63.

Meinhardt, Johannes. "Chuck Close." *Kunstforum International* (Germany) 127 (July–September 1994): 328–29.

Rosenblatt, Roger. "A Painter in a Wheelchair." *Men's Journal*, March 1994, 23–24.

Sonna, Birgit. "Chuck Close: Oszillation des Realen." *Kritik*, no. 3 (March, 1994): 42–47.

Stein, Deidre. "Chuck Close: 'It's Always Nice to Have Resistance.'" *ARTnews* 93, no. 1 (January 1994): 95–96.

———. "Reviews: Chuck Close–Pace." *ARTnews* 93, no. 2 (February 1994): 135–36.

1995

Greene, David A. "Chuck Close at PaceWildenstein," *Art Issues*, no. 40 (November–December 1995): 43.

Guare, John. "Close Encounters of an Incredible Kind," *Interview*, November 1995, 80–83.

Halle, Howard. "Close to You," *Time Out New York*, December 13–20, 1995, 22.

Kimmelman, Michael. "Art in Review: Chuck Close's Big Change." *New York Times*, December 8, 1995.

Landi, Ann. "The 50 Most Powerful People in the Art World." *ARTnews*, special issue (July 1995): 52–62.

Pagel, David. "Chuck Close at PaceWildenstein." *Art & Auction* 18, no. 2 (September 1995): 64, 66.

Yuskavage, Lisa. "Chuck Close." *Bomb*, no. 52 (summer 1995): 30–35.

1996

Angell, Roger. "Life Work." *New Yorker*, January 15, 1996, 48–49.

Artner, Alan G. "Work Ethic: Linking Chuck Close and Tom Friedman on the Basis of Effort." *Chicago Tribune*, May 3, 1996.

Blair, Dike. "Chuck Close at PaceWildenstein." *Flash Art*, no. 187 (March–April 1996): 111.

Bloom, Amy. "A Face in the Crowd." *Vogue*, December 1996, 293–97.

Grabner, Michelle. "Chuck Close and Tom Friedman." *Frieze*, no. 30 (September–October 1996): 76–77.

Halle, Howard. "Chuck Close, 'Large-Scale Photographs.'" *Time Out New York*, November 14–21, 1996, 46.

Katz, Vincent. "Review of 'Chuck Close: Life and Work, 1988–1995' by John Guare." *Print Collectors' Newsletter* 27, no. 2 (May–June 1996): 71.

"MoMA Gets Close," *ARTnews* 95, no. 3 (March 1996): 35.

Muchnic, Suzanne. "Chuck Close at PaceWildenstein, Beverly Hills." *ARTnews* 95, no. 1 (January 1996): 130–131.

Schjeldahl, Peter. "At Close Quarters." *The Village Voice*, January 9, 1996, 67.

Tully, Judd. "'To MoMA from Met.'" *Art & Auction* 18, no. 8 (March 1996): 25–26.

Vogel, Carol. "Chuck Close to Get a Show at the Modern." *New York Times*, January 31, 1996.

Wallis, Stephen. "Close to Home." *Art & Antiques* 19, no. 1 (January 1996): 80–81.

Wilk, Deborah. "Chuck Close, Tom Friedman." *New Art Examiner* 24, no. 1 (September 1996): 37–38.

1997
"Assignment: Times Square/A Special Photography Issue, REAL: Chuck Close Never Out of Character." *New York Times Magazine*, May 18, 1997.

Decker, Andrew. "Conjuring Consensus." *ARTnews* 96, no. 1 (January 1997): 58–59, 64.

Kimmelman, Michael. "At the Met with Chuck Close: Sought or Imposed, Limits Can Take Flight," *New York Times*, July 25, 1997.

Landi, Ann. "The 50 Most Powerful People in the Art World." *ARTnews* 96, no. 1 (January 1997): 90–97.

MacAdam, Barbara A. "Vasari Diary: Close to Bill." *ARTnews* 96, no. 1 (January 1997): 29.

1998
Adato, Allison, Jen M. R. Doman, and Timothy Greenfield-Sanders. "Chuck Close: The Magic of Art: A Master Shows How He Does It." *LIFE*, February 1998, 48–53.

Allen, Henry. "Chuck Close, Up Close and Impersonal: At the Hirshhorn, Staring Abstraction Right in the Face." *The Washington Post*, October 22, 1998.

Aloff, Mindy. "Chuck Close: Painting as Performing Art." *Graphis* 313 (1998): 32–41.

Arditti, Flamma. "Le teste fredde di Chuck Close." *La Stampa*, March 2, 1998.

Artner, Alan G. "The Power of Confrontations." *Chicago Tribune*, July 5, 1998.

Bock, Paula. "Art In Your Face: Chuck Close's astonishing portraits are a touchstone of contemporary American art." *Pacific Northwest: Seattle Times Magazine*, December 6, 1998, 20–35.

Belcove, Julie L. "Close Up: A New MoMA Retrospective Celebrates 30 Years of Chuck Close." *W*, February 1998, 204–8.

Braff, Phyllis. "A Concept and Conceptualism at the Parrish." Exhibition review of "Dreams for the Next Century." *New York Times* (Long Island Edition), August 9, 1998.

Brody, Jacqueline. "Chuck Close: Innovation through Process." *On Paper: The Journal of Prints, Drawings, and Photographs* 2, no. 4 (March–April 1998): 18–26.

Budick, Ariella. "About Faces: Contradictions Abound in MoMA Exhibit of Chuck Close's Colossal Mug Shots." *Newsday*, March 4, 1998.

Cameron, Donna. "Focus on Close." *Manhattan Arts International* 15, no. 1 (spring 1998): 14–15.

Cembalest, Robin. "Inside the Shrine with Straight-Talking Artist. Chuck Close on Renoir: 'Italian restaurant painting.'" *New York Times*, August 24, 1998.

Conroy, Sarah Booth. "For Friends of Art, a Welcome Home." *Washington Post*, June 1, 1998.

Costello, Daniel. "Chuck Close's Recommendations." *Wall Street Journal*, April 24, 1998.

Dobrzynski, Judith H. "Questions Over Met's Show of Minor Artist." *New York Times*, August 11, 1998,.

Drolet. Owen. "Chuck Close at MoMA." *Flash Art* 31, no. 198 (January–February 1998): 45.

Gardner, James. "Up Close and Impersonal." *National Review* 50, no. 9 (May 18, 1998): 58–59.

Goodrich, John. "Up Close and Personal." *Review* 3, no. 15 (May 1, 1998): 1, 5–6.

Gregg, Gail; photographs by Jason Schmidt. "The Making of a Retrospective." *ARTnews* 97, no. 4 (April 1998): 142–47.

Hewitt, Corin. "Traveling Exhibitions: Chuck Close." *Artforum* 37, no. 1 (September 1998): 53.

Hoban, Phoebe. "See the Art and Read the Book." *New York Times*, February 18, 1998.

———. "Artists, In Paint and In Person." *New York Times*, March 1, 1998.

Hogrefe, Jeffrey. "Chuck Close Up: A Portrait of the Artist." *New York Observer*, March 9, 1998, 20.

Holg, Garrett. "Closeup on Chuck Close: Retrospective Opens at the MCA." *Chicago Sun-Times*, June 14, 1998.

Huebner, Jeff. "A Conversation with Chuck Close." *Chicago Tribune* July 5, 1998.

Hughes, Robert. "Close Encounters." *Time*, April 13, 1998, 209–10.

Kamps, Louisa. "Facing Up to Chuck Close: A Retrospective for a Master Portraitist." *Mirabella*, January/February 1998, 26.

Kimmelman, Michael. "Playful Portraits Conveying Enigmatic Messages." *New York Times*, February 27, 1998.

Kramer, Hilton. "Chuck Close's MoMA Show? You Could Do A Lot Worse." *New York Observer*, March 9, 1998, 1, 26.

Lewis, Nicole. "Buried Treasure: A Close Call." *Washington Post*, May 28, 1998.

Lima, Marcelo Guimarães. "Chuck Close ganha mostra em Chicago." *Folha de São Paulo*, July 3, 1998.

Meijas, Jordan; photographs by Timothy Greenfield-Sanders. "Das fremde Gesicht: Chuck Close malt Robert Rauschenberg." *Frankfurter Allgemeine Magazin*, March 13, 1998, 30–33.

Morgan, Robert C. "Chuck Close." *Flash Art* 31, no. 200 (May–June 1998): 95.

Morse, Minna. "Close Calls in Life and Art." *Smithsonian* 29, no. 8 (November 1998): 40.

Naves, Mario. "An Ongoing Viability." *The New Criterion* 16, no. 9 (May 1998): 40–42.

Newhall, Edith. "Retrospective: Talking Pictures." *New York*, March 2, 1998, 78.

Packer, William. "An Artist Down to His Fingertips: William Packer on the Career of the American Painter, Chuck Close." *Financial Times* (London), April 7, 1998.

Perl, Jed. "Death and Realism." *The New Republic*, April 20, 1998, 25–30.

Rimanelli, David. "Preview: Winter/Spring '98. Chuck Close: Museum of Modern Art." *Artforum* 36, no. 5 (January 1998): 28–29.

Rockmore, Dan. "Mathematical Metaphors Abound in Art and Fiction." *New York Times*, September 1, 1998.

Roob, Rona. "From the Archives: Chuck Close and MoMA." *MoMA: The Magazine of The Museum of Modern Art*, March/April 1998, 34.

Schama, Simon. "Head Honcho: The Evolution of Chuck Close's Anti-Portraits." *The New Yorker*, March 23, 1998, 91–93.

Sheets, Hilarie M. "Up Now: Chuck Close," *ARTnews* 97, no. 5 (May 1998): 169.

Shiff, Richard. "Allover You." *Artforum* 36, no. 8 (April 1998): 92–98, 135, 138.

———. "L'Expérience digitale: Une problématique de la peinture moderne." *Le Cahiers du MNAM*, no. 66 (winter 1998): 51–77.

Smith, Roberta. "The Risk of Existence." *New York Times*, December 4, 1998.

Span, Paula. "Chuck Close, the Big Picture: The Artist's New Perspective after the 'Event' of a Lifetime." *Washington Post*, February 22, 1998.

Solomon, Deborah. "The Persistence of the Portraitist: Portraitist for the Information Age." *New York Times Magazine*, February 1, 1998.

———. "The Current States of Status: For Contemporary Painters, Getting into MoMA–in Miniature." *New York Times Magazine*, November 16, 1998.

Sozanski, Edward J. "Artist Chuck Close Gets a Lot of Face Time." *Philadelphia Inquirer*, March 22, 1998.

Stevens, Mark. "Machine Dreams." *New York*, March 9, 1998, 54–56.

Tansini, di Laura. "Teste di Chuck." *Arte* (September 1998).

Vincent, Steven. "Portrait of the Artist: Chuck Close." *Art & Auction* 20, no. 6 (February 1998): 60.

Vincent, Steven. "What's the Hurry?" *Art & Auction* 21, no. 6 (November 16–29, 1998): 44–49.

"Warum ist der Realismus nicht am Ende, Mister Close?" *Tagesspiegel*, July 15, 1998.

Williams, Kevin M. "Close & Personal: Portrait Artist Gets Intimate." *Chicago Sun-Times*, June 19, 1998.

Worth, Alexi. "The Close Web," *ARTnews* 97, no. 5 (May 1998): 100.

Yablonsky, Linda. "Close as Can Be." *Time Out New York*, March 12–19, 1998.

1999
Allfree, Claire. "Exhibition: Chuck Close & Full Moon." *Metro Life*, July 7, 1999.

"An Artist's Work Blurs Lines Between Art and Science." *New York Times*, August 10, 1999.

Barbieri, Annalisa. "Isn't a Camera Enough?" *The Independent on Sunday* (London), June 20, 1999.

Braff, Phyllis. "Collective Spaces, but Individual Visions." *New York Times* (Long Island Edition), August 22, 1999.

Brown, Mick. "Head and Shoulders above the Rest. Chuck Close, 30 Years a New York Painter and Disabled 'Mayor of Soho,' Meets Mick Brown on the Eve of His First British Show." *The Daily Telegraph*, July 10, 1999.

Buck, Louisa. "Here Come the Mirror Men, Two Shows Prove Self-Portraits Are More than Me, Myself and Eye." *Esquire* (England), July 1999, 62.

Burton, Jane. "Face, the Final Frontier." *The Independent* (England), July 22, 1999, 10–11.

Coomer, Martin. "Chuck Close: White Cube." *Time Out* (London), August 25–September 1, 1999, 50.

Cork, Richard. "Off the Wall and into Your Face." *The Times* (London), July 21, 1999.

Cumming, Laura. "Detail Is Everything. That Includes Dotting All the Eyes." *The Observer* (London), July 25, 1999.

D'Arcy, David. "Art Frontier." *Vanity Fair*, February 1999, 100.

Derrington, Andrew. "How Art Puts the Brain into a Fresh Perspective." *Financial Times*, August 6, 1999, Science Vision section, 10.

Downey, Roger. "Pixel Dust: The Magic of Chuck Close." *Seattle Weekly*, February 18, 1999, 22–27.

Gayford, Martin. "Max Headroom." *Harpers & Queen* (London), August 1999, 46.

Gott, Richard. "Up Close and Impersonal." *The Independent on Sunday*, July 25, 1999.5.

Hackett, Regina. "Chuck Close's Unique Brand of Portraiture Comes to SAM." *Seattle Post-Intelligencer*, February 18, 1999.

———. "'Self, Absorbed' Explores Old Subject in New Ways." *Seattle Post-Intelligencer*, October 5, 1999.

Halada, James. "Head Games: Chuck Close Comes Home in a Major Exhibition of His Landmark Portraits." *Where Seattle*, February 1999, 14–15.

Hawkes, Nigel. "'Hidden' Portraits Reveal How People See." *The Times* (London), August 6, 1999, 9.

Highfield, Roger. "Artist Gives Science a Whole New Perspective on Vision." *The Daily Telegraph* (London), June 8, 1999.

Januszczak, Waldemar. "Close Encounters." *The Sunday Times* (London), July 25, 1999, 8.

Kunitz, Daniel. "Changing Faces: The Portrait Is Back, but You Do Not Always Recognize It." *ARTnews* 98, no. 3 (March 1999): 106–11.

Lubbock, Tom. "Too Close for Comfort." *The Independent* (London), July 27, 1999, 10.

MacRitchie, Lynn. "Squared Up to Friends. Lynn MacRitchie Admires the Work of Chuck Close at London's Hayward Gallery." *Financial Times* (London), July 27, 1999.

Murphy, Dominic. "Heads I Win." *The Guardian Weekend* (London), July 3, 1999.

Nochlin, Linda, Richard Kalina, Lynne Tillman, and Jerry Saltz. "Four Close-Ups (and One Nude)." *Art in America* 87, no. 2 (February 1999): 66–72, 127.

O'Rorke, Imogen. "Chuck Close: Head Lines." *Tate: The Art Magazine* (London) (Summer 1999): 6–7.

Pelli, Dennis. "An Artist's Work Blurs Lines Between Art and Science." *New York Times*, August 10, 1999.

———. "Visual Science: Close Encounters–An Artist Shows that Size Affects Shape." *Science* 285, no. 5429 (August 6, 1999): 844–46.

330

Schrader, Christopher. "Der Kunst auf der Spur: Sie luften das Geheimnis der Fantasie und Erklaren Asthetik: Wissenschaftler bezeichnen Kunst als Instrument der Erforschung." *Facts: Das Schweizer Nachrichtenmagazin*, August 26, 1999, 114–18.

Searle, Adrian. "The Man with Two Brains." *The Guardian* (London), July 27, 1999.

Sewell, Brian. "How to Make a Mug Out of the South Bank." *The Evening Standard* (London), August 6, 1999.

Shiff, Richard. "Chuck Close: La Réalité dévisagée." *Beaux Arts Magazine*, No. 183 (August 1999): 36–41.

Sultan, Terrie. "Contemporary Portraiture's Split Reference." *Art on Paper*, March–April, 1999, 38–42.

Updike, Robin. "Face to Face with Chuck Close." *The Seattle Times*, February 17, 1999.

2000

Anderson, Maxwell. "Preserving the Perishable Art of the Digital Age." *The New York Times*, September 24, 2000.

Anton, Saul. "Skin Close." *Time Out New York*, March 16–23, 2000, 84.

Arditi, Fiama. "Il quadro come romanzo." *ARS*, no. 32 (August 2000): 102 –6.

"Beautiful Women." Photographed by Chuck Close. *Jane*, April 2000, 110–15.

Belcove, Julie L. "The Waiting Game." *W*, July 2000, 118.

Berwick, Carly. "Close Encounter." *ARTnews* 99, no. 77 (summer 2000): 40.

Dannatt, Adrian. "NY Diary: Closer than Ever." *The Art Newspaper* (London), March 2000, 77.

DiPietro, Monty. "Close and Personal." *ARTnews* 99, no. 5 (May 2000): 45.

Horton, Anne. "Color Specs." *Art + Auction* 22, no. 10 (October 2000): 24–129.

Keil, Beth Landman. "Close Encounters." *New York Magazine*, February 14, 2000, 20.

Pollack, Barbara. "Chuck Close." *ARTnews* 99, no. 2000 (summer 2000): 205.

Prose, Francine. "Distances and Faces of the Moon." *Parkett* 60 (2000): 18–22.

Protzman, Ferdinand. "Getting a Head of Himself: Chuck Close Bigger than Ever." *Washington Post*, October 5, 2000.

Rexer, Lyle. "Chuck Close Daguerreotypes." *Aperture*, no. 160 (summer 2000): 40–49.

Rexer, Lyle. "Chuck Close Rediscovers the Art in an Old Method." *New York Times*, March 12, 2000.

Siegel, Katy. "Can-Do Art." *Artforum: Best of 2000, A Special Issue* 39, no. 4 (December 2000): 116.

Shiff, Richard. "Raster + Vector = Animation Squared." *Parkett*, no. 60 (December 2000): 44–49.

Smith, Roberta. "Chuck Close/Pace Wildenenstein." *New York Times*, April 7, 2000.

Van Gelder, Lawrence. "Grid Master." *New York Times*, December 7, 2000.

2001

Baker, Kenneth. "Chuck Close's Many Faces. The Artist Has Explored the Portrait in a Multitude of Media." *San Francisco Chronicle*, March 18, 2001.

Bonetti, David. "The Artist's Portrait of Himself as an Aging Man: Chuck Close Show Covers Decades." *San Francisco Chronicle*, March 15, 2001.

Eberle, Todd. "Broad Strokes." *W*, September 2001, 549–60.

Greben, Deidre Stein. "Chuck Close and Franz Gertsch." *ARTnews* 100, no. 2 (February 2001): 159.

Riding, Alan. "A Loner Who Found a Universe in His Studio." *New York Times*, July 1, 2001.

2002

Diamonstein, Barbaralee. "Chuck Close: 'I'm Some Kind Of Slow-Motion Cornball.'" *ARTnews* 101, no. 10 (November 2002): 226.

Kino, Carol. "Hired Hands." *Art + Auction* 24, no. 2 (February 2002): 102–111.

Landi, Ann. "The Real Thing?" *ARTnews* 101, no. 6 (June 2002): 88–91.

Smith, Roberta. "Art In Review." *New York Times*, December 27, 2002.

2003

"Art Guide. Galleries: Chelsea: Chuck Close." *New York Times*, January 3, 2003.

Buck, Louisa. "Chuck Close: New Paintings. White Cube." *Art Newspaper* (London), Febuary 2003, 14.

Criqui, Jean-Pierre. "Locus Focus." *Artforum* 41, no. 10 (summer 2003): 150.

De L'ain, Alix Girod. "Connaissez-vous vraiment votre homme?" *Elle*, April 2003, 117–19.

Dykstra, Jean. "The World On A Plate." *Art + Auction* 26, no. 4 (November 2003): 143.

Horyn, Cathy. "Critic's Notebook: Fashion and Art Embrace, if Not Passionately." *New York Times*, August 5, 2003.

Kazanjian, Dodie. "Collective Spirit." *Vogue*, March 2003, 532–37.

Keats, Jonathan. "Through the Lesson of History." *Art + Auction* 25, no. 3 (March 2003): 74–85.

Morgan, Robert C. "Profiles: Chuck Close." *Tèma Celeste* (Milan) March–April: 2003: 86–87.

Mullins, Charlotte. "Up Close and Personal." *Financial Times*, February 9, 2003.

Nakamura, Marie-Pierre. "Chuck Close: Le Visage d'une personne est comme la carte de sa vie." *Art Actuel*, January–February 2003, 82–85.

Rexer, Lyle. "Chuck Close at Pace Wildenstein." *Art in America*, no. 5 (May 2003): 150.

Rubinstein, Raphael. "A Quiet Crisis." *Art in America*, no. 3 (March 2003): 39.

Tansini, di Laura. "Signore e Signori: A coloquio con Chuck Close nel suo studio di Manhattan." *Arte In* (Bologna), no. 14 (January 2003): 56–60.

2004

"Chuck Close Prints: Process and Collaboration, Metropolitan Museum of Art." *New York Times*, February 13, 2004.

Harrison, Helen A. "Following the Light, and Making Faces." *New York Times*, February 22, 2004.

Henry, Clare. "A Little Help from His Friends." *Financial Times*, January 21, 2004.

Hirsch, Faye. "Close and Company." *Art in America*, no. 3 (March 2004): 44–51.

Kimmelman, Michael. "Savoring Chuck Close by Savoring the Process." *New York Times*, January 16, 2004.

Kissel, Howard. "Ready for His Close-Up." *The Daily News*, January 16, 2004, 63.

Kunitz, Daniel. "Close, Close-Up." *The New York Sun*, January 22, 2004, 19.

Loos, Ted. "Pointillist Printmaker." *The New York Times Book Review*, April 11, 2004, 16.

Scott, Andrea K. "Proof Positive." *Time Out New York*, February 12–19, 2004.

Shaw-Eagle, Joanna. "Close Work: Printmaker Creates Complex Portraits." *The Washington Times*, March 13, 2004.

Smith, Roberta. "A Star Underground in Separate Constellations." *New York Times*, January 23, 2004.

Stevens, Mark. "Face-Lifts" *New York Magazine* (February 9, 2004): 59–60.

Thon Ute. "Die, Kanarienvogel im Bergwerk geben Alarm." *Art Magazine* August 2004: 123.

2005

Baker, Kenneth. "Giant Self-Portraits Should Be Revealing, Yet Chuck Close Still Paints Puzzles." *San Francisco Chronicle: Datebook*, November 19, 2005.

Cembalest, Robin. "Close Encounters." *ARTnews* 104, no. 7 (summer 2005): 46.

"Chuck Close, 'Self-Portraits 1967–2005.'" *New York Times*, September 11, 2005.

Coleman, David. "Up Close." *Elle Décor*, July–August 2005, 128–33.

Comita, Jenny. "Made in New York." *W*, October 2005, 78.

Danto, Arthur C. "Chuck Close: The Artist's Oversize Canvases Reshaped the Idea of the Portrait." *Smithsonian* 36, no. 8 (November 2005): 106–8.

Ewing, John. "Chuck Close: Recent Paintings, Pace Wildenstein." *Modern Painters*, September 2005, 108.

Gomez, Edward M. "Painting Up Close: With a Passion for Process, Chuck Close Has Reinvented the Portrait." *Art & Antiques* (March 2005): 87–90.

Greben, Deidre Stein. "Spitting Image." *ARTnews* 104, no. 2 (January 2005): 72.

Keats, Jonathon. "Presents at the Creation." *Art + Auction* 29, no. 3 (December 2005): 82–84.

McGrath, Charles. "A Portraitist Whose Canvas Is a Piano." *New York Times*, April 22, 2005.

Paparoni, Demetrio. "Il sorriso del Buddha." *Vernissage* 6, no. 66 (December 2005): 4.

Pasquariello, Lisa. "Chuck Close." *Artforum* 42, no. 9 (May 2005): 113.

Ruther, Tobias. "Der Rasterfahnder." *Monopol, Magazin für Kunst und Leben*, December–January 2005, 38–43.

Stevens, Isabel. "Ready for a Close-Up?" *Art Review*, May 2005, 25.

2006

Avery, Dan. "Close Encounter." *Time Out New York*, September 14–20, 2006, 104.

Ayers, Robert. "Portrait of a Portrait Painter." *ARTnews* 105, no. 10 (November 2006): 132.

Bonetti, David. "Promising Portrait Show Will Open at Pulitzer." *St. Louis Post-Dispatch: Get Out*, November 2, 2006.

"Close-Up." *Harper's Bazaar*, March 2006: 327.

Kutner, Janet. "Quick Studies." *The Dallas Morning News*, May 3, 2006.

Larson, Kay. "Such a Casual Man, but So Many Auras." *New York Times*, June 11, 2006.

2007

Brasó, Emma. "Entrevista con Chuck Close." *Exit Express*, no. 25 (February 2007): 22.

Cheng, Scarlet. "Proof is in the Printing." *Los Angeles Times*, January 21, 2007.

Chin, Jit Fong. "Up Close and Personal." *Squeeze OC*, February 8, 2007, 24–26.

Fuente, Manuel de la. "Me allegro de que Cézanne pintara manzanas, pero eso no es lo que me interesa." *ABC*, February 6, 2007, 83.

Rubio, Carlos. "Anticipa Close arte digital." *Reforma*, February 7, 2007, 10.

331

WORKS ILLUSTRATED

Following are the works by Chuck Close illustrated in this volume, organized by medium and date. Numbers in italic preceding each entry indicate the page on which it is reproduced.

PAINTINGS, UNIQUE WORKS ON PAPER, AND PHOTOGRAPHIC MAQUETTES

22. Self-Portrait, 1961. Ink on paper. Private collection, New York

25. Betsy Ross Revisited, c. 1961. Mixed media on canvas, 86 x 111 in. (218.4 x 281.9 cm) Private collection, New York

26. Seated Figure with Arms Raised, 1962. Oil on canvas, 96 x 60 in. (243.8 x 152.4 cm). Destroyed in fire at Everett Community College, Everett, Washington, 1987

35. Maquette for *Big Nude*, 1964. Photograph scored with ink, masking tape, and red tape, mounted on cardboard; within red tape: 6 1/4 x 13 1/2 in (15.9 x 34.3 cm); board size: 15 7/8 x 15 in. (38.1 x 38.4 cm). Private collection

36–37. Big Nude, 1967. Oil on canvas, 9 ft. 9 in. x 21 ft. 1 in. (297.2 x 642.6 cm). Collection of Jon and Mary Shirley, Medina, Washington

46. Self-Portrait Maquette, 1968. Photograph, pen and ink, pencil, masking tape, acrylic, wash and blue plastic strips on cardboard, 18 5/8 x 13 3/8 in. (47.9 x 34 cm). The Museum of Modern Art, New York; gift of Norman Dubrow

46. Self-Portrait Maquette, 1968. Four gelatin-silver prints scored with ink, masking tape, and airbrush paint mounted on foamcore, 30 x 24 in. (76.2 x 61 cm). Private collection, Greenwich, Connecticut

47. Big Self-Portrait, 1968. Acrylic on canvas, 107 1/2 x 83 1/2 in. (273 x 212.1 cm). Walker Art Center, Minneapolis; Art Center Acquisition Fund, 1969

53. Self-Portrait, 1968. Pencil on paper, 29 x 23 in. (73.7 x 58.4 cm). Museum of Fine Arts, Boston; gift of Susan W. Paine in memory of Stephen D. Paine and in honor of Clifford S. Ackley

55. Nancy, 1968. Acrylic on canvas, 108 3/8 x 82 1/4 in. (275.3 x 208.9 cm). Milwaukee Art Museum. Gift of Herbert H. Kohl Charities, Inc.

57. Frank, 1969. Acrylic on canvas, 108 x 84 in. (274.3 x 213.4 cm). The Minneapolis Institute of Arts, John R. Van Derlip Fund

58. Richard, 1969. Acrylic on canvas, 108 x 84 in. (274.3 x 213.4 cm). Ludwig Forum für Internationale Kunst, Aachen, Germany

59. Joe, 1969. Acrylic on canvas, 108 x 84 in. (274.3 x 213.4 cm). Osaka City Museum of Modern Art, Japan

60. Phil, 1969. Acrylic on canvas, 108 x 84 in. (274.3 x 213.4 cm). Whitney Museum of American Art, New York; purchase, with funds from Mrs. Robert M. Benjamin

64. Bob, 1970. Acrylic on canvas, 108 x 84 in. (274.3 x 213.4 cm). Australian National Gallery, Canberra

65. Keith, 1970. Acrylic on canvas, 108 1/4 x 84 in. (275 x 213.4 cm). The Saint Louis Art Museum; purchased with funds given by the Shoenberg Foundation, Inc.

72. Study for Kent, 1970. Watercolor on paper, 30 x 22 1/2 in. (76.2 x 57.2 cm). Allen Memorial Art Museum, Oberlin, Ohio

72. Small Kent, 1970. Pencil, colored pencil, and masking tape on paper; sheet: 24 x 21 1/2 in. (61 x 54.6 cm). Private collection, New York

73. Study for Kent in Three Colored Pencils, 1970. Colored pencils on paper, 45 x 38 1/2 in. (114.3 x 97.8 cm). Private collection, Portland, Oregon

75. Kent, 1970–71. Acrylic on canvas, 100 x 90 in. (254 x 228.6 cm). Art Gallery of Ontario, Toronto

77. Susan, 1971. Acrylic on canvas, 100 x 90 in. (254 x 228.6 cm). Morton Neumann Family Foundation Collection

79. John, 1971–72. Acrylic on canvas, 100 x 90 in. (254 x 228.6 cm). The Eli and Edythe L. Broad Collection, Los Angeles

80. Nat/Watercolor, 1972. Watercolor on paper mounted on canvas, 67 x 57 in. (170.2 x 144.8 cm). Museum of Contemporary Art/Ludwig Museum Budapest

81. Leslie/Watercolor, 1972–73. Watercolor on paper mounted on canvas, 72 1/2 x 57 in. (184.2 x 144.8 cm). Private collection, Rutherford, California

92. Keith/1,280, 1973. Ink and pencil on graph paper, sheet: 22 x 17 in. (55.9 x 43.2 cm). Private collection, New York

93. Keith/Three Drawing Set, 1973: ink on white paper version; white ink on black paper version; ink on graphite ground version; each sheet: 30 x 22 1/2 in. (76.2 x 57.2 cm). Private collection, San Francisco

99. Self-Portrait/58,424, 1973. Ink and pencil on paper mounted on canvas, 70 1/2 x 58 in. (179.1 x 147.3 cm). Private collection, Chicago

97. Robert/104,072, 1973–74. Acrylic on ink with graphite on canvas, 108 x 84 in. (274.3 x 213.4 cm). The Museum of Modern Art, New York; gift of Frederick J. Byers III and promised gift of an anonymous donor

94–95. Robert I/154; Robert II/616; Robert III/2,464; Robert IV/9,856. 1974. Ink and graphite on paper; each sheet: 30 x 22 in. (76.2 x 55.9 cm). Wexner Center for the Arts, The Ohio State University. Purchased in part with funds from the National Endowment for the Arts

102. Chris, 1974. Ink and pencil on paper, 30 x 22 in. (76.2 x 55.9 cm). Private collection, San Francisco

102. Don N., 1974. Ink and graphite on paper, 30 x 22 in. (76.2 x 55.9 cm). Private collection, Washington, D.C.

103. Barbara, 1974. Ink and graphite on paper, 30 x 22 in. (76.2 x 55.9 cm). Private collection, New York

98. Maquette for *Self-Portrait*, 1975. Black-and-white Polaroid photograph scored with ink, masking tape with ink, and acetate, 4 1/2 x 3 1/8 in. (11.4 x 7.9 cm); image mounted, 6 3/8 x 4 7/8 in. (16.2 x 12.4 cm). Private collection, New York

100. Self-Portrait, 1975. Ink and pencil on paper, sheet: 30 x 22 in. (76.2 x 55.9 cm). Private collection, New York

82–83. Color separation maquettes for *Linda*, 1975–76

85. Linda, 1975–76. Acrylic on canvas, 108 x 84 in. (274.3 x 213.4 cm). Akron Art Museum; purchased with funds from an anonymous contribution, and anonymous contribution in honor of Ruth C. Roush, and the Museum Acquisition Fund

107. Klaus, 1976. Watercolor on paper mounted on canvas, 80 x 58 in. (203.2 x 147.3 cm). Collection Sydney and Francis Lewis Foundation

114. Drawing for Phil/Rubberstamp, 1976. Ink on paper, 7 5/8 x 6 1/2 in. (19.4 x 16.5 cm). Private collection, New York

109. Self-Portrait/Watercolor, 1976–77. Watercolor on paper mounted on canvas, 80 1/2 x 59 in. (204.5 x 149.9 cm). Museum Moderner Kunst Stiftung Ludwig, Vienna

115. Phil/Watercolor, 1977. Watercolor on paper, 58 x 40 in. (147.3 x 101.6 cm). Private collection, Minneapolis

104–5. Linda/Eye Series, five drawings, 1977. Watercolor on paper; each sheet: 30 x 22 1/2 in. (76.2 x 57.2 cm). The Art Institute of Chicago; gift of the Lannan Foundation

156. Linda/Pastel, 1977. Pastel on watercolor-washed paper, sheet: 29 3/4 x 22 1/8 in. (76.2 x 57.2 cm). Collection of Doris and Donald Fisher, San Francisco

157. Leslie Pastel, 1977. Pastel and watercolor on paper, sheet: 30 x 22 in. (76.2 x 55.9 cm). Private collection, Minneapolis

106. Mark Watercolor/Unfinished, 1978. Watercolor and graphite on paper, 53 1/2 x 40 1/2 in. (135.9 x 102.9 cm). Collection Sydney and Francis Lewis Foundation

158. Large Mark Pastel, 1978–79. Pastel on paper, 56 x 44 in. (142.2 x 111.8 cm). The Museum of Modern Art, New York; partial and promised gift of UBS

87. Mark, 1978–79. Acrylic on canvas, 108 x 84 in. (274.3 x 213.4 cm). Private collection, New York

101. Self-Portrait/Conté Crayon, 1979. Conté crayon and pencil on paper, 29 1/2 x 22 in. (74.9 x 55.9 cm). Private collection, New York

112. Keith/Round Fingerprint Version, 1979. Stamp-pad ink on paper, sheet: 30 x 22 1/8 in. (76.2 x 56.2 cm). Reynolda House, Museum of American Art, Winston-Salem, North Carolina

113. Keith/Square Fingerprint Version, 1979. Stamp-pad ink on paper, sheet: 30 x 22 1/4 in. (76.2 x 56.5 cm). Reynolda House, Museum of American Art, Winston-Salem, North Carolina

116. Phil Fingerprint/Random, 1979. Stamp-pad ink on paper, 40 x 26 in. (101.6 x 66 cm). Seattle Art Museum

117. Phil/Fingerprint, 1980. Stamp-pad ink on paper, sheet: 93 x 69 in. (236.2 x 175.3 cm). Chase Manhattan Bank Collection, New York

114. Phil, 1980. Ink and pencil on paper, 29 1/2 x 22 1/4 in. (74.9 x 57.2 cm). Collection of Troy Taubman

116. Phil, 1980. Stamp-pad ink on gray paper, 15 3/4 x 11 1/2 in. (40 x 29.2 cm). Private collection

159. Stanley (Small Version), 1980. Oil on canvas, 55 x 42 in. (139.7 x 106.7 cm). Private collection, New York

160. Stanley (Large Version), 1980–81. Oil on canvas, 101 x 84 in. (256.5 x 213.4 cm). Solomon R. Guggenheim Museum, New York

135. Georgia, 1982. Pulp paper collage on canvas, 48 x 38 in. (121.9 x 76.2 cm). Private collection, New York

138. Jud, 1982. Pulp paper collage on canvas, 96 x 72 in. (243.8 x 182.9 cm). Virginia Museum of Fine Arts, Richmond; gift of the Sydney and Francis Lewis Foundation

154. Gwynne/Watercolor, 1982. Watercolor on paper, sheet: 74 1/4 x 58 1/4 in. (189.2 x 148 cm). Private collection, Wynnewood, Pennsylvania

133. Phil, 1983. Pulp paper on canvas, 92 x 72 in. (233.7 x 182.9 cm). Private collection

118. John/Progression, 1983. Litho ink on paper, 30 x 80 in. (76.2 x 203.2 cm). Private collection, Hillsborough, California

119. John/Fingerpainting, 1984. Oil-based ink on canvas, 24 1/2 x 20 1/2 in. (62.2 x 52.1 cm). Private collection, Orinda, California

140. Phyllis/Collage, 1984. Pulp paper collage on canvas, 96 x 72 in. (243.8 x 182.9 cm). Doris and Donald Fisher, San Francisco

124. Georgia/Fingerpainting, 1984. Oil on canvas, 48 x 36 in. (121.9 x 91.4 cm). Private collection, Tokyo

125. Leslie/Fingerpainting, 1985. Oil based ink on canvas, 102 x 84 in. (259.1 x 213.4 cm). Private collection, Los Angeles

121. Fanny/Fingerpainting, 1985. Oil-based ink on canvas, 102 x 84 in. (259.1 x 213.4 cm). National Gallery of Art, Washington, DC.; gift of Lila Acheson Wallace Fund

118. Leslie/Fingerpainting, 1985. Oil based ink on canvas, 102 x 84 in. (259.1 x 213.4 cm). Private collection, Los Angeles

162. Leslie/Watercolor II, 1986. Watercolor on paper, sheet: 30 1/2 x 22 1/4 in. (77.5 x 56.5 cm). Private collection, State College, Pennsylvania

165. Self-Portrait, 1986. Oil on canvas, 54 1/2 x 42 1/4 in. (138.4 x 107.3 cm). Private collection, Los Angeles

171. Lucas, 1986–87. Oil on canvas, 100 x 84 in. (254 x 213.4 cm). The Metropolitan Museum of Art, New York; purchase, Lila Acheson Wallace Gift, and Gift of Arnold and Milly Glimcher, 1987

173. Lucas II, 1987. Oil on canvas, 36 x 30 in. (91.4 x 76.2 cm). Collection of Jon and Mary Shirley, Medina, Washington

167. Self-Portrait, 1987. Oil on canvas, 72 x 60 in. (182.9 x 152.4 cm). Private collection

169. Alex, 1987. Oil on canvas, 100 x 84 in. (254 x 213.4 cm). The Toledo Art Museum, Toledo, Ohio

278. Janet (maquette), 1987. Polaroid photograph, tape and ink, mounted to foamcore, overall: 34 3/8 x 25 in. (87.2 x 63.5 cm). Private collection, New York

168. Francesco I, 1987–88. Oil on canvas, 100 x 84 in. (254 x 213.4 cm). The American Contemporary Art Foundation, Inc., Leonard A. Lauder, President

174. Francesco II, 1988. Oil on canvas, 72 x 60 in. (182.9 x 152.4 cm). Private collection, Dellwood, Minnesota

170. Cindy, 1988. Oil on canvas, 102 x 84 in. (259.1 x 213.4 cm). Museum of Contemporary Art, Chicago; gift of Camille Oliver-Hoffman

169. Cindy II, 1988. Oil on canvas, 72 x 60 in. (182.9 x 152.4 cm). Private collection, New York

190. Alex II, 1989. Oil on canvas, 36 x 30 in. (91.4 x 76.2 cm). Private collection, New York

193. Janet, 1989. Oil on canvas, 36 x 30 in. (91.4 x 76.2 cm). Collection of Jon and Mary Shirley, Medina, Washington

195. Elizabeth, 1989. Oil on canvas, 72 x 60 in. (182.9 x 152.4 cm). The Museum of Modern Art, New York; fractional gift of an anonymous donor

199. Judy, 1990. Oil on canvas, 72 x 60 in. (182.9 x 152.4 cm). Modern Art Museum of Fort Worth, Texas

201. Bill, 1990. Oil on canvas, 72 x 60 in. (182.9 x 152.4 cm). Private collection, Wynnewood, Pennsylvania

208. Alex, 1990. Oil on canvas, 36 x 30 in. (91.4 x 76.2 cm). Private collection, Darien, Connecticut

205. Eric, 1990. Oil on canvas, 100 x 84 in. (254 x 213.4 cm). Private collection, New York

278. Lucas (maquette), 1990. Polaroid photograph, tape and ink, mounted to foamcore, overall: 34 3/8 x 25 in. (87.2 x 63.5 cm). Private collection, New York

206. April, 1990–91. Oil on canvas, 100 x 84 in. (254 x 213.4 cm). The Eli and Edythe L. Broad Collection, Los Angeles

203. Lucas, 1991. Oil on canvas, 28 x 24 in. (71.1 x 61 cm). Private collection, New Albany, Ohio

209. Alex, 1991. Oil on canvas, 100 x 84 in. (254 x 213.4 cm). The Art Institute of Chicago; gift of the Lannan Foundation

211. Janet, 1992. Oil on canvas, 100 x 84 in. (254 x 213.4 cm). Albright-Knox Art Gallery, Buffalo, New York; George B. and Jenny R. Mathews Fund, 1992

212. John, 1992. Oil on canvas, 100 x 84 in. (254 x 213.4 cm). Private collection, Los Angeles

215. John II, 1993. Oil on canvas, 72 x 60 in. (182.9 x 152.4 cm). Private collection, New York

217. Self-Portrait, 1993. Oil on canvas, 72 x 60 in. (182.9 x 152.4 cm). Private collection, New York

218. Studio view of *Kiki*, 1993. Oil on canvas, 100 x 84 ins. (254 x 213.4 cm). Walker Art Center, Minneapolis; gift of Judy and Kenneth Dayton, 1994

220. Paul, 1994. Oil on canvas, 102 x 84 in. (259.1 x 213.4 cm). Philadelphia Museum of Art; purchased with funds from the gift of Mr. and Mrs. Cummins Catherwood, the Edith H. Bell Fund, and with funds contributed by the Committee on 20th Century Fox

222. Roy I, 1994. Oil on canvas, 102 x 84 in. (259.1 x 213.4 cm). Collection of Doris and Donald Fisher, San Francisco

222 and 223. Roy II, 1994. Oil on canvas, 102 x 84 in. (259.1 x 213.4 cm). Hirshhorn Museum and Sculpture Garden, Smithsonian Institution, Washington, D.C.; Regents Collections Acquisition Program with matching funds from the Joseph H. Hirshhorn Purchase Fund, 1995

226. Dorothea, 1995. Oil on canvas, 102 x 84 in. (259.1 x 213.4 cm). The Museum of Modern Art, New York; promised gift of Robert F. and Anna Marie Shapiro; Vincent D'Aquila and Harry Soviak bequest, Vassilis Cromwell Voglis Bequest, and the Lauder Foundation Fund

227. Lorna, 1995. Oil on canvas, 102 x 84 in. (259.1 x 213.4 cm). Collection of Doris and Donald Fisher, San Francisco

230. Self-Portrait I, 1995. Oil on canvas, 72 x 60 in. (182.9 x 152.4 cm). Collection Jon and Mary Shirley; bequest Henry Art Gallery, Seattle

231. Self-Portrait II, 1995. Oil on canvas, 72 x 60 in. (182.9 x 152.4 cm). Collection Jon and Mary Shirley; bequest Henry Art Gallery, Seattle

229. Georgia, 1996. Oil on canvas, 30 x 24 in. (76.2 x 61 cm). Private collection, New York

228. Robert, 1997. Oil on canvas, 102 x 84 in. (259.1 x 213.4 cm). San Francisco Museum of Modern Art; fractional and promised gift of Vicki and Kent Logan

233. Self-Portrait, 1997. Oil on canvas, 102 x 84 in. (259.1 x 213.4 cm). The Museum of Modern Art, New York; gift of Agnes Gund, Jo Carole and Ronald S. Lauder, Donald L. Bryant, Jr., Leon Black, Michael and Judy Ovitz, Anna Marie and Robert S. Shapiro, Leila and Melville Straus, Doris and Don Fisher

294. Lyle, 1999. Oil on canvas, 102 x 84 in. (259.1 x 213.4 cm). Whitney Museum of American Art, New York

307. Emma, 2000. Oil on canvas, 72 x 60 in. (182.9 x 152.4 cm). Private collection, New York

292. Self-Portrait (maquette), 2001. Color Polaroid with artist's tape mounted on foamcore, 33 1/4 x 22 in. (84.5 x 55.9 cm). Private collection, New York

293. Self-Portrait, 2001. Oil on canvas, 108 x 84 in. (274.3 x 213.4 cm). The Art Supporting Foundation to the San Francisco Museum of Modern Art

296. Robert II, 2001. Oil on canvas, 108 x 84 in. (274.3 x 213.4 cm). Private collection, New York

297. Lisa, 2002. Oil on canvas, 102 x 84 in. (259.1 x 213.4 cm). Collection of Jon and Mary Shirley, Medina, Washington

302. Self-Portrait, 2002-3. Oil on canvas, 72 x 60 in. (182.9 x 152.4 cm). High Museum of Art, Atlanta

301. Inka, 2003. Oil on canvas, 102 x 84 in. (259.1 x 213.4 cm). Private collection, New York

300. Andres, 2003. Oil on canvas, 108 1/2 x 84 in. (289.6 x 213.4 cm). Private collection, British Virgin Islands

308. Herb, 2003-4. Oil on canvas, 102 x 84 1/4 in. (259.1 x 214 cm). Private collection

304. Lynda, 2004. Oil on canvas, 114 x 84 in. (289.6 x 213.4 cm). Private collection, New York

295. Self-Portrait, 2004-5. Oil on canvas, 102 x 84 in. (259.1 x 213.4 cm). Private collection, New York

299. Self-Portrait, 2005. Oil on canvas, 108 3/4 x 84 in. (276.2 x 213.4 cm). Private collection, New York

302. Merce, 2005. Oil on canvas, 108 1/2 x 84 in. (259.1 x 213.4 cm). Private collection, Leawood, Kansas

306. Maggie, 2005-6. Oil on canvas, 102 x 84 in. (259 x 213 cm). Private collection, New York

312. Nat, 2005-6. Oil on canvas, 102 x 96 in. (259.1 x 243.8 cm). Private collection, New York

310. Bill Clinton, 2006. Oil on canvas, 108 1/2 x 84 in. (275.6 x 213.4 cm). Private collection, New York

290. Georgia, 2007. Oil on canvas, 102 x 84 in. (259.1 x 213.4 cm). Private collection, New York

315. Self-Portrait, 2007. Oil on canvas 72 x 60 in. (182.9 x 152.4 cm). Private collection, New York

PRINTS AND MULTIPLES

90. Keith/Mezzotint, 1972. Mezzotint on paper, sheet: 51 1/2 x 42 in. (130.8 x 106.7 cm). Edition of 10

127. Keith II, 1981. Handmade paper, press dried, each 35 x 26 1/4 in. (88.9 x 66.7 cm). Versions on grey, white, and black paper. Each edition of 20

129. Phil II, 1982. Handmade gray paper, press dried, 64 x 53 1/2 in. (162.6 x 135.9 cm). Edition of 15

130. Self-Portrait Manipulated, 1982. Handmade gray paper in 24 gray values, air dried, 38 x 30 in. (96.5 x 76.2 cm). Edition of 25

131. Self-Portrait/String, 1983. Handmade paper in 24 gray values and string, 37 x 27 in. (94 x 68.6 cm). Edition of 25

137. Georgia, 1984. Handmade paper, air dried, 56 x 44 in. (142.2 x 111.8 cm). Edition of 35

163. Leslie, 1986. Woodcut, 32 x 25 1/4 in. (81.3 x 64.1 cm). Edition of 150

258. Self-Portrait (detail), 1988. Spitbite etching, 20 1/2 x 15 5/8 in. (52.1 x 40 cm). Edition of 50

251. Alex, 1991. 95-color 47 Japanese-style woodcut, 28 x 23 1/2 in. (71.1 x 59.1 cm). Edition of 75

259. Self-Portrait, 1992. Etching, 19 1/2 x 15 1/2 in. (49.5 x 39.4 cm). Edition of 70

239. View of *Alex/Reduction Print* proofs, 1991-93. Reduction linocut and serigraph on T. H. Saunders watercolor paper, 72 x 58 in. (182.9 x 147.3 cm)

241. Alex/Reduction Print, 1993. Silkscreen, 79 3/8 x 60 3/8 in. (201.6 x 153.4 cm). Edition of 35

257. Lucas/Woodcut, 1993. Woodcut with pochoir, 46 1/2 x 36 in. (118.1 x 91.4 cm). Edition of 50

244. Self-Portrait, 1995. 80-color silkscreen, 64 1/2 x 54 in. (163.8 x 137.3 cm). Edition of 50

261. Phil/Spitbite, 1995. Spitbite etching, 28 x 20 in. (71.1 x 50.8 cm). Edition of 60

260. Self-Portrait/Spitbite/White on Black, 1997. Spitbite aquatint, 20 1/2 x 15 3/4 in. Edition of 50

270. Self-Portrait I (Dots), 1997. Reduction linoleum cut, 24 x 18 in. (61 x 45.7 cm). Edition of 70

248. John, 1998. 126-color silkscreen, 64 1/2 x 54 1/2 in. (163.8 x 138.4 cm). Edition of 80

262. Lyle, 2000. 8-color, soft-ground etching, 18 1/4 x 15 1/4 in. (46.4 x 38.7 cm). Edition of 60

262-65. Self-Portrait/Scribble/Etching Portfolio, 2000. 12 states, each displaying a single color from final etching print, 18 1/4 x 15 1/4 in. (46.4 x 38.7 cm). Edition of 15

262-65. Self-Portrait/Scribble/Etching Portfolio Progressive, 2000. 12 states, each displaying a progressive state from portfolio of 12 progressives, 12 states, and 1 final signed print, 18 1/4 x 15 1/4 in. (46.4 x 38.7 cm). Edition of 15

266. Self-Portrait/Scribble/Etching Portfolio Final Print, 2000. Final signed print from portfolio of 12 states and 12 progressives, 18 1/4 x 15 1/4 in. (46.4 x 38.7 cm). Edition of 15

261. Self-Portrait/Scribble/Etching, 2001. Softground etching from nine plates, 18 1/4 x 15 1/4 in. (46.4 x 38.7 cm). Edition of 60

274. Self-Portrait/Pulp, 2001. Stenciled handmade paper pulp in 11 grays, 57 1/2 x 40 in. (146.1 x 101.6 cm). Edition of 35

254. Emma, 2002. 123-color Japanese woodcut, 43 x 35 in. Edition of 35

250. Lyle, 2003. 149-color silkscreen, 65 1/2 x 53 7/8 in. (165.7 x 136.5 cm). Edition of 80

287. Self-Portrait, 2006. Jacquard tapestry, 103 x 79 in. (261.6 x 200.7 cm). Edition of 10 and 3 artist proofs

PHOTOGRAPHS

23. Experimental self-portraits done at Everett Junior College, 1958. Private collection, New York

45. Proof sheet for *Big Self-Portrait*, 1967. Private collection, New York

141. Selections from the *Ray Series*, 1979. Six Polaroid photographs, each 24 x 20 in. (61 x 50.8 cm). Private collection

142. Self-Portrait/Composite/Nine Parts, 1979. Polaroid photographs, overall: 83 x 69 in. (210.8 x 175.3 cm). Whitney Museum of American Art, New York, Gift of Barbara and Eugene Schwartz

145. Self-Portrait/ Composite, Six Parts, 1980. Polaroid photographs, overall: 170 x 133 in. (431.8 x 337.8 cm). Presumed destroyed

146. Laura I, 1984. Polaroid Polacolor II photographs, overall: 102 x 208 in. (215.9 x 528.3 cm). Private collection

147. Bertrand II, 1984. Polaroid Polacolor II photographs, overall: 102 x 208 in. (215.9 x 528.3 cm). Private collection

148. Laura Triptych, 1984. Polaroid Polacolor II photographs, 102 x 128 in. (215.9 x 325.1 cm). Private collection

149. Mark Diptych II, 1984. Polaroid Polacolor II photographs, each panel: 80 x 40 in. (203.2 x 101.6 cm). Buhl Collection

151. Sunflower Triptych (alive), 1987. Polaroid Polacolor ER photographs, overall: 102 x 129 in. (259.1 x 327.7 cm). Private collection

279. Bill, 1996. Two Polaroid photographs, each 26 1/2 x 22 in. (67.3 x 55.9 cm). Private collection

280. Julie, 1997. Polaroid photograph, 24 x 20 in. (61 x 50.8 cm). Private collection

280. Willem, 1997. Polaroid photograph, 24 x 20 in. (61 x 50.8 cm). Private collection

280. Judy, 1997. Polaroid photograph, 24 x 20 in. (61 x 50.8 cm). Private collection

284. Untitled Torso Diptych, 2000. Two daguerreotypes, each 8 1/2 x 6 1/2 in. (21.6 x 16.5 cm). Whitney Museum of American Art, New York. Private collection, New York

285. Untitled Torso Diptych, 2000. Two daguerreotypes, each 8 1/2 x 6 1/2 in. (21.6 x 16.5 cm). Whitney Museum of American Art, New York. Private collection

288. Olivier, 2000. Daguerreotype, 8 1/2 x 6 1/2 in. (21.6 x 16.5 cm). Private collection

283. Phil, 2001. Daguerreotype, 8 1/2 x 6 1/2 in. (21.6 x 16.5 cm). Private collection

283. Robert, 2001. Daguerreotype, 8 1/2 x 6 1/2 in. (21.6 x 16.5 cm). Private collection

336. Self-Portrait (5 Part), 2001. Five daguerreotypes, each 8 1/2 x 6 1/2 in. (21.6 x 16.5 cm). Whitney Museum of American Art, New York

282. Self-Portrait, 2002. Daguerreotype, 8 1/2 x 6 1/2 in. (21.6 x 16.5 cm). High Museum of Art, Atlanta

289. Self-Portrait, 2004. Daguerreotype, 8 1/2 x 6 1/2 in. (21.6 x 16.5 cm). Private collection

276. Self-Portrait/Diptych, 2005. Two color Polaroid photographs mounted on aluminum, overall: 103 x 80 in. (261.6 x 203.2 cm). Private collection, New York

281. Self-Portrait/Composite/Six Parts, 2005. Six color Polaroid photographs, overall: 183 x 122 in. (464.8 x 309.9 cm). Private collection

333

INDEX

334

Self-Portrait (5 Part), 2001.
Five daguerreotypes, each 8 1/2 x 6 1/2 in.
(21.6 x 16.5 cm)

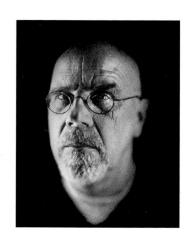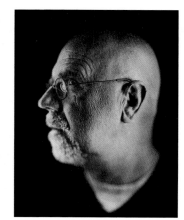

DATE DUE

JUL 0 7 2008	
NOV 3 0 2008	
MAY 0 4 2009	